International Directory of

International Directory of Arts

42nd Edition

International Directory of Art 2018

—

Volume 3

DE GRUYTER
SAUR

Redaktion:
Walter de Gruyter GmbH
Redaktion International Directory of Arts
Rosenheimer Str. 143
81671 München
Tel.: +49 (0)89/76902-316
Fax: +49 (0)89/76902-333
E-mail: artaddress@degruyter.com

Advertising Representatives /
Worldwide:
Walter de Gruyter GmbH
Claudia Neumann
Sales Associate Corporate Clients
Genthiner Str. 13
10785 Berlin
Tel.: +30 (0)30/26005-226
Fax: +30 (0)30/26005-322
E-mail: anzeigen@degruyter.com
http://www.degruyter.com

ISBN 978-3-11-051647-0
e-ISBN 978-3-11-051883-2

Library of Congress Cataloging-in-Publication Data
A CIP catalog record for this book has been applied for at the Library of Congress.

Bibliographic information published by the Deutsche Nationalbibliothek
The Deutsche Nationalbibliothek lists this publication in the Deutsche Nationalbibliografie;
detailed bibliographic data are available on the internet
at http://dnb.d-nb.de.

© 2017 Walter de Gruyter GmbH, Berlin/Boston
Typesetting: M. Wündisch and P. Tanovski, Leipzig
Printed and bound: Hubert & Co GmbH & Co KG, Göttingen
♾ Gedruckt auf säurefreiem Papier
Printed in Germany

www.degruyter.com

Contents

Volume 1

Volume 2

Volume 3

Inhalt

Index of Persons
Register der Personen

Directors, curators, presidents and scientific staff of museums
Direktoren, Kuratoren, Vorsitzende und wissenschaftliche Mitarbeiter der Museen

Grosfeld, Dr. J.F. 031924, 031925
Groß-Morgen, Markus . 021789, 021791
Groß, Helmut 017969
Gross, Jennifer 051195
Gross, Josef 021055
Gross, Martial 041485, 041811
Groß, Martin 001965
Gross, Miriam 051279
Groß, Nicole 021642
Gross, Dr. Raphael 018178
Gross, Renee 051279
Groß, Simone 021968
Groß, Thea 019988
Grossbard, Elayne 046905
Großer, Veronika 021642
Grosshans, Dr. Rainald 016938
Grossi, George 051914
Großkinsky, Dr. Manfred 018177
Grossman, Cissy 051288
Grossman, David J. 047839
Grossman, Grace Cohen 050409
Grossmann, Anna 034555
Großmann, Prof. Dr. G. Ulrich . 020493,
020494, 020518
Grossmann, Robert 015660
Grossmann, Dr. Robert 041666
Grosspietsch, J. 021685, 021686
Grote, Marina 019415
Grote, Dr. Udo 020243, 020244
Grothe, Susann 016872
Grotkamp-Schepers, Dr. Barbara 021497
Grotz, Helmut 021911
Grove, David 052705
Grover, Ruth 047556
Grover, Ryan 048309
Groves, Bonnie Sue 048300
Groves, Elke 050417
Grower, Steve 000930
Grozin, Vladimir 037117
Gruat, Philippe 013344, 014117, 015591
Grubb, Tom 048680
Grube, Prof. Dr. Nikolai. 017259
Grube, Susanne 017274
Gruben, Dr. Eva-Maria 017807
Gruber, F. 002219
Gruber, Franz 002220
Gruber, Dr. Gabriele 017591
Gruber, Herbert 001687
Gruber, Johannes 001992
Gruber, Petra 020725
Gruber, Sabine 021642
Gruber, Wolfgang 001792
Grubessi, Prof. Dr. Odino 027435
Grubler, Mitchell 048726
Grubola, James 050438
Grubola, Prof. James 050425
Grüger, Dr. Andreas 021608
Grün, Dr. G. 041922
Gründler, Ernst 041696
Grüner, Almut 020357, 044664
Grünewald, Dr. Mathilde 022344
Grünewald, Simone 018349
Grünhagen, Martina 017044
Grüning, Karin 041581
Grünwald, Karin ... 019870, 019876
Grünwald, Manfred 002492
Grünzweil, K. 045333
Grütter, Daniel 041698
Grütter, Prof. Heinrich Theodor . 018044,
018054
Grüttner, Marion 019347
Gruetzmacher, Mark 053555
Gruetzner, Sara Jane 005414
Gruffydd, Alun 043297, 044767
Gruhl, Ulrike 020821, 020838
Gruhs, Ernie 005895
Gruijthuijsen, Krist .. 001956, 016986
Grujić, Dragana 038009
Grumme Nielsen, Holger 009863, 010073,
010097, 010098, 010101, 010184,
010186
Grunberg, Evelina 004587
Grund, Dr. Rainer 017762
Grundler, Raymond 013366

Grundmann, Dietmar 019658
Grundmann, Thomas 017266
Grundner, Franz 021323
Grunenberg, Prof. Dr. Christoph . 017366
Grunenberg, Christoph 044744
Grunz, Karin 016922
Grunzweil, Karen 045086
Grusman, V.M. 037642
Gruzdeva, Tatjana Aleksandrovna 037730
Gruzska, Larysa Petrivna 043064
Grygarová, Dominika 009389
Grygiel, Prof. Ryszard 034797
Grygorenko, Iryna Vasylivna .. 042868
Gryka, Jan 034822
Grynszpan, Anna 034624
Grynsztejn, Madeleine 052917
Grys, Dr. Iwona 035194
Gryseels, Guido 003975
Gryspeert, Hans 003577
Grzechca-Mohr, Dr. Ursula ... 016582
Grzesiak, Marion 049775
Grześkowiak, Andrzej 034606
Grzymkowski, Andrzej 034851
Grzymski, Krzysztof 007031
Gschwantler, Dr. Kurt 002943
Gschwendtner, Stefan 002291
Gstöttner, Brigitte 002417
Gstrein, Josef 002087
Gu, Feng 008313
Gu, Jianxiang 007917
Gu, Wenxia 008133
Guadarrama Guevara, Jorge .. 031006
Gual Dolmau, Oriol 038880
Gualdoni, Flaminio 028097
Guardia, Gabriel de la 033994
Guardiola, Juan 038887
Guarino, Dr. Ariberto 027459
Guati Rojo, Prof. Alfredo 031062
Guay, Serge 006653
Guayasamín, Pablo 010317
Gubb, A.A. 038532
Gubbels, J.H.M. 032364
Gubčevskaja, Ljudmila
Aleksandrovna 037715
Gube, Gundula 019160
Gubel, Eric 003414
Gubíková, Mgr. Renáta 009363
Gubin, V.V. 037111
Gubler, Bernhard 041589
Gudelis, V. 030379
Guderzo, Dr. Mario 027256
Gudina, Jurij Volodymyrovyč .. 042983
Gudmundsdottir, Anna Lísa ... 023771
Gudnadóttir, Kristin 023778
Gudnason, Thorarinn 023757
Gudonytė, Alma 030362
Guedj, Gabrielle 013646
Gügel, M.A. Dominik 041664
Güiraldes, Consuelo 000469
Gül, Sebahat 042694
Guelbert de Rosenthal, Eva ... 000466
Güler, M. Güven 042702
Güllüce, Hamza 042634
Güllüoğlu, F. Nevin 042783
Gün, Zeynel 016872
Günaydın, Celal 042607
Gündogdu, Veysel 042602
Gündüz, Yaşar 042748
Guenette, Irene 006923
Guennec, Aude Le 012382
Günter, Werner 020585
Guenther-Sperber, Fabia 022486
Günther, Albert J. 017878
Günther, Bruce 052210
Günther, Clas 040799
Günther, Kurt 021126
Günther, Dr. Meike . 019672, 019682
Günther, Michael 019435
Günther, Dr. Olaf 016339
Günther, Rolf 018237
Günther, Dr. Sigrid 001845
Guenther, Todd 050079
Günther, Wolfgang 021499

Günzler, Lilo 018165
Guerbabi, Ali 000078
Guerber, Steve 047043
Guerci, Prof. Antonio 026255
Guerdy Lissade, Joseph 023078
Guerin, Charles A. 053716
Guerin, Kerry 001382
Guermont, Mauricette 015347
Guerra Pizòn, Olga 010285
Guerra, Jairo 008660
Guerra, Yolanda 008660
Guerrero Cestero, Felipe 039266
Guerrero, Doris 008492
Guerreschi, Prof. Antonio 027737
Guerri, Dr. Roberto ... 026645, 026649,
026651
Guersen, Pascale 014186
Gürtler, Dr. Eleonore 002115
Gürtler, Sonja 021514
Guest, Fiona 044608
Guest, Raechel 054077
Güthner, Dr. Tobias 022069
Guevara Hernández, Jorge ... 031386
Guex, Stéphanie 041450
Güzel, Selahattin 042632
Guezi, Dr. Angela 027898
Guffee, Eddie 052099
Guffee, Patti 052099
Gugelberger, Rachel 051406
Guggenberger, Hannes 002162
Guggenberger, Hans 002196
Gugger, Anna-Lena 041937
Gugier, Pierre 011825
Guheen, Elizabeth 047754, 051025
Guhl, Klaus 041220
Guibal, Jean 011512
Guibert, Etienne 011707
Guichard, Christiane 015256
Guichard, Marie-Claire 013106
Guichard, Vincent 014044
Guichaumon, Jean-Louis 013809
Guichon, Françoise 011386
Guidon, Suzanne 012491
Guidotti, Prof. Francesco 026599
Guidotti, Nives 025514
Guidry, Keith 051699
Guiducci, Dr. Anna Maria 027785
Guiffre, Florence 048733
Guigo, Elsa 014499
Guignon, Emmanuel 015671
Guihaumé, Antoine 015259
Guiheneuf, Bernrd 015230
Guilardian, D. 003387
Guilbaud, Laurence 015949
Guilbert, Manon 005760
Guilbot 013134
Guilbride, Kurt 006025
Guild, John 053390
Guild, John W. 053384
Guilhot, Jean-Olivier 012710
Guillard, Alain 013647
Guillard, Maire-Joe 013188
Guillaume 004058
Guillaut, Laurent 012104
Guillemeteaud, François 011924
Guillemin, Daniel 011542, 013026
Guillemin, Jean-Claude 011810
Guilleminot, Jacques 012259
Guillemot, Hélène 013415
Guillén Jiménez, Marilú 031442
Guillen, Dr. Carlos B. 010426
Guillerme, Lucienne 014170
Guillermo, Joseph 034260
Guilliem Arroyo, Salvador 031024
Guilliod, Raymond 023036
Guillot 013486
Guimarães, Prof. Dr. Edi Mendes 004279
Guinand, Jean 041354
Guinid, Rosario 034326
Guinness, Alison 048568
Guinness, Robert 024800
Guioli, Dr. Simona 025682
Guiotto, Prof. Dr. Mario 027847
guiraud, Louis 016020

Gujan-Dönier, Barbara 041385
Gulas, Karin 003027, 003028
Gulbina, Anna Alekseevna 037865
Gulbrandson, Alvhild 033572
Guldemond, J. 032647
Guljaev, Vladimir Andreevič .. 037333
Gullan, Penny J. 048126
Gullickson, Nancy 048339
Gullickson, Rachel 053188
Gullsvåg, Per Morten 033897
Gulyásné Gömöri, Anikó 023163
Gulyes, Andreas 002976
Gumă, Nicoleta 036187, 036188
Gumlich, Albrecht 041075
Gumnit, Daniel 050871
Gumpert, Lynn 051317
Gunarsa, Dr. Nyoman 024301
Gundacker, Reinhard 003059
Gundel, Dr. Marc ... 018861, 018863,
018864
Gunderson, Catherine F. 006819
Gundler, Dr. Bettina 020169
Gundry, Beverly F. 049304
Gunér, Tullan . 040542, 040543, 040546
Gunjić, Ranko 008743
Gunn, Don 046375
Gunn, Lorna 005949, 005950
Gunnarsson, Ann-Marie 040422
Gunnarsson, Annika 040822
Gunnarsson, Torsten 040825
Gunning, Judy 001500
Guntermann, Erika 019678
Guntermann, Sylvia 017850
Gunther, Uwe 038679
Guo, Erfu 007743
Guo, Kang 008151
Guo, Qinghua 007887
Guo, Xiankun 007484
Guo, Xingjian 007521
Guo, Yu'an 008196
Guo, Zhenghong 008128
Guohua, Gu 007919
Gupta Wiggers, Namita 052204
Gupta, Chitta Ranjandas 023867
Gupta, Preeti 048727
Gupta, V.N. 024029
Gupta, Dr. Vibha 024214
Guralnik, Nehama 025047
Guratzsch, Prof. Dr. Herwig ... 017432,
018544, 021270
Gurba, Norma 050061, 050062
Gurevič, Dr. E. 037275
Gurkina, Tatjana Aleksandrovna 037046
Gurley, Diana 005276
Gurney-Pringle, Chantal 000804
Gurney, George 054037
Gurney, Helen 044438
Gurney, Marilyn 005837
Gursky, Dr. André 018667
Gurtner, Max 002226
Gurtner, Nico 041112
Gusarov, Ass. Prof. Vladimir .. 033671
Guse, Ann 050684
Gusenleitner, Mag. Friedrich .. 002288
Gusenleitner, Mag. Fritz 002277
Gusenleitner, Fritz 002277
Gusev, Vladimir ... 037569, 037570
Gushulak, Ruth 005699
Gusjeva, Svitlana Ivanivna 042997
Guß, Martina 016412
Gust, Donald F. 046856
Gustafson, Donna 047803
Gustafson, Kelli 053248
Gustafsson Ekberg, Kent 040345
Gustafsson, Malin 040455
Gustafsson, Pierre 040944
Gustavson, Carrie 046981
Gustavson, Dr. phil.
Natalia 002946
Gustavson, Todd 052517
Gustin, Marcelo 000517
Gut, Andreas 017913
Gut, Ursula 041708
Gut, Werner 041809

Hirschler, Christa	021513	Hoefnagels, J.	003317	Hoffmann, Claudia	021608	Holcomb, Michael	048584
Hirschlieb, Brandy	052508	Hoegen, Friedrich	020029	Hoffmann, Dr. David Marc	041736	Holcombe, David C.	047771
Hirst, M.	038591	Høgestøl, Mari	033792	Hoffmann, Erika	017061	Holcombe, Holly	047786
Hirst, Marlys	046800	Höglander, Agneta	040689	Hoffmann, Dipl.-Rest. Frauke	017807	Holdcraft, Rose	047333
Hirte, Dr. Markus	021122	Höglmeier, M.A. Barbara	020337	Hoffmann, Heinrich	018738	Holden, Charles	044316
Hirth, Dr. Antoine	011849	Höhl, Dr. Claudia	018946	Hoffmann, Helmut W.	020408	Holden, Florence	047924
Hirvonen, Anna-Riikka	010822, 010823	Høibo, Roy	033482	Hoffmann , Dr. Ingrid-Sibylle	021644	Holden, Rebecca	053154
Hisa, Asuka	053020	Høibo, Roy	033739	Hoffmann, Dr. Ingrid-Sibylle	021137	Holden, Sally	043643
Hiscock, Donna	006740	Høie, Bjørn K.	033618	Hoffmann, Jens	052902	Holden, Steve	048983
Hiscock, E.	043407	Højgaard, Johnny	009902	Hoffmann, Joel M.	050773	Holden, Thomas	048345
Hiscock, Rosella	006548	Hoekstra-van Vuurde, C.J.	032001	Hoffmann, John	047643	Holdenbusch, Heinrich	021148
Hiscox, Margaret	001418	Hoel, Arild	033644	Hoffmann, Dr. Silke	017790	Holderbaum, Linda	046795
Hiss, Elfi	041527	Hoel, Randall	053169	Hoffmann, Susanne	020718	Holding, John	007135
Hita Garcia, Dr. Francisco	017591	Hölderle, Julia	019050	Hoffmann, Dr. Tobias	016884	Holdren, Greg	046937
Hitchmough, Dr. Wendy	044175	Höller, Anette	041080	Hoffmann, Walter	021089	Holdstock, Barry C.	044468
Hite, Andy	052056	Höller, Silvia	002109	Hoffmann, Will	030426	Holdsworth, Jane A.	051457
Hite, Jessie Otto	046661	Höllinger, Mag. Nina	001825	Hoffpauer, Diane	048042	Hole, Frank	051193
Hitov, Peicho	005066	Höllriegl, Renate	001965	Hofgartner, Heimo	001962, 001962	Holečková, Dana	009384
Hittaller, Hans Martin	001764	Hoelscher, Dr. Monika	016324	Hofmacher, Anna	002498	Holeman, Claude A.	048129
Hitzing, Jörg	021001	Höltken, Dr. Thomas	019386	Hofman, Jack	050135	Holen, Dr. Stephen	048222
Hiukka, Toini	011036	Höltl, Georg	020722, 021760	Hofman, O.	024988	Holeva, Daniel	050811
Hjermind, Jesper	010194	Hoeltzel, Susan	047197	Hofmann-Kastner, Dr. Iris	022479	Holian, Sarah	049154
Hjorth, Carl-Gustav	040871	Hölzel, Josef	001752	Hofmann-Randall, Dr. Christina	018009	Holland, J.	001540
Hladky, Michael	051340	Hoelzeman, Buddy	050987	Hofmann, Dr. Alexander	017015	Holland, Kim	051545
Hlaváčková, Dr. Miroslava	009705	Hölzinger, Nora	017598	Hofmann, Andreas	018345	Holland, M.	038559
Hlaváčková, Silvie	009757	Hölzl, Dr. Christian	002943	Hofmann, Dr. B.	041113	Holland, Neil	043113
Hlôška, L.	038305	Hölzl, Martin	016935	Hofmann, Beate Alice	018743, 018744	Holland, Rudolf	022480
Hlusko, Leslea	046908	Hölzl, Dr. Regina	002943	Hofmann, Bernard	047128	Hollander, Barbara J.	046392
Hnateyko, Olha	051403	Hölzl, Prof. Dr. S.	020457	Hofmann, C.	031682	Hollander, Stacy	051251
Ho, Keimei	028723	Höneisen, Markus	041698, 041704	Hofmann, Christa	002973	Hollberg, Dr. Cecilie	026106
Ho, Lynn	046582	Hönggi, Ambras	041558	Hofmann, Gertrud	019249	Holle, Thomas	019811
Hoag, Everett H.	051154	Hoenig, Thomas M.	049843, 049846	Hofmann, Helmut	002321	Hollein, Max	052895, 052896
Hoagland, Glenn D.	049011	Hönigmann-Tempelmayr, Mag.		Hofmann, Irene	051458	Hollender, G.	041960
Hoard, Constance G.	047248	Alexandra	002875, 002877, 002878,	Hofmann, Dr. Jochen Alexander	021192	Holler-Schuster, Günther	001966
Hoare, Adrian D.	046238		002926, 002931, 002997, 002998	Hofmann, Jürgen	019079	Holler, Prof. Dr. Wolfgang	018500,
Hoare, Nell	046177	Höper, Dr. Corinna	021655	Hofmann, Leo	017111		018567, 020663, 022073, 022075,
Hobaugh, J.H.	053051	Höpfner, Martin	016419, 016424, 016425,	Hofmann, Lois	048114		022079, 022080, 022081, 022085,
Hobbs, M.D.	044126		016429, 016431	Hofmann, Nina	017679		022087, 022088, 022089, 022090,
Hobbs, Patricia A.	050214	Höppl, Birgit	020325, 020326	Hofmann, Paul	016880		022092, 022093, 022094, 022095,
Hobein, Beate	018626	Hörack, Dr. Christian	041969	Hofmann, M.A. Rainer	020846		022097, 022199
Hoberg, Dr. Annegret	020227	Hördler, Dr. Stefan	020470	Hofmann, Ramona	022478	Hollerbach, Dr. R.	019362
Hobin, Ellen	005853	Hoerig, Dr. Karl	048738	Hofmann, Sabine	020812	Hollerová, Petra	009287
Hobl, PhDr Dalibor	009483	Hörker, Alois	002076	Hofmeister, Walter	019002	Hollerweger, Johann	002837
Hoboth, Nina	009839	Hörmann, Barbara	018928	Hofstad, Turid	033902	Holleschorsky, Catherine und	
Hobson, Marlena	053397	Hörmann, Fritz	002855	Hofstetter, Adolf	020725	Thomas	019963
Hoch, Manfred	021247	Hörmann, Romed	002092	Hofwolt, Gerald	049505	Hollfelder, Vera	020067, 020068
Hoch, Stefanie	041860	Hörner García, Gabriel	031226	Hogan, Jacqueline	046966	Holliday, Anne	051791
Hochberg, Dr. F.G.	052981	Hoerschelmann, Dr. Antonia	002862	Hogben, Barbara	001101	Holliger, C.	041159
Hochberger, Ernst	019201	Hösch, Jürgen	018176	Hogben, Ian	001101	Hollinetz, Alfred	002809
Hochdörfer, Achim	020199	Hoesgen, Jennifer	005900	Hoge, Robert	051254	Hollingworth, Dr. Brad	052876
Hoche, Frank	018817, 020666	Hoesli, Hans Rudolf	041153	Hogen, Tim	047111	Hollingworth, John	044821
Hochleitner, Dr. Martin	002283, 002585	Høvsgaard, Thomas	010159	Hogenhaug, Gunnar	033817	Hollingworth, Mar	050359
Hochleitner, Dr. Rupert	020204	Høyersten, Erlend G.	033544	Hogue, Kate	049944	Hollister, Robert	050397
Hochreiter, Otto	001955, 001969	Höylä, Risto	010832	Hoguet, Anne	014523	Hollitzer, Tobias	019653, 019866
Hochscheid, Christian	017807	Hofbauer, Erwin	001885	Hohbaum, R.	018375	Holló, Dr. Szilvia Andrea	023671, 023672,
Hochstrasser, Markus	041752	Hofbauer, John D.	046941	Hohberg, Dr. Karin	018457		023673
Hockett, Esther	048303	Hofbauer, Dipl.-Ing. Mag.		Hoheisel-Huxmann, Reinhard	017378	Hollomon, James W.	049302
Hockman, Winnie	006656	Raimund	002211	Hoheisel, Tim	054095	Hollosy, Gyuri	050737
Hodel, Daniel E.	041464	Hofer, Dimitri	041411	Hohenberg, Anita Fürstin von	001714	Holloway, Donald	049153
Hodel, R.	032391	Hofer, Elke	002039	Hohenlohe-Langenburg, Fürst zu	019571,	Holloway, James	044098
Hodge, Anne	024652	Hofer, Ernst	041700		019575	Hollows, Victoria	044235
Hodge, Dr. G. Jeannette	051215	Hofer, Manfred	002117	Hohenlohe-Oehringen, Katharina		Hollwedel, Dr. Alke	019793
Hodge, Katherine	049457	Hofer, Rudolf	002228	Fürstin zu	020349	Holm Sørensen, Bodil	010002
Hodges, Greg A.	052460	Hofer, Verena	041456	Hohenlohe, Prinz Constantin von	021258	Holm, Axel	051484
Hodges, Rhoda	048459	Hoff Jørgensen, Jan	033412	Hohensee, Falko	017703	Hólm, Geir	023752
Hodgins-Wollan, Sonya	005922	Hoff, Dr. Marlise	016974	Hohensee, Wolfgang	019645	Holm, Torben	010162
Hodgson, Beverly	049282	Hoff, Prof. Dr. Ralf von den	018209	Hohl, J.	022103	Holman, Graham	007196
Hodgson, Clarence	005700	Hoff, Svein Olav	033568	Hohmann, H.-J.	018905	Holman, Kurt	051906
Hodgson, Kenneth O.	051481	Hoffberger, Rebecca	046695	Hohmann, Markus	019774	Holman, Robin	050179
Hodgson, Polly	044114	Hofferer, Robert	002309	Hohrath, Daniel	019099	Holman, William M.	048302
Hodgson, Tom	043788, 043790	Hoffert, Tonia	053625	Hohri, Sasha	051268	Holmberg, Lori	050900
Hodkinson, Wendy	045131	Hoffman, Angela	052367	Hohut, Khrystyna	005653	Holmes Helgren, Heidi	047365
Hodslavská, Lenka	009478, 009479	Hoffman, Dan	006325	Hoiman, Dr. Sibylle	016869	Holmes, Carolyn C.	047543
Hodson, Janice	047328	Hoffman, Jill	053889	Hoisington, Rena	049350	Holmes, Dugald	001346
Höbler, Dr. Hans-Joachim	019665	Hoffman, Kate	049587	Hojer, Dr. Anette	021655	Holmes, Meryle	052926
Höfchen, Dr. Heinz	019171	Hoffman, Marilyn	053173	Hokanson, Randee	050988	Holmes, Saira	043383
Hoefer, Denise	053753	Hoffman, Dr. Richard S.	050663	Hol Haugen, Bjørn Sverre	033409	Holmes, Selean	047620
Hoefer, Dieter	017777	Hoffman, Steeven A.	053240	Holahan, Mary F.	054308	Holmes, Willard	049350
Höfer, Dr. Hubert	019209	Hoffman, Thomas	052965	Holahan, Paula M.	050537	Holmesland, Liv	033772
Höfert, Dr. Dorothee	019910	Hoffmann, Dr. Andreas	018685	Holben Ellis, Margaret	051343	Holmgrain, Ardith	051249
Höffer, Dr. Volker	021106	Hoffmann, Anja	017725	Holbrook, Christopher	047938	Holmgren, Bengt	040713
Höfler, Werner Oskar	018877	Hoffmann, Audrey	001623	Holbrook, Maureen	001291	Holmlund, Bertil	011029
Höfliger, Yvonne	041951	Hoffmann, Christa	022362	Holcomb, Grant	052518	Holmsted Olesen, Chritian	010014
Höfling, Eckart Hermann	004644	Hoffmann, Christian	011270	Holcomb, Julie	047974	Holmstrand-Krueger, Lena	040758

Nuber, Dr. W.	020265	Oanh, Phan	054740

Pedersen, Kenno	009889, 010175	Penard, Michel	016093

Pedersen, Kenno 009889, 010175
Pedersen, Knud 010018
Pedersen, Lisbeth 009998
Pedersen, Lykke 010045
Pedersen, Morten 009838
Pederson, T. 010037
Pederson, Curt 050864
Pederson, Jennifer 047680
Pedevillano, Diane 052247
Pedlar, Arthur 054163
Pedley, Maggie 043462
Pedneault, Richard 007159
Pedretti, Cornelia 041682
Pedrini, Dr. Claudia ... 026344, 026345, 026346, 026348, 026349
Pedrocco, Dr. Filippo .. 028115, 028124
Peduzzi, Dr. Paolo 041316
Peebles, Cheryl 007192
Peel, Prof. John S. .. 040912, 040913, 040925
Peele, Anna M. 048845
Peeperkorn-van Donselaar, Dr. L.A. 032620
Peer, Peter 001958, 001966
Peers-Gloyer, Axel 019868
Peers, Elida 006890
Peers, Dr. Laura 045406
Peet, Catherine 043329
Peeters Saenen, E. 003471
Peeters, Herman 003467
Peeters, L. 003239
Peeters, Ludo 003469
Peggie, David 044964
Peić Čaldarović, Dubravka 008871
Peiffer, Jacques 013066
Peik, Karl-Heinz 018714
Peikštenis, Eugenius 030345
Peill, James 043739
Pein, Max Gerrit von 021628
Peine, Christian 016309
Peiry, Lucienne 041415
Peisch, Dr. Sándor 016926
Peischl, Erich 002985
Peitler, Mag. Karl 001972
Peitler, Karl .. 001950, 001961, 002815
Pejčinova, Ekaterina 004892
Pejčochová, Michaela 009655
Pejković, Božidar 008756
Peková, M.A. Kateřina 009389
Peković, Mirko 038007
Peláez Arbeláez, Leopoldo 008468
Peláez Tremols, Dr. Lucía .. 039247, 039252
Pélatan, Martial 011367
Pelch, Andrea 052469
Pełczyk, Antoni 034771
Pelegrini, Dr. Béatrice 041305
Péligry, Christian 014425
Pelikánová, Jaroslava 009562
Pélissié, Gérald 012349
Pelkey, Ann 052095
Pella, Nicholas W. 051671
Pellard, Sandra-Diana 012303
Pellegrinetti, Jerri 006986
Pellegrino, Fabrizio 025995
Pelleman, Lode 003667
Pellen, Robin 043859
Pellew, Robin 044483
Pellmann, Dr. Hans 019873
Pelon-Ribeiro, Laurence 012547
Pelong, Dany 011846
Pelosio, Prof. Giuseppe 027050
Pelser, R. 038690
Pelsers, Dr. L. 032133
Peltier, Cynthia 050172
Pelz, H. 017406
Pelzer-Florack, Stefan 018530
Pemberton, E. 001148
Peña Castillo, Agustín 030958
Peña Javier, Estrellita 034414
Peña Reigosa, Maria Cristina .. 008964
Pena, Dr. Elizabeth 047267
Peñalver Gómez, Henriqueta ... 054700

Penard, Michel 016093
Penati, Fabio 026815
Pence, Debra 049370
Pence, Debra L. 047857
Pence, Noel 049564
Penčev, Prof. Dr. Vladimir ... 005086
Penčeva, Radka 005153
Penda, Octavian Ion 036139
Pendleton, Chris 048810
Penent, Jean 015792, 015793
Penetsdorfer, Christina .. 002578, 002579
Peng, Fang 008404
Peng, Guirong 007906
Peng, Qi 007598
Peng, Shifan 007900
Peng, Yunqiu 007961
Pengzeng, Yuguan 007626
Pénicaud, Pierre 012411
Penick, George 049328
Penick, Steven 052662
Penin, David R. 053549
Pénisson, Elisabeth 014632
Penka, Bradley 049980
Penketh, Sandra 046192
Penkina, Elena Ivanovna 036910
Penkov, Petio 005148, 005149
Penn, Joyce 047959
Penn, Michael 045828
Penna, Liisa 046555
Penna, Dr. Vasso 022562
Pennant 004002
Penndorf, Jutta 016338
Penner, E. Paul 007182
Penner, Jim 006906
Penner, Liisa 046552, 046556
Penney, David 048262
Penney, S.F.J. 006316
Penning, Dr. Mark 038528
Pennington, Claudia L. .. 049907, 049911, 049912
Pennino, Gaetano 027001
Pennock, David 049611
Pennruscoe, Stephen 033030
Penny, Nicholas 044964
Pensabene, Dr. Giovanni ... 026479
Pensom, Carole 005981
Pentangelo, John 046740
Pentrella, Dr. Ruggero 027455
Penvose, Jane 053647
Penzin, Viktor 037260
Penzo, Marta 028073
Pèon, Marie-Thérèse 013758
Peoples, Jo 000772
Peora, Prof. Oscar Carlos ... 000260
Pepall, Rosalind 006257
Pepich, Bruce W. 052347
Pepin, Didier 013322
Pepion, Loretta 047241
Pepper, Myles 044178
Pepper, Victoria 045692
Peppler, Tina 005387
Perac, Jelena 037990
Perales Piqueres, Rosa ... 038994
Peralta Juárez, Juan 038721
Peralta Vidal, Gabriel 007340
Peralta, Juan 034138
Peralta, Prof. Tole 007333
Perano, Jon 033105
Perchinske, Marlene 047864
Percival, Anthony 006707
Percival, Arthur 044165
Perco, Daniela 025786
Percy, Ann B. 051990
Percy, David O. 047523
Perego, Graziella 026309
Pereira Cabral, Augusto J. .. 031631
Pereira de Araujo, J. Hermes .. 004673
Pereira Herrera, David M. 004123
Pereira Neto, Prof. João 035631
Pereira, Maria Isabel de Sousa .. 035371
Pereira, Prof. Sonia Gomes .. 004666
Pereireira Reis, Brasiliano .. 004415
Perelló, Antonia M. 038887
Perencevic, Leni 021857

Perepelkina, Aleksandra Fёdorovna 037707
Perera, Diana 006239
Peretti, Pierre de 014094, 014100
Pereyra Salva de Impini, Prof. Nydia 000612
Pérez Avilés, José Javier 040100, 040103
Pérez Basurto, Alejandro 031007
Pérez Camps, Josep 039524
Perez Castro, Pedro 039847
Perez Gollan, Dr. José Antonio . 000229
Pérez González, Melba 009155
Pérez Gutiérrez, Arturo 031026
Pérez Maldonado, Raúl 023047
Pérez Mejía, Dr. Angela 008433
Pérez Mesuro, Dolores 040062
Pérez Moreno, Rafael 039439
Pérez Navarro, Amalia 039464
Pérez Ornes, Nora 010218
Pérez Outeiriño, Bieito 039930
Pérez Quintana, José Andrés . 008982, 009013
Pérez Recio, Manuel 039367
Pérez Rodríguez, Francisco Javier 039683
Pérez Ruán, Liliana 008661
Pérez Villarreal, Pedro 008635
Pérez, Fernando Alberto 008599
Pérez, Juan Fernando 010326
Pérez, Júlia 038910
Perez, Patricia 034295
Pérez, Rosa María 023057
Pería, Alejandra 031034
Périer-d'Ieteren, C. 003361
Perillat, Shirley 005614
Perin, Giovanni 027761
Périn, Dr. Patrick 015142
Périnet, Francine 006395, 006396
Perini, Mino 027333
Perisho, Sally L. 048214
Perissinotto, Antonio 026510
Perkins, Bruce C. 054377
Perkins, Deborah 053151
Perkins, Diane 045906
Perkins, Karen 045086
Perkins, Martin 048378
Perkins, Sophie 044889
Perkins, Stephen 049190
Perkko, Mariliina 010600, 010602
Perl, Alexander 017428
Perlee, A. 031542, 031549, 031555
Perlein, Gilbert 014282
Perline, Carol 052966
Perlis, Natasha 052893
Perlman, Patsy 046708
Perlov, Dr. Diane 050360
Perlt, Andrea 017817
Pernas Ojeda, Maria Emma .. 031001
Pernicka, Prof. Dr. Ernst 019917
Pernot, M.M. 053681
Pero, Linda 053423
Péron, Christian 014090
Peron, Claude 014198
Perot, Jacques 011887, 012457
Perra, Dr. Carla 025621
Perram, Richard 000829
Perraudin, Marguerite 041454
Perrault, Lise 007093
Perreault, Michel 005917
Perrefort, Dr. Maria 018734
Perren, Stephan 041908
Perrenoud, Raymond 041198
Perret-Sgualdo, Janine ... 041548
Perret, Gilles 041550
Perret, Jean-Claude 013561
Perret, Pascale 041425
Perrier, Dr. Danièle 016556
Perrigo, Thomas E. 001672
Perrine-Dubost 012205
Perron, Jean L. 006757

Perron, Michelle M. 048256
Perrot, Annick 014588
Perrot, C. 014159
Perrot, Mollie 051752
Perroud, Paul 013206
Perry, Andy 050427
Perry, Dr. Barbara 047539
Perry, Bob 046743
Perry, Carole 051575
Perry, Ed 053844
Perry, Gregory P. 051172
Perry, James 053802
Perry, John 054150
Perry, Karen E. 051490
Perry, Michael L. 049145
Perry, Nancy .. 049832, 050506, 052230
Perry, Peter 000950
Perry, Rianne 047564
Perry, Sheila 050671
Persan, Marquis de 012936
Perse, Marcell 019164
Persengieva, Marina 005003
Persson, Ann-Charlotte ... 040676
Persson, Bertil 040606
Persson, Curt 040607
Persson, Dr. Per-Edvin ... 011311
Persson, Sven 040462
Persson, Thomas 040543
Pertin, B. 023997
Pertl, Anton 002804
Pertola, Esko 010840
Péru, Dr. Laurent 014211
Peruga, Iris 054660
Pesarini, Dr. Fausto 026054
Pescaru-Rusu, Adriana 036255, 036306
Pesch, Irmlind 022394
Peschel-Wacha, Claudia .. 003011
Peschel, Dr. Patricia ... 019307
Peschel, Tina 017013
Pešek, Dr. Ladislav 009509
Pesenecker, Marita 018535
Pesi, Dr. Rossana 026479
Pešková, K. 038305
Peso, Jean-Michel del ... 015229
Pesqueira de Esesarte, Prof. Alicia 031150
Pesquer, Dr. Ismael Angulo .. 038715
Pesqueur, Jean-Yves 012113
Pessa, Joanna 051344
Pessa, Loredana 026264
Pessemier 's Gravendries, Paul de 003692
Pessey-Lux, Aude 011409
Pessina, Flavio 025304
Pessler, Monika 003000
Pessoa, Miguel 035472
Pessy, Emanuelle 015539
Pestel, Michael 052070
Pestiaux, Pierre 003765
Petchey, Tim 046168
Peter, Carolyn 050372
Peter, Christopher 038644, 038645
Peter, Dr. Frank-Manuel .. 019354
Peter, Jack 052651
Péter, Dr. László 023507
Peter, Dr. Markus 041041
Peter, Dr. Michael 041632
Peter, Nicole 041762
Petercsák, Dr. Tivadar . 023290, 023295, 023297, 023298
Peterposten, Carlo 041000
Peters Bowron, Edgar .. 049545
Peters-Schildgen, Dr. Susanne . 020910
Peters, Dr. Dirk J. 017378
Peters, Georg 018755
Peters, Dr. Gustav 017285
Peters, Irmtrude 017807
Peters, Weihbischof Jörg ... 021789
Peters, M. 032069
Peters, Michael 022283
Peters, Ted H. 052100
Peters, Dr. Ursula 020493
Peters, W. 005412

Radigois, Bertrand ... 013614, 013615
Radigonda, Ron 051645
Radin, Saul 047203
Radins, A. 030033
Radivojec, Milenko 004187
Radivojević, Milan 038008
Radley, Seán 024769
Radojičić, Milica 004174
Radovanović, Dragan 031577
Radović, Andelija 038007
Radović, Mate 008783
Radovič, Roman Bogdanovyč .. 042984
Radrizzani, Dominique 041844
Radschinski, Margitta 022467
Radtke, Edward 034779
Radulescu, Speranta 036152
Radulović, Ksenija 037989
Radut, Ion 036248
Radwan, Krzysztof 034729
Radycki, Dr. Diane 046933
Radzak, Lee 053747
Radzina, K. 030050
Raeder, Dr. Joachim 019284
Raemdonck, André 003401
Raemy Tournelle, Lic. Phil.
Carine 041429
Raetzer, Maren 018742
Rafal, Jasko 034559
Rafanelli, Dr. Simona 028178
Rafey, Souhad 051249
Raff, Lisa-Maria 021655
Raffaelli, Prof. Mauro 026126
Raffel, Suhanya 001500
Rafferty, Pauline ... 007148, 007156
Raffetseder, Christa 002353
Rafuse, Linda 006077, 006078
Ragan, Charlotte 047370
Ragbir, Ivar 050972
Ragionieri, Dr. Pina 026090
Ragni, Dr. Elena 025479
Ragon, Jacques 015218
Ragsdale, Tammie 050501
Raguindin, Ethelinda A. 034266
Rahaman, F. 024175
Rahe, Diane 049475
Rahe, Gebhard 021202
Rahe, Dr. Thomas 019768
Rahlff, Reiner 018086, 018087
Rahman-Steinert, Uta 017015
Rahmani, Dr. A.R. 024102
Rahmatulaev, I. 054574
Rahn, Kathleen 018761
Rahner, Stefan 018728
Rahoult, Lena 040791
Raič, Kristijan Dragan 008740
Raiger, Johann 020163
Raihle, Jan 040422
Raimond, Jean-Bernard 011788
Raimondi, Dr. Ludovico 026295
Rainbow, Prof. P. 044967
Rainer, Mag. Gerhard Florian . 003012
Rainer, Werner 002763
Raineri, Maguerite 049986
Raines, James L. 052812
Raines, K. 006137
Rainger, Don 045130
Rainsbury, Anne 043725
Rais, Dagmar 006302
Raisor, Jerry 052440
Raiss, Gerhard 018022
Rait, Eleanor 049397
Raith, Robert 017695
Raithel, Andreas 020276
Rajaej, Dr. Hossein 021654
Rajaram, K. 024131
Rajchevska, Tsvetana 005086
Rajić, Delfina 038010
Rajkinski, Dr. Ivan 005163, 005165
Rajkovic-Kamara, Julia 018190
Rajkumar, Kimcha 005803
Rak, Natalija Egorovna 037366
Rakonjac, Srdjan 037990
Rákossy, Anna 023149
Rakotoarisoa, Jean-Aimé 030468

Rakowitz, Mag. Dietlinde 001722
Raku XV, Kichizaemon 028792
Ral'čenko, Iryna Grygorivna .. 042853
Ralčev, Prof. Georgi 005093
Ralli, Efterpi 022616
Ralls, Nick 043372
Ralph, Honeycutt 047313
Ralston, B. 032962
Ramachandran, V.S. 024059
Ramade, Patrick 012095
Ramaekers, M.T. ... 003961, 003962
Ramalho, Prof. Dr. Miguel
Magalhães 035634
Raman, Anna 042668
Rambelli, Faustolo 026554
Rambourg, Bernard 014848
Rambow, Charles 048804
Rameder, Mag. Bernhard 001904
Ramesh, J. 023807
Ramet, Guy 004045
Ramet, Nathan 003777
Ramey, Marilyn 047966
Ramhorn, Amber 049716
Ramirez Casali, María Eliana . 007359
Ramírez de Lara, Ligia 008508
Ramírez Hernández, Jose Luis . 031344
Ramírez, Angel Antonio 008532
Ramirez, Jan 051371
Ramírez, Joe 047418
Ramírez, José Juan 040019
Ramírez, Marcela E. 030986
Ramírez, Mari Carmen 049545
Ramirez, Dr. Rey 054161
Ramírez, Suny 030826
Ramón Vilarasau, Sandra 054654
Ramon, René 043958
Ramond, Serge 015970
Ramond, Sylvie 013741
Ramoneda, Josep 038871
Ramoneda, Prof. Luis Alberto . 000383
Ramos Fernández, Dr. Rafael . 039176
Ramos Horta, Dr. José 010241
Ramos Pérez, Froilán 030942
Ramos Ruíz, Martha 008569
Ramos, Dr. Manuel Francisco
Castelo 035863
Ramos, Margarida 035648
Ramos, Salome D. 034436
Rampazzi, Filippo 041459
Ramsauer, Dr. Gabriele 002576, 002577
Ramsay, Gael 000816
Ramsay, Peter 001316
Ramsay, Susan 006910
Ramsden, Alan R. 006322
Ramsden, William 053458, 053461
Ramsey, Ron 001352
Ramsey, Steve 051510
Ramseyer, Anne 041552
Ramseyer, Dr. Denis 041355
Ramseyer, Stéphane 041429
Ramskjaer, Liv 033678
Ramsour, Bruce 046648
Ramus, Lourdes I. 035994
Ramuschi, Maria Cristina 027986
Ramut, Eliza 034456
Rana, A.K. 023900
Ranade, Dr. Hari Govind 024143
Ranaldi, Prof. Franco 027257
Rand, Michael 054102
Rand, Patrick 047810
Rand, Richard 054294
Randall, M. 038678
Randall, Partricia J. 053403
Randall, R. Dennis 049559
Randall, Ross 046366
Randall, Tori 052875
Randazzo, Giuseppe 027017
Randić Barlek, Mirjana 008861
Randin, Christophe 041427
Randow, Renate von 022210
Raney, Floyd 050289
Rangaraju, Dr. N.S. 024110
Range, Romy 020817
Rangström, Lena 040816

Raninen-Siiskonen, Tarja 010743,
010744
Ranjbaran, Sa'eid 024441
Rank-Beauchamp, Elizabeth . 053169
Rank, Karin 018203
Rankadi, Daniel 038490
Rankin, Gary 043677
Rankin, John L. 005863
Rankin, Marty 046889
Rankin jr, P.R. 048510
Rankin, Ray 044840
Rankin, Shan 048438
Ransom, Karen 051594
Ransome Wallis, Rosemary .. 044878
Ranšová, Eva 009566
Rantanen, Reijo 011332
Ranweiller, Margaret 052511
Rao, D.V. 024148
Rapetti, Rodolphe 014586
Rapisarda, Alfredo Pablo 000666
Rapkin, Grace 051328
Rapmund, J. 032647
Raposo, Luís 035639
Rappe-Weber, Dr. Susanne .. 022295
Rappe, Dr. des. Felicia 017039
Raptou, E. 009256
Raptou, Dr. Eustathios 009276
Ras-Dürschner, Dr. Kerstin ... 017379
Rasajski, Javor 038078
Rasario, Dr. Giovanna 026131
Rasbach, Dr. Gabriele 019476
Rasbury, Patricia 051116
Rasch, Elisabeth 040907
Rasch, Simone 020848
Rasch, Tone 033678
Rasche, Dr. Adelheid 016978
Rash, Roswitha M. ... 051924, 051927
Rasjid, A. 024306
Rask, Sven 009925
Rasmussen, Alan H. 009996
Rasmussen, Else 010020
Rasmussen, Jan 052022
Rasmussen, Keith 049987
Rasmussen, Dr. Pamela C. ... 048401
Rasmussen, Per A. 010103
Rasmussen, Robert 051890
Rasmussen, William 052465
Rasmussen, Allan 040980
Raspail, Thierry 013735
Rasser, Dr. Michael 021654
Rasson, Camille 003250
Rassweiler, Janet 051414
Rast, Hansruedi 041568
Rašticová, Dr. Blanka 009772
Rastorguyeva, Olga 036681
Rataiczyk, Matthias 018672
Ratajczak, Rafał 034972
Ratchford, Siobhan 043964
Ratcliffe, Shirley 043785
Rath, Andreas 003016
Rath, H. 021259
Rath, I. 021259
Rath, Lydia 018992
Rathbone, Eliza 054034
Rathburn, Robert R. 046975
Rathgeb, Dr. Sabine 019443
Rathore, Dr. Madhulika 023853
Raths, Ralf 020266
Ratier, Hugo 000476
Ratković-Bukovčan, mr. sc. Lada 008880
Ratner, Phillip 025058
Ratnikova, Marina Semënovna . 037898
Rattemeyer, Dr. Volker 022225
Rattenbury, Richard 051644
Ratti, Dr. Enrico 028133
Ratti, Dr. Marzia 026378
Ratti, Pietro 026375
Rattigan, John 024693
Ratzeburg, Wiebke ... 021817, 021856
Ratzenböck, Hans-Jörg 002278
Ratzky, Dr. Rita 023222
Rau, Armin 017663, 017664
Rau, Gudrun 018910

Rau, Lorraine 048688
Rau, Dr. Patrick 019431
Rauch, Alexandra 016448
Rauch, Elvira 022137
Rauch, L. 041719
Rauch, Peder 041720
Rauch, Werner 014395
Rauchbauer, Judith von 016371
Rauchenwald, Alexandra 001727
Raud, Anu 010441
Raudsepa, Ingrida 030002
Raudsepp, Renita 010497
Rauer, Helmut 017950
Rauf, Barb 048027
Rauhut, Prof. Dr. Oliver 020210
Raulff, Prof. Dr. Ulrich . 019923, 019925
Raunio, Erkki 010587
Rauø, Kåre William 033424
Raus, Edmund 050557
Rausch, Amalia 003056
Rausch, Guy 030420
Rausch, Jürgen 020734
Rauschenberg, Chris 052196
Rauschmann, PD Dr. Michael . 018154
Rausis, Jean-Pierre 041655
Raussmüller-Sauer, Christel .. 041695
Raussmüller, Urs 041695
Rauter Plančić, Biserka 008878
Rauter, Dietmar 002180
Rautjoki, Ville-Matti 010899
Rauzi, Prof. Estebar 000479
Ravanelli Guidotti, Dr. Carmen . 026023
Ravaonatoandro, Aldine 030470
Ravasi, Prof. Gianfranco 026666
Ravasio, Dr. Tiziana 025313
Raved, Noga 024847
Raveendran, K. 024193
Raveh, Kurt 024979
Ravel, Christian 013800
Ravelo Virgen, Margarita 031442
Ravenal, John 052466
Ravenswaay van, Dr. Lange ... 017929
Raverty, Norm 001047
Ravid, Zami 024974
Raviv, Efraim 024994
Ravnik Toman, Barbara 038315, 038316,
038350, 038351, 038352, 038440
Ravoire, Olivier 014386
Ravonatoandro, Aldine 030469
Raw, Jo 043191
Rawdon, David D. 038603
Rawe, Dr. Kai 020146
Rawle, Caroline 046104
Rawles III, S. Waite 052458
Rawlinson, Philippa 045453
Rawluk-Raus, Bożena 035003
Rawson, Geoff 001571
Rawson, Helen 045647
Rawstern, Sherri 046269
Rawsthorn, Alice 044854
Ray, Dulce Ivette 048864
Ray, Dr. Ella Maria 048222
Ray, Jeffrey 051940
Ray, Justice A.N. 024047
Ray, Randy W. 049540
Ray, Romita 046563
Ray, Sandra 046539
Rayburn, Ella S. 053104
Raymond, André 003878
Raymond, Dr. C. 048557
Raymond, Richard 054466
Raymond, Yves 006711
Raymond, Yvette 005940
Rayne, Angela 048607
Rayworth, Shelagh F. 006901
Razafindratsima, Clarisse 030473
Razzaq Moaz, Dr. Abdal 041981
Read, Albert J. 051689
Read, Bob 050125
Read, Judith 000994
Read, Peter 033008
Read, Robert F. 048062
Real, Nelson A. 000369
Reale, Giuseppe 026826

Sangvichien, Prof. Sood M.D. –
Schall Agnew, Ellen

Index of Persons

Index of Institutions and Companies
Register der Institutionen und Firmen

"A Schiewesch" Musée Rural,
Binsfeld 030394
008 Antiquités, Paris 070803
02 Gallery, Akureyri 109222
1 2 3 . . Art Now, Bruxelles . . 100398
1 Artshop, Frechen 075784
The 1 Gallery, Kingston-upon-
Hull 118265
1 Over 1a Gallery, Denver 120955
I. Türkiye Büyük Millet Meclisi Binası,
Ankara Kurtuluş Savaşı Müzesi,
Ankara 042542
1. Deutsches Bockbier-Museum,
Taucha 021709
1. Deutsches Bratwurstmuseum, Amt
Wachsenburg 016381
10 Chancery Lane Gallery, Hong
Kong 101915
100 kubik, Raum für spanische Kunst,
Köln 107570
100 Mile & District Historical Society,
100 Mile House 005203
100 Titres, Bruxelles 100399
100% Natural, Cancún 132739
1000 et 1 Collections, Montluçon 070212
1000 Objekte, Zürich 087727
De 1001 Dingenhal, Alkmaar . 082427
100th Bomb Group Memorial Museum,
Dickleburgh 043906
The 100th Meridian Museum,
Cozad 048012
103ans Antik och Kuriosa,
Sävedalen 086733
103rd Ohio Volunteer Infantry Civil
War Museum, Sheffield Lake . 053181
104 Antiques & Collectables,
Regina 064490
106 South Division Gallery, Calvin
College, Grand Rapids 049151
1066 Battle of Hastings Battlefield,
Abbey and Visitor Centre, Battle 043287
107 Workshop Gallery, Shaw . 119337
1078 Gallery, Chico 047670
108 Fine Art, Harrogate 118113
10th Avenue Antiques, Calgary . 064189
111 Place Gift Antiques, Tulsa . 097539
11th Avenue Grafic Visuals,
Regina 101389
12 Sedie, Torino 081472
12 Vancouver Service Battalion
Museum, Richmond 006639
121 Photography Gallery, San
Antonio 124249
1220 Productions, Los Angeles . 121698
123 Watts Gallery, New York . . 122508
1301 PE, Los Angeles 121699
13th Street Gallery, Omaha . . . 123551
14–1 Galerie, Stuttgart 108689
14 Sculptors Gallery, New York . 122509
1405 Art Gallery, New York . . . 122510
145 Antiques, New York 095019
14th Street Painters, New York . 122511,
122512
150 ans de Couture, Aix-les-
Bains 011385
15th Field Artillery Regiment Museum,
Vancouver 007095
15th Street Gallery, Salt Lake
City 124189
15th/19th The King's Royal Hussars
Museum, A Soldier's Life at The
Newcastle Discovery Museum,
Newcastle-upon-Tyne 045278
16th Street Gallery, Salt Lake
City 124190
17 Reasons, San Francisco 124446
17 Wing Heritage Collection,
Winnipeg 007248
1708 Gallery, Richmond 123962
1719 Galerie, Alkmaar 112178
XVIII. Kerületi Pedagógiai és
Helytörténeti Gyűjtemény,
Budapest 023134
The 1811 Old Lincoln County Jail

and 1839 Jailer's House Museum,
Wiscasset 054379
1822-Forum Frankfurter Sparkasse,
Frankfurt am Main 018144
1839 Contemporary Gallery,
Taipei 116975
1859 Jail-Marshal's Home and
Museum, Independence 049620
1874 House Antiques, Portland . 096183
1890 House-Museum and Center for
Arts, Cortland 047976
18m Galerie, Berlin 106085
19 Princelet Street, London . . . 044783
19 Vek, Sankt-Peterburg 085056
19. Sajandi Tartu Linnakodaniku
Muuseum, Tartu 010518
1900–1970, Bruxelles 063238
1908 Cash Register, Tampa . . . 097367
1910 Boomtown, Western
Development Museum,
Saskatoon 006808
1914 Plant City High School
Community Exhibition, Plant
City 052101
1918 Artspace, Shanghai 102061
1940s Swansea Bay, Swansea . 045923
198 Gallery, London 044784
1997 Avrupa'da Yılın Müzesi, Anadolu
Medeniyetleri Müzesi, Atpazarı 042567
19th Century Shop, Baltimore . . 144717
19th Century Willowbrook Village,
Newfield 051439
1blick – Galerie im Vorhaus –
Kunstprojekt, Hallein 099890
1st.iKON, Incheon 111631
2–28 Memorial Museum, Taipei 042217
2 Effe, Trento 111046
2 Erre, Modena 131947
2 Ravens, Kirkby Stephen 144266
II. Türkiye Büyük Millet Meclisi Binası,
Cumhuriyet Müzesi, Ankara . 042543
2 Willow Road, London 044785
2+3D.Grafika plus produkt,
Kraków 138991
20 Hoxton Square Projects,
London 118377
20 North Gallery, Toledo 124930
20/20, Dublin 138824
20/21 British Art Fair, London . 098183
20/21 International Art Fair,
London 098184
2000 & Novecento, Reggio
Emilia 110723
2000 Art Galleries, Sydney 099620
2000 Cadres & Idées, Paris . . 129119
2000 Ciutat Vella, Barcelona . . 133450
2023 Antiques, Louisville 094347
2040 Gallery, Austin 119913
20first Century Art, Godalming . 118061
20th Century Antiques,
Vancouver 064733
20th Century Consortium, Kansas
City 127538
20th Century Gallery, Baltimore . 092119
20th Street Art Gallery,
Sacramento 123999
21 Grand Gallery, Oakland . . . 123491
21 Notre Dame O, Montréal . . . 064301
21-seiki Gendai Bijutsukan,
Kanazawa 028583
21_21 Design Sight, Tokyo . . . 029303
217 Art Contemporain, La Croix-de-
Rozon 116329
21er Haus – Museum für
zeitgenössische Kunst, Wien . 002861
21st Centuary Gallery, Bungay . 117610
21st Century Antics, Salisbury . 091070
21st Century Bob, San Diego . 096882
221 Antiques, Forest 127490
222 Westlake Antique Mall,
Seattle 097219
23rd Street Antique Mall, Oklahoma
City 095758
24 Carat, Damascus 087822

24 Hour Museum, The National Virtual
Museum, Brighton 139155
243 Decorative Antiques, London 089683
24HR Art, Northern Territory Centre
for Contemporary Art, Parap . 001392
26 Martyrs Museum, Nagasaki . 028900
269 Antiques, London 089684
26th Field Regiment and XII Manitoba
Dragoons Museum, Brandon . 005354
274 Gallery, Northbridge, Western
Australia 099349
275 Antiques, London 089685
Le 29, L'Isle-sur-la-Sorgue 069493
29 Palms, Fresno 093323
291 Antiques, London 089686
2AH, Grenoble 068651
2bis Editions, Paris 137120
2X de Afstand, Zaltbommel . . . 112808
3 – Fil, Bari 079647
3 Arts Studio, Honolulu 093354
3 Chairs, Wellington 133127
3 Day Gallery, Dallas . 120810, 120811
3 Falk Gallery, Tucson 124954
3 Monkeys, Portland 096184
3 Punts Galerie, Berlin 106086
3 Ten Haustudio, Atlanta 119809
3 Vue Gallery, Chicago 120300
303 Gallery, New York 122513
313 Antiques, London 089687
313 Art Space, Seoul 111643
33rd Street Galleria, New York . 122514,
122515
34., Beograd 085151
364 Hayes Street Gallery, San
Francisco 124447
3AR, Versailles 129564
3Arts, Three Art Clubs of Chicago,
Chicago 120301
3d Gallery, Bristol 117567
3F, Versailles 073999
Le 3L, Toulon (Var) 129510
3M Collection of Contemporary
Western and Americana Art, Long
Lake 050333
4 Antiques, Nelson 083855
4 Art, Chicago 120302
4 Cats Gallery, Abbotsford . . . 098458
4-H Schoolhouse Museum,
Clarion 047726
4 Ladies Art Gallery, Chicago . 120303
4 Star Gallery, Indianapolis . . . 121439
40 George Street Contemporary Art,
Mount Eden 083842
401contemporary, Berlin 106087
41 Artecontemporanea, Torino . 110968
43rd Street Gallery, Richmond . 123963
45 Southside Gallery, Plymouth . 119143
4599 Antiques, Miami 094508
45th Infantry Division Museum,
Oklahoma City 051638
4731 Gallery, Detroit 121074
48th Highlands Museum, Toronto 006987
The 4th Floor Gallery, Surry Hills 099603
4th Infantry Division Museum, Fort
Hood 048773
5 + 5, New York 122516
5 Art, Tampa 124872
5 Clock Gallery, Lausanne . . . 116501
Le 5 Elément, Paris 140974
5 Elemente Museum, Waidhofen an
der Ybbs 002822
5 Green Boxes, Denver 120956
5 o.p.t. studio, Hong Kong . . . 101916
5-Star Collectibles, Honolulu . . 093355
50 Penn Place Art Gallery, Oklahoma
City 123522
500 X Gallery, Dallas 120812
50er Jahre Erlebniswelt,
Zusmarshausen 022480
50er-Jahre-Museum, Büdingen . 017433
511 Gallery, Lake Placid 121604
511 Gallery, New York 122517
515, Phoenix 123725
51st Avenue Art, Calgary 101074

539 Gallery, New Orleans 122359
54 the Gallery, London 118378
56 Gallery, Milano 110243
575 Wandsworth Road, London 044786
57th Street Antique Mall,
Sacramento 096425
5BE Gallery, New York 122518
5th and J Antiques, San Diego . 096883
5th Avenue Books, San Diego . . 145253
6 B Antik og Brocante,
København 065750
600 Jahre Kunst – Kunstsammlung
der Universität Leipzig, Kustodie der
Universität Leipzig, Leipzig . . 019637
602 Squadron Museum, Glasgow 044230
62 Ponsonby Vintage & Retro,
Auckland 083561
626 Art Gallery, Los Angeles . . . 121700
63 Sky Art, 63 Square, Seoul . . 111644
64 Steps, Toronto 101419
66 Cuadros, Valencia 115568
7 Galerie, Athinai 109025
7 Hammersmith Terrace, London 044787
El 7 Peus, Barcelona 085534
7. Antykwariat, Warszawa 143323
779, Paris 104391
799 Art Gallery, New York 122519
7th Avenue Antique Mall, Saint
Paul 096633
80 The Gallery, Richmond,
Surrey 119214
80 Washington Square East Gallery,
New York University, New York 051246
82 Republic, Hong Kong 101917
824 Gallery, Jacksonville 121507
825 Art, Denver 120957
825 Gallery, San José 102378
82nd Airborne Division War Memorial
Museum, Fort Bragg 048747
82nd Street Beanies,
Indianapolis 093679
84th Street Antiques Corporation, New
York 095020
871 Fine Arts, San Francisco . . 124448,
145272
88-Gallery, Antwerpen 100334
88-Gallery, London 118379
901 Gallery, Fort Worth 121129
918 Antique Gallery, Los Angeles 094071
921 Earthquake Museum, National
Museum of Natural Science,
Kengkou 042097
99° Art Center, Taipei 116976
9Art, Chiangrai 117061
A & A, Osnabrück 077877
A & A, Paris 065387
A & A Antique Restoration, Long
Beach 136039
A & A Antiques, Milwaukee . . . 094658,
127590
A & A Antiques, Pittsburgh . . . 096084
A & A Art, Denver 120958
A & A Art and Frame,
Washington 125093
A & A Upholstery Company, San
Antonio 136588
A & A Upholstry, New Orleans . . 136202
A & B Antique Furniture,
Albuquerque 091857
A & B Antique Furniture, San
Antonio 136589
A & B Antiques, Hampton 061578
A & B World Coins and Antiques,
Chicago 092479
A & C, Zeuthen 079047
A & C Upholstry, San Francisco 136640
A & D Antiquity, Birmingham . . 092214
A & D Gallery, London 118380
A & E Armitage Antique Gallery,
Chicago 092480, 135749
A & E Downtown Antiques, San
Antonio 096767
A & F Galleries, Tweed Heads
South 099706

Académie Internationale des Arts et Collections, Paris 058554
Académie Libanaise des Beaux-Arts, Université de Balamand, Beirut 056059
Académie Libanaise des Beaux-Arts, Université de Balamand, Deir El-Balamand 056063
Academie Noord, Brasschaat . . 054930
Academie Noord, Filiaal Essen, Essen 054946
Academie Noord, Filiaal Schilde, Schilde 054979
Academie Noord, Filiaal Stabroek, Stabroek 054983
Académie Noord, Filiaal Wuustwezel, Wuustwezel 054994
Académie Royale des Beaux-Arts, Liège 054964
Académie Royale des Beaux-Arts de Bruxelles, École Supérieure des Arts, Bruxelles 054934
Académie Royale des Sciences, des Lettres et des Beaux-Arts de Belgique, Bruxelles 054935
Academie Salesienne Conservatoire d'Art et d'Histoire, Annecy . . . 011487
Academie van Bouwkunst, Groningen 056118
Academie van Bouwkunst Amsterdam, Amsterdamse Hogeschool voor de Kunsten, Amsterdam 056109
Academie voor Beeldende Kunsten Mol, Mol 054970
Academie voor Beeldende Vorming, Harelbeke 054953
Academie voor Beeldende Vorming, Amsterdamse Hogeschool voor de Kunsten, Amsterdam 056110
Academie voor Schone Kunsten, Brugge 054931
Academie voor Schone Kunsten, Turnhout 054987
Academisch Historisch Museum van de Universiteit Leiden, Leiden . 032399
Academy Art Museum, Easton . 048414
Academy Billiard Company, West Byfleet 091643
Academy Fine Books, Las Vegas 144941
Academy Fireplaces, Dublin . . 079412
Academy Galleries, Wellington . . 033166
The Academy Gallery, Beverly Hills 046940
Academy Gallery, New Orleans
Academy of Fine Arts, New Orleans 051213
Academy Hall Museum of the Rocky Hill Historical Society, Rocky Hill 052556
Academy of Art Gallery, New York 051247
Academy of Art University, San Francisco 057812
Academy of Arts of the Ukraine, Kyïv 056450
Academy of Arts of Uzbekistan, Toshkent 058109
Academy of Fine Arts, Kolkata . 055742, 109406
Academy of Fine Arts, Tirupati . 055773
Academy of Fine Arts and Literature, Delhi 109313
Academy of Fine Arts Museum, Kolkata 024039
Academy of Natural Sciences of Philadelphia Museum, Philadelphia 051932
Academy of Spherical Arts, Toronto 006988
Academy of Wall Artistry, Alexandria 056596, 119798
Academy Picture Restorations, Sydney 127955
Academy Upholstery, Hull 134800
Acadia Art & Rare Books,

Toronto 140356
Acadia University Art Gallery, Wolfville 007295
L'Acajou, Beirut 082082
Acajou, Liège 128325
Acajou Bambou, Paris 070820
Acala Gallery, Bangkok 117016
Acanthe, Ambert 066488
Acanthe, Auch 066737
Acanthe, La Varenne-Saint-Hilaire 069060
Acanthe, Le Vésinet 069316
Acanthe, Nice 070494
Acanthe, Saint-Raphaël 073245
Acanthe, Vannes (Morbihan) . . . 073926
Acanthe, Versailles 074001
Acanthe Antiquités, Grenoble . . 068652
Acanthus, Cincinnati 092658
Acanthus, Twello 133021
Acanthus, Utrecht 143049
Acanthus & Reed, New York . . . 122528
Acanthus Ancient Art, New York 095029
Acanthus Gilding & Restoration, Norwich 135231
Acanthus Leaf Antiques, Houston 093418
Acanthus Press, New York 138424
Acanto, Almeria 114424
Acanto, Donostia-San Sebastián 133598
Acanto, Roma 081024
Acantus Antik, Liseleje 065915
A'capella Galleri, Köpingsvik . . 115808
Acapulco Arte Galeria, Bogotá . 102169
ACC Galerie Weimar, Weimar . . 108874
Accademia Albertina di Belle Arti, Torino 055931
Accademia Angelica Costantiniana di Lettere Arti e Scienze, Roma . 055908
Accademia Carrara di Belle Arti, Bergamo 055814
Accademia dei Concordi, Rovigo 055925
Accademia dei Virtuosi, Roma . . 142614
Accademia del Libro Usato San Gallo, Firenze 142481
Accademia di Architettura, Università della Svizzera Italiana, Mendrisio 056397
Accademia di Belle Arti, Bologna 055816
Accademia di Belle Arti, Carrara 055821
Accademia di Belle Arti, Catanzaro 055827
Accademia di Belle Arti, Frosinone 055850
Accademia di Belle Arti Aldo Galli, Como 055829
Accademia di Belle Arti Cuneo, Cuneo 055830
Accademia di Belle Arti dell'Aquila, L'Aquila 055857
Accademia di Belle Arti di Bari, Bari 055813
Accademia di Belle Arti di Brera, Milano 055865
Accademia di Belle Arti di Catania, Catania 055825
Accademia di Belle Arti di Firenze, Firenze 055834
Accademia di Belle Arti di Foggia, Foggia 055848
Accademia di Belle Arti di Lecce, Lecce 055859
Accademia di Belle Arti di Livorno, Livorno 055863
Accademia di Belle Arti di Macerata, Macerata 055864
Accademia di Belle Arti di Napoli, Napoli 055881
Accademia di Belle Arti di Palermo, Palermo 055889
Accademia di Belle Arti di Ravenna, Ravenna 055904
Accademia di Belle Arti di Reggio Calabria, Reggio Calabria . . . 055905
Accademia di Belle Arti di Roma, Roma 055909

Accademia di Belle Arti di San Remo, Istituto I. Duncan, Pavia . . . 055894
Accademia di Belle Arti di Sassari, Sassari 055928
Accademia di Belle Arti di Urbino, Urbino 055934
Accademia di Belle Arti di Venezia, Venezia 055939
Accademia di Belle arti e Restauro Nike, Catania 055826
Accademia di Belle Arti Fidia di Stefanaconi, Stefanaconi . . . 055929
Accademia di Belle Arti G.B. Cignaroli e Scuola Brenzoni, Verona . . . 055945
Accademia di Belle Arti Lorenzo da Viterbo – ABAV, Viterbo 055947
Accademia di Belle Arti Michelangelo di Agrigento, Agrigento 055809
Accademia di Belle Arti Picasso di Palermo, Palermo 055890
Accademia di Belle Arti Pietro Vannucci, Perugia 055898
Accademia di Belle Arti Santa Giulia di Brescia, Brescia 055817
Accademia Giacinto Gigante, Napoli 110530
Accademia Internazionale d'Arte Moderna, Roma 055910
Accademia Italiana di Restauro, Milano 055866
Accademia Ligustica di Belle Arti di Genova, Genova 055852
Accademia Nazionale dei Lincei, Roma 055911
Accademia Nazionale di Belle Arti, Parma 055892
Accademia Petrarca di Lettere, Arte e Scienze, Arezzo 055810
Accademia Tedesca Roma Villa Massimo, Roma 055912
Accart, Paris 104400
Accent Antiques, Austin 092038
Accent Arts, Minneapolis 122239
Accent Asia, Chicago 092486
Accent Fine Art, Phoenix 123726
Accent Fine Gifts, Phoenix 123727
Accent Gallery, Wembley 099736
Accent Office Art, Dallas 120813
Accent on, Portland 096185
Accent on Antiques, Pittsburgh . 096087
Accent on Books, Wellington . . . 143171
Accent on Design, Philadelphia . 095907
Accent Your Home, Jacksonville 093781
Accents and Beyond Consignment, Minneapolis 094724
Accents Antiques, Miami 094512
Accents Toniques, Marseille . . . 140899
Accès Bijoux, Montréal 064303
Access Art, Auckland 112830
Access Art, West Perth 127967
Access Artisans, New York 122529
AccessArts, Lefkosia 055223
The Accokeek Foundation, Accokeek 046284
Accord Galéria, Budapest 109131
Accordeon en Harmonica Museum, Malden 032454
Accou, Pascal, Seichamps 073437
Accra, Ille-sur-Têt 068811
l'Accroche-Coeur-Ducloy, Mons . 063735
L'Accrosonge, Paris 104401
Accton Arts Foundation, Hsinchu 042050
Accumulations, Birmingham . . . 092215
Accurate Antiques, Columbus . . 092819
Accurate Trading, London 089692
Ace Art, Winnipeg 007249, 101727
Ace Coin Shop, Salt Lake City . 096705
Ace Furniture Refinishers, San Antonio 136591
Ace Gallery, Los Angeles 121701
Ace Gallery, New York 122530
Ace International, Boronia 061166
Ace of Arts, Letterkenny 109671
Ace of Clubs House, Texarkana . 053607

Ace Traders, Palmerston North . 083910
Ace Upholstery, Albuquerque . . 135629
Acero, Giuseppe, Roma 132179
Acervo Antiguidade, Belo Horizonte 128347
Acervo Artístico Cultural dos Palácios do Governo, São Paulo 004764
Acervo Didático de Invertebrados I e II, Instituto de Biociências, São Paulo 004765
Aces High Aviation Gallery, Wendover 119608
Acetres, Sevilla 086260
Acevedo, Alicante 085511
Acevedo, William, Cali . 065150, 128527
ACF, Montpellier 070234
ACF les Sculptures, Yverdon-les-Bains 116820
Achallé, Marc, Fontenay-le-Comte 068516
Achard, Dominique, Bligny-sur-Ouche 103351
Acharya Jogesh Chandra Purakirti Bhavan, Bangiya Sahitya Parisat Bishnupur Branch, Bishnupur . 023867
Achat Antiquité Brocante, Athis-Mons 066708
Achat Antiquités, Nice 070495
Achdijan, Berdj, Paris 070821
Achenbach + Costa, Kunstverlag GmbH, Düsseldorf 075404
Achenseer Museumswelt, Maurach am Achensee 002335
Achète Tout, Bruxelles 063247
Achète Tout Antiques, Bruxelles 063248
Achille, Nice 070496
Achilli & Rossi, Milano 131756
Achkal, Jounieh 082133
Achnamian, Pierre, Le Rouret . . 069294
Acht P!, Bonn 106525
Achtelik, Peter-Michael, Gelsenkirchen 075912
Achter de Zuilen, Overveen . . . 032582
Achterhoeks Museum 1940–1945, Hengelo, Gelderland 032284
Achterkamp, H., Stanggaß 142219
Achternkamp, Petra, Darmstadt . 129925
Achternkamp, Stefan, Obernzenn 130846
Achtertalfam, Ottenhöfen im Schwarzwald 020679
Achtiani, Mehdi, Tours 073795
Acker, Rolf, Freiburg im Breisgau 075793
Ackerbürgermuseum, Gartz (Oder) 018321
Ackerbürgermuseum, Reichenbach, Oberlausitz 020969
Ackerbürgermuseum Haus Leck, Grebenstein 018517
Ackerl, Walter, Graz 128008
Ackerman, Waitara 062390
Ackermann Kunstverlag, München 137539
Ackermann, Wilhelm, Wuppertal 079005
Ackersgott, A., Duisburg 075498
Ackland Art Museum, University of North Carolina at Chapel Hill, Chapel Hill 047492
Acland Coal Mine Museum, Acland 000757
Acle Antiques, Acle 087999
Acme, Boston 135710
ACME – Accademia di Belle Arti Europea dei Media, Milano . . . 055867
ACME – Accademia di Belle Arti Europea dei Media, Novara . . 055885
ACME Art Gallery, Columbus . . 047896
ACME Fine Art, Boston 120106
ACME Gallery, Los Angeles . . . 121702
ACME Gallery, New Orleans . . . 122362
ACME Studios, London 059926
ACMI – Australian Centre for the Moving Image, Melbourne . . . 001261
Aconerre Arte Conservazione Restauri, Milano 131757

Admiralty House Museum and
 Archives, Mount Pearl 006300
Admirer, Sofia 101000
Admos Media GmbH, Galerie Villa Arte,
 Hamm, Westfalen 137458
ADN, Luxembourg 082172
Ado, Gdańsk 113540
Adobe, San Francisco 145276
Adolf-Bender-Zentrum, Sankt
 Wendel 021221
Adolf Dietrich-Haus, Berlingen . . 041098
Adolf, Christiane, Hildesheim . . 130346
Ådolfa Alunāna Memoriālais Muzejs,
 Jelgava 029955
Adolfs, M., Münster 077575
Adolfsson, Segeltorp 115903
Adonis Antiquités, Saint-Parres-aux-
 Tertres 073199
Adopt-A-Chair, Ulverstone 062362
Ador, Toulouse 129520
Adornments, Paddington,
 Queensland 062037
Adornments Contemporain,
 Albuquerque 135630
Adornos Antiguos, Buenos Aires 060836
Adornos Arañas Antiguas, Buenos
 Aires 060837
Adracare, Busselton 139704
Adrénaline Antiquités, Marseille . 069843
Adri-Art-16, Barcelona 114933
Adriaan, Den Haag 082860
Adriaan's Antiques, New Orleans 094880
Adrian, David, Knokke-Heist . . . 100582
Adriana, San Vito Al Tagliamento 110923
Adrianno's Fine Art Gallery,
 Forrestland 098903
Adrian's Ashgrove Antiques,
 Ashgrove 061056
Adriatica Editrice Divisione Arte,
 Bari 109775, 137716, 142441
Adrien Numismatic, Dijon 068255
Adro de Santos, Lisboa 084640
ADS Anticuarios, Buenos Aires . 060838
ADS Antiques, Miami 094513
Adscriptio Iberica Librariae
 Antiquariorum, Palma de
 Mallorca 059740
Adsera Carvajal, Maria Teresa,
 Barcelona 085537
Adsmore Museum, Princeton . . . 052269
Advanced Coatings, San Diego . 136621
Advanced Graphics London,
 London 118387
Advanced Refinishing, Nashville 136191
Advanced Wood Finishing, San
 Diego 136622
Advances in Art, Kansas City . . 121554
Advertising and Graphic Design
 Department, Southwestern
 Community College, Sylva 057925
Advertising Art Department,
 Chattanooga State Technical
 Community College,
 Chattanooga 056822
Advocate Art, London 118388
Ady Endre Emlékmúzeum, Petőfi
 Irodalmi Múzeum, Budapest . . 023135
Adyar, Sydney 139949
Adyar Art Club, Chennai 059276, 109286
Adygejskij Respublikanskij
 Kraevedčeskij Muzej, Majkop . 037044
Äänekosken Kaupunginmuseo,
 Äänekoski 010579
Æbelholt Klostermuseum,
 Hillerød 009960
Aebischer, Elisabeth,
 Schwarzenburg 116726
Aebischer, Erwin, Basel 087024
Aebischer, Erwin, Frenkendorf . 087240,
 134077
Aeby, François, Fribourg 116366
AeDis Kieferle Reiner Schmid GbR,
 Hochdorf 130355
Aedvilja, Tallinn 103050

Aegean Maritime Museum,
 Mykonos 022816
Aëgerter, Bernard, Marseille . . . 069844
Aegerter, Bernard, Nice 070498
Aegerter, Claude, Chêne-Bourg . 087177
Ægidius, Randers 102899
Ægidius, Anne Grethe & Ken,
 Randers 065976
Aegis, Ulm 142276
Æglageret Udstilllingslokaler,
 Holbæk 102808
Ägyptisches Museum der Universität
 Bonn, Bonn 017257
Ägyptisches Museum der Universität
 Leipzig – Georg Steindorff,
 Leipzig 019638
Ähtärin Kotiseutumuseo, Ähtäri . 010580
AEKO Veilingen, Hasselt 125609
Aelbrecht Galerie, Rotterdam . . 112715
Äldre Ting, Aakersberga 086438
Ängelholms Antikvariat,
 Ängelholm 143626
Aenigma, Amsterdam 142826
L'Æntre, Neuchâtel 116614
Aequitas, Lyon 069625
AER Verlag, Bolzano 137724
Aera Memorial Museum, San
 Pablo 034422
Aerial House Antiques, Long
 Melford 090457
Aero, Helsinki 066234
Aero Nautical Museum-Armadill,
 Mona Vale 001302
Aero Space Museum of Calgary,
 Calgary 005409
Ærø Museum, Ærøskøbing 009840
Ærøskøbing Antik, Ærøskøbing . 102732
Aeronautics Museum, Nanjing . . 007909
Aeronauticum – Deutsches Luftschiff-
 und Marinefliegermuseum Nordholz,
 Nordholz 020473
Aeroplastics Contemporary,
 Bruxelles 100401
Aeroseum, Göteborg 040450
Aérospatiale, Toulouse 015779
Aerts, S., Bruxelles 063249
AES Gallery, Chicago 120309
Aeschbach, Max, Derendingen . 087207
Aesthetic Eye, Chicago 120310
AF Galerie, Karlsruhe . 107487, 126239
AFAS Journal, Automotive Fine Arts
 Society, Brooksville 139267
AFC Edition, Wiesbaden 108913, 142312
Afdeling Nuttige en Fraaie
 Handwerken, Openluchtmuseum Het
 Hoogeland, Uithuizermeeden . 032755
Affaire d'Antique, Eindhoven . . 083017
Affaire d'Eau, Amsterdam 082487
Affairs Art Gallery, Mumbai . . . 109429
Affairs of the Art, Toronto 101421
Affaitati, Antonio, Napoli 080664
Affaitati, Giuseppe, Napoli 080665
Affari d'Epoca, Firenze 079905
Affenberger, Graz 062558
L'Affiche, Milano 110246, 110247,
 137766
L'Affiche, Nantes 104277
Affiche, Palermo 110603
Affiche Museum Hoorn, Hoorn . 032326
Affiches Anciennes, Paris 070824
The Affinity Art Gallery, Midsomer
 Norton 118938
Affinity's Antiques, Regina 064491
Affirmation Arts, New York 122536
Affolter, Konrad, Bern 116211
Afford-a-Bulls, Bulls 083663
Affordable Aboriginal Arts,
 Indooroopilly 061639
Affordable Antiques, Hale 089207,
 134746
Affordable Art, Dallas 120815
Affordable Art, Oklahoma City . 123523
Affordable Art, Virginia Beach . 125069
Affordable Art Fair, Amsterdam . 098101

Affordable Art Fair, Bruxelles . . . 097873
Affordable Art Fair, Hamburg . . . 097978
Affordable Art Fair, Hong Kong . 097906
Affordable Art Fair, London . . . 098187
Affordable Art Fair, Maastricht . 098100
Affordable Art Fair, Milano 098036
Affordable Art Fair, New York . 098244
Affordable Art Fair, Seoul 098085
Affordable Art Fair, Singapore . 098134
Affordable Art Fair, Stockholm . 098155
Affordable Art Fair Bristol, Bristol 098182
Affordable Art Fair London,
 London 098189
Affordable Art Gallery, Chicago . 120311,
 120312
Affordable Black Art, Jacksonville 121508
Affordable Books and Collectables,
 Phoenix 096013, 145162
Affordable Posh, Mittagong . . . 061856
Affresco di Piero della Francesca,
 Monterchi 026792
Affrica-African Art, Washington . 125099
Afif Abad Military Museum,
 Shiraz 024429
Afinsa, Madrid 126737
Afkari, Richard, New York 095031
Afken, Lisa, Wiesbaden 131155
Afnan, Cairo . . 102956, 102957, 102958,
 102959
Aforisma, Milano 142527
Africa, Cairo 066149
Africa & House, München 077378
Africa Art Gallery, Berlin 106090
Africa Dreaming, Gawler Belt . 061496
Africa Exclusive, Delft 082839
Africa Museum, Seoul 029805
Africa Visions Two Thousand One, Las
 Vegas 121607
Africa Within, Cincinnati 120591
African Accents, San Diego . . . 124333
African Accents Hawaii, Honolulu 093357
African American Art, Charlotte . 120253
African American Art Gallery, New
 York 122537
African American Historical and
 Cultural Society Museum, San
 Francisco 052886
African American Historical Museum,
 Cedar Rapids 047447
African American Movie Posters, Los
 Angeles 094076
African American Multicultural
 Museum, Scottsdale 053095
African American Museum,
 Cleveland 047766
African American Museum,
 Dallas 048072
African American Museum at Oakland,
 Oakland 051588
The African American Museum in
 Philadelphia, Philadelphia . . . 051933
African American Museums
 Association, Chicago 060279
African and Tribial Art Markus Gunti,
 Berlin 106091
African Art, Düren 075397
African Art, Saint-Denis 114201
African Art and Designs, Miami . 121999
African Art Center, Houston . . . 121264
African Art Centre, Durban 038518
African Art Gallery, Tampa 124874
African Art Museum of Maryland,
 Columbia 047858
African Art Museum of the S.M.A.
 Fathers, Tenafly 053595
African Art Room, Houston 121265
African Artists' Foundation,
 Lagos 059565
African Arts, Los Angeles 139268
African Arts, Tucson 124955
African Arts Collection, San Diego
 Mesa College, San Diego . . . 052858
African Arts Cultural Center, New
 York 122538

African Attractions, Virginia
 Beach 125070
African Connection, Saint Ives,
 Cornwall 119269
African Cultural Art Forum,
 Philadelphia 051934
African Ethno, Nairobi 082068
African Gallery, Bramsche 075075
African Gems, Denver 120962
African Hands, Washington 125100
African Hemingway Gallery, New
 York 122539
African Heritage, Amsterdam . . 082488
African Heritage, Nairobi 111568
African Heritage Gallery, Dallas . 120816
African Imports, Dallas 120817
African Imports, Fort Worth . . . 121133
African Legacy Gallery, Kirup . . 099062
African Muse Gallery, Paris 104405
African Mystical Arts, Balwyn . 098553
African Mystical Arts, Forest Hill 098901
African Odyssey, San Antonio . 124251
African Palace, Indianapolis . . . 121441
African Safari Imports, Chicago . 120313
African Tribal Art, Haarlem 112592
African Village, Detroit 121075
Africana, Zürich 116829
Africana Museum, Mariannhill . 038602
Africana Museum, Monrovia . . . 030120
AfricanColours, Nairobi 059442
Afric'Art, Château-Thierry 067819
Africart Motherland, New York . . 122540
Afrika Centrum, Cadier en Keer . 031954
Afrika Museum, Berg en Dal . . . 031886
Afrika-Museum, Bergen, Kreis
 Celle 016838
Afrika-Museum, Zug 041970
Afrika Múzeum, Balatonederics . 023106
Afrikaanse Taalmuseum, Paarl . 038615
Afrikahaus Museum und Nold-
 Namibia-Bibliothek, Sebnitz . . 021411
Afrikamuseum Schloss Riedegg,
 Gallneukirchen 001909
Afrikana Gallery, South
 Melbourne 099561
Afrique Arts Premiers, Nice 104306
Afrique Congo, Liège 063682
Afrique Congo Sculptures, Liège 063683
Afro-American Cultural Center,
 Charlotte 047531
Afro-American Historical Society
 Museum, Jersey City 049772
Afrocrafts, Manama 100268
Afrodite Antik, Stockholm 086770
Afrosiyob – Samarqand Thariki
 Muzeyi, Samarqand 054580
After Noah, London . . 089698, 089699,
 134895
After the Paint, Saint Louis . . . 096496
After-Words, Chicago 144768
Afterall, London 139156
Afterall, Valencia 139269
Afterimage, Rochester 139270
Afterimage Gallery, Dallas 120818
Aftermodern, San Francisco . . . 124451
Afton, Totland Bay 119521
Afval-Museum, Zwolle 032943
Afyon Devlet Güzel Sanatlar Galerisi,
 Afyon 042525
Afyon Etnografya Müzesi, Afyon 042526
Afyon Müzesi, Bolvadin Müzesi, Zafer
 Müzesi ve Dumlupınar Müzesi,
 Afyon 042527
Aga Khan Museum of Islamic Arts,
 Marawi 034382
Agabio, Cagliari 079803
Agale Antiques, London 089700
Agaméde, Paris 104406
Agamennone, Savona 110938
Agape, Albuquerque 091860
Agape, Cleveland 120672
Agapi, Bordeaux 103361
Agar, Rosie, Saintfield 091065
Agardh & Tornvall, Stockholm . 115922

Air Force Museum, Delhi 023902
Air Force Museum, Ha Noi . . . 054722
Air Force Museum, Tehrän . . . 024440
Air Galleries, New York 122543
Air Mobility Command Museum, Dover,
 Air Force Base 048318
Air of Art Museum, Bologna . . . 025365
Air Power Park and Museum,
 Hampton 049300
Air Victory Museum, Lumberton 050465
Air Victory Museum, Medford . . 050651
Airault, Jean-Marc, Brigueuil . . 067442
Airborne and Special Operations
 Museum, Fayetteville 048678
Airborne Forces Museum,
 Aldershot 043125
Airborne Museum Hartenstein,
 Oosterbeek 032542
Airbrush Action, Allenwood . . . 139272
Airbrush Art School, Werribee . . 099739
Aird, John B., Toronto 101423
Aireloom, Honolulu 135926
Airmen Memorial Museum,
 Suitland 053478
L'Airone, Messina 110232
The Airport Gallery, Edinburgh . . 117887
Airport Museum, Cairo 010361
Airpower Museum, Ottumwa . . . 051754
AirSpace Gallery, Stoke-on-Trent 059928
Airvault, Philippe, Châtelaillon-
 Plage 067844
Airworld Aviation Museum, Dinas
 Dinlle 043909
Aisling Antiques, Tralee 079597
Aisling Gallery,
 Newtownmountkennedy 109689
Aisne Collections, Bucy-le-Long 067474
Aisthesis, Jérôme Cordie, Paris . 129123
Aithousa Skoufa, Athinai 109028
Aitihasic Puratatva Sangrahalaya,
 Delhi 023903
Aitkin County Museum, Aitkin . . 046296
Aitonevan Turvemuseo, Kihniö . . 010825
Aître Saint-Saturnin, Blois 011892
Aittouarès, Paris 104410
Aiwan-i-Riffat Museum and Art Gallery,
 Karachi 033940
AIX, New York 095034
Aix Antiquités, Saint-Cannat . . . 072662
Aix-en-Provence Antiquités, Aix-en-
 Provence 066390
Aixia, Las Rozas de Madrid . . . 133769
AixLibris, Aachen 141353
Aizenman, Buenos Aires 139573
Aizkraukles Vēstures un Mäkslas
 Muzejs, Aizkraukle 029922
Aizpuru, Juana de, Madrid 115218
Aizpuru, Juana de, Sevilla 115523
AJ Net, Montigny-les-Cormeilles 070201
Ajak-Nostalgie, Halberstadt 076102
Ajanpatina, Helsinki 066235
Ajasse, Torino 081473, 110969
Ajasse, Lyon 140838
Ajax Museum, Amsterdam 031746
Ajia-no Mingeikan, Noda 029011
Ajisai, Kobe 111294
AJM, New York 122544
AJNA, Amiens 066501
Ájtte – Svenskt Fjäll- och
 Samemuseum, Jokkmokk 040527
Ajucla, Salamanca 115495
AK Akt e.V., Berlin 058669
AK Artist Run Centre, Saskatoon 101402
AK-Express, 45336 138712
Aka-Renga Kokusaikan,
 Yokohama 029527
Aka Salon Antykow i Galeria,
 Kraków 084375, 113610
Akad. Buchhandlung & Antiquariat
 Hierana, Erfurt 141653
Akadamija za Umetnosti 'Braco Karic',
 Beograd 056268
Akademia e Arteve e Tiranes,
 Tiranë 054788

Akademia Sztuk Pięknych,
 Gdańsk 056175
Akademia Sztuk Pięknych,
 Poznań 056181
Akademia Sztuk Pięknych,
 Warszawa 056186
Akademia Sztuk Pięknych im. Jana
 Matejki, Kraków 056176
Akademia Sztuk Pięknych im.
 Władysława Strzemińskiego,
 Łódź 056179
Akadémia Umení v Banskej Bystrici,
 Banská Bystrica 056281
Akademiai Kiadó, Budapest . . . 137681
Akademie der Bildenden Künste in
 Nürnberg, Nürnberg 055604
Akademie der Bildenden Künste
 München, München 055584
Akademie der bildenden Künste Wien,
 Wien 054894
Akademie der Künste, Berlin . . . 016857
Akademie Franz-Hitze-Haus,
 Münster 055599
Akademie für Malerei, Berlin . . . 055398
Akademie Mode und Design (AMD),
 Hamburg 055502
Akademie Schloss Solitude,
 Stuttgart 055646
Akademie voor Beeldende Kunsten en
 Vormgeving, Akademie Minerva,
 Groningen 056119
Akademie voor Kunst en
 Vormgeving/St. Joost, Breda . . 056114
Akademie voor Kunst en
 Vormgeving/St. Joost, 's-
 Hertogenbosch 056120
Akademie Výtvarných Umění,
 Praha 055236
Akademija, Vilnius 111848
Akademija Lepih Umetnosti,
 Beograd 056269
Akademija Likovnih Umetnosti
 Sarajevo, Sarajevo 054998
Akademija Likovnih Umjetnosti,
 Sveučilište u Zagrebu, Zagreb . 055214
Akademija za Likovno Umetnost,
 Ljubljana 056284
Akademija za Primenjene Umetnosti,
 Beograd 056270
Akademisches Kunstmuseum –
 Antikensammlung der Universität,
 Bonn 017258
Akademisches Münzkabinett, Institut
 für Altertumswissenschaften der
 Friedrich-Schiller-Universität Jena,
 Jena 019134
Akademisk Antikvariat, Odense . 140594
Akademkniga, Moskva 143438, 143439,
 143440, 143441
Akademkniga Magazin N1, Sankt-
 Peterburg 143469
Akademkniga Magazin N3, Sankt-
 Peterburg 143470
Akademkniga Magazin N4, Sankt-
 Peterburg 143471
Akademkniga Magazin N5, Sankt-
 Peterburg 143472
Akademski Slikar, Koper 114764
Akadimia Athinon, Athinai 055683
Akadomari-mura Folk Museum,
 Sado 029109
Akai, Nanmeido, Nara 081895
Akainyah, Chicago 120314
Akalo, Bordeaux 067243
Akama-jingu Homotsukan,
 Shimonoseki 029200
Akamon Bijutsukan, Sendai . . . 029174
Åkande, Holstebro 065711
Akane, Nagoya 111326
Akant, Praha 065391, 102606
Akant, Szczecin 143316
Akant, Wrocław 084588, 133273
Akanthus, Antwerpen 063128
Akanthus, Erftstadt 075582

akanthus Restaurierungen, Berlin 129689
Akantus Antikt, Visby 086976
Akar Prakar, Jaipur, Rajasthan . 109391
Akariya, Tokyo 081958
Akaroa Museum, Te Whare Taonga,
 Akaroa 032951
Åkarps Antikvariat, Lund 143692
Akasaka Green Gallery, Tokyo . . 111408
Akateeminen Kirjakauppa,
 Helsinki 140653
AKB – Angewandte Kunst Bremen,
 Scholen 058670
Akbank Bahariye Sanat Galerisi,
 İstanbul 117088
Akbank Bebek Sanat Galerisi,
 İstanbul 117089
Akbank Beylerbeyi Sanat Galerisi,
 İstanbul 117090
Akbarzadeh-Glatthard, A.,
 Oberdiessbach 116634
Akbarzadeh-Glatthard, Antoinette,
 Bern 116212
Akcent, Kwidzyń 113740
Akcent, Warszawa 113882
Akcija, Moskva 084983, 084984, 126684,
 143442
Akd-Forum, Basel 087025
Akemi, Singapore 085179
Akeroyd & Son, Rod, Preston . . 090902
Åkers Hembygdsmuseum,
 Strängnäs 040858
Akers, Timothy, Beckenham . . . 134403
Akershus Fylkesmuseum,
 Strømmen 033816
Akesu Zone Museum, Akesu . . . 007373
AKF Trading, New York 095035
Aki Gallery, Taipei 116977
Akiba, Miami 094514
Akiba Anti-ku Okimono Bijutsukan,
 Nasu 028284
Akimbek, Azat, Almaty 082060, 111558
Akimoto, Nagoya 081883
Akin, Boston 092275
Akin, A.R., Birmingham 092217
Akinci, Amsterdam 112213
Akira Ikeda Gallery, Yokosuka . . 111556
Akira Ikeda Gallery/ Berlin, Berlin 106093
Akita Daigaku Kogyo Hakubutsukan,
 Akita 028284
Akita-kenritsu Hakubutsukan,
 Akita 028285
Akita-kenritsu Kindai Bijutsukan,
 Yokote 029558
Akita Museum of Art, Akita 028286
Akita Senshu Bijutsukan, Kenzo Okada
 Kinenkan, Akita 028287
Akiyama, Tokyo 111409
Akiyoshi-dai Kagaku Hakubutsukan,
 Shuuhou 029226
Akizuki Hakubutsukan, Amagi . . 028289
Akko Gallery, Bangkok 117017
Akkolades, Den Haag 082861
Åklundh, Magnus, Malmö 115835
Akmal Ikramov nomidagi Tarikhi
 Kültüri va San"atshunoslik
 Özbekiston Khalqlari Davlat Müzeyi,
 Samarqand 054581
Akomena, San Zaccaria 132462
Akon, Warszawa 084514
Akpol Museum, Semarang 024339
Akránum, Budapest 079128
Akriti, Delhi 109315
Akron Art Museum, Akron 046299
Akropolis, Brescia 079740
Akros Gallery, Bilbao 115066
AKS Holographie-Galerie, Essen 106869
Aksanat Resim Galerisi, İstanbul 117091
Aksaray Müzesi ve Bağli Örenyerleri,
 Aksaray 042530
Akşehir Müzesi, Akşehir 042531
Aksel Bakuntz House-Museum,
 Goris 000694
Aksent 167, Leuven 100637
Akshaya Kumar Maitreya Museum,

Siliguri 024175
Aksum Archaeology Museum,
 Aksum 010557
Akta, Gabrovo 100987
Akta Lakota Museum,
 Chamberlain 047477
Aktaion, Zaandam 143077
Die Aktgalerie, Berlin 106094
Aktionsgalerie Bern, Wohlen
 (Bern) 116817
Aktis Gallery, London 118391
Aktives Museum Spiegelgasse für
 Deutsch-Jüdische Geschichte in
 Wiesbaden, Wiesbaden 022213
Aktives Museum Südwestfalen,
 Siegen 021452
Aktivmuseum Ländliches Brauchtum,
 Breitungen an der Werra 017358
AKUS Gallery, Eastern Connecticut
 State University, Willimantic . . 054297
Akvamarín, Znojmo 102715
Akvarel', Kyïv 117181
Akvarius, Chimki 114263
Akvarius, Moskva 114275
Akwesasne Museum,
 Hogansburg 049459
Akzente, Bremen 141570
Akzente, Mettmann 077300
Akzente, Nettetal 077627
Akzente, Versandbuchhandlung,
 Lahnstein 141921
Al-Ain Museum, Al-Ain 043067
AL Antik, Næstved 065927
Ål Auksjon, Ål 126548
Ål Bygdemuseum, Ål 033308
Al Desvan Antigüedades, Lima . 084255
Al Gallery, Podgorica 112098
Al-Harithy, İzmir 117165
Al Ibriz Orcadre, Rabat 082410, 112122
Al-Itekal, Chicago 144769
Al-Karak Museum for Archaeology and
 Folklore, Al-Karak 029576
Al Kassaba Museum Thafer al Masri
 Foundation, Nablus 033985
Al-Khor Museum, Al-Khor 036007
Al Mada'in Museum, Baghdad . . 024494
Al-Mahatah – Sharjah Aviation
 Museum, Sharjah 043073
Al-Mansora Museum Dar-ibn-Luqman,
 Daqahlia 010394
Al Manyal Palace and Nilometer,
 Cairo 010362
Al Mawsil Museum, Nineveh . . . 024507
Al Mercatino, Milano 080210
Al-Mukalla Museum, Al-Mukalla 054756
Al-Muntaza Palace Museum,
 Alexandria 010343
Al Piccolo Naviglio, Milano 080211
Al Portico, Verona 081718, 132648
Al Pozzo, Venezia 081649
Al-Rawi, Idris, Paris 104411
Al Shaheed Monument and Museum,
 Baghdad 024495
Al Sulaimaniya Museum,
 Sulaimaniya 024509
Al Tezzon, Camposampiero . . . 109944
Al-Toyan Tower Trading, Ruwi . . 084241
Al-Wakra Museum, Al-Wakra . . . 036008
Al Zubara Fort, Doha 036009
Al.ba.tro's, Toulouse 073694
Ala Moana, Honolulu 093358
Ala, Salvatore, Milano 110248
Alabama Administrative Office
 of Courts Museum Area,
 Montgomery 050950
Alabama Agricultural Museum,
 Dothan 048302
Alabama Art Agency, Klagenfurt 099932
Alabama Arts Magazine,
 Montgomery 139273
Alabama Auction Room,
 Birmingham 127408
Alabama-Coushatta Indian Museum,
 Livingston 050294

Albrow & Sons, Norwich 090723
Albry, Berrima 061129
Albu Mõisahoone, Albu 010431
Album, Paris 140981
Album-Het Nieuwe Reclamemuseum,
 Bruxelles 003347
Albums Books, New York .. 136220,
 145057
Albuquerque & Sousa, Lisboa .. 084641
Albuquerque Art Business Association,
 Albuquerque 060284
Albuquerque Coins, Albuquerque 091862
Albuquerque Furniture,
 Albuquerque 135631
The Albuquerque Museum of Art and
 History, Albuquerque 046328
Albuquerque, Celma, Belo
 Horizonte 100733
Albuquerque, Michael & Jane de,
 Wallingford 091567, 135533
Alburda, Lyon 140839
Albury Antiques, Albury 060972
Albury Regional Art Gallery,
 Albury 000784
Albury Regional Museum, Albury 000785
Alby, Cagliari 131455
Alcade, Lyon 140840
Alcal, Houston 135932
Alcalá, Madrid 126738
Alcan Museum and Archives,
 Montréal 006225
Alcarria, Sevilla 133785
Alcaston Gallery, Fitzroy 098876
Alcázar de Segovia, Segovia ... 039960
Alchemistenmuseum, Kirchberg am
 Wagram 002141
Alchemy: The Group for Collections
 Management in Yorkshire and
 Humberside, Halifax 059929
Alcheringa, Bodegraven 142906
Alcheringa Gallery, Victoria ... 101708
Alcheringa ou Le Temps du Rêve,
 Bordeaux 103362
Alchimia, Roma 081027, 132183
Alcina, La Rochelle 103850
Alcobas Fernandez, Juan Miguel,
 Cartagena 115094
Alcoforado, Washington 097634
Alcolado, Marcos Diez, Madrid . 115219
Alcolea, Madrid 085914, 115220
Alcolea, Fernando, Barcelona .. 085539,
 114355
Alcolea, Jorge, Madrid 115221
Alcon, Houston 135933
Alcott, Los Angeles 121705
Alcuin, Scottsdale 145312
Alcuvilla, Jérôme, Rivieres 072441
La Aldaba, A Coruña 085768
El Aldabon, Bogotá 065081
Aldborough Roman Site and Museum,
 Aldborough 043121
Aldea del Tiempo, Bucaramanga 065145
Aldea Gallery, Buenos Aires ... 098362
Aldebert, Alain, Neuville-de-
 Poitou 070475
Aldebert, Comdor, Castres 067664
Aldeburgh Museum, Aldeburgh . 043122
Aldeia Museu de João Franco,
 Mafra 035672
Alden, Denver 093074, 135874
Alden B. Dow Creativity Center,
 Northwood University, Midland 057402
Alden B. Dow Museum of Science and
 Art, Midland Center for the Arts,
 Midland 050803
Alden Hamilton, Richmond 096356
Alden Historical Society Museum,
 Alden 046345
Alden House, Duxbury 048374
Alden, Michael, New Orleans .. 122363
Aldenhoven, Hans-Heiner, Kerken 141868
Alder, Ha Noi 125340
Alder Cocinas, Alicante 133439
Aldermaston Antiques,

Aldermaston 088009
Alderney Railway – Braye Road
 Station, Alderney 043123
Alderney Society Museum,
 Alderney 043124
Aldersey Hall, Chester 088635
Aldershot Military Museum and
 Rushmoor Local History Gallery,
 Aldershot 043126
Alderson, C.J.R., Tetbury 091417
Aldfaers Erf Route, Museumdorp
 Allingawier, Allingawier 031719
Aldheidskeamer Uldrik Bottema,
 Aldeboarn 031713
Aldidea, León 085881, 085882
Aldine, Los Angeles 144947
Aldonga Auctions, Wodonga ... 125524
Aldredge House, Dallas 144844
Aldrich Museum of Contemporary Art,
 Ridgefield 052470
Aldridge, Bath 127002
Aldridge, F.W., Takeley 135467
Aldus, Braşov 143420
Aldus, Frederiksberg 140531
Ale-Kirja, Oulu 140701
Alecrim 50, Lisboa 114066
Alefeld, A.W., Bonn 075019
Alegria, Mandaluyong 113482
Alegria, San Antonio .. 096770, 136592
Alegria, Luis, Porto .. 084834, 114158
Aleksandra Čaka Memoriālais
 Dzīvoklis, Rīga 030000
Aleksandrovskaja Sloboda –
 Gosudarstvennyj Istoriko-
 architekturnyj i Chudožestvennyj
 Muzej-zapovednik, Aleksandrov 036675
Aleksandrovskij Chudožestvennyj
 Muzej, Aleksandrov 036676
Aleksandrovskij Dvorec –
 Gosudarstvennyj Muzej Carskoje
 Selo, Puškin 037498
Aleksandrovskij Literaturno-
 chudožestvennyj Muzej
 Mariny i Anastasii Cvetaevych,
 Aleksandrov 036677
Aleksandrovskij Narodnyj Muzej M.E.
 Pjatnickogo, Aleksandrovka .. 036678
Aleksiev, Rajko, Sofia 101001
Aleksis Kiven Syntymäkoti,
 Palojoki 011053
Ålen Bygdetun, Ålen 033310
Alencastro, Porto Alegre 100823
Aleph, Bruxelles 100403
Aleph Books, Utrecht 143050
Aleppo National Museum, Aleppo 041969
Alert Bay Museum, Alert Bay .. 005212
Aléry, Annecy 066574
Ales, Saint Paul 136550
Alésina, Eric, Clairvaux-les-Lacs 067940
Alésina, Eric, Saint-Étienne 072705,
 129453
Alessandri, Roma 132184
Alessandri, Roberto, Roma 110742
Alessandrino, Carmelo, Milano . 131719
Alessandro, Eduardo, Dundee . 117860
Alessi, Warszawa 084515
Alessia Librairie, Paris 140982
Ålesunds Museum, Ålesund ... 033311
Alex Brown Cycle History Museum,
 Thornhill, Dumfriesshire 045979
Alex Gallery, Washington 125101
Alex Youck School Museum,
 Regina 006613
Alex, Hans-Jürgen, Lüneburg .. 077144
Alex, Susanne, Geseke 075935
Alexander, Alassio 109748
Alexander, Haarlem 132892
Alexander, Henfield 089308
Alexander, Houston 135935
Alexander, New York .. 095039, 095040
Alexander, San Francisco 096990
Alexander, Sofia 101002
Alexander & Bonin, New York . 122547
Alexander & David Fax, Kristen,

Canberra 139715
Alexander & Thurlow, London .. 089704,
 134896
Alexander & Victor, New Orleans 122364
Alexander and Baldwin Sugar
 Museum, Puunene 052329
Alexander Antiques, Portrush . 090888
Alexander Antonow Verlag, Dr.
Alexander Antonow, Frankfurt am
 Main 137417
Alexander Brest Museum,
 Jacksonville 049725
Alexander College, Aradippou .. 055220
Alexander Fleming Laboratory
 Museum, London Museums of
 Health & Medicine, London .. 044788
The Alexander Gallery, Brighton 117533
Alexander Gallery, Bristol 088421,
 117568
Alexander Graham Bell National
 Historic Site, Baddeck 005267
Alexander Kazbegi Museum,
 Kazbegi 016188
Alexander Keiller Museum and Barn
 Gallery, Avebury 043203
Alexander-Mack-Museum, Bad
 Berleburg 016522
Alexander-Morgan, Dee, Epping 117951
Alexander Museum of Postal History
 and Philately, Tel Aviv 025010
Alexander Ochs Galleries Berlin /
 Beijing, Berlin 106095
Alexander Ramsey House, Saint
 Paul 052735
Alexander Spendiaryan House
 Museum, Yerevan 000716
Alexander Verlag Berlin, Berlin . 137309
Alexander, Julian, London 089703
Alexander, Keith, Vancouver ... 101593
Alexander, Marion, New York .. 122546
Alexander's, Oklahoma City ... 095762
Alexander's, San Francisco 096991
Alexanders, Titchfield . 091459, 135488
Alexanders Afsyrede Møbler,
 Frederiksberg 065587
Alexander's Antiques, Richmond 096357,
 127684
Alexander's Antiques, Saint Louis 096498
Alexander's Galerie, Telgte 108771
Alexander's Gallery, Saint Louis 124041
Alexander's Sculptural Service, New
 York 122548
Alexandra Antiquité, Groslay .. 068696
Alexandra Galleries, Beckenham 117396
Alexandra Timber Tramway and
 Museum, Alexandra 000786
Alexandre, Fort-de-France 142792
Alexandre, Namur 063749
Alexandre, New York 122549
Alexandre, Toronto 140357
Alexandre d'Or, Paris 070829
Alexandre Hogue Gallery, University of
 Tulsa, School of Art, Tulsa ... 053723
Alexandre, Charles, Montréal ... 101217
Alexandre, Jean-Christophe,
 Bavilliers 066909
Alexandria Antiques, Brighton . 088391
Alexandria Archaeology Museum,
 Alexandria 046352
Alexandria Black History Museum,
 Alexandria 046353
Alexandria Livros, Lisboa 143364
Alexandria Museum of Art,
 Alexandria 046348
Alexandria National Museum,
 Alexandria 010344
Alexandria Press, London 138236
Alexandris, Konst., Patras 079101
Alexandroff, Arnaud, Bénodet .. 067032
Alexandros Papanastassiou Museum,
 Levidion 022782
Alexandrovics, Ivanhoe 099017
Alexa's Treasures, Ballarat 061071
Alexia Gallery, Washington 125102

Alexia M Galerie, Lille 103947
Alex's Art Galerie, Klosters ... 116485
Alex's Now & Then Collectibles, New
 York 095041
Aleyne, Noëlle, Paris 104413
Alfa, Brno 140424
Alfa – Galerie Díla, Praha 102607
Alfa 2, Gdynia 084345
Alfa Antikvariat, Stockholm ... 143733
Alfa Antikvariat Väst, Stockholm 143734
Alfa-Art, Moskva 084985, 126685
Alfa Art, Sankt-Peterburg 126690
Alfa Böcker, Malmö 143699
Alfa Haganum, Den Haag 142918
Alfa-Omega, Karlovy Vary 102566
Alfa Restauri, Roma 132185
Alfa Studio Editoriale, Bologna . 137720
Alfabeta, Stockholm 138100
Alfano, Domenico, Bologna 131330
Alfano, Simone, Palermo 132070
Alfarrábios, Lisboa 143365
Alfarrabista Candelabro, Porto . 143410
Alfart, Napoli 131986
Alfazema, Porto Alegre 063898
Alfea Rare Books, Milano 142529
Alfia, Cluj-Napoca 143430
Alfican, Bruxelles 100404
Alfie's Antique Market, London . 089705
Alföldfásítási Gyüjtemény, Bugac 023251
Alföldi Galéria, Tornyai János Múzeum,
 Hódmezővásárhely 023363
The Alfoldy Gallery, Erikson ... 005678
Alfombras Ghali, Alicante 133440
Alfombras Miguel, Zaragoza ... 133844
Alfombras y Kilims, Madrid 085915,
 133649
Alfons Graber-Museum, Steinach 002719
Alfonsin, Marinete Rejane Zanetti,
 Porto Alegre 063899
Alford House-Anderson Fine Arts
 Center, Anderson 046442
Alford Manor House Museum, Alford,
 Lincolnshire 043134
Alford Studio and Gallery,
 Jacksonville 121509
Alfort, J.M., Stockholm 086772
Alfred Dunhill Museum and Archive,
 London 044789
Alfred East Art Gallery, Kettering 044549
Alfred Erhardt Stiftung, Berlin . 016858
Alfred Ost Museum, Zwijndrecht 004088
Alfred-Vogel-Museum, Teufen .. 041793
Alfred Wegener Museum,
 Rheinsberg 021024
Alfredo Jonušo Žemaitiška-japoniška
 Sodyba-muziejus, Telšiai 030316
Alfred's Antiques, Burpengary . 061227
Alfreton Antiques Centre, Alfreton 088013
Alfriston Antiques, Alfriston ... 088015
Alf's Antiques, Toronto 064523
Ålgården Konstnärernas Galleri,
 Borås 115680
Alger, Minneapolis 094726
Alger County Heritage Center,
 Munising 051047
Alger County Historical Society
 Heritage Centre, Munising ... 051048
Alghalaf, Saleh, Manama 100270
Algonkin, Braunschweig 141555
Algonquin College Museum,
 Nepean 006323
Algonquin Culture and Heritage Centre,
 Golden Lake 005779
Algonquin Logging Museum,
 Whitney 007229
L'Alguer, La Bisbal d'Empordà . 085720,
 133566
Alhambra, Maracaibo 097835
Alhambra Antigüedades, Buenos
 Aires 060839
Alhamra Art Gallery, Lahore ... 113406
Alhelm, Hameln 076283
Alhena, Fontainebleau 068509
Ali Baba, Le Havre 069216

American Abstract Artists, New York . 060290
American Academy in Rome, Roma 055913
American Academy of Appraisers of Art, Antiques and Rug, Upper Saint Clair 127749
American Academy of Art, Cambridge 056781
American Academy of Arts and Letters, New York 057499
American Academy of Arts and Letters Art Museum, New York 051249
American Advertising Museum, Portland 052195
American Airlines C.R. Smith Museum, Fort Worth 048856
American Airpower Heritage Museum, Midland 050807
American Antiquarian Society, Worcester 060291, 060292
American Antique Mall, Tucson . 097460
American Antique Restoration & Reconstruction, Cumberland . . 135840
American Antiques, Cleveland . . 092748
American Antiques Auction, New Brunswick 127598
American Art, Baltimore 119994
American Art Journal, Smithsonian American Art Museum, Washington 139275
American Art Resources, Houston 121267
American Art Review, Kansas City 139276
American Art Therapy Association, Alexandria 060293
American Artist, New York 139277
American Artists Professional League, New York 060294
American Arts Alliance, Washington 060295
American Arts Antiques Appraisals and Associates, Chicago . 092489, 092490
American Association for Museum Volunteers, Denver 060296
American Association for State and Local History, Nashville 060297
American Association of Museums, Washington 060298
American Baptist – Samuel Colgate Historical Library, Rochester . . 052513
American Bronzes, Las Vegas . 121608
American Catholic Historical Society Museum, Philadelphia 051935
American Center, Sofia 101003
American Ceramic Society, Westerville 060299
American Classical II, Nashville . 094798
American Classical Music Hall of Fame and Museum, Cincinnati 047698
American Classics, Minneapolis 094727
American Clock and Watch Museum, Bristol 047176
American Coin and Currency, Omaha 095857
American Coin and Jewelry, Oklahoma City 095764
American Coin Collectibles, Columbus 092822
American Coin Company, Cleveland 092749
American Coin Exchange, Fort Worth 093257
American Coin Exchange, Miami 094516
American Coins, Portland 096187
American Collectibles, Las Vegas 093943
American Collectibles, Norfolk . . 095678
American Color Print Society, Princeton 060300
American Contemporary Art Gallery, München 108024
American Council for the Arts, New York 060314

American Craft, New York 139278
American Craft Museum, New York 051250
American Craftsmen, Portland . . 136487
American Estates, Milwaukee . . 094661
American Estates and Antiques, Portland 096188
American-European Fine Art, New York 122552
American Federal Rare Coins, Phoenix 096014
American Federation of Arts, New York 060302
American Film Institute, Los Angeles 050353
American Fine Art and Frame, Dallas 120821
American Fine Art Editions, Scottsdale 124724, 139279
American Fine Art Show, Philadelphia 098245
American Folk Art Gallery, Zürich 087732
American Folk Art Museum, New York 051251
American Furniture Stripper, Melbourne 136120
American Gallery, Sylvania 053515
American Garage, Los Angeles . 094078
American Helicopter Museum & Education Center, West Chester 054170
American Heritage "Big Red" Fire Museum, Louisville 050445
The American Historical Foundation Museum, Richmond 052445
American Historical Print Collectors Society. Newsletter, Farmingdale 139280
American Illustration, New York . 139281
American Illustrators Gallery, New York 122553
American Independence Museum, Exeter 048611
American Indian Art Magazine, Scottsdale 139282
American Indian Contemporary Arts, San Francisco 052887
American Institute for Conservation of Historic and Artistic Works, Washington 060303
American Institute for Conservation of Historic and Artistic Works. Journal, Washington 139283
American Institute of Architects, Washington 060304
American Institute of Graphic Arts, New York 060305
American Interiors, Norfolk 136375
American Irish Historical Society Museum, New York 051252
American Jazz Museum, Kansas City 049831
American Jewelers and Coin Company, Chicago 092491
American Journal of Archaeology, Boston 139284
American Labor Museum, Haledon 049278
American Legacy Gallery, Kansas City 121555
American Legation Museum, Tanger 031618
American Maple Museum, Croghan 048033
American Memorabilia, Las Vegas 093944
American Merchant Marine Museum, Kings Point 049933
American Military Museum, Charleston 047504
American Motorcycle Museum, Raalte 032593
American Museum in Britain, Bath 043268
American Museum of Asmat Art, Saint

Paul 052736
American Museum of Fire Fighting, Hudson 049559
The American Museum of Fly Fishing, Manchester 050568
American Museum of Magic, Marshall 050644
American Museum of Natural History, New York 051253
American Museum of Nursing, Tempe 053582
American Museum of Radio and Eletricity, Bellingham 046862
American Museum of Science and Energy, Oak Ridge 051582
American Museum of Straw Art, Long Beach 050316
American Museum of the Miniature Arts, Dallas 048074
American Museum of the Moving Image, Astoria 046551
American Numismatic Association, Colorado Springs 060306
American Numismatic Society, New York 060307
American Numismatic Society Museum, New York 051254
American Photography, New York 139285
American Plating, Phoenix 136452
American Police Center and Museum, Chicago 047597
American Precious Metals, San Jose 097187
American Precision Museum, Windsor 054347
American Primitive, Columbus . . 092823
American Primitive Gallery, New York 095046, 136224
American Printing House for the Blind, Callahan Museum, Louisville . . 050426
American Quarter Horse Heritage Center and Museum, Amarillo . 046400
American Rare Coin and Collectibles, Minneapolis 094728
American Rare Coin and Jewelry, Kansas City 093890
American Rare Coins, Charlotte . 092407
American Red Cross Museum, Washington 053963
American Refinishing, Jacksonville 135993
American Renaissance for the 21st Century, New York 060308
The American Revolution Center, Wayne 054131
American Royal Museum, Kansas City 049832
American Saddlebred Horse Museum, Mexico 050755
American Saddlebred Museum, Lexington 050187
American School of Classical Studies at Athens, Athinai 055684
American School of Classical Studies at Athens, Princeton . . 057681, 138498
American Showcase, New York . 138425
American Society of Appraisers, Houston 060309
American Society of Appraisers, Kansas City 060310
American Society of Appraisers, Portland 060311
American Society of Portrait Artists – ASOPA, Montgomery 060312
American Sport Art Museum, Daphne 048113
American Studio Plus, Washington 125107
American Swedish Historical Museum, Philadelphia 051936
American Swedish Institute, Minneapolis 050864
American Table Design, Tampa . 097370
American Textile History Museum,

Lowell 050448
American Trading Company, Cincinnati 092659
American Truck Historical Society, Kansas City 049833
American Visionary Art Museum, Baltimore 046695
American Visions, Saint Louis . . 124042
American Watchmakers-Clockmakers Institute, Harrison 049335
American Watercolor Society, New York 060313
American Watercolor Society Newsletter, New York 139286
American West Heritage Center, Wellsville 054156
American Work Horse Museum, Lexington 050211
Americana Antiques, Miami 094517
Americana House, Chicago 144770
Americana Manse, Whitney-Halsey Home, Belmont 046871
Americana Museum, El Paso . . . 048462
Americana Museum, Terra Alta . 053598
Americans for the Arts, New York 060314
Americans for the Arts, Washington 060315, 139287
America's Black Holocaust Museum, Milwaukee 050842
America's Ice Cream and Dairy Museum, Medina 050698
America's National Music Museum, Vermillion 053836
Americas Society Art Gallery, New York 051255
America's Stonehenge, North Salem 051530
Amerigo Tot Múzeum, Janus Pannonius Múzeum, Pécs 023512
Amerika Museum Nederland, Cuijk 031962
Amerind Foundation, Dragoon . . 048329
Ameringer & Yohe, New York . . 122554
Amerongs Historisch Museum/ Tabaksmuseum, Amerongen . . 031729
Amersham Auction Rooms, Amersham 126989
Amersham Museum, Amersham 043157
Ames, Jacksonville 121510
The Ames Gallery, San Francisco 124456
Amethystwelt Maissau, Maissau 002310
Ameublement Comme Neuf Antiquités, Montréal 064306
Ameye, Croix 103598
Ameziane Museum, Nador 031609
Amfiaraion Archaeological Museum, Kalamos 022713
Amfora, Constanţa 114251
Amfora, Oostende 063755
AMG – Association of Museums and Galleries of Czech Republic, Praha 058505
Amgad, Elnily, Fgura 082230
Amherst County Museum, Amherst 046422
Amherst History Museum, Amherst 046412
Amherst Museum, Amherst 046421
Ami Cultural Center, Chengkung 042007
l'Ami de Musée, Paris 138672
L'Ami des Arts, Paris 104422
L'Ami des Lettres, Bordeaux . . . 103363
Ami Galerie, Hoi An 125429
Ami Voyage, Avignon 140731
Amiano, Juan, Pamplona 115478
Amiaux, Christiane, Sainte-Ruffine 073325
Amicale des Brocanteurs du Poitou Charentes, Niort 058557
Amici Antiques, Nashville 094799
Amici della Bonda, Mezzana Mortigliengo 059316
Amici, Francesco, Venezia 111100

Singapore 085182

Ancient Messene Museum,
Mauromati 022796

Ancient Monuments Society,
London 059931

Ancient of Days, Oklahoma City 095766

Ancient Order of Foresters,
Southampton 045802

Ancient Pearl, Las Vegas 093945

Ancient Spanish Monastery of Saint
Bernard de Clairvaux Cloisters,
Miami 050757

Ancient Traditions Gallery,
Albuquerque 091863

Ancient Treasure, Sacramento . . 096427

Ancient Valley, Singapore 085183

Ancora Ancora, San Jose 097188

Ancre Aldine, Lyon 140842

Ancre de Miséricorde, Saint-Malo (Ille-
et-Vilaine) 072871

Anczok, Maximilian, Stuttgart . . 078506

Anczkowski, C. & P., Münster . 108220

And Antiques, Calgary 064191

AND Gallery, Saint Paul 124136

AND Gallery, Trnava 114750

And So To Bed, London 089711, 134898

Andancas, Rio de Janeiro 100867

Andanti, Schwäbisch Gmünd . . 142200

Andelos, Amsterdam 132770

AndenHänden Køge Antikvariat,
Køge 140582

Andenken, Denver 120964

Andera, Maastricht 083267

Anderberg, Christin, Lund 133900

Anderby Drainage Museum,
Skegness 045784

Andere Welten, Hamburg 141759

Anders Svors Museet, Hornindal 053496

Anders, Bengt, Landskrona ... 115813

Andersch, Nürnberg 077733

Andersen, Aage, København 065756

Andersen, Anders, Ribe 065984

Andersen, Annamarie M., Zürich 087733, 116831

Andersen, Bjarne, Aalborg 065511

Andersen, Hanne, Helsingør ... 140544

Andersen, Jan, Vedbæk 066109

Andersen, Mikael, Berlin 106096

Andersen, Mikael, København .. 102824

Andersen, Per, København 065757

Andersen, Siv, Sandnes 113351

Andersen's Contemporary, Berlin 106097

Andersen's Contemporary,
København 102825, 102826

Anderson, Burford 117612

Anderson, Cremorne 139735

Anderson, Oakland 095716

Anderson, Saint Paul . 096636, 136551

Anderson, San Francisco 096995

Anderson & Garland, Westerhope 127354

Anderson & Paul, Dunedin ... 083742, 133091

Anderson Center for the Arts,
Anderson 046443

Anderson County Arts Center,
Anderson 046445

Anderson County Arts Council,
Anderson 060316

Anderson County Historical Museum,
Garnett 049016

Anderson County Museum,
Anderson 046446

Anderson Farm Museum, Madoc 006112

Anderson Farm Museum, Greater
Sudbury Heritage Museum,
Lively 006075

Anderson Gallery, Richmond .. 052446

Anderson Hill, Kingston-upon-
Thames 118270

Anderson Museum of Contemporary
Art, Roswell 052590

Anderson O'Day, London 118397

Anderson O'Brien, Omaha ... 123552

Anderson Park Art Gallery,

Invercargill 033045, 113005

Anderson Slater, Settle 091115, 135364

Anderson, A., Minneapolis 094729

Anderson, Alistair, Glasgow ... 118024, 118025, 134718

Anderson, Evelyn, Nashville ... 094800

Anderson & Son, F.E., Welshpool 091635

Anderson, H. & A., Stanwell Park 062232

Anderson, Jan, New York 122559

Anderson, Judith, Auckland ... 112831

Anderson, Vivien, Caulfield North 098733

Anderson/Abruzzo Albuquerque
International Balloon Museum,
Albuquerque 046329

Anderson's Guns, Hammer &
Damascus, Aberdeen 087978

Andersons, A., Clayfield 061321

Andersonville Prison,
Andersonville 046447

Anderssen, Trondheim . 084217, 126605

Andersson, Kalmar 086579

Andersson, Karlskrona 143682

Andersson, Börje G., Stockholm 115927

Andersson, F., Vevey 087676

Andersson, Gunnar, Lund 143693

Andersson, Herman, Tollarp ... 133942

Andersson, Stefan, Umeå 116059

Andersson, Thomas, Sala 143719

Andersson, Thomas, Uppsala .. 143794

Anderwereld, Groningen 112572

Andhra Academy of Arts,
Vijayawada 055780

Andhra Pradesh State Museum,
Hyderabad 023978

Andhra Sahitya Parishat Government
Museum, Kakinada 024020

Andia Blanco, Javier, Murcia ... 086134

Andiamo, Milwaukee 122168

Andijon Viloyat Adabiyot va San'at
Muzeyi, Andijon 054557

Andijon Viloyat Ülkashunoslik Muzeyi,
Andijon 054558

Andina, Miami 122004

Andino, Tshwane 085490

Andino, J.P. de, Washington ... 125108

Andipa Gallery, London 089712, 118398, 134899

Andi's Gallery, Jakarta 109536

Andjić, Beograd 114474

Andler & Co., A.R., Saint Paul . 124137

Ando, Sendai 081937

Andó, Fabio, Roma 081028

Andoe, Tulsa 125038

Andøymuseet, Risøyhamn ... 033713

Andong Folk Museum, Andong . 029708

Andor Gallery, London 118399

Andor Semsey Múzeum,
Balmazújváros 023113

Andorra Romànica Centre
d'Interpretació, La Massana . . 000093

Andover Gallery, New York 122560

Andover Historical Society Museum,
Andover 046449

Andover Museum, Andover ... 043159

Andra, Antwerpen 063130

Andrade, Gecy C., Belo Horizonte 063821

Andrade, José, Lisboa 084648

Andrä, Ernest Leopold, Krems .. 062663

Andraeas, Renate, Hamburg ... 107179

Andrášiovská Obrazáreň, Banícke
Múzeum Rožňava, Krásnohorské
Podhradie 038192

Andraz Antique, Bucureşti 084905

André, Paris 129129

André, Roma 110745

André Antiquités, Belfort-du-
Quercy 067013

Andre Emile, Vancouver 101594

André Kertész Fotómúzeum,
Szigetbecse 023643

André Schlechtriem Contemporary,
New York 122561

André, Anthony, Saint-Pierre-des-
Corps 073216

André, Jacques, Etampes 068422

André, Michel, Coutevroult 068155

Andrea Arte Contemporanea,
Vicenza 111223

Andrea Robbi Museum, Andrea Robbi-
Stiftung, Sils Maria 041735

Andréani, Jean-Claude, L'Isle-sur-la-
Sorgue 069495

Andreani, Luciano, Bern 087082

Andrea's Antiques, San Francisco 096996, 136642

Andrea's Antiques, Tauranga .. 083954

Andreas Grimm München,
München 108025

Andreas, S.C., Timişoara 084955

Andreasbutiken, Falköping ... 115704

Andreasen.Art, Højbjerg 102805

Andreasson, Järpås 143672

Andréemuseet, Stiftelsen
Grännamuseerna, Gränna ... 040470

Andreescu-Bernhardt, Despina,
Saarbrücken 078237

Andreevskij spusk 3, Kyïv 117182

Andréewitch, Stephan, Wien ... 062855

Andréhn-Schiptjenko, Stockholm 115928

Andreini, Milano 080219

Andreja Pumpura Muzejs,
Lielvārde 029976

Andreja Upīša Memoriālmāja,
Skrīveri 030065

Andreja Upīša Memoriālais Muzejs,
Rīga 030001

Andreotti, Raffaele, Bologna . . 131332

Andre's Art Gallery, San Diego . 124334

Andres Gonzalez, Jose Angel,
Zaragoza 115644

Andres Pico Adobe, San Fernando
Valley Historical Society Museum,
Mission Hills 050886

Andres Särevi Kortermuuseum,
Eesti Teatri- ja Muusikamuuseum,
Tallinn 010492

Andres, Marie-Christine, Mutzig 070353

Andresen, Berlin 141415

Andresen, Elke, Geesthacht ... 075902

Andrew and District Local History
Museum, Andrew 005238

Andrew Carnegie Birthplace Museum,
Dunfermline 043985

Andrew County Museum,
Savannah 053070

Andrew J. Blackbird Museum, Harbor
Springs 049315

Andrew Jackson Cottage & US Ranger
Centre, Carrickfergus 024555, 043672

Andrew Johnson National Historic Site,
Greeneville 049201

Andrew Logan Museum of Sculpture,
Welshpool 046101

Andrew Ross Museum, Kangaroo
Ground 001175

Andrew & Assoc., Brian, Chicago 092493

Andrew, Hilditch & Son,
Sandbach 127285

Andrew, William, Norwich ... 138490

Andrews & Andrews, New York . 095048

Andrew's Collectibles, Buffalo .. 092341

Andrew's Pueblo Pottery and Art
Gallery, Albuquerque 119726

Andrew's Refinishing, Dallas ... 135841

Andrews, Marilyn, Nelson 113040

Andrews, Meg, London 089713

Andrews, Michael, Milford,
Surrey 090605

Andrews, Stephen, Saint Peter
Port 091056

Andrien Antiquités, Dammart .. 068212

Andriesse, Paul, Amsterdam .. 112216

Andrieu-Bourelly, Edmonde,
Fumel 068562

Andrighetti Glasswork, Vancouver 101595

Andrin, Joël, Antibes-Juan-les-
Pins 066603

Andriola, Thom, Houston 121270

Andriot, Bernard, München 077381

Andrischewski, Heinz Joachim,
Düsseldorf 075405

Andrle, V., Praha 065394

Andrlová, Marie, Praha 065395

Andrøymuseet, Polar- og
Fiskerimuseet, Andenes 033323

Android's Dungeon, Oklahoma
City 095767

Andromeda Books, Athinai 142360

Androna degli Orti, Trieste 081614

Androscoggin Historical Society
Museum, Auburn 046620

Androt, Pierre, Beaulieu-sur-Mer 066938

Androx, Vigo 115628

Andruchowicz, Dietlinde,
Bodenheim 106520

Andrzej, Fedorowicz, Bamberg . 129669

Andy Warhol Art Authentication Board,
Andy Warhol Foundation, New
York 060317

The Andy Warhol Museum,
Pittsburgh 052062

Andy's Antique Restoration,
Killala 131278

Andy's Antiquitäten, Karlsruhe . 076618

Andy's Corner, Norwood 062001

Andy's Curio Shoppe, Gisborne . 083768

Andzelm Galeria, Lublin 113771

Ané, Patrick, Foix ... 103697, 128840

Anekojikan – Kyoto Mangekyo
Hakabutsukan, Kyoto 028733

Aneks, Kraków 113611

Anelim, Lisboa 084649

Anelli, Enrico, Genova 131681

Anet Antiquités, Anet 066534

Anew Fine Consignment,
Columbus 092824

Anfield Museum, Liverpool 044727

Anfiteatro, Milano 110252

Angarskij Gorodskoj Vystavočnyj Zal,
Angarsk 036683

Angarskij Muzej Časov, Angarsk 036684

Angarskij Muzej Mineralov,
Angarsk 036685

Angaston Abbey Trading,
Angaston 060989

Ånge Zoologiska Museum, Änge 040333

Angel Antiques, Petworth 090834

Angel Antiques, Redditch 090932

Angel Antiquités, Marseille ... 069846

Angel Arcade, London 089714

Angel Art Sanctuary, Rathdrum . 109694

The Angel Bookshop, North
Walsham 144505

L'Angel d'Or, Palma de Mallorca 086163

Angel Gento, Valencia 086322

Angel Mounds, Evansville 048602

Angel Orensanz Foundation, New
York 060318, 122562, 138426

Angel Row Gallery, Nottingham . 045350

Angel Town, Albuquerque 091864

Angel, David, Miami 094518

Angela & J.'s Gallery, New York 095049

Angela & J's Gallery, New York . 095050

Angela Blens – OA, Offerdingen 077836

Angela Reitz Art Forum, Galerie 45,
Riehen 116674

Angele, Montendre 070182

Angelfall Studios, Baltimore ... 119996

Angelfish, Denver 120965

Angélic'Art, Genève 087250

Angelier Antik, Quern 078030

Angelika Kauffmann Museum –
Gemeindemuseum, Schwarzenberg
in Vorarlberg 002679

Angelini, Alessandra, Roma ... 081029

Angelique's Cottage, El Paso .. 093220

Angell Gallery, Toronto 101425

Angell Street Curiosities,
Providence 096333

Angelo d'Oro, Bologna 131333

Angelo D'Oro, Parma 080921

Ano Moni Panagias Xenias,
Almyros 022530
Anoka County Museum, Anoka . 046476
Anola and District Museum,
Anola 005244
Anomaly, Portland 096192
Anonimo e d'Autore, Roma 081032
Años Luz Antiguedades,
Concepción 064883
Anotarte, Santiago de
Compostela 115532
Another Age Antiques, Austin . 092042
Another Antique Shop, Louisville 094352
Another Chance, Philadelphia . 095909
Another Man's Treasure, El Paso 093221
Another Period in Time,
Baltimore 092126
Another Time, San Francisco . 096997
Another Time, Seattle 097227
Another Time Antiques,
Christchurch 083679
Another Time Antiques, Detroit . 093193
Anouk Miga, Maastricht 083268
Anova Books, London 138237
Anqing Museum, Anqing 007377
Anqiu Museum, Anqiu 007378
Anquez, Etaples 068424
Anrep, Sabina, Milano 080221
An's Rommelzoo, Haarlem . . . 083125
Ansamblul Muzeal şi Monumental Dr.
Vasile Lucaciu, Şişeşti 036548
L'Anse aux Meadows National Historic
Park, Saint-Lunaire-Griquet . 006764
Anse-Blanchette, Forillon National
Park, Gaspé 005750
Anselme, Philippe, Saint-Bonnet-du-
Gard 072652
Anselmi, Guido Alessandro,
Firenze 131502
Anselmo Matučio Memorialinis
Muziejus, Alytus 030142
Ansermet, Pierre-Jean, Fribourg 134079
Anshan Museum, Anshan 007379
Anshun Zone Museum, Anshun . 007380
Ansley, Ruby, Birmingham . . . 092219
Anson, Tampa 124875
Anson-Cartwright, Hugh, Toronto 140359
Anson County Historical Society
Museum, Wadesboro 095724
Ansorena, Madrid . . . 085926, 115226,
115227, 126740, 126741
Anstead, Mary, San Diego . . . 127705
Anstead, Victoria, New York . . 122567
Anstensen, Kim, Göteborg . . . 115721
Anstey, Wetherby 119618
Ant Hill Gallery, Broken Hill . . 098647
Ant Hill Gallery, Wynnum 099788
Antal & Társa, Budapest 079130
Antalya Devlet Güzel Sanatlar Galerisi,
Antalya 042565
Antalya Müzesi, Antalya 042566
Antami Libros, Buenos Aires . 139576
Antan, Luxembourg 082174
Antaño, Buenos Aires 139577
Antaño, Estepona 085813
Antaño Antigüedades, Buenos
Aires 060844
Antano Baranausko ir Antano
Vienuolio-Žukausko Memorialinis
Muziejus, Anykščiai 030144
Antano ir Jono Juškų Etninēs
Kultūros Muziejus, Vilkija . . . 030337
Antano Jonyno Memorialinis Muziejus,
Alytus 030143
Antano Mončio Namai-Muziejus,
Palanga 030265
Antano Žmuidzinavičiaus Memorialinis
Muziejus, Nacionalinis M.K. Čiurlionio
Dailės Muziejus, Kaunas . . . 030177
Antar, Latifeh, Zghorta 082144
antbo, Berlin 141416
Anteak Interiör, Stockholm . . . 086777
Anteaques, Edinburgh 088949
Antéart, Dijon 068257

Antebellum, Blois 067190
Antebellum Antiques, New
Orleans 094885
Antelope County Historical Museum,
Neligh 051139
Antelope Valley Indian Museum,
Lancaster 050060
Anten-Gräfsnäs Järnväg,
Alingsås 040322
L'Antenato, Milano 080222
Antenne de l'Imprimerie de la Presse,
Louhans 013688
Anterieur, Leiden 083236
Anteros Arts Foundation,
Norwich 059932
Antes, Den Haag 082865
Anthea, Quimper 072297
Anthea's, Mitchelton 061855
Anthea's Antiques, Auckland . . 083565
Antheaume, Christiane, Rouen . 072515
Anthéaume, Fabrice,
Foussemagne 068547
Anthemion, Bruxelles 063256
Anthemion, Cartmel 088584
Anthemion Auctions, Cardiff . . 127043
Anthemion Gallery, Toronto . . . 064529
Anthéos, Bordeaux 067244
Anthèse, Arcueil 137072
Anthia, Charleville-Mézières . . 067785
Anthill, Richmond 096358
Anthinéa Brocante, Saint-Quentin
(Aisne) 073233
Anthology Film Archives, New
York 051258
Anthony, Dublin 079413
Anthony Antigüedades,
Fuengirola 085820
Anthony Henday Museum,
Delburne 005587
Anthony, Ivan, Auckland 083566
Anthony, John, Bletchingley . . 088284
Anthony, John, Kitchener 064278
Anthony's, Minneapolis 136172
Anthony's Antiques and Fine Arts, Salt
Lake City 096707
Anthracite Heritage Museum and Iron
Furnaces, Scranton 053099
Anthropological Museum, Xiamen 008239
Anthropological Museum, Department
of Anthropology, Guwahati University,
Guwahati 023954
The Anthropological National Folklore
Museum, Amman 029579
Anthropologische Sammlung der
Universität Göttingen, Göttingen 018465
Anthropology at Creswick,
Creswick 061364
Anthropology Museum, DeKalb . 048185
Anthropology Museum, Delhi . . 023904
Anthropology Museum,
Johannesburg 038563
Anthropology Museum, Ranchi . 024152
Anthropology Museum, Winnipeg 007251
Anthropology Museum, Southwest
State University, Marshall . . . 050646
Anthropology Museum, Sri Jai Narain
Degree College, Lucknow . . . 024061
Anthropology Museum, University of
Queensland, Saint Lucia 001471
Anthropos, Fribourg 139126
Anti-Keer, Hengelo, Overijssel . 142981
Anti-Kriegs-Museum, Berlin . . . 016864
Anti Reflets, Nantes . . 104279, 129590
Antic, Arras 066677
Antic – Starožitnosti, Ústí nad
Labem 065494
Antic . Arte, Roma 081033
Antic 190, Barcelona 085542
Antic 1900, Villeurbanne 074146
Antic 2000, Roquebrune-Cap-
Martin 072496
Antic 80, Abbeville 066348
Antic Art, Toulon (Var) 073659
Antic Art Connexion, Bezons . . 067125

Antic Art et Déco, Lege-Cap-
Ferret 069322
Antic Arts and Crafts, Atlanta . . 091940
Antic Atelier Cresta, Brienz
(Graubünden) 087144
Antic Atelier Cresta, Surava . . 087640
Antic Bisbal, La Bisbal
d'Empordá 085721, 085722
Antic Boutique, Luzern 087437
Antic Brocante, Barcelona 126714
Antic Center Informatique, Nice . 070502
Antic Comimpex, Bucureşti . . . 084906
Antic Daro, La Bisbal d'Empordá 085723,
133567
Antic Deco, Grenoble 068655
Antic Déco International, Loupian 069590
Antic Design, Saint-Étienne . . . 072708
Antic Dolls, Nice 070503
Antic Dolls-Toys, Lyon . 069630, 128933
Antic Ex Libris, Bucureşti 143421
Antic Julie & Renato, Toulon
(Var) 073660
Antic-Kaufhaus Falkenried,
Hamburg 076127, 130250
Antic-Land, Saint-Étienne 072709
Antic-Line, Perpignan 072027
Antic Renova Art, Savognin . . . 087603,
134323
Antic Restauro, Barcelona 133453
Antic Saint-Maclou, Rouen . . . 072516
The Antic Shop, Berlin 074702, 129691
Antic Shop, Neuilly-sur-Seine . . 070464
Antic Sud Loire, Saint-Melaine-sur-
Aubance 072935
Antic-Tac, Paris 070847, 129130
Antica, Angers 066539
Antica, Braunschweig 075078
Antica, Gex 068601
Antica, Marines 069824
Antica, Olomouc 065360
Antica, Paris 070848
Antica, Tarbes 073585
Antica, Vitry-aux-Loges 074220
Antica Antiques, Claremont . . . 061312
Antica GS, Sarreguemines . . . 073378
Antica Libreria Cappelli, Bologna 142445
Antica Libreria Cappelli, San Gregorio
di Catania 142662
ANTICA Namur, Namur 097874
Antica Opera Romana, Bari . . . 109776
Antica Persia, Napoli 080666
Anticaja, Roma 081034, 132189
Anticaja & Petrella, Roma 081035,
132190
Anticamente, Roma 081036
Antic'Ange, Saint-Cassien . . . 072666
Anticariat, Craiova 143435
Anticariat Curtea Veche,
Bucureşti 143422
Anticariat Galeria Halelor,
Bucureşti 114208, 143423
Anticariat Nr. 2, Bucureşti 143424
Anticariat Nr. 4, Bucureşti 143425
Anticariat Nr. 9, Bucureşti 143426
Antic'Art, Ajaccio 066433
Antic'art, Bouere 067317
Antic'Arte, Genova 110100
Antic'Arts, L'Absie 069074
Antic'Arts, Parthenay 071983
Antic'Brocante, Bayonne 066912
Antic'Diffusion, Clermont-Ferrand 067952
Antichi Maestri Pittori, Torino . . 110970
Antichi Ricordi, Milano 131761
Antichitá, Firenze 079907
Antichita, Glebe 061514
Antichità, Lignano Sabbiadoro . 110184
Antichità, Padova 132040
Antichità, Parma . . . 080922, 132103
Antichità Al Pozzo, Asolo 079643
Antichità alle Grazie, Milano . . 080223
Antichità all'Oratorio, Bologna . 079688
Antichità antiquarium di Lancioni
Francesco, Bologna 079689
Antichità Ardeatina, Roma 132191

Antichitá As, Messina 080191
Antichità Barberia, Bologna . . . 079690
Antichitá Belsito, Roma 081037
Antichitá Biedermeier, Milano . . 080224
Antichità Brunello, Treviso . . . 081612,
081613
Antichità Carlo III, Napoli 080667
Antichità Casolini, Milano 131762
Antichità Chiapuzzi, Alassio . . 079629
Antichità dal Luzzo, Bologna . . 079691
Antichità Dante, Palermo 080847
Antichità De Giosa, Milano . . . 080225
Antichità Dei Bardi, Firenze . . . 079908
Antichità della Moscova, Milano 080226
Antichità di Nobili Alessio, Canonica
Lambro 079839
Antichità Due Torri, Verona . . . 081720
Antichitá e Arte, Milano 080227
Antichità e Restauro, Firenze . . 131503
Antichità Estense, Modena . . . 080603
Antichità Federico II, Bari 079648
Antichità Fratelli Casagrande, Castel
San Pietro Terme 079847
Antichità G. N., Milano 080228
Antichità Gattemelata, Padova . 080791
Antichità Gatti, Crema 079891
Antichità Giardini, Modena . . . 131948
Antichità Giulia, Roma 081038
Antichità Gotha, Milano 080229
Antichità Grand Tour, Roma . . . 081039
Antichità Il Cherubino, Cagliari . 131456
Antichità Isabella, Roma 080230
Antichità M.M., Napoli 080668
Antichità Mona Lisa, Ascona . . 087009
Antichità Nirone 5678, Milano . . 080231
Antichitá Nova, Milano 080232
Antichità Piantarose, Perugia . . 080970
Antichità Piselli Balzano, Firenze 079909
Antichità Porta Venezia, Milano . 080233
Antichità Restauro, Roma 132192
Antichità Rinascimento, Roma . 081040
Antichità Ripetta, Roma 081041
Antichità Roberto Cocozza, Roma 081042
Antichità San Basso, Venezia . . 081651
Antichità San Federico, Torino . 081477
Antichità San Samuele, Venezia 081652
Antichità Santa Giulia di Borelli,
Brescia 079744
Antichità Santoro, Bologna . . . 079692
Antichità Sforza, Milano 080234
Antichità Sodani, Roma 081043
Antichità Sturni, Roma 081044
Antichità Tanca, Eredi Tanca,
Roma 081045
Antichità Unicorno, Cortina
d'Ampezzo 109993
Antichitá Vecci, Firenze 079910
Antichità Viola, Milano 080235, 142530
Antichitati Lu & Ad, Cluj-Napoca 084940
Antic'in, Le Grand-Saconnex . . 087322
Antic'Inn, Beauvoisin 066999
Antická Gerulata v Rusovciach,
Mestské Múzeum v Bratislave,
Bratislava 038118
Anticmag, Clermont (Oise) . . . 067951
Antico e Antico, Roma 081046
Antico Frantoio, Massa Marittima 026570
Antico Mania, Modena 131949
Antico Mondo, Köln 076779
Antico per Antico, Milano 080236
Antico Restauro, Roma 132193
L'Antico Viaggio Intorno Ad Un
Oggetto, Roma 081047
Antico, Marlene, Paddington, New
South Wales 099374
Antic'Oro, Brescia 079745
Antics, Paris 070454
Antics, Saint-Martin-d'Heres . . 072906
Antics Lleida, Lleida 085890
Anticthermal, Nancy 125925
Anticua, Barranquilla 102163
Anticuaria, Oviedo 086151
Anticuaria del Retiro, Buenos
Aires 139578

Antikvity Art Aukce, Brno 065274,
125685
Antikwest, Helsinki 066245
Antillaise, Fort-de-France 142793
Antillaise, Le Lamentin 142798
Antillaise, Rivière-Salée 142802
l'Antillaise Art Gallery, Austin .. 119915
Antilles Médailles, Chevilly-Larue 067911
Antilope, Casablanca 082357
L'Antilope, Lyon 104010
Antim, Bruxelles 063257
Antin, Brenda, Los Angeles ... 094082
Antin, Jean-Pierre, Lavérune ... 069154
Antiorario a Ritroso nel Tempo,
Modena 080604
Antipodean Gallery, Nedlands .. 139877
Antipodean Map and Print Gallery,
Subiaco 139944
Antiq' Art, Saint-Raphaël 073246
Antiq Déco, Quiberon 072292
Antiq Photo Gallery, Toulouse .. 073695
Antiq'Ardenne, Libramont 097875
Antiqart, Košice 085390, 143499
Antiq'Arts, Courthiezy 068144
Antiqe & Art Restoration by Wiebold,
Terrace Park 136737
Antiqe och Qriosa, Stockholm .. 086782
Antiqlädeli, Frauenfeld 087239
Antiqua, Amsterdam 142827
Antiqua, Athinai 079064
Antiqua, Emmerich am Rhein .. 075563
Antiqua, Firenze 079911
Antiqua, Göteborg 086509
Antiqua, Hradec Králové 065321
Antiqua, Jihlava 065330
Antiqua, Qormi 082241, 132722
Antiqua, Santiago de Chile ... 064896
Antiqua, Verona 081722, 081723
Antiqua, Warszawa 143324
Antiqua – Starožitnik, Jihlava .. 065330
Antiqua Coppédè, Rimini 081019,
132175
Antiqua Domus, Palermo 080848
Antiqua Galleria d'Arte, Trento .. 111047
Antiqua Novis, Funchal 084633
Antiqua Res, Roma 081050
Antiqua Russos, Setúbal 084889
Antiquado, Addlestone 088003, 134332
L'Antiquaille, Lausanne 087369
L'Antiquaire, Albi 066446
L'Antiquaire, Benfeld 067027
L'Antiquaire, Fribourg 087241
L'Antiquaire, Montréal 064308
Antiquaire, Provins 072274
l'Antiquaire, Sainte-Clotilde ... 084898
Antiquaire, San Francisco 096998
L'Antiquaire & the Connoisseur, New
York 095053
Antiquaire de Quinsac, Quinsac . 072314
Antiquaire des Gâtines Rouges, La
Chaussée-d'Ivry 068933
L'Antiquaire du Fourneau,
Balbigny 066865
L'Antiquaire du Tilleul, Fribourg . 087242
Antiquaire du Village, Saint-Leu-la-
Forêt 072853
Antiquaire d'Yerres, Yerres 074268
l'Antiquaire Galerie, Lefkosia .. 065241
L'Antiquaire Joyal, Montréal ... 064309
Antiquaire Suisse, Bruxelles ... 063258
Les Antiquaires, Milano 080238
Antiquaires de la Geôle,
Versailles 074003
Antiquaires de la Pauline, La
Garde 068986
Antiquaires de Lignane,
Puyricard 072288
Antiquaires de Sant-Vincens,
Perpignan 072028
Les Antiquaires de Stockel,
Bruxelles 063259
Antiquaires Drouot, Paris 070850
Les Antiquaires du Château,
Plougoumelen 072159

Antiquaires du Rhin, Strasbourg 073526
Antiqualha, Porto 084836, 133327
Antiqualhas Brasileiras Livraria, Rio de
Janeiro 140254
Antiquália, Lisboa 084652
Antiquária Salinha de Arte, São
Paulo 064092
Antiquaren Boekenbeurs Utrecht,
Utrecht 098103
Antiquária, Lisboa 126649
Antiquaria, Sliema 082249, 142791
Antiquaria, Tours 073796
Antiquaria Bok- & Bildantikvariat,
Göteborg 143650
Antiquaria di La Rosa & C.,
Catania 079851
Antiquaria-English Antiques,
Tours 073797
Antiquaria Sant'Angelo, Roma .. 081051,
142616
Antiquaria Veronese di Piazza S.
Anastasia, Verona 081724
Antiquariaat De Bilt, De Bilt ... 142917
Antiquariaat De Koppelpoort,
Amersfoort 142822
Antiquariaat De Oude Wereld,
Antwerpen 140115
Antiquariaat Friesland,
Leeuwarden 142990
Antiquariaat Sint Joris Maritiem,
Amstelveen ..082475, 132767, 142824
Antiquariaat Smedeman, Nieuw
Vennep 143015
Antiquarian, Plattsburgh 139288
Antiquarian, San Diego 096886
Antiquarian & Trading, Kingston 081785,
142711
Antiquarian and Landmarks Society
Museum, Hartford 049343
Antiquarian and Pre-Owned Books,
Miami 144994
Antiquarian Antiques, London .. 064286
Antiquarian Book Fair, Malvern,
Victoria 097854
Antiquarian Book Mart, Alamo
Heights 144688
Antiquarian Bookcrafts, Dublin . 131246,
142420
Antiquarian Booksellers, Glebe . 139779
Antiquarian Booksellers' Association,
London 059933
Antiquarian Booksellers Association of
America, New York 060319
Antiquarian Booksellers Association of
Canada, Victoria 058387
Antiquarian Booksellers Association of
Japan, Tokyo 059411
Antiquarian Booksellers Association of
Korea, Seoul 059449
Antiquarian Horological Society,
Ticehurst 059934
Antiquarian Horologists, New
York 095054, 136226
Antiquarian Maps and Prints, Potts
Point 139907
Antiquarian of Dallas, Dallas ... 144845
Antiquarian Restorers, New York 136227
Antiquarian's Delight,
Philadelphia 095910, 145144
Antiquariat, Bowral 139684
Antiquariat "Unter der Muren",
Wuppertal 142347
Antiquariat & Galerie R. Brehmer,
München 142006
Antiquariat 44, Berlin 141417
Antiquariat Adina Sommer,
München 130680, 142007
Antiquariat Aix-La-Chapelle,
Aachen 141354
Antiquariat am Bachhaus,
Eisenach 141650
Antiquariat am Bäckerbrunnen,
Wiesbaden 142313
Antiquariat Am Ballplatz, Mainz . 141971

Antiquariat am Bayerischen Platz,
Berlin 141418
Antiquariat am Dom, Trier 142256
Antiquariat am Domshof, Bremen 141572
Antiquariat am Fischtor, Mainz .. 141972
Antiquariat am Gendarmenmarkt,
Berlin 141419
Antiquariat am Hermannplatz,
Berlin 141420
Antiquariat am Kräherwald, Kirchheim
unter Teck 141878
Antiquariat am Marktplatz,
Solothurn 143923
Antiquariat am Moritzberg,
Hildesheim 141831
Antiquariat am Prater, Ihlow .. 141844
Antiquariat am Reileck, Halle,
Saale 141754
Antiquariat am Roßacker,
Rosenheim 142181
Antiquariat am Soonwald,
Sponheim 142217
Antiquariat am Stadtbach,
Memmingen 141991
Antiquariat am Vareler Hafen,
Varel 142281
Antiquariat am Westwall, Krefeld 141915
Antiquariat an der Donau, Neuburg an
der Donau 142081
Antiquariat an der Herderkirche,
Weimar 142300
Antiquariat an der Moritzburg, Halle,
Saale 141755
Antiquariat an der Nikolaikirche,
Leipzig 141932
Antiquariat an der Stiftskirche, Bad
Waldsee 141391
Antiquariat an der Universität, Freiburg
im Breisgau 141705
Antiquariat Analogon, Freiburg im
Breisgau 141706
Antiquariat Athenaeum,
Stockholm 143745
Antiquariat Atlas, Hamburg 141760
Antiquariat Aurora, Hannover ... 141800
Antiquariat Beim Steinernen Kreuz,
Bremen 141573
Antiquariat Bibermühle AG,
Ramsen 143909
Antiquariat Blechtrommel, Jena .. 141850
Antiquariat Buchfänger am
Pferdemarkt, Oldenburg 142115
Antiquariat Buchseite, Wien ... 140048
Antiquariat Buchstabei,
Oldenburg 142116
Antiquariat BücherParadies,
Kösseln 141908
Antiquariat Carpe Diem, Köln .. 141885
Antiquariat Christoph & Co. GmbH,
Bonn 126163, 141540
Antiquariat Curiosum, Benz, Kreis
Nordwestmecklenburg 141411
Antiquariat der Literatur, Zürich . 143942
Antiquariat Dieter Zipprich,
München 142008
Antiquariat Dr. Wolfgang Wanzke,
Gessertshausen 141734
Antiquariat FBV, Köln 141883
Antiquariat Flaster, München ... 142009
Antiquariat Franziska Bierl,
München 142010
Antiquariat für Musik und deutsche
Literatur J. Voerster, Stuttgart . 142227
Antiquariat Gallus GmbH,
Innsbruck 140013
Antiquariat Goethe & Co.,
Heidelberg 141816
Antiquariat Grimbart, Burgdorf . 141590
Antiquariat Hagenbrücke,
Braunschweig 141556
Antiquariat Hans Höchtberger,
München 142011
Antiquariat Hauser, Inh. Dr. Helene
Trottmann, München 142012

Antiquariat Heinz Rohlmann, Köln 141884
Antiquariat Helmut Mattheis,
München 142013
Antiquariat Helmut R Lang,
Rennerod 130954, 142174
Antiquariat Heureka, Bad
Staffelstein 141390
Antiquariat im Baldreit, Baden-
Baden 141393
Antiquariat im Hopfengarten,
Braunschweig 141557
Antiquariat im Hufelandhaus,
Berlin 141421
Antiquariat im Lenninger Tal,
Lenningen 141948
Antiquariat im Schnoor, Bremen 141574
Antiquariat im Seefeld, Zürich .. 143943
Antiquariat Im Willy-Brandt-Haus,
Berlin 141422
Antiquariat in Buckow, Buckow . 141586
Antiquariat in der Goltzstraße,
Berlin 141423
Antiquariat in der Scheune,
Uhlow 142275
Antiquariat Karla, Schnega 142196
Antiquariat Karlshorst, Berlin ... 141424
Antiquariat Katrin Brandel, Berlin 141425
Antiquariat Knuth, Potsdam 142155
Antiquariat Koenitz im Schloss Pillnitz,
Matthias Havenstein, Dresden . 141609
Antiquariat Kretzer – Bibliotheca-
Theologica, Kirchhain 141877
Antiquariat Kunstkabinett Heiland, Bad
Friedrichshall 074472, 141377
Antiquariat Les-Art, Gerlingen .. 141732
Antiquariat Libretto, Soest 142213
Antiquariat Lugauer, Inh. Carina
Lugauer, München 142014
Antiquariat Magister Tinius,
Falkensee 141672
Antiquariat Maxvorstadt I,
München 142015
Antiquariat Mephisto im
Bücherzentrum, Unna 142279
Antiquariat Mercurius, Köln 141885
Antiquariat Messidor, Bamberg . 141401
Antiquariat Montfort, Feldkirch . 062543,
140002
Antiquariat Numero 45, München 142016
Antiquariat Oktav, Zürich 143944
Antiquariat-Papierier, Sint
Jansteen 143039
Antiquariat Penzing, Oliver
Schützlhofer, Wien 140049
Antiquariat-Puls, Fredersdorf .. 141701
Antiquariat Querido, Düsseldorf . 141629
Antiquariat Rabenschwarz,
Braunschweig 141558
Antiquariat Robert Wölfle,
München 142017
Antiquariat Rosenstrasse,
Braunschweig 141559
Antiquariat Roter Stern, Marburg 141980
Antiquariat Schaper oHG,
Hamburg 076129, 141761
Antiquariat Suleika, Weimar ... 142301
Antiquariat Thomas Rezek,
München 142018
Antiquariat Tilmann Riemenschneider,
Osterode am Harz 142133
Antiquariat Tresor am Römer, Frankfurt
am Main 075723, 141678
Antiquariat und Galerie im
Rathausdurchgang, Winterthur 116811,
143938
Antiquariat Zwiebelfisch, Weimar 142302
Antiquariate Lorenz & Müller,
München 142019
Antiquariato, Milano 138834
Antiquariato, Parma 080923
Antiquariato, Pisa 080984
Antiquariato 1800 1900 e dintorni,
Venezia 081653
Antiquariato 800, Roma 081052

Antique City, Atlanta 091941
Antique-City, Knokke-Heist 063639
Antique City, Rozelle 062163
The Antique Clique, Kilkenny . . . 079534
Antique Clock Gallery, Long
 Beach 094025, 136041
Antique Clock Repair, Dallas . . . 135842
Antique Clock Repair and Antiques,
 Bowral 061170, 127840
Antique Clock Restoration,
 Columbus 135825
Antique Clock Restorer,
 Heathersett 089293, 134767
Antique Clock Shop, Saint Paul . 096637,
 136552
Antique Clocks, Harston 089249
Antique Clocks – Pendulantic, Saint-
 Blaise 087570, 134215
Antique Clocks by Mike, Oklahoma
 City . 095774
Antique Coins, Saint Paul 096638
Antique Collecting, Woodbridge . 139159
The Antique Collector, London . . 064287
Antique Collector's Club,
 Easthampton 138386
Antique Collectors' Club,
 Woodbridge 138349, 144674
Antique Company, Houston . . . 093430
The Antique Company,
 Sacramento 096431, 096432
Antique Connection, San Antonio 096889
Antique Connections, Fort Worth 093258
Antique Conservation, New York 136228
Antique Consignment, Los
 Angeles 094085
Antique Cooperative,
 Albuquerque 091866
Antique Cooperative, Oklahoma
 City . 095775
Antique Cooperative and Auction
 House, Malden 127568
Antique Corner, Bristol 088422, 134477
Antique Corner, Fort Worth 093259
Antique Corner, Narrandera . . . 061936,
 125497
Antique Cottage, Albuquerque . 091867
Antique Cottage, San Antonio . . 096773
Antique Cottage, San Diego . . . 096888
Antique Cottage at Estes Park,
 Omaha 095860
Antique Country Furniture and
 Interiors, Sandgate 091083
Antique de la Radio, Madrid . . . 085941
Antique Dealer and Collectors' Guide,
 London 139160
Antique Dealers, Shepparton . . 062197
Antique Dealers' Association of Poland,
 Kraków 059609
Antique Dealers Association of San
 Anselmo, San Anselmo 060321
Antique Dealers Fair, Dublin . . . 098033
Antique Decor, Armadale, Victoria 061000
Antique Decoration, Cluj-Napoca 084941,
 133366
Antique Decoration Art Noveau,
 Braşov 084899
Antique Department Store, Glebe 061515
Antique Depot, Richmond 096360
Antique Design, Philadelphia . . . 095911
Antique Design Center, Norfolk . 095679
Antique Detours, Sacramento . . 096433
The Antique Dining Room,
 Totnes 091477, 135493
Antique Doctor, Tucson 097464, 136749
Antique Doll Restorers, Auckland 133058
Antique Dolls and Bears, Torbay 083980
Antique East, Singapore 085186
Antique Effects, Ballarat 061072
Antique Elements, Leichhardt . . 061722
Antique Emporium, Albuquerque 091868
Antique Emporium, Dallas 092898
Antique Emporium, Healesville . 061601
Antique Emporium, Nashville . . 094801
Antique en Stock, Rouen 072517

Antique English Windsor Chairs,
 Chipping Norton 088667
Antique Engravings,
 Camperdown 061256
Antique Estate Jewelry Gallery, New
 Orleans 094887
Antique Europa, Houston 093431
Antique Exchange, Baltimore . . 092130
Antique Exchange, Denver 093081,
 127247
Antique Exchange, Winnipeg . . . 064856
Antique Eyes, Stockbridge 091283
Antique Firearms,
 Dommershausen 075325
Antique Fireplace Centre,
 Hartlepool 089250
Antique Fireplace Company, Prees
 Green 090901
Antique Fireplace Restoration,
 Dublin 079414, 131247
Antique Fireplaces, Liverpool . . . 089659
Antique Fireplaces, Manchester . 090533
Antique Forum, Newcastle-under-
 Lyme 090671
Antique Furniture, Baltimore . . . 092131
Antique Furniture, Brno 065275
Antique Furniture, Sherwood . . 127946
Antique Furniture, Toledo 136738
Antique Furniture Services,
 Miami 094520, 136136
Antique Furniture Warehouse,
 Houston 093432, 135934
Antique Furniture Warehouse,
 Stockport 091292
Antique Galerie, Düsseldorf 075406
The Antique Gallery, Belfast . . . 088206
Antique Gallery, Atlanta 091942
The Antique Gallery, Cleveland . . 092752
Antique Gallery, Los Angeles . . . 094086
Antique Gallery, Memphis 094445
Antique Gallery, New York 095058
Antique Gallery, Philadelphia . . 095912
Antique Gallery, Phoenix 096017
The Antique Gallery, Sutton 119458
Antique Garage, Yokohama 082047
Antique Garden, Saint Paul 096639
Antique Gas and Steam Engine
 Museum, Vista 053881
Antique Gatherings, Phoenix . . . 096018
Antique General Store,
 Narrabeen 061934
Antique Golf, Glasgow 089119
Antique Guild, Denver 093082
Antique Guild, Los Angeles 094087,
 136052
Antique Guild Japan, Tokyo 059412
Antique Guild United Kingdom,
 Burnley 059935
Antique Hardware Store, Oklahoma
 City . 095776
Antique Heaven, Miami 094521
Antique Helper, Indianapolis . . . 127523
Antique Home Improvement, Los
 Angeles 094088
Antique House, Cairo 066151
Antique House, Göteborg 086510
Antique House, Honolulu 093362
Antique House, Jacksonville 093787,
 135994
Antique House, Oklahoma City . 095777
Antique House, Te Awamutu . . . 083970
Antique Inspirations, Houston . . 093433
Antique Interiors, Charlotte 092408
Antique Interiors, Twickenham . . 091530
Antique Iron Market, Nashville . 094802
Antique Jewelry, Saint Paul 096640
Antique John's Auction, Clarinda 127445
Antique Junction, Columbus . . . 092827
Antique Junque Shoppe, Walcha 062392
Antique Kaprova, Praha 065405
Antique Kingdom, Charlotte . . . 092409
The Antique Lamp Shop, London 089721
Antique Lamp Shop, Maylands,
 Western Australia 061797

Antique Legacy, Sacramento . . . 096434
Antique Light, Abbotsford 060954
Antique Lighthouse, Philadelphia 095913,
 136419
Antique Lighting, Ottawa 064437
Antique Lighting Company,
 Seattle 097231
Antique Liquidators, Seattle . . . 097232
The Antique Loft, Clarecastle . . 079374
Antique Mall, Edmonton 064227
The Antique Mall, Las Vegas . . . 093947
Antique Mall, Regina 064493
Antique Mall, San Diego 096889
The Antique Mall, Tucson 097465
Antique Mall of Austin, Austin . . 092043
Antique Mall of Creve Coeur, Saint
 Louis 096501
Antique Mall of Green Hills,
 Nashville 094803
Antique Mall of Irvington,
 Indianapolis 093686
Antique Mall of Midtown,
 Memphis 094446
Antique Mall of Palma Ceia,
 Tampa 097373
Antique Mall of West Seattle,
 Seattle 097233
Antique Mall on Clark, Chicago . 092495
Antique Mall on Montgomery Street,
 Fort Worth 093260
Antique Mall Village, Houston . . 093434
The Antique Man, Baltimore . . . 092132
Antique Man, Buffalo 092342
Antique Manor, La Richardais . . 069006
Antique Manor, Tréméreuc 073841
Antique Map & Book Shop,
 Dorchester 144139
Antique Map & Print Gallery,
 Hallow 144210
Antique Maps, Belmont 139670
Antique Maps and Fine Prints,
 Dallas 144846, 144847
Antique Maps Room, Toronto . . 064532,
 140360
Antique Margurite, Ringe 065988
Antique Market, Adelaide 060957
Antique Market, Denver 093083
Antique Market, Hay-on-Wye . . 089283
Antique Market, Phoenix 096019
Antique Market, Sacramento . . 096435
Antique Market, Vancouver 064737,
 064738
Antique Market of Warrnambool,
 Warrnambool 062403
Antique Marketplace, Austin . . . 092044
Antique Mart, Saint Paul 096641
Antique Mattress, Houston 093435
Antique Max, Praha 065406
Antique Memories, San Jose . . . 097190
Antique Menagerie, Saint Louis . 096502
Antique Merchants Mall,
 Nashville 094804
Antique Mini-Mall, Tucson 097466
Antique Moderne, København . . 065773
Antique Odyssey, Seattle 097234
Antique Oise, Saint-Samson-la-
 Poterie 073258
Antique Oriental Rug Buyers,
 Miami 094522
Antique Oriental Rugs, Pittsburgh 096493,
 136468
Antique Oriental Rugs Center, Las
 Vegas 093948
Antique Outdoor Market, Long
 Beach 094026
Antique Outpost, Phoenix 096020
Antique Panache, Houston 093436
Antique Park, Bordeaux 067245
Antique Parlor, San Diego 096890
Antique Passion, Aulnay-sous-
 Bois . 066753
Antique Pavilion, Houston 093437
Antique Pendulum, Washington . 136785
Antique Pine & Country Furniture Shop,

Driffield 088892, 134655
Antique Place That, Houston . . . 093438
Antique Plus, Las Vegas 093949
Antique Plus, Los Angeles 094089
Antique Pohořelec, Praha 065407
Antique Presidio, Tucson 097467
Antique Print, Main Beach 061750
Antique Print Gallery,
 Christchurch 083680, 143109
Antique Print Room, Sydney . . . 062266,
 139950
Antique Print Shop, East
 Grinstead . . . 088920, 134659, 144147
Antique Print Shop, Redbourn . . 090928
Antique Prints, Dublin 142421
Antique Prints, Hawthorn 061590
Antique Radio and Audio Repair, San
 Diego 136624
Antique Radio Store, San Diego . 096891
Antique Refinishers, San Diego . 136625
Antique Refinishing, Virginia
 Beach 136775
Antique Repair, Cincinnati 135783
Antique Resources, Chicago . . . 092496
Antique Resources, Tulsa 097543
Antique Restoration, El Paso . . . 135899
Antique Restoration 45 Rose, San
 Francisco 097003, 136643
Antique Restoration Atelier,
 Washington 136786
The Antique Restoration Centre,
 Cheltenham 134547
Antique Restoration Service,
 Nashville 136192
Antique Restoration Services, Box
 Hill . 127841
Antique Restoration Services, East
 Norriton 135897
Antique Restoration Studio,
 Denver 135875
Antique Restoration Studio,
 Stafford 135421
Antique Restoration Tralee,
 Tralee 079599, 131295
Antique Restorations,
 Christchurch 083681, 133077
Antique Restorations, Hawkes
 Bay . 133096
Antique Restorations, Salt Lake
 City . 136570
Antique Restorations, Tulsa 136761
Antique Restorations of Unley,
 Unley 127964
Antique Riviera, Helsinki 066246
Antique Rooms, Maldon 090523
Antique Row, Dallas 092899
Antique Row on South Broadway,
 Denver 093084
Antique Rugs as Art, New York . 095059
Antique Salad, Vancouver 064739
Antique Salvage, Dublin 079415
Antique Sampler Shoppes, Kansas
 City . 093891
Antique Sampler Shoppes, Las
 Vegas 093950
Antique Services of Texas, San
 Antonio 096774
Antique Shop, Blaenau Ffestiniog 088279
Antique Shop, Bruton 088471
Antique Shop, Dunshaughlin . . . 079504
Antique Shop, Godalming 089139
Antique Shop, Hamilton, New South
 Wales 061567
The Antique Shop, Kirkcudbright 089521
Antique Shop, Kjustendil 064167
The Antique Shop, Langholm . . 089548
Antique Shop, Lille 069416
The Antique Shop, Newtonmore 090697
Antique Shop, Omaha 095861
The Antique Shop, Saint-Nom-la-
 Bretèche 072953
Antique Shop, Sutton Bridge . . . 091369
Antique Shop Saborna, Plovdiv . 064711
Antique Shoppe, Ottawa 064438

Antiques Houston, Houston 093443,
144898
Antiques Idées, Chelles 067897
Antiques Imp-Exp, Midwoud ... 132965
Antiques Import Export,
Stockport 091293, 135438
Antiques in Ashbourne,
Ashbourne 088062
Antiques in Indy, Indianapolis .. 093689
Antiques in Sassafras, Sassafras 062182
Antiques in Thames, Thames .. 083972
Antiques in the Bank, Cleveland 092753
Antiques in the Rough, San
Francisco 097007
Antiques in Time, Cleveland .. 092754,
135806
Antiques in Wales, Kidwelly ... 089487
Antiques International, Houston . 093444
Antiques International, Miami .. 094532
Antiques International, West
Hollywood 097704
Antiques Ireland, Saintfield Antiques &
Fine Books, Ballygowan 088113,
144000
Antiques Limited, Chicago 092497
Antiques Magazine, Birmingham 139161
Antiques Magazine, New Orleans 094890
Antiques Marie-Claire, Naarden . 083318
Antiques Market, Knokke-Heist . 063640
Antiques Memories, Qormi 082242
Antiques Minnesota Midway, Saint
Paul 096643
Antiques 'n Stuff, Oklahoma City 095778
Antiques 'n Stuff, Tampa 097376
Antiques Natalie, Lima 084268
The Antiques Network, Cincinnati 092661
Antiques Notre Dame, Montréal 064312
Antiques of Brentwood, Nashville 094806
Antiques of Cool Springs,
Nashville 094807
Antiques of Denver, Denver 093089
Antiques Of Epsom, Auckland .. 083572
Antiques of Georgetown,
Washington 097637
Antiques of Penrith, Penrith 090804
Antiques of Shadyside,
Pittsburgh 096091
Antiques of Sherborne,
Sherborne 091154, 135382
Antiques of Southside,
Birmingham 092222
Antiques of the Orient, Singapore 085187,
085188, 143492
Antiques of Tomorrow, Tshwane 085491
Antiques of Western NY, Buffalo 092344,
135721
Antiques of Woodstock,
Woodstock 091794, 135611
Antiques on Broadway,
Vancouver 064742
Antiques on Ellsworth, Pittsburgh 096092
Antiques on High, Armadale,
Victoria 061001
Antiques on High, Oxford 090777,
135256
Antiques on Hildebrand, San
Antonio 096777
Antiques on Lloyd, Moe 061860
Antiques on Locke, Hamilton ... 064258
Antiques on Macquarie, Hobart . 061617
Antiques On Manukau, Auckland 083573
Antiques on Memorial, Houston . 093445
Antiques on Mount Pleasant,
Toronto 064542
Antiques on Nineteenth, Houston 093446
Antiques on Queen, Toronto 064543
Antiques on Railway, Boonah ... 061164
Antiques on the River, Detroit .. 093194
Antiques on the Square,
Indianapolis 093690
Antiques on Victoria, Cambridge 083671
Antiques on View, Bendigo 061117
Antiques-Point Chev Plaza,
Auckland 083574

Antiques Productions, Houston . 093447
Antiques Provencal, New York .. 095065,
136229
Antiques Puces Libres, Montréal 064313,
128428
Antiques Restoration, New York . 136230
Antiques Rich Man Poor Man,
Montréal 064314
Antiques Riverwalk, Minneapolis 094731
Antiques Services, Bruxelles ... 063260
Antiques Show & Sale,
Minneapolis 098254
Antiques Starozitnosti, Bratislava 085367
Antiques Storehouse, Portsmouth 090889
Antiques Super Mall, Houston .. 093448
Antiques to Go, Winnipeg 064860
Antiques Tour, Auckland 083575
Antiques Trade Gazette, London 138238,
139162
Antiques Unique, Dallas 092904
Antiques Warehouse, Bath 088151
The Antiques Warehouse, Bristol 088423,
134478
Antiques Warehouse, Buxton .. 088527,
134516
The Antiques Warehouse,
Farnham 089049, 134700
Antiques Warehouse, Marlesford 090573
Antiques Warehouse, San
Antonio 096778
Antiques Warehouse, Whangarei 084063,
133137
Antiques White Bear, Saint Paul 096644
Antiques with Grace, New York . 095066
Antiques Within, Leek . 089577, 134855
Antiques Within, Memphis 094449
Antiques Workshop, San Antonio 136594
Antiques World, Brugge 063205
Antiques, Art and Investment Fair,
Seinäjoki 097930
Antiques, Books, Ephemera and
Collectibles, Atlanta . 091943, 144698
Antiques, Fine Art & Decorative
Furnishings Fair, Harrogate .. 098190
Antiques, Tiques & Toys,
Pittsburgh 096090
Antiques@Chicago, Chicago ... 092498
Antiques'Atelier, Camblain-l'Abbé 067554
Antiquest-Verity, Toronto 064544
Antiquetrade, Roma 081055
AntiqueWeek, Knightstown 139298
AntiqueWest, Knightstown 139299
Antiquitäten 1900, Viktring ... 062835
Antiquitäten 96, Berlin 074708
Antiquitäten am Alten Hof,
München 077383, 130681
Antiquitäten am Belvedere,
Weimar 078806
Antiquitäten am Berliner Platz, Kronberg
im Taunus . 076909, 076910, 130530
Antiquitäten am Ellinger Tor,
Weißenburg in Bayern 078827
Antiquitäten am Franziskanerplatz,
Würzburg 078986, 142337
Antiquitäten am Hafenplatz, Bad
Karlshafen 074494
Antiquitäten am Klosterplatz,
Solothurn 087622
Antiquitäten am Kosttor,
München 077384
Antiquitäten am Markt, Olpe ... 077869
Antiquitäten am Markt, Tübingen 078635,
131096
Antiquitäten am Rathaus,
Würzburg 078987, 126361
Antiquitäten am Schloß, Weimar 078807
Antiquitäten am Schloß Moyland,
Bedburg-Hau 074665
Antiquitäten am Schlossberg,
Pegnitz 077950
Antiquitäten am Schwabentor, Freiburg
im Breisgau 075795
Antiquitäten am Schwanenwall,
Dortmund 075334

Antiquitäten am See, Rottach-
Egern 078215
Antiquitäten am Thielenplatz,
Hannover 076300
Antiquitäten am Zielemp, Olten . 087527
Antiquitäten am Zielemp, Rickenbach
(Solothurn) 134209
Antiquitäten an der Heiliggeistkirche,
Landshut 076948
Antiquitäten-Atelier, St. Schreiner,
Restauratormeister, Meuselwitz 077304,
130660
Antiquitäten auf der Breite,
Schaffhausen 087604
Antiquitäten Diele, Wiefelstede . 078876
Antiquitäten Fasan, Wien 062859
Antiquitäten-Galerie, Abtwil 086993,
133963
Antiquitäten-Galerie, Erfurt 075587
Antiquitäten Gerling, A. und E. Gerling,
Grassau 076024
Antiquitäten Hofgut, Mannheim . 077189
Antiquitäten im alten Zollhaus,
Wallerfangen 078764
Antiquitäten im Bachgau,
Großostheim 076053
Antiquitäten im Beethovenhaus, Baden
bei Wien 062518
Antiquitäten im Bennohaus,
Meißen 077268
Antiquitäten im Hagenstal,
Hagenbuch 087329, 134103
Antiquitäten im Hinterhaus,
Lörrach 077081
Antiquitäten im Hof, Krefeld ... 076886
Antiquitäten im Holländerviertel,
Potsdam 077992
Antiquitäten im Kolerschloß, Lauf an
der Pegnitz 076967
Antiquitäten im Wolfgang-Borchert-
Haus, Hamburg 076130
Antiquitäten in Altdorf, Altdorf bei
Nürnberg 074352
Antiquitäten in Herrenhausen,
Hannover 076301
Antiquitäten Miklautz, Bad
Kleinkirchheim ... 062515, 127980
Antiquitäten-Münzen,
Quedlinburg 078025
Antiquitäten Pavillon, Andrea,
Stuttgart 078507
Antiquitäten Pöll, Kufstein 062676
Antiquitäten Rotenhahn,
Rotenhahn 078205, 130976
Antiquitäten Spatenmühle,
Wöllstein 078956
Antiquitäten Thum, Oer-
Erkenschwick 077823
Antiquitäten und Kunsttage,
Wasserburg 097982
Antiquitäten vom Schneeberg,
Wattendorf 078789
Antiquitäten Vorstadt,
Schwarzenberg 078339
Antiquitäten zum Bühlhof, Iffwil . 087343
Antiquitäten zum Heiligkreuz, Sankt
Gallen 087576
Antiquitäten zum Rosshof, Basel 087029
Antiquitäten zum Schlössli,
Zweisimmen 087821
Antiquitäten zur Zinglermühle,
Viktring 062836
Antiquitäten.Design.Raum,
Stuttgart 097983
Antiquitätengalerie, Potsdam .. 077993
Antiquitätengalerie Oben, Halle,
Saale 076105
Antiquitätenhalle Schüttorf,
Schüttorf 078323
Antiquitätenhandel, Nußdorf am
Attersee 062721
Antiquitätenhaus, Unterpleichfeld 078679
Antiquitätenwinkel, Hall in Tirol . 062605

Antiquitás, Budapest .. 079134, 079135
Antiquitás, Győr 079204
Antiquitat, Balatonfüred 079124
Antiquité, Cahors 067534
Antiquite, Dallas 092905
Antiquité, Québec 064464
Antiquite 56, Saint-Ouen 072969
Antiquité AJR, Saint-Maur-des-
Fossés 072920
Antiquité Art Ancien, Pérouges . 072023
Antiquité Art Ancien, Vaujours .. 073948
Antiquité Art Contemporain, Nice 070504
Antiquité au Chiabout, Luppy .. 069612
Antiquité au Temps Jadis,
Carcassonne 067608
Antiquité Au Temps Qui Passe,
Paris 070854
Antiquité Bonheur D'Autrefois,
Montréal 064315
Antiquité Brancion, Paris 070855
Antiquité Brocante, Coux 068158
Antiquité Brocante A, Reims ... 072334
Antiquité Brocante du Lac, L'Isle-
Jourdain 069490
Antiquité Brocante du Laonnois, Mons-
en-Laonnois 070119
Antiquité Brocante Guibert,
Narbonne 070437
L'Antiquité Classique, Louvain-la-
Neuve 138589
L'Antiquité Curiosité, Montréal .. 064316
Antiquité de Geneston, Pont-Saint-
Martin 072220
Antiquité de la Chapelle,
Plouigneau 072165
Antiquité de la Couronne,
Québec 064465
Antiquité de la Place, Codognan 068000
Antiquité de la Prefecture,
Orléans 070755
Antiquité de la Reine, Bourg-la-
Reine 067357
Antiquité de l'Abbaye, Hambye . 068727
Antiquité de l'Almanarre, Hyères 068795
Antiquité de l'Eglise, Sainte-
Geneviève 073311
Antiquité Décor, Dieppe 068239
Antiquité Décoration, Montville . 070290
Antiquité des Marais, Guérande 068703
Antiquité des Templiers, La Baule-
Escoublac 068889, 125874
Antiquité du Chalet, Caluire-et-
Cuire 067549
Antiquité du Château,
Rambouillet 072320
Antiquité du Hanau,
Philippsbourg 072108
Antiquité du Lac, Saulxures-sur-
Moselotte 073391
Antiquité du Musée, Troyes 073858
Antiquité du Rest, Pleuven 072145
Antiquité du Village Fleuri,
Rémérangles 072369
Antiquité Ehrmann, Metz 070033
Antiquité Fontaine aux Bretons,
Pornic 072237
Antiquité Franco Anglaise, Paris 070856
Antiquité Franco Anglaise, Villiers-le-
Bel 074198
Antiquité La Barbotine, Alençon . 066461
Antiquité La Méridienne, Le
Pellerin 069267
Antiquité La Vigie, Quiberon ... 072293
Antiquité le Grenier de Saint-Lié,
Charleville-Mézières . 067786, 067787
Antiquite les Deux Chênes,
Coutiches 068156
Antiquité Marie Rue Subes, Dax 068221
Antiquité Saint-Maur, Nantes .. 069927
Antiquité Saint-Prix, Saint-Prix . 073230
Antiquité TDC, Castres 067666
Antiquiteas, Brockenhurst 088460
Antiquites, Aubigny (Falaise) .. 066730
Antiquités, Bougival 067318

Art Athina, Athinai 098031
Art Attack, Cleveland 120675
The Art Attack, Jacksonville . . 121511
Art Attack, Manawatu 113022
Art Attack, Paraparaumu 113072
Art Attacks Too, New Orleans . . 122367
Art Attract, O'Connor 099363
Art au Carré, Angers 103186
L'Art au Zénith, Nyons 104367
Art Avenue, Vallauris 105759
Art Avenue Magazine, Vancouver 118487
Art Avenues, New York 122587
Art Bank, London 101195
Art Bank, Philadelphia 123599
Art Bank, Rosebery 062157
Art Bar, Albuquerque 119728
Art Bar, Calalzo di Cadore 109941
Art Baraka, Pamplona 115479
Art Barn, Washington 125113
Art Base, Singapore 114554
Art Base Book Research,
 Kitzingen 141879
Art Basel, Basel 098161
Art Basel Hong Kong, Hong Kong 097907
Art Basel Miami Beach, Miami
 Beach 098257
Art Beat Gallery, Louisville 121909
Art Beat International, Boston . 120111
Art Beatus, Hong Kong 101924
Art Beatus, Vancouver 101597
Art Best, Saint-Ouen 072976
Art Bodensee, Dornbirn 097860
The Art Book, Oxford 139171
Art Book Survey, London 138242
Art Books, San Jose 138516
Art Books International, London 138243
Art Books of London, London . . 144315
Art Boutique, Braintree 117512
Art-Box, Århus 065529
Art-Box, Galerie im Sporthotel, Sankt
 Anton am Arlberg 100048
Art Broker Bigli, Milano 080253, 126419
Art Brokering, Los Angeles 121709
ART Brussels, International
 Contemporary Art Fair,
 Bruxelles 097876
Art Brut Center Gugging,
 Klosterneuburg 058193
Art Bubamara, Beograd 114476
Art-Buks, Moskva 143444
Art Bulletin, New York 139309
Art Bureau NZ, Auckland 083580
Art Business News, Seven Hills . 139310
Art Business Today, London . . 138244,
 139172
Art by Design, Houston 121274
Art by God, Dallas 120827
Art by God, Miami 122007
Art by Nature, Tulsa 097547
Art by Querch, Seiersberg 100064
Art by the Sea, Auckland 112833
Art by Will, Philadelphia 123600
Art Caballero, Barcelona 085551
Art Cadre, Paris 104446
Art Cadre Dauphine, Paris 104447
Art Calendar, Orlando 139311
Art Calendar International,
 Dronningmølle 065567
Art Capital Group, New York . . 122588
Art Care, Singapore 133394
Art Care and Conservation,
 Dunedin 112958, 133092
Art Care Professional, Ellwangen 075550
Art Carnival, Toronto 064547
Art CC, Saint-Ouen 105520
Art Cellar Exchange, San Diego . 124338
The Art Center, Jeddah 085123
The Art Center, Mount Clemens 051011
d'Art Center, Norfolk 123476
Art Center, Porto Alegre 063901
Art Center at Fuller Lodge, Los
 Alamos 050346
Art Center Berlin Friedrichstrasse,
 Berlin 016867

Art Center College of Design,
 Pasadena 057608
Art Center Gallery, Central Missouri
 State University, Warrensburg . 053946
Art Center In Hargate, Saint Paul's
 School, Concord 047921
Art Center Lavradio, Rio de
 Janeiro 063963
Art Center of Battle Creek, Battle
 Creek 046795
Art Center of Corpus Christi, Corpus
 Christi 047965
Art Center of South Florida, Miami
 Beach 050778
Art Center of Waco, Waco 053889
Art Center Sarasota, Sarasota . 053032
Art Center, National Yunlin University
 of Science and Technology,
 Douliou 042029
Art Center, Queens College,
 Flushing 048723
Art Center, Tainan National University
 of the Arts, Tainan 042205
Art Centr Puškinskaja 10, Sankt-
 Peterburg 037544
ART Central, Hong Kong 097908
Art Central Gallery, Barry 043257
Art Centre, Barcelona 114939
Art Centre, Haifa 024860
Art Centre, Kathmandu 112138
Art Cetera Gallery of Memphis,
 Memphis 121959
Art Channel, Sendai 111392
L'Art Chez Soi, Baerenthal 066847
Art Chi, Düsseldorf 075407
Art Chicago, Chicago 098258
Art China, Shanghai 138640
Art Chronika, Moskva 139050
Art Circle, Amsterdam . 082499, 112221
Art-Cite, La Chaux-de-Fonds . . 116299
Art Clectic, Reims 105378
Art-Clinique, Bruxelles 128269
Art Clipper, Helsinki . . 066247, 103079
Art Co-Ordinates, Subiaco 062245
Art Collection, Rotterdam 083364
Art Collection, San Francisco . . 124458
Art Collection, Stirling 045856
Art Collection Canada, Toronto . 101431
Art Collection International,
 Amsterdam 082500
Art Collection Roméo,
 Luxembourg 111885
Art Collection, Australian National
 University, Acton 000759
Art Collections, Tulsa 125040
Art Collections Outlet, Miami . . 122008
Art Collective, Minneapolis . . . 122242
Art Collective Gallery, San
 Francisco 124459
Art Collector, Pisa 080985
Art Collector, San Diego 124339
Art Collector, Taupo 083951
Art College, Khorram-Abaad University,
 Khorram-Abaad 055784
Art Cologne, Internationaler
 Kunstmarkt, Köln 097988
Art Comes to Life, Milwaukee . . 122170
Art Company, Cincinnati 120594
Art Company, Eindhoven 112537
Art Company, Tshwane 085492
Art Company, Tucson 124961
Art Company, Virginia Beach . . 125071
Art Company the Art Gallery,
 Edmonton 101135
Art Compass, Wellington 113145
Art Complex Museum, Duxbury . 048375
Art Concept, Amsterdam 082501
Art Concept, Enghien-les-Bains . 068387
Art Concept, Nantes . . 070395, 104280
Art Concept, Paris 104448
Art Concorde, Paris . . . 104449, 137127
Art Conexion, Sabadell 115490
The Art Connection Eton, Eton . 117956
Art Connoisseurs International, New

York 122589
Art Conseil, Paris 104450
Art Conseil & Expertise, Paris . . 070894
Art Conservation, Vlaardingen . 133035
Art Conservation Associates, New
 York 136234
Art Conservation Framers,
 Melbourne 127911
Art Conservation Resource Center,
 Boston 135711
Art Conservation Service, Boston 135712
Art Conservation® Thomas Becker,
 Küsnacht 134117
Art Consultant, Los Angeles . . . 121710
Art Consulting, Praha 102609
Art Contact, London 118409
Art Contact, Marlborough 118914
Art Contacts, Maitland 114893
Art Container Steffisburg, Kunstraum
 im Freien, Steffisburg 041771
Art Copenhagen, Nordens Kunstmesse,
 Frederiksberg 097928
Art Corner, Roskilde 102907
Art Corporation, London 118410
Art Cottage, Louisville 121910
Art Criticism, Stony Brook 139312
Art Critics' Association, Moskva . 059687
Art Cru Muséum, Bordeaux . . . 011923
Art Cuadros, Lima 084269
Art Cuestion, Ourense 115412
The Art Cube, Düsseldorf 075408
Art d' Ameublement, Bielefeld . 106484
Art d'Aimer, Castillon-la-Bataille 067660
L'Art d'Aimer, Craponne (Rhône) 103592
Art Dais, Hyderabad 109365
Art Dallas, Dallas 120828
Art d'Antan, Grenoble 068659
Art Data, London 138245
Art de Asia, San Francisco 097015
Art de Basse-Normandie, Caen . 138674
Art de Chine, Nice 070510
Art de la Chine et du Japon,
 Paris 070895
Art de Vivre, Carcassonne 067610,
 067611
L'Art de Vivre, Hautefort 103760
Art de Vivre, L'Isle-sur-la-Sorgue 069498
l'Art de Vivre, New York 095073
L'Art de Vivre, Vevey 087677
Art Dealers Association of America,
 New York 060334
Art Dealers Association of California,
 Los Angeles 060335
Art Dealers Association of Canada,
 Association des marchands d'art du
 Canada, Toronto 058388
Art Dealers Association of Chicago,
 Chicago 060336
Art Dealers Association of Greater
 Washington, Washington 060337
Art Dec, Bourg-Saint-Bernard . . 067360,
 128756
Art Deco, Berlin 074712
Art Deco, Bruxelles 063269
Art Dèco, Kraków 084388, 084389,
 133201
Art Deco, München 077388
Art Deco, Poznań 113805
Art Deco, Torino 132474
Art-Deco, Warszawa 133234
Art Deco, Wien 062860, 062861
Art-Deco, Zürich 087735
Art Deco – Galerie Mili Vávrové,
 Praha 065409
Art Deco – Starožitnosti, Praha . 065410
Art Deco & Jugendstil, Wien . . . 062862
Art Déco 1930–1950, Nice 070511
Art Deco-Art Nouveau, Bruxelles 063270
Art Deco Collections, Oakland . . 095718
Art Deco en zo, Apeldoorn 082731
Art Deco en Zo, Hilversum 083211
Art Deco Français, San Francisco 097016
Art Deco Gallery, Roma 081066
Art-Deco-House, Breda 082786

Art Deco Marion Schäfer, Bonn . 075022
Art Deco Metropolis, Stuttgart . 078508
Art Deco Society of New York, New
 York 060338
L'Art Décor, Mereglise 070016
Art d'elite, Ortenberg, Baden . . 077874
d'Art Demain, Broken Hill 098648
Art Department, Bellingham . . . 056677
Art Department, Kwa Dlangezwa 056299
Art Department, San Diego 124340
Art Department 1072, University of
 Puget Sound, Tacoma 057932
Art Department Gallery, Community
 College of Rhode Island,
 Warwick 053955
Art Department, Abilene Christian
 University, Abilene 056577
Art Department, Acadia University,
 Wolfville 055111
Art Department, Agnes Scott College,
 Decatur 056951
Art Department, Alabama Southern
 Community College, Monroeville 057432
Art Department, Alabama State
 University, Montgomery 057438
Art Department, Albertus Magnus
 College, New Haven 057482
Art Department, Alice Lloyd College,
 Pippa Passes 057642
Art Department, Allegany Community
 College, Cumberland 056927
Art Department, Allen County
 Community College, Iola 057199
Art Department, Alverno College,
 Milwaukee 057409
Art Department, Alvin Community
 College, Alvin 056604
Art Department, Amarillo College,
 Amarillo 056605
Art Department, Ancilla College,
 Plymouth 057657
Art Department, Anderson University,
 Anderson 056613
Art Department, Angelo State
 University, San Angelo 057797
Art Department, Anoka Ramsey
 Community College, Coon
 Rapids 056912
Art Department, Aquinas College, East
 Grand Rapids 056989
Art Department, Art Division, Pacific
 University in Oregon, Forest
 Grove 057054
Art Department, Ashland University,
 Ashland 056626
Art Department, Augsburg College,
 Minneapolis 057416
Art Department, Augustana College,
 Sioux Falls 057879
Art Department, Aurora University,
 Aurora 056646
Art Department, Averett College,
 Danville 056939
Art Department, Baker University,
 Baldwin City 056654
Art Department, Baldwin-Wallace
 College, Berea 056685
Art Department, Barton College,
 Wilson 058078
Art Department, Bay de Noc
 Community College, Escanaba . 057018
Art Department, Belhaven College,
 Jackson 057208
Art Department, Belleville Area
 College, Belleville 056674
Art Department, Bellevue Community
 College, Bellevue 056675
Art Department, Benedictine College,
 Atchison 056629
Art Department, Berea College,
 Berea 056684
Art Department, Berry College, Mount
 Berry 057450
Art Department, Bethany Lutheran

NY, Brooklyn 056757
Art Department, Knox College,
Galesburg 057082
Art Department, La Grange College,
La Grange 057258
Art Department, La Sierra University,
Riverside 057725
Art Department, Lackawanna College,
Scranton 057849
Art Department, Lake City Community
College, Lake City 057268
Art Department, Lake Erie College,
Painesville 057601
Art Department, Lake Tahoe
Community College, South Lake
Tahoe 057886
Art Department, Lamar University,
Beaumont 056672
Art Department, Laney College,
Oakland 057564
Art Department, Le Moyne College,
Syracuse 057927
Art Department, Lehman College,
Bronx 056750
Art Department, Lenoir Community
College, Kinston 057249
Art Department, Lewis and Clark
College, Portland 057667
Art Department, Lewis and Clark
Community College, Godfrey . 057099
Art Department, Lewis-Clark State
College, Lewiston 057296
Art Department, Lincoln College,
Lincoln 057305
Art Department, Lindenwood
University, Saint Charles 057763
Art Department, Linfield College,
McMinnville 057341
Art Department, Linn Benton
Community College, Albany . . . 056590
Art Department, Long Island
University – Brooklyn Campus,
Brooklyn 056758
Art Department, Lorain County
Community College, Elyria . . . 057012
Art Department, Loras College,
Dubuque 056981
Art Department, Los Angeles City
College, Los Angeles 057325
Art Department, Los Angeles Harbor
College, Wilmington 058074
Art Department, Los Angeles Valley
College, Valley Glen 057999
Art Department, Lourdes College,
Sylvania 057926
Art Department, Lower Columbia
College, Longview 057319
Art Department, Luther College,
Decorah 056953
Art Department, Lutheran Brethren
Schools, Fergus Falls 057044
Art Department, Lynchburg College,
Lynchburg 057339
Art Department, Macomb Community
College, Warren 058018
Art Department, Manchester College,
North Manchester 057550
Art Department, Mansfield University,
Mansfield 057365
Art Department, Marian College, Fond
Du Lac 057052
Art Department, Marietta College,
Marietta 057367
Art Department, Mars Hill College,
Mars Hill 057373
Art Department, Marylhurst University,
Marylhurst 057376
Art Department, Marywood University,
Scranton 057850
Art Department, McMurry University,
Abilene 056578
Art Department, McPherson College,
McPherson 057345
Art Department, Mercer University,

Macon 057343
Art Department, Meredith College,
Raleigh 057703
Art Department, Merritt College,
Oakland 057565
Art Department, Mesa State College,
Grand Junction 057106
Art Department, Methodist College,
Fayetteville 057042
Art Department, Metropolitan State
College, Denver 056961
Art Department, Miami University,
Oxford 057599
Art Department, Middle Georgia
College, Cochran 056880
Art Department, Midland College,
Midland 057404
Art Department, Midway College,
Midway 057405
Art Department, Millersville University,
Millersville 057408
Art Department, Millikin University,
Decatur 056952
Art Department, Minnesota State
University, Mankato, Mankato . 057364
Art Department, Minot State University,
Minot 057421
Art Department, Miracosta College,
Oceanside 057570
Art Department, Mississippi State
University, Mississippi State . . 057423
Art Department, Missouri Western
State University, Saint Joseph . 057767
Art Department, Mohawk Valley
Community College, Utica . . . 057991
Art Department, Monmouth College,
Monmouth 057429
Art Department, Monroe Community
College, Rochester 057734
Art Department, Montana State
University Billings, Billings . . . 056696
Art Department, Montgomery County
Community College, Blue Bell . 056713
Art Department, Morehead State
University, Morehead 057446
Art Department, Morningside College,
Sioux City 057878
Art Department, Mount Marty College,
Yankton 058098
Art Department, Mount Mary College,
Milwaukee 057410
Art Department, Mount Mercy College,
Cedar Rapids 056807
Art Department, Mount Saint Mary's
College, Los Angeles 057326
Art Department, Mount San Antonio
College, Walnut 058016
Art Department, Mount San Jacinto
College, San Jacinto 057818
Art Department, Mount Vernon
Nazarene College, Mount
Vernon 057456
Art Department, Muskingum College,
New Concord 057481
Art Department, Nassau Community
College, Garden City 057085
Art Department, Navarro College,
Corsicana 056918
Art Department, Nazareth College of
Rochester, Rochester 057735
Art Department, Nebraska Wesleyan
University, Lincoln 057306
Art Department, New Mexico State
University, Las Cruces 057283
Art Department, Normandale
Community College,
Bloomington 056711
Art Department, North Arkansas
College, Harrison 057144
Art Department, North Carolina
Agricultural and Technical State
University, Greensboro 057118
Art Department, North Central
Michigan College, Bay View . . 056670

Art Department, North Hennepin
Community College, Brooklyn
Park 056763
Art Department, North Idaho College,
Coeur d'Alene 056881
Art Department, North Park University,
Chicago 056838
Art Department, North Seattle
Community College, Seattle . . 057853
Art Department, Northampton County
Community College, Bethlehem 056690
Art Department, Northeastern Illinois
University, Chicago 056839
Art Department, Northeastern
Oklahoma A & M College,
Miami 057397
Art Department, Northeastern State
University, Tahlequah 057935
Art Department, Northern Kentucky
University, Highland Heights . . 057162
Art Department, Northern State
University, Aberdeen 056576
Art Department, Northern Virginia
Community College, Annandale 056617
Art Department, Northwest College,
Powell 057677
Art Department, Northwest Nazarene
College, Nampa 057464
Art Department, Northwestern College,
Orange City 057584
Art Department, Northwestern
Michigan College, Traverse City 057962
Art Department, Notre Dame de
Namur University, Belmont . . . 056678
Art Department, Oklahoma State
University, Stillwater 057914
Art Department, Olympic College,
Bremerton 056741
Art Department, Orange
County Community College,
Scotchtown 057845
Art Department, Paris Junior College,
Paris 057605
Art Department, Park University,
Parkville 057607
Art Department, Peace College,
Raleigh 057704
Art Department, Penn Valley
Community College, Kansas
City . 057236
Art Department, Peru State Colllege,
Peru 057621
Art Department, Piedmont College,
Demorset 056957
Art Department, Pierce College,
Woodland Hills 058091
Art Department, Pittsburg State
University, Pittsburg 057643
Art Department, Plattsburgh State
University College, Plattsburgh 057654
Art Department, Plymouth State
University, Plymouth 057658
Art Department, Portland Community
College, Portland 057668
Art Department, Prairie State College,
Sauk village 057840
Art Department, Pratt Community
College, Pratt 057678
Art Department, Queens College,
Flushing 057051
Art Department, Radford University,
Radford 057701
Art Department, Rhode Island College,
Providence 057685
Art Department, Richard Bland
College, Petersburg 057622
Art Department, Ripon College,
Ripon 057722
Art Department, Rivier College,
Nashua 057467
Art Department, Roanoke College,
Salem 057790
Art Department, Roberts Wesleyan
College, Rochester 057736

Art Department, Rochester Community
College, Rochester 057732
Art Department, Rockland Community
College, Suffern 057920
Art Department, Rocky Mountain
College, Billings 056697
Art Department, Roger Williams
College, Providence 057686
Art Department, Rogers State College,
Claremore 056864
Art Department, Rowan University,
Glassboro 057094
Art Department, Sacramento City
College, Sacramento 057759
Art Department, Saint Ambrose
University, Davenport 056940
Art Department, Saint John's
University, Collegeville 056889
Art Department, Saint Louis
Community College at Meramec,
Saint Louis 057770
Art Department, Saint Mary-of-the-
Woods College, Saint Mary-of-the-
Woods 057776
Art Department, Saint Mary's School,
Raleigh 057705
Art Department, Saint Mary's
University of Minnesota,
Rochester 057733
Art Department, Saint Olaf College,
Northfield 057555
Art Department, Saint Thomas
Aquinas College, Sparkill 057889
Art Department, Salem College,
Winston-Salem 058084
Art Department, Salem State College,
Salem 057788
Art Department, Salisbury State
University, Salisbury 057793
Art Department, Salve Regina
University, Middletown 057401
Art Department, Sam Houston State
University, Huntsville 057186
Art Department, Samford University,
Birmingham 056701
Art Department, San Bernardino Valley
College, San Bernardino 057807
Art Department, San Diego Mesa
College, San Diego 057809
Art Department, San Francisco State
University, San Francisco 057813
Art Department, San Jacinto College
North, Houston 057173
Art Department, San Juan College,
Farmington 057038
Art Department, Santa Ana College,
Santa Ana 057827
Art Department, Santa Clara University,
Santa Clara 057830
Art Department, Santa Rosa Junior
College, Santa Rosa 057835
Art Department, Seattle Pacific
University, Seattle 057854
Art Department, Shepherd College,
Shepherdstown 057868
Art Department, Sheridan College,
Sheridan 057869
Art Department, Shippensburg
University, Shippensburg 057870
Art Department, Shorter College,
Rome 057754
Art Department, Siena Heights College,
Adrian 056583
Art Department, Sierra College,
Rocklin 057748
Art Department, Silver Lake College,
Manitowoc 057362
Art Department, Simpson College,
Indianola 057196
Art Department, Snow College,
Ephraim 057015
Art Department, South Carolina State
University, Orangeburg 057585
Art Department, South Dakota State

York 051267, 122611
Asian-American Arts Centre, New
York 051268
Asian and Primitive Art Gallery,
Paddington, New South Wales 099375
Asian Antique Art Gallery,
Ulaanbaatar 082350
Asian Antique Gallery, Denver . . 093094
Asian Antiques and Furniture, Los
Angeles 094097
Asian Antiques Center, Houston . 093454
Asian Art, Kathmandu 138968
Asian Art, Santa Fe 139351
Asian Art Center, Washington . . 136787
Asian Art Coordinating Council,
Denver 060376
Asian Art Gallery, London 089737
Asian Art Gallery, New York . . . 122612
Asian Art Gallery, Woollahra . . . 099769
Asian Art Museum, San
Francisco 052888
Asian Art News, Hong Kong . . . 137004,
138644
The Asian Art Newspaper,
London 139185
Asian Art Options, Singapore . . . 114574
Asian Arts, New York 095078
Asian Arts and Culture Center, Towson
University, Towson 053667
Asian Center Museum, Quezon
City 034408
Asian Civilisations Museum,
National Museums of Singapore,
Singapore 038087
Asian Connection Galleries, Noosa
Heads 061967
Asian Cultures Museum, Corpus
Christi 047967
Asian Design, New York 095079
Asian Feeling, Bruxelles 063275
Asian Galleries, Art Gallery of New
South Wales, Sydney 001533
Asian House of Chicago, Chicago 092501
Asian Resource Gallery, Oakland 123495
Asian Style, Bolzano 079724
Asian Style, Seattle 097239
Asianart, Honiton 089362
Asianart, North Newton 090704
Asiart Corner, Hong Kong 064956,
140406
Asiatic Arte, Buenos Aires 098371
Asiatic Fine Arts, Singapore . . . 085194
Asiatic Society, Kolkata 059280
Asiatic Society Museum, Kolkata 024040
Asiatica-Buchhandlung, Zürich . 143945
Asiatica Musée d'Art Oriental,
Biarritz 011843
Asiattitude, Senlis 073451
Asibelle, Couesmes 068120
Asie Antique, Paris 070914
L'Asie Exotique, New York 095080
Asien Antik, Berlin 074715
Asikkalan Kotiseutumuseo,
Asikkala 010587
Asil, Damascus 087825
Asil, Manama 063082, 100273
Asila, Cairo 102965
El Asilo del Libro, Valencia 143607
Asin Remírez de Esparza, F.,
Zaragoza 143622
L'Asino, Livorno 080147
Asioli Martini, Giovanni, Imola . . 080137
Aşiyan Müzesi, İstanbul 042650
Aska Antik, Sorunda 086763
Askanders, Indianapolis 135976
Asker Museum, Hvalstad 033504
Askeri Müze ve Kültür Sitesi
Komtuanlığı, İstanbul 042651
Askersunds Auktionskammare,
Askersund 126779
Askew Art, London 118426
Aski Galerie, Biarritz 103331
Askim Museum, Askim 033338
Asklepeion Epidaurus Archaeological

Museum, Ligourio 022784
Askon Museo, Lahti 010894
Aslamazyan Sisters Museum,
Gyumri 000696
Asmat Art Gallery,
Mönchengladbach 107996
Åsmundarsafn, Listasafn Reykjavíkur,
Reykjavík 023772
Asmundarsalur, Reykjavik 109235
Aso-gun Kazan Hakubutsukan-Orugoru
Kyouwakoku, Aso 028309
Asociace Starožitníků, Praha . . . 058507
Asociación Amigos del Museo
Nacional de Arte Decorativo, Buenos
Aires 058133
Asociación Amigos del Museo
Nacional de Bellas Artes, Buenos
Aires 058134
Asociación Argentina de Galeria de
Artes, Buenos Aires 058135
Asociación Colombiana de Museos,
ACOM, Bogotá 058480
Asociacion de Amigos de los Museos
Militares, Madrid 059747
Asociación de Anticuarios de Aragón,
Zaragoza 059748
Asociación de Artistas Visuales de
Euskal Herria, CreaZ, Donostia-San
Sebastián 059749
Asociación de Escritores y Artistas,
Madrid 059750
Asociación de Museos de Guatemala,
AMG, Guatemala 059251
Asociación del Amigos de Museo
Nacional de Arte Decorativo, Buenos
Aires 058136
Asociación Española de Archiveros,
Bibliotecarios, Museólogos y
Documentalistas, ANABAD,
Madrid 059751
Asociación Española de Fabricantes,
Comerciantes Mayoristas de Marcos,
Molduras y Productos afines,
Artecuadro, Madrid 059752
Asociación Española de Museólogos,
Madrid 059753
Asociación Española de Pintores y
Escultores, Madrid 059754
Asociación Española de Profesionales
del Diseño, Madrid 059755
Asociación Fotográfica Cordobesa,
Córdoba 059756
Asociación Galega de Artistas Visuais,
A Coruña 059757
Asociación Internacional Mujeres en
las Artes, Madrid 059758
Asociacion Madrileña de Galerias de
Arte, Madrid 059759
Asociacion Nacional Profesional de
Galerias de Arte, Madrid 059760
Asociación Numismática Española,
Barcelona 059761
Asociación Pintores y Escultores
de Chile, APECH, Santiago de
Chile 058451
Asociación Venezolana Amigos del
Arte Colonial, Caracas 060812
Asociatia Nationalá a Muzeelor in aer
Liber – România, Bucureşti . . . 059683
Aspaas, Trondheim 113383
Aspazijas Mája, Jürmalas Pilsétas
Muzejs, Jürmala 029961
Aspect Design, Hobart 098990
d'Aspect Jacques, Marseille . . . 140900
Aspect, The Chronicle of New Media
Art, Boston 139352
Aspects Gallery, Blairgowrie . . . 098607
Aspects Gallery in Appleby,
Nelson 113041
Aspects of Art, Leyburn 118336
Aspekt Galerie, Brno 102524
Aspelia Gallery, Larnaka 102469
Aspen, Denver 093095
Aspen Art Museum, Aspen 046549

Aspen Historical Society Museum,
Aspen 046550
Asperger, Berlin 106111
Aspex, Portsmouth 119177
Aspidistra Antiques, Woking . . . 091765
Aspinall, Walter, Sabden 091016
Aspingtons, Stockholm 143746
Aspire, Cleveland 127447
ASPN Galerie, Leipzig 107795
Aspö-Tosterö Hembygdsmuseum,
Strängnäs 040859
Asppan, Rivas-Vaciamadrid 138090
Asquier, Marie-Pierre, Veigné . . 129558
ASR, Hamburg 130252
Asri Environmental Education Center,
Bristol 047179
Assab One, Milano 059323
Assadi, D., Nyon 116629
Assai al-Hamra (Red Castle),
Tripoli 030124
Assam Forest Museum,
Guwahati 023955
Assam State Museum, Guwahati 023956
Åssamuséet, ÅSSA-Industri- och
Bilmuseum, Åtvidaberg 040355
Assanti, Edel, London 118427
Assar Art Gallery, Tehrān 109549
Assay, Caroline d', Paris 129145
Asseff, Henry, Cali 065157
Assembly Rooms Market,
Lancaster 089541
Assets Antiques, Buffalo 092345
Assiginack Historical Museum
and Norisle Heritage Park,
Manitowaning 006124
Assila, Giza 103039
Assinck, Ruud, Lochem 132948
Assiniboia and District Museum,
Assiniboia 005257
Assiniboia Gallery, Regina 101391
Assioma, Prato 110705
Assmann, Franz Josef, Graz . . . 062564
Associação Brasileira de
Conservadores-Restauradores de
Bens Culturais, Rio de Janeiro 058369
Associação Brasileira de Livreiros
Antiquarios, Petrópolis 058370
Associação dos Arquitectos de Macau,
Macau 058455
Associacão Portuguesa de Museologia,
Lisboa 059671
Associação Portuguesa dos
Antiquários, Lisboa 059672
Associacija Muzeev Rossii, Tula 059688
Associacija Muzej, Varna 058374
Associacio d'Amics de les Antiguitats,
Barcelona 059762
Associació d'Artistas Visuals de
Catalunya, Barcelona 059763
Associació d'Artistas Visuals de
les Illes Baleares, Palma de
Mallorca 059764
Associació de Galeries Art Barcelona,
Barcelona 059765
Associació del Museo de la
Ciència i de la Tècnica i
d'Arqueologia Industrial de Catalunya,
Terrassa 059766
Associació Difusora d'Obra Gràfica
Internacional, Barcelona 059767,
138042
Associated Antique Dealers of
America, Monticello 060377
Associated Artists of Pittsburgh,
Pittsburgh 060378
Associated Artists of Pittsburgh
Gallery, Pittsburgh 052064
Associated Artists of Winston-Salem,
Winston-Salem 054361, 060379
Association Alberto et Annette
Giacometti, Paris 058560
Association Art Promotion, Liège 058326
Association Artistique Général Gérard,
Ligny 058327

Association Arts de Faire,
Fribourg 059835
Association des Amis de Cholaïc,
Ayer 059836
Association des Amis des Arts et de
la Culture, Monaco 059493
Association des Amis du Musée Asia-
Africa, AMA, Genève 059837
Association des Antiquaires
Brocanteurs et Negociants
en Oeuvres d'Art du Poitou,
Poitiers 058561
Association des Antiquaires et
Brocanteurs de la Charente,
Angoulême 058562
Association des Antiquaires et
Brocanteurs de la Place du Foirail,
Pau 058563
Association des Antiquaires et
Brocanteurs de la Vendée, Les
Sables-d'Olonne 058564
Association des Antiquaires et
Brocanteurs de l'Aude, Conilhac-
Corbières 058565
Association des Antiquaires et
Brocanteurs des Deux-Sèvres,
Chauray 058566
Association des Artilleurs de la
Garnison, Lévis 006064
Association des Brocanteurs et
Antiquaires de Loire-Atlantique,
Nantes 058567
Association des Conservateurs
d'Antiquités, Athinai 059242
Association des Conservateurs et du
Personnel Scientifique des Musées
de la Ville de Paris, Paris 058568
Association des Galeries d'Art
Contemporain, Montréal 058391
Association des Galeries d'Art
Parisiennes, Paris 058569
Association des Musées Automobiles
de France, Paris 058570
Association des Musées et Centres
pour le Développement de la
Culture Scientifique, Technique et
Industrielle, AMCSTI, Dijon . . . 058571
Association des Musées Locaux
d'Alsace, Wingen-sur-Moder . . 016144
Association des Spécialistes en Art
Asiatique, Paris 058572
Association du Patrimoine Artistique,
Bruxelles 058328
Association Européenne des Musées
d'Histoire des Sciences Médicales
(AEMHSM), Paris 058573
Association for Cultural Advancement
through Visual Art, London . . . 059966
Association for Cultural Enterprises,
Worcester 059967
Association for Living History, Farm
and Agricultural Museums, North
Bloomfield 060380
Association for Public Art,
Philadelphia 060381
Association for Studies in the
Conservation of Historic Buildings,
London 059968
Association for Support of Women
Artists and Art Critics of Kyrgyzstan,
Bişkek 059456
Association for Visual Arts, Cape
Town 059729, 114838
Association Française des
Amateurs d'Horlogerie Ancienne,
Besançon 058574
Association Française des Directeurs
de Centres d'Art, Pougues-les-
Eaux 058575
Association Française des Musées
d'Agriculture et du Patrimoine Rural,
AFMA, Paris 058576
L' Association Francophone des
Musées de Belgique, Hornu . . 058329

Ballan Shire Historical Museum,
Ballan 000815
Ballance House, Glenavy 044269
Ballangen Bygdemuseet,
Ballangen 033346
Ballantine Publishing, New York 138431
Ballarat Clayfire Gallery, Magpie 099116
Ballarat Fine Art Gallery, Ballarat 000816
Ballarat Tramway Museum,
Ballarat 000817
Ballard, Seattle 136699
Ballard & Fetherston, Seattle . . 124740
Ballarin Marin, Enrique, Zaragoza 086415
Ballarin, Giancarlo, Venezia 132611
Ballarin, Teresa, Venezia 132612
Ballario, Georges, Le Cannet . . . 069177
La Balle de Plomb, Eguilles 068377
Ballenberg, Freilichtmuseum der
Schweiz, Hofstetten bei Brienz 041367
Ballerup Museum, Ballerup 009859
Ballet, Eddy, Thorey-Lyautey . . . 129508
Ballinderry Antiques, Lisburn . . 089646
Balling, Jan, Århus 065530
Ballon- en Luchtvaartmuseum
Zep/Allon, Lelystad 032410
Ballonmuseum Gersthofen,
Gersthofen 018395
Ballot, Saint-Étienne 126074
Ballot, Michel & Dany, Romenay 072484
Ballpark Gallery, San Francisco . 124475
Ball's Falls Historical Park,
Jordan 005931
Ballufin, Charles, Grenoble 068662
Bally, Miami 136138
Bally Schuhmuseum,
Schönenwerd 041708
Bally, Maurice & Gisèla, Colmar 068026
Ballybunion Heritage Museum,
Ballybunion 024530
Ballycastle Museum, Ballycastle 043225
Ballyheigue Maritime Centre,
Ballyheigue 024536
Ballymoney Museum,
Ballymoney 043231
Balmain Framers and Gallery,
Balmain 098549
Balmer, H.R., Zug 143976
Balmès Richelieu, Pierre, Paris . 070967
Balmoral, Toronto 064552
Balmoral Art Galleries, Hamlyn
Heights 098965
Balmoral Grist Mill Museum, Balmoral
Mills 005274
Balnarring Gallery, Balnarring . . 098552
Balneologické Múzeum, Piešťany 038242
Balocco Arte, Torino 110974
Balocco, Vassilli, Milano 080261
Balogh, Erika, Perchtoldsdorf . . 062732
Il Balôn, Torino 081485
Il Balon 2, Roma 081082
Al-Baloushi, Khalid Rasool Buksh
Osman, Muttrah 084235
Balroop, Susanna, Wien 128162
Balsalobre Oliva, Fernando,
Cartagena 085747
Balsano, Rosario, Torino 081486
Balser Morris, Shirley, Hampton 144893
Balser jun., Helmuth, Gernsbach 075929,
130197
Balsiger-Sax, Walter, Bad Ragaz 087019
Balsiger, Otto, Delémont 116337
Baltazar, Ostrava 065367
Balteau, Alain, Liège 063690
Balter, Steven F., Seattle 136700
Balters, Regensburg 078079
Baltic Art Centre, Visby 040970
BALTIC Centre for Contemporary Art,
Gateshead 044216
Baltic Crossroads, Los Angeles . 121716
Baltic Imports, Minneapolis . . . 122252
Balticsaktionsraum, Stralsund . . 108683
Baltimore Book Company,
Baltimore 127398, 144718
Baltimore Clayworks, Baltimore . 120002

Baltimore County Historical Museum,
Cockeysville 047814
Baltimore Gallery, Baltimore . . . 120003
Baltimore Gold & Silver Center,
Baltimore 092136
Baltimore Maritime Museum,
Baltimore 046699
The Baltimore Museum of Art,
Baltimore 046700
Baltimore Museum of Industry,
Baltimore 046701
Baltimore Public Works Museum,
Baltimore 046702
Baltimore Streetcar Museum,
Baltimore 046703
Baltimore's Black American Museum,
Baltimore 046704
Bałucki Ośrodek Kultury, Łódź . . 034783
Balugani, Aurelio, Zocca
Montombraro 081784
Balvu Novada Muzejs, Balvi . . . 029927
Balzac, Toronto 101439
Balzaretti, Daniela, Milano 080262
Balzeau, Liliane, Tours 073801
Balzekas Museum of Lithuanian
Culture, Chicago 047603
Balzo, Roland del, Grenoble . . . 068663
BAM – Beaux Arts Mons, Mons 003797
Bama Ngappi Ngappi Aboriginal
Corporation, Yarrabah 062494
Bambach, Klaus, Wiesbaden . . . 078883
Bamberger, Alan, San Francisco 145280
Bamberger, Chantal, Strasbourg 105633
Bamberger, Peter, Nürnberg . . . 126313
Bamble Museum, Langesund . . 033556
Bamboo, Jacksonville 121513
Bamboo, Kathmandu 112139
Bamboo Museum, Lugu 042105
Bamburgh Castle, Bamburgh . . 043233
Bame, Chris, Dallas 135845
Bamfield Community Museum,
Bamfield Community School
Association, Bamfield 005275
Bamfords, Derby 127080
Bamfords, Rowsley 127274
Bammler, Thomas, Traunstein . . 078606
Bamps, Véronique, Bruxelles . . 063290
Bampton Gallery, Bampton,
Devon 088115, 134371
Bamses Auktioner, Svedala 126894
Bamyan, Paris 070968
Ban Chiangcome, Chiang Mai . . 087870
Ban Kao Prehistoric Museum,
Kanchanaburi 042422
Banaemah, Jeddah 085125
Banana Hill Art Gallery, Nairobi . 111570
Banana Long, Busan 111582
Bananas, Wien 062869
Banas, Alessandro Pietro, Milano 131772
Banbury Cross Antiques,
Sacramento 096438
Banbury Cross Fine Arts and Antiques,
Ascot 061051
Banbury Fayre, London 089749
Banbury Museum, Banbury . . . 043235
Banc Public, Sainte-Cecile-
d'Andorge 105591
La Bancarella del Novecento, Monte
San Pietro 110521
Banchory Museum, Banchory . . 043237
Banco 22, Firenze 079918
Banco-Münzcabinett, Münster . . 077577
Bancroft, Cleveland 120680
Bancroft Historical Museum,
Bancroft 005277
Bancroft Mill Engine Trust,
Barnoldswick 043248
Bancroft's Decorative and Fine Arts
Society, Loughton 059976
The Band Museum, Pine Bluff . . 052046
Bandamora, Katoomba 099034
Bandaranaike Museum, Colombo 040727
La Bande des Six Nez, Bruxelles 100421,
140136

Bandeira, Rosário, Setúbal 114197
Bandekow, Fred, Vollerwiek . . . 108840
Bandelier National Monument, Los
Alamos 050347
Bandello, Rocco, Genk 063559
Bandigan, Sydney 099631
Bandinelli, Benito, Firenze 131513
Bandirma Arkeoloji Müzesi,
Bandirma 042574
BandiTrazos, Seoul 111658
Bandkeramik-Museum,
Schwanfeld 021369
Bandkowski, Andrzej, Wrocław . 114005
Bandol Antiquités, Bandol 066869,
128701
Bandwebermuseum, in der Friedrich-
Bayer-Realschule, Wuppertal . . 022394
BaneGården Kunst og Kultur,
Aabenraa 102718
Banegårdens Antik, Assens . . . 065544
Banes, Richmond 136505
The Banff Centre, Banff 055050
Banff Museum, Banff 043239
Banff Park Museum, Banff 005278
Bang, Cape Town 114841
Bang, Makel, København 065781
Bangabandhu Shek Mujibur Rahman
Museum, Dhaka 003140
Bangalow Antiques, Bangalow . 061090
Bangalow House Antiques,
Lismore 061731
Bangbu Museum, Bangbu 007394
Bangiya Sahitya Parisad Museum,
Kolkata 024042
Bangkok University Gallery,
Bangkok 042377
Bangla Academy Folklore Museum,
Dhaka 003141
Bangladesh National Museum,
Dhaka 003142
Bangladesh Shamorik Jadughar,
Dhaka 003143
Bangladesh Shilpakala Academy,
Dhaka 054920
Bangor Auctions, Bangor 126999
Bangor Historical Society Museum,
Bangor 046745
Bangs, Christopher, London . . . 089750
Bangsbo Museum, Frederikshavn 009909
Bangunan Alat Kebesaran Diraja,
Bandar Seri Begawan 004874
Banícke Múzeum, Gelnica 038171
Banicke Múzeum, Rožňava 038257
Banícky Dom, Vyšna Boca 038301
Bank Austria Kunstforum und
Kunstsammlung, Wien 002873
The Bank Eclectic Vintage,
Eltham 083761
Bank Gallery, Darlinghurst 098799
Bank Gallery, Los Angeles 121717
The Bank House Gallery,
Norwich 090725, 119028, 135232
Bank Leumi le-Israel Museum, Tel
Aviv 025012
Bank Museum, Meeetetse Museums,
Meeetetse 050703
Bank of England Museum,
London 044796
Bank of Mississippi Art Collection,
Tupelo 053728
Bank of Montreal Museum,
Montréal 006226
Bank of Valletta Museum, Sliema 030571
Bank of Victoria Museum, Royal
Historical Society Victoria,
Yackandandah 001661
Bank One Fort Worth Collection, Fort
Worth 048859
Bank Street Antiques, Ottawa . . 064442
Bank Street Arts, Sheffield 119339
Bank Street Gallery, Newquay . . 119003
Banker's Furniture, Phoenix . . . 096027
Bankert, Alexander, Mühlenbecker
Land 130673

Bankfield Museum, Halifax 044349
Bankmuseet, Stavanger 033793
Banko, Walter M., Montréal . . . 064338
Banks Peninsula Antiques,
Akaroa 083556
Banks, M.G., Christchurch 083686,
112918
Banks, Robert H ., Dallas 120838
Banks, Simon, Finedon 089065
Banks, Yvonne, Seattle 124741
Banksia Grove Gallery, Lake
Cathie 099076
Bankside Gallery, London 044797
Bannach, Anna, Düsseldorf . . . 130010
Banner County Historical Museum,
Harrisburg 049328
Bannier, Yves, Saint-Brandan . . 072654
The Banning Museum,
Wilmington 054306
Banning, J., New York 122629
Bannister, David, Cheltenham . . 134548,
144092
Bannister, Penny, Fremantle . . . 139770
Bannock County Historical Museum,
Pocatello 052129
Bannockburn Heritage Centre,
Stirling 045857
Bannow, Günther, Lübeck 077110
Banovsky, Chomutov 065309
Banovsky, Michel, Bagneux . . . 066852
Banq, Eric, Castres 067669
Banque du Livre, Saint-Étienne . 141290
Banquels, J., Courville-sur-Eure 068146
Banqueting House, Historic Royal
Palaces, London 044798
Bansaghi Fine Art Restoration, Miklos,
London 134907
Bansaghi Fine Art Restoration, Miklos,
Saint Albans 135332
Bansbach, B., Heidelberg 076371
Banské Múzeum v Prírode, Slovenské
Banské Múzeum, Banská
Štiavnica 038103
Bantam Dell Publishing, New
York 138432
Banting House, London 006080
Banting Interpretation Centre,
Musgrave Harbour 006304
Bantlin, Cornelius, Reutlingen . . 078128
Bantock House, Wolverhampton 046203
Bantry Historical Society Museum,
Bantry 024538
Bantry House, Bantry 024539
Bányászati Kiállítás, Gyöngyös . 023326
Bányászati Kiállítóhelye, Nógrádi
Történeti Múzeum, Salgótarján 023545
Banys Àrabs, Palma de Mallorca 039688
Banzhaf, Michael, Tübingen . . . 142262
Banzi, Barbara, Parma 132107
Banzon Antiques, Manila 084308
Bào Đại Palace Museum, Đà Lat 054717
Bao Tàng Dân Tôc Hoc Viêt Nam, Ha
Noi . 054723
Bao Tàng Hai Phong, Hai Phong 054733
Bao Tàng Quan Doi, Ha Noi . . . 054724
Bao Tàng Văn Hóa Các Dân Tôc Viêt
Nam, Thai Nguyen 054749
Bao, Ly, Hoi An 125430
Baobab, Amsterdam 082509
Baoguo Temple, Ningbo 007938
Baoji Museum, Baoji 007395
Baoji Xiàn Museum, Baoji 007396
Baoji Zhouyuan Museum, Fufeng 007583
Baoshan Museum, Baoshan . . . 007397
Baptista, A.M. Salgueiro, Lisboa 084663
Baqcheh Jooq Palace, Maku . . . 024412
Bar Anticuario, Montevideo . . . 097779
Bar Bookstore, Scarborough . . . 144569
Bar David Museum, Kibbutz Bar
Am . 024945
Bar Harbor Historical Society Museum,
Bar Harbor 046752
Bara Art, Lalitpur 112166
Barabas, Ladislav, Bratislava . . . 085369

Bedos, Raphaël, Paris 070982
Bedot, André, Tarascon (Bouches-du-
Rhône) 073581
Bedouin Market, Cairo 102968
Bedrijfsmuseum NUON-ENW
Amsterdam, Amsterdam . . . 031754
Bedriye Kazancıgil, İstanbul 087886
Bedsteads, Bath 088155, 134391
Bedwell, Peter, Prahran 062097
Bee, New Orleans 122377
Bee & Bear, Nagoya 142723
Bee Family Museum, Yuanshan . 042326
Bee, Kay, Boston 092282
Beech House, Sheffield 091131
Beeches & Rale, Hawthorn 061591
Beechey, Neville, Colac 061347
Beechmountain Art Gallery,
Beechmont 098570
Beechwold, Columbus 144832
Beechwood Gallery, Newport,
Gwent 118999
Beechworth Antiques,
Beechworth 061103
Beechworth Curiosity Shop,
Beechworth 061104
Beechworth Gallery, Beechworth 098571
Beechworth Historic Court House,
Beechworth 000838
Beechworth Past and Present,
Beechworth 061105
Beecroft Antiques, Beecroft 061108
Beecroft Art Gallery, Southend-on-
Sea 045813
Beecroft Treasure House,
Beecroft 061109
Beedham Antiques, Hungerford . 089406
Beehive, Salt Lake City 096715
Beehive Art Space, Albury 098476
Beehive House, Salt Lake City . . 052809
Beehive Old Wares, Maldon . . . 061755
Beek, Johan, Barneveld 142902
Beekhuizen, Jan, Amsterdam . . . 082511
Beekmans en Waning, Haarlem 083126,
132893, 142968
Beeld en Aambeeld Galerie,
Enschede 112560
Beeld in Beeld, Nijmegen 112688
Beeldentuin Belling Garde,
Bellingwolde 031880
De Beeldenwinkel, Amsterdam . 112242
Beeldlijn, Amersfoort 112199
Beenleigh and District Museum,
Beenleigh 000843
Beer Collectables, Beer 088203
De Beer Studios, London 134913
Beer, Franz X., Auerbach, Kreis
Deggendorf 129624
Beer, Franz X., München 077394,
130684
Beer, Hans-Peter, Québec 064472,
128441
Beer, Mike, Düsseldorf 130011
Beer, Mike, Köln 076787, 130458
Beer & Co., Monika, Wien 062872
Beere(n)wein Museum, Eulenbis 018070
Beerents, Anouk, Amsterdam . . 082512,
132771
Beerhorst, Ursula, Karlsruhe . . . 130404
Be'eri Archaeological Collection,
Be'eri 024846
Beermann, York-Werner, Garmisch-
Partenkirchen 075891, 130182
Beers, Sacramento 145222
Beers.Lambert Contemporary,
London 118441
Bees Antiques, Woodstock 091796
Beesley & Pace, Salt Lake City . 136572
Beesley's, D.T., Paignton 127253
Beeston Castle, Beeston 043309
Beeswax Antiques And Art Gallery,
Larnaka 065231, 102470
Beethoven Emlékmúzeum,
Martonvásár 023446
Beethoven Eroicahaus, Wien . . . 002875

Beethoven-Gedenkstätte Floridsdorf,
Wien 002876
Beethoven-Haus Bonn, Verein
Beethoven-Haus, Bonn 017264
Beethoven Pasqualatihaus, Wien 002877
Beethoven Wohnung Heiligenstadt,
Wien 002878
Beethovenhalle, Bonn 017265
Beethovenhaus, Krems 002198
Beethovenhaus Baden, Baden bei
Wien 001760
Beetles, Chris, London 089764, 118442
The Beetroot Tree, Draycott . . . 117852
Beetz, Kurt, Lübeck . . 077111, 130598
Beeville Art Museum, Beeville . . 046843
Bee'Z Arts, Lauzerte 103873
Before My Time, Toronto 064555
Befreiungshalle Kelheim, Bayerische
Verwaltung der staatlichen Schlösser,
Gärten und Seen, Kelheim . . 019258
Le Befroi et le Musée des Frères
Caudron, Rue 014988
Bega Valley Regional Gallery,
Bega 000845
Began, São Paulo 064103
Begas Haus – Museum für Kunst
und Regionalgeschichte Heinsberg,
Heinsberg 018873
Begas, G., Heerlen 112607
Begegnungsstätte Alte Synagoge,
Wuppertal 022395
Begemann, Karen, Hamburg . . . 130254
Begg, Jan, Stanmore 127951
Begijnhofkerk, Provinciaal Centrum
voor Cultureel Erfgoed, Sint-
Truiden 003945
Begijnhofmuseum, Dendermonde 003459
Begijnhofmuseum, Herentals . . . 003617
Begijnhofmuseum, Kortrijk 003678
Bégin Édition, Lévis 101194
Begleiter, Baltimore 135689
Bégné, Jean-Luc, Bordeaux . . . 067256
Begoña Alcorta Egaña, Donostia-San
Sebastián 085790, 085791
Begsteiger, Günther, Linz 062688
Béguelin, Vérena, Saint-Imier . . 087571
Beguet, Yves, Saintes 126085
The Beguiling, Toronto 140365
Béguinage d'Anderlecht,
Bruxelles 003353
Begunk, J., Stendal 078475
Behar, Renée, São Paulo 064104
Behavka, Karl, Wien 062873
Behind the Boxes – Art Deco,
London 089765
Behm & Brock, Toronto 064556
Behncke-Brahmer, D., Hamburg 107191
Behnke, Frank, Ahrensburg 141359
Het Behouden Blik,
Uithuizermeeden 032756
Behr, Örebro 086711
Behr, A.A., Kaiserslautern 107473
Behr, H.W., Augsburg 129626
Behr, Winfried, Zellingen 079043
Behrendt & Markus, Berlin 129696
Behrendt, Thomas, Erfurt 075588
Behrens, Hannover 130307
Behrens, Leck 076976
Behrens, Sorø 066067
Behrens, Thomas, Leck 076977
Behrens, Thomas, Rastede 078046
Behringer-Crawford Museum,
Covington 048006
Behrmann, Kurt von, Phoenix . . 123734
Behruz, Prahran 062098, 127933
Behzad Museum, Sa'd-Abad Cultural-
Historic Complex, Tehrān . . . 024442
Behzod National Museum,
Dušanbe 042339
Bei Tomi, Bologna 142446
Beiarn Bygdetun, Moldfjord 033611
Beier, Belgershain 074670

Beier, Hartmut, Leipzig . 076994, 141933
Beier, Viola, Köln 130459
Beighton, Paul, Rotherham 127273
Beihl, Werner, Bremen 129880
Beijers, Utrecht 126516, 143051
Beijing 798, Chen Ling Hui
Contemporary Space, Beijing . 101799
Beijing Ancient Architecture Museum,
Beijing 007401
Beijing Antique City, Los Angeles 094101
Beijing Antiques Shop, Hong
Kong 064957
Beijing Art Gallery, Beijing 101800,
101801
Beijing Art Museum, Beijing . . . 007402
Beijing Cao Chang Di, Chen Ling Hui
Contemporary Space, Beijing . 101802
Beijing China Nationality Museum,
Beijing 007403
Beijing Cloisonne, San Francisco 097024
Beijing Cultural Relic Protection
Foundation, Beijing 007404
Beijing Dabao Taixi Western Han Tomb
Museum, Beijing 007405
Beijing Drawing House, Beijing . 101803
Beijing Folklore Museum, Beijing 007406
Beijing Imperial Art Academy,
Beijing 055122
Beijing Katong Art Museum,
Beijing 007407
Beijing Man Zhoukoudian Museum,
Beijing 007408
Beijing Museum, Beijing 007409
Beijing Museum of Natural History,
Beijing 007410
Beijing Police Museum, Beijing . 007411
Beijing Theater Museum, Beijing 007412
Beijing Wabgfujing Paleolithic
Museum, Beijing 007413
Beijing Wen Shi Art Galley,
Beijing 101804
Beijing World Art Museum,
Beijing 007414
Beik Thano, Yangon 082423
Beil, H., Weilheim Kreis
Waldshut 078804
Beiliu Museum, Beiliu 007472
Beim Antiquaire, Machtum 082191
Beiner-Büth, Silke, Hamburg . . . 130255
Beirut Antiques Fair, Beirut 098088
Beisac, Hermien de, Wiesbaden 078884
Beisac, R. de, Wiesbaden 078885
Beisler, Weilheim in Oberbayern 142299
Beisler, W., Aschaffenburg 074391
Beissel, R., Bad Honnef 074488
Beissert, Hans-Werner,
Wildeshausen 108952
Beit Abraham Krinizi, Ramat Gan 024993
Beit al-Ajaib Museum with House of
Wonders Museum, Zanzibar . 042367
Beit Alfa Synagogue National Park,
Kibbutz Hefzibah 024955
Beit Hagdudim, Avihail 024843
Beit-Hagefen Art Gallery, Haifa . 024862
Beit Hameiri, Zefat 025057
Beit Hankin, Kfar Yehoshua . . . 024943
Beit Ha'Omanim, Jerusalem . . . 024891
Beit Hatfutsot, Museum of the Jewish
People, Tel Aviv 025013
Beit Lohamei Haghetaot-Yad Layeled,
Lohamei-Hagetaot 024971
Beit Miriam-Museum, Kibbutz
Palmachim 024962
Beit-Shean Museum, Beit Shean 024848
Beit Shturman Museum, Kibbutz Ein
Harod 024949
Beit Yad LaBanim Memorial Center,
Rehovot 025004
Al-Beit, Dunia, Riyadh 085140
Beiteddine Museum, Shouf 030113
Beitou Hot Spring Museum,
Taipei 042222
Beiträge zur Kunst des Christlichen
Ostens, Recklinghausen 138730

Bejannin, Saint-Ouen . 072995, 072996
Bejšovec, Jan, Praha 128578
Beker, Buenos Aires 139584
Békés Megyei Múzeumok
Igazgatósága, Munkácsy Mihály
Múzeuma, Békéscsaba 023122
Bekking & Blitz, Amersfoort . . . 137919
Bekko Crafts Museum, Nagasaki 028901
Bekman, Amsterdam 082513
De Bekoring, Gent 063574
Bel Age, Las Vegas 093957
Bel Air Gallery, Bournemouth . . 117496
Bel-Aire Coin, Saint Paul 096648
Bel Art, Novi Sad 114536
Bel Art, Québec 101354
Bel Art Gallery, Vancouver 101606
Bel-Arte, Lengnau (Bern) 116528
Bel-Canto Antiek, Hilversum . . . 083212
Le Bel Ecrin, Nice 070524
Bel Etage, Wien 062874
Bel Etage, Zürich 087743
Bel Fine Art, New York 095095
Bel Mondo, Karlsruhe 107488
Belair, Villeurbanne 074152
Belair Mansion, Bowie 047116
Belair Stable Museum, Bowie . . 047117
Belaja Galereja, Ekaterinburg . . 114265
Belaja Luna, Odesa 117222
Béland, D.M., Montréal 101227
Belanger, Michael, Los Angeles . 094102
Belarussian State Academy of Arts,
Minsk 054923
Belarussian State University of Culture
& Arts, Minsk 054924
Belasting en Douane Museum,
Rotterdam 032620
Belaych, Christian, Paris 070983
Belaž, Sankt-Peterburg 114414
Belbezier, Lille 069422
Belcarra Eviction Cottage,
Castlebar 024561
Belcher Studios, San Francisco . 124478
Belcher, Robert, Droitwich 088896
Belcourt Castle, Newport 051445
Belda, Praha 102616
Beldam Gallery, Brunel University,
Uxbridge 046041
Belenky Bros., New York 122639
Beleva, Kristina, Sofia 128389
Belfast Auctions, Belfast 127008
Belfast Exposed, Belfast 117407
Belfast Historical Society, Belfast 005310
Belfast Traders, Christchurch . . 083687
Belforte, Livorno 137759, 142518
Belga Traders, Sint-Niklaas . . . 063773
Belgazou, Rouen 072523
Belger Arts Center, University of
Missouri-Kansas City, Kansas
City 049834
Belger, Frank, Annaberg-
Buchholz 074375
Belghazi-Musée, Fès 031592
Belgischen Comic-Zentrum,
Bruxelles 003354
Belgorodskij Gosudarstvennyj
Chudožestvennyj Muzej, Belgorod Art
Museum, Belgorod 036715
Belgorodskij Gosudarstvennyj Institut
Iskusstv i Kultury, Belgorod . . 056214
Belgorodskij Gosudarstvennyj Istoriko-
Kraevedčeskij Muzej, Belgorod 036716
Belgrave Antique Centre, Darwen 088819
Belgrave Carpet Gallery, London 089766
Belgrave Gallery, London 118443
Belgrave Hall Museums and Gardens,
Leicester 044669
Belgrave St Ives Gallery, Saint Ives,
Cornwall 119271
Belgravia, San Giljan 126475
Belgravia Gallery, London 118444
Belhaven Memorial Museum,
Belhaven 046846
Les Béliers, Cellule 067685
Believe It Or Not Curiosity Museum,

Bernberg Fashion Museum, Museum Africa, Johannesburg 038567
Berndt Museum of Anthropology, University of Western Australia, Crawley 000997
Berndt, Brigitta, Solothurn 134242
Berndt, Pierre, Carouge 087161, 134060
Berndt, Pierre, Genève 087261, 134092
Bernecker, J., Bötzingen 141539
Berner, Deland 127464
Berner Design Stiftung, Bern ... 041101
Berner Kunst- und Antiquitätenmesse, Bern 098164
Bernera Museum, Urras Eachdraibh Sgire Bhearnaraidh, Bernera .. 043331
Berners, Richard, Köln 107579
Bernesga, León 115199
Bernet-Neumann, Ulrike, Erlenbach 134072
Bernett, F.A., Boston 144745
Bernges, Gesa, Freiburg im Breisgau 130156
Bernhagen, Bad Münstereifel .. 074513
Bernhammer, Horst & Frank, Bischoffen 074961
Bernhard & Vögeli-Müller, Winterthur 087708, 134280
Bernhard-Heiliger-Stiftung, Berlin 058699
Bernhard, René, Zürich 087744
BernhardHaus, Ohlsdorf 002434
Bernhardt Christensen, Niels, Kastrup 065741
Bernhardt, Torsten, Hamburg .. 141762
Bernheim, Ciudad de Panamá .. 084245, 113410
Bernheim-Jeune & Cie, Paris .. 104517, 104518, 137144, 141011, 141012
Bernheimer, Fine Old Masters, München 077398
Berni, Carla, Firenze 079923
Berni, Lazzaro, Parma 080930
Bernicat, G., Roanne 072443
Bernice Pauahi Bishop Museum, Honolulu 049484
Bernier & Eliades, Athinai 109037, 137671
Bernigaud, Fabrice, Saint-Martin-du-Mont 072908
Bernini, Andrea, Livorno 080150
Bernini, Dario, Parma 132109
Bernisches Historisches Museum, Musée d'Histoire de Berne, Bern 041102
Berns, Christiane & Günter, Neuwied 077695
Berns, Perry, Dallas 120842
Bernstein Huus, Esens 018028
Bernstein Museum Bad Füssing, Bad Füssing 016568
Bernstein & Co. Ltd., A. Nathan, New York 122644
Bernstein, David, New York 122645
Bernstein, M., Los Angeles 144952
Bernstein & Co., S., San Francisco 097026, 145281
Bernsteinmuseum, Sellin, Ostseebad 021439
Berntsen, Kaare, Oslo . 084142, 113289
Berntsson, Vetlanda 116095
Beronnet, Marcel, Villeurbanne . 074153
Berquat, Pascal, Marseille 125909
Berr, Karl, Tirschenreuth 078599
Berra, Clementina, Milano 080277, 080278
Berra, Paola, Milano 080279
Berre, Alain le, Kerlaz 068883
Berretta Lemoine, Veronique, Toulon (Var) 073665
Berrima District Art Society Gallery, Bowral 000874
Berrima Galleries, Berrima 098592
Berrima Museum, Berrima 000854
Berrington Hall, Leominster ... 044686
Berrino, Alassio 109749

Berrino, Monaco 112067
Berríos Valenzuela, Orlando, Santiago de Chile 064904
Berry, Saint-Maur 072918
Berry & Crowther, Huddersfield . 134796
Berry Antiques, Moreton-in-Marsh 090624
Berry Antiques & Interiors, Preston 090903
Berry Art Gallery, Berry 098593
Berry-Hill, New York 122646
Berry Museum, Berry 000855
Berry Street Bookshop, Wolverhampton 144670
Berry, J.J., Windsor, Ontario .. 064848
Berry, Lesley, Flamborough ... 089072
Berry, Ray, Maylands, Western Australia 061798
Berry, Sandra, New Orleans ... 122380
Berryware, Tucson 124968
Berselli, Milano 131778
Bersham Colliery Mining Museum, Bersham 043332
Bersham Heritage Centre and Ironworks, Wrexham 046229
Bersia Antiquariato, Milano 080280
Berson, Toronto 064560
Bersotti, Giuseppe, Brescia ... 131415
Bert, Providence 123944
Bert, Dominique, Paris 104519
Das Berta-Hummel-Museum im Hummelhaus, Massing 019976
Bertacchi, Orfeo, Modena 080606
Bertacchini, Gabriella, Modena . 131953
Bertana, Isabel S. de, Buenos Aires 060869
Bertarini, Aldo, Modena 080607
Bertaux, Baltimore 120004
Berte Museum – Livet på Landet, Slöinge 040764
La Bertesca, Genova 110109
Bertha V.B. Lederer Arts Gallery, Geneseo 049027
Bertha's Kunsthandel, Buchholz in der Nordheide 075164
Berthelin, Manuel, Cognac 068002
Berthelot, Saint-Denis-de-l'Hôtel 072689
Berthelot-Vinchon, Françoise, Paris 070999
Berthelot, Bertrand, Remouillé . 072374
Berthelot, Jean-Louis, Bourg-Beaudouin 067351, 128755
Berthet, André, Lyon 069653
Berthet, Anne-Sophie, Saint-Pourcain-sur-Sioule 073228
Berthier, Renée, Limoges 069463
Berthold, Gelsenkirchen 107067
Berthold-Auerbach-Museum, Horb am Neckar 019032
Bertholier, Joël, Le Pont-de-Beauvoisin 069277, 128904
Berthommier & Dominique Langlet, Geneviève, Ravarennes 072438
Berthoud, Le Vésinet 069317
Berti, Firenze 079924
Berti, Adriana, Firenze 079925
Berti, Luciano, Bern 087085
Bertilsson, Falkenberg 115701
Bertin Toublanc, Paris 071000
Bertocchi, Bologna 142448
Bertogalli, Parma 080931
Bertola Lauro Antichità, Torino . 081491
Bertola, Carlo, Torino 132482
Bertola, Lauro, Torino 132483
Bertolotti, Luciano, Brescia ... 131416
Bertoncelj, Danilo, Ljubljana .. 085431, 133425
Bertoncelli, Verona 132654
Bertone, Flavio, Torino 132484
Bertoni, Alberto, Venezia 142700
Bertoni, Andrea, Bologna 131339
Bertoni, Félix, Magagnosc ... 069747
Bertouy, Didier, Lyon 069654

Bertram, Bremen 075112
Bertram & Williams, Williamsburg 145384
Bertram House Museum, Iziko Museums of Cape Town, Cape Town 038494
Bertram, Sigynn, Lüneburg ... 107916
Bertran, Jean-Pierre, Villeneuve-sur-Lot 074126
Bertran, Michel, Rouen 072525, 105425
Bertran, Michèle & Etienne, Rouen 072526, 141279
Bertrand, Lisboa 138008
Bertrand, Ribaute-les-Tavernes . 072410
Bertrand, Tassin-la-Demi-Lune . 141315
Bertrand, Alex, Vendôme 073971
Bertrand, Arthus, Palaiseau ... 070794
Bertrand, Dominique, Cambrai . 125818
Bertrand, Michel, Noron-l'Abbaye 070695
Bertrandt, Dorota, Berlin 106122
Bertrandy, Philippe, Le Puy-en-Velay 140827
Bert's Antiques, San Diego 096902
Bertus, Rotterdam 083368
Berufsfachschule für Holzbildhauerei und Schreinerei des Landkreises Berchtesgadener Land, Berchtesgaden 055397
Berufsgruppe des Salzburger Kunst- und Antiquitätenhandels, Salzburg 058199
Berufsverband Bildender Künstler Berlins e.V., Berlin 058702
Berufsverband Bildender Künstler Hamburg, Hamburg 058703
Berufsverband Bildender Künstler München und Oberbayern, München 058704
Berufsverband Bildender Künstler Niederbayern, Fürstenzell 058705
Berufsverband Bildender Künstler Niederbayern/Oberpfalz, Regensburg 058706
Berufsverband Bildender Künstler Sachsen-Anhalt, Halle, Saale . 058707
Berufsverband Bildender Künstler Schwaben-Nord und Augsburg e.V., Augsburg 058708
Berufsverband Bildender Künstler, Bezirksverband Bergisch-Land, Wuppertal 058700
Berufsverband Bildender Künstler, Landesverband Bayern e.V., München 058701
Berufsverband Bildender Künstlerinnen und Künstler Frankfurt, Frankfurt am Main 058717, 106941
Berufsverband Bildender Künstlerinnen und Künstler Rheinland-Pfalz im Bundesverband e.V., Mainz ... 058718
Berufsverband Bildender Künstlerinnen und Künstler Südbaden, Freiburg im Breisgau 058719
Berufsverband Bildender Künstlerinnen und Künstler, Bezirk Osterholz-Worpswede, Worpswede ... 058711
Berufsverband Bildender Künstlerinnen und Künstler, Bezirk Schwaben-Süd, Kempten 058712
Berufsverband Bildender Künstlerinnen und Künstler, Bezirk Unterfranken, Würzburg 058713
Berufsverband Bildender Künstlerinnen und Künstler, Bezirksverband Ostwestfalen-Lippe, Bielefeld . 058709
Berufsverband Bildender Künstlerinnen und Künstler, Nürnberg Mittelfranken, Nürnberg 058714
Berufsverband Bildender Künstlerinnen und Künstler, Oberbayern Nord und Ingolstadt e.V., Ingolstadt 058715
Berufsverband Bildender Künstlerinnen und Künstler, Oberfranken, Bamberg 058716

Berufsverband Bildender Künstlerinnen und Künstler, Regionalverband Wiesbaden, Wiesbaden 058710
Berufsverband österreichischer Kunst- und Werkerzieher, Wien ... 058200
Berufsverband österreichischer Kunst- und Werkerzieher, Landesgruppe Niederösterreich, Kilb 058201
Berufsvereinigung Bildender Künstler Oberösterreich, Linz . 058202, 099963
Berufsvereinigung bildender Künstler Salzburg, Salzburg 058203
Berufsvereinigung bildender Künstlerinnen und Künstler Vorarlbergs, Künstlerhaus Palais Thurn und Taxis, Bregenz 058204, 099832
Berufsvereinigung der bildenden Künstler Österreichs, Landesverband für Wien, Niederösterreich und Burgenland, Wien 058205
Berufsvereinigung der bildenden Künstler Österreichs, Landesverband Kärnten, Klagenfurt 058206
Beruto, Carlo, Albisola Superiore 079632
Berwald, New York 095102
Berwick, Officer 062016
Berwick Barracks, Berwick-upon-Tweed 043333
Berwick Pakenham Historical Museum, Pakenham 001389
Beryl's Boutique Gallery, Bundoora 098674
Beryl's Old Charm Antiques, Chatswood 061305
Berzel, Speyer 078436, 078437
Berżera, Warszawa 113895
Bērzgales Pagasta Vēstures Muzejs, Bērzgale 029932
Berzolari, Andrea, Milano 131779
Berzsenyi Dániel Emlékmúzeum, Egyházashetye 023299
Berzsenyi Dániel Emlékmúzeum, Nikla 023486
Besættelsessamlingen 1940–45, Grindsted 009929
Besançon, Jacques & Dominique, Bordeaux 067258, 140748
Besançon, Philiberte, Aix-en-Provence 066396
Besch, Constant, Mâcon 069737
Besch, Gérard, Juziers 068878
Besenmuseum & Galerie, Ehingen 017861
Besenval, Jean-Pierre, Paris .. 129169
Besichtigungsstätte der Mumie des Ritter Kahlbutz, Neustadt, Dosse 020412
Beside the Wave, Falmouth ... 117976, 138218
Beşiktaş Kültür Merkezi, İstanbul 117107
Besim, Adil, Wien 062876
Besley, Beccles 134401, 144010
Besnard, Christian, Nançay ... 070356, 104265, 129054
Besnard, Michel, Mortagne-au-Perche 070303
Besnard, Mireille, Orléans 070760
Beso Ur och Antik, Göteborg .. 086514
Bespoke Gallery, New York 122647
Besrest, Jean-Jacques, Paris .. 071001
Bessard, Ghislaine, Velines ... 073959
Besseiche, Daniel, Courchevel . 103585
Besseiche, Daniel, Dinard 103642
Besseiche, Daniel, Paris 104520
Besseiche, Daniel, Pont-Aven . 105325
Besselaar, Utrecht ... 112780, 112781
Bessels, Hendrik-W., Oslo 084143
The Bessemer Gallery, Sheffield 119340
Bessemer Hall of History, Bessemer 046921
Bessenyei György Emlékszoba, Jósa András Múzeum, Tiszabercel . 023683
Besser Museum for Northeast Michigan, Alpena 046386

Boddington, Pat, Mount Glorious 099265
Bode, Karlsruhe 107489
Bode Galerie und Edition,
Nürnberg 108306, 137585
Bode-Museum – Münzkabinett,
Staatliche Museen zu Berlin –
Stiftung Preußischer Kulturbesitz,
Berlin 016879
Bode-Museum – Skulpturensammlung
und Museum für Byzantinische
Kunst, Staatliche Museen zu Berlin –
Stiftung Preußischer Kulturbesitz,
Berlin 016880
Bode, Katrin, Ratingen 130927
Bode, Klaus, Borgholzhausen . . 075060
Bode, Ralf, Bonn 075024
Bode, Wolfgang, Meckenheim,
Rheinland 077253
Bodeco, Paris 129172
La Bodeguita del Medio Obrero,
Medellín 102331
Bodek, Hannover 107324
Bodelwyddan Castle Museum,
Bodelwyddan 043430
Bodenheim Heimatmuseum,
Bodenheim 017227
Bodenheimer, Heinz, Frankfurt am
Main . 075729
Bodensee-Naturmuseum,
Konstanz 019432
Bodensee-Obstmuseum,
Frickingen 018246
Bodes & Bode, Den Haag 082874
Bodhi, Bergen op Zoom 082771
Bodhi, Delhi 109324
Bodhi, Mumbai 109439
Bodhi, New York 122668
Bodhi, Portland 096208
Bodhi, Singapore 114581
Bodhi Tree Bookstore, West
Hollywood 145381
Bodhouse Antiques, Birkenhead 088246
Bodiam Castle, Robertsbridge . . 045595
Bodie Park Museum, Bridgeport 047164
Bodijn, Jan, Leiderdorp 132943
Bodils Antik, Maribo 065923
Bodin, Strasbourg 073536
Bodin-Lemaire, Brigitte, Olonne-sur-
Mer . 070730
Bodin, François, Tours 073803
Bodin, Sophie, Soussans 073515
Bodin, Thierry, Paris 141015
Bodmin and Wenford Railway,
Bodmin 043431
Bodmin Town Museum, Bodmin 043432
Bodnar, Joseph, Somerset 127726
Bodø Kunstforening, Bodø 059574
Bodoque, J., Madrid 133665
Bodrogközi Kastélymúzeum,
Pácin 023500
Bodrum Sualti Arkeolojisi Müzesi,
Bodrum 042580
Bodt, Chicago 120356
Body Focus, Providence 096337
Body, Martin, London 134920
Bodybuilder & Sportsman Gallery,
Chicago 120357
Bø Museum, Bø i Telemark 033377
Boe, Patrick, Marennes 069817
Böblinger Kunstverein, Kunstverein für
Stadt und Landkreis Böblingen e.V.,
Böblingen 058723
Böck, Anton, Wien 062879, 128165
Boeck, de, Antwerpen 136913
Böck, Wilhelm & Sophie,
Langenbach 130541
Böckelmann, Uwe, Bretnig-
Hauswalde 129891
Böckli, August, Aathal-Seegräben 086992,
133962
Böcksteiner Montanmuseum Hohe
Tauern, Böckstein 001778
Böddeker & Schlichting,
Paderborn 130869

Bödeker, Erich, Hannover 107325
Bøgebjerg Antik, København . . . 065795
Bøger og Antik, Silkeborg 066032,
140616
Bøger og Kuriosa, København . . 065796,
140562
Bögge, Alfred, Hamm, Westfalen 076286
Böggemeyer, W., Hasbergen . . . 076348
Boegly, Serge, Rupt-sur-Moselle 072609
Böhlau Verlag GmbH & Co. KG,
Wien . 136879
Böhlau Verlag GmbH & Cie., Köln 137488
Böhler, Julius, Starnberg 078453
Böhler, Lothar, Oppenweiler . . . 077873
Boehm Art Gallery, San Marcos 052939
Böhm, Andreas, Wien 062880
Böhm, Bernhard, Freilassing . . . 130162
Böhm, Harald, Berlin . . 074722, 141437
Böhm, J., Bielefeld 074930
Böhme, Husum 141842
Böhme, Cornelia, Gutenberg bei Halle,
Saale 076079, 107149
Böhme, Sibylle, Berlin 141438
Böhme, Thomas W., Dresden . . 129968
Böhmer, Marita, Ostritz 142135
Böhmerwaldmuseum Wien und
Erzgebirger Heimatstube, Wien 002906
Böhmisch, Passau 077937
Böhmisch, Eva, Passau 077938
Böhmisch, Hans L., Passau 077939
Böhmländer, Ch., Herrenberg . . 076446
Böhnert, Charlotte, Neumünster 130811
Böhringer, Georg, Düsseldorf . . 075415,
130013
Böhringer, Heinrich, Wunsiedel . 142345
Boeijink & Boekel, Haarlem 132894
Boek & Glas, Amsterdam 142831
Het Boekdorado, Den Haag 142920
Böke Museum, Leer 019615
Boekenantiquairaat de Lezenaar,
Hasselt 140196
De Boekenbeurs, Middelburg . . 143013
De Boekenboet, Alkmaar 142818
De Boekenboot, Hallum 142976
Boekendaal, Gouda 142957
De Boekenhof Emmen, Emmen . 142948
't Boekenschuurtje, Warffum . . . 143072
De Boekenvriend, Albergen 142817
Böker, Bayreuth 074651
De Boekerij, Baarn 142901
Boekhout, Phoenix 096029
Boekie Woekie – Books by Artists,
Amsterdam 137924, 142832
Boekie Woekie, Books by Artists,
Amsterdam 112247
't Boektiekske, Holsbeek 140198
BÖKWE, Bildnerische Erziehung +
Technisches Werken + Textiles
Gestalten, Wien 138558
't Boekwerk Antiquariaat,
Nijmegen 143018
Boelens, Marian, Zwolle 083544
Bölicke, F., Schortens 078315
Böll, R., Flintbek 075705
Böllner, Herbert, Lauter 130549
Boema, Praha 102617
Boemboem, Utrecht 112782
Boer Tala Zhou Museum and Gallery,
Bole . 007476
Boer, H. de, Groningen 083091
Boer, M.L. de, Amsterdam 082517
Boer, Theo de, Zandpol 143079
Börde-Museum Burg Ummendorf,
Ummendorf Bördekreis 021860
Das Bördemuseum, Lamstedt . . 019533
Bördenheimatmuseum,
Heeslingen 018827
Boerderij Klein Hulze, Almen . . . 031723
Boerderij Museum Duurswold,
Slochteren 032701
Boerderijmuseum De Bovenstreek,
Oldebroek 032532
Boerderijmuseum De Lebbenbrugge,
Borculo 031904

Boerderijmuseum Zelhem,
Zelhem 032914
Boerenantiek, Eindhoven 083022
Boerenbondsmuseum, Gemert . 032162
Boerenkrijgmuseum, Overmere . 003864
Boerenwagenmuseum, Buren,
Gelderland 031946
Børgesen, Bent, København . . . 065797
Börjeson, Malmö 115836
Börjesson, Göteborg 115725
Børnenes Museum, Nationalmuseet,
København 010008
Boerner, C.G., Düsseldorf 075416,
141630
Boerner, C.G., New York 095113
Börner, Claudia, Radeburg 078033
Börnert, Armin, Eichenau 130061
Boerth, Richard, Seattle 097242, 136701
Bø's Jakob Antikk, Voss 084230
Bösch, Walter, Bayreuth 141408
Boesendorfer, New York 095114
Boesky, Marianne, New York . . . 122669
Boesmans, M., Köln 076788
Bössmann, Osnabrück 142124
Bøtø Nor Gl. Pumpestation,
Væggerløse 010181
Boettcher, Gerrit, Hannover 076305
Böttcher, H., Heidelberg 076373
Boetto, Genova 080070, 126410
Bœuf, Frederic, Toulon (Var) . . . 129512
Bœuf, Robert, Toulon (Var) 105664
Bofors Industrimuseum,
Karlskoga 040538
Bog-art, Holbæk 140549
Bog-Børsen, København 140563
Bogaev Museum, Pavlodar 029656
Bogan, Spartanburg 127728
Bogan House Antiques, Totnes . 091478
Bogantikken, Roskilde 140614
Bogapott, Tallinn 103052
Bogart, Groningen 083092
Bogart, Bremmer & Bradley,
Seattle 097243, 136702
Bogat, Baltimore 092138, 135690
Boğazköy Müzesi, Boğazkale . . 042581
Bogcentralen, Viborg 140635
Bogcentrum, Esbjerg 140529
Bogd Khaan Winter Palace Museum,
Ulaanbaatar 031541
Bogdanoff, New Orleans 122382
Bogena, Saint-Paul 105528
Boggiali, Milano 080287
Boggiano, H. & H., Buenos Aires 098377
Boghytten, København 140564
Bogkælderen, Hillerød 140547
Boglio, Jean-Louis & Janet,
Currumbin 139739
Bogner, E., Landshut 076950
Bogner, Willi, München 130687
Bognor Regis Museum, Bognor
Regis 043436
Bogormen, Esbjerg 065569
Bogormen, København 140565
Bogorodickij Dvorec-muzej i Park,
Bogorodick 036734
Bogselskabet, København 140566
Bogshoppen, Århus 140516
Bogshoppen, Holstebro 140550
Bogstad Gård, Oslo 033652
Bogstadveien Antikk, Oslo 084145
Bogtrykmuseet, Esbjerg 009883
Bogwood Sculpture Artists,
Newtowncashel 109688
Bogyoke Aung San Museum,
Yangon 031655
Bohard, Marie, Auch 066739
La Bohardilla, Santiago del
Estero 098446
Bohec, Alain, Nantes 070401
La Bohème, Gisborne 143128
Bohemia, Bromsgrove 117604
Bohemia Antiques, Vancouver . . 064749
Bohemia Art, Ústí nad Labem . . 102707
Bohemia Galleries, Beverly 117437

Bohemia Paper, Praha . 102618, 128579
Bohm, Malmköping . . . 086653, 126843
Bohm, Skogstorp 086753, 126874
Bohm, Siegfried, Göttingen 075985
Bohm, Stephanie, Göttingen . . . 075986
Bohman, Lars, Stockholm 115943
Bohn, Lörrach 107874
Bohn, Carl, København 065798
Bohn, Henry, Liverpool 144303
Bohnenkamp & Revale, Buenos
Aires . 098378
Bohnhoff & Pluntke, München . . 077400
Bohnsack, Hans-Jörg,
Strausberg 078498, 078499
Bohol Museum, Balay Hipusanan
sa Mgs Bilihong Butang sa Bohol,
Tagbilaran 034436
Bohr, Meldorf 077271
Bohr, Ingrid, Graz 062567
Bohrer, Elfie, Bonstetten 116258
Bohun, Henley-on-Thames 118168
Bohusgalleriet, Uddevalla 116056
Bohusläns Antikvariat, Skärhamn 143725
Bohusläns Museum, Uddevalla . 040899
Boi, Tran, Hue 125438
Boidet, Philippe, Chambéry 071030
Boige, Annie, Villennes-sur-Seine 105829
The Boiler House Graffitti Project,
Cardiff 117668
Boiler House Steam and Engine
Museum, Kurwongbah 001196
The BoilerHouse, Foxton 044201
Boille, Béatrice, Grasse 068646
Boillon-Tajan, Marie-Thérèse,
Paris . 104525
Boillot Maison, Rouen 072529
Boira & Barclay, Sant Cugat del
Vallès 133779
Bois d'Acanthe, Liège 063692
Le Bois Debout, Lyon . 069656, 104019,
140843
Bois Doré, Paris 104526
Bois l'Épicier, Maulette 069950
Bois Rose, Toulouse 073704
Bois Sacré, Genève 116383
Bois Secula, Saint-Paul 133350
Bois, Peter C. du, New York . . . 122670
Bois, Robin des, Levallois-Perret 069387
Boisard, Pierre, Barfleur 066889, 066890
Bois'Arts, Villeurbanne 074154, 129580
Boisbaudry, Loïc du, Paris 071017,
125956
Boise Art Museum, Boise 047040
Boisgirard & Ass., Paris 125957
Boisguérin, Annick, Guérande . . 068704
Boisnard, Jean Luc, Rouen 072530
Boisserée, Köln 107581, 141886
Boisseron Antiquités, Boisseron . 067215
Boissière, Nicole, Gazeran 068586
Boissieu, Frédéric de, Rouen . . . 072531
Boisson, Thierry, Sarcey 073369
Boissonnas SA, Pierre, Lucien &
Valentin Boissonnas, Zürich . . 134523
Boîte à Jouets, La Rochelle 069025
La Boîte à Musique, Paris 071018
La Boîte à Sons, Villeurbanne . . 105832
Boix, Barcelona 085560
Boj Restauri, Genova . 131684, 131685
Bojangles, Betty, Dublin 079422
Bojara & Krellinghaus, Osnabrück 142125
Bök, Leeuwarden 142991
Bok, Dr. Vladimir, Praha 128580
Bókasafn Menntaskólans á Ísafirði,
Ísafirði 023764
Bokcheon Municipal Museum,
Busan 029715
Boke, Nagoya 081885
Bokens Stad, Mellösa 143712
Bokfloran, Stockholm 143748
Bokhoven, Josine, Amsterdam . . 112248
Bokhulen, Oslo 143208
Bokhuset, Göteborg 143651
Bókin.is, Reykjavík 142410
Bokkistan, Göteborg 143652

Brocante des Quatre Vents,
Bourges 067366
Brocante des Valois, Angoulême 066567
La Brocante du Batiment,
Azerailles 066840
Brocante du Bourget la Barbotine, Le
Bourget-du-Lac 069170
Brocante du Château, Apremont 066633
Brocante du Château, La
Clayette 068940
Brocante du Donjon, Domfront . 068316
Brocante du Lavoir, Saint-Pol-de-
Léon 073226
Brocante du Lude, Albi 066451
La Brocante du Mas, Pierrelatte 072116
Brocante du Plot Art Populaire
Savoyard, Groisy 068694
Brocante du Pont de Coise,
Coise 068017
Brocante du Pont de Paris, Laval
(Mayenne) 069145
La Brocante du Port, Antibes-Juan-les-
Pins 066608
Brocante du Rempart, Eguisheim 068379
Brocante du Rohu, Saint-Pierre-
Quiberon 073224, 129472
Brocante du Trieves, Mens . . . 070004
Brocante du Valentin, Yverdon-les-
Bains 087719
Brocante la Petite Chine,
Meillonnas 069988
Brocante Merle, Pons 072192
Brocante Minaret, Rabat 082412
Brocante MV, Saint-Pierre-du-Val 073220
Brocante Normande, La
Ferté-Macé 068972
Brocante Réalmontaise,
Réalmont 072327
Brocante Saint-Eloi, Arbonne-la-
Forêt 066637
Brocante Saint-Nicolas, Moisdon-la-
Rivière 070088
Brocante Sainte-Cécile, Albi . . 066452
Brocante Service, Bellegarde-en-
Marche 067017
Brocante Vallée aux Loups, Le Plessis-
Robinson 069274
Brocante ZF, Alger 060823
De Brocanterie, Arnhem 082748
Brocanterie, Carcassonne 067612
Brocanterie, Honfleur 068772
La Brocanterie, Le Petit Quevilly 079275
Brocanterie, Palermo 132077
Brocanterie Annette, Haarlem . . 083128
Brocantour Koloniaal Teak, Venlo 083490
Brocanteurs, Amsterdam 082526
Brocanthèque, Chanceaux-sur-
Choisille 067765
Brocanthèque, Thionville 073616
Brocanthosaurus, Épinal 068397
Brocantic, Bouchain 067315
Brocantic, Le Havre 069219
Broc'antic, Lille 069425
Brocantic, Milano 110286
Brocantic, Nice 070530
Broc'Antic, Novalaise 070706
Brocantic, Oostende 063758
Brocantic, Saint-Quentin (Aisne) 073236
Broc'Antic Collection, Courlaoux 068134
Broc'Antics, Etampes 068423
Brocantics, Torcy-le-Grand . . . 073651
Brocantik, La Coucourde 068954
Brocantine, Corbigny 068089
Brocantine, Ecully 068372
Brocantine, Les Sables-d'Olonne 069371
Brocantine, Veneux-les-Sablons 073975
La Brocantine d'Autrecourt, Mesnières-
en-Bray 070026
Brocantique, Carcassonne ?
Brocantique, Genève . . 087263, 134094
Brocantique, Saint-Céré 072667
Brocant'oc, Laloubière 069092
Brocaphil Keller, Colmar 068029

Brocapuce, Bern 087090
Broc'Armony, Langon 069114
Brocart, Girona 085847
Broc'Art, Lay 069155
Broc'Art des Remparts, Calvi . . 067552,
140773
Brocastel, Vivier-Danger 074229
Broc'Avenue, Nice 070531
Brocchi, Roma 142620
Broccoletti, Remo, Roma 110760
Brochart, Jean-Paul & Brigitte,
Mazamet 069963
Brochu, Jean, Tour-en-Sologne . 073776
Brock, Dülmen 075394
Brock & Art, Liebefeld 087401
Brock, J., København 065803
Brock, Martin, Dülmen 075395
Brock, Nick, Dallas 092917
Brock, P. de, Knokke-Heist . . . 100595
Brockenstube, Brig 087145
Brockhaus Antiquarium,
Kornwestheim 141913
Brockmann, Daniela, Lugano . . 134149
Brockmann, H., Gescher 075933
Brockmanns, Dr. Karl-Josef,
Willich 108957
Brockshus, Bremen 129881
Brockville Museum, Brockville . . 005382
Broc's-en-Stock, Massillargues
Attuech 069940
Broc'Trente, Auxerre 066787
Brod Media Galerie, Wien 100110
Brode, Dr. K., Bergisch Gladbach 074686
Brodergave, København 065804
Broderick, Portland 123853
Brodersen, Peter, København . . 065805
Brodhag, Rosemarie, Berlin . . . 106132
Brodick Castle, Brodick 043544
Brodie / Stevenson,
Johannesburg 114873
Brodie Castle, Forres 044193
Brodney, Boston 092285
Brodoux, Germaine, Agen 066364,
103124
Brodsworth Hall & Gardens,
Doncaster 043918
Brody, Dalton, Washington . . . 097647
Broe-Andersen, Mogens,
Haderslev 125711
Brödlin, J., Effringen-Kirchen . . 075527
Brödlin, Johannes, Weil am
Rhein 078800
Bröhan-Museum, Landesmuseum
für Jugendstil, Art Deco und
Funktionalismus, Berlin 016884
Broeke, Henk, Den Haag 082878
Bröker, Bremerhaven . 106588, 141584
Broekhoff, Nijmegen 083323
Broelmuseum, Stedelijke Musea
Kortrijk, Kortrijk 003679
Brøndsted, Jeanette, Kongens
Lyngby 065906
Brøndum Antikvariat, Skørping . 140621
Brønshøj Antikvariat, Brønshøj . 140527
Broes, K., Brugge 100390
Broess, 's-Hertogenbosch 083196
Brötje, G., Oldenburg 077846
Brötzmann & Linke, Uffenheim . 078665
Broeze, Edam 132873
Broggiato, Daniele, Padova . . . 080804
Broggiato, Giancarlo,
Albignasego 079631
Broglin, Colmar 103568
Brohammer, Jürgen, Ettlingen . . 130116
Broich, Christian, Iserlohn 141849
Brok, Barcelona 085569, 126721
Broken Art Restoration, Chicago 135755
Broken Art Restoration,
Momence 136189
Broken-Beau Pioneer Village Museum,
Beauséjour 005304
Broken Hill Regional Art Gallery,
Broken Hill 000894
Brokensha, Anne, Unley 062364

Brokidée, Marcq-en-Barœul . . . 069808
Brol, Jacques, Bruxelles 063298
Brolga, Gundaroo 139786
Broman, Kalustamo, Helsinki . . 128652
Brome County Historical Society
Museum, Knowlton 006007
Bromer, Boston 144750
Bromfield, Boston 120127
Bromfield Art Gallery, Boston . . 047076
Bromfietsmuseum De Peel,
Ospel 032556
Bromham Mill and Art Gallery,
Bromham 043545
Bromley Museum, London 044819
Hal Bromm – Art & Design, New
York 122684
Broms, Helsinki 103084
Bromsen, Maury A., Boston . . . 144751
Bromsgrove Museum,
Bromsgrove 043547
Bromsten, Spånga 086764
Bromwell, Cincinnati 120604
Broncería Artistica, Buenos Aires 127788
Bronceria Mateu, Las Heras . . . 127817
Bronck Museum, Coxsackie . . . 048011
Bronès Buivydaitės Memorialinis
Muziejus, Anykščiai 030146
Bronès ir Bronius Radeckų Keramikos
Muziejus, Kuršėnai 030232
Bronet, Bruxelles 063299
Bronidève, Viroflay 074215
Bronikowska, Ewa, Warszawa . . 113897
Bronne, Henri, Monaco 112068
Bronner, L'Isle-sur-la-Sorgue . . 069506
Bronner, Astrid, Teningen 131085
Bronner, Christian, Coustellet . . 068149
Brons, L., Amsterdam 082527
Bronsin, Bruxelles 063300
Bronte Gallery, Mapua 113028
Brontë Parsonage Museum,
Haworth 044402
Bronx Council on the Arts, Bronx 060416
Bronx Museum of the Arts,
Bronx 047189
Bronx River Art Center, Bronx . . 047190
Bronz Stockholm, Stockholm . . 086795
Bronzart, Calgary 101082
Bronze and Brass Museum,
Bhaktapur 031691
Bronze et Lumière, Paris 129182
Bronzes et Sculptures, Metz . . . 070039
El Bronzino, Bogotá 065102
De Broodgalerie, Amsterdam . . 112252
Broodthaers, Marie-Puck,
Bruxelles 100431
Brook, Bad Homburg v.d. Höhe . 074479
The Brook Gallery, Budleigh
Salterton 117608
Brook Street Collectables,
Providence 096338
Brook, Michael, London 134928
Brookart Press, San Jose 138517
Brooke Gifford, Christchurch . . 083688
Brooke, Alexander, New York . . 122685,
138437
Brookes-Smith, Forest Row . . . 089087
Brookes, Diane, Tetney 119499
Brookes, Howard, Göteborg . . . 115726
Brookfield, Healesville 061602
Brookfield Craft Center,
Brookfield 047204
Brookgreen Gardens, Murrells
Inlet 051062
Brookings Arts Council,
Brookings 047207
Brookings County Museum,
Volga 053884
Brookings & Co., J.J., San Jose 124693
Brookland, Washington 125122
Brooklands Museum, Weybridge 046125
Brookline Auction Gallery,
Brookline 127414
Brookline Historical Society Museum,
Brookline 047210

Brookline Village Antiques,
Boston 092286
Brooklyn Arts Center,
Jacksonville 121517
Brooklyn Arts Council Gallery,
Bronx 047191
Brooklyn Arts Council News,
Brooklyn 139361
Brooklyn Children's Museum,
Brooklyn 047216
Brooklyn Galleria, Wellington . . 084027
Brooklyn Historical Society Museum,
Brooklyn 047217, 047235
Brooklyn Museum, Brooklyn . . . 047218
Brooklyn Sports Cards and Collectibles,
Cleveland 092761, 144822
Brooklyn Waterfront Artists,
Brooklyn 060417
Brooks, Den Haag 082879
Brooks, Dublin 079424
Brooks, Monaco 082315, 126483
Brooks, Sacramento 096443
Brooks, Washington 136788
Brooks Academy Museum,
Harwich 049360
Brooks and District Museum,
Brooks 005384
Brooksby, Angie Elizabeth,
Firenze 110053
Brookside Antiques, Kansas City 093897,
136025
Brookside Art Gallery, Kansas
City 121559
Brookside Museum, Ballston Spa 046692
Broome County Historical Society
Museum, Binghamton 046963
Broome Museum, Broome 000900
Broomehill Museum, Broomehill 000901
Broomer, A.R., New York 095124
Broqua, Christophe, Aire-sur-
l'Adour 128668
Bror Hjorths Hus, Uppsala 040910
Brora Heritage Centre, Brora . . 043550
Bros, Francoise, Bordeaux 128724
Brosa, Berthe, Tettnang 108774
Brose-Eiermann, Elly, Dresden . 106697
Brose, Oliver, Hamburg 076145
Brose, Oliver, Kayhude 076673
Brosig, Markus, Leipzig 130556
Broßhauser Mühle, Solingen . . 078411
Brossy, Robert, Rolle 087553
Brot- und Mühlen-Lehrmuseum,
Dirnbachermühle, Gloggnitz . . 001926
Brot und Spiele Galerie, Berlin . 106133
Brotfabrik Galerie, Berlin 016885
Brother, Philadelphia 095925
Brotherton, Naomi, Dallas 120843
Brotlose Kunst,
Mönchengladbach 077321
Brotonne, Frédéric, Feron 068469
Brouard, Gilles, Gemages 068587
Brouard, Gilles, Saint-Germain-de-la-
Coudre 072765
Les Broucants, Verona 132657
Broughton, Berry 061136
Broughton Gallery, Broughton . . 117606
Broughton House and Garden,
Kirkcudbright 044599
Broughton House Gallery,
Cambridge 117643
Broughton, Bob, Taroona 139957
Broughty Castle Museum, Broughty
Ferry 043552
Broughty Ferry Art Society,
Dundee 059999
Brouillard, Patrick, Corcelles . . 134067
Brouns, Konrad, Maastricht . . . 083272
Brous, Nancy, New York 095125
Brousse, Didier, Lourmarin . . . 103998
Broutta, Michèle, Paris 104544, 137150
Brouwershuis, Antwerpen 003202
Brouws Museum,
Brouwershaven 031936
Brovot, Köln 076789

Bryczkowska, Lena, Bydgoszcz . 113526
Brydone Jack Observatory Museum,
 Fredericton 005727
Bryggens Museum, Bergen 033356
Bryggerhuset, Vollen 084228
Bryggeriets Antik, Nyköping . . 086703,
 133913
Brynmawr & District Museum,
 Brynmawr 043554
Brzezinski, Ewa, Rennes (Ille-et-
 Vilaine) 129431
Brzostek, Phoenix 127664
Brzozowski, Kristof,
 Mönchengladbach 077322
BS Antique Trading, Singapore . 085201
BSAT Gallery, British Sporting Art
 Trust, Newmarket 045294
BSMD, Paris 104548
Bu Museum, Utne 033877
Buade, Québec 101357
Buadisch, Jens, Karlsruhe 130405
Bubba's Baseball Bullpen,
 Albuquerque 091878
The Bubblecar Museum,
 Langrick 044632
Bubbly, Singapore 085202
Bubbly Hills Vintage, Long Beach 094031
Buby, Trenčín 085420
Bucaro, León 085884
Bucat, Pierre, Paris 129185
Buccaneer, 's-Hertogenbosch . . 083197
Buccaneer Heaven, Tampa 097382
Bucceri, Padova 080805
Bucchi, Federica, Roma 081108
Bucci, Elico, Santiago de Chile . 101767
Bucciarelli, Giovanni, Firenze . . 131533
Buccleuch Mansion, New
 Brunswick 051170
Buccony, Buco, Bratislava 085370
Bucerius Kunst Forum gGmbH,
 Hamburg 018685
Buceti, Carmelo, Roma 132219
Buceti, D & S, Roma 081109
Buceti, Domenico, Messina 080194
Buch & Boje, Haderslev 125712
Buch & Kunst, Braunschweig . 106561,
 141560
Buch & Schudrowitz, Berlin . . . 129706
Buch I Druck I Kunst e.V., Gesellschaft
 zur Förderung zeitgenössischer
 Buchkunst, Hamburg 058728
Buch + Kunst, Wesseling 142310
Buch und Grafik Galerie der
 Büchergilde Bonn, Bonn 106527
Buch, Claudia, Oberhausen 077786
Buch, Nils Ole Funder, Brøndby . 128618
Buchan, K.S., Leigh-on-Sea . . . 089599
Buchanan Center for the Arts,
 Monmouth 050919
Buchanan, Duncan, Auckland . . 083589
Buchans Miners Museum,
 Buchans 005388
Buchantiquariat am Rhein, Basel 143821
Buchantiquariat Kloster Marienrode,
 Hildesheim 141832
Buchart, Antibes-Juan-les-Pins . 066609
Buchbinder Mergemeier,
 Düsseldorf 130016
Buchbinderei Depping, Edition und
 Galerie, Münster 108222, 137577
Buchdruckmuseum, Rohrbach in
 Oberösterreich 002554
Bucheit, Rita, Chicago 092515
Bucheli, Rocio E., Bath 117371
Bucheon, San Francisco 124490
Bucher Fiuza, Sandra, München 130690
Bucher, Alois, Innsbruck 062625
Bucher, Herbert, Absam 062502
Bucher, Jeanne, Paris . 104549, 137151
Buchfink, Brugg 143856
Buchfink, Lenzburg 143892
Der Buchfreund, Wien 140054
Buchgraitz, Gerda Louise & Frank,
 Horsens 065722

Buchhandlung Gastl GmbH,
 Tübingen 142263
Buchhandlung Johannesstift,
 Berlin 141439
Buchhandlung u. Galerie Böhler,
 Bensheim . . 106073, 137307, 141410
Buchhandlung Walther König,
 Köln 137489, 141887
Buchhandlung Walther König,
 München 142022
Buchhandwerk Hans Peter Bühler,
 Nürtingen 130839
Buchheim Museum, Sammlung
 Buchheim – Museum der Phantasie,
 Bernried 017113
Buchhold, Petra, Schrecksbach . 078320
Buchholz, Hannover 107327
Buchholz, Lisboa 143370
Buchholz & Pyroth, Hamburg . . 076146
Buchholz, Godula, Denklingen . . 106653
Buchholz, Karsten, Reinbek . . . 142172
Buchholz, Susanne, Kassel 130418
Buchinger, Otto, Linz . . 062690, 099966
Der Buchladen, Saarbrücken . . 142187
Buchloh, Helmut S. & Claudia,
 Schnaitsee 078300
Buchmann, Agra 116111
Buchmann, Berlin 106136
Buchmüller, J., Mülheim an der
 Ruhr 077366
Buchmuseum, Solothurn 041744
Buchmuseum der Sächsischen
 Landesbibliothek – Staats- und
 Universitätsbibliothek Dresden,
 Dresden 017740
Buchrestaurierung Leipzig GmbH,
 Leipzig 130557
Buchs, Oskar, Gstaad 116461
Buchtip, Wien 140055
buchWeger, Frankfurt am Main . 141679
Buchwelten, Oberpullendorf . . . 140024
Buchwerkstatt, Bremen 129883
Buck House, New York 095126
Buck House Antique Centre,
 Beaconsfield 088186
Buck Mountain Treasures, Oklahoma
 City 095791
Buck, Christopher, Sandgate . . 091084,
 135352
Buck, Daniel, Wickford 127761
Buck, J. de, Bruxelles 063303
Buck, Nicole, Strasbourg 105634
Buck, Siegfried & Hermine de,
 Gent 100552, 136948, 140187
Buck, Sven, Neustadt-Glewe . . . 077689
Buckboard Antiques, Oklahoma
 City 095792
Buckenham, Southwold 119396
Buckenmaier, Ulrich, Überlingen 108803,
 131103
Bucket Rider Gallery, Chicago . . 120362
Buckeye Furnace State Memorial,
 Wellston 054153
Buckfast Abbey, Buckfastleigh . 043555
Buckham Gallery, Flint 048707
Buckhaven Museum, Fife
 Council Libraries & Museums,
 Buckhaven 043559
Buckhead, Atlanta 135653, 144702
Buckhorn Saloon & Museum, San
 Antonio 052833
Buckhorn School of Fine Arts,
 Buckhorn 055051
Buckie and District Fishing Heritage
 Centre, Buckie 043560
Buckies, Cambridge . . 088540, 134518
Buckingham Antiques,
 Buckingham 088474, 134496
Buckingham Movie Museum,
 Buckingham 043562
Buckingham, C.W., Cadnam . . . 088532
Buckinghamshire County Museum,
 Aylesbury 043207
Buckinghamshire Railway Centre,

Quainton 045538
Buckland Abbey, Yelverton 046243
Buckland Gallery, Beechworth . . 098572
Buckland Southerst, Vancouver . 101611
Buckler's Hard Village Maritime
 Museum, Beaulieu 043293
Buckley, Memphis 094458
Buckley, Penrith 062062
Buckley Center Gallery, University of
 Portland, Portland 052197
Buckley Galleries, Sandycove . . 079587,
 097609, 126394
Buckley-Kohler, Columbus 092835
Buckley, Patrick, Edinburgh . . . 088952
Buckley, W., Congleton 088748
Buckleys Yesterday's World,
 Battle 043289
Bucknall, Moya, Solihull 119373
Buck's Stove Palace, Portland . . 096212
Bucksport Historical Museum,
 Bucksport 047259
Buckwitz, Sybille, Kronberg im
 Taunus 107742
Bucx, Ben, 's-Hertogenbosch . . 132913
Bucyrus Historical Society Museum,
 Bucyrus 047260
Bud & Bettys, Winnipeg 064862
Budai Antik, Budapest 079142
Budai Krónika, Budapest 142382
Budansky, A. Adriana, Buenos
 Aires 127789
Budaörser Heimatmuseum,
 Bretzfeld 017395
Budapest Galéria Kiállítóháza,
 Budapest 023145
Budapest Galéria Kiállítóterem,
 Budapest 023146
Budapest Galéria Varga Imre Állandó
 Kiállítóház, Budapest 023147
Budapesti Történeti Múzeum,
 Vármúzeum, Budapest 023148
Budatétényi Galéria, Budapest . 109141
Budavári Mátyás-templom
 Egyházművészeti Gyűjteménye,
 Budapest 023149
Budawang Antiques, Milton . . . 061847
Budde, Hermann, Lemgo 077015
Budde, Klaus, Warendorf 078778
Buddelschiff-Museum,
 Neuharlingersiel 020351
Buddelschiff-Museum,
 Tangerhütte 021699
Buddenbrookhaus, Heinrich-und-
 Thomas-Mann-Zentrum, Die
 Lübecker Museen, Lübeck 019816
Buddenbrooks, Boston 144752
Buddha Museum, Gorakhpur . . . 023945
Buddhawelt, Bremen 113717
The Buddhist Art Museum, Kaba Aye
 Pagoda, Yangon 031656
Budd's Beach Gallery, Surfers
 Paradise 099599
Buddy Holly Center, Lubbock . . 050455
Buddy's Antique Auction, Arab . 127389
Bude-Stratton Museum, The Castle
 Heritage Centre & Gallery, Bude 043564
Budenz-Ház – Ybl Gyűjtemény,
 Szent István Király Múzeum,
 Székesfehérvár 023606
Buderim Pioneer Cottage,
 Buderim 000904
Buderim Rare Books, Buderim . 139700
Buderus Zentralheizungsmuseum,
 Lollar 019774
Budget Antiques, Edmonton . . . 064231
BudiArt, Bussum 082830
Budil, S., Amsterdam 082528
Budinok-muzej A. Čechova, Sums'kyj
 oblasnyj krajeznavčyj muzej,
 Sumy 043038
Budinok-muzej Sevastopol's'ke
 Komunistične Pidpillja 1942–1944,
 Muzei geroičnoï oborony i
 vyzvolennja Sevastopolja,

Sevastopol 043025
Budja, Rudolf, Miami Beach . . . 122159
Budja, Rudolf, Salzburg 100021
Budja, Rudolf, Wien 100111
Budrus, Renate, Stadtallendorf . 078446
Buechel, Louisville 094361
Buechel Memorial Lakota Museum,
 Saint Francis 052664
Bücher-Brockenhaus, Bern 143846
Bücher-Brocky, Aarau 143814
Bücher-Brocky, Basel 143822
Bücher-Brocky, Luzern 143898
Bücher-Brocky, Zürich 143950
Bücher-Ernst, Wien 140056
Bücher-Fantasia, Zürich 143951
Bücher James, Bonn 141542
Bücher Oase, Wilhelmshaven . . 142328
Bücher Scheidegger, Affoltern am
 Albis 143816
Bücherbogen am Savignyplatz,
 Berlin 141440
Bücherbogen im Stülerbau,
 Berlin 141441
Bücherbogen in der Knesebeckstraße,
 Internationales Modernes Antiquariat,
 Berlin 141442
Bücherbogen in der Nationalgalerie,
 Berlin 141443
Bücheretage, Bonn 141543
Büchergalerie Westend,
 München 142023
Büchergilde Gutenberg
 Verlagsgesellschaft mbH, Frankfurt
 am Main 137418
Das Bücherhaus, Inh. Hermann
 Wiedenroth, Eldingen 141651
Bücherinsel, Leipzig 141934
Büchernarr, Wermelskirchen . . . 142305
Büchernische beim Neuen Dom,
 Linz 140016
Büchers Best, Dresden 141612
Die Bücherstube, Bad
 Kleinkirchheim 139999
Bücherstube am See, Konstanz . 141909
Der Bücherwurm, Dessau-Roßlau 141604
Bücherwurm, Kiel 141872
Bücherwurm, Schaffhausen . . . 143921
Büchi, Monaco 112069
Büchi, Max, Bern . . . 087091, 134018
Büchner, H., Sinsheim 078402
Büchner, Thomas, Berlin 129707
Büchnerhaus, Riedstadt 021043
Büchsenmacher- und Jagdmuseum,
 Ferlach 001875
Bücker-Luftfahrt- und Europäisches
 Eissegel-Museum, Rangsdorf . . 020899
Bückmann, Monika, Krefeld . . . 076890
Büdenhölzer, Brigitte,
 Emmendingen 075560
Bücheler-Hus, Kloten 041386
Bühler, Aschaffenburg 074393
Bühler, Irmtraud, Bremen 075114
Bühlmann, Astrid, Bern 134019
Bühlmayer, C., Wien . . 062883, 128167
Bühnemann, Brake 106554
Bühnemann, Michael, Berlin . . . 074729
Bühnemann, Rainer L., Hannover 076306
Bühning, Bohmte 075015
Bührer, Barbara, Neuhausen am
 Rheinfall 134190
Buekenhout, Jean, Bruxelles . . . 063304
Büker, Eberhard, Hamburg 076147
Bükki Üveghuták Ipartörténeti
 Múzeuma, Bükkszentkereszt . . 023250
Bülow, Holger, Berlin 129708
Bülow, Rose-Marie, København . 065808
Bültmann & Gerriets, Oldenburg 142117
El Buen Orden, Buenos Aires . . 060876
En Buen Uso, Logroño 085895
Buena Park Historical Society
 Museum, Buena Park 047261
Buena Vista, Dordrecht 112519
Bündner Kunstmuseum, Chur . . 041191
Bündner Naturmuseum, Chur . . 041192

Bundesverband Bildender Künstlerinnen
und Künstler, Regionalverband Kassel-
Nordhessen, Kassel . 058748, 058749
Bundesverband der
Jugendkunstschulen und
Kulturpädagogischen Einrichtungen
e.V., Unna 058769
Bundesverband des Deutschen
Kunst- und Antiquitätenhandels e.V,
Drestedt 058770
Bundesverband Deutscher Galerien
e.V., Köln 058771
Bundesverband Deutscher
Kunstversteigerer e.V.,
Wiesbaden 058772
Bundesverband Kunsthandwerk,
Berufsverband Handwerk Kunst
Design e.V., Frankfurt am Main 058773
Bundesverband Museumspädagogik
e.V., Geschäftsstelle, München 058774
Bundis-Arndt, Maren, Hamburg . 130258
Bundo, Daegu 111606
Bunědi Farhangi Isfara, Isfara . . 059902
Bunědi Farhangi Tojikiston,
Dušanbe 059903
Bunel, Patrick, L'Isle-sur-la-
Sorgue 069507
Bungalow Antiques, Oakland . . 095721
Bungalow Gallery, Indianapolis . 121450
Bungalow Porslin, Stockholm . . 086796
Bungalow Upholstery, Auckland 133061
Bungay Museum, Bungay 043569
The Bungeroosh Gallery, Brighton 117543
Bunglemarr Trading, Bundaberg 061223
Bunia, Sebastian-Jan, Krems . . 132058
H.K. Buniatyan Art Gallery, Gavar 000692
Buninong Antiques, Buninyong . 061226
Bunka Gakuen Fukushoku
Hakubutsukan, Tokyo 029308
Bunkamura Museum, Tokyo . . . 029309
Bunker Hill Museum,
Charlestown 047528
Bunker Museet, Frederikshavn . 009910
Bunker Stalina, Samara 037530
Das Bunkermuseum, Emden . . . 017928
Bunkermuseum Oberhausen,
Oberhausen 020541
Bunkermuseum Wurzenpass/Kärnten,
Riegersdorf 002546
Bunkier Sztuki Współczesnej,
Kraków 113622
Bunnell Street Gallery, Homer . 049478
Bunratty Castle and Folkpark,
Bunratty 024547
Bunryu, Tokyo 142739
Buntin, Robyn, Honolulu 093368, 093369,
121204
Bunting, Peter, Bakewell 088101
Bunun Culture Exhibition Center,
Taoyuan 042295
Buol, Eleonore von, München . . 142024
Buonasorte, Ugo, Milano 080303
Buono, Francesco, Roma 132221
Buonocore, Gennaro, Napoli . . 131992
Buonocore, Mario, Napoli 080680,
131993
Buqaish, Sharjah 117257
Buque Museo Corbeta Uruguay,
Buenos Aires 000149
Buque Museo Ex BAP América,
Iquitos 034118
Buque-Museo Fragata Presidente
Sarmiento, Buenos Aires 000150
Bur, Marie-France, La Celle-Saint-
Cloud 068909
Buraczyński, Tomasz, Warszawa 133236
Burapha Museum of Art, Chon
Buri . 042420
Burbage-Atter, Leeds 144278
Burbank, San Jose 097195
Burbiškio Dvaro Istorijos Ekspozicija,
Daugyvenės kultūros istorijos
muziejus-draustinis, Burbiškis . 030157
La Burbuja-Museo del Niño,

Hermosillo 030858
Burca, Eamon de, Blackrock . . 142417
Burcea, Ion, București . 084911, 133355
Burchard, Saint Petersburg . . . 127700
Burchard, Friedrich, Wuppertal . 142350
Burchard, Hans Martin, Hamburg 130259
Burchardt, Harald,
Schwarzenberg 108596
Burchfield-Penney Art Center, Buffalo
State College, Buffalo 047268
Burckardt, Helga, Bielefeld . . . 106489
Burden & Izett, New York 095127
Burden, Clive A., Rickmansworth 144544
Burdett, Melrose Park 061827
Burdett & Rawling, Hull 134801
Burdick, Washington 125125
Burdigal'Art, Bordeaux 013370
Burdur Devlet Güzel Sanatlar Galerisi,
Burdur 042585
Burdur Müzesi, Burdur 042586
Bureau County Historical Society
Museum, Princeton 052267
Bureau, Anne, Gaure 103715
Burel, Thierry, Paris 071051
Burel, Y., Luneray 069610
Burel, Roland, Paris 141025
Burford Antique Centre, Burford 088482,
134498
The Burford Gallery, Burford . . 117613
Burg- und Mühlenmuseum Pewsum,
Ostfriesisches Freilichtmuseum,
Krummhörn 019484
Burg- und Schloßmuseum Allstedt,
Allstedt 016318
Burg- und Schloßmuseum Jägersburg,
Homburg 019028
Burg- und Stadtmuseum Königstein,
Königstein im Taunus 019412
Burg-Antik, Nürnberg 077739
Burg Berwartstein, Erlenbach bei
Dahn 018018
Burg Breuberg mit Breuberg-Museum,
Breuberg 017396
Burg Eltz, Wierschem 022212
Burg Falkenberg, Falkenberg, Kreis
Tirschenreuth 018077
Burg Forchtenstein,
Forchtenstein 001883
Burg-Galerie, Brüggen 106596
Burg Giebichenstein, Hochschule für
Kunst und Design Halle, Halle,
Saale 055490
Burg Gnandstein, Staatsbetrieb
Staatliche Schlösser, Burgen und
Gärten Sachsen gGmbH, Kohren-
Sahlis 019425
Burg Gößweinstein,
Gößweinstein 018462
Burg Greifenstein, Greifenstein . 018521
Burg Hagen, Hagen im
Bremischen 018631
Burg Herzberg, Breitenbach am
Herzberg 017351
Burg Hochosterwitz, Launsdorf . 002240
Burg Hohenzollern, Burg
Hohenzollern 017452
Burg Kreuzen, Bad Kreuzen . . . 001744
Burg Kreuzenstein, Korneuburg . 002191
Burg Kronberg, Kronberg im
Taunus 019476
Burg Lauenstein, Bayerische
Verwaltung der staatlichen Schlösser,
Gärten und Seen, Ludwigsstadt 019808
Burg Meersburg GmbH,
Meersburg 019989
Burg Mildenstein, Leisnig 019688
Burg-Museum, Parsberg 020717
Burg Neustadt-Glewe, Neustadt-
Glewe 020415
Burg Pappenheim mit Natur- und
Jagdmuseum, Historischem
Museum, Botanischem Garten und
Kräutergarten, Pappenheim . . 020714
Burg Prunn, Bayerische Verwaltung

der staatlichen Schlösser, Gärten
und Seen, Riedenburg 021036
Burg Reichenstein,
Trechtingshausen 021778
Burg Sooneck, Niederheimbach . 020440
Burg Stollberg, Stolberg,
Rheinland 021603
Burg Stolpen, Staatliche Schloesser,
Burgen und Gärten Sachsen gGmbH,
Stolpen 021605
Burg Taufers, Campo Tures . . . 025578
Burg Thurant, Alken 016313
Burg Trausnitz, Landshut 019548
Burg Trifels, Annweiler am Trifels 016396
Burg Vischering, Münsterlandmuseum,
Lüdinghausen 019838
Burg Wäscherschloss,
Wäschenbeuren 021950
Burg zu Burghausen,
Burghausen 017458
Burg zu Burghausen, Bayerische
Verwaltung der staatlichen Schlösser,
Gärten und Seen, Burghausen . 017459
Burg Zwernitz, Bayerische Verwaltung
der staatlichen Schlösser, Gärten
und Seen, Wonsees 022338
Burgan, Claude, Paris 071052
burgart-presse, Rudolstadt . . . 137613
Burgaski Muzej, Burgas 004904
Burgassi, Lucia, Firenze 110054
Burgate Antique Centre,
Canterbury 088553
Burgauer Galerie, Burgau 106609
Burgauer Turmuseum, Burgau . 017455
Burge, Yale R. & Robert, New
York 095128
Burgen und Schlösser, Brauch 138732
Burgenmuseum, Dahn 017579
Burgenmuseum Eisenberg, Eisenberg,
Kreis Ostallgäu 017895
Burgeo Centennial Memorial Museum,
Burgeo 005390
Burger Waldmuseum mit
Naturerlebnisraum, Burg,
Dithmarschen 017451
Burger Weeshuis, Zierikzee . . . 032920
Burger, Anna-Maria, München . 108047
Burger, Christa, München 018048
Burger, Robert, Los Angeles . . 136059
Burger, Veronika, Tübingen . . . 108795
Burgerhuis, Stellenbosch 058651
Burgersdijk & Niermans, Leiden 142992
Burgersdorp Cultural Historical
Museum, Burgersdorp 038491
Burgert, Strasbourg . 073537, 129495
Burgess Farm Antiques,
Morestead 090621
Burgess Farm Antiques,
Winchester 091728
Burgess, Derek J., Parkstone . . 090792,
135265
Burgess, J & J, Cambridge 144065
Burgevin, Denis, Gien 068604
Burggalerie, Magdeburg 107921
Burggalerie Laa, Laa an der
Thaya 002219
Burghead Visitor Centre,
Burghead 043571
Burghley House, Stamford 045842
Burghofmuseum, Stadtgeschichtliches
Museum, Soest 021490
Burgi, Camille, Paris 071053
Burgin, Christine, New York . . . 122691

Burgio, Emanuele, Palermo . . . 080860
Burgio, Giuseppe, Palermo . . . 080861
Burgmuseum, Güssing 001997
Burgmuseum, Seebenstein . . . 002687
Burgmuseum Altnußberg,
Geiersthal 018331
Burgmuseum Archeo Norico,
Deutschlandsberg 001805
Burgmuseum Bad Bodenteich, Bad
Bodenteich 016536
Burgmuseum Burg Guttenberg,
Haßmersheim 018795
Burgmuseum Burg Neuhaus,
Wolfsburg 022319
Burgmuseum Clam, Klam 002169
Burgmuseum Grünwald,
Archäologische Staatssammlung
München, Grünwald 018590
Burgmuseum Kirschau, Kirschau 019315
Burgmuseum Krautheim,
Krautheim 019455
Burgmuseum Lenzen, Lenzen . . 019701
Burgmuseum Marksburg,
Deutsche Burgenvereinigung e.V,
Braubach 017328
Burgmuseum mit Burgturm, Plau am
See 020784
Burgmuseum Ortenberg, Ortenberg,
Hessen 020649
Burgmuseum Runneburg,
Weißensee 022134
Burgmuseum Schlitz, Schlitz . . 021280
Burgmuseum Schlossfreiheit,
Tangermünde 021700
Burgmuseum Schönfels,
Schönfels 021311
Burgmuseum Sonnenberg,
Wiesbaden 022214
Burgmuseum Sulzberg, Sulzberg 021684
Burgmuseum Waldeck, Waldeck 021965
Burgmuseum Wolfsegg,
Wolfsegg 022329
Burgruine Montclair, Mettlach . 020053
Burgruine Münzenberg,
Münzenberg 020261
Burgruine Teufelsberg, Überherrn 021833
Burgstaler, Markus, Templin . . 078590
Burgturm Davert, Ascheberg . . 016433
Burgues, Catherine, Gentilly . . 128849
Burguet, Monique, Montrouge . 070284
Burgverlag, Wien 140057
Burgwin-Wright Museum,
Wilmington 054319
Burica, New York 136243
Buried Treasures, Denver 093103
Buril, Madrid 085963
Buril, Sevilla 086271
Burin Heritage House, Burin . . . 005392
Burjatskij Respublikanskij
Chudožestvennyj Muzej im. C.S.
Sampilova, Ulan-Udė 037812
Burk, Jürgen J., Nürnberg 077740
Burkard, Gerhard & Viktoria,
Buttenwiesen 075191
Burkard, Peter, Luzern 116560, 126943
Burkart, Michael, Nürnberg . . . 077741
Burkart, Rolf A., Hilden 137467
Burke, Los Angeles 094114
Burke, Memphis 144991
Burke, New York 095129
Burke County Historical Powers Lake
Complex, Powers Lake 052251
Burke Museum of Natural History and
Culture, Seattle 053114
Burke News, Seattle 139363
Burke & Sons, John F., Cahir . . 079360
Burkert, George, San Francisco 136648
Burkhardt, Vaihingen an der Enz 108820
Burkhardt, Janet, Waramanga . 139977
Burkhardt, Klaus-Joachim,
Stuttgart 078514
Burk's Falls and District Museum,
Burk's Falls 005393
Burlando, Mauro Silvio, Genova . 080073

Canadian Baseball Hall of Fame & Museum, Saint Marys –
Cape Spear Lighthouse National Historic Site, Saint John's

Index of Institutions and Companies

Cape Town Holocaust Centre, Cape Town 038496
Cape Vincent Historical Museum, Cape Vincent 047385
Cape, Jonathan, London 138259
Čapek, Trebíč 102702
Čapek, Petr, Brno 128559
Y Capel, Llangollen 044772
Capel Mawr Collectors Centre, Criccieth 144132
A Capela, São Paulo 064112
Capella Brancacci, Firenze .. 026089
Capelle, Nano, Cahors 067535, 067536
Capelletti, Mario, Meda 080182
Capellotti, Michele, Saluzzo .. 081445
Ca'Pesaro – Galleria Internazionale d'Arte Moderna, Musei Civici Veneziani, Venezia 028114
Capet, Patrick, Royan 072586
Capet, Paul, Le Gosier 131208
Capharnaum, Saint-Gilles-du-Gard 072773
Capharnaum Ancient Synagogue, Kfar Nahum 024940
Capia, Robert, Paris .. 071074, 129189
Capitain Petzel, Berlin 106143
Capitain, Gisela, Köln 107584
Capital Antiques, San Antonio .. 096790
Capital Antiques, Washington .. 097651
Capital Art Corporation, Taipei .. 116986
Capital Corner, Bruxelles 100436
Capital Museum, Beijing 007415
Capital Pawn & Gun, Regina .. 064494
Capital Restoration, Saint Louis .. 136536
La Capitale Galerie, Paris ... 104566
Capitani Art Gallery, Milano .. 080314
Il Capitello, Torino 081506
Capitol Coin Company, Washington 097652
Capitol Furnishings, New York .. 095132
Capitol Hill Art League, Washington 060424
Capitol Hill Books, Denver .. 144861
Capitol Hill Books, Washington .. 145372
The Capitol Horsham Art Gallery, Horsham 044465
Capitol Reef National Park Visitor Center, Torrey 053661
Capitola Historical Museum, Capitola 047386
Capitole Echange Estimation, Toulouse 073712
Capitolium, Brescia 126403
Capitolium, Roma 081114, 081115
Capítulo Uno, Buenos Aires .. 139587
Caplain-Matignon, Paris 104567
Caplan, Elliott City 127480
Caplow, Minneapolis 136174
Capo, Philadelphia 095926
Capo D'Arte, São Paulo 128375
Capodistria Museum, Koukouritsa, Evropouli 022765
Capolavori, I., Seattle 124751
Capon, Patric, Bromley 088463, 134493
Capone, Pietro, Palermo 080862
Capozzi, Alberto, Genova ... 080078
Capozzi, Marco, Genova 080079
Cappelen, J.W., Oslo . 137978, 143209
Cappelens, J.W., Oslo . 126580, 143210
Cappella degli Scrovegni, Padova 026974
Cappella Sistina, Sala e Gallerie Affrescate, Musei Vaticani, Città del Vaticano 054616
Cappellaro, Luca, Padova ... 132047
Cappelletti, Gabriele, Milano .. 110291
Cappelletti, Renzo, Perugia .. 132133
Cappelli, Bologna 142449
Cappellini Libreria, Firenze .. 142486
Cappellini, Leonardo, Firenze .. 131538
Cappon House Museum, Holland 049463
Capponi, Ettore & C., Brescia .. 079756
Cappuzzo, Giuliano, Firenze .. 079938
Capra, Waldeck 108851
Caprara, Marisa, Bologna ... 131348

Capraro, Belisario, Milano 131800
Caprice, Bischwiller 067174
Caprice d'Antan, Saint-Ouen .. 073007
Caprices, Levallois-Perret 069388
Caprices, Paris 071075
Caprices du Temps, Angers ... 066543
Capricia, Le Blanc 069163
Capricious Magazine, Brooklyn . 139366
Capricorn, Smethwick 119371
Capricorn Antiques, Toronto .. 064568
Capricorn West, Kojonup 061690
Il Capricorno, Venezia 111118
Capricorno, Washington 125130
Capstick-Dale, Simon, New York 122697
CAPT Comics, Birmingham ... 092232
Captain Billys, Seevetal 078367
Captain Cook Birthplace Museum, Middlesbrough 045185
Captain Cook Memorial Museum, Whitby 046138
Captain Cook Schoolroom Museum, Great Ayton 044314
Captain Forbes House Museum, Milton 050837
Captain George Flavel House Museum, Astoria 046552
Captain John Wilson House, Cohasset 047821
Captain Kennedy Museum and Tea House, Saint Andrews 006695
Captain Nathaniel B. Palmer House, Stonington 053432
Captain Phillips' Rangers Memorial, Saxton 053071
Captain Salem Avery House Museum, Shady Side 053164
Captain's Cottage Museum, Murray Bridge 001324
Captain's Courtyard Antiques, New Orleans 094906
Captain's House, Scarborough .. 119323
Captain's Saloon, München ... 077404
Captier-Barnes, Paris 071077
Captier, Bernard, Paris 071076
Captive Inspirations Photographic Gallery, Brisbane 098637
Captured on Canvas Paintings of Australia, Wembley Downs .. 099737
Captured Visions, Saint Paul .. 124148
Capuano, Emanuele, Napoli .. 080682
Capucine, Rochefort (Charente-Maritime) 072455
Capus, Jean, Senningen 082203
Caputo, Bruno, Napoli 131997
Caputo, Lorenzo, Bari 079650
Caputo, Luciano, Padova 132048
Car and Carriage Museum, Pittsburgh 052065
CAR drde, Bologna 109827
Car Life Museum, Charlottetown 005487
Car, Jean-Pierre, Gardanne .. 068578
Cara y Cruz, Madrid 085969
Carabaux, New Orleans 122390
Carabe, Luis, Sevilla 086272
Carabelli, Nino, Creazzo 110010
I Caracci Arte Antica, Casalecchio di Reno 079843
Caracciolo, Italo, Genova 131689
Caracol Archaeological Site, Mayan Ruins, Caracol 004094
Caractère, Paris 104568
Caractères, La Rochelle 069026
Caraffi, Maleny 099126
Carafizi, São Paulo 100947
Caral de Montety & Cornut, Aix-en-Provence 066397
Caram, F., São Paulo 064113
Carambol, Basel 087041
El Carambolo, Sevilla 086273
Caramoor Center for Music and the Arts, Katonah 049856
Carantec, Carantec 103479

Carápan, Monterrey 082306
Carasi, Massimo, Mantova ... 110216
Carat, Bordeaux 103371
Carat, Gdańsk 113547
Carati, Ambrogio, Milano 131801
Caravan, Tehrãn 079316
Caravan Art, Toshkent 125324
Caravan Book Store, Los Angeles 144957
The Caravan Gallery, Portsmouth 119178
Caravanserai, Manama 100280
Caravanserai, München 077405
Caravanserail, Jounieh 082136
Caravansérail, Reims 072344
Caravati, Richmond 096368
Caravello, Beatrice, Palermo .. 110614
Caravello, Massimo & Giacomo, Palermo 110615, 132078
Carayol, Bayonne 125781
Carayol, Biarritz 067133, 125792
Carbajosa, Valentin Fernandez, León 085885
Carberry Plains Museum, Carberry 005453
Carberry, Valerie, Chicago ... 120363
Carbethon Folk Museum and Pioneer Village, Crows Nest, Queensland 001002
Carbon Based Studios, Brisbane 098638
Carbon County Museum, Rawlins 052383
Carbonari, Giuseppe, Verona .. 081735
Carbonaro, Davide, Roma 081116
Carbone, Torino 081507, 132495
Carbone Rieger Fine Arts, Toronto 101452
Carbone.to, Torino 110980
Carbonear Museum, Carbonear . 005455
Carboni, New York 122698
Carburantes Tarazona, Albacete 114914
Carby Art, Glasgow 118033
Carcoar Historic Village, Stoke Stable Museum, Firearms Technology Museum & Court House, Carcoar 000945
Card Traders of Austin, Austin .. 144715
Cardamom Antiques, Buenos Aires 060877
Cardana, Amersfoort 082464
Cardani, Daniel, Madrid 085970, 115254
Cardelli & Fontana, Sarzana .. 110933
Cardelli, Alessandro, Genova .. 131690
Cardellini, Roberto, Roma 132224, 132225
Cardellino, Emanuele, Torino .. 081508, 137845
Cardenas Olaya, Enrique, Bogotá 065105
Cardi, Francis, L'Ile-Rousse .. 069413
Cardiff Castle and Interpretation Centre, Cardiff 043653
Cardiff School of Art and Design, University of Wales Institute, Cardiff, Cardiff 056476
Cardiff Story Museum, Amgueddfa Stori Caerdydd, Cardiff 043654
Cardiff Violins, Cardiff 088567
Cardigan Heritage Centre, Cardigan 043662
Cardigan Street Gallery, Carlton, Victoria 098724
Cardilès, Jean, Onet-le-Château 070735
Cardin, Pierre, Paris 104569
Cardinal Gallery, Annapolis ... 046467
Cardinal Ó Fiaich Heritage Centre, Áras an Chairdiméil Ó Fiaich, Cullyhanna 043857
Cardinal, Suzanne, Voiron ... 074233
Cardingmill Antiques, Church Stretton 088690
Cardini, Andrea, Genova 080080
Cardini, Leon F., Los Angeles .. 136060
Cardona, Genova 080081
Cardona, Samwel, Zebbug ... 132729
Cardone, Roberta, Bari 079651
Cardoso, Amadeu, São Paulo .. 100948

Cardoso, Paulo Barreiros, Lisboa 133293
Cardwell Shire Museum, Tully .. 001591
Care of, Cusano Milanino 110014
Care of Collections Forum, Grangemouth 060004
Carel, Miami 122030
Carel, Jean-Lou, Le Castellet .. 103881
Carello Frères, Nice 070532
Careof – Fabbrica del Vapore, Milano 059347, 110292
Carette, Hervé, Linselles 069483
Caretto, Luigi, Torino 081509
Caretto, Patrizia, Torino 081510
Carew Castle and Tidal Mill, Tenby 045959
Carew Manor and Dovecote, Beddington 043303
Carey Museum, Serampore ... 024164
Ca'Rezzonico – Museo del Settecento Veneziano, Musei Civici Veneziani, Venezia 028115
Carfagna, Andrea, Roma 132226
Cargo, Hyères 068796
Cariano, Victoria 082261
Caribart, Amsterdam 112255
Caribbean Art Gallery, Montego Bay 111245
Caribbean Creations, Chicago .. 120364
Caribbean Gallery, Tampa ... 124889
Caribbean Primate Research Center Museum, San Juan 035983
Caricatura Galerie, Kassel ... 019219
Caricatura Museum Frankfurt, Museum für Komische Kunst, Frankfurt am Main 018148
Caricatura, Galerie für komische Kunst, Kassel 107513
Caricyno – Gosudarstvennyj Istoriko-architekturnyj, Chudožestvennyj i Landšaftnyj Muzej-Zapovednik, Moskva 037064
Carillon Antiques, Perth 062065
Carillon di Archita Calcante, Taranto 081464
Carillon Historical Park, Dayton . 048131
Carina Prints, London 118479
Carina Straub, Bild + Rahmen, Galerie im Künstlerhaus, Leonberg ... 107848
Carincotte, Delphine, Marseille . 104113
Carini, Pier Giuseppe, San Giovanni Valdarno 110915
Cariou, Bernard, Grenoble ... 140806
Cariou, Jean-Loup, Pont-Aven .. 105326
Caris, Gordon, Alnwick 088020, 134338
Caris, Gordon, Hexham 089327, 134777
Carisbrooke Castle Museum, Newport, Isle of Wight 045302
Carissa's Armoires and Antiques, Nashville 094817
Caristi, Dominic F., Boston ... 135713
Caritas Galerie, Berlin 106144
Carl-Benz-Haus, Ladenburg .. 019512
Carl Bosch Museum, Heidelberg 018832
Carl Eldhs Ateljémuseum, Stockholm 040796
Carl Freedman Gallery, London . 118480
Carl Goldmark-Gedenkhaus, Deutschkreutz 001803
Carl-Henning Pedersen og Else Alfelts Museum, Herning 009954
Carl Jularbo Museum, Avesta .. 040358
Carl-Julius-Weber-Gedenkstube, Langenburg 019570
Carl Larsson-Gården, Sundborn 040863
Carl-Lohse-Galerie, Bischofswerda 017179
Carl-Maria-von-Weber-Museum, Stadtmuseum Dresden, Dresden 017741
Carl-Millner-Galerie, Mindelheim 020069
Carl Nielsen Museet, Odense .. 010089
Carl Nielsens Barndomshjem, Árslev 009853
Carl Orff Museum, Dießen am

Cátedra Ediciones, Madrid 138075
Catedral Antiguidades, Rio de
Janeiro 063985
Catelin, Gilles, Montluçon 070213
Catellani, Anna, Stockholm 133920
Catelli, Milano 110297
Cater Museum, Billericay 043363
Catera, Carlo, Roma 132234
Caterina Tognon Arte Contemporanea,
Venezia 111119
Caters, Jacques-Emmanuel de,
Bruxelles 063308, 063309
Cates & Co., Mary, Dallas 092920
Cathach, Dublin 142422
Catharina, Groningen 083095
Cathay, Paris 071084
Cathay, Singapore 085205
Cathcart, Valerie, San Francisco 124495
Cathedral Church of Saint John the
Divine, New York 051275
Cathedral Gallery, Lichfield .. 118339
Cathedral Jewellers, Manchester 090535
Cathedral Museum, Mdina 030563
Cathedral of Christ The King Museum,
Mullingar 024774
Cathedral Treasury, Chichester . 043736
Cathedral Treasury Museum,
Carlisle 043664
Cathédrale d'Images, Les Baux-de-
Provence 013544
Cather's Furniture, Richmond . 136506
Catholic Historical Society of the
Roanoke Valley, Roanoke .. 052502
Cathomas, Maurus, Chur .. 087183,
116309
Cathrinesminde Teglværk, Museum
Sønderjylland, Broager ... 009867
Cathy's Antiques, Dallas 092921
Catley, Brendon, Tauranga .. 083958,
133121
The Catlin House Museum,
Scranton 053100
Catlins Historical Museum,
Owaka 033089
Cato, Lennox, Edenbridge 088945,
134669
Caton, Hyères 068797
Caton, Peter, Brighton, Victoria . 098630
Catot, Olivier, Marseille 128993
Catrice, Wasquehal 074253
Catrina, Jeannette, Stäfa 116749
Cats Eye, Chicago 092521
Cats Paw, Cleveland 092763
Cat's Whiskers Antiques,
Ashburton 083560
Cats, Bernard, Knokke-Heist .. 100597
Catskill Fly Fishing Center and
Museum, Livingston Manor .. 050296
Cattai, Michela, Corvara in Badia 079890
Cattai, Michela, Milano 080317
Cattaneo & C., Natalina, Genova 080802
Cattani, Gianfranco, Roma 132235
Cattaraugus Area Historical Center,
Cattaraugus 047430
Cattelani, Modena 110509
Cattet, Alexandre, Paris 071085
Cattiaux, Chantal, Douchy-les-
Mines 068339
Cattiaux, Didier, Josselin 068856
Cattle Raisers Museum, Fort
Worth 048860
Cattle, Barbara, York 091841
Catto, Gillian, London 118482
Catucci, Enrico, Genova 131692
Catùs-Arte, Bologna 109829
Caudine, Laurent, Moncayolle-Larrory-
Mendibi 129034
Caudron, Christian, Montreuil-sous-
Bois 129049
Caudwell's Mill & Craft Centre,
Matlock 045155
Cauet, Christian, Longueau ... 069565
Caula, Jacqueline, Pertuis 072071
Caulfeild Gallery, Vancouver .. 101616

Caulfield Antique Warehouse, Caulfield
South 061297, 127857
Caulfield Auction Centre,
Caulfield 125465
La Causa, Milwaukee 122184
Causans, Etienne de, Paris ... 071086,
104578
Causeway Collection, Tralee .. 079601
Causeway School Museum,
Bushmills 043601
Causey Antique Shop, Gosforth, Tyne
and Wear 089145
Causse, Georges, Saint-Sulpice-de-
Favières 073270
Causse, Henri, Sainte-Enimie . 073306
Caussignac, Jean-Claude, Lavaur 069151
CAV Antiques, Providence 096339
Cavalcade of Costume, Blandford
Forum 043425
Uchoa Cavalcanti, Rio de Janeiro 100879
Cavaleri, Carlo, Mendrisio 087475,
134179
Cavalier, Chicago 092522
Cavalier, Greenwich 121194
Cavalier, Nantucket 122337
Cavalier Antiques, Glenelg ... 061521,
127877
Cavaliere, Giancarlo, Milano .. 131804
Cavalière, Henri, Toulon (Var) .. 073668
Cavalieri, Luciano, Roma 132236
Cavaliero, New York 122704
Il Cavalletto, Locarno 116538
Il Cavallino, Reggio Emilia ... 110725
Cavallino Edizioni, Venezia ... 111110,
137856
Cavallo, Carlo, Torino . 081515, 132497
Cavan County Museum,
Ballyjamesduff 024537
Cavanacor Gallery, Lifford 109673
Cavanagh, D L, Edinburgh 088954
Cavani Antichità, Modena 080617
The Cave, Washington 125131
Cave au Grenier, Paris 071087
Cave au Grenier, Ségny 073433
La Cave aux Curiosités, Lyon .. 069662
La Cave aux Sculptures, Dénezé-sous-
Doué 012571
Cave Creek Museum, Cave
Creek 047432
La Cave D'Arts, Louviers 104001
Cave & Sons, R.G., Ludlow 090488
Caveau des Récollets, Château-du-
Loir 067814, 103527
Caveau Muséalisé, Cave Coopérative,
Cabrières 012082
Caveau-Musée Les Vignerons de
Roueïre, Quarante 014815
Cavecanem, Sevilla 115543
Cavedagna, Stefano, Falerna .. 079900
Cavedagna, Stefano, Napoli ... 080684
Cavehill Gallery, Belfast 117412
Cavellini, Piero, Brescia 109911
Cavendish, Fremantle 061478
Cavendish Fine Arts, Sonning-on-
Thames 091214
Cavendish Jewellers, York 091842
Cavendish Laboratory,
Cambridge 043631
Cavendish Philatelic Auctions,
Derby 127081
Cavendish Philatelic Auctions,
London 127186
Cavendish, Rupert, London ... 089816
La Caverne, Nangis 070384
Caverne, Tampa 097385
La Caverne d'Ali Baba, Cercles . 067691
La Caverne d'Ali Baba,
Perpignan 072031
Caverne d'Antan, Hangest-en-
Santerre 068731
La Caverne des Arts, Chantilly . 103522
La Caverne des Particuliers,
Alfortville 066476
Caverne des Particuliers, Créteil 068183

Caverne des Particuliers Alma,
Creil 068174
Cavernes de l'Abîme à Couvin,
Couvin 003447
Les Caves des Minimes,
Bruxelles 063310
Caves Muséalisées Byrrh, Thuir 015754
Les Caves Rupestres,
Rochecorbon 014920
Cavestany, Madrid 085976
Cavicchi Vannoni, Prato 081000
Cavicchioli, Rossella, Modena .. 080618
Caviezel, Claudio, Bern 134020
Caviglia, Enrico, Maroggia 087463
Cavin & Morris, New York 122705
Cavite City Library and Museum,
Cavite City 034288
Cavriolo, Brescia 142471
Cawdor Castle, Cawdor 043693
Cawi, Elisabeth, Hamburg 076150
Cawood Antiques, Cawood ... 088590
Caxton, Dublin 079425
Cayfosa, Santa Perpetua de
Mogoda 138092
Caylar, Guy, Bédarieux 067002
Caylus Anticuario, Madrid 085977
Cayman Arts, Miami 122031
Cayón, Madrid 126746
Cayon, Troyes 105730
Cayuga Museum, Auburn 046621
Cayuga-Owasco Lakes Historical
Society Museum, Moravia .. 050978
Cazac, Abel, Perpignan 072032
Cazal, Patrick, Biarritz 067134
Cazals de Fabel, Paris 071088
Cazanove, Michelle, Le Gosier . 109121
Cazaux, Christian, Bordeaux .. 125798
Cazenave, Edwina, Biarritz ... 067135
Cazzulani, Massimiliano, Milano 131805
CBA Gallery, Tokyo 111425
CBC, Perugia 132134
CBC Museum, Toronto 006999
CBC Radio Museum, Saint
John's 006744
CBK Amsterdam, Amsterdam . 112257
CBO Antiquités, Roanne 072445
CC Arts Gallery, Vancouver ... 101617
CC Kunst, Stuttgart 108697
CCA-Centre for Contemporary Arts,
Glasgow 044232
CCA Galleries Ltd., Beech Studio,
Tilford 119509, 138343
CCAA Glasgalerie Köln, Köln .. 107585
CCAA Museum of Art, Rancho
Cucamonga 052363
CCC Weeks Gallery, Jamestown 049743
CCNOA, Bruxelles 003359
CDS Gallery, New York 122705
Čebelarski Muzej, Muzeji radovljiške
občine, Radovljica 038415
Čeboksarskij Vystavočnyj Zal,
Čeboksary 036757
Cebriá Saez, Vicente, Valencia . 133813
Cebrian, Miguel, Zaragoza 086418
Cebu Archdiodesan Museum,
Cebu 034294
Cebu City Museum, Cebu 034295
Cebu City State College Museum,
Cebu 034296
CECA International Committee for
Education and Cultural Action of
Museums, Apeldoorn 059513
Ceccarelli, Evelino, Perugia ... 132135
Ceccherelli, Renato, Genova ... 080083
Cecchin, Donatella, Roma 132237
Cecchini, Perugia 110667
Cecchini, Aldo, Roma 132238
Ceccotti, Carlo, Roma 132239
Cecelia Coker Bell Gallery, Coker
College, Art Dept., Hartsville . 049353
Čech a Syn, Blansko 065272
Cech, Johannes, Wien 140058
Cechman, Franck, Versailles .. 074008
Cecil Higgins Art Gallery, Bedford 043306

Cecille R. Hunt Gallery, Webster
University, Sankt Louis 052972
Cedar Antique Centre, Hartley
Wintney 089253, 134756
Cedar Cliff Collectibles, Saint
Paul 096651
Cedar Falls Historical Museum, Cedar
Falls 047439
Cedar Grove Galleries, Morpeth . 061880
Cedar Grove Historical Society
Museum, Cedar Grove 047443
Cedar Grove Mansion Inn,
Vicksburg 053850
Cedar Grove Mansion, Philadelphia
Museum of Art, Philadelphia . 051944
Cedar House Antiques,
Mullumbimby 061919
Cedar House Gallery, Ripley,
Surrey 119227
Cedar Key Historical Society Museum,
Cedar Key 047444
Cedar Key State Park Museum, Cedar
Key 047445
Cedar Lodge Antiques, Newtown,
Victoria 061958
Cedar Rapids Museum of Art, Cedar
Rapids 047449
Cedar Ridge Creative Centre,
Scarborough 006835
Cedar Root Gallery, Vancouver . 101618
Cedar Street Galleries, Honolulu 121205,
121206
Cedar Valley Memories, Osage . 051731
Cederwall, San Francisco 124496
CEDIAS Musée Social, Paris ... 014432
Cédille, Paris 104579
Los Cedros, Madrid . 085978, 133670
Cee-Jay, Richmond . 096369, 136507
Cefer Cabbarlının Ev-Muzeyi,
Baki 003074
Cefn Coed Colliery Museum,
Neath 045252
Ceglédi Természetrajzi Vadászati
Múzeum, Cegléd 023255
Céide Fields Visitor Centre,
Ballycastle 024531
Ceilidh Place, Ullapool 119561
Cein, Julio & Fernando, Córdoba 060929
Ceiriog Memorial Institute, Glyn
Ceiriog 044280
Cejnar, Peter, Wien 128169
Cejudo Perez, Rafael, Córdoba . 085763
Celadon, Rio de Janeiro 063986
Celamuse – Porcelain Museum,
Seoul 029807
Celander, Anna, Malmö 133909
Celant, Geneviève, Clermont-
Ferrand 067959
Celantique, Paray-Vieille-Poste . 070800
Celbridge, Clane 131236
Celebration Antiques,
Philadelphia 095928
Celebrity Coin, Milwaukee 094676
Celebrity Sports Gallery, Houston 144904
Celest, Varna 101053
Celestat, Muzeum Historycznego m.
Krakowa, Kraków 034690
Celeste & Co., Las Vegas 093961
Celestial Galleries, Fortitude
Valley 098907
Celi, Maria Liliana, Taranto 081466
Celil Memmedquluzadenin Ev-Muzeyi,
Baki 003075
Celinda's Doll Shoppe,
Minneapolis 136175
Céline Antiquaire, Montréal ... 046346
Cell Project Space, London ... 044829
Cellar Antiques, Hawes 089280
Cellar Antiques, Orroroo 062026
Cellar Coin, San Diego 096906

Centro per l'Arte Contemporanea Luigi
Pecci, Prato 027271
Centro Pró-Memória do Club Athlético
Paulistano, São Paulo 004768
Centro Pró-Memória Hans Nobiling
do Esporte Clube Pinheiros, São
Paulo 004769
Centro Regional de Arqueologia
Ambiental, Piraju 004557
Centro Regional de Pesquisas
Archeológicas Mário Neme,
Piraju 004558
Centro Restauro Meranese,
Merano 131747
Centro Restauro Mobili Antichi,
Torino 081516, 132498
Centro Steccata, Parma 110644
Centro Studi Alfredo Muratori,
Modena 137798
Centro Studi I. Silone, Pescina . 027115
Centro Studi Naturalistici del Pollino Il
Nibbio, Morano Calabro 026813
Centro Universitario Belas Artes de
São Paulo, São Paulo 055034
Centro Universitario Europeo per i
Beni Culturali, Ravello 055903
Centro Visitantes Fabrica de Hielo,
Sanlúcar de Barrameda 039886
Centrul de Cultură Palatele
Brâncoveneşti, Mogoşoaia ... 036403
Centrum Arts and Creative Education,
Port Townsend 052166
Centrum Beeldende Kunst,
Groningen 032198
Centrum Beeldende Kunst,
Nijmegen 112690
Centrum Beeldende Kunst Dordrecht,
Dordrecht 112520
Centrum Beeldende Kunst Emmen,
Emmen 032124
Centrum Beeldende Kunst Utrecht,
Amersfoort 031732
Centrum Bohuslava Martinů v Poličce,
Městské Muzeum a Galerie Polička,
Polička 009611
Centrum för Arbetarhistoria,
Landskrona 040575
Centrum Fornikling, Oslo 084148
Centrum Hasičského Hnuti,
Přibyslav 009694
Centrum Kultury Dwór Artusa,
Toruń 035109
Centrum Kultury i Sztuki Afrykańskiej,
Kraków 034691
Centrum Kultury Żydowskiej,
Kraków 034692
Centrum Kunsthistorische
Documentatie, Radboud Universiteit,
Nijmegen 056124
Centrum Kunstlicht in de Kunst,
Eindhoven 032104
Centrum Młodzieży, Kraków 113626
Centrum Pamięci Gen. Józefa Hallera,
Władysławowo 035229
Centrum Rysunku i Grafiki im.
Tadeuza Kulisiewicza, Muzeum
Okręgowego Ziemi Kaliskiej w
Kaliszu, Kalisz 034632
Centrum Rzeźby Polskiej,
Orońsko 034913
Centrum Rzeźby Polskiej – Dział
Wydawnictw, Orońsko 137991
Centrum Scenografii Polskiej –
Galerija Anrzeja Majewskiego,
Muzeum Śląskie, Katowice ... 034644
Centrum Sztuki Studio im S.I.
Witkiewicza, Warszawa 035143
Centrum Sztuki Współczesnej Łaźnia,
Gdańsk 034557
Centrum Sztuki Współczesnej, Zamek
Ujazdowski, Warszawa 035144
Centrum voor de Vlaamse Kunst
van de 16de en de 17de Eeuw,
Antwerpen 003203

Centrum voor Heiligenbeelden,
Kranenburg 032377
Centrum voor Natuur en Landschap,
Terschelling-West 032735
Centura House Historical Society, A.J.
Snyder Estate, Rosendale ... 052584
Centuries, Birmingham 092233
Centuries, Minneapolis 094738
Centuries 46, Brno 065279
Centuries Old Maps and Prints, New
Orleans 145041
Centurion Galleries, Chicago .. 120368
Century, Charlotte 092418
Century Antique Watch,
Singapore 085206
Century Antiques, Cleveland .. 092764
Century Coins, Pittsburgh 096101
Century Fine Arts, Lymington . 090503
Century Galleries, Henley-on-
Thames 118169
Century Gallery, Slough 119368
Century Modern, Dallas 092922
Century of Stone Gallery,
Louisville 121916
Century Shop, Louisville 094363
Century Village Museum, Burton 047294
CEP Sanat Galerisi, İstanbul .. 117115
CEPA Photographic Galleries,
Buffalo 120234
CEPACI, Promotion de l'Artisanat de
Côte d'Ivoire, Bordeaux 103372
Cepade, Paris 104585
Cepade Centro Paulista de Arte e
Design, São Paulo 055035
Cepcolor, Mâcon 104092
Cepheus, Stockholm 115946
C'era Una Volta, Genova 080084
C'era Una Volta Il Mobile, Milano 131808
Ceralacca, Brescia . 079759, 142472
Ceram Antiek, Tilburg 083426
Cerami, Charleroi 063538
Ceramic Art Center, Mashiko .. 028815
Ceramic Collectors Society, North
Sydney 058158
Ceramic Restoration, New York . 136246
Ceramic Review, London 138260,
139194
Cerámica, Madrid 139087
Ceramica Arte 4, Cartagena .. 128541
Ceramics, Brighton 117546
Ceramics Collector, Strasbourg . 073538
Ceramics Monthly Magazine,
Westerville 139369
Ceramics Museum, Tel Aviv ... 025018
Céramiques du Château, Antibes-Juan-
les-Pins 103207
Cerclaje, Madrid 115261
Cercle des Beaux-Arts de
Liège 058334, 100642
Cercle des Beaux-Arts de Verviers,
Verviers 058335, 100683
Čerdynskij Kraevedčeskij Muzej A.S.
Puškina, Tcherdyn Regional Pushkin
Museum, Čerdyn 036768
Cereal Prairie Pioneer Museum,
Cereal 005481
Ceredigion Museum,
Aberystwyth 043112
Cerenna, Mattydale 127577
Ceres, New York 122707
Ceres Antiques, Ceres 088591
Ceresa, Ferdinando, Maglio di
Colla 116576
Ceri, M., Firenze ... 079949, 079950
Cerino Canova, Laura, Torino .. 081517
Cerioli e Calvi, Milano 110298
Čerkas'ke Učylyšče Mystectv i Kul'tury
im. S. Gulaka-Artemovs'kogo,
Čerkasy 056443
Čerkas'kyj Chudožnij Muzej,
Čerkasy 042850
Čerkas'kyj Oblasnyj Krajeznavčyj
Muzej, Čerkasy 042851
Čerkechskij Muzej Jakutskaja

Politlčeskaja Ssylka, Jakutskij
gosudarstvennyj muzej istorii
i kultury narodov severa im.
Jaroslavskogo, Čerkech 036775
Cerkljanski Muzej, Mestni muzej Idrija,
Cerkno 038322
Cerkov Ionna Predteči, Jaroslavskij
gosudarstvennyj istoriko-
architekturnyj i chudožestvennyj
muzej-zapovednik, Jaroslavl .. 036886
Cerkov Pokrova v Filjach,
Moskva 037075
Cerkov Položenija riz Presvjatoj
Bogorodicy, Gosudarstvennyj muzej-
zapovednik Moskovskij Kreml,
Moskva 037076
Cerkov Roždestva Christova,
Jaroslavskij gosudarstvennyj istoriko-
architekturnyj muzej-zapovednik,
Jaroslavl 036887
Cerkov Troicy v Nikitnikach,
Gosudarstvennyj istoričeskij muzej,
Moskva 037077
CERN – Microcosm, Globe de
la Science et de l'Innovation,
Genève 041292
Cernan Earth and Space Center, River
Grove 052487
Cerne Antiques, Cerne Abbas .. 088593
Černigivs'kyj Oblasnyj Chudožnij
Muzej, Černigiv 042853
Černigivs'kyjy Literaturno-memorial'nyj
Muzej-zapovidnik Mychajlo
Kocjubynskogo, Černigiv 042854
Černivci 056444
Černivec'kyj Chudožnij Muzej,
Černivci 042858
Černivec'kyj Krajeznavčyj Muzej,
Černivci 042859
Černivec'kyj Literaturno-Memorial'nyj
Muzej im. Ju.A. FedkovIča,
Černivci 042860
Černivec'kyj Literaturno-Memorial'nyj
Muzej O. Kobyljans'koï, Černivec'kyj
krajeznavčyj muzej, Černivci . 042861
Černivec'kyj Muzej Bukovins'koï
Diaspory, Černivci 042862
Černivec'kyj Muzej Narodnoï
Architektury ta Pobutu, Černivci 042863
Cernuschi, Ursula, Paris 104586
Cerny, Bern 116221
Cerny Inuit Collection, Bern ... 041103
Cerny Inuit Collection, Kunst aus dem
Polarkreis, Bern 041104
Černý Pavouk, Ostrava 140459
Cerny, P., Erlangen 075602
Ceros, Paris 141031
Cerruti, Massimo, Milano 131809
Cersósimo Picado, Emilia María, San
José 102385
Certainly Wood, Christchurch .. 133079
Cerutti & Miller, New York 122708
Cervantes Antiquités, Saint-Ouen 073009
Cervera, Jose, Valencia 086336
Cervera, Marta, Madrid 115262
CeSAC – Centro Sperimentale per le Arti
Contemporanee, Associazione Culturale
Marcovaldo, Caraglio . 059349, 109946
El Cesar, Bogotá 102187
Cesaretti, Roma 142623
Cesaris, Luisa, Milano 131810
Cesaro, Giorgio, Padova 080809
Cesaroni, Braşov 084900
Cesati, Alessandro, Milano ... 080319
Il Cesello, Firenze 110057
Česká Koruna, Praha 065416
České Muzeum Hudby – Zámek
Hořovice, NM Praha – České
Muzeum Hudby, Hořovice .. 009413
České muzeum stříbra – Hrádek,
Kutná Hora 009495

České Muzeum Výtvarných Umění,
Praha 009621
Çeşme Müzesi, Çeşme 042601
Cessane, Bogotá 102188
C'est Chouette, L'Isle-sur-la-
Sorgue 069510
C'est la Vie Antiques, San Diego 096907
Cesteria Al Mare, Brescia 079760
Cēsu Izstāžu Nams, Cēsis 029936
Cēsu Vēstures un Mākslas Muzejs,
Cēsis 029937
CESVI, Academia o escuela de Dibujo
y Pintura en Navarra, Pamplona 056339
Cetatea Braşov şi Fortificaţiile din Ţara
Bârsei, Braşov 036100
Cetatea de Scaun a Sucevei,
Suceava 036565
Cetatea Devei, Deva 036268
Cetatea Neamţului, Târgu Neamţ 036599
Cetatea Poienari, Căpăţânenii
Pământeni 036183
Cetatea Sucidava, Corabia ... 036235
Cetatea Ţărănească Râşnov,
Râşnov 036480
Cettour, Bernard, Trouville-sur-
Mer 073852
Ceuleers, Jan, Antwerpen ... 140116
Ceuleneers, Jan, Antwerpen .. 140117
Cevenol, Saint-Martin-de-
Valgalgues 072902
Cévenols, Le Vigan (Gard) ... 069319
Ceviz, Istanbul 087888
Ceylon, Dallas 092923
Ceylon Society of Arts, Colombo 059790
CFB Esquimalt Naval Museum and
Military Museum, Victoria ... 007142
CFB Petawawa Military Museum,
Petawawa 006487
CFCC Webber Center, Ocala .. 051606
CFM Gallery, New York 122709
CG Park, Saint-Paul-de-Vence . 073203
CGP London, London 044831
CG's Curiosity Shop,
Cockermouth 088721
CH Art, Miami 122034
Ch. Frenkelio Rūmai, Šiaulių Aušros
Muziejus, Šiauliai 030291
Chaa Creek Natural History Centre,
San Ignacio 004098
Chabanian, Annecy 103195
Chabanian-le Baron, Annecy .. 103196
Chabanian-le Baron, Saint-Paul-de-
Vence 105533, 105534
Chabanian-Perbet, Megève ... 104162
Chabanis, Roselyne, Bourg-Saint-
Andeol 067359
Chabanne, Michel, Pranles ... 072263
Chabannes, Cavaillon 067680
Chabarovskij Gosudarstvennyj Institut
Iskusstv i Kultury, Chabarovsk . 056216
Chabarovskij Gosudarstvennyj Muzej
Dalnego Vostoka im. N.I. Grodekova,
Chabarovsk 036778
Chabarovskij Muzej Archeologii im.
A.P. Okladnikova, Chabarovsk . 036779
Chabloz, Vincent, Morges 134182
Chabolle, Jean-François, Paris . 071090
Chabot Museum, Rotterdam .. 032621
Chac & Mool, West Hollywood . 125239
Chácara do Céu Museum, Museus
Castro Maya, Rio de Janeiro . 004612
Chacártegui Cirerol, Jorge, Palma de
Mallorca 115430
Chacewater Antiques,
Chacewater 088594
Chaco Culture National Historical Park,
Nageezi 051081
Chacon, Miguel, Vic-le-Comte . 074057
Chacon, Rodriguez, Madrid ... 133671
Chacun, Christian, Paris 071091
Chadelaud, Michel-Guy, Paris . 071092,
071093
Chadron State College Main Gallery,
Chadron 047472

Chadwell, Audrey & Jesse,
Buffalo 092351
Chadwick, Richmond 096370
Chadwick, Dolby, San Francisco 124497
Chadwick, Howard, Boston 092288
Chadz Antiques, New Plymouth . 083870
Chaffal, Roger, Morance 070291
Chaffee Art Center, Rutland . . . 052616
Chaffey, Pat, Tamworth 099665
Chagall-Galerie Wuyt,
Amsterdam 112259
Chagall House, Haifa 024864
Chagall Museum, Vitebsk 003177
Chagas, Funchal 126646, 126647
Chagas, Onedina L., Belo
Horizonte 063837
Chagford Galleries, Chagford . . 117701
Chagot, Francis, Tulle 073875
Chagrin Falls Historical Society
Museum, Chagrin Falls 047476
Chai Ma, Bangkok 087863
Chai-Yi 2–28 Memorial Park Museum,
Chai-Yi 041996
Chai-Yi Museum of Stone and Art,
Chai-Yi 041997
Chaieb, Daniel, Porto Alegre . . 063913
Chailloux, Maria, Amsterdam . . 112260
The Chaim Gross Studio Museum,
New York 051279
The Chain, Amsterdam 082530
Chain Academy of Art Press,
Hangzhou 136998
Chaineau, Jean-Marc, La Roche-
Clermault 069008
Chaini-zu Toji Bijutsukan, Usuki 029500
Chaintreuil, Georges, Ferney-
Voltaire 068466
Chair Doctor, Nashville 136193
Chair Re-Glue and Furniture Repair,
Saint Paul 136557
The Chair Set Antiques,
Woodstock 091797
La Chaise Antique, Stow-on-the-
Wold 091316, 135443
Chaise de Bois, Angers 066545
Chaix, Corine, Toulon (Var) 073669
Chaix, Corinne, Camps-la-Source 067568
Chaiya National Museum, Surat
Thani 042455
Chakasskij Respublikanskij
Kraevedčeskij Muzej, Abakan . 036669
Chakdara Museum, Chakdara . . 033928
Chak's, Hong Kong 064959
Chalabi Antik, İstanbul 087889
Chalais Brocante, Chalais 067707,
 128775
Chalancon, Saint-Étienne 072715
Chalancon, Jacqueline, Le
Conquet 103889
Le Chalet, Allouis 066480
Chalet, Berlin 074731
Le Chalet, Villefranche-sur-Cher 074110
Chalet of the Golden Fleece, New
Glarus 051183
Chalifour, Gérald, Bessé-sur-
Braye 067084
Chalk House, Saint Ives,
Cornwall 119272
Chalkwell Auctions, Southend-on-
Sea 127306
Challiss, San Francisco 097036
Chalmeton, Chappes 067778
Chalmont, Christophe, Durtal . . 068365
Chalmont, Richard, Paris 071094
Chalon Collections, Chalon-sur-
Saône 067718
Chalon, Nick, Chard 088603
Chalrignac, Laurent, Paris 071095
Chalvet, Mado, Houston 121093
Chalvignac Isabelle, Versailles . . 074009
Chalvin, Yves, Lyon . . . 069663, 104023
Chamarajendra Academy of Visual
Arts, Mysore 055757
Chamarande, Bruxelles 063313

Chamarilero, Madrid 085979
Chamberlain Furniture Restoration,
Denver 135877
Chamberlain Museum of Pathology,
Birmingham 043381
Chamberlayne School of Design,
Mount Ida College, Newton . . 057537
Chambers, Utrecht 083448
Chambers & Crosthwaite, Hamilton,
Queensland 061572
Chambers Fine Art, New York . . 122710
Chambers Gallery, Ipswich 118241
Chambers on Main, Greytown . . 083776
Chambers, Graham H., Lancaster 089542
Chambers, Ronald G., Petworth . 090841
Chambet, Jean-Paul, Saint-
Germain 072763
Chamblin Book Mine,
Jacksonville 144923
El Chambo, Vigo 086381
Chambon, C., Nogent-sur-Seine 070680
Chambon, Claude, Favars 068454
Chambon, Claudie, Saint-Aubin . 072638
Chambon, Philippe, La Chapelle-la-
Reine 068921
Chambord, Virginia Beach 097609
Chamboux, Jean-François, Tours 073807
La Chambre, Rotterdam 083372
Chambre Belge des Experts en
Œuvres d'Art, Bruxelles 058336
La Chambre Blanche, Québec . . 101359
Chambre d'Amis, Amsterdam . . 082531
Chambre Européenne des Experts-
Conseils en Oeuvres d'Art,
Paris 058590
Chambre Nationale des Commissaires-
Priseurs Judiciaires, Paris 058591,
 125965
Chambre Nationale des Experts
Spécialisés, Paris 058592
Chambre Professionnelle Belge de
la Librairie Ancienne et Moderne,
Bruxelles 058337
Chambre Professionnelle Belge de
la Librairie Ancienne et Moderne,
Bruxelles 058338
Chambre Royale des Antiquaires de
Belgique, Koninklijke Kamer van de
Antiquairs van Belgie, Bruxelles 058339
Chambre Syndicale de l'Estampe, du
Dessin et du Tableau, Paris . . 058593,
 104587
Chambre, Claire, Annecy 103197
Chambrelin, Joëlle, Attin 066710
Chambrion, Martine, Lyon 069664
Chambure, Marie de, Paris 104588
Chamchuri Art Gallery, Chulalongkorn
University, Bangkok 042380
Chameleon, Hong Kong 101937
Chameleon Antique Lighting, New
York 095142
Chameleon Gallery, Masterton . . 113032
Chaminade, Jacques, Lyon 140849
Chamizal National Memorial, El
Paso 048465
Chammard, Monique de, Paris . 104589
Chamonal, Rodolphe, Paris 141032
Chamoroff, Bianca C., Beirut . . 082089
Chamouleau, Armand, Paris . . . 071096
Chamouleau, Jean-Claude,
Fouquebrune 068543
Champ de Mars, San Francisco 097037
Champ des Possibles, Noirmoutier-en-
l'Ile 104362
Champ Libre, Montréal 101237
Champagne dit Lambert, Ottawa 064445
Champaign County Historical Museum,
Champaign 047481
Champaign County Historical Museum,
Urbana 053786
Champaloux, Emile, Limoges . . 103977
Champasak National Heritage
Museum, Vientiane 029912
Champavert, Toulouse 141321

Champeaux, Dominique, Thil . . . 073615
Champetier, Michelle, Cannes . . 103456
Champignonnière-Musée du Saut aux
Loups, Montsoreau 014120
Champion & Kusel, Nîmes 125938
Champion Mill, Champion 047485
Champion, Alain, Nantes 070405
Champion, Alain, Nuille-le-Jalais 070714
Champion, Josy, La Sauvetat . . 069043
Champions Lighting, Houston . . 093470
Champion's Refinishing, Houston 135946
Champkins, Paul, London 089818,
 134935
Champlain Trail Museum and Pioneer
Village, Pembroke 006479
Champs Chapel Museum, East
Hendred 044024
Champvallins, Jacqueline de,
Paris 104590, 137154
Chamsori Gramophone and Audio
Science Museum, Gangneung . 029748
Chan, San Francisco 097038
Chan Ngee, Singapore 085209
Chan, Kam Fuk, Hong Kong . . . 101938
Chan, P.F., Singapore 085207
Chan, Peter, Toronto 064569
Chan, Pui Kee, Singapore 085208,
 133395
Chance Operations Gallery,
Denver 120979
Chancellor Robert R. Livingston
Masonic Library and Museum, New
York 051280
Chancenotte, Jacques, Dijon . . . 128818
Chancery Lane Antiques,
Nashville 094818
Chandan, Kuala Lumpur 111955
Chandan Bulchand, Las Palmas de
Gran Canaria 086199
Chandannagar Museum, Hooghly 023975
Chandelier, Maurice, Atlanta . . . 091956
Chandeliers, Clancy, Dublin . . . 079426
Chandler Fine Art, San Francisco 124498
Chandler Gallery, Randolph . . . 052370
Chandler Museum, Chandler . . . 047486
Chandos Books, Bristol 144048
Chandradhari Museum,
Darbhanga 023894
Chang Da-Chien's Residence,
Taipei 042223
Chang Foundation Museum,
Taipei 042224
Chang Gung University Arts Center,
Gueishan 042041
Chang, Bobby, Singapore 114584
Chang, Theo, Caracas 097813
Changcheng, Wuxi 102150
Changdao Museum, Changdao . 007484
Changdao Voyage Museum,
Changdao 007485
Change des Saints Pères, Paris . 071097
Change du Port, Marseille 069867
Change Plus, Biarritz 067136
Changement de Décor, Châlons-en-
Champagne 067728, 103508
Changement de Décor, Épernay 068392,
 103667
Changi Village Antiques,
Singapore 085210
Changi Museum, Changji 007486
Changi Museum of Dinosaurs,
Urumqi 008190
Changping Yanjing Art Cooperative,
Beijing 101805
Changqing Museum, Changqing 007488
Changsha Museum, Changsha . 007489
Changshu Beike Museum,
Changshu 007493
Changshu Calligraphy and Painting
Gallery, Changshu 101880
Changshu Museum, Changshu . 007494
Changtai Museum, Changtai . . . 007495
Changting Museum, Changting . 007496
Changwu Museum, Changwu . . 007497

Changxing Museum, Changxing 007498
Changy, D. de, Bruxelles 063314
Changyangtu Sept Self-Rule Museum,
Yidu 008328
Changzhi Museum, Changzhi . . 007499
Changzhou Museum, Changzhou 007500
Chania Byzantine and Postbyzantine
Collection, Chania 022637
Chankit, Glenda, Toronto 064570
Channel Folk Museum, Lower
Snug 001231
Channel Islands Galleries, Saint Peter
Port 091057, 144563
Channel Islands Military Museum,
Saint Ouen 045683
Chanoit, Fréderic, Paris 071098, 104591
Chantal Muñoz, Rognac 129438
Chantal, Karli, Lausanne 134126
Chantala, Eric, Paris 071099
Chantebois, Chantilly . 067774, 128784
Chantek, Rumah, Singapore . . . 114585
Chanteloup, Marie de, Paris . . . 071100
Chantérac-Geiss, Alois,
Völklingen 131120
Chantharakasem National Museum,
Ayutthaya 042371
Chantier A.C. Davie, Lieu Listorique
national du Canada, Lévis 006506
Chantilly, Kelvin Grove 061666
Chantilly Museum, Geraardsbergse
Musea, Geraardsbergen 003569
Chantry Bookshop & Gallery,
Dartmouth 088818, 144135
Chantry Chapel, Wakefield 119581
Chantry House Gallery, Ripley, North
Yorkshire 119226
Chantry, Léon-Noël, Tours 073808
Chanu, Cedric, Narbonne 070442
Chanut, François, Paris 141033
Chao Hua Art Cooperative,
Beijing 101806
Chao Phraya Gallery, Washington 097654
Chaos Art Gallery, Budapest . . . 109142
Chaos Collections, Christchurch 083689
Chaosamphraya National Museum,
Ayutthaya 042372
Chaotiangong Palace, Nanjing City
Museum, Nanjing 007910
Chaoyang Museum, Chaoyang . 007502
Chaoyang Museum, Chaoyang,
Liaoning 007504
Chaozhou Museum, Chaozhou . 007505
Chap Ku, Tong, Hong Kong . . . 064960
Chapeau, Antwerpen 100343
Chapeau Clacque, Berkel-
Enschot 142904
La Chapeauthèque, Anduze . . . 011461
Chapel, Pittsburgh 136469
Chapel Antiques, Barmouth . . . 088123
Chapel Antiques, Nantwich . . . 090642,
 135202
Chapel Antiques Centre,
Sheffield 091132
Chapel Art Gallery, Riseley 119228
Chapel Books, Chepstow 144808
Chapel Emporium Antique Centre,
Long Sutton, Lincolnshire 090470
Chapel Gallery, Bracebridge . . . 005349
Chapel Gallery, North Battleford 006366
Chapel Hill Museum, Chapel Hill 047493
Chapel Hill Museum, Shag
Harbour 006845
Chapel House Fireplaces,
Holmfirth 089347
The Chapel of Art, Criccieth . . . 117813
Chapel off Chapel, Prahran 099464
Chapel Place Antiques, Tunbridge
Wells 091505
Chapel Street Antiques Arcade,
Penzance 090812
Chapel Street Bazaar, Prahran . 062209
Chapelaine Antiquités, La Chapelle-
sur-Erdre 068925
Chapelle de Bailly, Saint-Bris-le-

Christchurch Carpets,
Christchurch 088686
Christchurch Guild of Weavers and
Spinners, Christchurch 059546
Christchurch Mansion, Ipswich . 044511
Christel's Antiek, Utrecht 083449
Christen-Fankhauser, Jetta, Reinach
(Basel-Land) 087548
Christen, Mario, Luzern 134157
Christen, Richard K., Louisville . 094366
Christen, Rolf, Solothurn 116738
Christensen, Stavanger 133165
Christensen, Bent, Ahrensburg . 074324
Christensen, Erik, Nykøbing
Sjælland 102884
Christensen, Hjartvar, Odense . 140598
Christensen, Kenth, Varde 066106
Christensen, Lars, Gilleleje 065625
Christensen, Palle, Hellerup 065662
Christensen, Reinhold,
Frederiksberg 065593
Christensen, Rie & Jørgen,
Gilleleje 065626
Christi, Neuss 077669
Christian Art Distributors,
Vereeniging 138040
Christian Arts, London 060010
Christian Brandstätter Verlag,
Wien 136880
Christian C. Sanderson Museum,
Chadds Ford 047471
Christian Daniel Rauch-Museum,
Museum Bad Arolsen, Bad
Arolsen 016500
Christian Gallery, Merano 110225
Christian-Wagner-Haus, Stadtmuseum
Leonberg, Leonberg 019705
Christian-Wolff-Haus, Stadtmuseum
Halle, Halle, Saale 018664
Christian, Gert, Breitenau a. H. . 127988
Christiania City Auktionsforretning,
Oslo 126581
Christianity and the Arts,
Chicago 139374
Christiansted National Historic Site,
Saint Croix 052663
Christie, Cairo 066159
Christie, Midland 139857
Christie, Ottawa 064446
Christie Antique Show, Dundas . 097899
Christie Galerie, Mougins 104247
Christie, Robert, Carrickfergus . 088580
Christie's, Amsterdam 126487
Christie's, Bangkok 126977
Christie's, Barcelona 126723
Christie's, Beijing 125668
Christie's, Beverly Hills 127404
Christie's, Bordeaux 125799
Christie's, Bruxelles 125576
Christie's, Buenos Aires 125446
Christie's, Chicago 127430
Christie's, Doublebay 125468
Christie's, Dubai 126983
Christie's, Düsseldorf 126182
Christie's, Edinburgh 127096
Christie's, Firenze 126406
Christie's, Genève 126925
Christie's, Genova 126411
Christie's, Hamburg 126212
Christie's, Helsinki 125753
Christie's, Hong Kong 125674
Christie's, Jakarta 126379
Christie's, London 127188, 127189
Christie's, Madrid 126747
Christie's, Monaco 126484
Christie's, Moone 126393
Christie's, München 126280
Christie's, New York 127611
Christie's, Newport 127632
Christie's, Paris 125969
Christie's, Ramsey 126395
Christie's, Rio de Janeiro 125630
Christie's, San Francisco 127709
Christie's, Shanghai 125681

Christie's, South Yarra 125512
Christie's, Stuttgart 126344
Christie's, Taipei 126973
Christie's, Tel Aviv 126398
Christie's, Tokyo 126461
Christie's, Torino 126449
Christie's, Toronto 125650
Christie's, Venezia 126453
Christie's, Wien 125549
Christie's, Zürich 126957
Christie's Gallery, Dallas 120850
Christie's International Media Division,
London 138262
Christie's Magazine, London 139195
Christie's Publications, New York 138440
Christin Gallery, Toronto 101453
Christinaz, Alain, Biel 087128
Christine Antiquité, Noisy-le-
Grand 070689
Christine König Galerie, Wien ... 100114
Christinehof Slott, Brösarp 040386
Christinerose, New York 122724
Christine's Adapon Fine Arts,
Makati 113477
Christine's Art Gallery, Baguio .. 113469
Christine's Curiosity Shop,
Tucson 097480
Christine's Time, Helsinki 066250
Christine's Vintage Specialty Shop,
Cleveland 092765
Christmann, Wiesbaden 142314
Christmas Closet, Jacksonville . 093808
Christmas Morning, Dallas 092925
Christmas Museum Gallery, Horsley
Park 001153
Christmas Yorkshire Fine Art and
Antiques Fair, Harrogate 098209
Christodoulou, D.E., Amsterdam 142840
Christof, Franz, Schleusingen .. 078292
Christof, Franz, Weimar 078808
Christofski, Motueka 083838
Christophe, Clément, Embrun .. 103664
Christopher, Birmingham 092234,
135704
Christopher-Clark Fine Art, San
Francisco 124501
Christopher Henry Gallery, New
York 122725
Christopher, Alexander, Duncraig 127865
Christopher, Radko, Pittsburgh . 096104
Christopher's, Farnham 089052, 134702
Christopher's Collectibles, El
Paso 093230
Christopher's Discoveries, New
Orleans 094912
Christophs Friseur-Museum,
Leipheim 019635
Christo's, Glasgow 118035
Christos Capralos Art Gallery,
Agrinion 022525
Christos Capralos Museum,
Aegina 022518
Christusbruderschaft Selbitz Buch-
und Kunstverlag, Selbitz 137617
Christy Bird, Dublin 079427
Christy's Antiques, Virginia
Beach 097610
Chroma, Salt Lake City 124201
Chroma, San Francisco 124502
Chromatic Arts, Swindon 119476
Chromos, Belo Horizonte 100738,
100739
Chronicle Books, San Francisco 138510
Chronika, Böblingen 075011
Chronique d'Egypte, Bruxelles . 138594
Chronis, Nikol., Iráklion 079098
Chronos, Brugge 063209
Chrostowski, Witold, Kraków ... 084392
Chrysalis, East Melbourne 098851,
136816
Chrysanthos, Othonos, Paphos . 102517
The Chrysler Museum of Art,
Norfolk 051487
Chrysochoidis, Dimitrios, Athinai 079066

La Chrysolite, Auxerre 066789
Chrysolite, Paris 071115
Chryssikou, Angeliki G., Kifissia 109082
Chrystals Auctions, Ramsey ... 126396
Chrz, Jan, Žilna 085424
CHTJ Southard House Museum,
Richmond 052442
Chu Dong Tu Temple, Binh Minh 054716
Chu, Sammy, Los Angeles 121738
Chuan Cheng Art Center, Taipei . 042230
Chubu, Nagoya 111328
Chuck, San Francisco 097041
Chuck and Barb's Baseball Cards,
Columbus 092838
The Chuck Jones Studio Gallery, San
Diego 124360
Chudalla, Albert, München 130692
Chudleigh Park of Sassafras,
Sassafras 099541
Chudožestvena Galerija, Balčik . 004886
Chudožestvena Galerija, Burgas 004905
Chudožestvena Galerija,
Chaskovo 004912
Chudožestvena Galerija, Čirpan . 004915
Chudožestvena Galerija, Drjanovo 004928
Chudožestvena Galerija, Gabrovo 004936
Chudožestvena Galerija, Karlovo 004952
Chudožestvena Galerija, Kavarna 004957
Chudožestvena Galerija,
Kazanlâk 004960
Chudožestvena Galerija, Levski . 004986
Chudožestvena Galerija, Loveč . 004989
Chudožestvena Galerija, Mezdra 004997
Chudožestvena Galerija, Pernik . 005015
Chudožestvena Galerija, Plovdiv . 005028
Chudožestvena Galerija, Provadia 005041
Chudožestvena Galerija, Radnevo 005045
Chudožestvena Galerija, Silistra . 005061
Chudožestvena Galerija, Smoljan 100999
Chudožestvena Galerija, Sozopol 005101
Chudožestvena Galerija,
Velingrad 005158
Chudožestvena Galerija, Vidin .. 005160
Chudožestvena Galerija, Žeravna 005167
Chudožestvena Galerija "Petar
Persengiev", Novi Pazar 005003
Chudožestvena Galerija Boris Denev,
Veliko Tărnovo 005151
Chudožestvena Galerija Darenie
Kollekcia Svetlin Russev, Pleven 005020
Chudožestvena Galerija Dobrič,
Dobrič 004923
Chudožestvena Galerija Elena
Karamichajlova, Šumen 005106
Chudožestvena Galerija Georgi
Papazov, Jambol 004945
Chudožestvena Galerija Ilija Beškov,
Pleven 005021
Chudožestvena Galerija Kiril Petrov,
Montana 004999
Chudožestvena Galerija Nikola
Marinov, Targovište 005118
Chudožestvena Galerija Nikolaj
Pavlovič, Svištov 005112
Chudožestvena Galerija Prof. Ilija
Petrov, Razgrad 005048
Chudožestvena Galerija Ruse,
Ruse 005052
Chudožestvena Galerija Stanislav
Dospevski, Pazardžik 005010
Chudožestvena Galerija Varna,
Varna 005135
Chudožestvennaja Galereja –
Dom Kukly Tatjany Kalininoj,
Petrozavodsk 037477
Chudožestvenno-grafičeskij Fakultet,
Kubanskij Gosudarstvennyj
Universitet, Krasnodar 056227
Chudožestvenno-memorial'nyj
Muzej K.S. Petrova-Vodkina,
Chvalynsk 036786
Chudožestvenno-pedagogičeskij Muzej
Igruški – Kulturno-delovoj Centr,
Sergiev Posad 037682

Chudožestvenno-vystavočnyj
Kompleks, Muzej Istorii i Kultury
Srednego Prikamja, Sarapul .. 037664
Chudožestvennyj Moskovskij
Gusudarstvennyj Akademičeskij
Institut im. V.I. Surikova,
Moskva 056231
Chudožestvennyj Muzej, Staryj
Oskol 037719
Chudožestvennyj Muzej, Valujki . 037835
Chudožestvennyj muzej Ernsta
Neizvestnogo, Ekaterinburg ... 036806
Chudožestvennyj Muzej im. A.N.
Radiščeva, Saratov 037667
Chudožestvennyj Muzej im. M.S.
Tuganova, Vladikavkaz 037846
Chudožestvennyj Otdel Eleckogo
Kraevedčeskogo Muzeja, Elec . 036826
Chudožnij Muzej, Sevastopol ... 043026
Chudožnij Muzej, Žytomyr 043061
Chudožno-memorial'nyj Muzej Ivana
Truša, Nacionalnij Muzej u Lvovi,
Lviv 042969
Chudožno-memorial'nyj Muzej
Leopol'da Levyc'kogo, Nacionalnij
Muzej u Lvovi, Lviv 042970
Chudožno-memorial'nyj Muzej Oleksi
Novakivs'kogo, Nacionalnij Muzej u
Lvovi, Lviv 042971
Chudožno-memorial'nyj Muzej Oleni
Kul'čic'koï, Nacionalnij Muzej u Lvovi,
Lviv 042972
Chudožnyj Muzej im. O. Šovkunenka,
Cherson 042871
Chuen, Yue Pun Po, Hong Kong 064967
Chuey, Los Angeles 121739
Chugeisha, Takaoka 081952
Chugg, Keith, Swansea 091381
Chughtai Museum Trust, Lahore 033946
Chugoku, Kyoto 081838
Chulalongkorn Art Centre,
Bangkok 042381
Chulpan Yodgorlik Muzeyi, Andijon
Viloyat Adabiyot va San'at Muzeyi,
Andijon 054560
Chumacero, Lourdes, México .. 112023
Chumbhot-Punthip Museum,
Bangkok 042382
Chun Chan, Beijing 101809
Chun & Co., Peggy, Honolulu .. 121207
Chung, Seoul 111665
Chung Art Center, Chung Ang
University, Seoul 029809
Chung-Cheng Art Gallery, Saint John's
University, Jamaica 049738
Chung Cheng Aviation Museum,
Taoyuan 042297
Chung Hua University Arts Center,
Hsinchu 042051
Chung Jark, Seoul 111666
Chung Li-Ho Memorial Museum,
Meinong 042117
Chung Yi Gallery, Danshuei 042023
Chung, Marguerite, Fontanil-
Cornillon 068514
Chungchern Art Museum
and Jhongjheng Art Center,
Pingtung 042136
Chungju Museum, Chungju 029733
Chungnam Telecommunication
Museum, Daejeon 029740
Chung's Art Prod, Hong Kong .. 064968
Chuo Gallery, Nagoya 111329
Churburg, Sluderno 027795
Church Corner Antiques,
Christchurch 083690
Church Gallery, Chagford 117702
Church Gallery, Claremont 098747
Church Hall Farm Antique,
Broxted 088470
Church Hill Antiques, Los
Angeles 094123
Church Hill Antiques Centre,
Lewes 089616

City Auksjon, Oslo 126582
City Basement Books, Melbourne 139853
City Books, Pittsburgh 145174
City Clocks, London . . 089834, 134941
City County Pioneer Museum,
Sweetwater 053512
City Galerie, Hamburg 076151
City-Galerie, Linz 099967
City-Galerie, Regensburg 108465
City-Galerie, Wien 062885, 100116
The City Gallery, Leicester 044670
The City Gallery, Nottingham . . . 119042
City Gallery at Chastain, Atlanta 046582
City Gallery East, Atlanta 046583
City Gallery Wellington,
Wellington 033169
City Hall Art Gallery, Ottawa . . . 006442
City Hall Council Chamber Gallery,
Charleston 047509
City Island Nautical Museum,
Bronx 047192
City Kunst og Antik, Slagelse . . 066055
City Kunsthandel, København . . 065812
City-Mint, München 077407
City Museum, Ahmedabad 023805
City Museum, Makale 010559
City Museum, Saint Louis 052693
City Museum, Yirgalem 010560
City Museum and Art Gallery,
Gloucester 044275
City Museum and Art Gallery,
Plymouth 045470
City Museum and Records Office,
Portsmouth 045509
City of Armadale History House
Museum, Armadale, Western
Australia 000804
City of Belmont Museum,
Belmont 000847
City of Brea Gallery, Brea 047149
City of Calgary-Civic Art Collection,
Calgary 005413
City of Gilroy Museum, Gilroy . . 049064
City of Gosnells Museum,
Gosnells 001113
City of Kingston Fire Department
Museum, Kingston 005975
City of Las Vegas and Rough Riders
Memorial Museum, Las Vegas 050124
City of Le Sueur Museum, Le
Sueur 050148
City of London Phonograph
& Grammophone Society,
Edgmond 060014
City of London Phonograph &
Grammophone Society – London
Meetings, Croydon 060015
City of London Phonograph &
Grammophone Society – Midlands
Meetings, Wolverhampton 060016
City of London Phonograph &
Grammophone Society – Northern
Group, Barrow-in-Furness 060017
City of London Phonograph &
Grammophone Society – Thames
Valley Group, Charvil 060018
City of London Phonograph &
Grammophone Society – West of
England Meetings, Exeter 060019
City of London Police Museum,
London 044838
City of Melbourne Collection,
Melbourne 001266
City of Norwich Aviation Museum,
Horsham Saint Faith 044468
City of Saint John Gallery, Saint
John 006734
City of Unley Museum, Unley . . 001600
City of Wayne Historical Museum,
Wayne 054126
City of York Museum, York 007310
City Palace Museum, Pratap Museum,
Udaipur 024196
City Park Radio Museum,

Launceston 001208
City Pride, Canterbury 088555
City Salvage, Minneapolis 094739
City Streets Gallery, Toronto . . . 101454
City Strippers Restoration,
Wellington 133131
City Traders, Rockhampton 062150
City View Antique Mall, Dallas . . 092927
CityArt, Toronto 138621
Cityn kirja ja pap, Rovaniemi . 140705
Ciudadela, Punta del Este 125311
Le Civette, Trieste 081617
Civic Bookshop, Newcastle 139882
Civica Galleria d'Arte Contemporanea,
Lissone 026440
Civica Galleria d'Arte Contemporanea
F. Scroppo, Torre Pellice 027975
Civica Galleria d'Arte G. Sciortino,
Monreale 026729
Civica Galleria d'Arte Moderna,
Gallarate 026212
Civica Galleria d'Arte Moderna,
Genova 026238
Civica Galleria d'Arte Moderna,
Milano 026619
Civica Galleria di Palazzo Rocca,
Chiavari 025803
Civica Pinacoteca V. Crivelli,
Sant'Elpidio a Mare 027666
Civica Raccolta d'Arte, Medole . 026593
Civica Raccolta d'Arte, Roseto degli
Abruzzi 027496
Civica Raccolta d'Arte B. Biancolini,
Potenza Picena 027258
Civica Raccolta delle Stampe Achille
Bertarelli, Milano 026620
Civica Raccolta di Terraglia-Museo
Internazionale Design Cermico,
Laveno Mombello 026417
Civica Raccolta e Ceramiche
Rinascimentali, Camporgiano . 025588
Civiche Raccolte d'Arte, Busto
Arsizio 025516
Civiche Raccolte d'Arte Applicata,
Milano 026621
Civici Musei di Villa Paolina,
Pinacoteca L. Viani, Villa Paolina,
Viareggio 028180
Civici Musei e Gallerie di Storia ed
Arte, Udine 028047
Civico Gabinetto dei Disegni, Civiche
Raccolte Grafiche e Fotografiche,
Milano 026622
Civico Museo Antropologico,
Balestrate 025280
Civico Museo Archeologico, Acqui
Terme 025073
Civico Museo Archeologico, Arsago
Seprio 025213
Civico Museo Archeologico,
Camogli 025571
Civico Museo Archeologico,
Milano 026623
Civico Museo Archeologico,
Ozieri 026967
Civico Museo Archeologico e di
Scienze Naturali "Federico Eusebio",
Alba 025097
Civico Museo Archeologico L. Barni e
Pinacoteca C. Ottone, Vigevano 028201
Civico Museo Biblioteca dell'Attore del
Teatro, Genova 026239
Civico Museo d'Arte Contemporanea,
Milano 026624
Civico Museo d'Arte Moderne, Anticoli
Corrado 025167
Civico Museo d'Arte Orientale,
Trieste 028011
Civico Museo degli Strumenti Musicali,
Milano 026625
Civico Museo del Castello di San
Giusto, Armeria e Lapidario
Tergestino, Trieste 028012
Civico Museo del Mare, Trieste . 028013

Civico Museo del Merletto al Tombolo,
Villa Tigullio, Rapallo 027304
Civico Museo del Risorgimento e
Sacrario Oberdan, Trieste 028014
Civico Museo della Risiera di San
Sabba, Trieste 028015
Civico Museo di Guerra per la Pace
Diego de Henriquez, Trieste . . 028016
Civico Museo di Scienze Naturali,
Domodossola 025988
Civico Museo di Storia ed Arte – Orto
Lapidario, Trieste 028017
Civico Museo di Storia Naturale,
Trieste 028018
Civico Museo di Storia Naturale della
Lombardia, Jerago con Orago . 026368
Civico Museo di Storia Patria,
Trieste 028019
Civico Museo Dianese, Diano
Marina 025985
Civico Museo e Antiquarium
Comunale, Lanuvio 026397
Civico Museo Flaminio Massetano,
Massa Martana 026579
Civico Museo Frignanese, Pavullo nel
Frignano 027068
Civico Museo G. Galletti,
Domodossola 025989
Civico Museo G.V. Parisi-Valle,
Maccagno 026497
Civico Museo Ingauno, Albenga . 025099
Civico Museo Insubrico di Storia
Naturale, Clivio 025875
Civico Museo Morpurgo, Trieste 028020
Civico Museo Naturalistico,
Ovada 026966
Civico Museo Naturalistico Ferruccio
Lombardi, Stradella 027848
Civico Museo Sartorio, Trieste . . 028021
Civico Museo Setificio Monti, Abbadia
Lariana 025062
Civico Museo Storico, Palmanova 027026
Civico Museo Storico Archeologico,
Savona 027713
Civico Studio Museo Francesco
Messina, Milano 026626
Civiero, Diano Castello 110016
Civil War Museum, Philadelphia 051947
Civil War Museum of Lone Jack,
Jackson County, Lone Jack . . . 050314
Civil War Museum, McCook House,
Carrollton 047402
Civil War Store, New Orleans . . 094913
Civile, Andrea, Roma 081130
Civilian Conservation Corps Museum,
Highlands Hammock State Park,
Sebring 053138
Civilization Art Gallery, Columbus 120762
Civitat, Zwolle 083545
Civitella Ranieri Center,
Umbertide 059353
Civran, Fiorenza, Venezia 132617
Cizeron, Marie-Claude, Le Crozet 069205
Cizeron, Marie-Noël, Romans-sur-
Isère 072481
Çizgi, Istanbul 117116
Čižková, Jitka, Česká Lípa 140427
CK Collection, Singapore 085214
Claassen-Schmal, Barbara,
Bremen 106573
Clac, Naucelles 104301
Clackmannanshire Council Museum &
Heritage Service, Alloa 043138
Claër, Eric, Brignais 067440
Claes, Sävedalen 086734
Claes, Jules, Genk 100545
Claeshallen, Malmö . . 086662, 126847
Clagahé, Lyon 140850
Clair Obscur, Montréal 064352
Claire Lane Antiques,
Jacksonville 093810
Claire Oliver Gallery, New York . 122726
Claire Trevor School of the Arts,
University of California Irvine,

Irvine 057203
Clairefontaine, Luxembourg 111892,
111893
Clairemont, San Diego 096909
Clairon-Labarthe, Paris 129194
Clampart, New York 122727
Clan Armstrong Museum,
Langholm 044631
Clan Cameron Museum, Spean
Bridge 045829
Clan Donnachaidh Museum, Blair
Atholl 043423
Clan Grant Centre, Grantown-on-
Spey 044307
Clan Gunn Museum, Latheron . . 044637
Clan Macpherson House and Museum,
Newtonmore 045315
Clanart Gallery, Enniskillen 117947
Clancy, Bray 079356
Clandestine Immigration and Naval
Museum, Haifa 024865
Clandon Park, Guildford 044333
Claphams, Lane Cove 061707
Claphams National Clock Museum,
Whangarei 033187
Clapson, Jenny, Kingscote 099058
Clara Barton Birthplace, North
Oxford 051525
Clara Barton National Historic Site,
Glen Echo 049070
Clara-Zetkin-Museum,
Birkenwerder 017175
Claragh, Millstreet . . 079566, 131283
Clara's Attic, Seattle 097250
Clare Ancient House Museum,
Clare 043762
Clare Antique Warehouse, Clare 088705,
134591
Clare Archaeological Centre,
Corofin 024590
Clare County Archives, Ennis . . 024691
Clare County Museum, Ennis . . 024692
Clare Hall Company, Sudbury,
Suffolk 091354, 135452
Clare Heritage Centre, Corofin . . 024591
Clare Museum, Ennis 024693
Clare Old Police Station and
Courthouse Museum, National Trust,
Clare 000964
Claremont Gallery, Aberdeen . . . 117270
Claremont Museum, Claremont . 047722
Claremont Museum, Claremont,
Western Australia 000966
Claremont, Antiques and Modern Art,
Sevenoaks 091120, 119331
Claren, Latrobe 061710
Clarenbridge Antiques,
Clarenbridge 079375
Clarence House Antiques,
Watchet 091614, 144650
Clarence House, Royal Collections,
London 044839
Clarencetown and District Historical
Museum, Clarencetown 000968
Clarendon Books, Leicester 134860,
144283
Clarendon House, Evandale 001066
Claresholm Museum, Claresholm 005516
Clarfeld, Sabine, Seevetal 078368
Clarges, London 089835
Claridges Upholstery, Guildford . 134741
Clarin Ancestral House, Loay . . 034333
Clarinbridge Antiques, Marton . . 083826
Claringbold, Berry 061137
Clark, Towcester 091483, 135495
Clark & Smith, Bordeaux 067263
Clark Art, Northwich 119023
Clark Atlanta University Art Galleries,
Atlanta 046584
Clark County Historical Museum,
Vancouver 053822
Clark County Museum,
Henderson 049400
Clark County Museum, Marshall 050643

Collectors Gallery, Kooyong 099063
Collectors' Gallery, Shrewsbury . 091177
Collector's Heaven, Dallas 092933
Collectors News, Des Moines .. 139378
Collectors News & the Antique Report,
 Grundy Center 139379
Collectors Old Book Shop,
 Richmond 145213
Collectors Old Toy Shop and Antiques,
 Halifax 089212
Collectors Paradise, Albuquerque 091885
Collectors' Paradise, Leigh-on-
 Sea 089600
Collector's Paradise Watches,
 Chennai 079265
Collectors Path, Honolulu 093374
Collectors Pieces, Mount Eliza . 061898
Collector's Place, Shrewsbury .. 091178
Collector's Showcase,
 Jacksonville 093815
Collectors Showcase, Winnipeg . 064863
Collector's Sports Books,
 Earlwood 139751
The Collector's Store, Hamilton . 064260
Collectors Superstore, Virginia
 Beach 097611
Collector's Toystop, Milwaukee . 094682
Collector's Warehouse, Cleveland 092768
Collectors World, Cromer 088797
Collectors World, Nottingham .. 090743
Collectors World, Pittsburgh .. 096107
Colleen's Art, New Orleans ... 122395
Colleen's Collectables, Columbus 092844
Colleen's Station Gallery, Miami 122038
College Art Association of America, New
 York 060438, 139380
The College Art Gallery, College of
 New Jersey, Ewing 048608
College Book Rack, Jacksonville 144924
College Book Rack – Vol 2,
 Jacksonville 144925
College Bookstore, Houston ... 144905
Collège de France, Paris 055334
College Football Hall of Fame, South
 Bend 053275
College for Creative Studies,
 Detroit 056969
College Museum, Epsom 044126
College Museum, Maynooth ... 024768
College of Architecture and
 Design, Kansas State University,
 Manhattan 057361
College of Architecture and Design,
 Lawrence Technological University,
 Southfield 057888
College of Architecture and Fine
 Arts, University of Santo Tomas,
 Manila 056170
College of Architecture, Clemson
 University, Clemson 056869
College of Architecture, Georgia
 Institute of Technology, Atlanta 056637
College of Architecture, Illinois
 Institute of Technology, Chicago 056840
College of Architecture, Texas A & M
 University, College Station 056887
College of Architecture, University of
 Illinois at Chicago, Chicago .. 056841
College of Art, Delhi 055723
College of Art and Architecture,
 University of Idaho, Moscow .. 057449
College of Art and Communication,
 Beijing Normal University,
 Beijing 055126
College of Art and Design,
 Philadelphia 057626
College of Art and Design, Duksung
 Women's University, Seoul ... 056040
College of Art and Design, Konkuk
 University, Seoul 056041
College of Art and Humanities,
 Humboldt State University,
 Arcata 056621
College of Art and Science, Vanderbilt

University, Nashville 057468
College of Art Gallery, Kwame
 Nkrumah University of Science and
 Technology, Kumasi 022508
College of Art, Department of Art
 Education and Design, Shenzhen
 University, Shenzhen 055173
College of Art, Jilin University,
 Changchun 055131
College of Art, Kwame Nkrumah
 University of Science and Technology,
 Kumasi 055682
College of Art, Yanbian University,
 Yanji 055191
College of Art, Zhejiang University of
 Technology, Hangzhou 055147
College of Arts and Architecture,
 Pennsylvania State University,
 University Park 057988
College of Arts and Crafts, Faculty
 of Fine Arts, Lucknow University,
 Lucknow 055749
College of Arts and Crafts, Patna
 University, Patna 055761
College of Arts and Design, Ewha
 Womens University, Seoul ... 056044
College of Arts and Design, School
 of Fine Arts, Yeungnam University,
 Gyeongsan 056037
College of Arts and Humanities,
 Bangor University, Bangor 056467
College of Arts and Humanities,
 University of Maine at Augusta,
 Augusta 056645
College of Arts and Sciences
 Gallery, University of Miami, Coral
 Gables 047946
College of Arts and Sciences of
 Beijing Union University, Beijing 055127
College of Arts and Sciences, Bowling
 Green State University, Bowling
 Green 056735
College of Arts and Sciences, Georgia
 State University, Atlanta 056638
College of Arts and Sciences, Seton
 Hall University, South Orange . 057887
College of Arts and Sciences,
 University of Massachusetts Amherst,
 Amherst 056609
College of Arts and Sciences,
 University of Miami, Coral
 Gables 056914
College of Arts and Sciences,
 University of Tokyo, Tokyo 055991
College of Arts and Social Sciences,
 Australian National University,
 Canberra 054829
College of Arts Sichuan University,
 Chengdu 055135
College of Arts, Chung Ang University,
 Anseong 056027
College of Arts, Department of Fine
 Art, Hebei University, Baoding . 055121
College of Arts, Department
 of Fine Art, Jinan University,
 Guangzhou 055142
College of Arts, Department of Fine
 Arts, Chonnam National University,
 Gwangju 056036
College of Arts, Department of Fine
 Arts, Pusan National University,
 Busan 056029
College of Arts, Dept. of Visual Arts,
 Tamagawa Daigaku, Machida . 055967
College of Arts, Dong-A University,
 Busan 056028
College of Arts, Dongduk Women's
 University, Seoul 056042
College of Arts, Dongguk University,
 Seoul 056043
College of Arts, Fine Art Department,
 Changwon National University,
 Changwon 056031
College of Arts, Fu-Jen Catholic

University, Taipei 056414
College of Arts, Hue University,
 Hue 058123
College of Arts, King Saud University,
 Riyadh 056266
College of Arts, Kunsan National
 University, Gunsan 056035
College of Arts, Nihon University,
 Tokyo 055990
College of Arts, University of Baghdad,
 Baghdad 055791
College of Arts, University of Glasgow,
 Glasgow 056493
College of Arts, University of Nairobi,
 Nairobi 056023
College of Creative Arts, Massey
 University, Wellington 056144
College of Creative Arts, West Virginia
 University, Morgantown 057447
College of Design, Arizona State
 University, Tempe 057944
College of Design, North Carolina
 State University, Raleigh 057706
College of Design, Shih Chien
 University, Taipei 056415
College of Design, Shu-te University,
 Yanchao 056421
College of Eastern Utah Prehistoric
 Museum, Price 052264
College of Fine & Performing Arts,
 Western Washington University,
 Bellingham 056677
College of Fine and Applied Arts,
 Sudan University of Science and
 Technology, Khartoum 056354
College of Fine Arts – School of Visual
 Arts, Boston University, Boston 056725
College of Fine Arts & Music,
 Chungnam National University,
 Daejeon 056033
College of Fine Arts and Architecture,
 Jawaharlal Nehru Technological
 University, Hyderabad 055734
College of Fine Arts, Capital Normal
 University, Beijing 055128
College of Fine Arts, Carnegie-Mellon
 University, Pittsburgh 057645
College of Fine Arts, Chongqing
 Normal University, Chongqing . 055137
College of Fine Arts, Hongik University,
 Seoul 056045
College of Fine Arts, Hunan Normal
 University, Changsha 055132
College of Fine Arts, Marshall
 University, Huntington 057183
College of Fine Arts, Sehan University,
 Jeollanam-do 056038
College of Fine Arts, Seoul National
 University, Seoul 056046
College of Fine Arts, Seoul Women's
 University, Seoul 056047
College of Fine Arts, Sookmyung
 Women's University, Seoul ... 056048
College of Fine Arts, University of
 Kerala, Triruvananthapuram .. 055776
College of Fine Arts, University of
 Montevallo, Montevallo 057437
College of Fine Arts, University of New
 Mexico, Albuquerque 056592
College of Fine Arts, University of New
 South Wales, Paddington, New South
 Wales 054844
College of Fine Arts, University of the
 Philippines, Quezon City 056173
College of Fine Arts, Wichita State
 University, Wichita 058063
College of Imaging Arts and Sciences,
 Rochester Institute of Technology,
 Rochester 057737
College of Industrial Art, Fuzhou
 University, Fuzhou 055141
College of Liberal Arts and Education,
 Tuskegee University, Tuskegee 057977
College of Liberal Arts and Sciences,

Iowa State University, Ames .. 056607
College of Liberal Arts and Sciences,
 University of Florida, Gainesville 057078
College of Liberal Arts, Azusa Pacific
 University, Azusa 056652
College of Liberal Arts, Dakota State
 University, Madison 057349
College of Liberal Arts, Saint Cloud
 State University, Saint Cloud .. 057765
College of Marin Art Gallery,
 Kentfield 049890
College of Music and Visual Arts,
 Kyungpook National University,
 Daegu 056032
College of Music, Visual Arts and
 Theatre, James Cook University,
 Townsville 054850
College of New Jersey Art Gallery,
 Ewing 048609
College of New Rochelle, New
 Rochelle 057497
College of Photographic Art and
 Sciences, Rochester Institute of
 Technology, Rochester 057738
College of the Arts, Ohio State
 University, Columbus 056904
College of the Arts, University
 of Southwestern Louisiana,
 Lafayette 057264
College of Visual and Performing Arts,
 Kutztown University, Kutztown . 057253
College of Visual and Performing Arts,
 University of Mary Hardin-Baylor,
 Belton 056679
College of Visual and Performing
 Arts, University of Massachusetts
 Dartmouth, North Dartmouth .. 057549
College of Visual Arts, Saint Paul 057780
College of Visual Arts Gallery, Saint
 Paul 052737
The College of Wooster Art Museum,
 Wooster 054413
College Park Aviation Museum,
 College Park 047832
Collegi d'Arquitectes de Catalunya,
 Barcelona 059773
Collegium Artisticum, Sarajevo . 100717
Collegium Hungaricum Berlin,
 Berlin 016888
Collem Antiquités, Bruxelles .. 063321
Collet, Catherine, Saint-Mihiel . 072944
Collet, Henri Bertrand, Saint-Denis-
 d'Anjou 129450
Colleton Museum, Walterboro . 053924
Colletti, Russell, Chicago 092533
Colley, Reuben, Birmingham .. 117459
Collezionando di Palazzo Giampiero,
 Firenze 079956, 142489
Collezione A. Checchi, Palazzo Volta,
 Fucecchio 026201
Collezione Archeologica e Foro
 Romano, Assisi 025230
Collezione ASP Poveri Vergognosi,
 Bologna 025367
Collezione Borsari, Parma 027037
Collezione Calderara, Fondazinone
 Calderara, Ameno 025149
Collezione Civica d'Arte, Pinerolo 027159
Collezione Contini-Bonacossi,
 Firenze 026097
Collezione d'Arte della Banca Carige,
 Genova 026240
Collezione d'Arte di Santa Maria di
 Piazza, Ostra 026962
Collezione d'Arte Religiosa
 Moderna, Musei Vaticani, Città del
 Vaticano 054617
Collezione d'Arte Sacra,
 Saludecio 027539
Collezione d'arte Unicredit,
 Bologna 025368
Collezione di Carrozze, Villa Barbaro,
 Maser 026562
Collezione di Ceramiche Mostra

Cselley Ház, Hansági Múzeum,
Mosonmagyaróvár 023473
Csemadok, Dunajská Streda . . . 143498
Csepel Galéria és Helytörténeti
Gyűjtemény, Budapest 023150
Cserépfalvi Imre Emlékszoba,
Cserépfalu 023260
Cserno, Amsterdam 082535
Csillár Bazár, Budapest 079145
Csiszar, Csaba, Hamburg 130260
Csohány Galerie, Pásztói Múzeum,
Nógrádi Megyei Múzeum Szervezet,
Pásztó 023509
Csók István Képtár, Szent István Király
Múzeum, Székesfehérvár . . . 023607
Csók, István, Budapest 109143
Csokay, Gols 099857
Csonth, Istvan, Bamberg 074616
Csontváry Múzeum, Janus Pannonius
Múzeum, Pécs 023513
CSP111, Seoul 111668
Csúcsi Fazekasház, Tornyai János
Múzeum, Hódmezővásárhely . . 023364
CTS Turner Museum, Elkhart . . 048492
Čtvrtnik, Dobroslav, Praha 128582
Cu Heritage Center, University of
Colorado, Boulder 047109
Cu4rto Nivel Arte Contemporaneo,
Bogotá 102194
Cuadernos de Arte, Universidad de
Granada, Granada 139090
Cuadrado, Teresa, Valladolid . . 115619
Cuadro, Cartagena 115098
Cuadro, Las Palmas de Gran
Canaria 115471
Cuadros, Valencia 115575
Cuadros de Monterrey,
Monterrey 112060
Cuadros Vivos de la Sabana,
Corozal 008507
Cuare, México 138952
La Cuarenta, Madrid 085988
El Cuarto de San Alejo,
Bucaramanga 065146
Cuartoscuro, Cuauhtémoc 138953
Cuatro Casas, Madrid . 085989, 115265
Cuba Aereo, Miami 094558
Cuban Art Space, New York . . . 122760
Cuban Collection Fine Arts,
Miami 122043
Cuban Masters Collection, Miami 122044
Cuban Museum of Arts and Culture,
Miami 050761
Cubanostalgia, Miami 094559
Cubas Basterrechea, Carmen,
Madrid 133679
Cubby Hole Antiques, Portland . 096227
Cube, Bowden 098618
Cube Gallery, Bristol 117579
Cubeta, C., Castlemaine 061288
Cubic Gallery İteza, Kyoto 111306
Cubis Collection, North Sydney . 099342
Cubitt Artists, London . 060031, 118505
Cubus Kunsthalle, Duisburg . . . 017811
Cucchi, Paola, Roma 132270
Cuchifritos, New York 122761
The Cuckfield Gallery, Cuckfield 117822
Cuckfield Museum, Cuckfield . 043856
Cuddle Pot Collectables, Cudal . 061374
Cudgewa Antique Shop,
Cudgewa 061375
Cudrio Kystmuseum, Langesund 033557
Cudworth, Bath 117374
Cue Art Foundation, New York . 051290
Cuéllar, Arturo, Zürich 116851
Cuervo, Medellín 065196
Cueto Project, New York 122762
La Cueva de Caritas, Rosario . . 060941
Cuivrerie de Cerdon, Cerdon . . 012197
Cukier, Raymond, Romainville . . 072479
Cukormúzeum, Szerencs 023641
Culbertson Mansion, New Albany 051149
Culbertson Museum, Culbertson 048048
Culinair Historisch Kookmuseum de

Vleer, Appelscha 031838
Culinair Museum, Amersfoort . . 031733
Culinary Archives and Museum,
Johnson and Wales University,
Providence 052288
Cullen Antiques Centre, Cullen . 088808
Cullity Gallery, Nedlands 099291
Cullman County Museum,
Cullman 048050
Culloden Battlefield and Visitor Centre,
Inverness 044506
Culloden House Antiques,
Vancouver 064757
Cullompton Old Tannery Antiques,
Cullompton 088810
Culo, Delphine, Lorient 069580
Culotta, Rosolino, Palermo 080866
Cult, Wien 100119
Cultura 2000 – Kunst im Kuhstall,
Kirtorf 107551
Cultura Collection, Cleveland . . 120692
Cultura Popular Museum, Natal . 004506
Cultural Center and Museum,
Wabag 034014
Cultural Center Hellenic Cosmos,
Athínai 022564
The Cultural Center of Fine Arts,
Parkersburg 051836
Cultural Center of the Philippines
Museo, Pasay 034393
Cultural Centre de Dorval, Dorval 005606
Cultural Heritage Center Museum,
Confederated Tribes and Bands
of the Yakama Indian Nation,
Toppenish 053656
Cultural Museum at Scarritt-Bennett
Center's, Nashville 051107
Cultural Museum of Hemei,
Hemei 042045
Cultural Museum, State University
Museum, Kabacan 034321
Cultural Research Institute,
Kolkata 024045
Culturati Art Gallery, San Diego . 124364
Culture & Economics, Minden . . 107988
Culture Cache Gallery, San
Francisco 124511
Culture Exhibition Hall of Singang
Fengtian Temple, Singang 042183
Cultured Pearl, Portland 096228
Cultureel Centrum van Gogh,
Zundert 032935
Cultureel Maçonniek Centrum Prins
Frederik, Den Haag 031992
Cultuur-Historisch Museum
Sorgdrager, Hollum 032317
Cultuurhistorisch Museum
Valkenswaard, Valkenswaard . 032786
Cultuurhistorisch Streek- en
Handkarrenmuseum De Wemme,
Zuidwolde, Drenthe 032932
Cultuurhistorisch Streekmuseum De
Acht Zaligheden, Eersel 032098
Culzean Castle and Country Park,
Maybole 045161
Cum Tempore, Salzburg 062757
Cumalı Sanat Galerisi, İstanbul . 117117
Cumberland Art Conservation,
Nashville 136194
Cumberland Art Society,
Cookeville 060455
Cumberland County Historical Society
Museum, Greenwich 049235
Cumberland County Museum,
Amherst 005229
Cumberland Gallery, Chichester . 117733
Cumberland Gallery, Nashville . . 122342
Cumberland Gap National Historical
Park, Middlesboro 050793
Cumberland Heritage Village Museum,
Cumberland, Ontario 005562
Cumberland House, Regina 006614
Cumberland Museum and Archives,
Cumberland 005561

Cumberland Pencil Museum,
Keswick 044545
Cumberland Science Museum,
Nashville 051108
Cumberland Theatre Arts Gallery,
Cumberland 048054
Cumberland Township Historical
Society, Ottawa 006443
Cumberland Toy and Model Museum,
Cockermouth 043781
Cumbernauld Museum,
Cumbernauld 043860
Cumbria Architectural Salvage, Raughton
Head 090922, 135301
Cumbria Auction Rooms, Carlisle 127047
The Cumbrian Antiques Centre,
Brampton, Cumbria 088349
Cumhuriyet Devri Müzesi, Ankara 042549
Cumhuriyet Egitim Müzesi,
İstanbul 042661
Cumhuriyet Eğitim Müzesi,
Karataş 042714
Cuming Museum, London 044851
Cummer Museum of Art,
Jacksonville 049726
Cumming, A. & Y., Lewes 144290
Cumming's Corner, Kansas City . 093904
Cummings, J., Minneapolis 145012
Cummins, James, New York . . . 145072
Cunderdin Municipal Museum,
Cunderdin 001005
Cundiff, Bryan, Louisville 094369,
127561
Cuneo Mansion & Gardens, Vernon
Hills 053842
Cunha, Rio de Janeiro 063992
Cunha, Carlos, Porto 084846
Cunha, Ruben, Lisboa 114079
Cunha, Vitor Manuel, Lisboa . . . 143377
Cunha, Walter A., Rio de Janeiro 140257
Cuniberti, Beatrice, Firenze . . . 131551
Cunin, Marie-Noëlle, Lacoste . . 069075
Cuningham, Betty, New York . . . 122763
Cunnamore Galleries, Skibbereen 109699
Cunningham, New Orleans 122399
Cunningham, Portland 145182
Cunningham Dax Collection, Parkville,
Victoria 001394
Cunnington, Lynnette, Woollahra 062457
Cuny, André, Nantes 070411
Cuoccio, Antonio, Milano 080346
Cuoccio, Guisepe, Milano 080347,
131823
Cuoghi, Paola, Modena 080622
Cuomo, Baltimore 092148
Cuore, Buono, Rio de Janeiro . . 128362
Cupar and District Heritage Museum,
Cupar 005563
Cupboard Antiques, Amersham . 088037
Cupboard Collectables,
Minneapolis 094742
Cupertino Historical Museum,
Cupertino 048058
Cupertino S, Lisboa 114080
Cupid World of Beauty, Ettalong
Beach 061445
Cupid's Antiques, Oklahoma City 095802
Cupids Museum, Cupids 005564
Cupillard, Grenoble 103737
Cupola Gallery, Sheffield 119342
Cupola House, Egg Harbor 048450
Cuppacumbalong, Tharwa 099680
Cuppalot, Lyons 099105
Cupper, David, Norfolk 095685
Cupuri, Thannhausen 142252
Curá Antiques, London 089874
Curaçao Museum, Willemstad . . 009233
Curator, New York 139386
Curdnatta Art Gallery, Port
Augusta 099439
Curfman Gallery and Duhesa Lounge,
Fort Collins 048754
Le Curieux, Saint-Ouen 073022
Curio Arts, Kathmandu 112142

Curio Books, Hahndorf 139788
Curio-City, Singapore 085217
Curio City, Southend-on-Sea . . . 091226
Curio Corner, Tynemouth 091539
Curio Corner Books, Austin 144716
The Curio Shop, Dublin 079433
Curio Warehouse, Guildford . . . 061556
Curios City, Vancouver 064758
The Curios House, Udaipur 079311
Curios Limited Antiques, Norfolk 095686
Curios of Chale, Chale, Isle of
Wight 088598
Curios on Oxford, Levin 083812
Curiosa, Breda 082792
Curiosa de Markies Roosendaal,
Roosendaal 083355
Curiosa, Meubelen & Hebbedingen,
Den Haag 082885
Curiosamuseum Heraldiek en Folklore,
Alveringem 003186
Curioser & Curioser, Bendigo . . 061121
Curiosidade's Guatemala, Oklahoma
City 095803
Curiosité, Evian-les-Bains 068434
Curiosités, Besançon 067063
Curiosités, Sallanches 073344
Curiosités Marocaine, Rabat . . . 082413
Curiosities, Highgate, Western
Australia 061614
Curiosities Shop, Vancouver . . . 064759
Curiosity Corner, Dallas 092943
Curiosity Corner, North Shore . . 083879
The Curiosity Shop, Barry 088142
Curiosity Shop, Hawkes Bay . . . 083788
Curiosity Shop, Las Vegas 093967
Curiosity Shop, Nashville 094824
The Curiosity Shop, Saint
Sampson 091062
The Curiosity Shop, South
Shields 091219
The Curiosity Shop, Winnipeg . . 064864
Curiosity Shoppe, Jacksonville . 093817
The Curiosity Shoppe, Ranfurly . 083923
Curiosum, Caslano 087167
Curious Art Co-Op, Chinderah . . 098740
Curious Arts, Singapore 114591
Curious Duke Gallery, London . . 118506
The Curious Kids' Museum, Saint
Joseph 052679
Curious Sofa, Kansas City 093905
Curragh Military Museum,
Curragh 024592
Currahee Military Museum,
Virden 007166
Currency Museum of the Bank of
Canada, Ottawa 006444
Currency Press, Redfern 136823
Currier Museum of Art,
Manchester 050563
Curry Historical Society Museum, Gold
Beach 049105
Cursief, Brugge 125573, 140130
Curso Artes Visuais, Universidade
do Extremo Sul Catarinense,
Criciúma 055005
Curso de Artes Visuais, Universidade
de Ijuí, Dept. DELAC, Ijuí . . . 055012
Curso de Educação Artística,
Universidade Estadual de Campinas,
Campinas 055004
Curso de Educação Artística,
Universidade Federal do Maranhão,
São Luís 055032
Curso de Pintura, Fortaleza . . . 100799
Curtessão, Porto Alegre 063915
Curti, Paolo, Milano 110309
Curtins, 2010 ehp; 2010 RL;, Sankt
Moritz 116712
Curtis, Long Melford 090460
Curtis Museum, Alton 043149
Curtis, Edward S., Seattle 124760
Curtis, Lee A. & Eva, München . 142026
Curtiss, Louis F., San Diego . . . 096913
Curtze, Dr. Heike, Wien 100120

Dasun, Gwacheon 111625
Dat Antiek, Den Haag 132851
Date, Busan 111583
Datian Museum, Datian 007541
Datina, Prato 081002
Datong Museum, Datong 007542
Datrino, Marco, Torre Canavese 081608
D'Attili, Maria Novella, Roma . . . 081154
Datu Fine Arts, Wishaw 119661
Datura, Chicago 120386
Daubet, Francis, Floirac 068492
Daubisse, Isabelle, Ribérac . . . 072414
Daubitz & Son, Dallas 135849
Daubrée, Valérie, Paris 129206
Daudet, Alain, Toulouse 073721, 105688
Dauerausstellung Württembergische
 Schwarzwaldbahn, Calw 017486
Daugaard, Peter, Stege 140624
Daugava, Rīga 111811
Daugavas Muzejs, Salaspils . . . 030061
Daugavpils Novadpētniecības un
 Mākslas Muzejs, Daugavpils . . 029938
Daugavpils Universitātes Muzejs,
 Daugavpils 029939
Daugé, Claude, Richelieu 072417
Dauger, Yves, Paris 071177
Daughters of the American Revolution
 Museum, Washington 053977
Daughters of Utah Pioneers Pioneer
 Memorial Museum, Salt Lake
 City 052814
Daugyvenės Kultūros Istorijos
 Muziejus-draustinis, Radviliškis 030279
Daulaus, Nice 070541
Daum Museum of Contemporary Art,
 Sedalia 053141
Daumarie, Jacques, Amphion-les-
 Bains 103183
Daumas, Jean-Paul, Aigues-
 Mortes 066377
Daune, Alain, Paris 104619
Dauphin, Singapore 114592
Le Dauphin Bernard, Paris 071178
Dauphin-Descours, New York . . . 095172
Dauphin Publishing, Oxford 138327
Dauphin, Cedric le, Bruxelles . . 063332
Dauphine Street Books, New
 Orleans 145044
Dauphinoise, Le Bouchage 103877
Daura Gallery, Lynchburg College,
 Lynchburg 050470
Dauriac, Jean-Louis, Dieupentale 068247
Dautrait, Daniel, Clermont-
 Ferrand 128801
Dauvillier, Middelburg 112677
Dauwe, Christel, Antwerpen . . . 063144
Davaco, Doornspijk 137949
Davaki, Eleni, Iráklion 079099
Davao Museum, Davao 034312
Dave & Bill's Trading Post, Saint
 Louis 096519
Dave Antique, Paris 071179
Daveau, Jacqueline, Paris 071180
Davenham Antique Centre,
 Davenham 088825
Davenport House Museum,
 Savannah 053059
Davenport Museum of Art,
 Davenport 048117
Davenport, Karl & Claire, Enfield 131272
Daventry Museum, Daventry . . . 043879
Daverio, Chrisgeni, Nice 129090
Daves, Tucson 136752
Dave's Antiques, Louisville 094371
Dave's World, Houston 093492
Davi, Timişoara 084961
David, Los Angeles 094142
David, Singapore 085218
David & Charles, Newton Abbot 138323
David & David, Philadelphia . . . 123617
David & Laure Soustiel, Marie-
 Christine, Paris 071182
David Aaron Ancient Arts,

London 089879, 134962
David Bradford House,
 Washington 054061
David Conklin Farmhouse, Huntington
 Historical Society, Huntington . 049577
David Crawford House,
 Newburgh 051428
The David Davis Mansion,
 Bloomington 047010
David de Sauzéa, Rambert, Nice 070542
David et ses Filles, Paris 071183
David L. Mason Children's Art
 Museum, Dunedin 048355
David Livingstone Centre,
 Blantyre 043427
David Palombo Museum,
 Jerusalem 024897
David S.r.l., Cortina d'Ampezzo . 079889
David S.r.l., Riccione 081018
Davíd Stefánsson Memorial Museum,
 Akureyri 023738
David Strawn Art Gallery, Art
 Association of Jacksonville,
 Jacksonville 049736
David Winton Bell Gallery, Brown
 University, Providence 052289
David, Bernadette, Langoiran . . . 069112
David, Charles, Providence 123947
David, Francine Marie,
 Beatenberg 116208
David, G., Cambridge 144066
David, Jean-Marc, La Trimouille 069052
David, Marie-Christine, Paris . . . 071181
David, Philippe, Limey-
 Remenauville 069457
Daviddi, Farmington 135905
Davidov, Lina, Paris 104620
Davidowski, F., Almelo 082439
David's, Brampton,
 Cambridgeshire 088348
Davids, Miami 122046
David's, New Orleans 094920
David's Antiques, Chicago 092536
David's Art, Memphis 121966
Davids Book Exchange, Brighton 144035
David's Gallery, Pittsburgh 096111
Davids Samling, København . . . 010013
David's Timeless Treasures,
 Toorak 062314
Davidsfonds, Leuven 136953
Davidson, Calgary 128397
Davidson, London 089880
Davidson, Newcastle-upon-Tyne 090676
Davidson, Saint-Ouen 073025
Davidson, Salt Lake City 096724, 136577
Davidson, Seattle . . . 097258, 124762
Davidson County Historical Museum,
 Lexington 050207
Davidson County Museum of Art,
 Lexington 050208
Davidson, Greg, Seattle 097259
Davidson, Maxwell, New York . . . 122770
Davie, Tickhill 119507
Davies Antiques, Ormond 062023
Davies, Christian, Darwen 088820
Davies, Daryl, Ringwood 119225, 138335
Davies & Son, Edmund, Whalley 091679,
 135573
Davies, Hugh, London 089881
Davies, Jeffrey, San Francisco . . 097048
Davies, John, Stow-on-the-Wold 091320,
 119431, 135445
Davies, Phillip, Swansea 119469, 135460
Davila Camargo, Antonio Maria,
 Bogotá 065112, 128512, 140413
Davinci, Vancouver 064760
Davioud, André, Lille 128914
Davioud, Georges, Lille 069430
Davis, Austin 119938
Davis, Dallas 135850
Davis, Houston 093493
Davis, Long Beach 094033
Davis & Co., Los Angeles 094143
Davis, New Orleans 122401

Davis, Perry 127653
Davis, Worcester 138534
Davis & Davis, London 134963
Davis & Gardner, New York 095173
Davis & Langdale Company, New
 York 122771
Davis & Leron Galries, Brooklyn 120220
Davis Art Center, Davis 048123
Davis Art Gallery, Columbia . . . 047861
Davis Astrof Gallery, Montréal . . 101240
Davis Dominguez, Tucson 124976
Davis Mardine, Los Angeles . . . 121747
Davis Museum, Wellesley College,
 Wellesley Hills 054145
Davis Place Antiques, Saint
 Louis 096520
Davis, A.B., London 089882
Davis, Barbara, Houston 121305
Davis, Caleb, Boston 135714
Davis, Kenneth, London 089883
Davis, Leslie, Milwaukee 122187
Davis, Rachel, Cleveland 120694,
 127448
Davis, Reginald, Oxford 090779, 135257
Davis, Roger A., Great Bookham 089164,
 134734
Davis, Sharyl, San Antonio 096802
Davishire Interiors, Nashville . . . 094825
DavisKlemmGallery, München . . 108050
DavisKlemmGallery, Wiesbaden . 108918
Davison Art Center, Wesleyan
 University, Middletown 050795
Davison Gallery, Holywood 118202
Davoud-Salmani, Bruxelles 063333
Davoy, Coufouleux 068121
Davril, Bogotá 102196
Davut, Mahrli, Wien 062887
Davy, Anthony Kent, Hong Kong 101942
Davy, Michel, Saumur 073394
Dawa, Kathmandu 112144
Dawes County Historical Society
 Museum, Chadron 047473
Dawes, Philip, Royston 090998, 135324
Dawes, Valentyne, Ludlow 090491,
 135160
Dawlish Museum, Dawlish 043880
Dawne, Morgan, Vancouver 101631
Dawo, Udo, Saarbrücken 078242,
 126334
Dawson, Jacksonville 121519
Dawson, Rotorua 113087
Dawson, Vancouver 128471
Dawson City Museum, Dawson
 City 005578
Dawson County Historical Museum,
 Lexington 050206
Dawson Creek Art Gallery, Dawson
 Creek 005580
Dawson Creek Station Museum,
 Dawson Creek 005581
Dawson Folk Museum, Theodore 001572
Dawson of Stamford, Stamford . 091258
Dawson Springs Museum and Art
 Center, Dawson Springs 048129
Dawson, Douglas, Chicago 120387
Dawson, Michael, Los Angeles . 144962
Dawson, P., Bentley . . . 088215, 134411
Dawson, Phillip, Twickenham . . . 144636
Dawu Museum, Dawu 007543
Daxer & Marschall, München . . . 077410
Daxin Museum, Daxin 007544
Daxing Xing Du Art Cooperative,
 Beijing 101812
Day Antiques, Tetbury 091424
Day, Christopher, Paddington, New
 South Wales 099383
Day, Dean, Houston 121306
Day, Edward, Toronto 101458
Day, John, Eastbourne 088934, 134666
Dayan, Paris 071184
Dayan, Hubert, Saint-Jean-Cap-
 Ferrat 105486
Dayboro Shed, Samsonvale . . . 062175
Daye Museum, Daye 007545

Dayi Liu's Manor-House Museum,
 Chengdu 007509
Daylesford and District Historical
 Museum, Daylesford 001020
Dayna's Antiques, Jacksonville . 093818
Days Gone By Antiques,
 Kitchener 064280
Days of Grace, Budleigh
 Salterton 088475
Days of Olde Antiques, Ballarat . 061074
Daystar Collectibles, Tucson . . . 097486
Dayton Art Institute, Dayton . . . 048132
Dayton Historical Depot Society
 Museum, Dayton 048140
Dayton Visual Arts Center,
 Dayton 048133
Daytona Gallery, Tauranga 113110
Daza, Francisco, Jerez de la
 Frontera 115191
Dazaifu Tenman-gu Hômotsuden,
 Dazaifu 028338
Daze Gone By, Gympie 061559
Dazenière, Michel, Boulazac . . . 067329
Dazhong Siguzhong Museum,
 Beijing 007426
Dazibao, Centre de Photographies
 Actuelles, Montréal 006236
Dazy, Christian, Dijon 103625
Dazy, Christian, Megève 104163
Dazzle, Helmsley 118154
DB Museum, Nürnberg 020486
DBL Diffusion, Nice 070543
dbv Deutscher Buchverlag GmbH,
 Oldenburg 137590
DC Antiques, Los Angeles 094144
DC Collection, Tucson 097487
DCI Gallery, Memphis 121967
DCKT Contemporary, New York . 122772
DD Starožitnosti, Praha 065420
DDR-Motorradmuseum, Borna . . 017299
DDR Museum, Berlin 016892
DDR-Museum im Filmpalast,
 Malchow 019899
DDR-Museum Radebeul,
 Dresden 017742
DDS Antique Restoration, New
 York 136254
De, Beograd 085160
De Amicis Point, Milano 080351
De Angelis, Antonio, Napoli 080691
De Angelis, Fabio, Roma 132275
De Antoni, Gaetano, Sarcedo . . 110931
De Antoni, Maria Luigia, Padova 080813
De Artis, Zug 116956
De Benedetti, Augusto, Roma . . 110771
De Bianchi, Luciano, Verona . . . 081738
De Bortoli, Alberto, Venezia . . . 132621
De Bretts, Moonee Ponds 061868
De Capola, Mario, Napoli 080692
De Cardenas, Monica, Milano . . 110311
De Carlo Studio, Milano 110313
De Carlo, Massimo, Milano 110312
De Carolis, Massimo, Modena . . 110511,
 131959
De Celles, Aliénor, Marseille . . . 104117
De Chene, Gene, Los Angeles . . 144963
De Chhitiz, Kathmandu 112145
De Choses en Choses, Reims . . 072348
De Cillia, Udine 111081
De Colellis, Urbano, Torino 132511
De Crescenzo, Roma 081155
De Crescenzo, Antonio, Roma . . 081156
De Domenico, Luigi, Messina . . . 080198
De Donno, Rocco, Biel 087129, 134044
De Falco, Alberto, Napoli 080693
De Fazio, Indianapolis 121455
De Ferrari, Renata, Genova 080088,
 131699
De Filippis, Domenica, Messina . 080199
De Filippo, Gianluca, Napoli . . . 080694
de freo gallery, Berlin 106157
De Giovanni Argenteria, Milano . 080352
De Girardi, Stefano, Roma 132276
De Goudron, Laura, Napoli 132004

Deep Water Shark Gallery,
Tinonee 099689
Deepe, W., Beckeln 074660
Deepgroove-Antiquariat,
Freilassing 141718
Deer Isle-Stonington Historical Society
Museum, Deer Isle 048174
Deer Valley Rock Art Center,
Glendale 049078
Deerberg, Ralf, Porta Westfalica 130895
Deere Museum, Moline 050915
Deerfield, Oakland 095724
Deerfield Beach Historical Society
Museum, Deerfield Beach . . . 048182
Deerstalker Antiques, Whitchurch,
Buckinghamshire . . . 091688, 135577
Deeside Books, Berkhamsted . . 144012
Defachelle, Michel, Les Attaques 069343
Defacto Art e.V., Lübeck 107897
Defence Services Museum,
Adelaide 000766
Defence Services Museum,
Yangon 031657
Défense d'Afficher, Paris 104624
Defeo, L.B., Dordrecht 082990
Defet, Hansfried, Nürnberg 108308
Deffarges, Montvert 070289
Defiance Gallery, Newtown, New
South Wales 099316
Defina, Ennio, Venezia 132623
DeFinis, Kevin J., Philadelphia . 095937
Definition Press, New York 138443
Defrawi, Cairo 066161
Defrocourt, Cathy, Bresles 067402
Defuns, Gioni, Trun 116764
Degan, Bruno, Venezia 111124
Degani, Giuliano, Verona 132663
Degas Pastel Society, New
Orleans 060458
Degenaar, Amsterdam 082539
Degener Japenese Fine Prints,
Meerbusch 141986
Degenfeld, Regina von,
Waibstadt 078740
Degenhart Paperweight and Glass
Museum, Cambridge 047337
Degenhart, J., Memmingen 077277
Degenkolbe, Leipzig 076995
Degeorge, Charles, Le Boulou . . 128892
Degerfors Fotbollsmuseum,
Degerfors 040392
Degheldere, Willy, Brugge 140131
Degieux, Marc, Rots 105419
Degioanni, Léopold, Villeurbanne 074164
Degli Esposti, Paola Maria,
Bologna 131354
Deglise, Nicolas, Paris 129209
Degrange, Philippe, Charlieu . . . 067793
DeGrazia Gallery in the Sun,
Tucson 053702
Degrémont, Madeleine, Clamecy 067948
Degrugillier, Hélène, Lagnes . . . 069082
Degutsch, Ingrid, Stuttgart 142230
Degwitz, Uelzen 078663
Dehaan, Bankstown 098559
Dehennin, Guy, Cotignac 068112
Dehler, Remlingen 078115
Dehler, C., Raunheim 078062
Dehner jun., Georg, Bachhagel . 074445
Dehoogh, Philadelphia 069548
Dehua Ceramic Museum, Dehua 007549
Deià Museo Arqueológico, Deià . 039154
Deichmann, von, Schaan 132701
Deichsel, Jan, Erfurt 130085
Deichtorhallen Hamburg, Haus der
Photographie – Aktuelle Kunst,
Hamburg 018687
Ulrich Deicke & Regina Himmel-Deicke,
Süderholz 078558, 131081
Deike, Horst, Konstanz 137503
Deile, Bodo, Dresden 075363
Deiller-Ducatel, Dijon 128819
Deillon, Robert, Villeneuve 087687
Deilmann, Dietrich & Maureen,

Herdecke 076435
Deinbacher, Andreas, Sankt
Pölten 140034
Deinert, U. & M., Herzebrock-
Clarholz 076454
Deines Cultural Center, Russell . 052606
Deinhard-Kellermuseum, Koblenz 019340
Deininger, Charlotte, Augsburg . 129627
Deir ez-Zor Museum, Deir ez-Zor 041982
Deitch, Jeffrey, New York 122779,
122780
Déja Vu, Gouda 083075
Déja Vu, Winnipeg 064865
Déjà Vu Antik, Uppsala 086932
Deja Vu Antiques, Leigh-on-Sea 089601
Deja Vu Antiques, Shrewsbury . 091179
Deja Vu Books, Hobart 139802
Dejak Artistique Monumental/
Exhibition Gardens, Lagos . . 033257
Dejans, P., Kortrijk 063662
Dejbjerg Jernalder, Skjern 010146
Dejima-machi Hakabutsukan,
Nagasaki 028903
Deju Art, Carluke 117686
Dejwis Bis, Gdańsk 113548
DeKalb Historical Society Museum,
Decatur 048161
Dekanatsmuseum, Haus im
Ennstal 002041
Dekema State, Jelsum 032349
Deketelaere, Oostende 100662
Dekker, Amsterdam 082540
Dekker & Inkelaar, Amsterdam . 132775
Dekorativi Lietiškąs Mäkslas Muzejs,
Riga 030004
Dekorativnoe Iskusstvo, Moskva 139051
Dekorator, Warszawa 084540
Del Bono, Domenico Savio,
Napoli 080697
Del Borgo, Giglio, Roma 081161
Del Cardal, Montevideo 125291
Del Cerro Gallery, San Diego . . 124365
Del Infinito Arte, Buenos Aires . 098388
Del Mestre, Umberto, Torino . . . 132513
Del Monte, Renzo, Roma 132282
Del Prado, Bucaramanga 102285
Del Recuerdo, Buenos Aires . . . 139594
Del Ventisette, Renzo, Milano . . 080357
Delacour, Puymirol 072287
Delacour, Jean-Claude, La Palme 069001
Delacroix, Punta del Este 125312
Delacroix, Jean-Arnauld, Paris . 071189
Delacroix, Jean-Paul, Saint-Malo (Ille-
et-Vilaine) 072875
Delafontaine, Carouge 116285
Delafosse, Wormhout 074265
Delage, Philippe, Villeurbanne . . 074165
Delahaye, Didier, Pleurtuit 072143
Delahaye, Isabelle, Paris 071190
Delahaye, Olivier, Chaumont (Haute-
Marne) 067876
Delahenty, Olinda 099367
Delahoche, Gérard, Rémérangles 072370
Delaine, Rémi, Dole 068310
Delalande, Paris 071191
Delalande, Dominique & Eric,
Paris 071192
Delamain, Paris 141047
Delamarche, Thierry, Lecousse . 069321
Delamare, David, Portland 123861
Delan, Patrick, Pau 071995
Delaney, Los Angeles 094145
Delank, Claudia, Köln 107586
Delannoy, Xavier, La Garde-
Freinet 103841
Delano Heritage Park Museum,
Delano 048191
Delany, Newport 079577
Delarce, Paris 071193
Delarue, Etretat 103673
Delarue-Turcat, Paris 129210
Delarue, Alain, Bordeaux 128727
Delarue, Dominique, Excideuil . . 068442
Delaunay, Fabrice, Vitry-le-

François 074221
Delaune, Francis, Segré 073435
Delaune, Yves, Saumur 073395
Delaveau, Jean-Marc, Saint-
Mammès 072883
Delaware Agricultural Museum,
Dover 048310
Delaware and Hudson Canal Museum,
High Falls 049425
Delaware Art Museum,
Wilmington 054308
Delaware Center for the Contemporary
Arts, Wilmington 054309
Delaware Market, Tulsa 097560
Delaware Museum, Wilmington . 054310
Delaware Museum of Natural History,
Wilmington 054311
Delaware State Museums, Dover 048311
Delawood, Hunstanton . 089424, 144252
Delbarre, Fabien, Lille 069431
Delbos, Frédéric, Chaumont (Haute-
Marne) 067877, 140786
Delbos, Jacques, Paris 071194
Delboy, Francoise, Vezin-le-
Coquet 074047
Delbridge Museum, Sioux Falls . 053236
Delcampo, Ricardo, Miami 094562
Delclaux, Myriam, Aurillac 066763
Déléage, Michel, Yssingeaux . . . 074275
Deleau, Jacques, Carcassonne . 125821
Delecaut, M., Charleroi 063542
Delectable Collectibles,
Philadelphia 095939
Delectus Books, London 144342
Delehar, Peter, London 089885
DELEIKA, Dinkelsbühl 075313
DeLeon White, Toronto 101459
Delerive, Antoine, Lille 069432
Deletaille, Emile, Bruxelles 063335
Deleu, Vincent, Antwerpen 063145
Deleuil, Huguette, Marignane . . 069821,
104107
Delfhavens, Rotterdam 112720
Delfi, Padova 080814
Delfina Foundation, London . . . 044853
Delfino, Thierry, Marseille 128996
Delfitto, Alberto, Milano 131825
Delforge, M.-F., Bruxelles 063336
Delfour, Claude, Clermont-
Ferrand 067964
Delftenco, Bruxelles 063337
Delgatie Castle, Turriff 046014
Delhaye, Thierry, Craponne
(Rhône) 068165
Delhi Art Gallery, Delhi 109326
Delhi Ontario Tobacco Museum &
Heritage Centre, Delhi 005588
Delic, Čačak 114528
Delicias Galeria, Madrid 115267
Delicias Restauración, Madrid . . 133681
Delight Hamilton, Seattle 124763
Delignières, Jean-Marc, Sailly-sur-la-
Lys 072615
Delikatessenhaus e.V., Leipzig . 058780,
107799
Delille, Francis, Paris 137162
Délire en Formation, Paris 104625
D'Eliso & Tomè, Trieste 132602
Delitz-Kater, Wilma, Hannover . 107328
Delius, Cornelia, Bielefeld 074931
Delizsánsz Kiállítóterem,
Debrecen 023269
Dell, Baesweiler 070850
Dell, Buffalo 092357, 144758
Dell, Detroit 093195
Dell, Klaus-M., Moers 077340
Della Corte, Vignola 111229
Della Porta, Roberto, Roma . . . 132283
Della Toffola, Santa Venezia . . . 081664
Dellacasa, Renata, Torino 081526
Dellachá Vaj, Maria Luisa, Torino 081527
Dellacherie, Alain, Bergerac . . . 067043
Dellapiana Antichità, Alba 079630
Dell'Aquila, Alfredo, Torino 132514

Dell'Aria, Ignace, Marseille 069876,
104118
Delle Fave, Roberto, Roma 110773
Dellefant, Klaus, Puchheim 078017
Delley, François & Marina, Nyon 087516
Dellière, Christiane, Bellême . . . 067018
Dello Ioio, Napoli 080698
Delloye Thoumyre, Anne-Marie,
Châteauroux 128790
Dellus, Jacques, Noirmoutier-en-
l'Ile 070685
Dellview, San Antonio 096803
Delmar, Hurst Green 089432
DelMar Gallery, Saskatoon 101408
Delmas, Bruguières 067465
Delmas, Solange, Paris 141048
Delmes & Zander, Berlin 106158
Delmes & Zander, Köln 107587
Delmon, Mennan 063088
Delmon, J F, Toulouse 073723
Delmore Gallery, Alice Springs . 098482
Delomosne & Son, North Wraxall 090708
Delon, Jean-Paul, Marigny-Saint-
Marcel 140897
Delon, Michel, Malemort-sur-
Corrèze 069771
Delor, Nîmes 070641, 070642
Delor, Léon, Nîmes 070643
Deloraine Museum, Deloraine . . 001021
DeLorenzo, New York . 095179, 095180
Delorme, Paris 104626
Delorme, Chantal, Milano 080358
Delorme, Daniele, Paris 104627
Delorme, Francis, Avèze (Sarthe) 066810
Delorme, Marc, Saint-Ouen . . . 073026
Delorme, Michel, Eaubonne . . . 068368
Delorme, Patricio, Santiago de
Chile 064910
Delotte, Alain, Montrouge 070286
Delouche, Olivier, Saint-Malo (Ille-et-
Vilaine) 072876
Delourmel, Nadine, Rennes (Ille-et-
Vilaine) 105387
Delozier, D.L., Virginia Beach . . 136776
Delpani, Luciano, Brescia 079767
Delperie, Adrien, Toulouse 073724
Delpero, Antonio, Genova 080090
Delphi Antiques, Dublin 079436
Delphica Restauri, Roma 132284
Delpierre, Philippe, Paris 071195
Delpire, Paris 137163
Delpla, Eric, Saint-Ouen 073027
Delpuech, Charles, Bonnieux . . 067237
Delrey, Rio de Janeiro 063996
Delshan Art Gallery, Armadale,
Victoria 098508
Delsing, Gerard, Maastricht . . . 083274
Delta, Paris 104628
Delta, Rotterdam 112721
Delta – Arte, Donostia-San
Sebastián 115134
Delta Antiques, İstanbul 087891
Delta Blues Museum, Clarksdale 047732
Delta Change, Antibes-Juan-les-
Pins 066612
Delta County Historical Society
Museum, Escanaba 048561
Delta County Museum, Delta . . . 048196
Delta Cultural Center, Helena . . 049388
Delta Museum, Delta 005589
Delta-Phot, Limoges 103978
Delteil, Montréal 140325
Deltos, Firenze 131553
Deluermoz, Martine, Ussel 073881
Delusions of Grandeur, Ottawa . 101334
Deluxe Junk, Seattle 097260
Delvaille, Olivier, Paris 071196
Delvaux, Jean-Marc, Paris 125976
Delvecchio, Erica, Aviano 131304
Delvigne, Hervé, Ham 068725
Delvoie, M., Maastricht 083275
Dely, Nice 070544
Delzongle, Jean-Paul, Drugeac . 068353
Demago, Maribor 085442

Department of Art and Art Education,
Indiana University of Pennsylvania,
Indiana 057192
Department of Art and Art History,
Adelphi University, Garden City 057086
Department of Art and Art History,
Albion College, Albion 056591
Department of Art and Art History,
Bucknell University, Lewisburg 057295
Department of Art and Art History,
Carleton College, Northfield . . . 057556
Department of Art and Art History,
Colgate University, Hamilton . . 057133
Department of Art and Art History,
College of William and Mary,
Williamsburg 058070
Department of Art and Art History,
College of Wooster, Wooster . . 058093
Department of Art and Art History,
DePaul University, Chicago . . . 056842
Department of Art and Art History,
Dickinson College, Carlisle . . . 056797
Department of Art and Art History,
Duke University, Durham 056988
Department of Art and Art History,
Florida Southern College,
Lakeland 057273
Department of Art and Art History,
Franklin and Marshall College,
Lancaster 057279
Department of Art and Art History,
George Mason University,
Fairfax 057030
Department of Art and Art History,
Lawrence University, Appleton . 056619
Department of Art and Art History,
Maple Woods Community College,
Kansas City 057238
Department of Art and Art History,
Mary Baldwin College, Staunton 057908
Department of Art and Art History,
Mary Washington College,
Fredericksburg 057067
Department of Art and Art History,
Mesa Community College,
Mesa 057388
Department of Art and art History,
Michigan State University, East
Lansing 056990
Department of Art and Art History,
Oakland University, Rochester . 057731
Department of Art and Art History,
Pomona College, Claremont . . 056860,
056861
Department of Art and Art History,
Scripps College, Claremont . . . 056862
Department of Art and Art History,
Sonoma State University, Rohnert
Park 057753
Department of Art and Art History,
Texas Christian University, Fort
Worth 057061
Department of Art and Art History,
University of Alabama at
Birmingham, Birmingham 056702
Department of Art and Art History,
University of Alabama in Huntsville,
Huntsville 057185
Department of Art and Art History,
University of Colorado Boulder,
Boulder 056731
Department of Art and Art History,
University of Connecticut,
Storrs 057919
Department of Art and Art History,
University of Miami, Coral
Gables 056915
Department of Art and Art History,
University of Missouri Saint Louis,
Saint Louis 057773
Department of Art and Art History,
University of Nebraska, Lincoln 057307
Department of Art and Art History,
University of Nebraska at Omaha,

Omaha 057579
Department of Art and Art History,
University of New Mexico,
Albuquerque 056593
Department of Art and Art History,
University of Rhode Island,
Kingston 057247
Department of Art and Art
History, University of Rochester,
Rochester 057739
Department of Art and Art History,
University of Saskatchewan,
Saskatoon 055089
Department of Art and Art History,
University of South Alabama,
Mobile 057425
Department of Art and Art History,
University of Texas at Austin,
Austin 056648
Department of Art and Art History,
University of Texas at San Antonio,
San Antonio 057801
Department of Art and Art
History, University of the Pacific,
Stockton 057915
Department of Art and Art
History, University of the South,
Sewanee 057862
Department of Art and Art History,
University of Utah, Salt Lake
City 057795
Department of Art and Art History,
Vanderbilt University, Nashville 057469
Department of Art and Art History,
Wayne State University, Detroit 056970
Department of Art and Art History,
Western Maryland College,
Westminster 058053
Department of Art and Art History,
Wright State University, Dayton 056943
Department of Art and Art Professions,
New York University, New York 057508
Department of Art and Classics, Troy
State University, Troy 057965
Department of Art and Design
Arts, Barton Institute of TAFE,
Richmond 054846
Department of Art and Design,
California Polytechnic State
University at San Luis Obispo, San
Luis Obispo 057822
Department of Art and Design,
California State University Fresno,
College of Arts, Fresno 057071
Department of Art and Design,
California University of Pennsylvania,
California 056780
Department of Art and Design,
Charles Darwin University,
Darwin 054832
Department of Art and Design,
Chatham College, Pittsburgh . . 057647
Department of Art and Design,
Converse College, Spartanburg 057890
Department of Art and Design,
Crowder College, Neosho 057473
Department of Art and Design, East
Tennessee State University, Johnson
City 057227
Department of Art and Design, KvB
Institute of Technology, North
Sydney 054842
Department of Art and Design,
Missouri State Univeristy,
Springfield 057901
Department of Art and Design,
Montclair State University, Upper
Montclair 057990
Department of Art and Design,
Northern Michigan University,
Marquette 057372
Department of Art and Design,
Oklahoma Christian University,
Edmond 056998

Department of Art and Design, Pacific
Union College, Angwin 056614
Department of Art and Design, Red
Deer College, Red Deer 055085
Department of Art and Design,
Saginaw Valley State University,
Zilwaukee 058105
Department of Art and Design, Saint
Xavier University, Chicago 056843
Department of Art and Design,
Schoolcraft College, Livonia . . 057313
Department of Art and Design,
Southern Arkansas University,
Magnolia 057354
Department of Art and Design,
Southern Illinois University
Edwardsville, Edwardsville . . . 057000
Department of Art and Design,
Southwest Texas State University,
San Marcos 057823
Department of Art and Design,
University of Alberta, Edmonton 055058
Department of Art and Design,
University of Charleston,
Charleston 056817
Department of Art and Design,
University of Minnesota Duluth,
Duluth 056983
Department of Art and Design,
University of Papua New Guinea,
Boroko 056163
Department of Art and Design,
University of Wisconsin Eau Claire,
Eau Claire 056994
Department of Art and Design,
University of Wisconsin Stevens
Point, Stevens Point 057911
Department of Art and Design,
University of Wisconsin Stout,
Menomonie 057385
Department of Art and Design,
Vancouver Community College,
Vancouver 055100
Department of Art and Design,
West Nottinghamshire College,
Mansfield 056542
Department of Art and Industrial
Technology, Western State College of
Colorado, Gunnison 057130
Department of Art and Music,
Assumption College, Worcester 058095
Department of Art and Painting, SNDT
Women's University, Faculty of Fine
Arts, Mumbai 055751
Department of Art and Photography,
Phoenix College, Phoenix 057637
Department of Art and Photography,
Queensborough Community College,
Bayside 056671
Department of Art as Applied to
Medicine, Johns Hopkins University,
Baltimore 056657
Department of Art History &
Archaeology Visual Resources
Collection, Columbia University, New
York 051295
Department of Art History and
Archaeology, New York 057510
Department of Art History and
Archaeology, University of Missouri,
Columbia 056894
Department of Art History and Art,
Case Western Reserve University,
Cleveland 056875
Department of Art History and
Communication Studies, Faculty of
Arts, McGill University, Montréal 055074
Department of Art History and
Humanities, John Carroll University,
University Heights 057986
Department of Art History and Theory,
University of Otago, Dunedin . . 056137
Department of Art History and Theory,
University of Sydney, Faculty of Arts,

Camperdown 054827
Department of Art History and
Visual Arts, Occidental College, Los
Angeles 057329
Department of Art History, Columbia
University, New York 057509
Department of Art History, Dartmouth
College, Hanover 057142
Department of Art History,
Northwestern University,
Evanston 057023
Department of Art History, Rutgers
State University of New Jersey, New
Brunswick 057477
Department of Art History, State
University of New York at
Binghamton, Binghamton 056698
Department of Art History, Trinity
College, Hartford 057147
Department of Art History, University
of Brighton, Brighton 056471
Department of Art History, University
of Chicago, Chicago 056844
Department of Art History, University
of Maryland, College Park 056886
Department of Art History, University
of Minnesota, Minneapolis . . . 057418
Department of Art History, University
of Nottingham, Nottingham . . . 056548
Department of Art History, University
of Saint Thomas, Saint Paul . . 057783
Department of Art History, University
of Wisconsin Madison, Madison 057353
Department of Art History, Villanova
University, Villanova 058007
Department of Art History, Visual Art
and Theory, University of British
Columbia, Vancouver 055101
Department of Art History, Visual Arts
and Musicology, University of South
Africa, Tshwane 056303
Department of Art Practice, University
of California Berkeley, Berkeley 056686
Department of Art Theory and
Practice, Northwestern University
Evanston, Evanston 057024
Department of Art, Albright College,
Reading 057710
Department of Art, Alma College,
Alma 056601
Department of Art, American River
College, Sacramento 057760
Department of Art, American
University, Washington 058024
Department of Art, Anna Maria
College, Paxton 057611
Department of Art, Appalachian State
University, Boone 056720
Department of Art, Arkansas State
University, Jonesboro 057230
Department of Art, Arkansas Tech
University, Russellville 057756
Department of Art, Art History and
Design, Andrews University, Berrien
Springs 056687
Department of Art, Art History and
Design, University of Notre Dame,
Notre Dame 057560
Department of Art, Art History and
Film Studies Program, Mount
Holyoke College, South Hadley 057884
Department of Art, Auburn University,
Auburn 056642
Department of Art, Augustana College,
Rock Island 057744
Department of Art, Austin Peay State
University, Clarksville 056868
Department of Art, Ball State
University, Muncie 057458
Department of Art, Barat College,
Lake Forest 057269
Department of Art, Bay Path College,
Longmeadow 057318
Department of Art, Baylor University,

University, Lubbock 057337
Department of Art, Thiel College, Greenville 057124
Department of Art, Towson State University, Towson 057961
Department of Art, Trinity University, San Antonio 057800
Department of Art, Union College, Schenectady 057844
Department of Art, Union University, College of Arts and Sciences, Jackson 057212
Department of Art, University at Buffalo, Buffalo 056775
Department of Art, University of Alaska Anchorage, Anchorage . 056612
Department of Art, University of Alaska Fairbanks, Fairbanks . . 057029
Department of Art, University of Arizona, Tucson 057971
Department of Art, University of Calgary, Calgary 055054
Department of Art, University of California Los Angeles, Los Angeles 057328
Department of Art, University of California Santa Barbara, Santa Barbara 057828
Department of Art, University of Delaware, Newark 057529
Department of Art, University of Hawaii at Manoa, Honolulu . . . 057169
Department of Art, University of Houston, Houston 057177
Department of Art, University of Kansas, Lawrence 057288
Department of Art, University of Kentucky, Lexington 057298
Department of Art, University of La Verne, La Verne 057263
Department of Art, University of Maine, Orono 057590
Department of Art, University of Maryland, College Park 056885
Department of Art, University of Massachusetts, Lowell 057336
Department of Art, University of Mississippi, University 057984
Department of Art, University of Montana, Missoula 057424
Department of Art, University of Nebraska Kearney, Kearney . . 057240
Department of Art, University of Nevada Las Vegas, Las Vegas . 057284
Department of Art, University of North Alabama, Florence 057049
Department of Art, University of North Carolina at Asheville, Asheville 056625
Department of Art, University of North Carolina at Greensboro, Greensboro 057120
Department of Art, University of North Carolina at Pembroke, Pembroke 057614
Department of Art, University of Northern Iowa, Cedar Falls . . . 056806
Department of Art, University of San Diego, San Diego 057810
Department of Art, University of Sioux Falls, Sioux Falls 057880
Department of Art, University of South Carolina, Columbia 056897
Department of Art, University of South Dakota, Vermillion 058003
Department of Art, University of Tampa, Tampa 057939
Department of Art, University of Tennessee at Chattanooga, Chattanooga 056823
Department of Art, University of Texas of Permian Basin, Odessa 057571
Department of Art, University of the Cumberlands, Williamsburg . . . 058069
Department of Art, University of the

Ozarks, Clarksville 056867
Department of Art, University of Toledo, Toledo 057955
Department of Art, University of West Florida, Pensacola 057617
Department of Art, University of Wisconsin, Rice Lake 057715
Department of Art, University of Wisconsin Madison, Madison . 057352
Department of Art, University of Wisconsin Oshkosh, Oshkosh . 057591
Department of Art, University of Wyoming, Laramie 057282
Department of Art, Utah State University, Logan 057316
Department of Art, Valdosta State University, Valdosta 057994
Department of Art, Wake Forest University, Winston-Salem 058086
Department of Art, Wartburg College, Waverly 058033
Department of Art, Washburn University of Topeka, Topeka . . 057956
Department of Art, Waubonsee Community College, Sugar Grove 057921
Department of Art, Wayland Baptist University, Plainview 057651
Department of Art, Wayne Community College, Goldsboro 057100
Department of Art, Weatherford College, Weatherford 058038
Department of Art, Wells College, Aurora 056647
Department of Art, West Texas A & M University, Canyon 056793
Department of Art, Western Carolina University, Cullowhee 056926
Department of Art, Western Michigan University, Kalamazoo 057234
Department of Art, Westminster College, Salt Lake City 057794
Department of Art, Wheaton College, Wheaton 058056
Department of Art, Whittier College, Whittier 058060
Department of Art, Wilkes University, Wilkes-Barre 058068
Department of Art, Williams Baptist College, Light 057303
Department of Art, Winona State University, Winona 058082
Department of Art, Wuhan University, Wuhan 055180
Department of Art, York College of Pennsylvania, York 058101
Department of Art, Young Harris College, Young Harris 058102
Department of Art, Youngstown State University, Youngstown 058103
Department of Arts & Sciences, Wilberfoce University, Wilberforce 058067
Department of Arts and Design, Guangzhou University, Guangzhou 055143
Department of Arts and Languages, Fisk University, Nashville 057470
Department of Arts and Sciences, Fuji Joshi Daigaku, Sapporo 055981
Department of Arts, Chadron State College, Chadron 056811
Department of Arts, Fudan University, Shanghai 055163
Department of Arts, Goddard College, Plainsfield 057650
Department of Arts, Otero Junior College, La Junta 057260
Department of Arts, Rutgers University Newark, Newark 057530
Department of Arts, Seiju University, Faculty of Arts and Literature, Tokyo 055992
Department of Arts, Slippery Rock

University of Pennsylvania, Slippery Rock 057881
Department of Arts, Southeast University, Nanjing 055158
Department of Arts, University of Central Oklahoma, Edmond . . . 056999
Department of Arts, University of Minnesota, Minneapolis 057419
Department of Arts, University of New Hampshire, Durham 056986
Department of Byzantine Museums, Athinai 059244
Department of Communication and Fine Arts, Lubbock Christian College, Lubbock 057338
Department of Communication Design, Fine Art and Photography, Virginia Western Community College, Roanoke 057730
Department of Communications and Visual Arts, University of North Florida, Jacksonville 057216
Department of Creative Art, Purdue University, Hammond 057136
Department of Creative Arts, Muskegon Community College, Muskegon 057462
Department of Creative Arts, Siena College, Loudonville 057333
Department of Creative Studies, University of British Columbia Okanagan, Kelowna 055067
Department of Design and Technology, Loughborough University, Loughborough 056533
Department of Design, Housing and Apparel, University of Minnesota, Saint Paul 057784
Department of Design, Lowestoft College, Lowestoft 056534
Department of Design, University of Kansas, Lawrence 057289
Department of Display and Design, Langara College, Vancouver . . 055102
Department of Expressive Arts, Western New Mexico University, Silver City 057875
Department of Fine and Applied Art, Solano Community College, Fairfield 057031
Department of Fine and Applied Arts, University of Nigeria, Nsukka . 056149
Department of Fine and Communication Art, Coppin State College, Baltimore 056658
Department of Fine and Graphic Arts, Northwestern State University of Lousiana, Natchitoches 057472
Department of Fine and Performing Arts, Baruch College, City University of New York, New York 057511
Department of Fine and Performing Arts, Johnson State College, Johnson 057226
Department of Fine and Performing Arts, Saint Joseph's University, Philadelphia 057630
Department of Fine and Performing Arts, Saint Louis University, Saint Louis 057774
Department of Fine and Performing Arts, Spring Hill College, Mobile 057426
Department of Fine Art, Chipola Junior College, Marianna 057366
Department of Fine Art, Dongeui University, College of Art and Sport Science, Busan 056030
Department of Fine Art, Sul Ross State University, Alpine 056602
Department of Fine Art, University of Chester, Chester 056480
Department of Fine Art, University of Reading, Reading 056559
Department of Fine Art, University of

Toronto, Toronto 055092
Department of Fine Art, University of Wisconson Platteville, Platteville 057652
Department of Fine Art, Washington State University, Pullman 057694
Department of Fine Art, West Virginia Wesleyan College, Buckhannon 056772
Department of Fine Arta and History, George Washington University, Washington 058027
Department of Fine Arts, Montgomery 057440
Department of Fine Arts, Taichung 056412
Department of Fine Arts, Taipei . 056416
Department of Fine Arts and Design, Louisiana State University at Alexandria, Alexandria 056595
Department of Fine Arts Gallery, Decatur 048159
Department of Fine Arts, Ahmadu Bello University, Samaru 056150
Department of Fine Arts, Alcorn State University, Lorman 057321
Department of Fine Arts, Allen R. Hite Art Institute, University of Louisville, Louisville 057334
Department of Fine Arts, Amherst College, Amherst 056610
Department of Fine Arts, Andong National University, Andong . . . 056026
Department of Fine Arts, Anhui Normal University, Wuhu 055183
Department of Fine Arts, Arcadia University, Glenside 057097
Department of Fine Arts, Art History and Humanities, Hofstra University, Hempstead 057155
Department of Fine Arts, Augusta State University, Augusta 056644
Department of Fine Arts, Baltimore City Community College, Baltimore 056659
Department of Fine Arts, Barry University, Miami 057391
Department of Fine Arts, Berkshire Community College, Pittsfield . 057649
Department of Fine Arts, Bethany College, Bethany 056689
Department of Fine Arts, Bowie State University, Bowie 056733
Department of Fine Arts, Brandeis University, Waltham 058017
Department of Fine Arts, Butte Community College, Pulga . . . 057693
Department of Fine Arts, Cabrini College, Radnor 057702
Department of Fine Arts, Calhoun State Community College, Decatur 056950
Department of Fine Arts, Cheyney University of Pennsylvania, Cheyney 056829
Department of Fine Arts, Claremont Graduate School, Claremont . . 056863
Department of Fine Arts, College of our Lady of the Elms, Chicopee 056853
Department of Fine Arts, Concordia University, Austin 056649
Department of Fine Arts, Daytona Beach Community College, Daytona Beach 056946
Department of Fine Arts, Delgado College, New Orleans 057490
Department of Fine Arts, Ellsworth Community College, Iowa Falls 057201
Department of Fine Arts, Francis Marion University, Florence . . . 057050
Department of Fine Arts, Gangneung-Wonju National University, Gangneung 056034
Department of Fine Arts, Georgia Southwestern State University, Americus 056606

Deutsches Schaustellermuseum,
Lambrecht 019531
Deutsches Schiefermuseum
Steinach/Thür., Steinach, Kreis
Sonneberg 021570
Deutsches Schiffahrtsmuseum,
Institut der Leibniz-Gemeinschaft,
Bremerhaven 017378
Deutsches Schilder- und Lichtreklame-
Museum, Lahr 019519
Deutsches Schloss-und
Beschlägemuseum, Velbert ... 021897
Deutsches Schuhmuseum Hauenstein,
Hauenstein 018808
Deutsches Schustermuseum,
Burgkunstadt 017467
Deutsches Schweinemuseum
Ruhlsdorf, Teltow 021721
Deutsches Segelflugmuseum mit
Modellflug, Gersfeld 018388
Deutsches Sielhafenmuseum in
Carolinensiel, Wittmund 022290
Deutsches Skimuseum, Planegg 020782
Deutsches Spiele-Archiv,
Nürnberg 020487
Deutsches SPIELEmuseum e.V.,
Chemnitz 017500
Deutsches Spielkartenmuseum,
Landesmuseum Württemberg,
Leinfelden-Echterdingen ... 019628
Deutsches Spielzeugmuseum,
Sonneberg 021514
Deutsches Sport- und Olympia
Museum, Köln 019353
Deutsches Straßenmuseum,
Germersheim 018379
Deutsches Stuhlbaumuseum,
Rabenau 020878
Deutsches Tabak- und
Zigarrenmuseum, Museum Bünde,
Bünde 017441
Deutsches Tabakpfeifenmuseum,
Oberelsbach 020538
Deutsches Tanzarchiv Köln, SK
Stiftung Kultur, Köln 019354
Deutsches Tapetenmuseum,
Museumslandschaft Hessen Kassel,
Kassel 019220
Deutsches Technikmuseum,
Berlin 016900
Deutsches Telefon-Museum,
Morbach 020117
Deutsches Teppichmuseum, Museum
Schloß Voigtsberg, Oelsnitz ... 020606
Deutsches Textilmuseum Krefeld,
Krefeld 019457
Deutsches Theatermuseum,
München 020170
Deutsches Traktoren und Modellauto
Museum e.V., Paderborn 020701
Deutsches Uhrenmuseum, Furtwangen
im Schwarzwald 018298
Deutsches Uhrenmuseum Glashütte,
Glashütte 018428
Deutsches Verpackungs-Museum,
Heidelberg 018834
Deutsches Vulkanmuseum,
Mendig 020025
Deutsches Weinbaumuseum,
Oppenheim 020640
Deutsches Werkzeugmuseum,
Historisches Zentrum der Stadt
Remscheid, Remscheid 020986
Deutsches Zeitungsmuseum, Stiftung
Saarländischer Kulturbesitz,
Wadgassen 021947
Deutsches Zementmuseum,
Hemmoor 018890
Deutsches Zinnfigurenmuseum,
Kulmbach 019499
Deutsches Zollmuseum,
Hamburg 018689
Deutsches Zweirad- und NSU-
Museum, Neckarsulm 020304

Deutschheim State Historic Site,
Hermann 049411
Deutschordensmuseum
Bad Mergentheim, Bad
Mergentheim 016611
Deux Anglès, Flers 103695
Les Deux Ebenistes, Marseille . 128997
Les Deux Illes, New York ... 136256
Les Deux-Mondes, Paris 141049
Les Deux Orphelines, Paris ... 071211
Deux Rue Antiquités, Caluire-et-
Cuire 067550
Deux Rue Antiquités,
Villeurbanne 074166
Deux, Henri, Delft 082843
Deuxièmement, Montréal 064360
Deva, Hartley Wintney 089255
Deva, Marseille 128998
Déva, New York 122781
DeValera Museum and Bruree
Heritage Centre, Bruree 024545
Devaney, Carol, Dublin 079437
Devar, Minneapolis 122259
Devauchelle, Alain, Paris 129218
Devaud, René, Sarras 073374
DeVaults, Tulsa 097561
Devaux, Alain, Camps-en-
Amienois 067567
Devaux, F.J., Bruxelles 128281
Devaux, Ghislaine, Lyon 069675
Devaux, J.F., Charleroi 063543
Devaux, Jean-Claude, Caen ... 067507
Devaux, Jean-Luc, Moulins
(Allier) 140930
Deveau, Robert, Toronto 101462, 125651
Deveaud, Laurent, Bois-le-Roi . 067213
Deveaux, Los Angeles 094152
Deveko, Fourmies 068546
Devereaux, Emile, New Orleans 094922
Devereux Antiques, Linden Park 061729
Deveron Jewellers, Aberdeen . 087982
Devic, Auch 066741
Devilé, Leiden 083241
Deville, Mâcon 069739
DeVille, New Orleans 145045
Deville, Saint-Étienne 072721
Deville, Bernard, Bernot-par-
Guise 067055
Devillé, J., Liège 063696
Devilleneuve, Philippe, Tonnerre 126095
Devillers, Bonnières 067235
Devillers, Liège 063907
Devillers, Charlie, Amiens ... 066510
Devil's Coulee Dinosaur Heritage
Museum, Royal Tyrrell Museum of
Paleontology, Warner 007176
The Devil's Porridge, Eastriggs . 044046
Devils Tower Visitor Center, Devils
Tower 048280
Devisme, Bruno, Amiens 066511
Devisme, Bruno, Flesselles ... 068486
Devivi, Raymond, Saint-Paul-de-
Vence 105537
Devlay, Philippe, Cairo 066162
Devo, Brive-la-Gaillarde 067449
Devon and Cornwall Police
Heritage and Learning Resource,
Okehampton 045377
Devon Gallery, Vancouver 101633
Devon Guild of Craftsmen, Bovey
Tracey 060039
Devon Guild of Craftsmen Gallery,
Bovey Tracey 043453
Devon Pottery Collectors Group, Saint
Albans 060040
Devonia, Boston 094153
Devonport Antiques, North Shore 083880
Devonport Gallery and Arts Centre,
Devonport 001023
Devonport Maritime Museum,
Devonport 001024
Devonport Naval Heritage Centre,
Devonport 043904
DeVos Art Museum, Northern

Michigan University, Marquette 050640
Devotional Art, Los Angeles .. 094153
Devoto, Genova 110116
Devroe, J., Bruxelles 140143
Dew, Roderick, Eastbourne ... 144150
Dewa Roman Experience,
Chester 043729
Dewa San-Zan History Museum,
Tsuruoka 029477
Dewanoyuki Sake Museum,
Tsuruoka 029478
Dewards, Greenslopes 098956
Dewart, Bruxelles 100450
Dewasmes, Jean-Charles, Arras 066678
Dewazakura Bijutsukan, Tendo 029291
Dewberry Valley Museum,
Dewberry 005596
Deweer Gallery, Otegem ... 100675
Dewenter, Runhild, Krefeld .. 130517
Dewey Hotel, Dewey 048281
Dewey Museum, Warminster . 046070
Dewi Lewis, Stockport 138339
Dewindt, Bruxelles 063341
DeWitt County Historical Museum,
Cuero 048047
DeWitt Historical Society Museum,
Ithaca 049695
DeWitt Stetten Jr., Museum of
Medical Research, Bethesda . 046925
DeWitt Wallace Decorative Arts
Museum, Williamsburg 054287
Dewsbury Museum, Dewsbury . 043905
Dewulf, Patrick, Froidestrees ... 068560
Dexing Museum, Dexing ... 007553
Dexter Area Museum, Dexter . 048284
Dexter Historical Society Museum,
Dexter 048283
Dextera, Bilbao 133543
Dey Mansion, Washington's
Headquarters Museum, Wayne 054129
Dey, J.C.A., Marnes-la-Coquette 069832
Deya, Buenos Aires 060886
Deyang Museum, Deyang ... 007554
Deydier, Christian, Paris 071212
Deygas, Bernard, Lyon 128947
Deyl, Wolfgang, Salzburg ... 062759
Dezign House, Jefferson 049756
Dezuttere, Brugge 063213
DF Gallery, Windsor, Ontario . 101717
D'Fab, Brunswick 061213
DG.Art, Paris 104633
DGLM Gallery, Philadelphia .. 123618
Dhaka City Museum, Dhaka .. 003144
Dhaka College of Fine Arts,
Dhaka 054921
Dhakshini, Bangalore 079241
Dharma, Cazadero 138370
Dharma Fine Art, Buenos Aires . 098389
Dhénin, Jean, Saint-Loup-de-
Naud 072859
Dhenkanal Science Centre,
Dhenkanal 023934
Dhennequin, Michèle, Paris ... 141050
D'Hier à Aujourd'hui, Génolhac 068594
D'Hier à Aujourd'hui, Versailles . 074013
D'Hier et Aujourd'hui,
Fontainebleau 068510
D'Hier et d'Ailleurs, Annet-sur-
Marne 066595
D'Hier et d'Ailleurs, Lagny-sur-
Marne 069083
D'Hier et d'Ailleurs,
Wambrechies 074251
D'Hier et d'Aujourdhui, Sisteron 073485
Dhikéos, Pierre, Lyon 104029
Dhoomimal Gallery, Delhi 109369
Dhouailly & Cie., Paris 071213, 141051
Dhyäna-Bernardin, Gap 103710
Di, Norfolk 095687
Di Antonietta, Roma 081163
Di Baio, Milano 137773
Di Bella Concetta, Catania ... 109963
Di Bella, Pietro, Palermo 080867, 132083
Di Blanco, Avignon 103256

Di Blanco, Montélimar 104211
Di Blasi, Marcella, Altenahr ... 105927
Di Castro, Alberto, Roma ... 081164
Di Castro, Angelo, Roma ... 081165
Di Castro, Leone, Roma 081166
Di Castro, Richard, Roma ... 081167,
 081168
Di Cave, Giuliana, Roma 142627
Di Clemente, Simone, Firenze . 079963
Di Colman, Orange 099370
Di Consiglio, Gioia, Roma ... 081169
Di Domizio, Atlanta 091962
Di Elsden, Yandilla 099796
Di Gesaro, Angelo, Palermo .. 110618
Di Giacinto Romani, Tilde,
Bologna 131355
Di Giaimo, Saverio, Napoli ... 080699
Di Giugno, Catania 079864
Di Giugno, Angela, Catania .. 131484
Di Iacovo, Rosanna, Roma ... 081170
Di Ka, Changsha 101879
Di Ka, Liuyang 102041
Di Là Dal Fiume e Tra Gli Alberi,
Concesio 109987
Di Maccio, Laetitia, Sidi Bou
Saïd 117077
Di Maio, Felice, Roma . 081171, 110774,
 132188
Di Marco, Lidia, Roma 081172
Di Marco, Ugo, Roma . 081173, 132289
Di Maria, Massimiliano, Palermo 080868,
 132084
Di Matteo, Stefano, Roma 132290
Di Mauro, Emilio, Cava dei
Tirreni 137732
Di Meglio, Paloma, Milano ... 131827
Di Méo, Paris 104634
Di Napoli, Raffaele, Napoli ... 080700
Di Palma 1961, Napoli 080701, 132006
Di Paolo Arte, Bologna 109831
Di Pasquale, Rocco, Bari 079659
Di Pasquale, Vincenzo, Bari ... 131315
Di Pietrantonio, Alfonso, Roma . 132291
Di Pietro, Giulia, Roma 132292
Di Pinto, Laura & Claudio, Trieste 081621,
 142695
Di Pirro, Roma 132293
Di Pumpo, Matteo, Milano ... 131828
Di Rollo, Edinburgh 117901
Di Sabbato, Fausto, Roma ... 132294
Di Salvatore, Marseille 069877
Di Salvatore, Puyricard 072289
Di Sciascio, Virginia, New York 095184,
 136257
Di Simone, Antonio, Palermo . 132085
Di Stefano, Giuseppe, Palermo . 080869
Di Summa, Giovanni, Roma . 081174,
 110775
Di Teodoro, Dafne, Bari 079660
Di Tutto, Bogotá 065113
Di Vara, Isabella, Roma 081175
Di Veroli, Paris 104635
Dia Art Foundation, New York . 051296
Dia Center for the Arts, New
York 051297
Dia Center for the Arts, Dia Art
Foundation, Quemado 052334
Dia:Beacon, Riggio Galleries, Dia Art
Foundation, Beacon 046812
Dia:Chelsea, Dia Art Foundation, New
York 051298
Diabira, Carole, Bernay-Saint-
Martin 067053
Le Diable Bouilli, Amiens 066512
Diachroniki Gallery, Lefkosia . 065244
Diadema, Saratov 085105
Diagram, Nice 070547
Dial Gallery, Warkworth 119593
Dialogues with the Art of Central
Eastern Europe, Trieste 138860
Diamante Pictures, New York . 122782
Diamantmuseum, Antwerpen . 003204
Diamantmuseum, Grobbendonk . 003582
Diamantschleifermuseum,

Diözesanmuseum Graz, Das Museum der Steirischen Kirche, Graz . . 001953
Diözesanmuseum Linz, Linz . . 002279
Diözesanmuseum Rottenburg, Rottenburg am Neckar . . 021133
Diözesanmuseum Sankt Afra, Augsburg 016451
Diözesanmuseum Sankt Pölten, Sankt Pölten 002639
Diözesanmuseum Sankt Ulrich, Regensburg 020938
Diogenes, Nußdorf-Debant . . 062722
Diogenes Verlag, Zürich 138171
Diomedea, Palermo 110619
Dion Archaeological Museum, Dion 022658
Dion, Jean-Michel de, Bruxelles 063343
Dionie, Cholargos 109074
Dionis Bennàssar, Madrid 039431
Dionisi Antichità, Susegana . . 081460
Dionizo Poškos Baubliai, Šiaulių Aušros Muziejus, Bijotai 030151
Dionne Quints Museum, North Bay 006369
Diop, Baba, Bordeaux 128728
Diorama "Bitva za Dnepr", Dnipropetrovskyj deržavnij istoričnij muzej im Javornic'kogo, Dnipropetrovs'k 042880
Diorama Arts, London 044856
Diorama Bethlehem, Einsiedeln . 041230
Diorama der Schlacht bei Roßbach, Reichardtswerben . . 020964
Diorama Kurskaja Bitva – Belgorodskoe Napravlenie, Belgorodskij Gosudarstvennyj Chudožestvennyj Muzej, Belgorod 036717
Diorama Saint-Bénilde, Sauques-en-Gévaudan 015501
Diorama Šturm Izmaïla, Izmaïl . 042894
Dioramenschau Altötting, Altötting 016356
Dios, Margarita de, Madrid 143566
Diósgyőri Papírgyár Zrt. Papíripari Múzeuma, Miskolc 023456
Diósgyőri Vármúzeum, Miskolc . 023457
Dip 'n' Strip, Calgary 128399
Dip-Strip, Dún Laoghaire 079495, 131268
Dipartimento Ambienta, Construzioni e Design (DACD, Scuola Universitaria Professionale della Svizzera Italiana (SUPSI), Canobbio 056383
Dipartimento di Discipline Artistiche, Musicali e dello Spettacolo, Università degli Studi di Torino, Torino 055932
Dipartimento di Scienze Archeologiche e Storico Artistiche, Università di Cagliari, Cagliari 055819
Dipartimento di Scienze dell' Antichità, Università di Padova, Padova . 055887
Dipartimento di Scienze per l'Architettura (DSA), Università Genova, Genova 055853
Dipartimento di Storia dell'Arte Medievale e Moderna, Università degli Studi di Roma, Roma . . . 055915
Dipartimento di Storia dell'Arte, Facoltà di Lettere e Filosofia, Università degli Studi di Roma La Sapienza, Roma 055914
Dipartimento di Storia delle Arti e dello Spettacolo, Università degli Studi di Firenze, Firenze 055836
Dipartimento di Storia delle Arti, della Musica e dello Spettacolo, Università degli Studi di Milano, Milano . . 055868
Dipartimento di Storia delle Arti, Università di Pisa, Pisa 055900
Dipinti Antichi, Bergamo 079682
Dipinti Antichi, Roma 081177
Dipinti, Enrico, Milano 110319

Diplomatic History Museum, Seoul 029813
Dipressa, Rosina, Torino 132515
Diquero, Yves, Malansac 069769
Diquéro, Yves, Rochefort-en-Terre 072461
Dirección General de Archivos, Bibliotecas y Museos del Paraguay, Asunción 059603
Direct Auction Galleries, Chicago 127431
De Directiekamer, Middelburg . 112678
Direction de Musées de France, Paris 058605
Directiques, New York 095188
Direzione Generale per l'Architettura e l'Arte Contemporanee, Roma . 059357
Diriwächter, Kurt, Luzern 087443
Dirkedaen, Wilnis 133046
Dirksen, Marion, Wiesbaden . . 078886
Dirkx, Mariska, Roermond 112705
Dirt Gallery, West Hollywood . . 125241
Dirven, Jan, Schoten . 063770, 100676
Disabled Person Art Cooperative, Wuxi 058463, 102152
Disagården, Upplandsmuseet, Uppsala 040911
Disaro, Roberto, Milano 142539
Dischinger Heimatmuseum, Dischingen 017675
Discount Graphics, San Francisco 124516
Discover Art Now, London 118515
Discover Greenwich Visitor Centre, Old Royal Naval College, London . . 044857
Discover Houston County Visitors Center-Museum, Crockett . . . 048032
Discover Nepal, Kathmandu . . . 112146
Discover Stamford, Stamford . . 045843
'Discover Tel Aviv' Center at Shalom Mayer Tower, Tel Aviv 025019
Discoveries, Oklahoma City . . . 095804
Discovery, Noosa Heads 061968
Discovery Antiques, Stirling . . . 062237
Discovery Center, Fresno 048939
Discovery Center Museum, Rockford 052536
Discovery Center of Idaho, Boise 047041
Discovery Center of Springfield, Springfield 053353
Discovery Center of Taipei, Taipei 042235
Discovery Center of the Southern Tier, Binghamton 046964
Discovery Center Science Museum, Fort Collins 048755
Discovery Corner, Clayfield . . . 061324
Discovery Creek Children's Museum of Washington DC, Washington . 053981
Discovery Harbour, Penetanguishene 006480
The Discovery Museum, Bridgeport 047166
Discovery Museum, Newcastle-upon-Tyne 045282
Discovery Museum, Science and Space Center, Sacramento . . 052629
The Discovery Museums, Acton 046286
Discovery North Bay Museum, North Bay 006370
Discovery Place, Charlotte 047535
Discovery Point, Dundee 043972
Discovery Science Center of Central Florida, Ocala 051607
Discovery World – The James Lovell Museum of Science, Economics and Technology, Milwaukee . . . 050845
Disella, Kolding 065900
Diseño Muebles Antiguos, Medellín 065197
Dishes From the Past, Fort Worth 093278
Dishman Art Gallery, Beaumont . 046826
Disjointed, Rotterdam 083377
Disparate, Bilbao 085691
Dispela, Los Angeles 094154

La Dispute, Paris 141053
Diss Antiques, Diss . . 088850, 134638
Diss Museum, Diss 043913
Disselhoff, Los Angeles 094155
Dissmann, Jörg, Essen 106872
Distanz-Verlag, Berlin . 137318, 137319
Distanza, Leeuwarden 112632
Distefani, Daniela, Bari 131316
Distill, Toronto 101464
Distilled Art, Bagnolet . 103273, 137076
Distillerie du Périgord, Sarlat-la-Canéda 015486
Distin Auction Room, Eric, Callington 127040
Distinctive African American Art, Salt Lake City 124203
Distinctive Antiques, Claremont . 061315
Distinctive Consignments, Richmond 096374
Distinctive Desks, Dunedin 083746
Distinctive Furnishings, New York 095189
Distomo Archaeological Collection, Distomo 022659
Distribution Group, Bucureşti . . 114220
District Archaeological Museum, Dhar 023928
District Fine Arts, Washington . 125138
District Gallery, Memphis 094466
District Museum, Barpeta 023841
District Museum, Darrang 023897
District Museum, Gulbarga . . . 023951
District Museum, Pillalamarri . . 024130
District Museum, Shimoga 024171
District Museum, Shivpuri 024172
District of Columbia Arts Center, Washington 053982
District Science Centre, Dharampur 023929
District Science Centre, Purulia . 024145
District Science Centre, Tirunelveli 024188
District Six Museum, Cape Town 038498
Distrito Arte, A Coruña 115120
Distrito Cuatro, Donostia-San Sebastián 115135
Dit-Elle, Grignan 140813
DIT Faculty of Applied Arts (Art, Design & Printing), Dublin Institute of Technology, Dublin 055798
Ditchburn & Boxshall, Armadale, Victoria 061013
Ditchling Museum, Ditchling . . . 043914
Ditec, Lisboa 114083
Ditesheim, François, Neuchâtel . 116616
Dithmarscher Landesmuseum, Meldorf 020010
Ditjes en Datjes, Tilburg 083427
Dits, Hornu 138596
Ditt og Datt, Stavanger 084200
Ditterke, Gehrden bei Hannover 075905
Dittmann, A., Daun 075220
Dittmar, Berlin 106164, 137320
Dittmar, Ratingen 078053
Dittmar Memorial Gallery, Nothwestern University, Evanston 048594
Il Ditto Magico, Marseille 128999
Dittrich, Praha 128583
Dittrich, Klaus, Seligenstadt . . . 108615
Dittrick Museum of Medical History, Case Western Reserve University, Cleveland 047774
Dittus, Oberreichenbach 077795
Dittus, Alexander, Zürich 134295
Ditzoff, Bernard, Coppet 116319
Diva Designz, Oakland 123502
Diva Fine Art, Paris 071217
Diva Gallery, Bruxelles 100451
Divadelní Galerie, Uherské Hradiště 102705
Divalco, Mechelen 128332
Divan Edebiyatı Müzesi, İstanbul 042663
Divari Kaleva, Helsinki 140662
Divary, Helsinki 140663
Diverse Works, Houston 049533

Diversified, Oklahoma City 136393
Diversified Collectibles, Indianapolis 093712
The Diversion Gallery, Blenheim 083660
Diversity Books, Mordialloc . . . 139862
Diversity Gallery, Saint Louis . . 124068
Diverso, Amsterdam 082541
Diverssikauppa, Nummi 066330
Divet, Rennes (Ille-et-Vilaine) . . 072393, 072394, 105388, 105389
Divide County Historical Society Museum, Crosby 048036
La Divine Comédie, Aix-en-Provence 103146
Divine Trash, Miami 094564
Divine Word University Museum, Tacloban 034432
Divinely, Seattle 097261
Divisão de Museus, Patrimônio e Arquivo Histórico, Taubaté . . 004838
División Museo e Investigaciones Históricas de la Policía Federal, Buenos Aires 000155
Division of Art and Design, Purdue University West Lafayete, West Lafayette 058046
Division of Art, Design and Architecture, Judson College, Elgin 057002
Division of Art, Elmira College, Elmira 057010
Division of Art, Florida College, Temple Terrace 057947
Division of Art, Meadows School of the Arts, Southern Methodist University, Dallas 056935
Division of Art, School of Fine Arts, Nicholls State University, Thibodaux 057952
Division of Art, University of Lethbridge, Lethbridge 055070
Division of Arts and Sciences, Concordia University, Mequon . 057386
Division of Arts, Harrisburg Area Community College, Harrisburg 057143
Division of Arts, Laramie County Community College, Cheyenne 056828
Division of Arts, Russell Sage College, Troy 057968
Division of Arts, Sage Junior College of Albany, Albany 056589
Division of Arts, Western Nebraska Community College, Scottsbluff 057846
Division of Communication and Fine Arts, Unibetsedåt Guahan, Mangilao 055692
Division of Computer Graphics, Graphic Design and Photography, Sullivan County Community College, Loch Sheldrake 057314
Division of Fine and Performing Arts, Mississippi University for Women, Columbus 056901
Division of Fine and Performing Arts, Sinclair Community College, Dayton 056945
Division of Fine Arts, Brevard College, Brevard 056742
Division of Fine Arts, El Camino College, Torrance 057957
Division of Fine Arts, Fullerton College, Fullerton 057074
Division of Fine Arts, Gulf Coast Community College, Panama City 057603
Division of Fine Arts, Judson College, Marion 057370
Division of Fine Arts, Maryville College, Maryville 057379
Division of Fine Arts, Midwestern State University, Wichita Falls . 058065
Division of Fine Arts, North Central Texas College, Gainesville . . . 057081
Division of Fine Arts, Oakland City

Dunguaire Castle, Kinvara 024737
Dunham Massey Hall, Altrincham 043150
Dunham Tavern Museum,
Cleveland 047775
Dunhill, Cleveland 092772, 135811
Dunhuang Glaswegiansu Guan,
Dunhuang 007566
Dunhuang Museum, Dunhuang . 007567
Dunili Arts, Casuarina 061291
Dunkel, Helmut, Berlin 074740
Dunkeld Antiques, Dunkeld 088907
Dunkeld Cathedral Chapter House
Museum, Dunkeld 043991
Dunker & Nellissen, Münster . . . 142060
Dunkers Kulturhus, Helsingborgs
Museer, Helsingborg 040494
Dunklin County Museum,
Kennett 049881
Dunlop Art Gallery, Regina 006615
Dunluce Antiques, Bushmills . . 088526,
134515
Dunluce House Museum,
Kimberley 038584
Dunmore Cave Visitor Centre,
Ballyfoyle 024535
Dunn & Brown, Dallas 120868
Dunn & Sonnier, New Orleans . 094926
Dunn-Seiler Museum, Mississippi
State 050888
Dunn & Co, Capes, Manchester 127225
Dunn, Hamish, Wooler 091801, 144678
Dunn, John D. & Francis W., Malvern,
Victoria 061772
Dunn, Oliver, Washington 097667
Dunne, Mary, Portarlington 079580
Dunnes, San Jose 136693
Dunnet Pavilion, Castletown . . . 043686
Dunolly Museum, Dunolly 001038
Dunoon Castle House Museum,
Dunoon 043993
Dunrobin Castle Museum,
Golspie 044286
Duns Collection Room, Duns . . . 043997
Dunsborough Gallery,
Dunsborough 098845
Dunsheath, Anah, Auckland . . . 143090
Dunster Castle, Dunster 043999
Dunster, K.W., Staines 091254
Dunvegan Castle, Dunvegan . . . 044000
Dunwell and Community Museum,
Weekes 007190
Duo, Paris 071229
Duo Yun Xuan, Shanghai 102071
Duodecimo, Gent 128302
Il Duomo, New York 095198
Dupard, Yvonne, Pougues-les-
Eaux 072253
Dupasquier, Pierre-Alain, Bulle . 087153,
134058
Dupeux, L'Isle-d'Espagnac 140833
Dupeyron, Claude, Castelmoron-sur-
Lot 067649
Dupeyron, Dominique, Orléans . 070764
Dupin, Juliette, Paris 129225
Duplan, Frédéric, Lille 069433
Duplantier, Mireille, Hasparren . 068739
Duplessis, Jacques Vigoureux,
Vignory 074086, 141346
Dupont, Kortrijk 063663
Dupont, Washington 125139
DuPont-Antiquités, Saint-Ouen . 073032
Dupont Gallery, Lexington 050212
DuPont Historical Museum,
DuPont 048359
Dupont, Chantal, Troyes 073863
Dupont, Eric, Paris 104655
Dupont, Jean, Troyes 073864
Dupont, Marlène Edith, Montreuil-sous-
Bois 129050
Dupont, Roberte, Troyes 073865
Dupont, Sophie, Paris 071230
Dupont, Thérèse, Fribourg 134081
Dupoux & Co, Wien 128173
Duprat, Miguel, Saintes 073333

Dupraz, Jean-Baptiste, Villars-sur-
Glâne 134268
Dupré, Rob, Amsterdam 082551
Duprez, Monique, Paris 071231
Dupront, Salon-de-Provence . . . 073348
Dupuis, Bernard, Nice 129093
Dupuis, Dominique, Saint-Quentin
(Aisne) 129474
Dupuis, Joël, Condette 103578
Dupuis, Joël, Hardelot-Plage . . . 103757
Dupuis, Robert Alexander René,
Berlin 129712
Duputel, Paris 071232, 104656
Dupuy, Daniel, Pujols 072282
Dupuy, Eonnet, Paris 104657
Dupuy, Francis, Honfleur 125871
Dupuy, Michèle, Paris 071233
Dura-Strip of Santa Monica, Los
Angeles 136064
Dural Antiques, Dural 061411
Dural Galleries, Dural 098847
Durán, Madrid 085997, 115270, 126749
Duran, Exposiciones de Arte,
Madrid 115271
Durán, Fernando, Madrid 085998,
085999, 126750, 126751, 126752,
126753, 143567
Durán, Pedro, Madrid 126754
Durance, G., Nantes 140943
Durand, Calgary 101095
Durand-Réville, Françoise, Paris 071234
Durand-Ruel & Cie., Paris 104658
Durand, Brigitte, Saint-Maur-des-
Fossés 072924
Durand, Brigitte, Sens 073458
Durand, Gilles, Villeurbanne . . . 074168
Durand, Guy, Montceau-les-
Mines 070172
Durand, Jean-Michel, Menil-la-
Tour 070000
Durandot, Denis, Dijon 128820
Durango, Carmen, Valladolid . . 115620
Durant & Kotek, Bruxelles 063349
Durant, Eliane, Saint-Laurent-de-la-
Salanque 072842
Durante, Giovanni, Roma 081179
Durations Gallery, Baltimore . . . 120012
Durban Art, Westbridge 059731
Durban Art Gallery, Durban 038520
Durban House Heritage Centre, D.H.
Lawrence Birthplace Museum,
Eastwood 044048
Durban Natural Science Museum,
Durban 038521
Durban Segnini, Caracas 125326
Durban Segnini, Miami 122052
Durbes Pils, Tukums 030069
Ďurčanský, Alexej, Trnava 133422
Durchblick-Galerie, Leipzig 107801
Durden, Memphis 121968
Dureau, Laurence, Bourges 067370
Durero, Gijón 115158
Duret Dujarric, Paris 104659
Durga's Art, Mumbai 109447
Durham Art Gallery, Durham . . . 005624
Durham Art Guild, Durham 048368
Durham Cathedral Treasures of Saint
Cuthbert, Durham 044004
Durham Center Museum, East
Durham 048386
Durham Heritage Centre and Museum,
Durham 044005
Durham Historic Association Museum,
Durham 048363
Durham House Antiques Centre, Stow-
on-the-Wold 091321
Durham Light Infantry Museum and
Durham Art Gallery, Durham . . 044006
Durham Western Heritage Museum,
Omaha 051673
Durier, Limony 069481
Duriez, Alain, Grignan 068687
Durif, Rennes (Ille-et-Vilaine) . . . 072395
Durjaven Kulturen Center Dvoreca,

Balčik 004887
Durkee, Michael, Wincanton . . . 135588
Durlacher, Natasha, London . . . 118521
Durot, Charles, Beaurepaire-en-
Bresse 066994
Durot, Gilles, Saint-Bris-le-
Vineux 072660, 129448
Duroub, Cairo 102977
Durrell Museum, Durrell 005625
Durrenberger, Henri, Molieres . . 104195
Durrow High Cross and Early Christian
Monastic Site, Durrow 024689
Durst, H., Kirchheim unter Teck 076742
Durst, Jean, Paris 071235, 129226
Duru Artspace, Seoul 111676
Dury, Christian, Nice 104311
Dusable Museum of African-American
History, Chicago 047620
Dusan, Wollongong 062437
Dusan, Bartko, Halle, Saale . . . 076107
Dusarduijn, Robert, Amsterdam . 082552
Dusart, Jean-Luc, Poitiers 072179
Dusch, Peter, Speyer 078439
Duse, Leonardo, Brescia 079768
Duseaux, Paris 071236
Duson, Los Angeles 094158
Duss, Martin, Niederrohrdorf . . . 116627
Dussably, Marie-Thérèse,
Charolles 067800
Dussi, Paola, Milano 131831
Dussort, Maurice, Beaune 066959
Dussouchaud, Didier, Saint-
Junien 072830
Dust, Las Vegas 121625
Dust & Rust, Murchison 083843
Dust Jacket, Cincinnati 144808
Dutch Art, Rotterdam 112723
Dutch Dakota Association Exhibition,
Schiphol 032677
Dutch Iris, Baltimore 092154
Dutch Museum Amsterdam,
Amsterdam 112268, 137927
Dutch Period Museum, Colombo 040279
Dutch Touch Gallery, Philadelphia 123622
Dutch Wall Art, Hilversum 112622
Dutchess County Arts Council,
Poughkeepsie 060462
Dutchess County Historical Society,
Glebe House & Clinton House,
Poughkeepsie 052244
Dutel, Jean-Pierre, Paris 141056
Duteurtre, Philippe, Valognes . . 073916,
129555
Dutilleul, Albi 066454, 103167
Dutilleul, Noel & Giuseppe,
Firenze 079966
Dutko, Jean-Jacques, Paris 071237,
104660
Dutoit, Marcel, Unterentfelden . . 087666,
134262
Dutrieux, F., Bruxelles 063349
Dutta, Genève 087271, 116391
Duttenhofers Books, Cincinnati . 144809
Dutto, Riccardo, Torino 081528
Dutton, Charlie, London 118522
Dutton, D., Los Angeles 144964
Duval, Jacksonville 093821
Duval, Anne-Sophie, Paris 071238
Duval, Raymonde, Paris 104661
Duval, Robert & Myriam,
Équeurdreville-Hainneville . . . 103668
Duvall, Atlanta 091964
Duvallier, L. & W., Dublin 079440
Duvauchelle, Frédéric, Bannalec 066872
Duvauchelle, Frédéric, Paris . . . 071239
Duveau-Sage, Catherine & Philippe,
Paris 071240
Duvert, Martial, Crest 068179
Duvieu, Jacques, Villerville 074145
Duvillard, André, Beaune 066960
Duvillard, Guy, Beaune 066961
Duvillier, Arnaud, Chaumont (Haute-
Marne) 125831

Duvivier, Jacques & Anne, Châtillon
(Hauts-de-Seine) 067858
Duwisib Castle, Maltahohe 031668
Dux, Frank, Bath 088161
Duxbury Rural and Historical Society,
Duxbury 048376
Duyn, Joop, Kenmare 131276
Duys, Oss 083338
Dväsätts Auktionsbyrå,
Östersund 126859
D'Vine House, Fredericksburg . . 127493
Dviračių Muziejus, Šiaulių Aušros
Muziejus, Šiauliai 030292
Dvor Trakoščan, Trakoščan 008839
Dvor Veliki Tabor, Muzeji Hrvatskog
Zagorja, Desinić 008735
Dvorac u Čelarevu, Čelarevo . . . 038013
Dvořáček, Kolín 065337
Dvořák, České Budějovice 065300
Dvořák, Jan, Benešov 102521
Dvořáková, Jana, Náchod 065358
Dvořákovo Muzeum Kolínska v
Pravěku, Regionální Muzeum v Kolín
in ancient time, Kolín 009473
Dvorec-Muzej Betnava, Maribor 038390
Dvorec-Muzej Petra I, Sankt-
Peterburg 037556
Dvorec-muzej Petra III, Muzej-
zapovednik Oranienbaum,
Lomonosov 037028
Dvorec Petra I, Strelna 037729
Dvorec Štatenberg, Makole 038389
Dwarf Gallery, Reykjavík 109236
DWF French Polishers, London . 134971
Dwight D. Eisenhower Library-
Museum, Abilene 046273
Dwight Frederick Boyden Gallery,
Saint Mary's College of Maryland,
Saint Mary's City 052731
Dwór Artusa, Muzeum Historyczne
Miasta Gdańska, Gdańsk . . . 034559
Dwór w Dołędze, Muzeum Okręgowe
w Tarnowie, Zabórów 035272
Dworek Jana Matejki w
Krzesławicach, Kraków 034696
Dworek Wincentego Pola, Muzeum
Lubelskie, Lublin 034820
Dworski, Marijana, Hay-on-Wye 144221
Dwyer, Paul, Melbourne 099167
Dwyer, Sammie, Austin 092062
Dyansen, Boston 120141
Dybeck, Stockholm 086803
Dycheling Antiques, Ditchling . . 088851
Dyck International Art Collection,
Rosny-sous-Bois 105417
Dycke, Everhard F., München . . 142027
Dyckman Farmhouse Museum, New
York 051300
Dyehouse Gallery, Waterford . . . 109711
Dyekjær & Kaae, Lemvig 065914
Dyer Memorial Library, Abington 046280
Dyer & Sons, W., Hayle 089287
Dyfed Antiques, Haverfordwest . 089277
Dyhrfjeld, Jørgen, Frederikssund 065616
Dyka, Corinne, Nice 070549
Dykällans Antik, Frändefors . . . 086490
Dylan, Garches 068557
Dylan, Swansea 144614
Dylan Thomas Boathouse,
Laugharne 044639
Dylan Thomas Centre, Swansea 045924
Dylan's Bookstore, Swansea . . . 144615
Dyma, Walter & Steffen, Rottweil 108534
Dyna, Dallas 135851
Dynamic Impressions, Calgary . 101096
Dynamic Traders, Milwaukee . . 094686
Dynamo Arts, Vancouver 101639
Dynasties Antique and Art Gallery,
Singapore 085222, 114596
Dynasties Art, Montréal 064361
Dynasty Antiques Gallery, Hong
Kong 064977
Dynasty Art Gallery, Taipei 116991,
138186

Ebbas Hus, Malmö Museer,
Malmö 040626
Ebbw Vale Works Museum, Ebbw
Vale 044049
Ebeck, Aabenraa 102719
Ebeling, Bergisch Gladbach 074687
Ebeling, Köln 076791
Ebeling, Barbara, Aumühle . . . 129632
Ebeltoft Antikvariat, Ebeltoft . . 140528
Ebeltoft Kunstforening, Ebeltoft . 058518
Ebeltoft Museum, Ebeltoft 009878
Ebene, Paris 071241
Ebène et Sycomore, Gex 068602
Ebène Original, Cannes 103458
Ebenezer Maxwell Mansion,
Philadelphia 051953
Ebenhoch, Inge, Feldkirch 062544
Ebenhofer, Leopold, Perg 062734
L'ebéniste, Nice 129094
Ebeniste, D., New York 095200, 136262
Ebénisterie & Tradition, Ancenis 066528
Ebénistrie d'Art Campagna,
Marseille 129002
Ebensperger, Patrick, Graz 099861
Éber Emlékház, Türr István Múzeum,
Baja 023100
Eberhard, Solothurn 087623
Eberhard und Barbara Linke Stiftung,
Flonheim 058808
Eberhardt, Petra & Wolfgang,
Münstermaifeld 108237
Eberhart, Karl, Ermatingen . . . 087225
Eberhart, Robert,
Schönholzerswilen 087611
Eberhart, Robert, Sulgen 087639
Eberl, H., Berlin 129713
Ebersberg, Erbach,
Odenwaldkreis 075578
Ebersdorfer Schulmuseum,
Chemnitz 017501
Ebert & Björk, Stockholm 115949
Ebert-Schwarz, Rebekka,
München 130696
Ebert, Karl-Otto & Monika,
Klingenberg am Main 076761
Eberwein, Freiburg im Breisgau 075805
Eberwein, Roswitha, Göttingen . 075987
Ebes, Douwma, Melbourne . . . 061808,
099168
Ebetsu-shi Bijutsu Togeikan,
Ebetsu 028341
Ebinger Heimatmuseum, Albstadt 016296
Ebinger, Jürgen, Bad Neuenahr-
Ahrweiler 074518
Ebinger, Michael, Würzburg . . . 078990
Ebisons & Harounian, New York 095201
Ebisubashi, Osaka 111364
Ebiya, Tokyo 081966
Ebjay, Merbein 061833
Ebland, Verona 111202
Ebner Numismatik, Freiburg im
Breisgau 075806, 126203
Ebner von Eschenbach, Kristian,
Berlin 074741
Ebony, Dallas 120869
Ebony Elevations, Indianapolis . 121459
Ebony Framing Gallery, Limerick 109675
Ebran, Patrick, Le Havre 069223
Ebreuil, Royan 072587
Eburne, Paris 071242
ECA, Pézenas 072092
Ecce, Rotterdam 112724
Ecce Homo, Jerusalem 024899
Eccentricities, London 089900
Eccles Community Arts Center,
Ogden 051625
Eccles Road Antiques, London . 089901
Ecclesiastical Museum, Komotini 022757
Ecclesiastical Museum, Sifnos . . 022919
Ecclesiastical Museum
of Alexandroupolis,
Alexandroupolis 022529
Ecclesiastical Museum of the Holy
Bishopry of Maroneia and Komotini,

Komotini 022758
Ecclesiastical Museum, Cathedral of
Christ the King, Mullingar 024775
Ecco Arte, Graz 062569
Eccola, Los Angeles 094160
Echancrure Galerie, Bruxelles . . 100453
Echandi, Enrique, San José . . . 102388
Echange, Maurice, Brumath . . . 125814
Echarri, Pamplona 086211
Echauguette, Nevers 070488
Echauri, Fermin, Pamplona . . . 086212,
115481, 115482
Echeberria Monteberria, J., Donostia-
San Sebastián 115136
Echenard, Michel, Villars-sous-
Mont 087686
Echeverri Valasquez, Eduardo,
Medellín 102334
Echeverría, Zaragoza 086420
Echigo-Tsumari Art Triennial,
Tokamachi 098078
Echizen Crab Museum, Echizen 028342
Echizen Pottery Gallery, Echizen 028343
Echizen Take-ningyo-no-sato,
Maruoka 028814
Echmiadzin Art Gallery,
Echmiadzin 000686
Echmiadzin Cathedral Complex and
Museum, Echmiadzin 000687
Echnaton Gallery, Cairo 102978
Echo, Columbus 092850
Echo, Toledo 097439
Echo Antiques, Reepham 090940,
135306
Echo Art Deco, Zürich 087754
Echo Chamber, Aptos 119807
Echo du Passé, Le Havre 140826
Echo Gallery, Chicago 120392
Echo Gallery, Washington 125140
Echo Historical Museum, Echo . 048428
Echo Home, Tulsa 097563
Echoes, Todmorden . . 091463, 135489
L'Echoppe du Cloître, Aigle . . . 086997
Echoppe Saint-Guénhaël, Vannes
(Morbihan) 105775
Echos d'Art, Ollioules 104373
Echos From the Past, San
Antonio 096804
Echuca Gem Club Collection,
Echuca 001045
Echuca Museum, Echuca 001046
Eckardt, Dr. Hans-Georg, Berlin . 141452
Eckart, Hans, Altenmarkt im
Pongau 127976
Eckart, Karl-Heinz, Ellwangen . . 075551
Ecker, Brigitte, Ingolstadt 076548
Ecker, Helmut, Spiegel 134244
Eckert, Indianapolis 112548
Eckert & Nolde, Erfurt . 075590, 126192
Eckert, D., Bremen 141577
Eckert, Iris, Kampen 107482
Eckhardt, M., Aglasterhausen . . 074322
Ecklé, Bruno, Nogent-le-Rotrou . 125940
Eckley Miners' Village, Eckley . . 048430
Eckley Miners' Village, Pennsylvania
Historical & Museum Commission,
Weatherly 054137
Eclat d'Art, Colmar 103570
Eclectic, Abu Dhabi 087915
Eclectic, Nelson 083859
Eclectic Art Gallery, Pittsburgh . 123788
Eclectic Attic, Singapore 085224
Eclectica, London 089902
Eclectica, Saint Louis 096530
Eclectique, Exeter 089019
Eclectique Antiques, New
Orleans 094927
Eclectics, New York 095202
Eclectiques Antique Mall,
Columbus 092851
Eclectors, Houston 093497
Eclips, Nijmegen 112691
Eclipse, Calgary 101097
Ecliptic Gallery, Armadale,

Victoria 098509
Eco Bush Art Gallery, Surfers
Paradise 099597
Eco d'Arte Moderna, Firenze . . 059359,
137745, 138864
Éco-Musée de la Blanchisserie,
Grezieu-la-Varenne 013004
Éco-Musée de la Noix, Castelnaud-la-
Chapelle 012172
Eco-Musée des Etouvières,
Thônes 015741
Éco Musée Vivant de Provence, La
Gaude 013235
Ecodrome Zwolle, Zwolle 032944
Ecole Bohemiarte, Montréal . . . 055075
Ecole Camondo, Paris 055336
Ecole Cantonale d'Art de Lausanne –
ECAL, Lausanne 056390
Ecole Cantonale d'Art du Valais,
Sierre 056399
Ecole d'Architecture de Strasbourg,
Strasbourg 055358
Ecole d'Art, La Chaux-de-Fonds 056384
École d'Art d'Avignon, Avignon . 055294
École d'Art du Havre, Le Havre . 055312
École d'Art Gérard Jacot, Belfort 055295
Ecole d'Art Marseille-Luminy,
Marseille 055318
École d'Art, Annecy 055291
École d'Arts de Rueil-Malmaison,
Rueil-Malmaison 055310
École de l'Image d'Epinal, Epinal 055310
École de Recherche Graphique – ERG-
ESA, Bruxelles 054937
École Dentellière, Bailleul 011691
Ecole des Arts, Bruxelles 054938
Ecole des Arts Appliqués, Haute
Ecole Supérieure d'Arts Appliqués,
Genève 056387
École des Arts et Céramique,
Tarbes 055361
Ecole des Arts Visuelles, Université
Laval, Québec 055084
Ecole des Beaux-Arts, Wavre . . 054990
Ecole des Beaux-Arts de Bordeaux,
Bordeaux 055297
École des Beaux-Arts de la Réunion,
Le Port 056202
Ecole des Beaux-Arts, Galerie des
Beaux-Arts, Cherbourg-Octeville 055304
Ecole des Buissonnets, Sierre . . 116728
Ecole du Louvre, Paris 055337
École du Rang II d'Authier,
Authier 005263
Ecole Municipal d'Art Plastique
E.M.A.P., Nice 055328
École Municipal d'Arts Plastiques,
Saint-Jean-de-Védas 055357
École Municipale d'Arts Plastiques,
Menton 055321
Ecole Municipale d'Arts Plastiques,
Riom 055353
Ecole Municipale des Beaux
Arts, Collège Marcel Duchamp,
Châteauroux 055303
Ecole-Musée de Champagny,
Champagny 012247
Ecole Nationale d'Art Décoratif,
Aubusson 055293
Ecole Nationale des Arts, Bangui 055112
Ecole Nationale des Arts d'Haïti, Port-
au-Prince 055695
Ecole Nationale des Arts Douta Seck,
Médina 056267
Ecole Nationale des Beaux-Arts de
Lyon, Lyon 055317
Ecole Nationale des Chartes,
Paris 055338
École Nationale Supérieure d'Art,
Dijon 055307
Ecole Nationale Supérieure d'Art de
Nancy, Nancy 055326
Ecole Nationale Supérieure d'Art
Décoratif de Limoges-Aubusson,

Limoges 055314
Ecole Nationale Supérieure d'Arts de
Bourges, Bourges 055298
École Nationale Superieure d'Arts de
Cergy-Pontoise, Cergy-Pontoise 055302
École Nationale Supérieure d'Arts
et Métiers, Université Française
d'Egypte, El Shorouq 055276
École Nationale Supérieure de
Création Industrielle ENSCI,
Paris 055339
École Nationale Supérieure de la
Photographie, Arles 055292
École Nationale Supérieure des Arts
Appliqués Duperré, Paris 055340
Ecole Nationale Supérieure des Arts
Décoratifs (Ensad), Paris 055341
École Nationale Supérieure des Arts
Visuels de la Cambre, Bruxelles 054939
Ecole Nationale Supérieure des Beaux-
Arts, Paris 055342, 137172
École Régionale d'Artce,
Dunkerque 055309
École Règionale d'Arts Plastiques,
Fort-de-France 056080
Ecole Régionale des Beaux-Arts,
Nantes 055327
Ecole Régionale des Beaux-Arts,
Rennes (Ille-et-Vilaine) 055352
Ecole Régionale des Beaux-Arts,
Rouen 055354
Ecole Régionale des Beaux-Arts de
Caen, Caen 055300
Ecole Régionale des Beaux-Arts de
Valence, Valence 055368
Ecole Régionale des Beaux-Arts et
Arts Appliqués, Besançon . . . 055296
Ecole Régionale Supérieure
d'Expression Plastique,
Tourcoing 055365
École Spéciale d'Architecture,
Paris 055343
Ecole Supérieur des Arts Saint-Luc
Liège, Liège 054965
Ecole Supérieure d-Art et de Design
de Saint-Étienne, Saint-Étienne 055356
Ecole Supérieure d'Art, Cambrai 055301
Ecole Supérieure d'Art, Metz . . 055322
École Supérieure d'Art d'Aix-en-
Provence, Aix-en-Provence . . . 055287
Ecole Supérieure d'Art de Clermont
Communauté, Clermont-Ferrand 055305
École Supérieure d'Art de Grenoble,
Grenoble 055311
Ecole Supérieure d'Art de Toulon,
Toulon (Var) 055362
Ecole Supérieure d'Art et de Design
ESAD, Amiens 055288
Ecole Supérieure d'Art et Design,
Reims 055351
École Supérieure d'Arts de Brest,
Brest 055299
École Supérieure d'Arts de Lorient,
Lorient 055315
École Supérieure de l'Image,
Poitiers 055349
École Supérieure de l'Image ESI,
Angoulême 055290
Ecole Supérieure des Arts Décoratifs,
Strasbourg 055359
École Supérieure des Arts et de la
Communication de Pau, Pau . . 055347
Ecole Supérieure des Arts Institut
Saint-Luc à Tournai, Ramegnies-
Chin 054974
École Supérieure des Arts Staint-Luc,
Bruxelles 054940
École Supérieure des Beaux-Arts,
Nîmes 055330
École Supérieure des Beaux-Arts,
Toulouse 055363
École Supérieure des Beaux-Arts
Ahmed et Rabah-Salim Asselah
(L'ESBA), Alger 054789

Epping Forest District Museum,
Waltham Abbey 046062
Eppler, Karlsruhe 141855
Eps, H.J., Michelstadt . 077307, 130661
Epsom Art Gallery, Auckland . . . 112849
Eptek Art & Culture Centre, Centre
des Arts et de la Culture – Prince
Edward Island Museum and Heritage
Foundation, Summerside 006931
Epworth Old Rectory, Epworth . . 044127
Equator Gallery, Boston 120143
Equatorial America, New York . . 122811
Equilibrium, Folkestone 117998
Equilibro, Solothurn 143924
Equine Images, Fort Dodge . . . 139392
Equine Museum, Gwacheon . . . 029763
Equine Museum of Japan & JRA
Racing Museum, Yokohama . . 029528
Equinocial Antiguidades, Rio de
Janeiro 064000
Equinox Gallery, Vancouver . . . 101640
Equinox Studio Gallery, Enmore . 098859
Equinoxe Groupe Artisanat
Contemporain, Yvoire 105841
Equipement Culturel Les Pénitents,
Gap . 068573
Equipo Patina, Madrid 133688
Equity Art Brokers, New York . . 122812,
122813
Equrna Gallery, Ljubljana 114781
Era, Toronto 064586
Erard, Patrick, Sauxillanges . . . 129484
Erasmus, Amsterdam 142844
The Erasmus Smith Trust Archive,
Dublin 024623
Erasmushaus, Basel 143823
Erba, Bari 079663
Erbar, Kurt, Cochem 075219
Erbario, Università di Bologna,
Bologna 025372
Erbe, Ulli, Bad Bertrich 129638
Erben, Kurt, Wien 062902
Erben, Thomas, New York 122814
Erbetta, Paolo, Foggia 110092
Erbguth, Eckhardt, Dabel 106636
Erbland, Pierre, Paris 141063
Erbs-Mailleux, E., Angers 128684
Erbstück, Stade 078444
Erckens, Fritz, Aachen 074293
Ercoa, Bilbao 133544
Ercsi Helytörténeti Gyűjtemény,
Ercsi 023301
Erdai Art Hall, Magong 042113
Erddig, Wrexham 046230
Erdefunkstelle Aflenz, Au bei
Aflenz 001723
Erdész, Szentendre 079222
Erdészeti & Szabadtéri Erdészeti
Múzeum, Szilvásvárad 023648
Erdészeti-, Faipari- és
Földméréstörténeti Gyűjtemény,
Sopron 023563
Erdgeschichtliches Museum, Lauffen
am Neckar 019602
Erdmann, Erika, Konstanz 141910
Erdőhegyi, Péter, Budapest . . . 109149
Erdős Kamill Cigány Múzeum,
Pécs 023515
Erdos Renée-Ház – Kiállítóterem,
Budapest 023154
Erdos, John, Singapore 085227
L'Ere du Temps, Genève 087273
Ere du Temps, Sainte-Savine . . 073327
Erebouni Museum of the
Establishment of Yerevan,
Yerevan 000725
Eredi Antonio Esposito, Firenze . 079967
Eredi Giuseppe Tanca, Roma . . 081182
Erегli Müzesi, Ereğli 042621
Erelöf, Stefan, Stockholm 086807,
133924
Eremita, Mario, Ponzano Veneto 110689
Eremiten-Presse, Düsseldorf . . 137394
Eremus Antichità, Langhirano . . 080139

Eren, İstanbul 117120
Erents, Almere 082456
Eretz-Israel Museum, Tel Aviv . . 025020
Eretz-Israel Museum Tel Aviv, Tel
Aviv 025021
Erewash Museum, Ilkeston 044489
't Erf Antiek, Rotterdam 083380, 132998
Erfahrungswelt Entfaltung der Sinne,
Essen 018040
Erfatal-Museum Hardheim,
Hardheim 018773
ErfinderZeiten, Auto & Uhrenmuseum
Schramberg, Schramberg 021334
Erfurter Kunstverein e.V., Erfurt . 058811
Ergon Verlag, Würzburg 137663
Erhardt-Kayser, Nina, Berlin . . . 129715
Eric Carle Museum of Picture Book
Art, Amherst 046415
Eric Thomas Galley Museum,
Queenstown 001438
Erica Antique, Uppsala 086934
Erich-Bödeker-Gesellschaft für naive
Kunst e.V., Hannover 058812
Erich Comeriner Archiv und Nachlass,
Bielefeld 017150
Erich Dohrendorf
Restaurierungswerkstatt,
Hamburg 130264
Erich Johann Czernoch, ars
poetica Verlag für Literatur und
Kunst, Grafenau, Kreis Freyung-
Grafenau 137438
Erich Kästner Museum Dresden,
Micromuseum, Dresden 017744
Erich Mäder-Glasmuseum,
Grünenplan 018584
Erich-Mäder-Glasmuseum,
Grünenplan 018585
Erich Maria Remarque-
Friedenszentrum, Osnabrück . . 020655
Erichsen, Jørgen, Helsingør . . . 065672
Erichsens Gaard, Bornholms Museum,
Rønne 010119
Erichson, Jörn, Bad Gandersheim 129645
Erickson, Arthur W., Portland . . 096236
Erickson, Dan, Saint Paul 096656
Erickson, Elaine, Milwaukee . . . 122192
Ericson, David, Salt Lake City . . 124206
Erie Art Museum, Erie 048556
Erie Canal Museum, Syracuse . . 053517
Erie Canal Village, Rome 052572
Erie History Center, Erie 048557
Erika-Fuchs-Haus, Museum für Comic
und Sprachkunst, Schwarzenbach an
der Saale 021375
Erikas Puppenstube, Bamberg . . 074618
Erikdals- och Söderboden Antik,
Stockholm 086808
Eriksbergs Museum, Tranås . . . 040885
Eriksborg Vagnmuseum, Ystad . 040980
Eriksdale Creamery Museum,
Eriksdale 005677
Eriksen, Trondheim 133169
Eriksen, Tone, Oslo 133153
Eriksson, Anita, Falun 143642
Eriksson, Olle, Grums 115764
Erin House Prints, Burn 117618
Erindale's Antiques, Erindale . . 061442
Erinnerungsstätte an die
Zwangsarbeit auf dem Gelände des
Volkswagenwerk, Wolfsburg . . 022320
Erinnerungsstätte Baltringer Haufen –
Bauernkrieg in Oberschwaben,
Mietingen 020064
Erinnerungsstätte Luftbrücke
Berlin in Fassberg, Technisches
Ausbildungszentrum der Luftwaffe,
Fassberg 018085
Erinnerungsstätte Notaufnahmelager
Marienfelde, Berlin 016905
Erinnerungsstätte Ständehaus,
Karlsruhe 019198
Eritrean Archaeological Museum,
Asmara 010430

Erkebispegården, Trondheim . . . 033852
Erkel Ferenc Emlékház, Corvin János
Múzeum, Gyula 023347
Erkel Ferenc Múzeum, Gyula . . . 023348
Erkenbert-Museum, Frankenthal,
Pfalz 018138
Erker-Galerie, Sankt Gallen . . . 116698,
138154, 143915
Erland Lee Museum, Stoney
Creek 006911
Erlauftaler Feuerwehrmuseum,
Purgstall an der Erlauf 002497
Erlbacher, Erika, Wagrain 062837
Erlebnis-Zentrum Terra Vulcania,
Mayen 019983
Erlebnismuseum "Mensch und
Landschaft", Hermeskeil 018910
Erlebnismuseum Anzenaumühle, Bad
Goisern 001733
Erlebnismuseum Grottoneum,
Saalfeld/Saale 021162
Erlebniswelt Blockflöte, Fulda . . 018286
Erlebniswelt Flederwisch, Furth im
Wald 018294
Erlebniswelt Grundwasser,
Langenau 019565
Erlebniswelt Haus MEISSEN in der
Manufaktur MEISSEN, Meißen . 020005
Erlebniswelt Renaissance –
Schloß Bevern, Bevern, Kreis
Holzminden 017126
Erlebniswelt U-Boot GmbH,
Sassnitz 021229
ErlebnisZentrum Bergbau
Röhrigschacht, Sangerhausen . 021197
Erlemann, Hartmut, Eutin 141671
Erlen, Steffisburg 087635
Erlengut, Steffisburg 116751
Erler, Berlin 106174
Erler, Hans Jörg, Wien 062903
erlesenes – Antiquariat & Buchhandlung,
Mag. Joy Antoni, Wien 128176, 140062
Erlianhaote Saurian Museum,
Erlianhaote 007570
Erlinger, Günter, Nürnberg 077743
L'Erma, Roma 138866
Ermatinger Old Stone House, Clergue
National Historic Site, Sault Sainte
Marie 006829
L'Ermete, Roma 110782
Ermgassen, H., Hermannsburg . 076443
Ermini, Bastia 066900
Ermita de San Antonio de la Florida
y Museo Panteón de Goya,
Madrid 039432
Ermita de San Baudelio de Berlanga,
Caltojar 039020
Ermita de Sant Feliu, Xàtiva . . . 040235
Ermitaż Antikvarno-juvelirnyj Salon,
Nižnij Novgorod 085049
Erna och Victor Hasselblads
Fotografiska Centrum, Göteborg 040452
Ernes, E., Liège 063699, 128328
Ernest, Cluj-Napoca . . 084943, 143432
Ernest and Marion Davis Medical
History Collection, Auckland . . 032965
Ernest Hemingway House Museum,
Key West 049908
The Ernest W. Michel Historical
Judaica Collection, New York . 051302
Ernesta Birznieka-Upiša Muzejs
Bisnieki, Pastariņa Muzejs,
Zentene 030090
Ernhardt, Holger, Stuttgart 078517
Erni, Muttenz 134187
Erni & Fornara-Erni, Simone,
Luzern 116561
Ernie Pyle Museum, Dana 048099
Ernie's Antiques, Jacksonville . . 093824
Ernst, Konstanz 107701
Ernst, Paderborn 108363
Ernst Barlach Gesellschaft e.V.,
Wedel 058813
Ernst Barlach Haus, Stiftung Hermann

F. Reemtsma, Hamburg 018693
Ernst Barlach Museum,
Ratzeburg 020914
Ernst Barlach Museum Wedel,
Wedel 022033
Ernst Barlach Stiftung Güstrow,
Atelierhaus, Ausstellungsforum und
Graphikkabinett, Güstrow 018598
Ernst Barlach Stiftung Güstrow,
Gertrudenkapelle, Güstrow . . . 018599
Ernst-Bloch-Zentrum, Ludwigshafen
am Rhein 019798
Ernst Fuchs Museum, Wien . . . 002912
Ernst-Haeckel-Haus, Jena 019137
Ernst-Moritz-Arndt-Haus,
Stadtmuseum Bonn, Bonn . . . 017269
Ernst-Moritz-Arndt-Museum,
Garz 018323
Ernst Múzeum, Budapest 023155
Ernst, Albert J., Saarbrücken . . 078244
Ernst, Manfred, Ronnenberg . . 130969
Ernst, Rolf-Gerhard, München . . 130701
Ernsts Samlinger, Assens 009855
Erotic Art Museum Hamburg,
Hamburg 018694
Erotics Gallery, New York 122815
Erotisch Museum, Amsterdam . . 031762
Errance, Paris 137196
Errico, Umberto, Napoli 080704
Érseki Gyűjteményi Központ,
Eger 023291
Ersta Diakonimuseum,
Stockholm 040798
Erstes Bayerisches Schulmuseum,
Sulzbach-Rosenberg 021681
Erstes Buchdruckmuseum
Mecklenburg/Vorpommern, Krakow
am See 019452
Erstes Deutsches Fliesenmuseum
Boizenburg e.V. Boizenburg . . 017254
Erstes Deutsches Motorroller-Museum,
Kaub 019243
Erstes Deutsches Strumpfmuseum,
Gelenau 018345
Erstes Deutsches Türmermuseum,
Vilseck 021928
Erstes Imaginäres Museum,
Sammlung Günter Dietz, Wasserburg
am Inn 022025
Erstes Kärntner Handwerksmuseum,
Baldramsdorf 001765
Erstes Magdeburger Circusmuseum,
Magdeburg 019868
Erstes Niederbayerisches
Automobil- und Motorrad-Museum,
Adlkofen 016277
Erstes Niederrheinisches Karneval-
Museum, Duisburg 017812
Erstes Oberösterreichisches
Schnapsmuseum, Sankt Oswald bei
Freistadt 002628
Erstes Österreichisches Biermuseum,
Laa an der Thaya 002220
Erstes österreichisches
Bodenschätzungsmuseum,
Hollabrunn 002075
Erstes österreichisches
Computermuseum, Bad
Pirawarth 001748
Erstes Österreichisches
Friedensmuseum und Heimatstube,
Wolfsegg am Hausruck 003044
Erstes Österreichisches Museum für
Alltagsgeschichte, Neupölla . . 002404
Erstes Österreichisches
Rettungsmuseum, Frastanz . . . 001889
Erstes Österreichisches Tischler-
Museum, Pöchlarn 002465
Erstes Österreichisches
Tonbandmuseum, Wien 002913
Erstes Rundfunkmuseum Rheinland-
Pfalz, Münchweiler an der
Alsenz 020235

Fachbereich Design, Fachhochschule Anhalt, Abteilung Dessau, –
Faculty of Arts Media and Social Sciences, University of

Index of Institutions and Companies

Ferjan, Ljubljana 085435
Ferlelund Antiques, Gilleleje ... 065627
Ferlini, Bruno, Mons .. 063739, 140218
Ferlini, Renata, Bologna 131358
Ferma, Barcelona 085591
Fermanagh County Museum at Enniskillen Castle, Enniskillen . 044121
Ferme aux Abeilles, Saint-Brévin-les-Pins 015041
La Ferme Caussenarde d'Autrefois, Hures-la-Parade 013088
Ferme d'Antan, Plédéliac 014689
Ferme de Hot Springs, Mohon . 070084
Ferme de la Claison, Saint-Étienne-du-Bois 015109
Ferme de la Fontaine, Lausanne 087378, 134129
Ferme de Paris, Paris 014449
Ferme des Bois Nois, Saint-Eloy La-Glaciere 015097
La Ferme des Étoiles, Mauroux . 013895
Ferme des Mangettes, Saint-Étienne-du-Bois 015110
Ferme d'Hier et d'Aujourd'hui, Aviré 011663
Ferme du Château, Beveuge ... 067100
Ferme du Château, Saint-Fargeau 015113
La Ferme Marine-Musée de l'Huître et du Coquillage, Cancale . 012121
Ferme-Musée à Pans de Bois de Sougey, Montrevel-en-Bresse . 014111
Ferme-Musée de Bray, Sommery 015631
Ferme Musée de la Soyotte, Musée Arts et Traditions Populaires, Sainte-Marguerite 015415
Ferme-Musée de la Tonnelière, Courcerault 012509
Ferme-Musée des Frères Perrel, Moudeyres 014148
Ferme-Musée du Contentin, Sainte-Mère-Eglise 015424
Ferme-Musée du Léon, Tréflaouenan 015829
Ferme-Musée du Montagnon, Fournets-Luisans 012851
Fermes-Musée du Pays Horloger, Grand-Combe-Châteleu 012955
Fermette, Épreville 068404
Fermin Garcia, Felipe, Madrid . 086006
Fermynwoods, Brigstock 117566
Fern Avenue Antiques Centre, Newcastle-upon-Tyne 090677
Fernandes & Costa, Carlos, Lisboa 084710
Fernandes, Paulo, Rio de Janeiro 100886
Fernandez, Zamora 086406
Fernández Alfaro, José Antonio, Alajuela 102365
Fernandez Antiguedades, Sevilla 086276
Fernandez Battagliese, Isaura, Vigo 086383
Fernández Blanco Libros Antiguos, Buenos Aires 139600
Fernandez de Bobadilla, Teresa, Madrid 133694
Fernandez-Escarzaga, Belen Roiz, Santander 086250
Fernandez Gallart, Manuela, Valencia 086340
Fernandez Lopez, Maria Consuelo, Murcia 086138
Fernandez Muñiz, Maria Jesus, Gijón 115160
Fernandez, J., Barcelona 085592
Fernández, Jesús Angel, León .. 085887
Fernández, José, Santiago de Chile 064914
Fernandez, Miguel, Rosières ... 072503
Fernandez, Salvador, Barcelona . 085593
Fernando, Luis, New York 136271
Fernando, Pedro, Belo Horizonte 100746
Fernando, Saskia, Colombo ... 115661
Fernbank Museum of Natural History,

Atlanta 046585
Fernbank Science Center, Atlanta 046586
Fernbrook Gallery, Kurrajong Heights 099075
Ferndown Gallery, Ferndown ... 117990
Ferner Galleries, Auckland 112850, 112851
Ferner Galleries, Taupo 113108
Fernhill House, The People's Museum, Belfast 043312
Fernie and District Historical Society Museum, Fernie 005693
Fernlea Antiques, Manchester .. 090538
Fernmeldemuseum Aachen, Aachen 016244
Fernwold, Pittsburgh 096122
Féron, Richard, Agon-Coutainville 066371
Ferra, Ray, Los Angeles 094170
Ferracini & Paglia, Bologna 079704
Ferraglia, Parma 080943, 080944
Ferraguti, Parma 142600
Ferran Cano, Palma de Mallorca 115433
Ferrand, Michel, Dammarie 068209
Ferrando Guerra, Santiago, Buenos Aires 060892
Ferrando, Andrea Armando, Genova 131703
Ferrando, Francesca, Genova .. 080092
Ferranti, Ugo, Roma 110786
Ferrara, Paris 071283
Ferrara, Jonathan, New Orleans 122411
Ferrara, Rosario, Catania 079866, 131486
Ferrari, Milano 131834
Ferrari, Saint Louis 096540
Ferrari, Treviglio 111057
Ferrari Antiquités, Martignargues 069932
Ferrari-Auer, Bolzano 142469
Ferrari Auer, Bolzano 137727
Ferrari Museum of Art, Gotemba 028389
Ferrari Rosetta de Antigüedades, Caracas 097815
Ferrari Sarzábal, Aldo, Montevideo 127771
Ferrari, Bernard, Nice 070553
Ferrari, Gian-Mario, Rambrisio . 084678
Ferrari, Giorgio, Roma . 081196, 132306
Ferrari, Neldo, Modena 131962
Ferrari, Olivier, Châlonvillars ... 067732
Ferrari, Pierluigi, Milano 131835
Ferrario Arte, Rovereto 110899
Ferraris, Paolo, Torino 132522
Ferraro, Roma 110787
Ferraro, Arturo, Napoli 132008
Ferraroni, Patrizia, Modena 080625
Ferraton, Alain, Bruxelles 125579, 140144
Ferrazza, Renato, Roma 081197
Ferrazzutti, Pam, Toronto 064594
Ferré, Jacqueline, Ingrandes-sur-Loire 068816
Ferré, Patrick, Saint-Mathurin-sur-Loire 072917
Ferreira, Bruxelles 063367
Ferreira, Oakland 136387
Ferreira & Manteigas, Lisboa .. 084713
Ferreira Vicente, José, Lisboa . 143380
Ferreira Vicente, José, Paço de Arcos 143409
Ferreira, António Almeida, Braga 084606
Ferreira, Felismina, Porto 084851
Ferreira, Gilberto M. Teves, Ponta Delgada 133324
Ferreira, Helena Simões, Lisboa 084711
Ferreira, Henrique Meneses, Porto 084852
Ferreira, João, Cape Town 114847
Ferreira, Licínio S. Santos, Mafra 084830
Ferreira, Luísa & David, Porto .. 084849
Ferreira, Manuel, Porto 126669, 143414
Ferreira, Maria Lurdes, Lisboa . 084712
Ferreira, Maria Meira, Lisboa .. 084850
Ferreira, Matos, Lisboa 114089, 143379
Ferrer Carrer, Ramon, Barcelona 114971

Ferrer Marcs, Barcelona 114972
Ferrer Martí, Valencia 086341
Ferrería de Mirandaola, Lenbur Museo-Lurradea, Legazpia 039362
Ferrero, Nice 104313
Ferrero Zendrini, Carlo, Monaco 082319
Ferrero Zendrini, Carlo, Torino .. 081529
Ferrers, Staunton Harold 119412
Ferret Bookshop, Wellington ... 143178
Ferret, Georges, Villers-les-Guise 074142
Ferretti & Guerrini, Roma 081198
Ferretti, Gino, Maranello 080181
Ferretti, Sergio, Langhirano 080140
Ferrey, Laurent, Pirey 072124
Ferreyra Lesye & Comp, Córdoba 060930
Ferri Associés, Paris 125988
Ferri, Daniele, Bologna 131359
Ferriani, Milano 131836
Ferrien-Marcognet, Eric, Paris .. 071284
Ferrier, Patrick, L'Isle-sur-la-Sorgue 069513
Ferriere de Lassus, André & Vonia, Chomerac 067931
Ferrigno, Gaetano, Napoli 132009
Ferris, Sacramento 096457
Ferris, Maurice, Oklahoma City . 095807, 136394
Ferrito, Giancarlo, Palermo 080874
Ferro, Antonino, Palermo 080875
Ferro, Nunzio, Messina 131750
Ferro, Paola, Milano 080379
Ferroni, Montréal 064364
Ferroni, Alice, Genova 131704
Ferrow, David, Great Yarmouth . 134739, 144207
Ferrucci, Arnaldo, Roma 081199
FeRRUM – Welt des Eisens, Ybbsitz 003047
Ferruzzi, Balbi Ferruccio, Venezia 081670
Ferry Antique Centre, Christchurch 083697, 143113
Ferry Antiques, Wargrave 091586, 135544
Ferry Park Gallery, MacLean, New South Wales 099111
Ferry, Marcel, Rambervillers ... 072319
Ferry, Nicole, Paris 104691
Ferrycroft Visitor Centre, Lairg . 044619
Ferrymead Heritage Park, Christchurch 032991
Fersen, Monaco 082320
Fersini, Andrea, Roma 132307
Fersini, Massimo, Roma 132308
Fersini, Rocco, Roma 132309
Ferstl, Robert, Karlsruhe 076628, 130406
Fert, Yvoire 105842
Fert-Rifaï, Nathalie, Nyons 070717, 140971
Fesel, Bernd, Sonsbeck 108649
Fesseler, K., Berlin 129717
Fester, Den Haag 112465
Festetics-Kastély, Dég 023276
Festetics-Kastély, Helikon Kastélymúzeum, Keszthely ... 023415
Festina Lente – italiAntiquariaat, Groningen 142959
Festival-Institute Museum, James Dick Foundation, Round Top ... 052594
Festival Internacional de Fotografía y Artes Visuales, Madrid 098148
Festung Kniepass, Unken 002786
Festung Königstein, Königstein . 019411
Festung Marienberg mit Fürstenbaumuseum, Bayerische Verwaltung der staatlichen Schlösser, Gärten und Seen, Würzburg . 022368
Die Festung Rosenberg – Deutsches Festungsmuseum, Kronach ... 019473
Festung Wilhelmstein im Steinhuder Meer, Wunstorf 022390
Festungs- und Heimatmuseum, Kufstein 002216
Festungsmuseum Crestawald, Filisur 041255

Festungsmuseum Heldsberg, Sankt Margrethen 041679
Festungsmuseum Nauders, Nauders 002384
Festungsmuseum Reuenthal, Fortress Museum, Reuenthal 041623
Festungsmuseum, Museum Salzburg, Salzburg 002569
Festungsturm Peitz, Peitz 020738
Fethard Park and Folk Museum, Fethard 024699
Fethiye Cami Müzesi, Ayasofya Müzesi, İstanbul 042667
Fethiye Kültür Merkezi, Fethiye . 042632
Fethiye Müzesi, Fethiye 042633
Fetlar Interpretive Centre, Fetlar 044170
Fetoon, Sharjah 117258
Fetsund Lenser Fløtingsmuseum, Fetsund 033423
Fetterman, Peter, Santa Monica 124717
Fetting & Minx, Berlin 141455
Fety, F., Bruxelles 063368
Fety, Margaret, Bordeaux 140751
Fetzer, Sontheim an der Brenz . 108651
Fetzer, J., Ludwigsburg 141957
Fetzian & Kourd, Athinai 079067
Feuchtmayer Museum, Salem, Baden 021181
Feuer, Zach, New York 122834
Feuerman, Carole A., New York . 122835
Feuerschiff, Wilhelmshaven 022245
Feuerstein, G. & E., Aachen ... 074294
Feuerstein, Karl Heinz, Dornbirn 062532
Feuerstein, Wolfgang, Dornbirn . 127992
Feuerwehr- und Handwerkermuseum, Endingen 041238
Feuerwehr- und Technikmuseum, Städtisches Museum, Eisenhüttenstadt 017900
Feuerwehr Erlebnis Museum, Rheinland-Pfälzisches Feuerwehrmuseum Hermeskeil, Hermeskeil 018911
Feuerwehr-Helm-Museum, Stuttgart 021627
Feuerwehr Museum, Lahr 019520
Feuerwehr-Museum Schloß Waldmannshofen, Creglingen . 017549
Feuerwehrhistorische Ausstellung, Dahlen 017576
Feuerwehrmuseum, Adligenswil 040992
Feuerwehrmuseum, Altenkirchen, Westerwald 016342
Feuerwehrmuseum, Asperg 016438
Feuerwehrmuseum, Dobersberg 001809
Feuerwehrmuseum, Kreuzlingen 041392
Feuerwehrmuseum, Lengenfeld . 019696
Feuerwehrmuseum, Pegau 020730
Feuerwehrmuseum, Perchtoldsdorf 002447
Feuerwehrmuseum, Rehau 020959
Feuerwehrmuseum, Roding 021066
Feuerwehrmuseum, Sankt Leonhard am Forst 002617
Feuerwehrmuseum, Sayda 021236
Feuerwehrmuseum, Spalt 021523
Feuerwehrmuseum, Stadtprozelten 021556
Feuerwehrmuseum, Stetten am kalten Markt 021599
Feuerwehrmuseum, Steyrermühl 002731
Feuerwehrmuseum, Türnitz ... 002776
Feuerwehrmuseum, Wasserburg am Inn 022026
Feuerwehrmuseum Berlin, Berlin 016907
Feuerwehrmuseum Ellricher Spritzenhaus, Ellrich 017911
Feuerwehrmuseum Grethen, Parthenstein 020719
Feuerwehrmuseum Hannover, Hannover 018753
Feuerwehrmuseum Hordorf, Cremlingen 017555
Feuerwehrmuseum Kaufbeuren –

Framing & Art Centre, Hamilton 101180
Framing & Art Centre, Kitchener 101189
Framing & Art Centre, London . 101204
Framing & Art Centre, Vancouver 101646
Framing and Art, Charlotte 120269
Framing and Art Matters,
 Randwick 099473
Framing Concepts and Gallery, El
 Paso 121110
The Framing Gallery, Portlaoise . 109691
The Framing Machine & Gallery,
 Swansea 119470
Framing Place and Gallery, Saint
 Paul 124153, 124154
The Framing Workshop, Bath . 117376,
 134394
Framingham Historical Museum,
 Framingham 048878
Framlingham Castle and Exhibition,
 Framlingham 044203
Frammuseet, Oslo 033659
Framtidsantiken Skrot & Korn,
 Stockholm 086813
Fran Hill Gallery, Toronto 101473
Franc Segent, Marly-le-Roi 069827
Franc, Isabelle, Villeurbanne . . 074170
Franca, Rio de Janeiro 064004
França Trasuna Muzejs Kolnasäta,
 Sakstagals 030059
Franca, Godofredo, Rio de
 Janeiro 064005, 100889
Français, Jacky, Vittel 074228
La France, Tampa 097393
France Afrique, Bayonne 103293
France Création Style, Barbizon 066886
France Création Style, Les Baux-de-
 Provence 069345
France Expertises Enchères,
 Montastruc-la-Conseillère 104199
France Lejeune, Mechelen 100649
France Loisirs Antilles, Fort-de-
 France 142797
France Tradition, Los Angeles . . 094173
France, Sophie, São Paulo 064123
Francelet-Grosz, Jacqueline, Saint-
 Pierre-Quiberon 073225
Frances Burke Textile Resource
 Centre-Collections, RMIT University,
 School of Architecture and Design,
 Melbourne 001267
The Frances Lehman Loeb Art Center,
 Poughkeepsie 052245
Frances Willard House Museum,
 WCTU Museum, Evanston 048597
Frances, Lyliane, Châtelaillon-
 Plage 067845
Francés, Ricardo, Pamplona . . . 086213
Francesc Mestre Art, Barcelona 114976
Francesca's Collections, Houston 093506
Francesca's Italian Arts and Antiques,
 Sacramento 096460
Franceschi, Severino, Firenze . . 131570
Franceschini, Roberto, Brescia . 079771,
 142474
Francesco della Gola, Scuol . . . 087613
Francescoli, Rosemary, Tavannes 087644
Franchi, Daniel, Paris 104663
Franchini, Firenze . . . 079973, 142493
Franchini, Stefano, Bologna . . . 131363
Franchino, Gherardo, Torino . . . 132523
Franchitti, Natalina, Genova . . . 131707
Franci, Mario, Roma 081208
Francia Antigüedades, Lima . . . 084284
Francis Colburn Gallery,
 Burlington 047290
Francis Land House, Virginia
 Beach 053873
Francis Ledwidge Cottage and
 Museum, Slane 024798
Francis McCray Gallery, Western New
 Mexico University, Silver City . 053220
Francis Skaryna Belarusian Museum,
 London 044870
Francis, Annie & Martin,

Jacksonville 121533
Francis, C., Providence 123951
Francis, Howard, Stockport 119419
Francis, Paolo, Croydon 117819
Francis, Peter, Carmarthen 127049
Francis, Peter, Saintfield 091068
Francisco-Deutch Fine Arts, New
 York 122856
Francisco Fort Museum, La Veta 050003
Francisco Romero, Julian,
 Valencia 133819
Franck & Jean-Pierre, Nice 129096
Franck-Haus, Marktheidenfeld . . 019958
Franck Laigneau, Paris 071302
Franck, Georges, Paris 071301
Franck, Gérard & Lydia, Colmar 068034
Franck, Isabelle, Cahuzac-sur-
 Vere 067542
Franck, Katharina, Münchhausen 108219
Franck, Patrick, Couches 068114
Die Franckeschen Stiftungen zu Halle,
 Halle, Saale 018665
Franco, Cannes 067581
Franco, El Paso 121111
Franco, Nice 070554
Franco Serrano, Maria del Rosario,
 Barcelona 114977
Franco, Cristian, Badajoz 114931
Francoarte, Medellín 102337
Francois & Catherine,
 Amsterdam 082564
François & Martine, Villers
 (Semeuse) 074138
François Antiquités, Sedan 073427
François-Miron, Paris 104696
Francois Pierre Antiquaire,
 Martel 069929
François, Denis, Paris 071303
François, Marie-Cecile, Bruxelles 063374
François, Roger, Gevigney-et-
 Mercey 068598
Francoise Cottage, Ulladulla . . . 062358
Franconeri, Palermo 080878
Frandl, Johann, Gundertshausen 128027
Frandsen, Varde 102941
Franek, Wolfgang, Wien 140065
Frangos, Stratjs, Zürich 087761
Franic, M., Domažlice 065314
Franjevački Samostan Gorica,
 Livno 004183
Franjevački Samostan Jajce,
 Jajce 004180
Franjevački Samostan Kraljeva
 Sutjeska, Kraljeva Sutjeska . . . 004181
Franjevački Samostan Krešovo,
 Krešovo 004182
Frank, Möglingen 077313
Frank & Dunya, Seattle 124776
Frank & Joe Gallery, New York . 122857
Frank Cameron Museum of Wynyard,
 Wynyard 007304
Frank H. McClung Museum, University
 of Tennessee, Knoxville 049965
Frank-Iniesta, Madrid 086009
Frank Lloyd Wright Home and Studio,
 Oak Park 051579
Frank Lloyd Wright Museum, Richland
 Center 052432
Frank-Loebsches Haus, Landau in der
 Pfalz 019538
Frank McCourt Museum,
 Limerick 024748
Frank Partridge V.C. Military Museum,
 Bowraville 000876
Frank Phillips Home, Oklahoma
 Historical Society, Bartlesville . 046770
Frank Pictures Gallery, Santa
 Monica 124718
Frank Slide Interpretive Centre,
 Crowsnest Pass 005558
Frank, Anna, Krün 076916
Frank, Bertolin, Unterschleißheim 131109
Frank, Hans-Peter, Elsbethen . . 127995
Frank, Jean, Mulhouse 070339

Frank, John, Phoenix 096048
Frank, Manfred, Mandern 077188
Frank, Michael, Waiblingen 078738
Franke & Seij, Rotterdam 143029
Franke, B., Großostheim 076054
Franke, Dr. J., Wien 062910
Franke, M., Berlin 074746
Franke, R., Dohnsen 075323
Frankel, E. & J., New York 095238
Franken, Dordrecht . . . 082992, 082993
Franken Galerie, Kronach 107737
Frankenberger Art Gallery, University
 of Charleston, Charleston 047526
Frankenburger Heimatstube,
 Frankenburg 001885
Frankenmuth Historical Museum,
 Frankenmuth 048881
Frankenwaldmuseum, Kronach . 019475
Frankfort Area Historical Museum,
 West Frankfort 054177
Frankfurter Antiquariatsmesse, in der
 Frankfurter Buchmesse, Frankfurt am
 Main 097998
Frankfurter Feldbahnmuseum,
 Frankfurt am Main 018159
Frankfurter Künstlerclub e.V., Frankfurt
 am Main 058831
Frankfurter Kunstverein e.V., Frankfurt
 (Oder) 058832
Frankfurter Kunstverein e.V., Frankfurt
 am Main 058833
Frankfurter Münzhandlung, Frankfurt
 am Main 075734
Frankfurter Numismatische
 Gesellschaft, Frankfurt am Main 058834
Frankfurter Sportmuseum, Frankfurt
 am Main 018160
Frankfurter Westend Galerie, Frankfurt
 am Main 106950
Frankie G. Weems Gallery &
 Rotunda Gallery, Meredith College,
 Raleigh 052353
Franklin 54 Gallery, New York . . 122858
Franklin Arts and Cultural Centre,
 Pukekohe 033114
Franklin College of Arts and Sciences,
 Department of Art, University of
 Georgia, Athens 056630
Franklin County Historical Museum,
 Pasco 051849
Franklin County Museum,
 Brookville 047239
Franklin County Old Jail Museum,
 Winchester 054340
Franklin D. Roosevelt Presidential
 Library-Museum, Hyde Park . . 049607
Franklin Furnace Archive,
 Brooklyn 047222
Franklin G. Burroughs-Simeon
 B. Chapin Art Museum, Myrtle
 Beach 051075
Franklin Historical Society Museum,
 Franklin 048897
Franklin House, Launceston . . . 001209
The Franklin Institute,
 Philadelphia 051960
Franklin Mineral Museum,
 Franklin 048898
The Franklin Mint, Birmingham . 092243
Franklin Mint Museum, Franklin
 Center 048902
Franklin Pierce Homestead,
 Hillsborough 049442
Franklin Street Gallery, Buffalo . 120236
Franklin Town Antiques, El Paso 093237
Franklin, David, Columbus 092865
Franklin, John, San Diego 096921
Franklin, Lynda, Hungerford . . . 089411,
 134805
Franklin, N. & I., London 089947
Frankly Speaking Antiques,
 Yackandandah 062487
Franks Antique Doll Museum,
 Marshall 050650

Frank's Auctions, Hilliard 127508
Frank's Coin Shop, Las Vegas . . 093977,
 093978
Frank's Coins, Buffalo 092360
Frank's Upholstering Shop,
 Detroit 135892
Frank's Used Furniture & Antiques,
 Port Adelaide 062080
Frankston Auction Mart,
 Frankston 125473
Frankston Primary Old School
 Museum, Frankston 001079
Frånö Antikbod, Helsingborg . . . 086552
Frånö Antikbod, Kramfors 086601
Fran's Antiques, Virginia Beach . 097615
Fran's Fantasies Antiques,
 Norfolk 095690
Frans Hals Museum, Haarlem . . 032213
Frans Walkate Archief/ SNS Historisch
 Archief, Kampen 032353
Franses, S., London . . 089948, 134985
Franses, Victor, London 134986
Fransız Kültür Merkezi, İstanbul 117124
Fransk Bokhandel l'Arc Librairie
 Française, Stockholm 143753
Franska Liljan, Västerås 086955
Fransson, Landvetter 086615
Fransu-tupa, Himanka 010710
Franta, G., Köln 076798
Frantz, Walther & Renate,
 München 077428
Franz Daurach-Sammlung,
 Hadres 002015
Franz Kafka Libreria, Cuernavaca 142805
Franz Kafka museum, Praha . . . 009628
Franz-Liszt-Museum der Stadt
 Bayreuth, Bayreuth 016776
Franz Marc Museum, Kochel am
 See 019348
Franz Michael Felder Museum,
 Schoppernau 002668
Franz Radziwill Haus, Varel . . . 021890
Franz Schmidt Gemäldekram,
 Knappenhof, Perchtoldsdorf . . . 002448
Franz Steiner Verlag GmbH,
 Stuttgart 137626
Franz-Stock-Museum, Franz-
 Stock-Komitee für Deutschland,
 Arnsberg 016409
Franz Traunfellner-Dokumentation,
 Pöggstall 002468
Franz Xaver Gruber-Gedächtnishaus,
 Ach 001677
Franz, H., Cremlingen 075233
Franz, H., Stuttgart 142233
Franz, Volker, Michelau in
 Oberfranken 141992
Franzensburg, Laxenburg 002244
Franzin & C., Milano 080383
Franzini-Heinen, Arlette, Pont-Sainte-
 Maxence 072223
Franziskanermuseum, Villingen-
 Schwenningen 021919
Franzke, Wien 100129
Franztaler Heimatstube, Mondsee 002367
Frapin Beauge, Houston 121318
Frasassi-Le Grotte, Genga 026234
Frasca, Guglielmo, Roma 132321
Frasch Art Studio, Leipzig 107802
Frascione, Enrico, Firenze 079974
Frascione, Giulio, Firenze 079975
Fraser, Coldstream . . . 088737, 134606
Fraser, Washington 125152
Fraser, Woodbridge 119682
Fraser-Fort George Regional Museum,
 Prince George 006565
Fraser Gifford, Tucson 136753
Fraser-Sinclair, South Godstone . 135410
Fraserburgh Heritage Centre,
 Fraserburgh 044206
Fraserorr, Robin, New Orleans . 136205
Frasers, Inverness 127154
Frasnetti, Maurice, Cusset 068203
Frassine, Roberto, Brescia 131429

Fukuoka 028365
Fukushima Kaiyo Kagakukan,
Iwaki 028534
Fukushima-ken Bunka Centre,
Fukushima 028370
Fukushima-kenritsu Bijutsukan,
Fukushima 028371
Fukushima-kenritsu Hakubutsukan,
Aizuwakamatsu 028281
Fukuyama Auto and Clock Museum,
Fukuyama 028372
Fukuyama Bijutsukan, Fukuyama 028373
Fukuyama Bungakukan, Fukuyama
Gaijutsu Bunka Shinko Zaidan,
Fukuyama 028374
Fukuyama Castle Museum,
Fukuyama 028375
Fukuyama City Human Rights and
Peace Museum, Fukuyama . . . 028376
Fukuyama-renritsu Rekishi
Hakubutsukan, Fukuyama . . . 028377
Fukuzawa Ichiro Memorial Museum,
Nakatsu 028954
Fulcheri & Figli, Cuneo 079894, 131500
Fulcrand, Bessan 067081
Fulda Gallery, Salford . 119307, 135347
Fulda, Constance, Paris 104699
Fuldaer Münze, Ebersburg 075513
Fulham, London 089956
Fuling Museum, Fuling 007588
Full Circle, San Diego 096922
Full Circle Architectural Antiques,
Hawthorn 061592
Full Circle Art Consultancy,
London 118557
Fullam, Dublin 079449
Fuller Craft Museum, Brockton . 047185
Fuller, D'Arch & Smith, London . 144365
Fuller, Ernest, Denver 120998
Fuller, Jeffrey, Philadelphia . . . 123629
Fullerton Museum Center,
Fullerton 048955
Fullyjie Zone Museum, Bijie . . 007474
Fulton, Fresno 093337
Fulton County Historical Museum,
Wauseon 054116
Fulton County Historical Society
Museum, Rochester 052506
Fulton County Museum,
Groversville 049251
Fulton Mansion, Rockport 052548
Fulton Street Art Gallery, New
York 122869
Fultz House Museum, Lower
Sackville 006099
Fulwood Gallery, Preston 119185
Fumagalli, Luigi, Honolulu 121215
Fumelli, Adele Maria, Roma . . . 081209
Fumi, Okegawa 111358
Fumiki, San Francisco 097071
Fumusa, Vincenzo, Milano . . . 131839
Funabashi Bijutsu Gakuin,
Funabashi 055951
Funaki, Melbourne 099172
Function + Art, Chicago 120410
Fund & Arte, Medellín 128546
Fundação Arpad Szenes e Vieira da
Silva, Lisboa 035590
Fundação Casa de Jorge Amado,
Salvador 004707
Fundação Clóuis Salgado – Palácio
das Artes, Belo Horizonte . . . 004259
Fundação Cultural do Estado da Bahia,
Praça Thomé de Souza, Paláco Rio
Branco, Salvador 058373
Fundação Cultural Ema Gordon Klabin,
São Paulo 004774
Fundação Eça de Queiroz, Santa Cruz
do Douro 035824
Fundação Eva Klabin Rappaport, Rio
de Janeiro 004618
Fundação Hansen Bahia,
Cachoeira 004293
Fundação Maria Luisa e Oscar

Americano, São Paulo 004775
Fundação Memorial da América
Latina, São Paulo 004776
Fundação Museu do Zebu Edilson
Lamartine Mendes, Uberaba . . 004855
Fundaçao Oscar Niemeyer, Rio de
Janeiro 004619
Fundação Ricardo do Espírito Santo
Silva, Lisboa 035591
Fundacija Jože Ciuha, Bled 114756
Fundació Antoni Tàpies,
Barcelona 038873
Fundació Barceló, Palma de
Mallorca 039695
Fundació Casa Museu Llorenç
Villalonga, Binissalem 038962
Fundacio Espais, Girona 039253
Fundacio Fita, Girona 039254
Fundació Joan Miró, Barcelona . 038874
Fundació la Caixa, Revista el treua,
Barcelona 139096
Fundació Pilar i Joan Miró, Palma de
Mallorca 039696
Fundació Privada Espai Guinovart,
Agramunt 038703
Fundació Pública Institut d'Estudis
Ilerdencs, Fons Bibliogràfic i
Documental, Lleida 039387
Fundación Alfredo L. Palacios, Buenos
Aires 000157
Fundación Archivo Gráfico y Museo
Histórico de la Ciudad de San
Francisco y la Región, San
Francisco 000569
Fundación Banco Francés, Buenos
Aires 000158
Fundación Carlos de Amberes,
Madrid 039433
Fundación César Manrique,
Teguise 040019
Fundación Cultural Otero Pedrayo,
Amoeiro 038785
Fundación de Fomento a las Artes, La
Paz 004128
Fundación Federico Jorge Klemm,
Buenos Aires 000159
Fundacion Federico Klemm, Buenos
Aires 098397
Fundación Folch, Barcelona . . . 038875
Fundación Juan March, Madrid . 039434
Fundación Luis Muñoz Marín, San
Juan 035987
Fundación Luis Seoane, A
Coruña 039129
Fundación Museo de las Ferias,
Medina del Campo 039550
Fundación NMAC Montenmedio de
Arte Contemporáneo, Vejer de la
Frontera 040164
Fundación Pablo o Ruiz Picasso
Museo Casa Natal, Málaga . . 039509
Fundación Pi y Margall, Madrid . 059779,
115285
Fundación Vela Zanetti, Casona de
Villapérez, León 039365
Fundación Yannick y Ben Jakober,
Finca Sa Bassa Blanca, Alcúdia
(Baleares) 038747
Fundacja Artgard, Warszawa . . 137997
Fundatia Galeria de Artă, Cluj-
Napoca 114245
Fundaziun Planta Samedan
Wohnmuseum, Samedan . . . 041666
Funder, Dover 139749
Fundgrube, Glücksburg 075953
Fundgrube zur Laterne, Sursee . 087641
Fundus, Berlin 141460
Fundus, Sankt-Peterburg 114416
Fundus-Props for Yesterday, New
York 095242
Fundy Geological Museum,
Parrsboro 006469
Fune no Kagakukan, Tokyo . . . 029320

Fung, Martin, Hong Kong 064981,
064982
Funk House, Las Vegas 093979
Funk, Robert, Saskatoon 064507,
128448
Funk, Werner, Grasbrunn 076022
Funkar Art Gallery, Karachi . . . 113402
Funke, Peter, Sundern 078568
Funktionall Art, Minneapolis . . 122267
Funky Furnishings, Sacramento 096461
Funky Junktion, Whangamata . 084062
Funnefoss Industriarbeidermuseum,
Årnes 033330
Funnix, Wittmund 078952
Funque's, Austin 092065
Funtiques, Seattle 097278
Fuoricentro, Roma 110791
Fur Fossiler 55.000.000 år, Fur . 009917
Fur Museum, Fur 009918
Furas Levin, Sergio N.,
Montevideo 097789
Furdyna, Józef, Kraków 133205
Fureai Minatokan, Osaka 029060
Fureaikan – Kyoto Museum of
Traditional Crafts, Kyoto . . . 028740
Furesø Museer, Farum 009903
Furiko, Fukuoka 081794
Furini Arte Contemporaenea,
Arezzo 137713
Furini Arte Contemporaenea,
Roma 110792
Furletti, Belo Horizonte 063847
The Furlong Gallery, University of
Wisconsin-Stout, Menomonie . 050731
Furlotti, Alessandra, Milano . . . 082803,
131840, 142540
Furman jr., Donald, Buffalo . . . 092361
Furn Davies, Holt, Wales 089358,
134784
Furnarture Gallery, Chicago . . . 120411
Furnas-Gosper Historical Society and
Museum, Arapahoe 046487
Furneaux Museum, Flinders
Island 001071
Furness Abbey and Visitor Centre,
Barrow-in-Furness 043255
The Furnishing Touch, Tauranga 083960,
133122
Furnishings off Foster, Portland . 096241
Furniture and Refinishing,
Cincinnati 135791
Furniture and Upholstery,
Houston 135952
Furniture Artisans, Philadelphia . 136430
Furniture Artist Repair, Miami . 136142
Furniture by School Masters,
Milwaukee 136165
Furniture Cave, Aberystwyth . . 087992,
134328
The Furniture Cave, London . . . 089957
Furniture Cave, Preston 127934
Furniture Conservatory,
Indianapolis 135981
Furniture Craft Company, Los
Angeles 136068
Furniture Craftsman, Cincinnati . 135792
Furniture Craftsman, San Antonio 136600
Furniture Craftsman, Tucson . . 136754
Furniture Depot, Denver 093125
The Furniture Doctor, Vestaburg 136773
Furniture Exchange, Atlanta . . . 091973,
135661
Furniture Haven, Honolulu . . . 093378
Furniture Heaven, Regina 064497
Furniture History Society, Haywards
Heath 060083
Furniture History Society, Surry
Hills 058164
Furniture Manufacturing Museum in
Tainan, Rende 042152
Furniture Mart, Margate 090547, 135176
Furniture Medic, Cleveland . . . 135813
Furniture Medic, Littleton 136038
Furniture Medic, Louisville . . . 136106

Furniture Medic, Memphis . . . 136125
Furniture Medic, Miami 136143
Furniture Medic, Phoenix 136456
Furniture Medic, Sacramento . . 136528
Furniture Medic, San Antonio . . 136601
Furniture Medic, Towcester . . . 135496
Furniture Now and Then, Albany 060966
Furniture on Consignment,
Albuquerque 091891
Furniture Refinishing, Denver . . 135882
Furniture Renovations Company,
London 134990
Furniture Restoration, London . . 134991
Furniture Restoration Center, Sunland
Park 136718
Furniture Restorations, Houston 135953
Furniture Revisited, Brunswick . 061214
Furniture Revival, Hawthorn . . 061593
Furniture Service, Dunedin . . . 133093
Furniture Shoppe, Norfolk 136376
Furniture Stripping, Kansas City 136027
Furniture Trading Company, Botley,
Hampshire 088302
Furniture Vault, London 089958
Furniture Wizards, Winnipeg . . 128487
Furniture Workshop, San
Francisco 136656
Furnitures Friend, Seattle 136704
Furonnet, Jean-Louis, Langon . . 069117
Furphy, John, Armadale, Victoria 061017
Furrer, Martin, Brig 134055
Fursdon House, Cadbury 043606
Furstenberg, Paris 104700
Furthmühle, Egenhofen 017855
Furthof, Heiligenberg 076414
Furtwengler, Uwe, Baden-Baden 074593
Furukawa Bijutsukan, Nagoya . . 028931
Fusa, Marta, Verona 081744
Fusay, Jean-Paul, Reims 129420
Fusban, Daniel, Utting am
Ammersee 078687
Fusco, Toni, Aarau 086985, 133957
Fuse Magazine, Toronto 138625
Fusebox, Washington 125154
Fushun Calligraphy and Painting
Gallery, Fushun 101891
Fushun Museum, Fushun 007589
Mario Fusi & Alberto Barigazzi,
Lugano 087424
Fusiliers London Volunteer Museum,
London 044872
Fusiliers' Museum Lancashire, Bury,
Lancashire 043593
Fusiliers Museum of Northumberland,
Alnwick 043141
Fusion, Milwaukee 122197
Fusion, Portland 096242
Fusion Art Gallery, Torino 110989
Fusion Fine Arts, Mandurah . . . 099136
Fusions Gallery, Fortitude Valley 001075
Fustat Rare Books, Cairo 140638
Fustier, Maxime, Paris 071310
Futelsaar, Erna, Amsterdam . . . 112275
Futter, Lothar, Sundern 078569
Futterknecht, Ralf, Stuttgart . . 131052
Futur Antérieur, Bruxelles 063376
Futur Anterieur, Le Touquet-Paris-
Plage 069305
Futur Antérieur, Paris 071311
Futur Antérieur, Saint-Ouen . . . 073045
Futura, Paris 104701, 137201
Futurama, Los Angeles 094175
Futurart, Roma 081210, 132322
Futuras Antigüedades, Barcelona 085594
Future Antique Furniture,
Silverwater 062204
Future Antiques, Saint Louis . . . 096544
Future Antiques, Norfolk 095692
Futures Past, Dallas 092962
Futuro, Meisterschwanden . . . 139130
Futuro – Associazione per l'Arte,
Roma 059381
Futurotroc, Chasseneuil-du-
Poitou 067806

Galeria G'Arte, Braga 114045
Galería Gemis, Bogotá 102221
Galeria Gestual Artes, Porto
 Alegre 100840
Galeria Giart, Girona 115169
Galería Goya 2, Valencia 115584
Galeria Graça Brandão, Porto .. 114175,
 114176
Galeria Grafiki i Plakatu,
 Warszawa 113921
Galería Gran Avenida, Bogotá .. 102222
Galeria Greca, Barcelona 114992
Galería Grifus Negrus, Bogotá .. 102223
Galeria Grodzka, Lublin 113777
Galeria H2O, Barcelona 114993
Galeria Habitante, Ciudad de
 Panamá 113411
Galeria Hemar, Lublin 113778
Galeria Hemmerling, Gdańsk .. 113555
Galeria Henry, Lisboa 114105
Galería Hermida, Bogotá 102224
Galeria Hetmańska, Kraków ... 084399,
 113651
Galéria Horný Val, Žilina 114754
Galeria Humb-Humbi, Luanda .. 098360
Galeria i Ośrodek Plastycznej
 Twórczości Dziecka, Toruń ... 035113
Galería IFAL, Instituto Francés de
 América Latina, México 030973
Galeria III, Porto 114177
Galeria Ikona Księży Młyn, Łódź 113753
Galería Imperio, São Paulo 064129
Galeria Indigo, Lima 113447
Galeria Infantas, Lima 115301
Galeria Instituto d'Estudis Fotografics
 da Catalunya, Barcelona 038879
Galeria Italia, Alicante 114918
Galería Itinerante, Santiago de
 Chile 101775
Galería Itzcazú, San José 102396
Galeria J M, Málaga 115390
Galeria JAD, Kalisz 113593
Galéria Jána Koniarka v Trnave –
 Kopplov Kaštieľ', Trnava 038293
Galeria Janelas Verdes, Lisboa . 114106
Galeria Jatki, Małopolskie Biuro
 Wystaw Artystycznych, Nowy
 Targ 034886
Galeria Jaume III, Palma de
 Mallorca 115438
Galería Javier Román, Málaga . 115391
Galeria Joani, Fortaleza 100807
Galeria Jorge Juan, Madrid ... 115302
Galeria Jorge Shirley, Lisboa ... 114107
Galeria José María Velasco,
 Instituto Nacional de Bellas Artes,
 México 030974
Galéria Jozefa Kollára, Slovenské
 Banské Múzeum, Banská
 Štiavnica 038105
Galeria Kanon, Sosnowiec 113856
Galeria Kantorek, Bydgoszcz .. 113530
Galeria Kazimierz, Kraków 113652
Galería Kin, México 112029
Galeria Klub Kolekcionerów,
 Kraków 113653
Galeria Kolegium, Wrocław ... 114019
Galeria Kolumnada, Łódź 113754
Galéria KOMART, Bratislava 038125
Galeria Kombetare e Arteve,
 Tiranë 098339
Galeria Koneser, Lublin 084455, 113779
Galeria Kont, Lublin 113780
Galeria Kontrast, Kraków 084400,
 113654
Galeria Kontur, Kraków 113655
Galeria Kontynenty, Warszawa . 113922
Galeria Krakowskiej Fundacji Hamlet,
 Kraków 113656
Galeria Królewska, Lublin 084456,
 113781
Galeria Krypta u Pijarów, Kraków 084401
Galeria Krytyków Pokaz, Mazowieckie
 Centrum Kultury i Sztuki,

 Warszawa 035152
Galeria la Aurora, Murcia 115404
Galeria La Bagatela, Bogotá ... 102225
Galeria la Capella de l'Antic, Hospital
 de la Santa Creu I Sant Pau,
 Barcelona 038880
Galería la Cometa, Bogotá 102226
Galería La Consolata, Medellín .. 102347
Galería la Francia Arte, Medellín 102348
Galeria La Quinta, Lima 113448
Galeria Labirynt 2 BWA, Lublin . 113782
Galería Las Pintadas, Estelí ... 033199
Galería Latina, Montevideo 125298,
 125299
Galería Latino Americana, La
 Habana 102466
Galería Lázaro, San José 102397
Galeria Leo, Lisboa 114108
La Galería l'Ermitage, Medellín . 102349
Galeria Lifeforart, Dąbrowa
 Górnicza 113539
Galeria Lipert, Kraków 113657, 113658
Galería Lonty-Petry, Częstochowa 113536
Galería Los Oficios, La Habana . 008981
Galéria Luca Marco, Prešov ... 114748
Galeria Lufcik, Warszawa 113923
Galería Luhian 12, București .. 114226
Galería Luluberlu, Limón 102374
Galeria M, Kraków 113659
Galeria M, Wrocław 114020
Galería M Odwach, Wrocław ... 114021
Galéria M.A. Bazovského, Trenčín 038289
Galeria Maeght, Barcelona ... 114994
Galeria Maes, Madrid 115303
Galeria Majolika, Gdańsk 113556
Galeria Malarstwa Akademii Sztuk
 Pięknych im. Jana Matejki,
 Kraków 034701
Galeria Mar Dulce, Buenos Aires 098406
Galeria Mar Gaita, Palma de
 Mallorca 115439
Galéria Maráky, Bratislava 085376
Galeria Margem, Faro 114057
Galeria Mariacka, Gdańsk 113557
Galéria Márie Medveckej, Oravská
 galéria, Tvrdošín 038297
Galeria Marii Ritter, Muzeum
 Okręgowe, Nowy Sącz 034881
Galeria Marlborough, Madrid .. 115304
Galeria Mat Mar T, Lublin 113783
Galeria Mata, San José 102398
Galeria Matahari, Szczecin ... 113861
Galería Matiz, San José 102399
Galeria MBWA, Leszno 113742
Galería Medicci, Caracas 125333
Galeria Mediterrània, Palma de
 Mallorca 115440
Galéria Mesta Bratislavy,
 Bratislava 038126
Galería Metropolitano, México .. 112030
Galeria Mexicana de Diseño,
 México 030975
Galeria Międzynarodowego Centrum
 Kultury, Kraków 034702
Galeria Miejski Arsenał, Poznań 137992
Galeria Miejska BWA, Bydgoszcz 113531
Galeria Miejsko, Gminny Ośrodek
 Kultury, Stary Sącz 035055
Galeria Milano, Warszawa 113924
Galeria Millenium, Gdynia 113585
Galeria Minimal, Porto 114178
Galería Minotauro, Caracas ... 125334
Galería Miro, Bogotá 102227
Galería Miró, San José 102400
Galeria Mistral, Kraków 113660
Galería Mölln, Mölln 077314
Galeria Mokra, Poznań 084466, 113812
Galería Monaliza, San José ... 102401
Galeria Monet, Palma de
 Mallorca 115441, 115442
Galeria Monumental, Lisboa ... 114109
Galería Monumento Histórico Nacional
 a la Bandera, Rosario 000537
Galeria Multiarte, Fortaleza 100808

Galeria Mun, Madrid 115305
Galería Mundo, Bogotá 102228
Galería Mundo Arte, Medellín .. 102350
Galeria Municipal de Arte,
 Almada 035337
Galería Municipal de Arte Moderno,
 Barcelona 054638
Galeria Municipal Trem, Faro .. 035518
Galeria Muntaner, Barcelona .. 114995
Galeria Muro, Valencia 115585
Galeria Muz, Dom Muz – Miejska
 Instytucja Kultury, Toruń 035114
Galeria na Freta, Warszawa .. 084547,
 113925
Galeria Na Piętrze – BWA w Kielcach,
 Kielce 113604
Galeria na Piwnej, Warszawa . 084548,
 113926
Galeria na Strychu, Wrocław .. 114022
Galeria na Tarczyńskiej,
 Warszawa 113927
Galería Nacional de Arte,
 Comayagua 023079
Galería Nacional de Arte
 Contemporáneo, San José .. 008686
Galería Nacional y Museo de los
 Niños, San José 008687
Galería Nacional, Instituto de Cultura
 Puertorriqueña, San Juan .. 035988
Galeria Nadir, Valencia 115586
Galería Namu, San José 102402
Galeria Nave Diez, Valencia .. 115587
Galeria Nazareth's, Porto 114179
Galeria Nova, Kraków 113661
Galeria Nova, Łódź 034791
Galeria Nova, Poznań 113813
Galeria Nowa Przestrzeń, Patio
 Centrum Sztukii Wyższej Szkoły
 Humanistyczno-Ekonomicznej,
 Łódź 034792
Galeria Nowohuckiego Centrum
 Kultury, Kraków 113662
Galeria Nr 1, Zbigniew,
 Warszawa 113928
Galeria Nuevoarte, Sevilla ... 115545
Galeria Nusantara, Muzeum Azji i
 Pacyfiku, Warszawa 035153
Galeria Oamenilor de Seamă,
 Fălticeni 036290
Galería Obsidiana, Lima 113449
Galeria Oeste, São Paulo 100958
Galeria Okendo, Vitoria-Gasteiz . 115612
Galeria Olimpus, Łódź 113755
Galeria Olympia, Kraków 113663
Galería OMR, México 112031
Galeria On, Poznań 113814
Galeria OPK Gaude Mater,
 Częstochowa 113537
Galeria Opus, Łódź 113756
Galería Orfila, Madrid 115306
Galería Oriente, Santiago de
 Cuba 009179
Galería Orizont, București ... 114227
Galeria Osiedlowego Domu Kultury
 Pod Lipami, Poznań 034947
Galeria Osobliwości Este, Kraków 084402,
 113664
Galeria Ostrołęka, Centrum Kultury,
 Ostrołęka 034915
Galeria Passe-Partout, Lisboa .. 114110,
 114111
Galeria Patio, Patio Centrum Sztuki
 Wyższej Szkoły Humanistyczno-
 Ekonomicznej, Łódź 034793
Galería Pazos, Bogotá 102229
Galeria Pedro Cera, Lisboa ... 114112
Galeria Pegaz, Kraków 113665
Galeria Persja, Kraków 084403
Galeria Petra Michala Bohúňa,
 Liptovský Mikuláš 038201
Galería Picasso, Bogotá 102230
Galería Picasso, Medellín 102351
Galería Piekary, Poznań 113815
Galeria Pies, Poznań 113816

Galeria Pilares, Cuenca 115128, 115129
Galeria Piotra Uznańskiego, Łódź 084439,
 113757
Galería Piurarte, Piura 034216
Galeria Piwnice – BWA w Kielcach,
 Kielce 113605
Galería Pizarro, Valencia 115588, 115589
Galeria Plakatów, Warszawa .. 113929
Galeria Plakatu, Kraków 113666
Galeria Plakatu Astrid, Gdynia .. 113586
Galeria Plan B, Cluj-Napoca .. 114247
Galeria Plater, Warszawa 084549,
 113930, 126632
Galería Plazuela del Artista,
 Medellín 102352
Galería Pluma, Bogotá 102231
Galería Pocitos, Montevideo .. 054511
Galeria Pod Arkadami, Białystok 113514
Galeria Pod Kopcem, Kraków .. 113667
Galeria pod Plafonem, Wrocław 114023
Galeria Pod Podłogą, Lublin .. 113784
Galeria pod Rejentem, Kraków . 113668
Galeria Pod Sufitem, Katowice . 113598
Galeria Podlaska, Miejski Ośrodek
 Kultury, Biała Podlaska 034466
Galéria Poláková, Bratislava .. 114730
Galeria Polony, Poznań 113817
Galeria Polskiego Plakatu,
 Warszawa 113931
Galeria Ponto Artes, São Paulo . 064130
Galeria Ponto das Artes, Lisboa 114113
Galeria Por Amor à Arte, Porto . 114180
Galeria Potocka – Kolekcja Artystów,
 Kraków 113669
Galeria Praxis, Lima 113450
Galeria Praxis, México 112032
Galería Presença, Porto 114181
Galería Prestige, Caracas 097817
Galeria Pro Arte, Oświęcim .. 113800
Galeria Pro-Arte, San José ... 102403
Galeria Prof. Sylvio Vasconcellos,
 Instituto Cultural Brasil-Estados
 Unidos, Belo Horizonte 004260
Galeria Profil, Poznań 113818
Galeria Profile, Gdynia 113587
Galeria Promocyjna, Warszawa . 113932
Galeria Przy Piastów, Szczecin . 113862
Galeria Przyssawka, Szczecin . 113863
Galeria Puenta, Sopot 113846
Galeria Puerta de Alcala, Madrid 115307
Galería Punto, Valencia 115590
Galería Punto Arte, Barcelona . 114996
Galeria Quadrado Azul, Porto .. 114182
Galeria r, Poznań 113819
Galeria Radwan, Sopot 113847
Galería Rafael, Valladolid 115621
Galería Ratton Cerâmicas, Lisboa 114114
Galería Rembrant, Cali 102310
Galeria Restelo, Lisboa 114115
Galeria Retxa, Ciutadella de
 Menorca 115112
Galería Reyes Católicos,
 Salamanca 115499
Galería Río de la Plata,
 Montevideo 125300
Galería Rodas, Bogotá 102232
Galeria Roglan, Barcelona 114997
Galeria Rojo y Negro, Bogotá .. 102233
Galeria Romana, Bydgoszcz .. 113532
Galeria Rosengasse, Heide ... 107361
Galeria Rovira i Monti Se'Leccio,
 Sabadell 115493
Galeria Rynek, Miejski Ośrodek
 Kultury, Olsztyn 034901
Galeria Safia, Barcelona 114998
Galeria Sam, Bucaramanga ... 102291
Galería San Antón, Pamplona . 115483
Galería San Francisco, Caracas . 125335
Galeria San Francisco, Lima .. 113451
Galería San Ysidro, El Paso .. 093238
Galeria São Mamede, Lisboa .. 114116
Galeria Sardon, León 115200
Galeria SARP, Wrocław 035248
Galeria Sen, Madrid 115308

Galerie 3K, Rechberghausen . . . 108453
Galerie 4, Cheb 102549
Galerie 41, Monaco . . 082322, 112070
Galerie 419, Brisbane 098643
Galerie 422 Margund Lössl,
 Gmunden 099855
Galerie 43, Paris 104713
Galerie 48, Saarbrücken 108542
Galerie 49, Saumur 105616
Galerie 49 Ann'Cadres, Angers . 066547
La Galerie 5, Toulouse 105691
Galerie 5020, Salzburg 002570
Galerie 53, Paris 104714
Galerie 54, Paris 104715
Galerie 57, Biel 116248
Galerie 58, Magny-en-Vexin . . . 069749
Galerie 58, Montreux . . 087484, 116598
Galerie 59, Wuppertal 109005
Galerie 5ünf Sinne, Halle, Saale . 107162
Galerie 6, Dijon 068273, 103627, 128822
Galerie 60, Feldkirch 099849
Galerie 64, Kriens 116490
Galerie 67, Bern 116223
Galerie 67, Québec 101362
Galerie 7, Riegersdorf 100013
Galerie 73, Bordeaux 067273
Galerie 78, Le Chesnay 103888
Galerie 7ème Avenue, Paris . . . 071315
Galerie 7Kunst/Wordspeicher,
 Quedlinburg 108429
Galerie 83, Inh. Arno Firmian,
 Zollikerberg 116826
Galerie 88, Kolkata 109413
Galerie 89, Aarwangen 116106
Galerie 9, Paris 071316, 104716
Galerie 92, Bruxelles 063378
Galerie 95, Luxembourg 111899
Galerie 96, Bourglinster 111873
Galerie A & A, Tokyo 111436
Galerie à la Grue, Gruyères 116459
Galerie a Muzeum Litoměřické
 Diecéze, Litoměřice 009512
Galerie A, Harry Ruhé,
 Amsterdam 082567, 137929
Galerie A. & S., Husum 107431
Galerie A+O, Borken, Westfalen . 106547
Galerie A16, Thalwil 116757
Galerie AA, Clermont-Ferrand . . 103554
Galerie AAA, Ostrava . . 065368, 102594,
 125688
Galerie AB, Paris 071317, 104717,
 141079
Galerie Abélard, Sens 105625
Galerie Academia, Salzburg . . . 100023
Galerie Accord, Marseille 104120
Galerie Action, Sierentz 105628
Galerie Adam, Paris 071318
Galerie Adina, Irene Stumpp,
 Giebenbach 116444
Galerie Adlergasse, riesa efau,
 Dresden 017745
Galerie Adolf Blaim, Messern . . 002343
Galerie Afrique, Ramatuelle 072318
Galerie Agnes Dutko, Atelier Bonaparte,
 Paris 071319, 104718
Galerie Akzente, Minden 107989
Galerie Albane, Nantes 104289
Galerie Alberghina, Bad Homburg v.d.
 Höhe 106012
Galerie Albert Baumgarten, Freiburg
 im Breisgau 107014
Galerie Albert Prem1er, Bruxelles 100462
Galerie Albis, Ústí nad Labem . . 102708
Galerie Albrecht, Berlin 106193
Galerie Alexander E. Räber,
 Zürich 116864
Galerie Alif Ba, Casablanca 112113
Galerie Alte Kunst, Baden-Baden 074594,
 106053
Galerie Alte Meister, Köln 076801
Galerie Alte Mühle, Würenlos . . 116819
Galerie Alte Schule, Bramstedt . 106556
Galerie Alte Schule Ahrenshoop,
 Ahrenshoop, Ostseebad 105920

Galerie Alte Schule Wittstedt,
 Bramstedt 017317
Galerie Alte Technik, Berlin 074752
Galerie Alte und Moderne Kunst,
 Koblenz 107557
Galerie Alte Wache, Cuxhaven . . 106633
Galerie Altes Kraftwerk, Borken,
 Hessen 106546
Galerie Altstadt, Krems 062664, 099945
Galerie Altstadt, Speyer 108657
Galerie am Abend, München . . . 108065
Galerie am Alten Garten, Siegen 108623
Galerie am Alten Rathaus, Rupert
 Kraus, Regensburg 108466
Galerie am Altpörtel, Speyer . . . 108658
Galerie am Bach, Neustadt an der
 Weinstraße 108266
Galerie am Bach, Obererlinsbach 116638
Galerie am Berg, Oberwiesenthal,
 Kurort 108337
Galerie am Berg,
 Windischgarsten 100262
Galerie am Blauen Wunder,
 Dresden 106703
Galerie am Brasselsberg, Kassel 107517
Galerie am Brunnen, Bergisch
 Gladbach 106080
Galerie am Brunnental, Lauingen 107787
Galerie am Carlsplatz, Düsseldorf 075425
Galerie am Damm, Dresden . . . 106704
Galerie am Dillberg,
 Marktheidenfeld 107962
Galerie am Dom, Aachen 105883
Galerie am Dom, Billerbeck 074954
Galerie am Dom, Frankfurt am
 Main 106952
Galerie am Dom, Wetzlar 022192
Galerie am Domhof, Zwickau . . 022485
Galerie am Domplatz, Hamburg 076165
Galerie am Eichhof, Kiel 108538
Galerie Am Elisengarten, Aachen 105884
Galerie am Fluß, Pegestorf 108380
Galerie am Gendarmenmarkt,
 Berlin 106194
Galerie am Graben, Augsburg . . 016454
Galerie am Hafen, Glückstadt . . 107092
Galerie am Hafen, Ulsnis 108816
Galerie am Hauptplatz,
 Großaitingen 107131
Galerie am Hechtplatz, Zürich . . 087762
Galerie am Hellweg, Werl 108889
Galerie am Hengstbrunnen, Bad
 Tatzmannsdorf 099824
Galerie am Holzmarkt,
 Wolfenbüttel 078964
Galerie am Jakobsbrunnen,
 Stuttgart 108702
Galerie am Johannisplatz, Jena . 107901
Galerie am Judenberg, Augsburg 105977
Galerie am Kamp, Teterow 021731
Galerie am Kietz, Schwedt /
 Oder 108597
Galerie am Kleinen Plan, Celle . 106620
Galerie am Kloster, Hausach . . . 076360
Galerie am Kloster, Lorsch 107881
Galerie am Kloster, München . . 108066
Galerie am Kreuzplatz,
 Frauenfeld 116364
Galerie am Kröpke, Hannover . . 107333
Galerie am Kulm, Neustadt am
 Kulm 108261
Galerie am Leewasser, Brunnen 116266
Galerie am Lindenplatz, Vaduz . 111835,
 137901
Galerie am Lobkowitzplatz, Wien 100134
Galerie am Maintor,
 Sommershausen 108644
Galerie am Markt, Bad Düben . . 106002
Galerie Am Markt, Bad Saulgau 016649
Galerie am Markt, Waldkirch . . . 108853
Galerie am Marktplatz, Büren an der
 Aare 116272
Galerie am Michel, Hamburg . . 107210
Galerie am Münster, Ulm 108812

Galerie am Museum, Flensburg . 106919
Galerie am Museum Glasgarten,
 Frauenau 107007
Galerie am Nikolaikirchhof,
 Leipzig 107804
Galerie am Paradeplatz, Zürich . 116865
Galerie Am Park, Kühlungsborn,
 Ostseebad 107756
Galerie am Park, Sankt Gallen . 087579,
 116700
Galerie am Park, Wien 100135
Galerie am Platz, Eglisau 116349
Galerie am Rathaus, Höxter . . . 107414
Galerie am Ratswall, Bitterfeld . . 017184
Galerie Am Rex, Wilnsdorf 108958
Galerie Am Rhein, Eglisau 087212
Galerie am Rotbrunnen, Schopp 108577
Galerie am Sachsenplatz, Leipzig 107805
Galerie am Salzgries, Wien 100136
Galerie am Savignyplatz, Berlin . 106195
Galerie am Schloss, Gottlieben . 116453
Galerie am Schloßgarten,
 Mötzingen 108008
Galerie am Schrottturm,
 Schweinfurt 108598
Galerie am Spalengraben, Basel . 116166
Galerie am Stadthaus, Bonn . . . 106529
Galerie am Stein, Schärding . . . 105056
Galerie am Stern, Essen 075627, 106875,
 106876, 130101
Galerie am Strichweg, Cuxhaven 106634
Galerie am Styg, Safnern 116690
Galerie am Tegernsee, Rottach-
 Egern 108531
Galerie am Turm, Büren 106607
Galerie am Turm, Waiblingen . . 108846
Galerie am Undertor, Stein am
 Rhein 087636
Galerie am Weinberg,
 Mainstockheim 077168
Galerie am Weinkeller, Wien . . . 100137
Galerie Ambiente, Flensburg . . . 106920
Galerie Ambiente, Hamburg . . . 076166
Galerie Ambiente, Kronach 107738,
 107739
Galerie Amicorum, Paris 104719
Galerie Ammar Farhat, Sidi Bou
 Saïd 117078
Galerie Amsterdam / Amsterdam
 Outsider Art, Amsterdam 112280
Galerie Amyot, Paris 104720
Galerie an der Börse, Düsseldorf 075426,
 106753
Galerie an der Brenz, Sontheim an der
 Brenz 078425
Galerie an der Pinakothek der
 Moderne, München 108067
Galerie an der Schirn, Frankfurt am
 Main 141683
Galerie an der Sierichstraße,
 Hamburg 076167
Galerie an der Steige Zwei,
 Mainz 107937
Galerie Anais, München 108068
Galerie Analix Forever, Genève . 116395
Galerie Anatome, Paris 104721
Galerie Anderswo, Berlin 106196
Galerie Ando, Tokyo 111437
Galerie Ange Antoine, Morlaix . . 104243
Galerie Anima, Waldshut-Tiengen 108854
Galerie Anita Beckers, Frankfurt am
 Main 106953
Galerie Anke Zeisler, Berlin 106197
Galerie Anna Paulownahuis,
 Soest 032710
Galerie Anne de Villepoix, Paris . 104722
Galerie Annick Mancheron, Paris 071320
Galerie Anno 1589, Bensheim . . 106074
Galerie Ansichtssache, Lübeck . 107898
Galerie Antenna, Dakar 037935
Galerie Antic, Objat 070724
Galerie Antického Umění,
 Hostinné 009416
Galerie Antilope, Düsseldorf . . . 106754

Galerie Antja Wachs, Berlin . . . 106198
Galerie Anton, Agen . . 066367, 103125
Galerie Antonigasse, Bremgarten
 (Aargau) 116262
Galerie Antonina Chittussiho, Ronov
 nad Doubravou 009704
Galerie Antonine Catzéflis, Paris 104723
Galerie Antonins, Nîmes 104348
Galerie Anzbach und Goldammer
 Museum, Maria Anzbach 099980
Galerie AO, Emsdetten 106845
Galerie AP, Brno 102527
Galerie Apart, Bad Wimpfen . . . 106044
Galerie Apart, Pforzheim 108387
Galerie Applanos, Asilah 112103
Galerie Aquarelle, Biel 116249
Galerie Aquatinta, Lenzburg . . . 116529
Galerie Aratora, Artern 105954
Galerie Arcanes, Paris 071321
Galerie Arche, Hameln 107305
Galerie Architektur und Arbeit,
 Gelsenkirchen 018350
Galerie Architektury Brno, Brno . 009308
Galerie Arcturus, Paris 104724
Galerie argus fotokunst, Berlin . 106199
Galerie Ariadne, Wien 100138
Galerie Ariane, Dijon 103628
Galerie Arkade, Kufstein 099953
Galerie Arkade, Linz 099969
Galerie Arkade, Salzburg 100024
Galerie Arkade, Wien 100139
Galerie Arnstein, Weismain 108883
Galerie Arrigoni, Cham 087169
Galerie Ars, Brno 102528
Galerie ARS, Stuttgart 108703
Galerie Art, Biarritz 103334
Galerie Art & Craft, Praha 102626
Galerie Art & Ride, Tholey 108777
Galerie Art + Vision, Bern 116224
Galerie Art Céleste, Bordeaux . . 103379
Galerie Art Comparaison, Carnac 103484
Galerie Art Comparaison, La Baule-
 Escoublac 103813
Galerie Art Comparaison, Paris . 104725
Galerie Art du Temps, Metz . . . 104174
Galerie Art et Culture, Montréal . 101250
Galerie Art et Patrimoine, Paris . 104726
Galerie Art G, Béziers 103327
Galerie Art-In, Meerane 107967
Galerie Art International, Nancy . 104270
Galerie Art Lympia, Nice 070555
Galerie Art Seiller, Saint-Paul-de-
 Vence 105539
Galerie Art Stuttgart, Stuttgart . . 108704
Galerie Art und Weise, Heide . . 107362
Galerie Art'7, Nice 104314
Galerie Artcadache, Vallorbe . . . 116777
Galerie Artemons/Artemons
 Contemporary, Herwig Dunzendorfer,
 Hellmonsödt 099891
Galerie Artès, Barbizon 103280
Galerie Arthéna, Eguisheim 103663
Galerie Artificado, Hildesheim . . 107408
Galerie Artina, Paris 104727
Galerie Artina, Ebersdorf 099844
Galerie Artischocke, Bad
 Schussenried 106036
Galerie Artisty, Hamburg 107211
Galerie Artitude, Montréal 101251
Galerie Artlantis, Bad Homburg v.d.
 Höhe 106013
Galerie Artpark, Linz 099970
Galerie Arts Multiples, Metz . . . 104175
Galerie artziwna, Wien 100140
Galerie Asa, Praha 102627
Galerie Asakusa, Marseille 104121
Galerie Aspekte, Waibstadt 078741
Galerie at Lincoln Center, New
 York 051310
Galerie-Atelier III, Barmstedt . . . 106066
Galerie Athanor, Marseille 104122
Galerie Athena, Bruxelles 100463,
 125580
Galerie Atlantis, Cottbus 075228

Drummondville 005611
Galerie d'Art Moderne, Passavant-la-
Rochère 014607
Galerie d'Art Municipale,
Oberkorn 030424
Galerie d'Art Municipale,
Rumelange 030425
Galerie d'Art Royale, Windsor,
Ontario 101718
Galerie d'Art Saint-Honoré, Paris 104746
Galerie d'Art Saint-Pierre,
Vézelay 105808
Galerie d'Art Stewart Hall, Pointe-
Claire 006517
Galerie d'Art Stewart Hall, Centre
Culturel de Pointe-Claire, Pointe-
Claire 006518
Galerie d'Art, Université de Moncton,
Moncton 006214
Galerie d'Artisanat d'Art Kalloné,
Crémieu 103594
Galerie D'Arts Contemporains,
Montréal 101255
Galerie d'Arts Decoratifs, Miami 094570
Galerie Das Da, Zug 116958
Galerie David, Bielefeld 106491
Galerie D'Avignon, Montréal . . . 101256
La Galerie de Alliance Française de
Manille, Makati 113480
Galerie de Beaune, Paris 071332,
129242
Galerie de Bel Air, Loudun 069587
Galerie de Bel Air, Verrue 073998
Galerie de Berne, Wabern 087689,
134271
Galerie de Bourglinster,
Bourglinster 030395
Galerie de Bretagne, Quimper . . 105370
Galerie de Breyne-Lamy,
Bruxelles 063380
Galerie de Briord, Nantes 104290
Galerie de Buci, Paris 104747
Galerie de Cannes, Cannes 103460
Galerie de Chai du Terral, Saint-Jean-
de-Védas 015183
Galerie de Chartres, Chartres . . 125826
Galerie de Corbez, Saint-Germain-les-
Corbeil 072771
Galerie de Crécy, Crécy-la-
Chapelle 068171, 103593
Galerie de Crécy, Voulangis . . . 074240
Galerie de Dampierre, Dampierre-en-
Yvelines 103603
Galerie De Di By, Paris 104748
Galerie de Florence, Paris 104749
Galerie de France, Paris 104750
Galerie de Grancy – Centre
International d'Art Contemporain,
Lausanne 116510
Galerie de Guise, Dijon 103629
Galerie de L'Isle, Montréal . . . 101257
Galerie de Jonckheere, Paris . . 104751
Galerie de Joss Joss, Dijon 103630
Galerie de Kerbrest, Guidel . . . 103755
Galerie de la Bièvre, Paris 104752
Galerie de la Broye, Payerne . . 116651
Galerie de la Cathédrale, Aix-en-
Provence 066402
Galerie de la Cathédrale,
Monaco 112072
Galerie de la Charité, Lyon . . . 104035
Galerie de la Cité, Penne-
d'Agenais 105289
Galerie de la Colombe, Vallauris 105761
Galerie de la Corraterie, Genève 116398
Galerie de la Coste, Beaune . . . 103302
Galerie de la Daurade, Toulouse 105693
Galerie de la Ferme de la Chapelle,
Grand-Lancy 116455
Galerie de la Fontaine, La Bresse 103826,
128876
Galerie de la Gare, Bayonne . . . 103294
Galerie de la Gare, Molleges . . . 070097

Galerie de la Gare, Nice 070556, 104317
Galerie de la Grenette, Sion . . . 041738
Galerie de la Huchette, Paris . . . 104753
Galerie de la Loge, Lyon 069682
Galerie de la Louve, Gland 087317,
116445
Galerie de la Madeleine, Béziers 067117,
103328
Galerie de la Maison, Champagne-
Vigny 103515
Galerie de la Marine, Cherbourg-
Octeville 103540
Galerie de la Marine, Nice . . . 014277
Galerie de la Méditerranée, Saint-Paul-
de-Vence 105541
Galerie de la Mer, Paris 104754
Galerie de la Place, Lyon 104036
Galerie de la Place, Paris 104755
Galerie de la Place Ziem,
Beaune 103303
Galerie de la Présidence, Paris . 104756
Galerie de la Rivière, Saint-
Savinien 105573
Galerie de la Rotonde, Paris . . 104757
Galerie de la Scala, Paris 104758
Galerie de la Schürra,
Pierrafortscha 116656
Galerie de la Sorbonne, Paris . . 104759
Galerie de la Tour, Bazens 011746
Galerie de la Vielle Fontaine,
Sion 087618, 116733
Galerie-de-l'Alpage I, Megève . . 104164
Galerie de l'Alpage II, Courchevel 103586
Galerie de l'Ancien Courrier,
Montpellier 104227
Galerie de l'Ancienne Douane,
Strasbourg 015664
Galerie de l'Ancienne Poste,
Toucy 073653, 105662
Galerie de Lange, Emmen 032125
La Galerie de Lans, Chambéry . 103510
Galerie de Lara, Litomyšl 102579
Galerie de l'Arcade, Pézenas . . 072094
Galerie de l'Arche, Ecueille . . . 068371
Galerie de l'Art Erotique,
Newstead 099310
Galerie de l'Aspic, Nîmes 104350
Galerie de l'Atelier, Bordeaux . . 058616,
103381
Galerie de l'Echarpe, Toulouse . 105694
Galerie de l'École d'Art, Marseille 013844
Galerie de l'École la Chaufferie, École
Superieure des arts décoratifs,
Strasbourg 015665
Galerie de l'École Nationale des
Beaux-Arts, Nancy 014204
Galerie de l'École Régionale des
Beaux-Arts, Nantes 014214
Galerie de l'Ecusson, Montpellier 104228
Galerie de l'Empreinte, Court . . 116324
Galerie de l'Encadrement,
Etampes 103671
Galerie de l'Ermitage, Le Touquet-
Paris-Plage 103921
Galerie de l'Estampe, Lyon . . . 069683,
104037
Galerie de l'Estuaire, Honfleur . 103780
Galerie de l'Europe, Paris 104760
Galerie de l'Evêché, Vence 105787
Galerie de l'Hibiscus, Pont-
l'Évêque 105342
Galerie de l'Hôtel de Saulx,
Beaune 103304
Galerie de l'Hôtel de Wicque,
Pézenas 105308
La Galerie de l'Impasse, Lyon . . 104038
Galerie de l'Iroise, Dournenez . 103655
Galerie de l'Isle, Montpellier . . 070246
Galerie de l'Olympe, Lyon 104039
Galerie de l'Olympe, Perpignan . 072038,
105293
Galerie de l'Opéra, Vichy 105810
Galerie de l'Orne, Rémalard . . . 072365,
105383

Galerie de l'Université, Lyon . . . 104040
Galerie de l'UQAM, Montréal . . 006238
La Galerie de Marjac, Saint-Bauzille-
de-Putois 072647
Galerie de Médicis, Paris 104761
Galerie de Messine, Paris 104762
Galerie de Minéralogie, Paris . . 014456
Galerie de Nemours, Annecy . . . 103199
Galerie de Nesle – Exposition,
Paris 014457
La Galerie de Noisy, Noisy-le-
Sec 014325
Galerie de Normandie, Saint-Vaast-la-
Hougue 105587
Galerie de Paléobotanique, Paris 014458
Galerie de Pézénas, Pézenas . . . 072095
Galerie de Pontaillac, Royan . . 105442
Galerie de Pouzauges,
Pouzauges 014785
Galerie de Prêt d'Œuvres d'Art,
Bruxelles 100464, 136932
Galerie de Prêt Ville d'Angers,
Angers 011467
Galerie de Rue, Rue 116686
Galerie De Ruimte, Eersel 112535
Galerie de SOUZY, Paris 071334, 104763
Galerie de Varenne-Gincourt,
Paris 104764, 137202
Galerie de Vigreyos, Noailhac . . 104358
Galerie de Villiers, Le Touquet-Paris-
Plage 103922
Galerie de Villiers, Paris 104765, 104766
Galerie de Vinci, Bruxelles 100465
Galerie De Vink, Utrecht 083459, 112786
Galerie de Winter, Paris 104767
La Galerie d'Egmont, Bruxelles . 063381
Galerie Deï Barri, Gassin 103713
Galerie Deichstrasse, Hamburg . 107216
Galerie Deichstraße, Holm 107421
Galerie Déjà vu, Frankfurt am
Main 106955
Galerie Dekorat, Lübeck 107899
Galerie Dekorat, Neumünster . . 108254,
108255
Galerie del'Art, Dinan 103635
Galerie Delfi Form, Zwolle 112820
Galerie Delta 98, Den Haag . . . 082897
Galerie Demay Debève, Le Touquet-
Paris-Plage 103923
Galerie d'Enfer, Bruxelles 100466
Galerie Depelmann Edition, Verlag GmbH,
Langenhagen 107783, 137509
Galerie der Berliner Graphikpresse,
Berlin 106214
Galerie der Bezirksbibliothek
Rheinhausen, Duisburg 017813
Galerie der Dinge, München . . . 108073
Galerie der Fekete-Stiftung,
Südhessisches Handwerksmuseum,
Roßdorf 021099
Galerie der Heimat, Hamm, Sieg 107308
Galerie der Hochschule für Graphik
und Buchkunst Leipzig, Gallery of
the Academy of Visual Arts Leipzig,
Leipzig 019649
Galerie der Kreissparkasse Esslingen-
Nürtingen, Esslingen 018060
Galerie der Künste, Berlin 016914
Galerie der Künstler, München . 108074
Galerie der Künstler, Berufsverband
Bildender Künstler München und
Oberbayern, München 020175
Galerie der Künstlergruppe Experiment
Stuttgart, Stuttgart 108705
Galerie der Kunstuniversität Linz,
Linz 002280
Galerie der Malschule See,
Lupburg 107920
Galerie der Mitte, Oberösterreichische
Künstlerbund, Linz 002281
Galerie der Sinne, Erding 106848
Galerie Der Spiegel, Köln 107600,
137493
Galerie der Stadt Backnang,

Turmschulhaus, Backnang 016490
Galerie der Stadt Fellbach,
Fellbach 018094
Galerie der Stadt Plochingen,
Plochingen 020797
Galerie der Stadt Remscheid,
Remscheid 020987
Galerie der Stadt Salzburg im
Mirabellgarten, Salzburg 002571
Galerie der Stadt Sindelfingen,
Sindelfingen 021471
Galerie der Stadt Traun, Traun . 002772
Galerie der Stadt Tuttlingen,
Tuttlingen 021827
Galerie der Stadt Vöcklabruck,
Vöcklabruck 002799
Galerie der Stadt Wels, Wels . . 002849,
100087
Galerie der Stadt Wendlingen am Neckar,
Wendlingen am Neckar 022148, 058851
Galerie der Stiftung S BC – pro arte,
Biberach an der Riß 017132
Galerie der Volksbank, Lindenberg im
Allgäu 107865
Galerie der Volksbank, Weinheim 108880
Galerie der Zülow-Gruppe, Linz . 099972
Galerie Derby, Zürich . 087763, 116866,
143956
Galerie des 30, Mazamet 104159
Galerie des 4 Coins, Hauterives 103761
Galerie des Ambassadeurs,
Hyères 068801
Galerie des Antiquaires, Saint-
Ouen 073050
Galerie des Antiques, Saint-Rémy-de-
Provence 105564
Galerie des Arcades, Arcachon . 103216
Galerie des Arcades, Noyers-sur-
Serein 070709
Galerie des Arcs, Cortona 110002
Galerie des Artistes, Bergerac . . 067044
Galerie des Artistes l'Art dans la Rue,
Moulins (Allier) 104257
Galerie des Arts, Kaarst 107471
Galerie des Arts, Lailly-en-Val . . 103865
Galerie des Arts, New York . . . 122876
Galerie des Arts, Nîmes 104351
Galerie des Arts, Trigance 105727
Galerie des Arts – Ouaiss Antiquités,
Paris 104768
Galerie des Augustins, Avignon . 103259,
140732
Galerie des Beaux Arts, Charleroi 063544
Galerie des Bildungshauses Sodalitas,
Tainach 002744
Galerie des Brotteaux, Lyon . . . 104041
Galerie des Chartons, Bordeaux 067274
Galerie des Chartreuses, Gosnay 103724
Galerie des Dames, Musée de Cires,
Chenonceaux 012358
Galerie des Docks, Nice 104318
Galerie des Ducs, Nevers 104304
Galerie des Escaliers,
Saint-Émilion 105463
Galerie des Estampes, Lille . . . 103957
Galerie des Estampes, Rouen . . 014964
Galerie des Expositions Pablo Picasso,
Denain 012565
Galerie des Franciscains, Saint-
Nazaire 105516
Galerie des Glaciers, Aigle 116112
Galerie des Grands-Augustins,
Paris 104769
Galerie des Iles d'Or, Hyères . . 068802,
128864
Galerie des Joueries, Saint-Germain-
en-Laye 072767
Galerie des Kultur- und
Festspielhauses Wittenberge,
Wittenberge 022285
Galerie des Kultur-Forum-Amthof,
Feldkirchen in Kärnten 001872
Galerie des Kunstvereins,
Wetzlar 108906

Galerie Finartis, Zug 116959
Galerie Fine Art, Eymet 103676
Galerie FL Arts, Villefranche-sur-
Mer . 105820
Galerie Flak, Paris 071342, 104795,
137203, 141080
Galerie flash, international
contemporary, München . . . 108079
Galerie Fleury, Paris . . 104796, 141081
Galerie Flip-Flop, Hamburg 107218
Galerie Flo, Aigues-Mortes . . . 103131
Galerie Flora, Paris 104797
Galerie Flore, Saint-Brieuc 105451
Galerie Florence-Basset, Flassans-sur-
Issole 103693
Galerie Florian, Sceaux 073417
Galerie Florian Trampler,
München 108080
Galerie Förster, Berlin 106221
Galerie Fondation Vromans, IJlst 112629
Galerie Fonderie, Toulouse 105696
Galerie Formart, Cuxhaven 106635
Galerie Forsblom, Helsinki 103085
Galerie Fortlaan 17, Tallieu & Tallieu,
Gent 100554
Galerie Fortuna, Zürich 087765, 143957
Galerie Forum, Mainz 107938
Galerie Forum Lindenthal, Dr. Hans
Thomas, Köln 107601
Galerie foto-forum, Bolzano 109890
Galerie Fototreppe 42, Hanau . . 107313
Galerie Framond, Paris 104798
Galerie Française, München . . 108081,
137554
Galerie France des Arts, Lillers . 103970
Galerie Franck, Paris 104799
Galerie Frank, München 108082
Galerie Frank Schlag & Cie. GmbH,
Essen 116877
Galerie Frankengasse, Zürich . . 116868
Galerie Fred, Lyon 069684
Galerie Freihausgasse, Galerie der
Stadt Villach, Villach 002793
Galerie freiRAUM, Lohfelden . . . 107877
Galerie Freitags, Alzenau in
Unterfranken 105932
Galerie Fuchstal, Fuchstal 107037
Galerie für angewandte Kunst,
München 108083
Galerie für gegenständliche Kunst,
Kirchheim unter Teck 107547
Galerie für Gegenwartskunst,
Bonstetten 116260
Galerie für Geschenke, Elisabeth
Krekel, Mengerskirchen 107977
Galerie für Landschaftskunst,
Hamburg 107219
Galerie für orientalische textile Kunst,
Dortmund 075336
Galerie für Zeitgenössische Kunst
Leipzig, Leipzig 019650
Galerie Fueterchrippe, Zuckenriet 116828
Galerie Fusion, Toulouse 105697
galerie futura, Berlin 106222
Galerie G, Heidelberg 107366
Galerie G, Judenburg 099923
Galerie G22, La Rochelle 103853
Galerie Gärtner GmbH, Berlin . . 106223
Galerie Gala, Montréal 101261
Galerie Gala Amalvy, Valence
(Drôme) 105755
Galerie Galax, Göteborg 115729
Galerie Galipette, Hamburg 107220
Galerie Galya, Neuchâtel 116620
Galerie Gambra, Praha 102632
Galerie Gamma, Wien 062917
Galerie Ganesha, Mersch 082195
Galerie Georges-Goguen,
Moncton 006215
Galerie Gérard, Carcassonne . . . 067615
Galerie Gerbi, Grindelwald 116458
Galerie Gerersdorfer, Wien 100147
Galerie Gerken, Berlin 106224

Galerie Gersag Emmen,
Emmenbrücke 041236
Galerie Gesellschaft, Berlin 106225
Galerie Gibel, Büron 116275
Galerie Gilgamesh, Paris 071344
Galerie Giovanni, Paris 071345
Galerie Glacis, Graz 062572
Galerie Gladys Sani, Paris 071346
Galerie Glaswerk, Germersheim . 107075
Galerie Glockengasse, Köln 019360
Galerie Gloggner Luzern, Luzern 126945
Galerie Gloria, Karlovy Vary . . . 102567
Galerie Gluri Suter Huus,
Wettingen 041866
Galerie Gmünd, Gmünd, Kärnten 001929
Galerie Gmurzynska, Zürich . . . 116869
Galerie GNG, Paris 104800
Galerie GNG, Verneuil-sur-Avre . 105796
Galerie Godot, Praha 102633
Galerie Göttlicher, Krems-Stein . 099949
Galerie Marie-Claude Goinard,
Paris 104801
Galerie Goldener Engel, Hall in
Tirol 062606, 099887
Galerie Goldener Engl, Hall in
Tirol 099888
Galerie Goldturm, Sankt Gallen . 116701
Galerie Gong, Pardubice 102600
Galerie Gora, Montréal 101262
Galerie Gouverneur-Château
d'Homecourt, Homécourt . . . 103765,
137096
Galerie Graff, Montréal 101263
Galerie Grand-Rue, Genève . . . 116400,
143872
Galerie Grand Siecle, Taipei . . . 116995
Galerie Grande Fontaine, Sion . . 116734
Galerie Grand'Rue, Poitiers 105322
Galerie Granero, Bern . 087094, 116225
Galerie Grard, Fenin 116358
Galerie Grashey, Konstanz 107703
Galerie Grażyna, Ústí nad Labem 102709
Galerie Grita Insam, Wien 100148
Galerie Groeneveld, Almelo 112189
Galerie Gronert, München 108084
Galerie Grounded, Chemnitz . . . 106623
Galerie Grounded, Uwe Kreißig,
Chemnitz 106624
Galerie Grünstraße, Berlin 016915
Galerie Günther Frey, Radenthein 100009
Galerie Guillaume, Paris 104802
Galerie Guislain – États d'Art,
Paris 104803
Galerie Gunzenhauser, München 077433,
108085
Galerie Gut Gasteil, Prigglitz . . . 100008
Galerie H 17, Wien 100149
Galerie Hakim, Asilah 112104
Galerie Hall du Mouggar, Alger . 098353
Galerie Hamelin, Honfleur 103783
Galerie Handwerk, München . . . 020176
Galerie Hanna Bekker vom Rath,
Frankfurt am Main 106956
Galerie Hans, Hamburg 076168
Galerie 'Hans Steger', Zeulenroda-
Triebes 022448
Galerie Hanssler, München 108086
Galerie Haus 23, Cottbus 017541
Galerie Hegemann, München . . . 108087
Galerie Heilig, Ettlingen 106903
Galerie Heimberge, Arnstadt . . . 105952
Galerie Heimeshoff, Essen 106878
Galerie Heinz Teufel Multimedia,
Zingst, Ostseebad 022459
Galerie Heinz Teufel Schule des
Sehens, Zingst, Ostseebad . . 022460
Galerie Heinz Teufel Villa Ruh, Zingst,
Ostseebad 022461
Galerie Heitz, Strasbourg 015667
Galerie Heja, Freiburg im
Breisgau 075811, 130157
Galerie Helbing, Hamm,
Westfalen 107309
Galerie Hell, München 108088

Galerie Henri Sie, Saint-Tropez . 105581
Galerie Henseler, München . . . 077434,
108089
Galerie Henze & Ketterer & Triebold,
Riehen 116675
Galerie Henze & Ketterer AG,
Wichtrach . . . 116806, 138163, 143937
Galerie Herr.die Neuen, Potsdam 108408
Galerie Hilaneh von Kories,
Hamburg 107221
Galerie Hilt, Basel 116169
galerie hiltawsky, Berlin 106226
Galerie Himmelreich, Magdeburg 107925
Galerie Himmelsweg, Tostedt . . 078604
Galerie Hinter dem Rathaus,
Gemeinschaft Wismarer Künstler und
Kunstfreunde e.V., Wismar . . 022278
Galerie Hirschmann, Berlin 106227
Galerie Hlavního Mĕsta Prahy –
Mĕstská knihovna, Praha 009629
Galerie Hochmauren, Rottweil . . 108537
Galerie Hof 12, Amersfoort 112201
Galerie Holbein, Lindau 107863
Galerie Hollenstein, Lustenau . . 002306
Galerie Home from home, English
Contemporary, München 108090
Galerie Hommage, Uelzen 108808
Galerie Hopilliart Leroux, Paris . 071347
Galerie Horizon, Hermance 116472
Galerie Horizon, Marseille 104127
Galerie Horst Dietrich, Berlin . . . 106228,
137327
Galerie Hubert, Bremen 075119
Galerie Hübner & Hübner, Frankfurt
am Main 106957
Galerie Huihuaijie, Berlin 106229
Galerie Humus, Lausanne 116513
Galerie Hunchentoot, Berlin 106230
Galerie I.E.M, Antibes-Juan-les-
Pins 103209
Galerie I.S Thomas, Paris 104804
Galerie Icon, Berlin 106231
Galerie ID., Carouge 116288
Galerie IHB Spectrum, Unterseen 116768
Galerie III, Bussum 112444
Galerie il Quadro, Aachen 105885
Galerie Ilsa, Paris 071348
Galerie im 44er Haus, Leonding . 002261
Galerie im Adlon, Berlin 106232
Galerie im Ahlbecker Hof, Ahlbeck,
Seebad 105915
Galerie im alten Kloster, Köln . . 107602
Galerie im Alten Rathaus, Prien am
Chiemsee 020856
Galerie im Amtshaus, Bad
Wurzach 016700
Galerie im Andechshof,
Innsbruck 099907
Galerie im Angelburger Kunst- und
Kulturhaus, Angelburg 016384
Galerie im Arthouse, Ahrensburg 105918
Galerie im Atelier, Aalen 105905
Galerie im Behnisch-Haus, Sabine
Broekmann, Krefeld 107225
Galerie im Bettli, Dübendorf . . . 116346
Galerie im Bildhauerhaus und
Skulpturenanlage, Einöde . . . 001843
Galerie im Bürger- und
Gemeindezentrum, Hofstetten-
Grünau 002069
Galerie im Bürgerhaus, Castrop-
Rauxel 106616
Galerie im Bulgarischen Kulturinstitut,
Berlin 106233
Galerie im Einewelt-Haus,
Magdeburg 107926
Galerie im Einstein, Berlin 106234
Galerie im Elisabethenhof, Bad
Wimpfen 106045
Galerie im ersten Stock, Kunst im
Raum, Mödling 099984
Galerie im Finnland-Institut,
Berlin 106235
Galerie im Fontanahaus, Berlin . 016916

Galerie im Ganserhaus, Arbeitskreis
68, Wasserburg am Inn 108863
Galerie im Gemeinschaftshaus,
Berlin 016917
Galerie im Gericht, Berlin 106236
Galerie im Gewölbe, Vorchdorf . 100084
Galerie im Graben, Zollikofen . . 116827
Galerie im Gut, Förderverein für
junge Künstler e.V., Ulm 108813
Galerie im Haus Knotenbaum,
Todtnau 108780
Galerie im Höchhuus, Küsnacht . 116493
Galerie im Hof, Groß-Umstadt . . 076047,
107130
Galerie im Hofmannschen Gut,
Dürröhrsdorf-Dittersbach 106742
Galerie im Hühnerstall, Krummin 107754
Galerie im Kapellenhof,
Obertshausen 108332
Galerie im Kehrwiederturm,
Hildesheim 018947
Galerie im Kies, Altach 099817
Galerie im Kloster, Magdeburg . 107927
Galerie im Kloster, Ribnitz-
Damgarten 108506
Galerie im Körnerpark, Kommunale
Galerie Neukölln, Berlin 016918
Galerie im Kornfeld, Zehdenick . 109016
Galerie im Kornhauskeller der Ulmer
Kunststiftung Pro Arte, Ulm . . 021848
Galerie im Kulturhaus Spandau,
Berlin 016919
Galerie im Kurpark, Bad Steben 106041
Galerie im Lend, Graz 099862
Galerie im Mänihaus, Frutigen . . 116368
Galerie im Malzhaus, Plauen . . . 020786
Galerie im Maritim, Lübeck 107900
Galerie im Neuen Augusteum,
Universität Leipzig, Leipzig . . 019651
Galerie im Prater, Berlin 016920
Galerie im Prediger, Schwäbisch
Gmünd 021352
Galerie Im Rahmen, Herten 107400
Galerie im Rahmen, Koblenz . . . 107558
Galerie im Rathaus, Bad Aussee 001725
Galerie im Rathaus, Bad
Windsheim 106047
Galerie im Rathaus Köpenick,
Berlin 016921
Galerie im Ratscafe, Bielefeld . . 106492
Galerie im Rittergut, Niederwiesa 108288
Galerie im Saalbau, Kommunale
Galerie Neukölln, Berlin 016922
Galerie im Sankt Gertrude Verlag,
Hamburg 107222
Galerie im Schlössli,
Gontenschwil 116449
Galerie im Schloss Porcia, Spittal an
der Drau 002707
Galerie Im Schloßgarten, Leimen 107790
Galerie im Schopf, Reinach
(Aargau) 116669
Galerie im Seewinkel, Gwatt . . . 116467
Galerie im Stil, Dresden 106711
Galerie im Taschenbergpalais,
Dresden 106712
Galerie im Taxispalais, Galerie des
Landes Tirol, Innsbruck 002097
Galerie im Teisenhoferhof der
Malschule Motiv Wachau,
Weißenkirchen in der Wachau . 002838
Galerie im Theater am Saumarkt,
Feldkirch 001868
Galerie im Tor, Emmendingen . . 106841
Galerie im Traklhaus, Salzburg . 002572,
100025
Galerie im Troadkasten, Pram . . 002481
Galerie im Turm, Berlin 016923
Galerie im Unteren Tor, Bietigheim-
Bissingen 106502
Galerie Im Vest, Recklinghausen 108455
Galerie im Volkspark, Burg
Giebichstein Hochschule für Kunst
und Design Halle, Halle, Saale 018666

Latem 100678
Galerie Linzergasse – Weihergut, Salzburg . . . 062762, 100027, 136867
Galerie Lions'Y, Lyon 104049
Galerie Liotard, Genève 116402
Galerie Litera, Praha 102638
Galerie Lithoart, Charlottenlund . 102748
Galerie LiTo, Detmold 106659
Galerie Litvinov, Litvínov 009519
Galerie LM Art, Trier 108787
Galerie l'Objet d'Art, Brignoles . 103422
Galerie Löwe, Hannover 076311
Galerie Loft, Paris 104816
Galerie Loïc de Pors-Mellec, Locquirec 103992
Galerie Loisel Grafik, Pörtschach am Wörther See 100004
Galerie Loock/ Wohnmaschine, Berlin 106242
Galerie l'Orange, Le Havre 103894
Galerie l'Orangerie, Chambrelien 116296
Galerie Louis-Pierre, Leuven . . . 063675
Galerie Lous Martin, Delft 112445
Galerie Louvre, Praha 102639
Galerie Lovers of Fine Arts, Gstaad 116462
Galerie Luciano Fasciati, Chur . 116312, 138121
Galerie Ludvika Kuby a Městské Muzeum, Březnice 009304
Galerie Ludwig, Kulmbach 107760
Galerie Ludwig Bürgel, Seekirchen am Wallersee 002691
Galerie Lüth und Pictus Verlag, Husum 107432, 137476
Galerie Luftschloß, Münster . . 108225
Galerie Luise, Bielefeld 106494
Le Galerie Luministe, Miami . . 122068
Galerie Luther, Dinslaken 106665, 137383
Galerie LWS, Paris . . . 137206, 141082
Galerie M, Altenrhein 116116
Galerie M, Berlin 016927
Galerie M, Kirchstetten 099928
Galerie M & K, Jihlava 102562
Galerie M & N Uzal, Bruxelles . . 063384, 100470
Galerie M & N Uzal, Paris . . . 071351, 104817
Galerie M + R Fricke, Berlin . . 074753, 106243
Galerie M Bochum, Bochum . . 106514
Galerie M.IQ, Kunsthandlung, Mannheim 107952
Galerie M.R., Angoulême 103189
Galerie Ma, Villach 100076
Galerie Mad, Graz 099864
Galerie Mäder, Basel . . 116170, 138113
Galerie Maegle, im Palais Harrach, Wien 100152, 140069
Galerie Magnet, Völkermarkt . . 100082, 136872, 140043
Galerie Magnus P. Gerdsen, Hamburg 107226
Galerie Mainz, Mainz 107939
Galerie MAINZER KUNST!, Mainz 107940
Galerie Majestic, Paris 104818
Galerie Malwerk 2000, Erdweg . 106850
Galerie Mana, Wien 100153
Galerie Mandos-Feldmann, Westerstede 108903
Galerie Mani, Weimar 108876
Galerie Mansarte, Sankt Anton am Arlberg 100048
Galerie Marco, Bonn . . 075030, 141546
Galerie Marengo, Angoulême . . 103190
Galerie Marenzihaus, Leibnitz . 099956
Galerie Maria Lund, Paris 104819
Galerie Marie-Christine, Bruxelles 063385, 125581
Galerie Marie de Holmsky, Paris 071352, 104820

Galerie Marie-Laure de l'Ecotais, Paris 071353, 104821
Galerie Marie Louis, La Baule-Escoublac 103817
Galerie Marie-Louise, Grenoble . 103738
Galerie Marina, Avignon 103263
Galerie Marina, Cassis 103488
Galerie Marine, Saint-Malo (Ille-et-Vilaine) 072878
Galerie Marion, Perpignan . . 072039, 105294
Galerie Maritim, Hamburg . . 107227
Galerie Markt Bruckmühl, Bruckmühl 017409
Galerie Marktstätte, Konstanz . 107704
Galerie Marschall, Bamberg . . 106475
Galerie Martin Jamda, Wien . . 100154
Galerie Martin Suppan, Wien . . . 100155, 100156, 136888, 136890
Galerie Martina Detterer, Frankfurt am Main 106958
Galerie Matignon, Paris 104822
Galerie Matignon 32, Paris . . 104823
Galerie Maulberger, München . 108099
Galerie Mauritiushof, Bad Zurzach 116142
Galerie Max 21, Iphofen 107446
Galerie Maxim, Villefranche-sur-Mer 074112
Galerie May, Savigny-sur-Orge . 105618
Galerie Mazarin, Nice 070558
Galerie Mazarine, Paris 104824
Galerie Mazur, Kroměříž 102572
Galerie Méditerranée, Bonifacio . 103356
Galerie Méduse, Montréal . . . 064368, 101267
Galerie Meisterschueler, Berlin . 106244
Galerie Melantrich, Polabské muzeum Poděbrady, Rožďalovice 009707
Galerie Mémoires, Albi . 066455, 103169
Galerie meng-art, Lübeck 107901
Galerie Mensing, Berlin 106245
Galerie Mensing, Düsseldorf . . 106757
Galerie Mensing, Hamburg . . 107228
Galerie Mensing, Hamm, Westfalen 107310
Galerie Mensing, Hannover . . 107339
Galerie Mensing, Köln 107607
Galerie Mensing, Konstanz . . 107705
Galerie Mensing, Palma de Mallorca 115443
Galerie Mensing, Sylt 108754
Galerie Mercure, Paris 071354
Galerie Mermoz, Paris . 071355, 071356, 104825, 104826
Galerie Mĕsta Blanska, Blansko . 009292
Galerie Mĕstského Muzea Čáslav, Čáslav 009333
Galerie Meyer Kainer, Wien . . 100157
Galerie MG, Paris 071357
Galerie Michael Heufelder, München 108100
Galerie Michael Neff, Frankfurt am Main 106959
Galerie Michael Werner, Trebbin 108785
Galerie Michael Wiesehöfer, Köln 107608
Galerie Michel, Paris . . 104827, 141083
Galerie Michel-Angelo, Montréal 101268
Galerie Michelangelo, Las Vegas 121628
Galerie Micro, Stockholm 115952
Galerie Miejskie, Łódź . 084441, 113763
Galerie Milada, Praha 102640
Galerie Millennium, Praha . . . 102641
Galerie Minnepand, Gent 100556
Galerie Mirages, Edinburgh . . 117907
Galerie Mirko Mayer, Köln . . 107609
Galerie Miro, Praha 102642
Galerie mit der blauen Tür, Nürnberg 108311
Galerie Mitte, Dresden 106716
Galerie Mobile, Bad Wimpfen . 106046
Galerie Modena Art, Wien . . 100158
Galerie Moderne, Bad Zwischenahn 106051

Galerie Moderne, Bruxelles 125582
Galerie Moderne, Silkeborg . . . 102917
Galerie Moderního Umění, Hradec Králové 102558
Galerie Moderního Umění, Hradec Králové 009418
Galerie Mohamed El Fassi, Rabat 112124
Galerie Mohamed Kacimi, Un nouvel espace d'art contemporain, Fès 112119
Galerie Mollwo, Riehen 116676
Galerie Mona Lisa, Paris 104828
Galerie Monaco Fine Arts, Monaco 112076
Galerie Mondsee, Mondsee 099987
Galerie Monique Bornstein, Villefranche-sur-Mer 105821
Galerie Mont-Blanc, Chamonix-Mont-Blanc 103512, 140780
Galerie Montaigne, Monaco . . . 082325
Galerie Montana, Apeldoorn . . 112406
Galerie Montcalm, Gatineau . . 005757
Galerie Montgautier, Poitiers . . 105323
Galerie Montparnasse, Genève . 116403, 143873
Galerie Morgenland, Hamburg . 107229
Galerie Moulay Youssef, Casablanca 082377
Galerie Müller & Plate, München 108101
Galerie Münsterland e.V., Emsdetten 017951
Galerie Municipale, Montesquieu 014056
Galerie Municipale, Vitry-sur-Seine 016105
Galerie Municipale d'Art Contemporain Julio-Gonzalez, Arcueil 011529
Galerie Municipale Edouard Manet, Gennevilliers 012901
Galerie Municipale, Salle Aliénor, Biscarrosse 103348
Galerie Municipale, Salle Pourbal, Biscarrosse 103349
Galerie Museal, Luxembourg . . 082185
Galerie-Musée Le Petit Chapitre, Fosses-la-Ville 003527
Galerie Museum Rabalderhaus, Kunst in Schwaz, Schwaz 002681
Galerie Mûstek, Praha 102643
Galerie MXM, Praha 102644
Galerie MY, Jablonec nad Nisou 102560
Galerie N, Kunstvereinigung Wasgau e.V., Dahn 017580
Galerie Nadia B, Dieulefit 103621
Galerie nächst St. Stephan, Rosemarie Schwarzwälder, Wien 100159, 136891
Galerie Nagel Draxler, Berlin . . 106246
Galerie Nagel Draxler, Köln . . . 107610
Galerie Naja, Le Cap-d'Agde . . 103878
Galerie Nando, Lausanne 116514
Galerie Nationale d'Art, Dakar . 037936
Galerie Nationale de la Tapisserie et de l'Art Textile, Beauvais 011772
Galerie Nei Liicht, Dudelange . 111875
Galerie Nemo, Eckernförde . . 106817, 137402
Galerie Nero, Wiesbaden 108923
Galerie Neu, Berlin 106247
Galerie neu & alt, Freudenberg . 075847
Galerie Neue Meister, Staatliche Kunstsammlungen Dresden, Dresden 017746
Galerie Neues Rathaus, Wetzlar 108907
Galerie Neumühle, Edenkoben . 106823
Galerie Neunte Kunst, Bastei Freunde Klubzeitung, Niederkrüchten . . 137584
Galerie Neuse Kunsthandel GmbH, Bremen 075120
Galerie Neverland, Wien 100160
Galerie Nieves Fernandez, Madrid 115311, 138083
Galerie Nilius, Köln 107611
Galerie Nischke, München . . 108102, 108103
Galerie No Smoking, Strasbourg 105644

Galerie No. 9, Praha 102645
Galerie Noah, Augsburg 105979
Galerie Noctua, Říčany u Prahy . 140503
Galerie Nöfa, Wels . . . 100089, 136875
Galerie Noodlebärg, Basel . . 116171
Galerie Noord, Groningen 112578
Galerie Noordeinde, Den Haag . 112469
Galerie Noran, Lübeck 107902
Galerie Noran, Lüdinghausen . 107914, 107915
Galerie Noran, Panker 108370
Galerie Nord, Halle, Saale 107164
Galerie Nord-Est, Strasbourg . . 105645
Galerie Nord-Kunstverein Tiergarten, Berlin 016928
Galerie Nord-Sam, Salzburg . . 100028
Galerie Normand, Paris 104829
Galerie Nota Bene, Genève . . . 116404
Galerie Nothburga, Innsbruck . 099908
Galerie November, Berlin 106248
Galerie Nový Svět, Praha 102646
Galerie Nr 7, Bad Doberan . . 105998
Galerie Nuances, Saint-Gilles-Croix-de-Vie 105481
Galerie Nuances et Lumière, Lyon 104050
Galerie Numero 16, Noordbroek 032517
Galerie O, Schaffhausen 116721
Galerie Oben, Chemnitz 106625
Galerie Oberkampf, Paris 104830
Galerie Obkirchen, Sachseln . . 116689
Galerie of Art, Bad Bentheim . 105989
Galerie of Modern Art, Berlin . 106249
Galerie Offenes Atelier D.U.Design, Villach 002794
Galerie Onze, La Colle-sur-Loup 103834
Galerie Opaque, Berlin 106250
Galerie Open, Berlin 106251
Galerie Ora-Ora, Hong Kong . 101955
Galerie Orangerie, Köln 107612
Galerie Orlando, Zürich 116876
Galerie Orly, O. & P. Wille, Basel 116172
Galerie Orsel, Paris 104831
Galerie Ost-Art, Berlin 106252
Galerie Ostrov, Praha 102647
Galerie Otto, Wien 062919, 100161
Galerie Otto – Rudolf Otto KG, Wien 062920
Galerie Otto OG, Wien 062921
Galerie Ovadia, Nancy 104271
Galerie OVO, Taipei 116996
Galerie P, Carouge 116829
Galerie P, Wittingen 108968
Galerie P, Zürich 116877
Galerie Pablo Picasso, Amsterdam 112284
Galerie Packschuppen, Baruth . 106068
Galerie Page, Biarritz 103335
Galerie Painen, Berlin 106253
Galerie Palais Starhemberg, Wien 062922
Galerie Palette, Oldenburg . . 108353
Galerie Palme, Hamburg 116669
Galerie Palú, Pontresina 116878
Galerie Pamme-Vogelsang, Köln 107613
Galerie Pamyr, Paris 071358
Galerie Panache, Hong Kong . 101956
Galerie Pankow, Berlin 016929
Galerie Pappelhof, Appenzell . 116123
Galerie Parchemine, Montréal . 101269
Galerie Parcours, Metz 070044
Galerie Paris-Isphahan, Paris . 071359
Galerie Parterre Berlin, Kunstsammlung Pankow, Berlin 016930
Galerie Patrick Cramer, Genève . 116405, 138126
Galerie Patro, Ostrava 102596
Galerie Páv, Liberec 102576
Galerie Pazyryk, Aix-en-Provence 103148, 128669
Galerie Peithner-Lichtenfels, Wien 100162
Galerie Pendo, Zürich 116878
Galerie Pesko, Lenzerheide . . . 116530

Galleria La Casa, Vaglio	116776
Galleria La Colomba, Viganello	116791
Galleria La Cornice, Norderstedt	108295
Galleria La Meridiana, Verona	111207
Galleria La Nevera, Gordola	116450
Galleria La Rocca, Aosta	109761
Galleria La Rocca, Torino	110996
Galleria La Sirena, Tucson	124985
Galleria Lapiccirella, Firenze	079977
Galleria Lapidaria, Musei Vaticani, Città del Vaticano	054619
Galleria Le Muse, Messina	110237
Galleria Liguria, Genova	110121
Galleria Lo Spazio, Brescia	109918
Galleria Luce, Venezia	111137
Galleria M. Rizzi, Sestri Levante	027768
Galleria Magenta, Brescia	109919
Galleria Magenta, Magenta	110210
Galleria Malair, Piacenza	080983
Galleria Marconi, Cupra Marittima	110013
Galleria Marescalchi, Bologna	109849
Galleria Marescalchi, Cortina d'Ampezzo	109998
Galleria Maria Theresia, Brunico	109932, 109933
Galleria Marieschi, Milano	110355
Galleria Marilena Bonomo, Bari	109778
Galleria Masini, Firenze	110072
Galleria Matasci, Museo d'Arte, Tenero	041792
Galleria Maze, Torino	110997
Galleria Menhir, La Spezia	110171
Galleria Meria, Linköping	115824
Galleria Meridiana, Pordenone	110692
Galleria Micati, Giulianova	110159
Galleria Michelangelo Buonarroti, Brugge	063219
Galleria Michelangelo, Arte Antica e Moderna, Bergamo	109806
Galleria Mignanelli, Roma	110810
Galleria Milano, Milano	110356
Galleria Massimo Minini, Brescia	109920
Galleria Modigliani, Milano	110357
Galleria Mondiale, Surry Hills	099608
Galleria Morone, Milano	110358
Galleria Muciaccia, Roma	110811
Galleria Municipale, Francavilla al Mare	026190
Galleria Museo, Bolzano	109897
Galleria Mystica, Pune	079307
Galleria Narciso, Torino	110998
Galleria Nazionale, Parma	027039
Galleria Nazionale d'Arte Antica, Trieste	028023
Galleria Nazionale d'Arte Antica Palazzo Barberini, Roma	027391
Galleria Nazionale d'Arte Antica Palazzo Corsini, Roma	027392
Galleria Nazionale d'Arte Moderna e Contemporanea, Roma	027393
Galleria Nazionale delle Marche, Urbino	028059
Galleria Nazionale dell'Umbria, Perugia	027086
Galleria Nazionale di Arte Moderna e Contemporanea, San Marino	037918
Galleria Nazionale di Cosenza, Cosenza	025937
Galleria Nazionale di Palazzo Spinola, Genova	026242
Galleria Nella Longari, Milano	080393
Galleria Niccoli, Parma	110645
Galleria No Code, Bologna	109850
Galleria Nova, Ronco sopra Ascona	116683
Galleria Novelli, Verona	111208
Galleria Nuovo, Lahti	103114
Galleria Nuovo Spazio, Udine	111585
Galleria Nuovo Spazio, Venezia	111138
Galleria Oddi Baglioni di Emanuela Lenzi, Roma	110812
Galleria on Third, New York	122881
Galleria Orti Sauli, Genova	110122

Galleria Otso, Espoo	103075
Galleria Pace, Milano	110359
Galleria PaciArte Contemporanea, Brescia	109921
Galleria Pack, Milano	110360
Galleria Palatina e Appartamenti Reali, Firenze	026107
Galleria Palazzo Cini, Venezia	028119
Galleria Palazzo Dami, Firenze	079978
La Galleria Pall Mall, London	089960
Galleria Palladio, Lugano	116546
Galleria Pananti, Firenze	079979, 110073, 126407, 137748
Galleria Perera, Roma	081215, 110813
Galleria Perugi, Padova	110584
Galleria Petrofil Arte, Milano	110361
Galleria Pianeti, Falconara Marittima	110028
Galleria Piemonte Reale Armi Antiche, Torino	081536
Galleria Pinacotheca, Jyväskylän Yliopiston Museo – Kultuurihistoriallinen Osasto, Jyväskylä	010758
Galleria Pinciana, Roma	081216
Galleria Pinocchio, Birchington	088244
Galleria Pollin, Treviso	111062
Galleria Previtali, Bergamo	079683
Galleria Primavera, Helsinki	103095
Galleria Quadreria, San Stino di Livenza	110922
Galleria Quadreria Den Hertog, Bari	109779
Galleria Quadrum, Villafranca di Verona	111230
Galleria Ravagnan, Venezia	111139
Galleria Refinishers Too, Seattle	136706
Galleria Regionale d'Arte Moderna e Contemporanea, Sassoferrato	027698
Galleria Regionale della Sicilia, Palermo	027008
Galleria Regionale di Palazzo Bellomo, Siracusa	027791
Galleria Rettori Tribbio 2, Trieste	111070
Galleria Rinaldo Carnielo, Firenze	026108
Galleria Riviera, Padova	110585
Galleria Romana dell'Ottocento, Roma	081217
Galleria Rusticana, Oslo	084153
Galleria Sabauda, Torino	027939
Galleria San Bernardo, Genova	110123
Galleria San Carlo, Milano	110362
Galleria San Giorgio, Modena	080626
Galleria San Giovanni, Perugia	080976
Galleria San Lorenzo Al Ducale, Genova	110124
Galleria San Maurizio, Venezia	111140
Galleria San Tomaso, Milano	110363
Galleria Sant'Agostino, Torino	110999, 126450
Galleria Sant'Antonin, Venezia	111141
Galleria Santo Stefano, Venezia	111142
Galleria Schreiber, Brescia	109922
Galleria Sculptor, Helsinki	103096
La Galleria Second Classe, New York	122882
Galleria Senato, Milano	110364
Galleria Serego, Verona	111209
Galleria Serodine, Ascona	087014
Galleria Silva, Milano	110368
Galleria Silvy Bassanese, Biella	109817
Galleria Simonini, Modena	080627
Galleria Soave, Alessandria	109756
Galleria Spada, Roma	027394
Galleria Spagnoli Arte, Valtournenche	111095
Galleria Spazia, Bologna	109851
Galleria Spinetti, Firenze	110074
Galleria Stefano Forni, Bologna	109852
Galleria Stendhal, Parma	080948
Galleria Studio G 7, Bologna	109853
Galleria sul Po, Torino	111000
Galleria Tartaglia Arte, Roma	110814
Galleria Tecne, Padova	110586

Galleria Tega, Milano	110365
Galleria Il Tempo, Conselve	109990
Galleria Titanik, Turku	103120
Galleria Tocchetti, Lugano	116547, 126941
Galleria Tornabuoni, Firenze	110075
Galleria Tornabuoni, Pietrasanta	110673
Galleria Toscani, Gradisca d'Isonzo	110163
Galleria Traghetto, Venezia	111143
Galleria Uusitalo, Helsinki	103097
Galleria Vanna Casati, Bergamo	109807
Galleria Varotto, Susano di Castel D'Ario	110961
Galleria Vecchiato, Padova	110587
Galleria Veneziani, Roma	081218
Galleria Verde, Roma	081219
Galleria Veronese, New Orleans	122420
Galleria Vesterinen, Helsinki	103098
Galleria Vinciana, Milano	110366
Galleria Vittoria, Roma	110815
Galleria Wanda, Wolverhampton	119678
Galleria Wehrlin, Milano	080395
La Galleria, Studio Numismatico, Pescara	080982
GALLERIAPIU, Bologna	109854
Gallerie 91, Charlottenlund	065556, 102749
Gallerie Alegria, Birmingham	120076
Gallerie am Markt, Kirchhain	107545
Gallerie am Rathausmarkt, Viersen	108832
Gallerie Antiques, Hainault	089206, 134745
Gallerie Arts Graphiques, Villars-Colmar	016019
Gallerie BeArte, Karlslunde	102817
Gallerie Bella, Athinai	109045
Gallerie d'Arte del Design e dell'Arredamento, Cantù	109945
Gallerie dell'Accademia, Venezia	028120
Gallerie di Palazzo Leoni Montanari, Vicenza	028188
Gallerie Dragehøj, Holmegaard	065709
Gallerie Ethnos, Ettlingen	075670
Gallerie FeinSinn, Überlingen	108804
Gallerie Ganesha, Delhi	109331
Gallerie Lavelle, Bangalore	079243
Gallerie l'Orientaliste, Fitzroy North	098891
Gallerie Marin, Appledore, Devon	117313
Gallerie Moderne, New York	122883
Gallerie Namyslok, Kunsthandel, Werdau	108886
Gallerie Picamm, Harpstedt	107352
Gallerie Q14, Oderberg	108339
Gallerie Rasmus, Kolding	102861
Gallerie Rasmus, Odense	102890
Gallerie Restigouche, Campbellton	005440
Gallerie Rosini & C., Riccione	110732
Gallerie Vedbæk, Charlottenlund	065557, 102750
Gallerie Veronique, Enfield	088998, 134684
Gallerie Via Borromei, Milano	110367
Gallerie Zen, Bangalore	109270
Galleriea Graziosa Giger, Leuk Stadt	116531
Galleries America, Las Vegas	121630
Galleries' Association of Korea, Seoul	059450
The Galleries at Moore, Moore College of Art and Design, Philadelphia	051962
Galleries at Raven's Nest, Denver	121000
Galleries of Contemporary Art, University of Colorado, Colorado Springs	047847
Galleries of Justice, Nottingham	045354
The Galleries of Texas Tech, Texas Tech University, Lubbock	050456
Galleries Primitf, Woollahra	099778
Galleriet, Kolding	102862

Galleriet, Stavanger	113369
Gallerikroken, Oslo	113319
Gallerina, Darlington	117823
Gallerix, Lidköping	115818
The Gallery, Abbotsbury	117264
The Gallery, Al-Harthy	113392
The Gallery, Ardingly	117317
The Gallery, Beer	117402
The Gallery, Blandford Forum	117482
The Gallery, Blenheim	112908
The Gallery, Burnham-on-Sea	117624
The Gallery, Chichester	117735
The Gallery, Clare	117755
The Gallery, Dunfanaghy	109639
Gallery, El Paso	121112
The Gallery, Gateshead	044218
The Gallery, Gisborne	112983
The Gallery, Greystones	109649
The Gallery, Hampton	118108
The Gallery, Kidderminster	118256
The Gallery, Leek	089580
Gallery, Los Angeles	121767
The Gallery, Lynton	118873
The Gallery, Mount Victoria	061914
Gallery, New Orleans	122421
The Gallery, New York	122884
Gallery, Oklahoma City	123533
The Gallery, Oundle	119083
Gallery, Praha	102655
The Gallery, Reigate	090942, 135307
The Gallery, Rhosneigr	119208
The Gallery, Richmond	123980
The Gallery, La Romana	010208
The Gallery, Saint Helens	119267
Gallery, Tbilisi	105856
Gallery, Vallauris	073913
The Gallery, Vancouver	101647
The Gallery, Virginia Beach	125078
The Gallery, Wymondham, Norfolk	119701
Gallery – University of Toronto, Scarborough	006836
The Gallery & Beyond Words Gallery, Marygrove College, Detroit	048267
Gallery & Innovations, Toronto	101474
Gallery @ 49, New York	122885
Gallery 10, Washington	125158
Gallery 101, Houston	121321
Gallery 101, Malmö	115855
Gallery 101, Melbourne	099173
Gallery 101, University of Wisconsin-River Falls, River Falls	052486
Gallery 11, Reykjavik	109249
Gallery 110 North, Plymouth Arts Foundation, Plymouth	052126
Gallery 114, Portland	123871
Gallery 117, Long Beach	121677
Gallery 119, Coorparoo	098781
Gallery 12 18, Holmfirth	118191
Gallery 121, Aberdeen	117271
Gallery 13, Epworth	117954
Gallery 136, London	118562
Gallery 138, New York	122886
Gallery 14, Chalkida	109073
Gallery 14, Sandwich	119318
Gallery 14, Sutton Coldfield	119462
Gallery 148, Holywood	118203
Gallery 16, San Francisco	124532
Gallery 177, Northampton	119018
The Gallery 18, Falmouth	117977
Gallery 181, Johannesburg	114877
Gallery 181, Iowa State University, Ames	046407
Gallery 185, Halifax	118102
Gallery 19, London	118563
Gallery 2, Chicago	047624
Gallery 2, Johannesburg	114878
Gallery 2 on Edward, Brisbane	098644
Gallery-2000, Aldershot	117293
Gallery 2000, Baltimore	120016
Gallery 2000, Bonn	106532
Gallery 2000, West End	099743
Gallery 203, Chicago	120412
Gallery 203, Nelson	113044

Gesellschaft für Bildende Kunst
und Vaterländische Altertümer,
Emden 058863
Gesellschaft für das Weinbaumuseum
am Zürichsee, Au 041037
Gesellschaft für fotografische Kunst
GFFK e.V., Köln 058864
Gesellschaft für Goldschmiedekunst
e.V., Hanau 058865
Gesellschaft für Kunst und Gestaltung
e.V., Bonn 058866
Gesellschaft für Kunst und Kultur,
Sigmaringen 058867
Gesellschaft für Landeskunde und
Denkmalpflege von Oberösterreich,
Linz 058225
Gesellschaft für Moderne Kunst in
Dresden e.V, Dresden 058868
Gesellschaft für Schweizerische
Kunstgeschichte, Bern 059843, 116229
Gesellschaft für vergleichende
Kunstforschung, Wien 058226
Gesellschaft Photo Archiv e.V.,
Bonn 058869
Gesellschaft zur Förderung Frankfurter
Malerei e.V., Frankfurt am Main 058870
Gesenkschmiede Lubenbach, Zella-
Mehlis 022441
Gesler, Frank & Brigitte,
Neckarsulm 077621
Geslin, Patrick, La Chapelle-
Janson 068920, 128877
Gessani & C., Paolo, Roma 132324
Gessinger, Wiesbaden 108926
Gessler, Robert, Friedrichshafen 137432
Gesta, New York 139406
Gestaltung und Kunst, Hochschule der
Künste Bern, Bern 056379
Gestarte, Roma 081227
Gestas & Martine Simorre-Gestas, Jean-
Pierre, Pau 071997, 126049
Gesterbyn Kartano – Kirkkonummen
Kunnan Museoalue,
Kirkkonummi 010833
Gestütsmuseum Offenhausen,
Gomadingen 018482
Gestures, Saint Kilda, Victoria . . 062170
Get Rare, Savigny-sur-Orge 073413
Get Stuffed, London . . 089968, 134993
Get the Picture, Los Angeles . . . 121772
Getaway Gallery, Columbus 120775
Getchell & Getchell, Minneapolis 094750
Gethmann, Berlin 106272
Getijdenmolen Kruibeke,
Rupelmonde 003908
Getler, Helen, New York 122902
Getty Images Gallery, London . . 118572
Getty Publications, Los Angeles 138403
Gettysburg National Military Park,
Gettysburg 049053
Getz, Michael, Washington 097673
Geuer, Grevenbroich 107122
Geukens & de Vil, Knokke-Heist 100602
Geursen, J. & M.I., Richmond,
Tasmania 099491
Geus, K.H. de, Eindhoven 083029
Geusau, Pia, Wels 128155
Geuthner, Paul, Paris . 137209, 141086
Gevaert, Yves, Bruxelles 136933
Het Geveltje, Middelburg 083306
Gevik, Toronto 101479
Gevorg Grigoryan – Giotto – Studio-
Museum, National Gallery of
Armenia, Yerevan 000728
Gewehr, T., Murnau am
Staffelsee 108239
Gewehr, Vera Lucia, Porto Alegre 063917
Gewerbe-Museum, Spaichingen 021522
Gewerbemuseum im Germanischen
Nationalmuseum, Nürnberg . . . 020494
Gewerbemuseum Winterthur,
Winterthur 041883
Gewölbe Galerie, Biel 116251

Geyer, Fritz, Plauen . . . 108398, 130891
Geymüller, Dr. Johannes von,
Essen 106881
Geyns, S., Bruxelles 063392
Gezira Center for Modern Art,
Cairo 102989
GFL Fine Art, Nedlands 061937
Ggantija, Xaghra 082265, 111999
Ggantija Prehistoric Temples,
Xaghra 030591
GH Art, Atlanta 119850
Ghafari, Sharjah 087957
Ghafary Habibullah, Philadelphia 123638
Ghalib Museum, Delhi 023910
Ghalim, Bruxelles 063393
Ghana Armed Forces Museum,
Kumasi 022509
Ghana Museums and Monuments
Board, Cape Coast 059238
Ghanassia, Danielle, Paris 104870
Ghandour, Soraya, Beirut 082097
Ghani, Abdul, Jeddah 085127
Ghar Dalam Cave and Museum,
Birzebbuga 030560
Gharb Folklore Museum, Gharb . 030561
Gharibi, M., Konstanz 107707
Ghattas, Pierre, Beirut 082098
Ghazarian, Mulhouse 070340
Ghazarian, Alain, Benfeld 067028
Ghazni Provincial Museum,
Ghazni 000001
Ghelfi, Vicenza 111226
Ghelfi, Giorgio, Verona 111210
Ghent, Norfolk 095693
Gheorghiu, A., Bucureşti 084922
Gherardi, Cristiano, Roma 081228,
081229
Ghetto Gloss, Los Angeles 121773
Ghezelbash, David, Paris 071382
Ghezzi, Johannes, Teesdorf 128141
Ghiglieri, Finale Ligure 110037
Ghiglione, Biot 103344
Ghini, Aldo, Firenze 131577
Ghinolfi, Andreas, Zürich 087771
Ghio, Dario, Monaco 082327
Ghio, Hervé, Pont-Aven 105335
Ghiordian Knot, New York 095253
Ghiotti, Alain, Buno-Bonnevaux . 067478
Ghirardini, Silvana, Torino 081540
Ghiretti, Cendrine, Montauban . . 104200
La Ghirlandina, Formigine 080061
Ghislain, Saint-Ouen . 073052, 073053
Ghislaine, David, Paris 071383
Ghisoni-Giordano, Bruxelles 063394
Ghobadi, M., Göttingen 075989
Ghoniem, Cairo 066173
Ghoochan Museum, Ghoochan . 024388
Ghost Dog Gallery, Nashville . . . 122343
Giaccheri, Riccardo, London . . . 134994
Giacla, Genova 080095
Giacobbo, Bruno, Ossingen 087529
Giacobbo, Bruno, Rheinau 116670
Giacomini, Vincenzo, Firenze . . 131578
Giacomo Lo Bue, Córdoba 098439,
136812
Giacomoni, Henri, Monaco 132747,
132748
Giaconi, Firenze 079983
Giacosa, Paola, Firenze 131579
Giada Restaurati, Firenze 131580
Giafferi, Paris 125992
Giagnoni, Patrizia Assunta,
Cagliari 079816
Giai-Miniet, Daniel, La Bazoge . 068897
Giallo, Bologna 131364
Giambattista, Sabrina, Brescia . 131432
Giamblanco, Torino . . 081541, 111001,
132527
Giammona, Giuseppe, Palermo . 132086
Gian Ferrari, Claudia, Milano . . 110369
Giancarlo Politi Editore, Milano . 137778,
142541
Giancatarina, Maria, L'Isle-sur-la-
Sorgue 069514

Giancorrado Forin, Roma 081230
Giandebiagi, Gino, Noceto 080785
Gianella, Lucien, Genève 087278
Gianferrari, Giovanna, Sassuolo . 081452
Gianferro, Ascenzio, Roma 132325
GianFu Classic Art Museum,
Beijing 007433
Giangiacomi, Monaco 132749
Giangiacomo Ottorino, Roma . . . 081231
Giangrossi, Rodolfo, Milano . . . 131844
Giangualano, Renato, Brescia . . 131433
Il Gianicolo, Perugia 110658
Giannetti, Elena, Firenze 131581
Giannini & Marchi, Firenze 131582
Giannone, Pisa 110682
Giannoudis, Sozos, Chalandri . . 109069
Gianola, Claudio, Venezia 081674
Giant MacAskill Museum,
Dunvegan 044001
Giantomassi & Zari, Roma 132326
Giant's Castle, Marazion 045143
Giant's Causeway and Bushmills
Railway, Bushmills 043602
Giant's Causeway Visitor Centre,
Bushmills 043603
Giaquinto & Turrian, Lausanne . . 087380
Giard, Fr., Marcq-en-Barœul . . . 140896
Il Giardino, Trieste 081623
Giardino di Boboli, Firenze 026109
Giardino Storico e Villa Garzoni,
Pescia 027111
La Giarina, Verona 111211
Giarla's Coin Studio, Boston . . . 092307
Giavolucci, Loretta, San Marino . 085112
Gibault, Paris 129249
Gibbard, A. & T., Eastbourne . . . 144151
Gibberd, Jane, London 144367
Gibbes Museum of Art,
Charleston 047511
Gibbins, Carol, Houston 093509
Gibbins, Colin, Houston 093510
Gibbins, David, Woodbridge . . . 091778
Gibbons, Stanley, London 127196,
144368
Gibbs Farm Museum, Museum of
Pioneer and Dakota Life, Falcon
Heights 048644
Gibbs, Christopher, London 089969
Gibbs, Paul, Conwy 088753
Gibernau, Barcelona 143524
Giberton, Marie-Claude,
Vauvillers 073953
Gibier, Chantal, Chatellerault . . . 067848
Gibraltar Museum, Gibraltar . . . 022517
Gibran Museum, Gibran National
Committee, Bsharri 030105
Gibson Barham Gallery, Lake
Charles 050023
Gibson Gallery, Fort Malden Guild of
Arts and Crafts, Amherstburg . 005231
Gibson House Museum, Boston . 047081
Gibson House Museum, North
York 006387
Gibson Mill Visitor Centre at
Hardcastle Crags, Hebden
Bridge 044407
Gibson-Riley, Houston 121325
Gibson Street Gallery, Cooks Hill 098774
Gibson, Colin, Newtownards . . . 119010
Gibson, G. 514 E Pike St, Seattle 124780
Gibson, Michael, Atlanta 091976
Gibson, Michael, London 101207
Gibson, Robin, Darlinghurst . . . 098801
Gibson, Roderick, Nantwich . . . 090643
Le Gibus, La Couronne 068959
GIC, Rouen 072545
Gicquel, Pierre, Vouvray 129586
Gidalya, New York 122903
Gidding, Anton, Saint-Cyprien . . 105456
Giddings, J.C., Wiveliscombe . . 091758
Gideon, West Hollywood 124244
Gidiemme, Venezia 111147
Gidts, Amsterdam 082572

Giefarte, Lisboa 114120
Gieling, Marcel, Utrecht 083461
Giellevivi, Milano 080400
Giencke, Gisela, Graz 128013
Gieraths, Heiko, Gerwisch 130199
Gierek, Joseph, Tulsa 125053
Gierhards, Ralph, Düsseldorf . . . 075430
Gierig, Timm, Frankfurt am Main 106964,
137420
Gierke, Andreas, Boostedt 129871
Gierre Antichitá, Roma . 081232, 081233
Giesberts, Haarlem 083141
Gieschen, U. & B., Lindlar 107868
Giese & Schweiger, Wien 062927,
100177
Giese, Peter, Hamburg 076172
Giesicke, Dr. Barbara,
Badenweiler 074607
Gießler, M., Hohberg 076494
Gietzelt, Michael, Berlin 074758
Giffard, Patrick, Dieppe 125843
Gifford, Auckland 112858
Gifford-Mead, Nicholas, London 089970
Gift Horse Gallery, Cardiff 117677
Gifts for the Soul, Takapuna . . . 113098
Gifu-ken Bijutsukan, Gifu 028388
Gifu-ken Gendai Togei Bijutsukan,
Tajimi 029244
Gifu-ken Hakubutsukan, Seki . . 029173
Gifu-ken Toji Shiryokan, Tajimi . 029245
Gig Harbor Peninsula Historical
Society Museum, Gig Harbor . . 049058
Gigante, Fabio, Varese 081646
Gigengack, Gerardus,
Hombrechtikon 087336
Gigi's, Birmingham 120078
Giglio & C., Pasquale, Milano . . 080401,
126425, 131845
I Giglioli de' Castagni, Castrocaro
Terme 109957, 109958
Gijon, Francisco, Madrid 133697
Gil Fernandez, Gregorio, Madrid 133698
Gil Navares, Nemesio, Madrid . . 086018
Gil, Claudio, Rio de Janeiro 100896,
100897
Gil, Matt, San Francisco 124536
Gil, Natalia, Valencia 115599
Gila Cliff Dwelling Visitor Center, Silver
City 053221
Gila County Historical Museum,
Globe 049094
Gilardoni Arte, Novara 110564
Gilbach, Gabriele, Essen 130102
Gilbert, Canberra 061262, 139716
Gilbert, Detroit 093199
Gilbert, Miami 094572, 136144
Gilbert, Philadelphia 136431
Gilbert, Turner 062343, 139966
Gilbert & Dale, Ilchester 089440
Gilbert Historical Museum,
Gilbert 049059
Gilbert House, Atlanta 046590
The Gilbert Stuart Museum,
Saunderstown 053054
Gilbert White's House and the Oates
Museum, Selborne 045731
Gilbert, Adrian, Leura 099092
Gilbert, Albert, Zürich 116886
Gilbert, David, Sandgate 091088
Gilbert, John, Robin Hood's Bay 090971,
135316
Gilbert, M., Uppingham 091550
Gilbert, Philip, Horsell . 089396, 134792
Gilbert's Bar House of Refuge,
Stuart 053463
Gilbreath, Kay, Houston 093511
Gilchrist, Sacramento 124015
Gilchrist & Gilchrist, Nashville . . 094837
Gilcrease Museum, Tulsa 053724
Gild, Katariina, Tallinn . 058537, 103056
Gildart, Roma 110818
Gilde-Museum, Museumshof,
Oldenburg in Holstein 020636
The Gilded Cage Gallery, Calgary 101105

Paris 097945, 097946
Grand Monde, Paris 129253
Grand Oriental Rugs, Saint Paul 096661
Grand Portage National Monument,
Grand Portage 049150
Grand Prairie Arts Council,
Stuttgart 060497
Grand-Pré National Historic Site,
Grand-Pré 005795
Grand Prix Museum, Macau . . . 007865
Grand Quartier Général Allemand,
Musée de la Resistance, Brûly-de-
Pesche 003346
Grand Rapids Art Museum, Grand
Rapids 049154
Grand Rapids Children's Museum,
Grand Rapids 049155
Grand Rapids Kendall College of Art &
Design, Ferris State University, Big
Rapids 056695
Grand River Historical Society &
Museum, Chillicothe 047678
Grand Shaft and Western Heights,
Dover 043942
The Grand Style Gallery,
Baltimore 120024
Grand Traverse Heritage Center,
Museum and Con Foster Collection,
Traverse City 053672
Grand View Fine Art Gallery,
Cleveland 098752
Grand Village of the Natchez Indians,
Natchez 051123
Grandad's Antiques, London . . . 089982
La Grande Fenêtre, Lyon 140860
La Grande Ferme, Centre d'Initiation
au Ppatrimoine, Saint-Joachim 006732
La Grande Ile, Bruxelles 063396
Grande Museo, Fabriano 026015
Grande Prairie Museum, Grande
Prairie 005798
Grande Victoria Gardens, Saint
Paul . 096662
Grandfather Clocks, Cincinnati . 092697,
135794
Grandfather's Clock Gallery and Clinic,
Tulsa 097569, 136765
Grandfather's Clockshop, Ballarat 061075
Grandfather's Collections,
Singapore 085238
Grandi Antichità, Ozzano Taro . . 080787
Grandi, Claudia, Bologna 131367
Grandière Frères, Paris 129254
Grandin, Christian, Paris 125994
Grandits, Johann, Stegersbach . 062814
Grandmaître, Jean-Henri, Châtillon-sur-
Marne 067865
Grandmaître, Jean-Henri, Dormans-en-
Champagne 068332
Grandma's Attic, Saint Paul 096663
Grandma's Corner, Miami 094576
Grandma's Place, Tampa 097396
Grandma's Things, Jacksonville . 093831
Grandma's Top Drawer, Whyalla . 062418
Grandmont, Detroit 121086
Grandmother Treasures, Dallas . 092968
Grandoni, Claudio, Roma 132330
Grandpa Snazzys Hardware,
Denver 093130
Grandpa's Antiques, Miami 094577
Grandpa's Antiques, Sacramento 096464
Grandpa's Shed, Fitzroy Falls . . 061463
Grandview Antiques, Columbus . 092860
Grandview Auction, Roanoke . . . 127686
Grandview Mercantile Company,
Columbus 092861
Grandville & Old Nick, Niklaus Voellmy,
Basel 143825
Granec & Mitteldorf, Augsburg . 105980
Granelli, Livorno 110196
Grangärde Hembygdsgården,
Grangärde 040473
Grange, Cassel 067643
The Grange, Toronto 007010

La Grange, Zaltbommel 083515
La Grange Antichità, Milano . . . 080405
Grange Antiques, Latrobe 061711
La Grange aux Affaires, Châteauneuf-les-
Martigues 067838
La Grange Aux Arts, Peroy-les-
Gombries 072026
La Grange aux Moines, Megève 069982
La Grange aux Oies, Collonges-la-
Rouge 012435
La Grange Béranger, Musée d'Arts
Populaires, Beblenheim 011777
La Grange de Concise, Thonon-les-
Bains 073628
Grange de l'Ermitage, Armoy . . 066668
Grange de Liselotte, Vouzan . . . 074245
Grange des Artisans, Sainte-
Suzanne 015431
Grange des Ongliers, Chandai . . 067766,
128783
La Grange du Cap Lande, La Teste-de-
Buch 069047
Grange Gallery, Oldtown 109690
Grange Gallery, Saint Saviour . . 091064,
135344
La Grange Moulin, Les Ardillats 069342
Grange Notre-Dame, Labastide-
d'Armagnac 069069, 128886
Grange Old Style Furniture,
Grange 061545
Grange Road Antiques, Glen
Huntly 061518
La Grange Saint-Firmin, Nempont-
Saint-Firmin 070450
Grange, Allan, Landulph 118294
Grange, Gilbert, Dijon 068279
Grangemouth Museum,
Grangemouth 044302
Granger, Audes 066745
Granger Homestead Society Museum,
Canandaigua 047360
Granger House, Marion 050625
Granger, Jean-Claude, Dreux . . 125850
Granger, Jenny, Whitstable 119631
Granges de Servette, Musée Paysan
et Espace d'Exposition, Chens-sur-
Léman 012360
Granier, Christian, Bielefeld . . . 141527
Granier, Didier, Castelnaudary . 067654
Granier, Nadine, Albi 103170
Granier, Olivier, Valros 073919
Granini, Mesola 110231
Graniou, Christian, Monflanquin . 070112,
104196
Granisle Museum, Granisle 005801
Granit Sanat, İstanbul 117137
Granitabbaumuseum Königshainer Berge,
Königshain 019407, 058873
Granitsa Folklore Museum,
Granitsa 022686
Granma Memorial, La Habana . . 008982
Grannie Used To Have One,
Longhaven 090472
Grannie's Parlour, Kingston-upon-
Hull . 089504
Grannona, Portbail 072242
Granny's Cupboard, Wisbech . . . 091751
Granny's Antique Furniture Mall,
Tucson 097502
Granny's Antiques, Mildura 061844
Granny's Attic, Naas 079571
Granny's Attic, Ramsgate 090920
Granny's Attic Antiques,
Cootamundra 061358
Grannys Bottom Drawer, Kinsale 079541
Granny's Goodies, Oklahoma City 095812
Granny's Jumble Sale, Zaandam 083509
Granny's Market, Armadale,
Victoria 061023
Granny's Wonders, Oklahoma
City . 095813
Granösunds Fiskeläge, Södra
Vallgrund 011183
Granoff, Katia, Cannes 103463

Granoff, Katia, Honfleur 103787
Granow, Hans-Dieter, Trier 142257
Grans Lantbruksmuseum, Piteå . 040715
Gran's Trunk Shop, Edinburgh . . 088962
Grant, Barnard Castle 117358
Grant, Droitwich 144144
Grant, Newcastle 118977
Grant & Gower, Henley 118162
Grant & Shaw, Edinburgh 144158
Grant Arts Center, San Francisco 124537
The Grant Bradley Gallery, Bristol 117583
Grant County Historical Museum,
Canyon City 047378
Grant County Historical Museum,
Elbow Lake 048480
Grant County Historical Museum,
Ephrata 048552
Grant County Museum, Elgin . . . 048483
Grant County Museum, Hyannis 049605
Grant County Museum, Medford 050692
Grant County Museum, Sheridan 053191
Grant County Museum, Aka Historic
Adobe Museum, Ulysses 053757
Grant-Humphreys Mansion,
Denver 048227
Grant-Kohrs Ranch, Deer Lodge 048176
Grant Medical College Museum,
Mumbai 024098
Grant Museum of Zoology and
Comparative Anatomy, University
College London, London 044881
Grant Street Art Gallery, Ballarat 098545
Grant, Anthony, New York 122916
Grant, Denzil, Drinkstone 088895
Grant, Jonathan, Auckland 112862,
133067
Grantham, Cleveland 120704
Grantham Clocks, Grantham . . . 089154,
134730
Grantham Furniture Emporium,
Grantham 089155
Grantham Museum, Grantham . 044305
Grantown Museum and Heritage
Centre, Grantown-on-Spey . . . 044308
Grants, Detroit 135893
Grant's Birthplace State Memorial,
Point Pleasant 052134
Grant's Books, Prahran 139911
Grants Old Mill, Winnipeg 007259
Grants Pass Museum of Art, Grants
Pass 049167
Granviarte, Lisboa 114121
Granville Antiques, Petworth . . . 090848,
135279
Granville Collections, Granville . . 068641
Granville County Historical Society
Museum, Oxford 051775
Granville Gallery, Chicago 120422
Granville Gallery, Granville 103731
Granville Historical Museum,
Granville 049173
Granville's, Paroa 083905
Granvin Bygdamuseum, Granvin 033449
Grapevine, Burnham Market . . . 117621
Grapevine Museum, Chiltern . . . 000962
Grapheo, Roma 132331
Graphia, Sint-Niklaas . 058349, 138598
Graphic Art Division, Milwaukee Area
Technical College, Milwaukee . 057411
Graphic Art Publishing, Miami . . 138412
Graphic Artists Guild, New York 060498
Graphic Artists Guild's Directory of
Illustration, Santa Barbara . . . 139408
Graphic Arts and Visual
Communication Faculty, Eszterházy
Károly Föiskola, Eger 055704
Graphic Arts Gallery, Miami . . . 122075
Graphic Concepts, Omaha 095880
Graphic Conservation Company,
Chicago 135766
Graphic Design Department, Salt
Lake Community College, Salt Lake
City . 057130
Graphic Design Department, State

of Connecticut Tunxis Community
College, Farmington 057036
Graphic Design: USA, New York 139409
Graphic Presentations,
Philadelphia 123640
Graphic Station Gallery,
Kitakyushu 111292
Graphic Studio Gallery, Dublin . . 024632
Graphic World, Singapore 114612
Graphicom, Vicenza 137863
Graphics Division, Western Wisconsin
Technical Institute, La Crosse . 057256
Graphics Gallery, San Ramon . . 127712
Graphics Home Gallery, Breda . . 082797
Graphics Plus Frames, Saint
Albans 119255
Graphics World, Maidstone 139218
Graphicstudio, Tampa 138529
Graphigro, Paris 141091
Graphik Edition Dornick, Emmerich
am Rhein 137407
Graphik-Kabinett der Stadt Backnang,
Albrecht Dürer und die europäische
Druckgrafik, Backnang 016491
Graphiker-Verein e.V., München 058874
Graphique de France, Noisiel . . 137117
Graphis, Toronto 101484
Graphis, Woollahra 099780
Graphis Arte, Livorno . 110197, 137760
Graphische Kunst, Memmingen . 138744
Graphische Revue Österreichs,
Wien 138564
Graphische Sammlung am
Kunsthistorischen Institut der
Universität Tübingen, Tübingen 021807
Graphische Sammlung der
Eidgenössischen Technischen
Hochschule Zürich, Zürich 041923
Graphische Sammlung der Friedrich-
Alexander-Universität (FAU),
Erlangen 018009
Graphische Sammlung und Fotoarchiv
der Zentralbibliothek Zürich,
Zürich 041924
Graphische Sammlung,
Museumslandschaft Hessen Kassel,
Kassel 019223
Graphische Werkstatt im Traklhaus,
Edition Antagon, Salzburg . . . 136868
Graphothek Berlin, Berlin 016940
Grapin, Joël, Thonon-les-Bains . 073629,
129507
Gras, Eric, Romilly-sur-Seine . . 072485
Grasiela, Vincennes . . . 074205, 141350
Graslitzer Gedenk- und
Informationsraum,
Aschaffenburg 016420
Grass, Wien 140070
Grassagården Miljömuseum,
Strängnäs 040860
GRASSI Museum für Völkerkunde zu
Leipzig, Leipzig 019655
Grassi, P., Hohenberg an der
Eger 076495
Grassimuseum für Angewandte Kunst,
Leipzig 019656
Grassimuseum für Musikinstrumente
der Universität Leipzig, Leipzig 019657
Grassimuseum für Völkerkunde zu
Leipzig, Staatliche Ethnographische
Sammlungen Sachsen, Staatliche
Kunstsammlungen Dresden,
Leipzig 019658
Grassin, Jean, Carnac . 103485, 137080,
140776
Grassland Gallery, Minneapolis . 122272
Grassroots, Regina 064498
Gratan Sur S.L., Granada 133625
Grate Expectations, Washington 091613
Grate Restorations, Belfast 134408
Il Grattacielo, Livorno 110198
Grattepanche, Pascal, Artres . . 066694
Grau Massana, Marta, Barcelona 085606
Graue Mill and Museum, Oak

York 122924
Greenfield, Milwaukee 094694
Greenfield Historical Society Museum,
 Greenfield 049208
Greenfield Museum, Greenfield . 049207
Greenfield Valley Museum,
 Greenfield 044327
Greenfield & Son, H.S.,
 Canterbury 088558, 134527
Greengage Gallery, Chalfont Saint
 Giles 117705
Greengrass Antiques, Chobham . 088680
Greenhill Covenanter's House,
 Biggar 043360
Greenhill Galleries, Birmingham 117460
Greenhill Galleries, Perth 099425
Greenhill Galleries Adelaide, North
 Adelaide 099334
Greenhouse Gallery of Fine Art, San
 Antonio 124284
The Greenhouse Gallery, Martin
 Decent, Sheffield 119343
Greenlane Gallery, Dingle .. 109601
Greenmark Art Gallery, Delhi ... 099335
Greenoaks Gallery, Launceston . 099081
Greens of Cheltenham,
 Cheltenham 088614
Green's Windmill and Science Centre,
 Nottingham 045355
Greensboro Artists' League,
 Greensboro 060500
Greensboro Artists' League Gallery,
 Greensboro 049212
Greensboro Historical Museum,
 Greensboro 049213
Greenslade, Taylor & Hunt,
 Taunton 127325
Greensleeves, Aldgate 060979
Greensleeves, Richmond, North
 Yorkshire 119211
Greenstein, Saul, London 089990
Greensward Gallery, Oregon State
 University, Corvallis 047983
Greentown Glass Museum,
 Greentown 049222
Greenville County Museum of Art,
 Greenville 049230
Greenville Museum of Art,
 Greenville 049225
Greenwall, June, Cleveland ... 092780
Greenwall, Jonathan, Sandgate . 091089
Greenway, Dallas 144852
Greenway, Galmpton 044214
Greenway, Colin, Witney 091753
Greenwich Art Society,
 Greenwich 060501
Greenwich Auctions Partnership Ltd.,
 London 127197
Greenwich Heritage Centre,
 London 044883
Greenwich Local History Centre,
 London 044884
Greenwich Printmakers, London 118582,
 138269
Greenwood Antique Mall, Seattle 097284
Greenwood Books, Seattle 145325
Greenwood Centre for Living History,
 Hudson 005896
Greenwood County Historical Society,
 Eureka 048588
Greenwood Great House Museum,
 Greenwood 028258
Greenwood Military Aviation Museum,
 Greenwood, Nova Scotia .. 005808
Greenwood Museum, Greenwood,
 British Columbia 005807
Greenwood Press, London .. 138270
Greenwood, David, Ilkley 118229
Greenwood, Judy, London 089991
Greenwood, W., Burneston ... 088499,
 134507
Greenwood, William, Darmstadt 106642
Greer, Robin, London 144374
Grefe, Dr. Uta, Puchheim 078018

Greger, Malmö 143702
Greger, Stockholm 115986
Gregg & Co., Albuquerque ... 119752
Gregg County Historical Museum,
 Longview 050338
Greggie, Atlanta 119853, 144706
Gregor Rare Books, Langley ... 144940
Gregori, Anna, Verona 132668
Gregorics, Alexander, Oslip ... 128090
Gregoris, Elena, Brescia 131434
Gregor's Studios, Dallas 092970
Gregory, Bottley & Lloyd, London 089993
Gregory, Henry, London 089992
Gregory, Martyn, London ... 118583
Gregory's Antiques and Lights,
 Fitzroy 061459
Gregory's of Greerton, Tauranga 083961
Greg's Antiques, Cincinnati ... 092698,
 127439
Greg's Antiques, Cleveland ... 092781
Greg's Upholstery, Long Beach . 136044
Gregson, Thornleigh 127959
Greifengalerie, Greifswald 107116
Greim, Dr. Gerhard, Forchheim . 075709,
 141676
Greiner, Albert, Garmisch-
 Partenkirchen 075893
Greiner, Daniel, Paris 104881
Greinwald, Adelgunde & Manfred,
 Schliersee 078294
Greinwald, R., Immenstadt im
 Allgäu 076540
Greisen, Praha 125694
Greiser, Olaf, Schriesheim ... 108583,
 142199
Greisinger, A., Baden-Baden ... 074597
Grekiskt Kulturcentrum,
 Stockholm 040803
El Greko, Skopje 111936
Grelet, Eric, Manosque 069785
Gremes, Augsburg 074421
Gremese, Roma 137835
Gremi, Barcelona 085608
Gremi d'Antiquaris de Catalunya,
 Barcelona 059780
Gremi d'Antiquaris i Brocanters de les
 Comarques Gironines, Girona . 059781
Gremi de Llibreters de Vell de
 Catalunya, Barcelona 143525
Gremillion & Co., Austin 119954
Gremillion & Co., Dallas 120885
Gremillion & Co., Houston ... 121329
Gremm-Roloff, Thomas,
 Schopfheim 078309
Gremm, T., Mannheim 077199
Grenada National Museum, Saint
 George's 023025
De Grenadier, Groningen 083103
Grenen Kunstmuseum, Skagen . 010137
De Grenen Schuur, Leiden ... 083243
Grenfell and District History Museum,
 Grenfell 001119
Grenfell Community Museum,
 Grenfell 005809
Grenfell House Museum, Saint
 Anthony 006701
Grenier, Ajaccio 066438
Le Grenier, Montpellier 070250
Le Grenier, Saint-Denis 084893
Le Grenier, Saint-Nicolas-de-
 Redon 072951
Le Grenier, Villers-Allerand 074139
Le Grenier, Villuis 074199
Grenier & Chocolat, New Orleans 094944
Le Grenier Animé, Sainte-Foy-de-
 Peyrolières 073308
Grenier Antiquité Bar, Blonville-sur-
 Mer 067204
Le Grenier Antiquités, Quimper . 072303
Grenier au Relais, Belfort 067011
Grenier Bovary, Ry 072610
Le Grenier Crémolan, Crémieu . 074176
Grenier d'Adèle, Porto-Vecchio . 072247
Grenier d'Alexandre, Saïx 073338

Le Grenier d'Aliénor, Castillon-la-
 Bataille 067661
Le Grenier d'Aliénor, Sainte-Terre 073331
Grenier d'Anaïs, Rennes (Ille-et-
 Vilaine) 072397
Grenier d'Annick, Gavray 068585
Le Grenier d'Argenteuil,
 Argenteuil 066655
Grenier d'Aurelianis, Orléans ... 070765
Grenier de Bricquebec,
 Bricquebec 067433
Grenier de Chine, Larmor Plage 069132
Grenier de Françoise, La Roche-
 Bernard 069007
Le Grenier de la Chapelle,
 Bruxelles 063397
Le Grenier de la Reine Margot, Saint-
 Saturnin 073259
Le Grenier de la Vallée, Salins-les-
 Thermes 073342
Grenier de l'Autan, Caraman ... 067606
Grenier de Margot, Saint-Germain-en-
 Laye 072768
Grenier de Marie, Thierville ... 073614
Grenier de Montesson,
 Montesson 070187
Grenier de Pierrot, Arpajon 066674
Grenier de Recouvrance, Brest . 067415,
 128761
Grenier de Saint-Léger, Saint-Léger-
 des-Vignes 072849
Grenier de Sucy, Sucy-en-Brie . 073565
Grenier de Thomas, Chaumont (Haute-
 Marne) 067878
Le Grenier de Valenciennes,
 Valenciennes 073906
Le Grenier de Vauban, Briançon 067430
Le Grenier de Vulaines, Vulaines 074247
Grenier de Xavier, Champs-sur-
 Yonne 067762
Grenier d'Emilie, Blere 067188
Grenier des Collectionneurs,
 Épinal 068399
Grenier d'Hélène, Versailles ... 074019
Le Grenier d'Olivier, Molsheim . 070098
Grenier du Cambrésis, Le Cateau-
 Cambrésis 069187
Le Grenier du Cap, Lege-Cap-
 Ferret 069323
Grenier du Chapeau Rouge,
 Montélimar 070181
Le Grenier du Château, La
 Rochefoucauld 069019
Le Grenier du Chti, Roubaix ... 072508
Le Grenier du Moulin, Argent-sur-
 Sauldre 066650
Grenier du Pévèle, Orchies ... 070744,
 070745
Le Grenier du Pilon, Sainte-
 Maxime 073317
Le Grenier du Pin, Castelnau-le-
 Lez 067653
Le Grenier du Pin, Lattes 069141
Grenier du Val, Le Val-Saint-
 Germain 069312
Grenier Lamalgue, Toulon (Var) 073674
Grenier Moretain, Moret-sur-
 Loing 070294
Le Grenier Nivernais,
 Champlemy 067759
Grenier Picard, Mauregny-en-
 Haye 069955
Grenier Saint Pierre, Carnac ... 067630
Grenier Savoyard, Aix-les-Bains 066422
Les Greniers de Saint-Martin, Saint-
 Georges-sur-Moulon 072762
Greniers de Sophie, Choisy-la-
 Victoire 067924
Les Greniers d'Ici et d'Ailleurs,
 Megève 069983
Les Greniers du Père Sauce, Rancourt-
 sur-Ornain 072321
Greniers du Père Sauce, Vandœuvre-
 lès-Nancy 073923

Grenik, Bicheno 061144
Grenna Museum, Stiftelsen
 Grännamuseerna, Gränna ... 040471
Grenot, Jean-Claude & Marie-Agnès,
 Urimenil 073877
Grenouillère, La Rochelle 069032
Grenslandmuseum, Dinxperlo . 032051
grenzART, Hollabrunn 058227
Grenzhus Schlagsdorf,
 Informationszentrum zur
 innerdeutschen Grenze,
 Schlagsdorf 021266
Grenzland- und Trenckmuseum,
 Waldmünchen 021985
Grenzland-Galerie, Aachen 105888
Grenzland-Museum Bad Sachsa, Bad
 Sachsa 016640
Grenzlandmuseum,
 Schnackenburg 021293
Grenzlandmuseum Eichsfeld,
 Teistungen 021718
Grenzlandmuseum Raabs an der
 Thaya, Raabs an der Thaya . 002504
Grenzlandmuseum Swinmark,
 Schnega 021297
Grenzmuseum Philippsthal (Werra),
 Philippsthal 020771
Grenzmuseum Schifflersgrund,
 Asbach-Sickenberg 016418
Grenzsteinmuseum Ostrach,
 Ostrach 020676
Grenzwald-Destillation Museum,
 Crottendorf 017561
Gresham, Crewkerne 144131
Gresham History Museum,
 Gresham 049239
Grésilières, Marie-Hélène, Villefranche-
 de-Rouergue 074107
Gresse, Monique, Montpellier .. 070251
Gressenhall Farm and Workhouse,
 Gressenhall 044330
Gressler, Patrick, Ars-en-Ré ... 066688
Gressler, Rainer, Frankfurt am
 Main 075738
Greta, Zagreb 102461
Greta Antiques, Greta 061551
Grether, Eberhard, Freiburg im
 Breisgau 130158
Gretillat, Jean-Claude, Neuchâtel 087507
Grétry, Liège 063707
Greul, Aree, Frankfurt am Main . 141684
Greulich, Potsdam 077997
Greulich, Achim, Wiesbaden .. 131157
Greulich, Andreas, Frankfurt am
 Main 106965
Greutert, M.H., Amsterdam ... 132781
Greuzat, Patrice, Pionsat 072123
Greuze, Jean-Baptiste, Tournus . 073789
Grev Wedels Plass Auksjoner,
 Oslo 126584
Greve Museum, Greve 009928
Greve, Karsten, Köln 107623
Greve, Karsten, Paris 104882
Greve, Karsten, Saint Moritz .. 116715
Greven Verlag Köln, Köln 137494
Greven, Karel, 's-Hertogenbosch 083202
Grevenbroek Museum, Hamont-
 Achel 003593
Grévendal, J.-L., Bruxelles 063398
Grevesmühlener Mühle,
 Grevesmühlen 018531
Grewe, R., Bissendorf 074965
Grewe, Theodor, Haltern am See 076120
Grey Art Gallery, New York University
 Art Collection, New York ... 051317
Grey Dog Trading, Tucson 124988
Grey Goose Studio, Salt Lake
 City 124212
Grey Goose Studio @ Trolley Square,
 Salt Lake City 124213
Grey Gums Gallery, MacLean,
 Queensland 099112
Grey-Harris & Co, Bristol ... 088436
Grey Roots Heritage, Owen

Ezyon 024858
Gussio, Lucia, Roma . . 081242, 132334
Gustaf-Dalman-Institut für biblische
Landes- und Altertumskunde,
Greifswald 018524
Gustafs Galleri i Lund, Lund . . . 115831
Gustafson Gallery, Colorado State
University, Fort Collins . . . 048757
Gustafsson, Gudrun, Stockholm . 086815
Gustav-Adolf-Gedenkstätte,
Lützen 019851
Gustav-Adolf-Museum, Geleitshaus,
Museum Schloß Neu-Augustusburg,
Weißenfels 022128
Gustav-Freytag-Archiv und Museum,
Wangen im Allgäu 022006
Gustav III:s Antikmuseum,
Stockholm 040804
Gustav III:s Paviljong, Solna . . . 040777
Gustav Jeeninga Museum of
Bible and Near Eastern Studies,
Anderson 046444
Gustav-Lübcke Museum, Hamm,
Westfalen 018734
Gustav Wolf Kunstgalerie,
Östringen 020610
Gustava Skiltera Memoriālais Muzejs,
Riga 030009
Gustavsbergs Porslinmuseum,
Gustavsberg 040478
Guszahn, P. & R., Kirchlengern . 076745,
076746
Gut of Canso Museum, Port
Hastings 006538
Gut Seekamp der Hans Kock-Stiftung,
Kiel 019286
Gut Zernikow, Großwoltersdorf . 018582
Gut, Rahel, Zürich 116889
Gut, Werner & Mägi, Triengen . 087659
Gutao Ure Museum, Beijing . . . 007436
Das Gute Buch, Zürich 143959
Gutenberg Al Colosseo, Roma . . 110821,
142634
Gutenberg-Gedenkstätte, Eltville am
Rhein 017923
Gutenberg-Museum, Mainz 019888
Guth, Tangermünde 108764
Guth-Maas & Maas, Reutlingen . 108488
Gutharc-Ballin, Paris 104894
Guthmann, Steffen,
Langenbernsdorf 076961
Guthschmidt, Den Haag 112473
Gutian Museum, Gutian 007634
Gutierrez Carrasquilla, Enrique,
Sevilla 133789
Gutierrez, Eric, Dallas 135856
Gutierrez, Raul, San Antonio . . . 124286
Gutlin Clocks, London . 090000, 135003
Gutman, Jean-Pierre, Versailles . 105800
Gutshaus Steglitz, Berlin 016944
Gutshof Pinnow, Pinnow 020773
Guttmann, Max, Helsingør 065673
Guust, den, Breda 082798
Guwahati Medical Museum, Gauhati
Medical College, Guwahati . . 023960
Guwu Xuan Art, Suzhou 102140
The Guy On Motor, Los Angeles 094186
Guy, Adam, Bruxelles 140147
Guy, Gerard, Bewdley . 088232, 134419
Guy, Jacques, Buchères 067473
Guy, Jean, Mons 070118
Guyana Museum, Georgetown . . 023072
Guyart, Brugge 100392
Guyet, Annick, Rouen 072546
Guyomarc, Noël, Montréal 101283
Guyon, Alain, Besançon 067068
Guyot, Camille, Dinan 068295
Guyot, Florence, Paris 071412
Guyot, Gérard, Vanves 073937
Guyot, Marion, Atlanta 119854
Guyot, Thierry, Notre-Dame-du-
Pre 070702
Guyuan Museum, Guyuan 007635

Guzman, Valencia 086347, 115600
Gvozdenovic, Ivica, Stuttgart . . 078523
Gwangju Municipal Folk Museum,
Gwangju 029766
Gwangju National Museum,
Gwangju 029767
Gwen, Fort Worth 121148
Gwili Steam Railway, Bronwydd 043548
Gwilliam, Edred A.F., Cricklade . 088794
Gwinnett History Museum,
Lawrenceville 050141
Gwydir Street Antiques,
Cambridge 088544
Gwylfan Moelfre Seawatch Centre,
Moelfre 045209
Gwynby, Cleveland 092782
Gwynedd Education and Culture,
Archives, Museums and Galleries,
Caernarfon 043611
Gwynedd Museum and Art Gallery,
Amgueddfa ac Oriel Gwynedd,
Bangor, Gwynedd 043242
Gwynfair, Holyhead 089359
Gx gallery, London 118586
Gyard, Christian, Saint-Martin-en-
Haut 072912
Gyemyung University Museum,
Daegu 029737
Gyeongbo Museum of Paleontology,
Namjeong 029797
Gyeongbuk National University
Museum, Daegu 029738
Gyeonggi Provincial Museum,
Yongin 029883
Gyeongju National Museum,
Gyeongju 029770
Gyeongju University Museum,
Gyeongju 029771
Gyermek- és ifjúságszervezet-történeti
Múzeum, Zánka 023730
Gyertyás Antikvitás, Szeged . . . 079219
Gyla Byggningen, Gustavsberg . 115765
Gyldenløwe, Oslo 084157
Gyllene Ängeln, Stockholm 086816
Gyllner, Stockholm 115988
Det Gylne Snitt, Oslo 084158
Gympie and District Historical and
Gold Mining Museum, Gympie 001127
Gympie Antiques, Gympie 061560,
127881
Gyönygszem Galéria, Pécs 109213
Győr Egyházmegyei Könyvtár es
Kincstár, Győr 023336
Győrffy István Nagykun Múzeum,
Karcag 023392
Győry & Osiris, Miami 122076
Győző, Farkas, Fertőd 131217
Gyokudo Bijutsukan, Ōme 029042
Gyokuei-do Shoten, Tokyo 142741
Gyor-Moson-Sopron Megyei Tűzoltó
Kiállítás, Mosonmagyaróvár . . 023474
Gypsy Caravan Antiques, Las
Vegas 093987
Gypsy Savage, Houston 093516
Gysbers & Van Loon, Arnhem . . 142898
It Gysbert Japicxhûs Museum,
Bolsward 031901
Gysin, Bob, Zürich 116890
Gyüjtemények Háza, Thorma János
Múzeum, Kiskunhalas 023424
Gyzmo Projects, Gent 100557
H & B Gallery, Minneapolis 094753
H & G Furniture Restoration,
Atlanta 135664
H & N, Praha 128587
H & R Antiques, Memphis 094472
H & S Art, New York 122927
H D Konst, Stockholm 115989
H-Galerie, Carin Schlee, Dürnau 076493
H Gallery, Bangkok 117027
H Gallery, New York 122928
H&H Fine Art GmbH, Leipzig . . 076999
H&M Kunstwinkel, Dordrecht . . 112522
H. Earl Clack Museum, Havre . . 049369

The H. H. Franklin Museum,
Tucson 053707
H.a.Déco, Fecamp 068463
H.B. Antiquités, Marckolsheim . . 069804
H.C. Ørsteds Antikvariat,
Frederiksberg 140534
H.C.Andersen-koen Kodomotachi
Hakubutsukan, Funabashi 028383
H.E.H The Nizam's Museum,
Hyderabad 023982
H.G. Albee Memorial Museum,
Estherville 048575
H.H. Antique Mall, Toledo 097441
H.H. Maharaja Jayaji Rao Scindia
Museum, Gwalior 023964
H.J. van de Kamp Museum, Sint
Oedenrode 032694
H.L.B. Antiques, Bournemouth . . 088315
H.M. Frigate Unicorn, Dundee . . 043975
H.Q. Art Gallery, Leicester 118320
H.R. MacMillan Space Centre,
Vancouver 007111
H.Th. Wenner, Antiquariat – Verlag,
Osnabrück 137593, 142126
H2 – Zentrum für Gegenwartskunst
im Glaspalast, Kunstsammlungen
und Museen Augsburg,
Augsburg 016456
Hå Bygdemuseum, Varhaug . . . 033891
Hå Gamle Prestegard, Varhaug . 033892
Ha Noi Fine Arts Association, Ha
Noi 060815
Ha Noi Gallery, Ha Noi 125359
Ha Noi Studio, Ho Chi Minh City 125397
Ha Noi University of Fine Arts, Ha
Noi 058117
Haaf, Franz-Josef, Meckesheim . 077254,
130647
Haag & Scott, Bad Kreuznach . . 074504
Haag, Gérard, Zellwiller 074282
Haagen, Los Angeles 121781
Haager Heimatstuben, Haag am
Hausruck 002010
Haagmans, Essen 130103
Haags Historisch Museum, Den
Haag 031996
Haags Openbaar Vervoer Museum,
Den Haag 031997
Haagse Kunstkring, Den Haag . . 059521,
112474
Haaken, Oslo 113322
Haaksman, D.J., Amsterdam . . . 082576
Haakú Museum, Sky City Cultural
Center, Pueblo of Acoma 052319
Haapasalo, Kari, Helsinki 066258
Haardplatenmuseum Klarenbeek,
Klarenbeek 032366
Haardt, Anton, New Orleans . . . 122426
Haarener Mühle, Waldfeucht . . . 021972
Haarlem Antiek, Haarlem 083143
Haas, Budapest 109155
Haas, Cicero 135782
Haas, Zürich 116891
Haas & Fuchs, Berlin 106276
Haas Bowmaker, Steven,
Milwaukee 094695
Haas Gallery of Art, Bloomsburg 047023
Haas-Lilienthal House, San
Francisco 052899
Haas, de, Amsterdam 082577
Haas, Heinrich, Schaan 082147
Haas, Johann, Wels 140045
Haas, Mariette, Ingolstadt 107440
Haas, Michael, Berlin 106275
Haas, Otto, London 144377
Haas, Raul, Cincinnati 092700
Haas, Reinhold, Randersacker . . 130923
Haas, Susan P., Seattle 124786
Haas, Tom, Phoenix 123744
Haas, Wolfgang, Berlin 074775
Haase, Chemnitz 075206
Haase, Mülheim an der Ruhr . . . 077368
Haase, S., Horn-Bad Meinberg . . 076513
Haase, Torsten,

Neukirchen/Erzgebirge 077658
Haasner, Brigitte, Wiesbaden . . 108929
Haastrup Folkemindesamling,
Faaborg 009893
Hab und Gut, Hannover 076312
Hab und Gut, Sankt Pölten 062797
Habari, Wien 100178
Habashi, Alexandria 066144
Habatat, Chicago 120430
Habbekrats, Gent 063584
Georg Haber & Joh.L.L. Brandner,
Berlin 129728
Georg Haber & Joh.L.L. Brandner,
Regensburg 130933
Haber-Feist, Osterhofen 130865
Haber, Laura, Buenos Aires 098410,
098411
Haber, Robert, New York 095274
Haberfellner, Gerda, Wien 062931
Haberhauer, Herford 076438
Habernicht, Marianne, Trier . . . 078616
Habernickel, K. & A., Much 077356
Habersetzer, Schortens 078316
Habert, Eric & Catherine, Le
Passage 069265
Haberzettl, Adolf, Feuchtwangen 075687
Haberzettl, Anna-Maria,
München 077442
Habitaat Art and Craft, Mumbai 109460
Habitare, Genova 080098
l'Habitat, Indianapolis 093721
Habitat Antiques, Port Macquarie 062085
Habite, San Francisco 097082
Haboldt & Co., Bob, Paris 104895
Haboldt, Bob, New York 122929
Habres & Partner, Wien 062932
Hachem, Moussa, Paris 104896
Hachette, Paris 137213
Hachidai, Hiroshima 081807
Hachiga Minzoku Bijutsukan,
Takayama 029269
Hachinohe-shi Bijutsukan,
Hachinohe 028392
Hachinohe-shi Hakubutsukan,
Hachinohe 028393
Hachinohe-shiritsu Rekishi
Hakubutsukan, Hachinohe . . . 028394
Hachioji-shi Rekishi Hakubutsukan,
Hachioji 028396
Hachmeister, Petershagen 142147
Hachmeister, Dr. Heiner, Münster 108229
Hacı Bayram Camii, Ankara 042552
Hacı Ömer Sabancı Kültür Merkezi,
Adana 042523
Hacienda Art Gallery, Phoenix . . 123745
Hacienda Buena Vista, Ponce . . 035969
La Hacienda de Soldeca,
Zaragoza 133856
Hacienda El Paraíso, El Cerrito . 008514
Hack, Rainer, Zella-Mehlis 109017
Hacke, Axel, München 130713
Hackelbury, London 118587
Hackenberger Mühle, Saarburg . 021175
Hacker Strand Art, New York . . 145083
Hacker, Roland, Hamburg 076175
Hackett & Freedman, San
Francisco 124540
Hackettstown Historical Society
Museum, Hackettstown 049263
Hackhofer, B., Sankt Wendel . . 142191
Hackley & Hume Houses,
Muskegon 051066
Hackney Home Antiques, Barlow 088122
Hackney Museum, London 044889
Hadalhondi, Bilbao . . . 085694, 133553
Hadassa, New York . . . 095275, 136280
Haddenham Auctions, Norwich . 127245
Haddo House, Methlick, Ellon . . 045180
Haddon Galleries, Torquay 119518
Haddon Hall, Maastricht 083279
Haddon Hall, Venlo 083491
Haddonfield Museum,
Haddonfield 049265
Haddy, Jeffery, Prahran 062101

Hales, S.J., Bovey Tracey 127025
Halesworth and District Museum,
Halesworth 044348
Halewijn Missiaen, Gent 100558
Haley, Albuquerque 091894
Haley, Pat, Malvern, Victoria .. 061773,
125489
Half Back, Dee Why 139743
Half Moon Antiques, Prospect .. 062114
Half Price Books Records Magazines,
Kensington 144936
Half Retro, Bucureşti 084923
Halfa Museum, Wadi Halfa 040305
Halff, Harry, San Antonio 124287
Halfmann, Essen 075633
Halfmann, Peter, Duisburg 141640
Halfmoon Antique Mall, San
Antonio 096809
Halgene, New York 095278
Hali, Lidingö 086621, 143685
The HALI Fair, Antique Carpet and
Textile Art Fair, London ... 098217
Hali Publication, London 138272
Hali Publications, London 139220
Halı, Kilim ve Düz Dokuma Yaygılar
Müzesi, İstanbul 042669
Haliburton Highlands Museum,
Haliburton 005825
Haliburton House Museum, Windsor,
Nova Scotia 007239
Haliden, Bath 118682
Halifax Antiques Centre, Halifax 089213
Halifax Citadel, Halifax 005833
Halifax Historical Museum, Daytona
Beach 048141
Halifax Police Museum, Halifax . 005834
Halikkon Museo, Halikko 010625
Halin Metsäkämppämuseo, Virrat 011335
Halina, Warszawa 113940
Halk Sanatları Müzesi, Girne ... 033287
Halkjær, Eva M., Kalundborg ... 065739
Halkyone, Hamburg 141768
Hall, Chester 127057
Hall, Dallas 120886
Hall & Knight, London 090003
Hall & Knight, New York 095279
La Hall aux Arts, Angoulême ... 103191
Hall Museum, Meeteetse Museums,
Meeteetse 050705
Hall of Fame, Buffalo 092366
Hall of Fame, Zouk Mikayel ... 030117
Hall of Fame and Classic Car Museum,
Weedsport 054141
Hall of Fame for Great Americans,
Bronx Community College,
Bronx 047195
Hall of Flame – Museum of
Firefighting, Phoenix 052026
Hall Place, Bexley 043349
Hall, Anthony C., Twickenham .. 144637
Hall, Greg, Ruislip 091002
Hall & Son, Peter, Staveley 135429
Hall, Robert, London 090002
Hall, Thomas, Dallas 120887
Hallands Auktionsverk, Halmstad 126803
Hallar Gallery, Kansas City 121572
Hallard, Nigel, Mousehole 118955
Hallaton Museum, Hallaton 044356
Die Halle, Langnau am Albis ... 116499
HALLE 14, Leipzig 107818
Halle Aux Antiquités, Buhl-
Lorraine 067475
La Halle aux Oiseaux, Marseillan 013840
Halle für Kunst Lüneburg e.V.,
Lüneburg 019843
Halle Heart Center, Tempe 053586
Halle Saint-Pierre Museum, Paris 014464
Hallén, Stockholm 143755
Hallen für neue Kunst,
Schaffhausen 041695
De Hallen Haarlem, Haarlem ... 032214
Haller & Evans, Kingston-upon-
Hull 127158

Haller Akademie der Künste,
Schwäbisch Hall 055642
Haller Feuerwehrmuseum, Schwäbisch
Hall 021356
Haller, H., Pforzheim 077962
Haller, Stephen, New York 122932
Hallerbosmuseum, Halle 003587
Hallertauer Heimat- und
Hopfenmuseum, Mainburg .. 019882
Hallertauer Hopfen- und
Heimatmuseum, Geisenfeld ... 018336
Les Halles de la Brocante, Nice 070564
Hallescher Kunstverein, Halle,
Saale 058877
Halliday, Swindon 119478
Hallidays Antiques, Dorchester-on-
Thames 088862
Hallie Ford Museum of Art, Willamette
University, Salem 052789
Halligans, Auckland 143093
Hallin, Sven, Färnäs 126788
Hallingdal Folkemuseum,
Nesbyen 033629
Halliwell's House Museum,
Selkirk 045733
Hallmark, Brighton 088403
Hallmark, San Diego 096929
Hallmark Society, Victoria 007147
Hallockville Museum Farm,
Riverhead 052489
Hall's Bookshop, Tunbridge Wells 144634
Hall's Croft, Shakespeare Birthplace
Trust, Stratford-upon-Avon .. 045887
Halls Fine Art Auctioneers,
Shrewsbury 127299
Hallstattzeitliches Museum Grosskein,
Großklein 001988
Hallwalls Arts Center, Buffalo . 047270
Hallwylska Museet, Stockholm . 040805
Hallynck, Jean-Philippe, Croix .. 128815
Halm, E., Köln 076805
Halmens Hus, Halmslöjdsmuseum,
Bengtsfors 040365
Halmstads Auktionskammare,
Halmstad 126804
Halos, Utrecht 143054
Halosenniemi Museo, Tuusula . 011278
Haloux, Félix, Paris 104897
Halper, Susan L., New York ... 122933
Halpern, Herbert, New Orleans . 122427
Halsey Gallery, College of Charleston,
Charleston 047512
Halszka-Polonez, Poznań 113826
La Halte, Plaisance 072128
Halter, K., Türkheim 078647
Halter, Martin, Bern 134026
Halter, Yves, Rennes (Ille-et-
Vilaine) 105393
Halton Region Museum, Milton . 006188
Haluška, Pavel, Liptovský
Mikuláš 085401
Halwany, Ismat, Beirut 082099
Ham House, Richmond, Surrey . 045585
Hama National Museum, Hama . 041983
Hamacher, H., Aachen 074296
Hamacher, Joachim, Krefeld ... 130518
Hamada Gallery, Cairo 102990
Hamadryade, Paris 071418
Hamaland-Museum, Vreden ... 021942
Hamamatsu-shi Gakki Hakubutukan,
Hamamatsu 028414
Hamamatsu-shi Hakubutukan,
Hamamatsu 028415
Hamamatsu-shiritsu Bijutsukan,
Hamamatsu 028416
Hamamatsu-shiritsu Kagakukan,
Hamamatsu 028417
Hamana-ko Orugorukan,
Hamamatsu 028418
Hamana-ko Tateyama-ji Bijutsukan,
Hamamatsu 028419
Hamard, Annette, Bar-le-Duc . 066878,
066879, 066880, 128702
Hamarøy Bygdetun, Harmarøy . 033465

Hamayu, Yokohama 082051
Hambacher Schloss, Neustadt an der
Weinstraße 020407
Hamberger, Stefan & Roswitha,
Stammham 108668
Hambidge Center for the Creative Arts
and Sciences, Rabun Gap .. 052345
Hambleton, Vancouver 101652
Hamblin, John, Yeovil . 091838, 135623
Hamboise, Montpellier 104231
Hambros Antik og Kunst,
Ålesund 084071
Hamburg Dungeon, Hamburg . 018699
Hamburg State Park Museum,
Mitchell 050896
Die Hamburger Galerie, Hamburg 107245
Hamburger Kunsthalle, Hamburg 018700
Hamburger Schulmuseum,
Hamburg 018701
Hamecher, Horst, Kassel 141862
Hamelin, Sébastien, Les Pieux . 069362
Hamer, Amsterdam 112297
Hamer, Großhansdorf 107135
Hamers & Penz, Halle, Saale .. 107166
Hames, Peter, Bideford 144016
Hametner, Roland, Stoob 100067
Hamhung Historical Museum,
Hamhung 029697
Hamich-Rafensteiner, Ilse,
Nördlingen 108291
Hamidèche, Dominique, Lens .. 069328
Hamill, Boston 120152
Hamilton, Knokke-Heist 063647
Hamilton, Phoenix 136457
Hamilton, Woodbridge 091779
Hamilton & Miller, Camperdown 125464
Hamilton & Selway, West
Hollywood 125247
Hamilton Art Gallery, Hamilton,
Victoria 001133
Hamilton Arteffects, Hamilton . 098963
Hamilton Artists, Hamilton 005852
Hamilton Billards & Games,
Knebworth 099530, 134840
The Hamilton Children's Museum,
Hamilton 005853
Hamilton Grange National Memorial,
New York 051318
Hamilton Heritage Museum, Hamilton,
Tasmania 001132
Hamilton House, South Berwick 053282
Hamilton Hume Museum, Yass . 001669
Hamilton Kerr Institute,
Cambridge 134520
Hamilton Library and Two Mile House,
Carlisle 047390
Hamilton Low Parks Museum,
Hamilton 044360
Hamilton Military Museum,
Hamilton 005854
Hamilton Museum of Steam and
Technology, Hamilton 005855
Hamilton Osborne King, Dublin . 126385
Hamilton Psychiatric Hospital Museum,
Hamilton 005856
Hamilton van Wogener Museum,
Clifton 047794
Hamilton & Co, A.D., Glasgow . 089124
Hamilton, Anne, Burnham Market 088502
Hamilton, Beth, Fairlight 098870
Hamilton, Jane, Tucson 124991
Hamilton, Rosemary, London .. 135004
Hamilton, Ross, London 090004
Hamiltons, London 118590
Hamilton's, Tacoma 127736
Hamilton's Gallery, London ... 044890
Haminan Kaupunginmuseo,
Hamina 010626
Hamiota Pioneer Club Museum,

Hamiota 005863
Hamish Morrison Galerie, Berlin 106277
Hamish, Clark, Woollahra 062462
Hamizgaga Museum, Kibbutz
Nachsholim 024960
Hamlin Garland Homestead, West
Salem 054200
Hamline University Galleries, Saint
Paul 052740
Hamlyn Lodge, Ollerton 090762, 135248
Hamm, Lampertheim 076936
Hamm, Gitta, Darmstadt 129928
Hamm, Pierre, Benfeld 067029
Hammarlund, Stockholm 143756
Hammarö Auktionsverk, Skoghall 126873
Hammars Antik, Örebro 086716
Hammaslääketieteen Museo,
Helsinki 010650
Hammelehle & Ahrens, Köln .. 107625
Hammelrath, Birgit, Köln 107626
Hammer, Augsburg 105981
Hammer, New York 122934
Hammer- und Waffenschmiede-
Museum Hexenagger,
Altmannstein 016352
Hammer Museum, University
of California Los Angeles, Los
Angeles 050373
Hammer, Carl, Chicago 120431
Hammer, Ingo R., Köfering ... 076776,
130455
Hammer, Klaus, Olching 077842
Hammer, Ludwig, Regensburg . 108468
Hammer, Udo, Werbach 078837
Hammerberg, Bob, Seattle 097285
Hammerblow, Tucson 097503
Hammered Design, Denver 121010
Hammerichs Hus, Ærøskøbing . 009842
Hammermuseum zu Hannover,
Hannover 018755
Hammerschmiede Gröningen,
Satteldorf 021233
Hammerschmiede mit Heimatmuseum
und Bienengarten, Lahr 019522
Hammerschmiede und Stockerhof,
Neuburg an der Kammel ... 020338
Hammersite, Ramat Aviv 126397
Hammerstein, Hans, München . 142034
Hammill, Janet, Thornbury 127958
Hamminoff, Chris, Caen 067512, 140770
Hammond, Saint Louis 145235
Hammond Castle Museum,
Gloucester 049097
Hammond Hall Antiques, Wagga
Wagga 062388
Hammond-Harwood House Museum,
Annapolis 046471
Hammond Historical Museum,
Hammond 049292
Hammond Museum, North Salem 051531
Hammond, Jeffery, Leominster . 089611
Hammond, John, Fürth 107043
Hammond, Thomas, Tampa ... 124906
Hamnladans Antikt, Norrtälje .. 086701
Hamnmuseét, Varberg 040950
Hamon, Claude, Lampaul-
Guimiliau 069102
Hamon, Jean-Pierre, Le Havre . 103896
Hampden-Booth Theatre Library at the
Players, New York 051319
Hampden Junque, Baltimore .. 092165
Hampden Stores, Otago 083898
Hampden Street Antique, Denver 093133
Hampe, Richard, Klosterneuburg 062656
Hampel Fine Art Auctions GmbH & Co
KG, München 126285
Hampel, A., Friedenweiler 075857
Hampshire Antique Restoration,
Southampton 135415
Hampshire Antiques, Vancouver 064773
Hampshire Contemporary Artists,
Lymington 118869
Hampshire Farm Museum,
Bursledon 043584

Hanson, San Francisco 124545
Susan Hanson & Paul Weber,
 Berlin 141463
Hansong Womens College Museum,
 Seoul 029822
Hansons Auctioneers, Etwall ... 127104
Hansord & Son, Lincoln 089634, 134877
Hansord at No 2, Lincoln 089635
Hansson, Höör 143669
Hansson, Malmö 115856
Hansson, Stockholm 086818
Hanstein, Marlies, Saarbrücken . 108546
Hansure, Hong Kong 064986
Hantho Galleri, Haugesund 084102
Hantise, La Ciotat ... 068936, 128878
Hantke, Jan, Valencia 133820
Hantverks- och Sjörfartsmuseét
 på Norra Berget, Medelpads
 Fornminnesförening, Sundsvall 040866
Hantverksloftet, Simrishamn ... 040747
Hantverksmuseet, Ängelholm .. 040316
Hanul cu Tei, Bucureşti 114231
Hanul Domnesc, Suceava 036567
Hanuš & Aufricht, Cheb 065308
Hanusek, Heinz, Nürnberg 077747
Hanwon Art Museum, Seoul ... 029823
Hanza-Kruger, Szeged 079220
Haos Galerija Beograd, Beograd 114500
Haour, Marie, Paris 129260
Hap Moore, York 127767
Hapart, Philippe, Paris 071421
Ha'Penny Bridge Galleries,
 Dublin 079451
Hapetian, J.Z., Lisboa . 084724, 133300
Happach, Hans-P., Starnberg .. 131031
Happening, Frankfurt am Main . 075740
Happy Angel Antiques, Los
 Angeles 094189
Happy Art, New Orleans 122429
Happy Days For Old Toys,
 Amsterdam 082579
Happy Thought's, Milwaukee .. 122202
Hapu Galerie, Wien 100180
Har-Ber Village, Grove 049248
Har-El, Jaffa 137709
Har., Sjøfn, Reykjavik 109250
Hara Gendai Bijutsukan, Tokyo . 029329
Hara Museum ARC, Shibukawa . 029189
Hara-shobo Japanese Prints,
 Tokyo 081975
Harajuku, Piga, Tokyo 111452
Harák, Praha 065428
Haralambous, Martin, Hamburg . 076176
Harald, H., Vienenburg 078709
Harare School of Art, Harare ... 058126
Harbeck, Carindale 139717
Harbin Museum, Harbin 007652, 007653
Harbor Branch Oceanographic
 Institution, Fort Pierce 048816
Harbor Defense Museum of New York
 City, Brooklyn 047224
Harbor Gallery, Norfolk 123478
Harborough Museum, Market
 Harborough 045150
Harbour Antiques, Tewantin ... 062306
Harbour Cottage Gallery,
 Kirkcudbright 118277
Harbour Gallery, Dundee 117864
Harbour Gallery, Saint Mary's . 119298
Harbour Gallery, Whitstable ... 119632
Harbour Life Exhibition, Bridport 043502
Harbour Lights Gallery, Porthgain 119170
Harbour Museum, Derry 043898
Harbour View Gallery, Port-of-
 Ness 119169
The Harbourmaster's House,
 Dysart 044014
Harboyan, Krikor, Los Angeles . 094190
Harcourt Antiques, London 090007
Harcourt House Antiques,
 Harcourt 061587
Hard 2 Find Toyz, Las Vegas .. 093988
Hard To Find, Whangarei 143190

Hard To Find Books, Auckland . 143094,
 143095
Hard To Find Bookshop,
 Auckland 143096
Hardanger Antikk, Norheimsund 084129
Hardanger Folkemuseum, Utne . 033878,
 033879
Hardeman, G., Leersum 132935
Hardenburg, Wuppertal 142351
Harder-Kuhner, Jakob, Benken . 087081
Harder-Kuhner, Jakob, Kaltbrunn 087349
Harder, Paul, Utrecht 083465
Hardie, Rebecca, London 144379
Hardie, Timothy, Perth 090826
Hardin County Historical Museum,
 Kenton 049891
Harding Home and Museum,
 Marion 050629
Harding Museum, Franklin 048899
Harding, Keith, Northleach 090718,
 135230
Harding, Yiri, Lisarow 061730
The Hardmans' House, Liverpool 044734
Hardner, Gerd, Dresden 075370, 141616
Hardt, Peter, Radevormwald ... 078035,
 108434
Hardtmuseum, Durmersheim ... 017827
Hardware Fine Art, Saint
 Leonards 099533
Hardwick Hall, Chesterfield ... 043733
Hardwick Historical Museum,
 Hardwick 049317
Hardy Country, Melbury Osmond 090584
Hardy, Barbara, Trier 131092
Hardy, James, Darlington 088816
Hardy & Co., James, London .. 090008,
 135005
Hardy, Joyce, Hacheston 089199
Hardy's Cottage, Higher
 Bockhampton 044443
Hareng Saur, Decazeville 068230,
 103612
Hares, Cirencester ... 088699, 134587
Hare's, Northallerton 119017
Harestanes Countryside Visitor Centre,
 Jedburgh 044527
Haret, Serge le, Huisseau-en-
 Beauce 068792
Harewood House, Harewood ... 044362
Harford, Camperdown 061258
Frank Hargesheimer & Maik Günther,
 Düsseldorf 075433, 126185
Hari Om, Mumbai 109461
Haring, A., Amsterdam 142850
Hariphunchai National Museum,
 Lampun 042427
Haris, Warszawa 084552, 084553
Harishin, Kobe 081823
Haritos Gallery, Athinai 109049
Hariya Razna and Ahmed Urabi
 Museum, Zaqaziq 010415
Harjamäen Sairaalamuseo,
 Siilinjärvi 011175
Harjukosken Vesimylly, Mikkeli . 010980
Harjumaa Museum, Keila 010455
Harkányi Galéria, Pécs 109214
Harkins, Brian, London 090009
Harkins, Hammond, Columbus . 120777
Harkort, U., Wiesbaden 078891
Harlan & Weaver, New York .. 122936
Harlan-Lincoln House, Mount
 Pleasant 051022
Harland, Tom, North Ferriby .. 119014
Harlech Castle and Visitor Centre,
 Harlech 044363
Harlekin-Antik, Steyr 062817
Harlem Art, New York 122937
Harlem Art Gallery, New York . 122938
Harlequin, Budapest 109156
Harlequin Antiques, Armadale,
 Victoria 061024
Harlequin Antiques, Edinburgh . 088964
Harlequin Antiques, Grantham . 089156

Harlequin Antiques, Porthcawl . 090885,
 144537
Harlequin Books, Bristol 144051
Harlequin Books, London 144380
Harlequin Gallery, Lincoln 144299
Harlequin Gallery, London 118594
Harlequin Horse Antiques,
 Kalamunda 061654
Harleston, Harleston 118109
Harley, Christian Malford 088689
Harley Gallery, Worksop 046225, 119697
Harlinger Aardewerk Museum,
 Harlingen 032235
Harlinghausen, Barbara,
 Lengerich 077021
Harlinghausen, Klaus, Osnabrück 142127
Harlow Carr Museum of Gardening,
 Royal Horticultural Society,
 Harrogate 044369
Harlow Ceramics Collection & Kleven
 Print Collection, Bemidji State
 University, College of Arts and
 Letters, Bemidji 046882
Harlow Gallery, Kennebec Valley Art
 Association, Hallowell 049280
Harmakhis, Bruxelles 063402
Harman, Paul & Nicholas,
 Dorking 088871, 134648
Harmar Station, Marietta 050617
Harmattan, Fouesnant 068536
Harmatys, Maria, Kraków 143287
Harmel, Berlin 074780
Harmer, H.R., New York 127616
Harmer, Johnson, New York ... 145084
Harmers, London 127199
Harmeyer, M., Bremen 075123
Harmonies, Beir-Mery 137899
Harmonikamuseum Zwota, Sammlung
 historischer und neuzeitlicher
 Zungeninstrumente, Zwota ... 022497
Harmonium-Art-Museum, Schelle 003919
Harmonium-Museum, Liestal ... 041441
Harmony, Dol-de-Bretagne 068307
Harmony, Roaring Spring 127687
Harmony Arts, Ahmedabad 109260
Harms, Mirja, Hildesheim 130348
Harmsen, B., Erlangen 075605
Harn Homestead and 1889er Museum,
 Oklahoma City 051639
Harness Racing Museum and Hall of
 Fame, Goshen 049129
Harnett, William, Newcastle West 079974,
 131289
Harney County Historical Museum,
 Burns 047293
Harnisch, Michael, Stuttgart ... 078524
Harold, Sacramento .. 096466, 136530
Harold M. Freund American Museum
 of Baking, Manhattan 050574
Harold Warp Pioneer Village
 Foundation, Minden 050860
Haroonian, Los Angeles 094191
Harouni, New Orleans 122430
Harp & Rose, Norwich 090827
Harper, Poynton 090899, 135296
Harper, York 091847
Harper City Historical Museum,
 Harper 049323
Harper Collins, New York 138449
Harper-James, Montrose 090617,
 135195
Harper, Jeff, Wellington 113156
Harper, Martin & Dorothy,
 Bakewell 088103, 134366
Harpers, New Orleans 094945
Harpers Ferry National Historical Park,
 Harpers Ferry 049325
Harput Müzesi, Elazığ 042620
Harraca-Roehl, Paris 104900
Harrassowitz, Otto, Wiesbaden . 142316
Harrewyn, Frédéric, Cucq 068198
Harrewyn, Frédéric, Le Touquet-Paris-
 Plage 069306
Harriann, Minneapolis 136179

Harries, Hamburg 076177
Harriet Beecher Stowe Center,
 Hartford 049345
Harriets Art Gallery,
 Peterborough 119132
Harriman, John, Lima 113455
Harringer, Rutzenmoos 062752
Harringer, Alexander, Gmunden . 062554
Harrington, Albion 060970
Harrington College of Design,
 Chicago 056846
Harrington Mill Studios,
 Nottingham 119048
Harrington Street Gallery,
 Chippendale 098741
Harrington, Adrian, London 135006,
 144381
Harrington, Peter, London 135007,
 144382
Harris, Fort Worth 093288
Harris, Houston 121335
Harris, Richmond 136510
Harris, Toronto 101486
Harris & Barr, Baltimore 092166, 127399
Harris & Holt, Chester 088640
Harris Art Gallery, James M. Lykes
 Maritime Gallery and Hutchings
 Gallery, Galveston 048997
Harris Auction Galleries,
 Baltimore 127400
Harris Courtin, Paddington, New South
 Wales 099387
Harris Exhibit Hall, Oxford 051776
Harris Heritage and Museum,
 Harris 005871
Harris Lindsay, London 090011
Harris Museum and Art Gallery,
 Preston 045526
Harris, Colin, Eversley 089015
Harris, Elizabeth, New York 122939
Harris, James, Seattle 124787
Harris, Jonathan, London 090010
Harris, Lisa, Seattle 124788
Harris, Lorraine, Colac 061349
Harris, Marlene, Pittsburgh ... 096128
Harris, Michael, Toronto 064610
Harris, Michael, Winnipeg 064872
Harris, O.K., New York 122940
Harris, Richard, Forster 125472
Harris, Rupert, London 135008
Harris, Thelma, Oakland 123505
Harris, Tom, Marshalltown 127574
Harrison, Richmond .. 096385, 136511
Harrison, Tauranga 113112
Harrison, Vancouver .. 101653, 101654
Harrison County Historical Museum,
 Marshall 050651
Harrison Galleries, Calgary 101106
Harrison Galleries, Vancouver .. 101655
Harrison House, Branford 047144
The Harrison Lord Gallery,
 Brighouse 117532
Harrison, Anna, Gosforth, Tyne and
 Wear 089146, 134725
Harrison, John, Aston Tirrold .. 088085
Harrison, Steven, Stockholm .. 086819
The Harris's Arcade, London .. 090012
Harrods, London 090013
Harrogate Antique and Fine Art Fair,
 Harrogate 098218
Harrogate Antique Fair,
 Harrogate 098219
Harrogate House, Singapore ... 085242
Harrogate Pavilions Antiques and Fine
 Art Fair, Harrogate 098220
Harrop Fold Clocks, Bolton-by-
 Bowland 088293, 134443
Harrow Art Society, Harrow ... 060096
Harrow Auctions, Harrow 127141
The Harrow Decorative and Fine Arts
 Society, Kenton 060097
Harrow Museum, Harrow 044373
Harrströmin Myllymäkimuseo,
 Harrström 010632

Heeseler, Georg, Krefeld 076894
Heeswyk, J., Ediger-Eller 075524
Hefaistos, Bucureşti 133359
Hefaistos, Děčín 102553
Hefeng Museum, Hefeng 007660
Heffel, Montréal 125640
Heffel, Ottawa 125642
Heffel, Toronto 125653
Heffel, Vancouver 125659
Heffernan, John, Douglas 079406,
131241
Heffner, Bratislava 114734
Heffner, Tegernsee 078588
Hefner Zoology Museum, Miami
University, Oxford 051777
Hegartys, Bandon 131229
Hegau-Bodensee-Galerie, Singen 108634
Hegau-Museum, Singen 021476
Hegdehaugen Antikvariat, Oslo . 143214
Hegelhaus, Stuttgart 021633
Hegemann, Hagen 107154
Hegemann, A & G, Hamburg . . . 076180
Hegemann, H., Hannover 076313
Hegenbart, Günther, Wien 062934,
128186
Hegenbart jun., Werner, Wien . . 062935
Hegenberg, Hans sen., Essen . . 075634
Hegetschweiler, Marlène,
Ottenbach 116649
Heggeli, Oslo 084160
Hegglin, Lotti, Unterkulm 134263
Hegmataneh Museum, Samedan 024425
Hegnauer & Schwarzenbach,
Bern 143848
Hegyvidék Galéria, Budapest . . 023165
Hegyvidéki Helytörténeti Gyűjtemény,
Budapest 023166
Heian, Houston 093520
Heian, Kyoto 081846, 111311
Heiando, Kyoto 142717
De Heibergske Samlinger – Sogn
Folkemuseum, Kaupanger . . . 033521
Heick, W., Oldenburg 077851
Heickmann, Chemnitz 075207
Heidbüchel, B., Düren 106738
HeiDe, Velen 078700
Heide Museum of Modern Art,
Bulleen 000906
Heidefeld & Partner, Krefeld . . . 107726
Heidegalerie, Babenhausen,
Hessen 105986
Heidelberger Kunstverein,
Heidelberg 018835
Heidema, Groningen 083106
Heidemuseum Dat ole Huus,
Bispingen 017180
Heidemuseum Rischmannshof
Walsrode, Freilichtmuseum,
Walsrode 021999
Heidenberg, Lillian, New York . . 122949
Heidenreich, Manfred, Hemhofen 076428
Heidenreich, Manfred,
Heroldsbach 076444
Het Heidenrijck, Nijmegen 083325
Heidi Weber-Museum, Zürich . . 041926
Heidi's Attic Wares, Taree 062299
Heidkamp, Ludwig, Düsseldorf . 075434,
130022
Heidrich, Buenos Aires 127795
Heidrichs Kunsthandlung, Berlin 106279
Heights Antiques on Yale,
Houston 093521
Heights Gallery, Houston 121337
Heights Station Antiques,
Houston 093522
Heights Theater Antiques,
Houston 093523
Heigl, Traunreut 108783
Heihe Museum, Heihe 007661
Heijboer, Anton, Amsterdam . . . 112299
Heijokyuseki Shiryokan, Nara
Bunkazaikenkyusho, Nara . . . 028961
Heikintupa, Pohjaslahti 011082
Heikkilä, Helsinki 066260

Heilers, W., Isterberg 076570
Heilig, Andreas B., Frankfurt am
Main 075741
Heiligenstedten, Tornesch 078603
Heiligeistkirche, Museen der Stadt
Landshut, Landshut 019549
Heilongjiang Nationality Museum,
Harbin 007654
Heilsarmee – Museum und Archiv,
Bern 041106
Heim, Miami 122080
Heim & Kollmann, Waldsolms . . 078759
Heim, Chanin, New York 122950
Heim, Jean-François, Paris 104904
Heim, Philippe, Paris 104905
Heim, Reinhold, Chemnitz 129907
Heimat- und Bauernkriegsmuseum
"Blaue Ente", Leipheim 019636
Heimat- und Bauernmuseum Bruck,
Bruck in der Oberpfalz 017408
Heimat- und Bergbaumuseum,
Erbendorf 017980
Heimat- und Bergbaumuseum Lugau,
Lugau 019853
Heimat- und Bergbaumuseum
Nentershausen, Nentershausen 020309
Heimat- und Bergbaumuseum
Reinsdorf, Reinsdorf bei
Zwickau 020976
Heimat- und Brauereimuseum
Pleinfeld, Pleinfeld 020791
Heimat- und Braunkohlemuseum
Steinberg, Steinberg, Kreis
Schwandorf 021578
Heimat- und Buddelmuseum Osten,
Osten 020665
Heimat- und Bürstenbindermuseum,
Ramberg 020894
Heimat- und Burgmuseum,
Kirkel 019314
Heimat- und FIS-Skimuseum,
Braunlage 017331
Heimat- und Glasmuseum,
Stützerbach 021620
Heimat- und Grimmelshausenmuseum,
Oberkirch 020547
Heimat- und Hafnermuseum,
Heidenheim 018852
Heimat- und
Handfeuerwaffenmuseum,
Kemnath 019265
Heimat- und Heringsfängermuseum
Heimsen, Petershagen 020748
Heimat- und Hugenottenmuseum
Stutensee-Friedrichstal,
Stutensee 021622
Heimat- und Humboldtmuseum,
Eibau 017867
Heimat- und Industriemuseum
Kolbermoor, Kolbermoor 019429
Heimat- und Industriemuseum
Wackersdorf, Wackersdorf . . . 021944
Heimat- und Keramikmuseum,
Kandern 019186
Heimat- und Kleinbrennermuseum,
Steinach, Ortenaukreis 021571
Heimat- und Krippenmuseum,
Zirl 003054
Heimat- und Kulturstube Brunkensen,
Alfeld 016309
Heimat- und Landlermuseum, Bad
Goisern 001734
Heimat- und Miedermuseum Heubach,
Heubach 018938
Heimat- und Naturkunde-Museum
Wanne-Eickel, Herne 018916
Heimat- und Palitzsch-Museum
Prohlis, Dresden 017750
Heimat- und Pfarrmuseum, Museum
Wildalpen, Wildalpen 003027
Heimat- und Rebbaumuseum
Spiez 041755
Heimat- und Schiffahrtsmuseum,
Heinsen 018876

Heimat- und Schmiedemuseum,
Widdern 022204
Heimat- und Schulmuseum,
Himmelpforten e.V.,
Himmelpforten 018957
Heimat- und Ständemuseum,
Tragöß 002766
Heimat- und Torfmuseum,
Gröbenzell 018542
Heimat- und Uhrenmuseum, Villingen-
Schwenningen 021920
Heimat- und Vorgeschichtsmuseum,
Motto: Steinzeit, Ritter, alte Knacker,
Poppenlauer 020810
Heimat- und Waldmuseum,
Eppenbrunn 017971
Heimat- und Zunftmuseum,
Adenau 016276
Heimat-Haus Großderschau,
Großderschau 018559
Heimat-Museum Maintal, Maintal 019885
Heimat und Bildhauer Kern Museum,
Forchtenberg 018126
Heimat-und Handwerkermuseum,
Leutershausen 019713
HEIMAT.MUSEUM:
Röhrnbach.Kaltenbach,
Röhrnbach 021073
Heimatdiele Kutenholz, Kutenholz 019504
Heimatecke am Seifenbach,
Beierfeld 016808
Heimatgeschichtliche Sammlung,
Bodelshausen 017224
Heimathaus, Königswiesen . . . 002186
Heimathaus, Litzelsdorf 002295
Heimathaus, Obernberg am Inn . 002416
Heimathaus, Sankt Georgen an der
Gusen 002600
Heimathaus, Schörfling am
Attersee 002667
Heimathaus, Steinbach am
Attersee 002720
Heimathaus, Ulrichsberg 002785
Heimathaus Alte Mühle,
Schladen 021265
Heimathaus Aying, Aying 016484
Heimathaus Beandhaus, Sankt Johann
am Walde 002611
Heimathaus Bevergern, Hörstel . 018982
Heimathaus De Theeshof,
Schneverdingen 021298
Heimathaus der Stadt Lauingen,
Lauingen 019604
Heimathaus des Rupertiwinkels und
Heimatstube der Sudetendeutschen,
Tittmoning 021761
Heimathaus Diedenhausen, Bad
Berleburg 016524
Heimathaus Ebensee, Ebensee . 001824
Heimathaus Gallneukirchen,
Gallneukirchen 001910
Heimathaus Greven Worth,
Selsingen 021441
Heimathaus-Handwerkermuseum,
Scheidegg 021248
Heimathaus im Alten Turm,
Haslach 002036
Heimathaus Julbach, Julbach . . 002126
Heimathaus Lohnsburg, Lohnsburg am
Kobernaußerwald 002300
Heimathaus Mehedorf,
Bremervörde 017387
Heimathaus mit Photographiemuseum,
Mariazell 002323
Heimathaus Mörbisch, Mörbisch 002365
Heimathaus Nesselwang,
Nesselwang 020317
Heimathaus Neuchl-Anwesen,
Hohenschäftlarn 019004
Heimathaus Neudorf – Seoski muzej,
Neudorf bei Parndorf 002388
Heimathaus Neufelden,
Neufelden 002389
Heimathaus Ollershof, Munster . 020267

Heimathaus Pfarrkirchen,
Pfarrkirchen 020755
Heimathaus Plettenberg,
Plettenberg 020793
Heimathaus Prieros, Heidesee . . 018857
Heimathaus Richard Eichinger und
Steinmuseum, Enzenkirchen . . 001861
Heimathaus Sittensen, Sittensen 021485
Heimathaus Sonthofen,
Sonthofen 021519
Heimathaus-Stadtmuseum
Vöcklabruck, Vöcklabruck . . . 002800
Heimathaus und Schimuseum,
Saalbach 002564
Heimathaus und Stadtmuseum,
Perg 002452
Heimathaus Wartberg an der Krems,
Wartberg an der Krems 002829
Heimathaus Welver, Welver 022141
Heimathaus Wenigzell, Wenigzell 002853
Heimathaus, Bräustüberl Museum,
Biersandkeller in der Kellergröppe,
Raab 002502
Heimathausanlage Schafstall,
Bremervörde 017388
Heimathof Emsbüren, Emsbüren 017949
Heimathof Hüll, Drochtersen . . . 017778
Heimatkabinett Westerholt,
Herten 018930
Heimatkundehaus und Münzkabinett,
Sankt Marien 002622
Heimatkundesammlung Inzersdorf,
Herzogenburg 002057
Heimatkundliche Sammlung,
Holzheim 019021
Heimatkundliche Sammlung,
Uznach 041827
Heimatkundliche Sammlung Blaustein,
Blaustein 017198
Heimatkundliche Sammlung Burg
Rheinfels, Sankt Goar 021209
Heimatkundliche Sammlung Heideck,
Heideck 018830
Heimatkundliche Sammlung
Heroldsbach, Heroldsbach . . . 018921
Heimatkundliche Sammlung Isen,
Isen 019115
Heimatkundliche Sammlung Pfronten,
Pfronten 020762
Heimatkundliche Sammlung Strick,
Bad Mitterndorf 001746
Heimatkundliche Sammlung und
Ausstellung, Hermannsburg . . 018907
Heimatkundliche Sammlung, Haus
zum Bären, Richterswil 041625
Heimatkundliche Sammlung, Mühle
Oberkleinich, Kleinich 019320
Heimatkundliches Museum Medaria,
Matrei in Osttirol 002329
Heimatkundliches Museum Wetzlhäusl,
Sankt Gilgen 002606
Heimatmuseum, Abstatt 016266
Heimatmuseum, Adelsdorf 016271
Heimatmuseum, Aesch 040993
Heimatmuseum, Affalterbach . . 016279
Heimatmuseum, Ahlen 016282
Heimatmuseum, Aken 016294
Heimatmuseum, Alfdorf 016307
Heimatmuseum, Algermissen . . 016312
Heimatmuseum, Allendorf 016315
Heimatmuseum, Allensbach . . . 016316
Heimatmuseum, Altenkirchen, Kreis
Kusel 016341
Heimatmuseum, Altenmarkt im
Pongau 001700
Heimatmuseum, Althütte 016348
Heimatmuseum, Amöneburg . . . 016377
Heimatmuseum, Annaburg 016395
Heimatmuseum, Arendsee 016406
Heimatmuseum, Arneburg 016408
Heimatmuseum, Arzberg 001715
Heimatmuseum, Aßlar 016440
Heimatmuseum, Attiswil 041036
Heimatmuseum, Auetal 016446

Heimatmuseum Wiesenbach,
Wiesenbach 022227
Heimatmuseum Windischgarsten,
Windischgarsten 003040
Heimatmuseum Winterberg im
Böhmerwald, Freyung 018243
Heimatmuseum Wißmar,
Wettenberg 022188
Heimatmuseum Wörgl, Wörgl . . 003041
Heimatmuseum Wolfskehlen,
Riedstadt 021047
Heimatmuseum Wommelshausen, Bad
Endbach 016559
Heimatmuseum Worben, Worben 041901
Heimatmuseum Worms Abenheim,
Worms 022340
Heimatmuseum Worms Horchheim,
Worms 022341
Heimatmuseum Worms-Weinsheim,
Worms 022342
Heimatmuseum Zehlendorf,
Berlin 016954
Heimatmuseum Zwischen Venn und
Schneifel, Sankt Vith 003917
Heimatmuseum, Arcun da Tradiziun,
Waltensburg 041858
Heimatmuseum, Goethehaus
Volpertshausen, Hüttenberg . . . 019057
Heimatmuseum, Grafschaft Hoya,
Hoya / Weser 019042
Heimatmuseum, Marner Skatklub von
1873, Marne 019970
Heimatmuseum, Schloss Dätzingen,
Grafenau, Kreis Böblingen 018503
Heimatmuseum, Stäblistübli,
Brugg 041159
Heimatmuseum, und Tourist-
Information, Bergneustadt 016853
Heimatscheune, Zschepplin 022477
Heimatstube, Altenstadt an der
Waldnaab 016343
Heimatstube, Benneckenstein . . 016824
Heimatstube, Brüel 017412
Heimatstube, Calbe, Saale 017484
Heimatstube, Dabel 017568
Heimatstube, Derenburg 017626
Heimatstube, Eggesin 017860
Heimatstube, Enkirch 017966
Heimatstube, Esslingen 018061
Heimatstube, Fehrbellin 018088
Heimatstube, Gittelde 018424
Heimatstube, Goslar 018486
Heimatstube, Hasselfelde 018790,
018791
Heimatstube, Hinternah 018958
Heimatstube, Hohenzieritz 019010
Heimatstube, Lahstedt 019524
Heimatstube, Lenzkirch 019702
Heimatstube, Liepgarten 019731
Heimatstube, Marlow 019969
Heimatstube, Matzlow-Garwitz . . 019978
Heimatstube, Neuruppin 020387
Heimatstube, Quellendorf 020875
Heimatstube, Remseck am
Neckar 020990
Heimatstube, Schönwalde,
Altmark 021318
Heimatstube, Schonach im
Schwarzwald 021322
Heimatstube, Schwedt / Oder . . 021379
Heimatstube, Tanne 021706
Heimatstube, Zörbig 022472
Heimatstube – Diebsturm, Spalt 021524
Heimatstube "Der Große Hof",
Wienrode 022211
Heimatstube 1813 Möckern,
Möckern 020087
Heimatstube Adlergebirge,
Waldkraiburg 021981
Heimatstube Altenau, Altenau . . 016332
Heimatstube Arenborn,
Oberweser 020583
Heimatstube Bliedersdorf,
Bliedersdorf 017203

Heimatstube Börnecke,
Blankenburg 017187
Heimatstube Bredenbeck,
Wennigsen 022152
Heimatstube der Gemeinde und des
Harzklub Zweigvereins Bad Suderode,
Bad Suderode 016673
Heimatstube des Heimatkreises
Reichenberg, Augsburg 016459
Heimatstube Dessau-Alten, Dessau-
Roßlau 017631
Heimatstube Dreetz, Dreetz 017738
Heimatstube Eime, Eime 017884
Heimatstube Elbingerode, Elbingerode,
Harz 017905
Heimatstube Eltze, Uetze 021842
Heimatstube Endersbach,
Weinstadt 022109
Heimatstube Feldberg, Feldberger
Seenlandschaft 018091
Heimatstube Fischbach,
Niedereschach 020439
Heimatstube Freest, Kröslin 019472
Heimatstube Gadenstedt,
Lahstedt 019525
Heimatstube Gräfenhain/ Nauendorf,
Georgenthal 018365
Heimatstube Groß Denkte,
Denkte 017624
Heimatstube Groß Gleidingen,
Vechelde 021893
Heimatstube Groß Lafferde,
Lahstedt 019526
Heimatstube Groß Nemerow und
Schulmuseum, Groß Nemerow 018552
Heimatstube Großbodungen,
Großbodungen 018557
Heimatstube Großbraming,
Reichraming 002531
Heimatstube Gutenberg,
Oberostendorf 020561
Heimatstube Hänigsen, Uetze . . 021843
Heimatstube Hetzdorf, Uckerland 021832
Heimatstube Hohenhameln,
Hohenhameln 018999
Heimatstube im alten Rathaus,
Hessigheim 018933
Heimatstube in der Wasserburg,
Gerswalde 018397
Heimatstube Kappel, Lenzkirch . 019703
Heimatstube Lichtenstadt,
Zirndorf 022464
Heimatstube mit A. Stifter-
Dauerausstellung, Schwarzenberg
am Böhmerwald 002677
Heimatstube Mühlhausen, Villingen-
Schwenningen 021922
Heimatstube Münstedt, Lahstedt 019527
Heimatstube Neckarrems, Remseck
am Neckar 020991
Heimatstube Nendingen,
Tuttlingen 021828
Heimatstube Neuhaus-Schierschnitz,
Neuhaus-Schierschnitz 020354
Heimatstube Oberg, Lahstedt . . 019528
Heimatstube Radegast, Radegast 020884
Heimatstube Rautheim,
Braunschweig 017335
Heimatstube Röckwitz, Röckwitz 021069
Heimatstube Rothenklempenow,
Rothenklempenow 021129
Heimatstube Sechshelden, Haiger-
Sechshelden 018639
Heimatstube Seeheilbad Graal-Müritz,
Graal-Müritz, Seeheilbad 018498
Heimatstube Sitzenroda, Belgern-
Schildau 016814
Heimatstube Sperenberg, Am
Mellensee 016368
Heimatstube Thal, Ruhla 021153
Heimatstube Tribsees, Tribsees . 021787
Heimatstube Trochtelfingen,
Bopfingen 017287
Heimatstube Usedom, Usedom . 021877

Heimatstube Vietmannsdorf,
Templin 021724
Heimatstube Wahrenbrück, Uebigau-
Wahrenbrück 021837
Heimatstube Warthe, Boitzenburger
Land 017251
Heimatstube Wendhausen,
Schellerten 021251
Heimatstube Wiesental,
Waghäusel 021952
Heimatstube/Gedenkstätte,
Elsterau 017921
Heimatstuben, Langelsheim 019559
Heimatstuben, Waldbronn 021963
Heimatstuben der Stadt, Titisee-
Neustadt 021759
Heimatstuben im Arrestturm,
Spalt 021524
Heimatstuben im Oberen Tor,
Scheinfeld 021249
Heimatstuben Weipert
und Erzgebirgsschau,
Gunzenhausen 018610
Heimatsube, Stendal 021593
Heimatsube Klaushagen,
Boitzenburger Land 017252
Heimatsube Staupitz, Pflückuff . 020757
Heimattreff Gersweiler,
Saarbrücken 021166
Heimatverein Dingden, Humberghaus,
Hamminkeln 018738
Heimatverein Ditfurt e.V., Ditfurt 017678
Heimatverein Räntzelstecher Güsten
Osmarsleben e.V, Güsten 018597
Heimatvertriebenen-Stuben,
Traun 002774
Heimerdinger, Debra, Brevard . . 120217
Heimethüs, Denzlingen 017625
Heimilisidnardarsafnid Halldórustofa,
Blönduós 023746
Heimroth, Alain, Paris 071425
Heimschneidermuseum,
Großwallstadt 018580
Heimtali Koduloomuuseum,
Heimtali 010441
Heimweberei-Museum
Schalkenmehren,
Schalkenmehren 021240
Hein, Bitburg 074970
Hein, Christoph, Dresden 129981
Hein, Jörg, Berlin 129730
Heinänen, Helsinki 066261
Heindl, Günter, Heidelberg 130334
Heindl, Karin, Oldenburg 142118
Heine-Haus, Altonaer Museum in
Hamburg, Hamburg 018703
Heine, Hildegard, Berlin 129731
Heine, Thorsten, Dannenberg . . 075250
Heineck, Ralph, Heidelberg 076384
Heineken Experience,
Amsterdam 031767
Heinemann, Paul, Starnberg . . . 142220
Heinemann, William, London . . . 138273
Heinicke, Hans-Jürgen, Potsdam 077998
Heinicke, Thomas, Oberwiera . . 130850
Heinisch, Wieland, Knetzgau . . . 076763
Heinlein, Christian, Windheim . . 078933,
131168
Heinley, Boston 120154
Heino Lubja Kaalumuuseum,
Mustvee 010468
Heinolan Kaupunginmuseo,
Heinola 010638
Heinonen, Helsinki 128655
Heinrich, Wien 100184
Heinrich-Blickle-Museum, Sammlung
Gußeiserner Ofenplatten,
Rosenfeld 021090
Heinrich-Büssing-Haus,
Wolfsburg 022321
Heinrich-Hansjakob-Gedenkstätte,
Freiburg im Breisgau 018213
Heinrich Harrer-Museum,
Hüttenberg 002083

Heinrich Heine Antiquariat,
Düsseldorf 141634
Heinrich-Heine-Institut-Museum,
Düsseldorf 017791
Heinrich Hugendubel Verlag,
München 137558
Heinrich-Schliemann-Gedenkstätte,
Neubukow 020330
Heinrich-Schliemann-Museum,
Ankershagen 016387
Heinrich-Schütz-Haus Weißenfels,
Weißenfels 022129
Heinrich-Schütz-Haus, Forschungs-
und Gedenkstätte im Geburtshaus
des Komponisten, Bad Köstritz 016595
Heinrich-Sohnrey-Archiv und
Gedächtnisstätte, Mautturn, Jühnder
Schloß, Jühnde 019163
Heinrich-Vogeler Museum –
Barkenhoff Stiftung Worpswede,
Worpsweder Museumsverbund e.V.,
Worpswede 022352
Heinrich-von-Zügel-Gedächtnisgalerie,
Wörth am Rhein 022304
Heinrich Zille Museum, Berlin . . 016955
Heinrich, G., Bielefeld 074935
Heinrich, Herbert, Rottenburg an der
Laaber 130981
Heinrich, J., Olching 077843
Heinrich, Marie-Luce, Köln 076806
Heinrich, Michael, Braunschweig 075086
Heinrich, Nick, Boppard 075059
Heinrich, Peter, Hamburg 076181
Heinrich, Peter, Schorndorf 131005
Heinrichs, Bernd, Celle 075202
Hein's Mühle, Bendorf 016820
Heins, Marlene, Niedernhausen . 108286
Heinsch, Hans, Denkte 075286
Heinsch, Hans, Wolfenbüttel . . . 078965
Heintzelman, Albert, Los Angeles 136069
Heinz & Heinz, Hannover 107342
Heinz & Heinz, Lüneburg 107917
Heinz Nixdorf MuseumsForum,
Paderborn 020703
Heinz, Anneli, Hofheim am
Taunus 076490
Heinz, Carolyn, Hamburg 107246
Heinz, Marcel, Carcès 103482
Heinze, Friedrich, Salzburg 100033
Heinzel, Aberdeen 117272
Heinzel, B., Kassel 107518
Heinzerling & Achenbach-Heinzerling,
Hungen 107429
Heinzl, Luise, Viechtach 078706
Heinzl, Walter, Wien . . 062936, 128187
Heinzmann, Villingen-
Schwenningen 078714
Heirler, Dresden 106719
Heirloom, Harrogate 118118
Heirloom, Honolulu 093386
Heirloom & Howard, West Yatton 091651
Heirloom Antiques, Winnipeg . . 064873
Heirloom Furniture, Denver 093134,
135883
Heirloom Jewels, Baltimore 092167
Heirlooms, Coconut Grove 061340
Heirlooms, Dún Laoghaire 079496
Heirlooms, Durban 085468
Heirlooms, Sandton 085485
Heirlooms, Wareham . . 091582, 135541
Heirlooms, Worcester 091812
Heirlooms International, Tulsa . . . 097571
Heisando, Tokyo 081977, 132694
Heise, T., München 077447
Heisey Museum, Lock Haven . . . 050298
Heisey News, Newark 139413
Heiss, Günther, München 077448
Heiss, Julia, Mainleus 077167
Heiß, Margot, Zapfendorf 079038
Heitmann, Kerstin, Köln 130469
Heitsch, Françoise, München . . . 108135
Heitsch, Jörg, München 108136
Heitz et Darmancier, Bourges . . 125810
Heitz, Anthony & Daniel, Basel . 087050

Darmstadt 017591
Hessisches Puppenmuseum,
Hanau 018742
Hest, Ljubljana 114799, 114800
Hest, Maribor 114813
Hester Gallery, Leeds 118312
Hester Rupert Art Museum, Graaff-
Reinet 038543
Hestié Antichitá, Taranto 081467
Het Cuypershuis, Roermond . . . 032616
Hétéroclite, Bordeaux 103387
Hetjens-Museum – Deutsches
Keramikmuseum, Düsseldorf . . 017792
Hétroy, Hugues, Béhen 128707
Hettinger County Historical Society
Museum, Regent 052408
Hettmer, V., Burgthann 075184
Hetzel, Herbert, Goch 075962
Hetzler, Gerhard, Würzburg 078994
Hetzler, Max, Berlin 106284
Hetzner, Ingeborg, Ansbach . . . 105945
Heubeck, Nürnberg 142097
Heubel, L., Bergisch Gladbach . . 074688
Heubel, Lothar, Düsseldorf . . . 075436,
075437
Heubel, Lothar, Frankfurt am
Main 075742
Heubel, Lothar, Köln 076810
Heuberger, Roman, Köln 141893
Heuchel, Ute, Stuttgart 131055
Heugas, Michèle, Pau 071999
Heuneburgmuseum,
Herbertingen 018895
Heuner, Jürgen, Neu-Anspach . . 130804
Heupgen, Th. J., Haag in
Oberbayern 076084
L'Heure Bleue, Paris 071432
L'Heure Bleue, Rouen 072550
Heureka – The Finnish Science Centre,
Vantaa 011311
L'Heureux, Claude, Montréal . . 064376
Heurich House Museum,
Washington 053994
Heurtebise, Dijon 140792
Heusbourg, Brachtenbach 132709
Heuschneider, Ronny, Potsdam . 130901
Heusel, Monika, Frankfurt (Oder) 075716
Heuser Art Center, Peoria 051895
Heuser, Christa, Karlsdorf-
Neuthard 076617
Heuson-Museum im Rathaus,
Büdingen 017435
Heuss, Didier, Le Thillot 069296
Heussenstamm Stiftung, Frankfurt am
Main 018166
Heuts, M., Köln 076811
Heutz, J., Gangelt 075885
Hever Castle and Gardens,
Edenbridge 044052
Hevesi Múzeumi Kiállítóhely,
Heves 023360
Hewitt, Charles, Paddington, New South
Wales 099388, 127929, 139893
Hewitt, Muir, Halifax 089214
Hewitt, Sue, Mosman 099251
Hexagone, Aachen 105889
Hexehäusl, Schwetzingen 078357
Hexenbürgermeisterhaus, Städtisches
Museum, Lemgo 019691
Hexenmuseum, Riegersburg,
Steiermark 002545
Hexenmuseum, Ringelai 021055
Hexham Old Gaol, Hexham 044439
Hexter, London 064295
Hey Betty, Pittsburgh 096129
Heybutzki, Gerd, Köln 141894
Heydar Aliyev Museum, Naxçivan 003106
Heydenbluth, E., Barsinghausen . 074638
Heydenryk jr., New York 095289, 136285
Heyder, Johannes, Wildenfels . . 078924
Heyduck, Manfred, Düsseldorf . 075438
Heye, Friedrich.W, Unterhaching 137643
Heyer, François, Pfefferhouse . . 072106
Heym-Oliver House, Russell . . . 052609

Heyman, H., Zaltbommel 112809
Heymann, Darmstadt 075255
Heymann, F., Hannover 076315
Heymans, P.B.W., Den Haag . . 132853
Heyn, Johannes, Klagenfurt . . . 140015
Heytesbury, Farnham 089053
Heyuan Museum, Heyuan 007668
Heyvaert, M., Gent 063586
Heyward-Washington House,
Charleston 047513
Heywood, Minneapolis 122277
Heywood Hill, G., London 144386
Heywood, W.O., Whangarei . . . 133138
Heze Museum, Heze 007669
Heze Zone Museum, Heze 007670
Hezlett House, Coleraine 043795
HfG-Archiv, Ulmer Museum, Ulm 021849
HGST Antik, Göteborg 086525
Hi-Desert Nature Museum, Yucca
Valley 054482
Hi Oo, Kingston 111243
Hibberd, H., Philadelphia 145152
Hibbing Historical Museum,
Hibbing 049416
Hibel Museum of Art, Jupiter . . 049808
Hibernia-Antiques.com, Dublin . 079452
Hibernian Historical Trust Collection,
Edinburgh 044068
Hibiscus, Modena 080633
Hick, David, Saint Helier 091035
Hick, David, Saint Lawrence . . . 091046
Hickl, Reinhard, Koppl 062660
Hickl, Reinhard, Salzburg 062766
Hickman, Miami 136146
Hickmet, David, London 090027
Hickories Museum, Elyria 048533
Hickory Grove Rural School Museum,
Ogden 051624
Hickory Museum of Art, Hickory 049418
Hicks, London 118600
Hicks, Walton-on-Thames 135538
Hicks Art Center, Newtown . . . 051471
Hicks, Purdy, London 118601
Hickson, Lewis E., Gilberdyke . 089117
Hicksville Gregory Museum,
Hicksville 049421
Hið Íslenzka Reðasafn, Reykjavík 023776
Hida Kokusei Kougei Gakuen,
Takayama 055985
Hida Minzoku Kokokan,
Takayama 029270
Hida Minzoku-mura, Takayama . 029271
Hida Takayama Bijutsukan,
Takayama 029272
Hida Takayama Shunkei Kaikan,
Takayama 029273
Hidalgo Pumphouse Heritage,
Hidalgo 049422
Hidalgo, Victoria, Madrid 115324
Hidden House, Whangarei 113194,
133139
The Hidden Lane Gallery,
Glasgow 118041
Hidden Place, Miami 094580
Hidden Splendor, Salt Lake City 124214,
124215
Hidden Treasures, Los Angeles . 094195
Hidden Treasures, Minneapolis . 094754
Hidden Treasures, New York . . . 095290
Hidden Treasures, Philadelphia . 095949,
136433
Hidden Treasures, Richmond . . 096065
Hidden Treasures of Tulsa, Tulsa 097572
Hidden Treasures, Museum of Lead
Mining, Wanlockhead 046065
Hiddenite Center, Hiddenite . . . 049423
Hideaway, West Hollywood . . . 097730
Hideaway Antiques, Toronto . . . 064612
Hidell Brooks, Charlotte 120272
Hideout, Hawkes Bay 112998
Hidra, Eivissa 115148
Hidson, Pat, Milwaukee 122203
Hiekan Taidemuseo, Tampere . . 011215

Hieke, Dr. Ursula, Wien 062939, 100186
Hien, Minh, Ho Chi Minh City . . 097848
Hienert, Wolfgang, Wien 128188
Hier & Ailleurs, Paris 071433
Hier Aujourd'hui Demain, Paris . 071434
Hier Comme Aujourd'hui, Calais 067545
Hier et Ailleurs, Montceau-les-
Mines 070173
Hier et Aujourd'hui, Avallon . . . 066805
Hier et Aujourd'hui, Rivière-Salée 082271
Hier et Avant Hier Antiguidades, Rio
de Janeiro 064011
Hier le Der, Montier-en-Der . . . 070198
Hierapolis Arkeoloji Müzesi,
Denizli 042608
Hiermeier, Karl-Heinz,
Eggenfelden 075528
Hieronymus, Dresden 106720
Hierse, K., Neuenkirchen bei
Neubrandenburg 077645
Hietzgern, Mag. Hans Jörg,
Rossatz 062750
Higashi-Hiroshima-shiritsu Bijutsukan,
Higashi-Hiroshima 028433
Higashi Kiyo Gallery, West
Hollywood 125248
Higashi-Osaka Art Center, Higashi-
Osaka 028436
Higashi-Osaka-shiritsu Kyodo
Hakubutsukan, Higashi-Osaka . 028437
Higashi-yamate District Historic
Preservation Center, Nagasaki 028906
Higashimurayama Mingeikan,
Higashimurayama 028438
Higashiyama Kaii Gallery,
Nagano 028886
Higdon &Sons, Jo, Tucson . . . 136755
Higgins & Maxwell, Louisville . . 121930
Higgins Armory Museum,
Worcester 054417
Higgins Art Gallery, Cape Cod
Community College, West
Barnstable 054165
Higgins Museum, Okoboji 051654
Higgins Press, Lostwithiel 090476
Higgins, Barbara, South Yarra . 062217
Higgins & Sons, Michael D.,
Tucson 097506
Higgins, Richard, Longnor,
Shropshire 135153
High Cliff General Store Museum,
Sherwood 053194
High Desert Museum, Bend . . . 046884
High Museum of Art, Atlanta . . . 046592
High Noon, Los Angeles 094196
High on Art, Armadale, Victoria . 098512
High Plains Heritage Center, Cascade
County Historical Museum & Society,
Great Falls 049181
High Plains Museum, Goodland . 049122
High Plains Museum, McCook . . 050488
High Point Museum, High Point . 049426
High Prairie and District Museum,
High Prairie 005883
High Road Auctions, London . . 127200
High Road Auctions, Twickenham 127336
High Street Antiques, Alcester . 088005
High Street Antiques & Jewellery,
Bantry 079348
High Street Book Shop, Hastings 144215
High Street Books, Honiton . . . 144245
High Street Gallery, Glasgow . . 118042
High Touch, Manama 100293
High Wire Gallery, Philadelphia . 123645
Highbrow, Winnipeg 140399
Highfields Fine Art, Highfields . . 098987
Highgate Antiques, Highgate, South
Australia 061613
Highgate Fine Art, London 118602
Highland Antiques, Cleveland . . 092783
Highland Aviation Museum,
Inverness 044508
Highland Cultural Arts Gallery,
Highland Cultural Center,

Highland 049429
Highland Folk Museum,
Newtonmore 045316
Highland House Museum,
Hillsboro 049438
Highland Landscapes, Gairloch . 118010
Highland Maple Museum,
Monterey 050946
Highland Museum of Childhood,
Strathpeffer 045896
Highland Park Antiques, Dallas . 092976
Highland Park Antiques, New
York 095291
Highland Park Gallery, Dallas . . 120889
Highland Park Historical Museum,
Highland Park 049432
Highland Pioneers Museum, Great Hall
of the Clans, Baddeck 005268
Highland Trading Company,
Edmonton 064241
Highland Village Museum, An Clachan
Gàidhealach, Iona 005918
Highlanders of Strathalbyn,
Strathalbyn 062238
The Highlanders' Regimental Museum,
The Queen's Own Highlanders
Collection, Ardersier 043172
Highlands, Fort Washington . . . 048849
Highlands Museum and Discovery
Center, Ashland 046533
Highlands Museum of the Arts,
Sebring 053139
Highlands Vault, Birmingham . . 092246
Highlanes Gallery, Drogheda . . 024598
Highpoint Center for Printmaking,
Minneapolis 122278, 138416
Highsmith, David, San Francisco 145297
Hightower, Fred, Philadelphia . . 136434
Highway, København 065843
Highway Antique Mall, Miami . . 094581
Highway Antiques, Coffs Harbour 061343
Highway Galleria, Williams 099749
Highway Gallery, Mount Waverley 099276
The Highway Gallery, Upton-upon-
Severn 091556
Highwic, Auckland 032969
Higuiner, Bruno, Châteauneuf-la-
Forêt 067837
Hiihtomuseo, Lahden
Kaupunginmuseo, Lahti 010895
Hiiumaa Muuseum, Kärdla 010450
Hijman, D.J., Utrecht 133023
Hikarinotani Metaru Bijutsukan,
Imba 028499
Hikmet, Pinar, İstanbul 087898
Hiko-Antik, Salzburg 062767
Hiko-Antik, Seewalchen am
Attersee 062809
Hikobae, Kobe 111298
Hikone Castle Museum, Hikone . 028440
Al-Hilal, Manama 100294
Hilary Chapman Fine Prints, Richmond,
Surrey 119218
Hilary, Vincent, Igoville 068810
Hilber, Basel 116177
Hilbert, Ferdinand, Mettenheim . 077297
Hilbert, Franz & Ute, Aachen . . 074297
Hilbrandt, Katja, Haiger 141751
Hild, Bernd, Weilburg 142298
Hildebrand, Kashya, New York . 122952
Hildebrand, Kashya, Zürich . . . 116896
Hildebrandt, Harald, Neuss . . . 142083
Hildebrandt, Petra, Hamburg . . 141770
Hildene, Manchester 050569
Hilding, Frank, Svendborg 066083
Hildt, Jeremy, Chicago 092561
Hiles, Kansas City 136029
Hilgemann, Kai, Berlin 106285
Hilgenberg, U., Knüllwald 076764
Hilger, Ernst, Paris 104910
Hill, Gdańsk 084334, 143263
Hill, Oklahoma City 136395
Hill & Wang, New York 138451
Hill Aerospace Museum, Hill Air Force

Museum, Hobro 009968
Hobrovejens Bogantikvariat,
Aalborg 140510
Hobson, Ursula, Philadelphia ... 095951
Hobsons, Wellington 084034
Hobstar, Ramona 139418
Hoch+Partner, Galerie und Werkstatt
für Holzschnitt und Hochdruck,
Leipzig 107821
Hochbrau-Museum,
Emmendingen 017935
Hochhauser, Mainburg 062702
Hochheimer Kunstsammlung,
Hochheim am Main 018968
Hochhuth, Walter D., Hamburg . 141771
Hochman, Irena, New York 122955
Hochofen-Museum Bundschuh,
Thomatal 002763
Hochofenmuseum Radwerk IV,
Vordernberg 002813
Hochreuther, Max S, Zürich 116897
Hochrheinmuseum, Bad
Säckingen 016642
Hochschule der Bildenden Künste
Saar, Saarbrücken 055638
Hochschule der Künste Bern, Berner
Fachhochschule, Bern 056380
Hochschule für Bildende Künste
Braunschweig, Braunschweig . 055431
Hochschule für Bildende Künste
Dresden, Dresden 055456
Hochschule für bildende Künste
Hamburg, Hamburg 055509
Hochschule für Gestaltung Offenbach
am Main, Kunsthochschule des
Landes Hessen, Offenbach am
Main 055612
Hochschule für Gestaltung und Kunst
HGK FHNW, Basel 056368
Hochschule für Gestaltung und Kunst
Luzern, Luzern 056395
Hochschule für Gestaltung,
Fachhochschule Schwäbisch-Hall,
Schwäbisch Hall 055643
Hochschule für Grafik und Buchkunst,
Leipzig 055565
Hochschule für Grafik und Buchkunst
Leipzig, Leipzig 055566, 137516
Hochschule für Kunsttherapie
Nürtingen, Nürtingen 055609
Hochschwabmuseum, Sankt
Ilgen 002610
Hochstaffl, Michael, Kufstein ... 062678
Hochstift Meissen, Meißen 020006
Hochwaldmuseum, Hermeskeil . 018913
Hock, B., Miami 122082
Hock, Hong, Singapore 114616
Hockaday Museum of Arts,
Kalispell 049819
Hockey Hall of Fame, Toronto .. 007014
Hockey, Garry, Hamilton, Victoria 061576
Hockin, Keith, Stow-on-the-Wold 091324
Hocking Valley Museum of Theatrical
History, Nelsonville 051141
Hockley, William, Petworth 090849
Hodesh & Assoc., Cincinnati ... 127440
Hodge, Sarah, Worcester 091813
Hodgen House Museum Complex,
Ellsworth 048517
Hodgen, Judy, Benalla 061115
Hodgepodge, Austin 092071
Hodges Taylor, Charlotte 120273
Hodges, Bill, New York 122956
Hodges, Linda, Seattle 124789
Hodges, William G., Richmond . 096388
Hodgeville Community Museum,
Hodgeville 005889
Hodgins, Calgary 125633
Hodgkins & Co, Ian, Slad 144592
Hodgkinson, Kenthurst 099046
Hodgson, Alan, Great Shefford . 089178,
 134738
Hodiny & Hubeny, Praha 065429
Hodkins, Ian, Stroud 144607

Hodnet Antiques, Hodnet 089346
Hodsoll, Christopher, London .. 090033
Hoëbeke, Paris 137218
Höch, Janine, Villach 100080
Höchsmann, Sven,
Neckarwestheim 077622
Höchstetter, Renate, Bamberg .. 074621
Hoeckhuys, Breda 082800, 132835
Höckner, Walter, Salzburg 062768
Höderath, Ulla & Peter, Bergisch
Gladbach 074689
Hoedt, W., Frankfurt am Main .. 075743
Hoeff, Korst van der, 's-
Hertogenbosch 126505
Höfler, Joachim, Darmstadt ... 129929
Höganäs Museum och Konsthall,
Höganäs 040503
Högarps Bymuseum, Vetlanda .. 040958
Höglinger, Barbara, Gmunden .. 062555
Höglinger, Wolfgang, Laakirchen 062680
Höglund, Linköping 086628
Höhere Abteilung für Kunst und
Design, HTBLVA Graz-Ortweinschule,
Graz 054859
Höhere Bundeslehranstalt für
künstlerische Gestaltung,
Ausbildungsschwerpunkt: Objekt –
Bild – Medien, Linz 054879
Höhere Grafik und
Kommunikationsdesign, HTL Bau und
Kunst – Innsbruck, Innsbruck . 054871
Höhere Graphische Bundes-Lehr- und
Versuchsanstalt, Wien 054895
Höhlenkundemuseum Dechenhöhle,
Iserlohn 019117
Höhlenmuseum, Frasdorf 018192
Höhlenmuseum, Obertraun ... 018193
Höhlenmuseum Eisensteinhöhle, Bad
Fischau-Brunn 001731
Höhlenmuseum in der Lurgrotte,
Landesmuseum Joanneum,
Peggau 002444
Höhlenmuseum Kubacher Kristallhöhle
und Freilicht-Steinemuseum,
Kubach 019486
Höhlenmuseum, St. Beatus-Höhlen,
Sundlauenen 041784
Höhn, Marie, Wien 062940
Höhn, Ulrich, Flonheim 130135
Höhne, Andreas, München 108137
Høiland, Thomas, Egå 125706
Høiland, Thomas, København .. 125725
Højbo Antik, Århus 065532
Højer Mølle- og Marskmuseum,
Højer 009971
Højgaard Nielsen, Lis, Kongens
Lyngby 065908
Højgaard, Poul, Ringe 065992
Højriis, Susanne, Vejby .. 066113, 102944
Højrup Antik, Hjørring 065695
Hoek, Groningen 083107, 142961
't Hoekje, Den Haag 082898
Hoekstra, Jubbega 132929
Höland, Karl-Günter, Erlbach .. 130096
Hölder, Doris, Ravensburg ... 108448
Hölderlinturm, Tübingen 021808
Höllbacher, Erentrud, Salzburg . 062769
Hoelle, Christian, Bordeaux ... 067279
Hoelle, Christian, Villegouge .. 074115
Höller, Alfred N., Wuppertal ... 079013
Höller, Hanne, Bielefeld 074937
Hølonda Skimuseum of Bygdasamling,
Gåsbakken 033442
Höls, Maria, Düren ... 075399, 075400,
 130009
Hölscher, Detlev, Enger 075573
Hölty-Stube, Göttingen 141741
Hölz, Christine, Grevenbroich .. 107123
Hölzl, Cora, Düsseldorf 106763
Hölzle, Jörg, Ladenburg 130534
Hölzli & Weiss, Bad Waldsee .. 074569
Hömberg, Klaus, Arnsberg 105949
Hönig, Silke, Halle, Saale 130240
Höpfner, Martin, Großostheim . 130222

Höpner, Gudrun, Herne 130341
Höpperger, Innsbruck 062626
Hoeppner, Hans & Marc,
Hamburg 107250, 137444
Hörby Museum, Hörby 040507
Hörbach Verein, Sankt Lorenz . 058228,
 100053
Hoermann, Gaby, Deidesheim .. 075274
Hörner, Hans-Joachim,
Wiesbaden 108932
Hörrle, Oskar, Heidelberg 076385,
 126229
Hörselbergmuseum, Wutha-
Farnroda 022414
Hørsholm Egns Museum,
Hørsholm 009973
Hörstemeier, Melle 077272
Hörter, Aschaffenburg 074395
Hösch, Wolfgang, Elsenfeld ... 075556
Hoeschler, Harsewinkel 107353
Hösel, Magdeburg 077157
Høvåg Museum, Høvåg 033485
Hoeve, Victoria, Sittard 112764
Hövelmann, Michael, Bedburg-
Hau 074666
Hövels, Wendelin, Dreieich ... 075358
Hövermann, G., Verden 078701
Høy, Frantz, Horsens 065726
Hof & Hof, Groningen 112579
Hof & Huyser, Amsterdam 112301
Hof Espe, Museum Landwirtschaft
und Brauchtum, Bad Berleburg 016525
Hof ter Lieffebrughe, Gent 063587
Hof van Edens, Zaltbommel ... 083516
Hof van Hessen, Huissen 032338
Hofbauer, Ken, Las Vegas 121633
Hofburg Innsbruck, Innsbruck .. 002099
Hofer, Brigitte, Freistadt 062547
Hofer, Christine, Luzern 134159
Hofer, Dr. Tiina, Wien 062942
Hofer, Herbert, Wien 128189
Hofer, Ingrid, Graz 062575
Hofer, Jürgen, Saarbrücken ... 078247
Hofer & Sohn, Karl, Wien 062941
Hofer, Rupert, Mödling 062711, 128083
Hoferick, Frank, Radebeul 130916
Hoferick, Ines, Radebeul 130917
Hoff, Ahaus 105912
Hoff von, Amelie, Hamburg 130270
Hoff, Bernard, Wasselonne ... 074254,
 074255
Hoff, Markus, Nordhausen 077722
Hoffeld & Co., Jeffrey, New York 122957
Hoffer, Jean-Jacques, Paris ... 071437
Hoffinger, Wieland, Wien 128190
Hoffman, Columbus 144837
Hoffman Gallery, Oregon College of
Art and Craft, Portland 052202
Hoffman, A., Stockholm 086821
Hoffman, Nancy, New York 122958
Hoffman, Rhona, Chicago 120434
Hoffman, Ronald, New York ... 095295
Hoffman, Stephen, München ... 108138
Hoffmann, Bad Griesbach 106008
Hoffmann, Dortmund 075339
Hoffmann, Nordhorn 142091
Hoffmann, Radeberg 108431
Hoffmann, Sønderborg 066063
Hoffmann & Schneider,
Hückelhoven 076516
Hoffmann Galerie, Zwolle 112821
Hoffmann-Schimpf, Bernd,
Mannheim 130628
Hoffmann-von-Fallersleben-Museum,
Wolfsburg 022322
Hoffmann, A., Lienen 077043
Hoffmann, A., Rheine 108504
Hoffmann, Anne, Bremen 129885
Hoffmann, Claudia, Erlangen .. 130095
Hoffmann, F., Troisdorf 078628
Hoffmann, Judith, Lebach 076975
Hoffmann, Karl-Josef, Attendorn 105971
Hoffmann, Lothar, Ahrensburg . 129599
Hoffmann, M., Paderborn 108365

Hoffmann, Michael, Rott 078214
Hoffmann, Natascha, Gattikon . 087247
Hoffmann, Roland, Paris 071438
Hoffmann, Roland, Saint-Ouen . 073067
Hoffmann, Rosa F., Koblenz ... 076769
Hoffmann, U. & M., Schwäbisch
Gmünd 078325
Hoffmann, Ulrich, Stuttgart ... 108713
Hoffmann, V., Ludwigshafen am
Rhein 077101
Hoffmeister, Wolfenbüttel 142332
Hoffmeister-zur Nedden, Angelica,
Leipzig 130562
Hoffmeister, Ulrike, Lüdenscheid 107910
Hoffschild, Hubertus H., Lübeck 077114
Hoffstead II, Negril 111250
Hofft, Joanna, Maastricht 132953
Hofft, Joanna, Melick-Roerdalen 132959
Hofgalerie, Füssen 107046
Hofgalerie, Wien 062943, 100187
Hofgalerie am See & Kreativ
Werkstatt, Kairn Weiß, Dümmer 106735
Hofinger, Andreas, Steinerkirchen an
der Traun 128138
Hofjagd- und Rüstkammer,
Kunsthistorisches Museum,
Wien 002929
Hofje Van Gratie, Delft 031980
Hofland, Rogier, Amsterdam .. 132783
Hofmann, Luzern 087448
Hofmann, Oberursel 077809
Hofmann & von Sell, Berlin ... 106286
Hofmann, Angelika, Pforzheim . 142151
Hofmann, Antonia, Berlin 129740
Hofmann, Erich, Innsbruck ... 062627
Hofmann, Gerd, Olbernhau ... 077840
Hofmann, Gerhard, Neustadt an der
Weinstraße 108268
Hofmann, Gudrun, München ... 142037
Hofmann, Gunther, Glashütten . 075950
Hofmann, Heinrich & Petra,
Itzgrund 076572
Hofmann, Jürgen, Heidelberg .. 076386
Hofmann, R., Offenbach 077831
Hofmann, Rupert, Oberkirch .. 077790
Hofmann, Sylvia, Feldafing ... 130125
Hofmann, Ursula, Nürnberg ... 130831
Hofmarkmuseum, Eggenfelden . 017856
Hofmarkmuseum Schloß Eggersberg,
Riedenburg 021037
Hofmatt Galerie, Sarnen 116718
Hofmeister, Hans & Emmi,
Colmberg 075223
Hofmeister, Margot, Massing .. 107964
Hofmeister, Sabine, Stuttgart .. 131056
Hofmobiliendepot, Möbelmuseum
Wien, Wien 002930
Hofner, Gerhard, Nürnberg ... 142098
Hofsäss, Theo, Freiburg im
Breisgau 107020
Hofstätter, Ingrid, Wien 100188
Hofstätter, Reinhold, Wien 062944
Hofstede, Deventer 082970
Hofsteenge, C., Groningen ... 083108
Hofstetter, Jean-Jacques,
Fribourg 116367
Hofstra Museum, Hempstead .. 049397
Hofu Tenmangu History Museum,
Hofu 028475
Hofwyl-Broadfield Plantation,
Brunswick 047249
Hog Hollow Art Gallery, Saint
Louis 124080
Hog Wild Collectible Toys, Austin 092072
Hoga, Benjamin Alexander, San
Diego 124380
Hogan, Athlone 079334
Hogan, Collingwood 098769
Hogarte Deco, Caracas 097821
Hogarth, Paddington, New South
Wales 099389
Hogarth's House, London 044895
Hoge, Jürgen, Wuppertal 142352
Hogervorst, M., Dordrecht 082994

Igartzako Museoa, Beasain 038925
Igavel, New York 127619
Igel, Manya, London .. 090055, 118618
Iggy's, San Antonio 096813
Iglesia Caro, Jose de la, Madrid 086023
Iglesia ni Cristo Museum and Gallery,
New Era University, Quezon
City 034414
Iglińska, Anna, Kraków 113689
Iglinski, Grzegorz, Hamburg ... 076188
Iglou Art Esquimau, Douai 103654
Ignaszewski, Georg, Berlin ... 129745
Ignatowicz-Woźniakowska, Dorota,
Warszawa 133243
Ignaz Günther Museum,
Altmannstein 016354
Ignotus Technika, Budapest ... 142385
Igong, Daejeon 111619
Iguana Gallery, Stroud 119448
Ihle-Wirth, Franziska & Geroon,
Fulda 130178
Ihler, Christian, La Garde 068990
Ihn Gallery, Seoul 111705
Ihrke, Christine, Berlin 106290
II. Yesemek Heykel Atölyesi ve
Açikhava Müzesi, İslahiye 042646
Iida-shi Bijutsu Hakubutsukan,
Iida 028489
Iida-shiritsu Kokokan, Iida 028490
III Wash Design, Houston 121342
Iisakin Jussin Tupa, Kauhava .. 010799
Iisaku Muuseum, Iisaku 010445
Iittalan lasimuseo, Iittala 010720
Ijevan Local Lore Museum,
Ijevan 000702
Ijff en van Velzen, Maastricht .. 132954
IK Galerie, Maastricht 112664
Ikaros, Slany 065487, 102698
Ike Taiga Bijutsukan, Kyoto ... 028745
Ikea Museum, Älmhult 040312
Ikebana Arts, San Jose 124698
Ikebana Bijutsukan, Kyoto 028746
Ikeda & Iokker, Tokyo 111457
Ikeda 20-seiki Bijutsukan, Ito ... 028522
Ikeder, Bilbao 115082
Ikegami & Takebi, Kyoto 081847
Ikels, Rena, Rellingen 108479
Ikkan, New York 122973
Iklektik Designs, Houston 121343
IKO Kunstacademie Hoogstraten,
Hoogstraten 054958
ikob, Museum für zeitgenössische
Kunst, Eupen 003510
Ikodespotiko Paleopolio, Lefkosia 065248
Ikodinovic & Co., Nenad,
Waterloo 063799
Ikon- och Konstföreningen,
Stockholm 059798
Ikon Gallery, Birmingham 043383
Ikon Show Room, Haderslev ... 102783
Ikona Photo Gallery, Venezia .. 111149
Ikonen Galerie, Berlin 074788
Ikonen-Galerie, Bern 116232
Ikonen-Galerie Dritsoulas,
München 077456, 130716
Ikonen Galerie Sophia, Zürich .. 087778,
134301
Ikonen-Museum der Stadt Frankfurt
am Main, Stiftung Dr. Schmidt-Voigt,
Frankfurt am Main 018168
Ikonen-Museum, Museen
der Stadt Recklinghausen,
Recklinghausen 020928
Ikonengalerie Dritsoulas,
München 108143
Ikonenmuseum, Ichtenhausen .. 019069
Ikonenmuseum, Potzneusiedl .. 002476
Ikonenzentrum Alexej Saweljew,
Traben-Trarbach 021769
Ikonos, Burgos 133570
Ikor, Sapporo 111388
Ikuno Kobutsukan no Kogyo
Hakubutsukan, Ikuno 028496
Ikuo Hirayama Bijutsukan,

Onomichi 029051
Il Etait Une Fois, Beausoleil .. 066995
Il était une fois, Plaisance-du-
Touch 072129
Il Etait Une Fois, Remiremont .. 072373
Il-Kartell, Tarxien 082254
Il Mauriziano, Reggio Emilia .. 027326
Ilana Goor Museum, Tel Aviv .. 025025
Ilchester Museum, Ilchester ... 044487
Ilchmann, Dagmar, Templin ... 108772
Ildiko, Malvern, Victoria 061774
Ile au Trésor, Biarritz 067143
Ile aux Antiquités, Victot-Pontfol 074077
Ile aux Trésors, Grenoble 068676,
140807
Ile aux Trésors, Neufchâtel-en-
Bray 070461
Ile du Temps, Libourne 069404
Ilene & Wayne, Honolulu 093389
Iles, Francis, Rochester 090975, 119232,
135317
ILevel, New York 122974
Ilfracombe Arts Society,
Ilfracombe 118227, 118228
Ilfracombe Machinery and Heritage
Museum, Ilfracombe 001160
Ilfracombe Museum, Ilfracombe 044488
Ilg, Hansruedi, Zürich 134302
Ilgner, Jürgen, Melle 077273
Ilhami Atalay Sanat Galerisi,
İstanbul 117139
Ilia Chavchavadze's house & museum,
Kvareli 016193
Iliad, New York 095305
Ilias Lalaounis Jewelry Museum,
Athinai 022575
Ilias, Antonis, Angers .. 066549, 128685
Ilić, Boza, Prokuplje 114539
Iliev, Rumen, Köln 107629, 137497
Iligan Museum, Iligan 034315
Iliopoulou, Anna, Glyfada 079096
Ilisso, Nuoro 137806
Ilja Chavchavadze House Museum,
Tbilisi 016213
Ilja Chavchavadze Literature-Memorial
Museum, Tbilisi 016214
Ilko, C., Salzburg 062770
Illawarra Museum, Wollongong . 001649
Illegaard, Tartu 103072
Illi, Raymond & Alexandre,
Genève 087282, 116417, 143874
Illingworth Kerr Gallery, Calgary 005417
Illinois and Michigan Canal Museum,
Lockport 050300
Illinois Art Gallery, Chicago ... 047629
Illinois Artisans and Visitors Centers,
Whittington 054258
Illinois Arts Alliance, Chicago .. 060519
Illinois Association of Museums,
Springfield 060520
Illinois Citizen Soldier Museum,
Galesburg 048985
Illinois Holocauts Museum and
Eduaction Center, Skokie 053246
Illinois Institute of Art, Chicago . 056847
Illinois Railway Museum, Union . 053760
Illinois State Museum,
Springfield 053336
Illmer Kunst + Design,
Osnabrück 108358
Illmert, Sylvia, Saarbrücken ... 108548
Illo Tempore, Bari 131317
Illos, Buffalo 135725
Illulian, Milano 080412
Illum, Miami 094584
Illuminary Art, Toronto 101491
Illuminata Gallery, Houston ... 121344
Illuminati, Milano 080413
Het Illuseum, Gent 003549
Illusoria-Land, Museum und Galerie
für optische Täuschungen und
Holographien, Hettiswil bei
Hindelbank 041363
Illustrated Gallery, Philadelphia . 123646

Illustration House, New York ... 095306,
127620
Illustration Magazine, Saint Louis 139423
Illustrations and Graphic Design
Department, Harcum College, Bryn
Mawr 056771
Illustrator, Minneapolis 139424
Illustratoren Organisation e.V.,
Frankfurt am Main 058886
Illustrious Brighton, Brighton .. 117552
Illy, Günther, Timelkam 062826
Ilmajoen Museo, Ilmajoki 010721
Ilmatorjuntamuseo, Tuusula ... 011279
Ilmavoimien Viestikoulun
Perinnehuone, Tikkakoski ... 011240
Ilmin Museum of Art, Seoul ... 029828
Ilocaniana Cultural Museum,
Magsingal 034337
Iloniemen Pajamuseo, Raatala .. 011115
Îlot des Palais, Québec 006581
L'Ilotrésor, Chavannes-près-
Renens 087175
Iloulian, John, Los Angeles ... 094203,
136071
Iloulian, John, West Hollywood . 097733
Ils Sont Fous ces Romains, Ville-
d'Avray 074093
Ilse B., Paris 071447
ILTE- Industria Libraria Tipografica
Editrice, Moncalieri 137800
Ilulissani Katersugaasivik,
Ilulissat 023007
Ilumina-Art, Bochum 106516
Ilwaco Heritage Museum, Ilwaco 049617
Im Autorenregister, Köln 141895
IM Gallery, Singapore 114619
Im Obersteg, Sankt Gallen ... 087583
Imabari-shiritsu Kono Bijutsukan,
Imabari 028497
Imabayashi, Fukuoka 081796
Imafronte, Murcia 139101
Image, Łomianki 113770
Image 54 Gallery, Calgary 101108
L'image amusée, Céret 103499
Image Art, Gillingham, Dorset . 118019,
138221
Image Arts Etc ., Omaha 123573
Image Arts Etc., San Diego ... 124382
Image Complete, Denver 121013
Image Direct, Amsterdam 112305
Image Document, Châtillon (Hauts-de-
Seine) 067859
Image Document, Paris 071448
Image en Plus, Nîmes 104352
Image et le Livre, Strasbourg .. 141312
Image Factory, Indianapolis ... 121469
Image Fotografisk Galleri, Århus 102737
Image Gallery, York 119714
Image Graphics, Oakland 123506
Image in, Gérardmer 068596
Image Museum of Hsinchu City,
Hsinchu 042055
Image of Art, Hyderabad 109374
Image One International,
Houston 121345
Image Shed, Halifax 118104
Image Showcase, Albuquerque . 119756
Image State, New York 095307
Image Vault Ltd, Christchurch . 137975
Image Visions Gallery, South
Yarra 099569
Imagem Galeria, Fortaleza ... 100810
Imagerie, Den Haag 142924
Imagerie, Lannion 103871
Imagerie d'Epinal, Épinal 137090
Images, London 090056
Les Images, Newtownabbey ... 119008
Images a Gallery, San Francisco 124550
Images and Frames, Boston ... 120155
Images Art, Toronto 101492
Images Art & Life, Modena ... 138876
Images Art Gallery, Bangalore . 109272
Images Art Gallery, Kansas City 121569
Images de la Mer, La Trinité-sur-

Mer 069053
Images du Faubourg, Annecy .. 066583
Images du Passé, Lignieres ... 069408
Images Festival, Toronto 058416
Images Fine Art, Pittsburgh ... 123802
Images Gallery, Toledo 124940
Images in Frames, London ... 118619,
118620
Images International, Honolulu . 121221
Images of Austin and the Southwest,
Austin 119957
Images of Nature, Denver 121014
Images of Nature, Las Vegas .. 121636
Images of Nature, Omaha 123574
Images of the North, San
Francisco 124551
Images Under Glass, Minneapolis 122281
Images Under Glass, Saint Paul 124164,
124165
Imagina, Venezia 111150
Imagina-Museo Interactivo Puebla,
Puebla 031191
Imaginaciones Arte, Cali 102314
L'Imaginaire, Bruxelles 140152
The Imaginarium Gallery,
Haworth 118136
Imaginarium Hands-On Museum, Fort
Myers 048812
Imaginary Places, Philadelphia . 123647
Imagination Station Science Museum,
Wilson 054331
Imagination Unlimited, Miami .. 094585
Imagine, Fuchu 081792
Imagine, Luxembourg 111909
Imagine, Maastricht 112665
Imagine Arts Espaces Matières,
Bordeaux 103388
Imagine Interiors, Memphis ... 094475
Imagine Venezia London, Venezia 111151
Imaging Solutions, Richmond . 123983
Imaginosity, Dublin Children's
Museum, Dublin 024636
Imago, Wernigerode 078847
imago fotokunst, Berlin 106291
Imago Grafica, Perugia 110659
Imago Lignea, Torino . 081546, 111004,
132533
Imago Mundi, Buenos Aires ... 139605
Imaian, Las Rozas 115193
Imaian, Madrid 115326
Imaizumi Hakubutsukan,
Shiozawa 029210
Imari, Porto Alegre 063922
Imari-shi Rekishi Minzoku Shiryokan,
Imari 028498
Imasterpiece, Miami 122086
Imatran Kulttuurihistoriallinen
Kaupunginmuseo, Imatra ... 010724
Imatran Taidemuseo, Imatra ... 010725
Imavision Gallery, Taipei 116997
Imazoo, Seoul 111706
Imbard, Patrick, Paris 071449
Imbert, Didier, Paris 104916
Imelda, Knokke-Heist 100604
Imeson Collection, Windsor,
Ontario 064850
IMF Center Exhibit, Washington . 054000
Imhoff Art Gallery, Saint Walburg 006785
Imker- und Heimatmuseum
Wassertrüdingen,
Wassertrüdingen 022031
Imkereigeschichtliche und
bienenkundliche Sammlungen,
Celle 017493
Imkereimuseum, Pöggstall 002470
Imkereimuseum, Sitzenberg-
Reidling 002702
Imkereimuseum "Plattner Bienenhof",
Soprabolzano 027813
Imkereimuseum Grüningen,
Grüningen 041338
Imkereimuseum Müli, Grüningen 041339
Imkerijmuseum Poppendamme,
Grijpskerke 032192

Industriemuseen Euregio Maas-Rhein,
Blegny 058351
Industriemuseum, Limbach-
Oberfrohna 019737
Industriemuseum Brandenburg,
Brandenburg an der Havel . . 017324
Industriemuseum Elmshorn,
Elmshorn 017918
Industriemuseum Freudenthaler
Sensenhammer, Leverkusen . . 019718
Industriemuseum Geschichtswerkstatt
Herrenwyk, Die Lübecker Museen,
Lübeck 019819
Industriemuseum Hartha, Hartha 018781
Industriemuseum im Bunker 29,
Waldkraiburg 021982
Industriemuseum Lauf, Lauf an der
Pegnitz 019598
Industriemuseum Lohne, Lohne 019771
Industrieviertel-Museum, Museum für
Industrie und Arbeitsgeschichte,
Wiener Neustadt 003022
Industrimuseet, Horsens 009986
Industrimuseet, Kopperå 033538
Industrimuseet C.W. Thorstensons
Mekaniska Verkstad, Åmål . . 040328
Industrimuseet Frederiksværk,
Frederiksværk 009914
Industrimuseet Tollereds Öfvre
Kraftstation, Tollered 040880
Industrion Museum for Industry and
Society, Kerkrade 032364
Inecos, Roma 081246
Ineichen, Zürich 126962
Ineichen, Josef, Rupperswil . . 134214
Ines Art Gallery, Singapore . . 114622
Inetllibre, Barcelona 143526
Infanterie Museum, Harskamp . 032237
Infantry and Small Arms School Corps
Weapons Collection, Warminster 046071
Infinity Photography, Edinburgh 117911
Infinito, Sapporo 081927
Infinity Antique Furniture, Hong
Kong 064993
Infinity Fine Arts, New York . . 122977
Info-Musées, Roma 138599
Informationsdienst KUNST,
Regensburg 138745
Informationsstelle des Naturparks
Fichtelgebirge, Zell im
Fichtelgebirge 022436
Informationszentrum am
Wasserstraßenkreuz Minden,
Minden 020076
Informationszentrum Donnersberghaus,
Dannenfels 017585
l'Informatore Europeo d'Arte e di
Antiquariato, Bologna 138877
Infusion Art Studio, Tucson . . 124994
Infusion Design Art Glass Gallery,
Tucson 124995
Ingatestone Hall, Ingatestone . 044493
Ingbar, Michael F., New York . . 122978
Ingeborgmuseet Fredheim,
Tangen 033830
Ingeborrarps Friluftsmuseum,
Örkelljunga Hembygdsförening,
Örkelljunga 040699
Ingebrigt Vik's Museum, Øystese 033643
Ingelbrecht, Helge Velo, Oslo . . 113324
Ingelmark Antik och Design,
Ängelholm 126773
Ingelmark Antik och Design,
Visby 126910
Ingels-Humblot, Véronique,
Roanne 126062
Ingels, F., Gent 128303
Inger & Dan, Stockholm 086823
Ingerslev, København 065845
Ingersol, Tonya, Baltimore . . . 120026
Ingersoll Cheese Factory Museum and
Sports Hall of Fame, Ingersoll . 005911
Ingiulla, Roma 081247
Ingle, Virginia Beach 097618

Ingleby Gallery, Edinburgh 117912
Ingleby Gallery, Ingleby 118232
Ingledale, Stoney Creek 006912
Inglenook, Harpole 089223
Inglenook, Ramsbury . 090917, 135299
Inglett, Susan, New York 122979
Inglewood District Historical Museum,
Inglewood 001162
ingo fincke, London 118623
Ingrained, Rockingham 062154
Ingram, Toronto 064622
Ingram Gallery, Toronto 101494
Ingrao, New York 095309
Ingrids Art, Hawkes Bay 112999
Ingrow Loco Museum, Keighley . 044534
Ingstrup Antik, Løkken 065917
Ingurugiro Etxea, Museo Medio
Ambiental, Azpeitia 038846
Inguškij Gosudarstvennyj Muzej
Kraevedenija im. T.Ch. Malsagova,
Nazran 037369
Inherited Arts, Singapore 114623
Inhof, Ryde 127944
Inhofer, Edith, Regensburg 078086
Inhouse, Toronto 064623
Iniesta Gloria, Moissac 070091
Inishie, Nara 081898
Inishowen Maritime Museum,
Greencastle 024714
Initial Tree Gallery, San Antonio . 124290
Initiative, Sankt-Peterburg 114428
Initiative Münchner Galerien
zeitgenössischer Kunst,
München 058887
Injalak Arts & Crafts, Oenpelli . . 062015
Inje, Den Haag 112477
Injuka, München 077458
Ink Factory Auction, Saint Marys 127697
Ink Miami, Miami Beach 098282
Ink Tree Editions, Zürich 138175
ink_d Gallery, Brighton 117553
Inkjet Galerie, Spaichingen 078427
Inkoart, Kyïv 117203
Inkspecta, Mitcham 099220
Inkt Delft, Delft 112446
Inkworks, Los Angeles 144969
Inky Parrot Press, Oxford 138328
Inland Seas Maritime Museum,
Vermilion 053835
Inland-Water Ecological Laboratory
Collection, Jerusalem 024903
Inlibris, Wien 140077
Inlight Art Glass, Buffalo 092369, 135726
Inliquid, Philadelphia 123649
Inmaculada Concepcion, Bogotá . 065102
Inman, Kerry F., Houston 121348
Inman, Raymond P., Hove 127150
Inmans, Hove 127151
Inn-Museum, Wasserbau- und
Schiffahrtstechnische Sammlung,
Rosenheim 021094
The Inner Bookshop, Oxford . . . 144516
Inner City Art Gallery, New York 122980
Inner Eye Velo, Leven 118335
Inner Galeria Nacisku Brow-art,
Wrocław 114030
Inner Mongolia Museum, Hohhot 007672
Inner Vision Antiques, Los
Angeles 094204
Innervisions Posters, Seattle . . . 124796
Inniscara Art & Framing,
Rathcoole 109693
Innisfail and District Historical
Museum, Innisfail 001163
Innisfail and District Historical Village,
Innisfail 005912
Inniskeen Folk Museum,
Inniskeen 024718
Innisville and District Museum,
Innisville 005913
Innocent Fine Art, Bristol 117584
Innocenti, Ferdinando & Filippo,
Firenze 079992, 142496
Innocenti, Roberto, Firenze 079993

Innovanet, Auckland 112866
Innovatum Kunskapens Hus,
Trollhättan 040889
Inns of Court and City Yeomanry
Museum, London 044904
Innuit Gallery, London 101209
Innviertler Freilichtmuseum
Brunnbauerhof, Andorf 001706
Innviertler Künstlergilde, Ried im
Innkreis 058231
İnönü Evi Müzesi, İzmir 042703
Inoue, Tokyo 142742
Inouye & Son, T. Edo, Tokyo . . 081979
Inpa Coleções Zoológicas,
Manaus 004473
Inprint, Stroud 144608
Inprints, Seattle 124797
Inquadrature Arte e Cornici,
Trieste 111072
Inquadro, Piobesi Torinese 110678
Inquisitive, Toronto 064624
Inquisitor's Palace, National
Museum of Ethnography of Malta,
Vittoriosa 030588
Inro Bijitsukan, Takayama 029275
Insa Gallery, Seoul 111708
Insam, Josef & Angelika,
Regensburg 078087
Insam, Peter, Regensburg 078088,
130934
The Insch Connection Museum,
Insch 044499
Insect Collections at the Entomology
Department, National Taiwan
University, Taipei 042241
Insectarium de Montréal, Muséums
Nature de Montréal, Montréal . 066241
Insects Museum, Amman 029585
Inselgalerie, Berlin 106292
Inselgalerie, Frauenchiemsee . . 107009
Inselgalerie, Wittdün 108965
Inselmuseum, Pellworm 020739
Inselmuseum "Alter Leuchtturm",
Wangerooge 022011
Inselmuseum Spiekeroog,
Spiekeroog 021537
Insensatez, Lisboa 114126
Inside, Cleveland 120710
Inside Out, Penkridge 090802
Inside Out, San Antonio 096814
Inside Outside, Houston 093540
Inside Secrets, Portland 096258
Inside Space, London 090058
Inside, Magazine di Arte e Cultura
Contemporanea, Brescia 138878
Insight Art Gallery, Springbrook . 099575
Insights – El Paso Science Center, El
Paso 048471
Insolite, Bordeaux 067281
Insolite, Saint-Ouen 073069
Insolite, Troyes 073867
Inspirations, Orpington 119072
Inspirations Gallery, Mildura . . . 099205
Inspire, Listowel 079556
Inspire – Hands-on Science Centre,
Norwich 045341
Inspire Fine Art, Chicago 120441
Inspires Art Gallery, Oxford 119087
Inst Superior de Conservación y
Restauración Yachaywasi, Lima 133175
Installation Gallery, San Diego . . 124383
Instanbul to Samarkand Gallery,
Austin 092078
L'Instant Durable, Clermont-
Ferrand 137084
Institut Art et Archéologie de Byzance,
Strasbourg 055360
Institut Culturel Avataq,
Westmount 007204
Institut d'archéologie et des sciences
de l'antiquité, Université de
Lausanne, Lausanne 056392
Institut d'Art Conservation et Couleur,
Paris 129271

Institut d'Art Contemporain,
Villeurbanne 016083
Institut d'Art Médiéval, Université Paul
Valery, Montpellier 055324
Institut d'Arts Visuels, Orléans . 055331
Institut de France, Saint-Jean-Cap-
Ferrat 015167
Institut d'Egypte, Cairo 055274
Institut der Künste, Pädagogische
Hochschule Freiburg, Freiburg im
Breisgau 055483
Institut der Künste, Pädagogische
Hochschule Schwäbisch Gmünd,
Schwäbisch Gmünd 055641
Institut des Beaux-Arts Section IV,
Université Libanaise, Chouf . . . 056062
Institut des Beaux-Arts, Section I,
Université Libanaise, Beirut . . . 056061
Institut des Beaux-Arts, Section II,
Université Libanaise, Furn El-
Chebbak 056064
Institut des Beaux-Arts, Section III,
Université Libanaise, Tripoli . . . 056066
Institut des Communications
Graphiques, Montréal 055078
Institut Design- und Kunstforschung,
Hochschule für Gestaltung und Kunst
HGK FHNW, Basel 056369
Institut d'Histoire de l'Art et de
Muséologie, Université de Neuchâtel,
Neuchâtel 056398
Institut et Musée Voltaire,
Genève 041297
Institut Finlandais, Paris 104918
Institut for Kunst- og Kulturvidenskab,
Københavns Universitet,
København 055248
Institut für Ästhetisch-Kulturelle
Bildung, Universität Flensburg,
Flensburg 055474
Institut für Archäologie,
Denkmalkunde und Kunstgeschichte,
Abt. Kunstgeschichte, Otto-Friedrich-
Universität Bamberg, Bamberg 055393
Institut für Architektur und Medien,
Technische Universität Graz,
Graz 054860
Institut für Architektur und Städtebau,
Universität der Künste Berlin,
Fakultät Gestaltung, Berlin . . . 055406
Institut für Architektur, Fachgebiet
Bau- und Kunstgeschichte,
Technische Universität Berlin,
Berlin 055405
Institut für Kunstgeschichte,
Universität Stuttgart, Stuttgart . 055653
Institut für Architekturtheorie, Kunst-
und Kulturwissenschaft, Technische
Universität Graz, Graz 054861
Institut für Architekturzeichnen
und Raumgestaltung, Technische
Universität Carolo-Wilhelmina zu
Braunschweig, Braunschweig . 055432
Institut für Ausbildung in bildender
Kunst und Kunsttherapie,
Bochum 055427
Institut für Auslandsbeziehungen e.V. –
Abt. Kunst, Stuttgart 021640
Institut für Auslandsbeziehungen, ifa-
Galerie Stuttgart, Stuttgart . . . 021639
Institut für Baugeschichte,
Architekturtheorie und
Denkmalpflege, Technische
Universität Dresden, Dresden . 055457
Institut für Baugestaltung, Universität
Karlsruhe (TH), Karlsruhe 055538
Institut für Bildende Künste,
Universität Karlsruhe (TH),
Karlsruhe 055539
Institut für Bildende Kunst
und Kulturwissenschaften,
Kunstuniversität Linz, Linz . . . 054881
Institut für Bildende Kunst und
Kunstwissenschaft, Universität

Institut für Bildende Kunst, Akademie der bildenden Künste, –
Institut Lehrberufe für Gestaltung und Kunst, Hochschule für

Index of Institutions and Companies

Jellicoe Arts, Nelson 113049
Jellicoe, Colin, Manchester 118900
Jellicoe, Roderick, London 090066
Jellinek, Tobias, Twickenham . . 091531
Jelling, Vejle 066120
Jelly van den Bosch Museum,
 Roden 032612
Jeltsch, T., Bönnigheim 075014
Jem, Kelmscott 061665
JEM – Journal of Education in
 Museums, Gillingham, Kent . . . 139224
Jem Coins, Fresno 093339
Jemez State Monument, Jemez
 Springs 049766
Jemo, Villeurbanne 074175
Jems, El Paso 093239
Jena, Tokyo 142744
Jenack, William J., Chester . . . 127426
Jenaer Kunstverein e.V., Jena . . 058898
Jenaer Kunstverein, Galerie im
 Stadtspeicher, Jena 019141
Jenbacher Museum, Jenbach . . 002120
Jenco, Chicago 120445
Jenei Béla Betű, Budapest 142386
Jeneverhuis Van Hoorebeke,
 Eeklo 003495
Jenin, Claude, Lille 128916
Jenisch Haus, Museum für Kunst und
 Kultur an der Elbe, Hamburg . . 018706
Jenischek, O., Bergisch
 Gladbach 141412
Jenkins Johnson Gallery, San
 Francisco 124556
Jenko's, Charlotte 092444
Jenkova Kasarna, Zgornje
 Jezersko 038456
Jenle Museum, Nanna og Jeppe
 Aakjærs Hjem, Roslev 010128
Jennemann, Dr. S., Isny im
 Allgäu 107455
Jenner, Le Havre 069226
Jenner Museum, Berkeley 043328
Jennings-Brown House Female
 Academy, Bennettsville 046888
Jennings, Paul, Angarrack 088047
Jennrich, Merzenich 077291
Jennrich, E. & U., Düren 075401
Jenny-Marx-Haus, Salzwedel . . 021191
Jennywell Hall Antiques, Crosby
 Ravensworth 088798
Jens Nielsens & Olivia Holm-Møller
 Museet, Holstebro 009978
Jens Søndergaard Museet,
 Lemvig 010055
Jensen, Auckland 112867
Jensen, Helsingør 102790
Jensen Arctic Museum, Western
 Oregon University, Monmouth . 050922
Jensen, Birgit, Rønne 066007
Jensen, Dean, Milwaukee 122207
Jensen, Else, København 065848
Jensen, Frank, Otterup 065973
Jensen, Gert, Farum 065582
Jensen, Helge, Valby 140630
Jensen, Joan, Svaneke 066076
Jensen, Karin, Gilleleje 065628
Jensen, Leif, Valby . . . 066101, 102939
Jensen, Niels, Nykøbing Falster . 140592
Jensen, Ove & Nina, Grindsted . 065644
Jensen, Soren, New York 095321
Jensen, Tommy, Sorø 066068
Jente, Saint Louis 136543
Jentsch, Remplin 078116
Jentsch, Detlef, Gütersloh 076066,
 126209
Jentzsch, Carl-Rainer, Adelberg . 105910
Jeonju Municipal Museum,
 Jeonju 029785
Jeonju National Museum, Jeonju 029786
Jeoufen Art Gallery, Rueifang . . 042153
Jeph's Stuff, Portland 096260
Jéquel, Mathilde, Lyon 128953
Jered, San Diego 124384
Jeremiah Lee Mansion,

Marblehead 050602
Jeremy, London 090067
Jérez, Jean-Luc, Saint-Julien-de-
 Lampon 072820
Jeri, Jean, Fontaine-de-Vaucluse 068502
Jericho, Oxford 144517
Jericho Historical Society, Jericho
 Corners 049770
Jerie, Sylvia, München 130717
Jerilderie Doll World, Jerilderie . 001168
Jermuk Art Gallery, Jermuk 000703
Jermy & Westerman, Nottingham 144510
Jermy, Pete, Ulverstone 139970
Jernander, A., Bruxelles 063416
Jerner, Stockholm 086827
Jernigan & Wicker, San
 Francisco 124557
Jerome County Historical Society,
 Jerome 049771
Jerome K. Jerome Birthplace Museum,
 Walsall 046057
Jérome, Jean-Luc, Cravant 068168
Jérôme, Jean-Luc, Meung-sur-
 Loire 070054
Jerrari, Youssef, Casablanca . . . 082381
Jerrye, Ann, Indianapolis 093728
Jerry's Fine Art, Miami 122092
Jerry's Refinishing, Fresno 135916
Jerschewski, Volker, Flensburg . 106922
Jersey Antiques, Osborne Park . 062027
Jersey Battle of Flowers Museum,
 Saint Ouen 045684
Jersey City Museum, Jersey City 049775
Jersey Heritage Trust, Saint Dominick,
 Jersey 045660
Jersey Museum, Saint Helier . . 045666
Jersey Photographic Museum, Saint
 Helier 045667
Jersey War Tunnels, Saint
 Lawrence 045676
Jersin, Nikki, Denver 093138
Jerstedt, Goslar 076005
Jerusalem Art's, Houston 121351
Jerusalemhaus mit Verwaltung der
 Städtischen Sammlungen Wetzlar,
 Städtische Sammlungen Wetzlar,
 Wetzlar 022195
Jerxheimer Kunstverein,
 Jerxheim 058899
Jeschek, Angelika, Augsburg . . 074424
Jeske, Norbert, Stollberg,
 Erzgebirge 078485
Jeske, O., Bevern, Holstein 074924
Jessa, Denise, Montereau-Fault-
 Yonne 070185, 129036
Jesse James Bank Museum,
 Liberty 050222
Jesse James Farm and Museum,
 Kearney 049862
Jesse James Home Museum, Saint
 Joseph 052684
Jesse Peter Museum, Santa Rosa
 Junior College, Santa Rosa . . . 053025
Jessie's Art Work, Los Angeles . 094210
Jessop, London 090068
Jessy & Raymond's Gallery, Ciudad de
 Panamá 113412
Jesteburger Mühle, Jesteburg . . 076584
Jester Antiques, Tetbury 091427
Jeta, Singapore 114628
Jetter, Edgar, Vreden 131123
Jeu de l'Oie, Biarritz 067144
Jeu de Paume, Site Concorde,
 Paris 014467
Jeu de Paume, Site Sully, Paris . 014468
Jeudy, I., Tournai 063789
Jeunesse, E.R., Paris 141110
Jeunink, Brigitte, Gleize 068618
Jevons, Francis, London 090069, 135023
Jevrejski Istorijski Muzej,
 Beograd 037967
Jewel Antiques, Leek 089584
Jewel Box, Dallas 092982
The Jewel Casket, Dublin 079456

Jewel of Tibel, Toronto 064628
Jewel of Tibel, San Francisco . . 097095
Jewel Tower, London 044910
The Jewel Tree, Cape Town . . . 085460
Jewell County Historical Museum,
 Mankato 050587
Jewelry and Coin Center, Buffalo 092371
Jewelry Box Antiques, Kansas
 City 093913
Jewelry by Mimi, Philadelphia . . 095957
Jewelry Palace, Las Vegas 093989
Jewett Hall Gallery, Augusta . . . 046635
Jewish Battalions Museum,
 Ahivil 024835
Jewish History Centre of Thessaloniki,
 Thessaloniki 022955
Jewish Holocaust Centre,
 Elsternwick 001056
Jewish Institute for the Arts, Boca
 Raton 047036
Jewish Military Museum, London 044911
Jewish Museum, London 044912
The Jewish Museum, New York . 051328
Jewish Museum of Australia, Gandel
 Centre of Judaica, Saint Kilda,
 Victoria 001467
Jewish Museum of Florida, Miami
 Beach 050780
Jewish Museum of Maryland,
 Baltimore 046719
Jewish Museum of Thessaloniki,
 Thessaloniki 022956
Jewish National Fund House, Museum
 of Provisional Peoples Council and
 Administration, Tel Aviv 025033
Jewitt &Co., J.B., Cleveland . . . 135816
Jewry Wall Museum, Leicester
 Museums, Leicester 044672
Jeypore Branch Museum, Jaipur,
 Orissa 023998
Jezebel, New Orleans 094950
Jeżewski, Wiesław, Warszawa . . 133245
JF Galerie, Zürich 116900
JFF Fire Brigade & Military
 Collectables, Bedhampton 088200
JFK Special Warfare Museum, Fort
 Bragg 048748
JGalerie, Paris 104933
jgallery, Moulton 118954
Jhak, Seoul 111710
Jhalawar Archaeology Museum,
 Jhalawar 024012
Jharokha, Delhi 109339
Jheng Cheng-Gong Memorial Hall,
 Sikou 042176
Jhenlangong Mazu Exhibition Hall,
 Dajia 042019
JHS Antiques, Ashbourne 088066
Ji Ce's Antikt, Nyköping 086704
JI Gallery, Los Angeles 094211
Ji Ya, Shenzhen 120129
Ji, Zhon, Shenyang 102113
Jia-Art, Taipei 116998
Jia Friendship Union, Beijing . . . 101833
Jia Society Yiyuan, Beijing 101834
Jiading District Museum,
 Shanghai 008048
Jian Museum, Jian 042073
Jian Museum, Jian, Jiangxi 007734
Jiangdu Museum, Jiangdu 007737
Jiangmen Museum, Jiangmen . . 007740
Jiangnan, Shanghai 102082
Jiangnan Gongyuan History Display
 Center, Nanjing 007912
Jiangning Museum, Jiangning . . 007741
Jiangshan Museum, Jiangshan . 007742
Jiangsu, Singapore 085263
Jiangsu Chinese Painting Gallery,
 Nanjing 102043
Jiangsu Fine Arts Publishing House,
 Nanjing 137017
Jiangxi Fine Arts Publishing House,
 Nanchang 137016
Jiangxi Provincial Museum,

Nanchang 007900
Jiangxian Museum, Jiangxian . . 007743
Jiangyin Calligraphy and Painting
 Gallery, Jiangyin 102030
Jiangyin Museum, Jiangyin 007744
Jian'ou Museum, Jian'ou 007745
Jianyang Museum, Jianyang . . . 007746
Jianzhou, Singapore 114629
Jiaoling Museum, Jiaoling 007747
Jiaonan Museum, Jiaonan 007748
Jiaoshan Beike Stone Museum,
 Zhenjiang 008385
Jiaosi Museum, Jiaosi 042074
Jiaozhou Museum, Jiaozhou . . . 007749
Jiaozhuang Hu Didao Station,
 Beijing 007438
Jiaozuo Museum, Jiaozuo 007750
Jiashan Museum, Jiashan 007751
Jiaxing Museum, Jiaxing 007752
Jiayuguan Changcity Museum,
 Jiayuguan 007753
Jibac, Tampa 124908
Jibei Cultural Relics Exhibition Hall,
 Baisha 041987
Jibreen, Muscat 084234, 113984
Jidaiya, Kobe 081826
Jie Jie Art, Shanghai 102083
Jierjia Sweet Potato Museum,
 Taichung 042195
Jiexi Museum, Jiexi 007754
Jiexiu Museum, Jiexiu 007755
Jieyang Museum, Jieyang 007756
Jigsaw Gallery and Bridgetown
 Heritage Museum, Bridgetown . 000885
Jihočeské Muzeum v Českých
 Budějovicích, České Budějovice 009348
Jihomoravské Muzeum ve Znojmě,
 Znojmo 009830
Jiji Railway Museum, Jiji 042076
Jika Kram, Hjørring 065696
Jikjiseongbo Museum, Gimcheon 029756
Jikyu-an Zen Art, Kyoto 081849
Jilin City Museum, Jilin 007757
Jilin Provincial Museum,
 Changchun 007479
Jilin Provincial Museum of Natural
 History, Changchun 007480
Jilin Provincial Museum of Revolution,
 Changchun 007481
Jilin University Museum,
 Changchun 007482
Jilin Wenmiao Museum, Jilin . . . 007758
Jillings, Newent 090684, 135219
Jim & Shirley's Antiques, Long
 Beach 094040
Jim Clark Room, Duns 043998
Jim Crow Museum, Ferris State
 University, Big Rapids 046946
Jim Gatchell Memorial Museum,
 Buffalo 047276
Jim Kempner Fine Art, New York 122997
The Jim Thompson House,
 Bangkok 042390
Jim Thorpe Home, Oklahoma
 Historical Society, Yale 054440
Jiménez Alvárez, Carmen Maria, La
 Laguna 133638
Jimenez Garcia, Mario, Madrid . 143573
Jimenez, Christine, Pougues-les-
 Eaux 072254
Jiménez, Javier, Madrid 086026
Jimmie Rodgers Museum,
 Meridian 050739
The Jimmy Stewart Museum,
 Indiana 049632
Jimnette, Tshwane 085497
Jimo Museum, Jimo 007759
Jimpy's Antiques, Nelson 093428
Jim's Antiques, Phoenix 096055, 136459
Jim's Shop, Fresno 135917
Jin, Kitakyushu 111293
Jin, Tokyo 081983
Jin Ancestral Hall Museum,
 Taiyuan 008152

John Paul Jones Birthplace Museum, Arbigland 043166
John Paul Jones House Museum, Portsmouth 052219
The John Q. Adams Center for the History of Otolaryngology – Head and Neck Surgery, Alexandria . 046362
John R. Jackson House, Winlock 054352
John R. Park Homestead, Harrow 005873
John Ralston Museum, Mendham 050725
John Rivers Communications Museum, Charleston 047515
John Rylands University Library-Special Collections, Manchester 045128
John S. Barry Historical Society Museum, Constantine 047929
John Slade Ely House, New Haven 051190
John Smart House, Medina County Historical Society, Medina 050699
The John Southern Gallery, Dobwalls 043915
John Stark Edwards House, Warren 053942
John Strong Mansion, Addison . 046290
John Sydnor's 1847 Powhatan House, Galveston 048998
John Szoke Editions, New York . 138453
John Taylor Bellfoundry Museum, Loughborough 045071
John-Wagener-Haus Sievern, Langen, Kreis Cuxhaven 019563
John Walter Museum, Edmonton 005644
John Weaver Sculpture Museum, Hope 005893
The John Wesley House and The Museum of Methodism, London 044913
John Wesley Powell Memorial Museum, Page 051797
John Whitehead Works of Art, London 090071
John Woolman Memorial, Mount Holly 051019
John Wornall House Museum, Independence 049626
John, C., London . . . 090070, 135024
Johnathan Novak Contemporary Art, Los Angeles 121794
Johndandy, Toronto 101498
Johnen, Berlin 106301
Johnen Galerie, Berlin 106302
John's Antiques, Saint Louis . . 096555
John's Antiques, Saint Paul 096666
John's Antiques Studio, Chicago 092565, 135767
John's Art and Antiques, Baltimore 092172
John's Book Shop, Mosman . . 139866
The Johns Hopkins University Archaeological Collection, Baltimore 046720
John's Krambu, Stavanger 084204
Johns, Derek, London . 090072, 118629
Johnson, Chicago 092566
Johnson, Edmonton . . 101155, 101156
Johnson, Long Beach 136045
Johnson, Memphis . . . 094478, 136129
Johnson, West Hollywood 125252
Johnson & Johnson, Seattle . . . 097297
Johnson Atelier, Mercerville . . . 050737
Johnson Collection of Photographs, Movies and Memorabilia, Safari Museum, Chanute 047489
Johnson County Historical Society Museum, Coralville 047952
Johnson County Historical Society Museum, Tecumseh 053578
Johnson County Historical Society Museum, Warrensburg 053948
Johnson County History Museum, Franklin 048896
Johnson County Museums, Shawnee 053175

Johnson Ferry House Museum, Titusville 053633
Johnson-Feugère, Dun-le-Palestel 068355, 103658
Johnson Hall, Johnstown 049786
Johnson Heritage Post Art Gallery, Grand Marais 049149
Johnson-Humrickhouse Museum, Coshocton 047986
Johnson Willard, E., Oklahoma City 123536
Johnson & Sons, Arthur, Nottingham 127246
Johnson, David, San Antonio . . 096819
Johnson, Ernest, Ottawa 064450
Johnson, Eron, Denver 093139
Johnson, Howard, Saint Louis . 136544
Johnson, Jan, Montréal 140328
Johnson, Lucy, London 090073
Johnson, Margot, New York . . . 095323
Johnson, Matthew R., Seattle . . 097296
Johnson, Pat, Houston 093545
Johnson, Peter, Penzance . . . 090814, 135272
Johnson, R. Stanley, Chicago . 120446
Johnson & Sons, Rex, Birmingham 088258
Johnson, Robert, Brasilia 063879
Johnson, Robert R., San Francisco 097097
Johnson, Sam, Los Angeles . . 144970
Johnson, Samuel, Armadale, Victoria 098514
Johnson, Sarah, San Francisco . 136665
Johnson, Steve, Newcastle-upon-Tyne 090679
Johnson, Walker & Tolhurst, London 090074, 135025
Johnson, William E., Dallas . . . 120893
Johnsonese, Chicago 120447
Johnson's, Leek 089585
Johnssen, Carol, München 108147
Johnston, Dublin 079457
Johnston, Hunters Hill 099007
Johnston, Mayen 077248
Johnston, Pittsburgh 123806
Johnston & Shine, Tampa 097399
Johnstone, Saint Paul 096667
Johnstown Area Heritage Association, Johnstown 049789
Johnstown Historical Society Museum, Johnstown 049787
Johyun, Busan 111586
Johyun Gallery, Busan 111587
Joigny, Renaud de, Nantes . . . 129072
Joint Jacky, Saint-Quentin (Aisne) 073237
Joint Publishing, Hong Kong . . 137007
Joint Venture Antiques, Saint Louis 096556
Jojo's Place, Vancouver 064779
Jojo's Treasures, Fort Worth . . 093290
Jojuma! Electronic Art Gallery, El Paso 121114
Jókai Mór Emlékmúzeum, Balatonfüred 023107
Jókai Mór Emlékszoba és Tájház, Tardona 023670
Jokioisten Museorautatie ja Kapearaidemuseo, Jokioinen . 010745
Jokioisten Naulamuseo, Jokioinen 010746
Jokioisten Pappilamuseo, Jokioinen 010747
Jokkmokks Stencenter, Jokkmokk 040528
Joli, Memphis 121975
Joliat, André, Dübendorf 087209
Joliat, André, Zürich 087780
Joliet Area Historical Museum, Joliet 049791
Jolly Farm Antiques, Villers-sur-Mer 074143
Jolly Gorgeous Gallery, Brighton 117556

Jolly, Thomas, Chicago 092567
Joly Antiquités, Namur 063754
Joly, Alain, La Frette 068982
Joly, Claude, Ligueil 069410
Joly, Marc, Belfort 067012
Joly, Patrick, Thezy-Glimont . . . 073610
Jolyon Warwick, James, Woollahra 062465
Jomain, Marie-Claire, Orange . . 070739
Jomamo, Palma de Mallorca . . . 086182
Jomier, Daniel, Meaulne 069972
Jomon Bijutsukan, Nakaniida . . 028950
Jomon-Kan, Kizukuri 028651
Jon, New Orleans 094951
Jonard, Robert, Paris 141111
Jonas Hörna, Huskvarna 086567
Jonas Verlag, Marburg 137533
Jonathan Hager House and Museum, Hagerstown 049271
Jonathan Swift Art Gallery, Belfast 117420
Jonavos Krašto Muziejus, Jonava 030168
Jonckers, Sittard 083421
Jones, Gräfelfing 076012
Jones, London 090075, 135026
Jones, Stockholm 143759
Jones & Jacob, Watlington 127347
Jones & Vicente, Punta del Este 125317
Jones Art Gallery, Dungarvan . . 109640
The Jones Museum of Glass and Ceramics, Sebago 053136
Jones, Alan & Margaret, Auckland 083613
Jones, C.V., Ballarat . 061077, 098546
Jones, Cameron, New Orleans . 122437
Jones, Casey, Louisville 094400
Jones, Christopher, Flore 089078
Jones, Christopher, London . . . 090076
Jones & Co., Clark, New York . 095324
Jones, Dave & Pamela, Yarrahapinni 099801
Jones, Elfed, Colwyn Bay 144122
Jones, Helen, Sacramento 124020
Jones, Herb, Norfolk 123480
Jones, Howard, London 090077
Jones, Jane E., Dallas 120894
Jones, Kevin, Dublin 079458
Jones, Louis & Susan, Norfolk . 123481, 123482
Jones, Louis & Susan, Virginia Beach 125083
Jones, Michael, Northampton . . 090713
Jones, Paul, Clayfield 061326
Jones, Peter, London 090078
Jones, Solomon, Indianapolis . . 093729
Jones, Solway, Los Angeles . . . 094214
Jones, Stella, New Orleans 122438
Jones, Steven, Beaumaris 117394
Jones, Tiffany, Buderim 061218
Jonesborough-Washington County History Museum, Jonesborough 049796
de Jong, Eindhoven 083032
Jong, A. de, Utrecht 133024
Jong, Anne de, Berlicum 132817
Jong, de, Amsterdam 082586
Jong, Harry, Amsterdam 082587
Jong, Leo de, Rotterdam 112730
Jong, R.F.G.J. de, Den Haag . . 082903
Jong, Ria, Amsterdam 082588
Jong, Sophie, Alkmaar 112186
Jongbloed, A., Leiden 142993
Jonge, Fabery de, Middelburg . . 083310
Jonge, Jon de, Mount Nelson . . 099270
Jonge, Maartje de, Amsterdam . 082589
Jongeneel, Pieter-Pierre, Bergen 112425
Jongert & Jongert, Amsterdam . 112310
Jongh, Matthys de, Zutphen . . . 143082
Jongma, Juliette, Amsterdam . . 112311
Jonina, Maastricht 083282
Joniskeit, Reiner D., Stuttgart . 108715
Joniškio Istorijos ir Kultūros Muziejus, Joniškis 030169
Jonitz, Dana, Hildesheim 130349
Jonker, Bert, Zwolle 133053

Jonker, Henk, Egmond ad Hoef . 132877
Jonkers, Christian, Henley-on-Thames 144228
Jonny's Antiques, Toronto 064629
Jono Biliūno Memorialinis Muziejus, Anykščiai 030148
Jono Bugailiškio, Vilnius 111851
Jonquet, Etienne, Paris 125996
Jonson Gallery, University of New Mexico Art Museum, Albuquerque 046333
Jonsson, K.A., Stockholm 133926
Jonsson, Stig, Leksand 086617
Joods Historisch Museum, Amsterdam 031772
Joods Museum van Deportatie en Verzet, Mechelen 003777
Joodse Schooltje, Leek 032384
Joongang University Museum, Seoul 029829
Joop, Den Haag 112478
Joos, Ursula, Würzburg 131186
Joosten, Yolanda, Arnhem 132806
Jopie Huisman Museum, Workum 032882
Jordan, Denver 093140
Jordan / Seydoux – Drawings & Prints, Berlin 106303
Jordan Archaeological Museum, Amman 029587
Jordan-Fahrbach, Eva, Braunschweig 129878
Jordan Folklore Museum, Amman 029588
Jordan Historical Museum of the Twenty, Jordan 005932
Jordan Museum of Popular Tradition, Amman 029589
Jordan National Gallery of Fine Arts, Amman 029590
Jordan Natural History Museum, Irbid 029598
Jordan Schnitzer Museum of Art at the University of Oregon, Eugene 048578
Jordan-Witte, Meike, Todendorf . 108779
Jordan, Stefan, München 077460
Jordan, T.B. & R., Stockton-on-Tees 091301, 119420
Jordanow, München 108148
Jorde, Ursula, München 077461
Jordi Ramos, Barcelona 133484
Jordi, Peter & Ursula, Wabern . . 134272
Jordi, Rosa, La Bisbal d'Empordá 085725
Jorge & Silva Upholstery, London 135027
Jorge B. Vargas Museum and Filipiana Research Center, University of the Philippines, Quezon City 034415
Jorge B. Vargas Museum and Filipiniana Research Center, Quezon 034405
Jorge Barlin National Monument, Baao 034262
Jorgensen, Dublin 109615
Joris, E.E., Breda 082806
Jorns, Markus, Unterseen 087667
Joroisten Kotiseutumuseo, Joroinen 010748
Joron-Derem, Christophe, Paris . 125997
Jorvik Museum, York 046255
Jos Art, Amsterdam 112312
Jo's Gallery, Detroit 121087
Jos National Museum and Museum of Traditional Nigerian Architecture, Jos 033253
Jósa András Múzeum, Nyíregyháza 023488
Jose Antonio, Sevilla 086277
José Drudis-Biada Art Gallery, Los Angeles 050384
José Lins do Rego Museum, João Pessoa 004432
Jose P. Laurel Memorial Museum, Manila 034363

Kibbutz Negba Museum, Kibbutz Negba 024961
Kibi Kokoshizou, Yamateson . . . 029519
Kibiji Kyodo Hakubutsukan, Soja 029227
Kibler, Alain, Haguenau 068721
Kibo Art Gallery, Marangu 042361
KIBO Gallery, Seattle 124801
Kiboko Projects, New York 051330
KiC – Kunst in der Carlshütte, Büdelsdorf 106603
Kiche, Seoul 111720
Kichline, H., Atlanta 091984
Kick Gallery, Northcote 099352
KickArts, Cairns 098695
Kicken Berlin, Berlin 106305
Kicki's Antiques, Kungsgården . . 086610
Kidder & Smith, Boston 120162
Kidderminster Railway Museum, Kidderminster 044555
Kidding Awound, Toronto 064632
Kidner, George, Lymington 127220
Kido, Tokyo 111463, 137881
Kidogo Arthouse, Fremantle . . 098919
Kids Can Press, Toronto 136978
Kids' Science Museum of Photons, Kizu 028650
Kidspace Children's Museum, Pasadena 051842
Kidsquest Children's Museum, Bellevue 046859
Kidwelly Industrial Museum, Kidwelly 044557
Kiebler, Kurt, Bad Wurzach . . . 129662
Kiecken Duthoit, Dunkerque . . 068359
Kiefer, Eva Brigitta, Salzburg . . 128113
Kiefer, Hans, Basel 133990
Kiefer, Mariele, Bad Kreuznach . 074505
Kiefer, T., Mannheim 077201
Kiehle Gallery, Saint Cloud State University, Saint Cloud 052661
Kiek es Antikes, Borken, Westfalen 075062
Kiek in beim Turm, Lemgo 077016
Kiek in de Kök, Tallinna Linnamuuseum, Tallinn 010506
Kiekeboe, Gent 140191
Kiekebusch, Jörg, Wunstorf . . 108998, 137666
't Kiekenkot, Gent 063589
't Kiekhuus, Wolvega 032879
Kiel, Albert, Darmstadt 075258
Kieler Stadt- und Schiffahrtsmuseum, Kiel 019287
Kiener, Paris 071478
Kiener, Chantal, Paris 104945
Kiener, Martin, Zürich 087783
Kienhorst, IJzendijke 083223
Kienzle & Gmeiner, Berlin 106306
Kienzle, Andr. Claus, Augsburg . 129628
Kienzler-Schmiede, Kirchzarten . 019312
Kiepert, Berlin 141473
Kieppi-Luontomuseo ja Mineraalikokoelma, Kokkola . . 010845
Kierat 1 – Galeria Sztuki Związek Polskich Artystów Plastyków, Szczecin 113866
Kierat 2 – Galeria Sztuki Związek Polskich Artystów Plastyków, Szczecin 113867
Kiernan, Mosman Park 061890
Kierondino, Groningen 083109
Kiesel, G., Ismaning 130384
Kieselbach, Budapest . 079160, 109161
The Kilvert Gallery, Clyro 117764
Kilwinning Abbey Tower Heritage Centre, Kilwinning 044571
Kim, Murcia 086139, 115406
Kim 3, Los Angeles 094217
Kim 3, San Francisco 097099
Kim Jae Sun, Busan 111589
Kim Turner Vaadia Fine Art, New York 095347, 123026
Kim, Hyon Joo, Seoul 111721
Kim, Jae Sun, Busan 111588
Kim, Leong, Singapore 085273

Torpparimuseum/Esinemuseo, Kiikoinen 010828
Kiimingin Museo, Kiiminki 010829
Kiippa, Tapani, Helsinki 103103
Kijarat Kiadó, Budapest 137685
Kijk- en Luistermuseum, Bant . . 031870
Kijk en Luister Museum, Bennekom 031884
Kikas, Christofis, Lefkosia 102487
Kikava Sanat Evi, Samsun 087912
Kikel, A., Bodman-Ludwigshafen 075010
Kikkermuseum, Den Haag 031999
Kiko, Wilhelm, Soest 078406
Kikori, Nishitokyo 081906
Kiko's Fossil and Mineral Museum, Banciao 041991
Kiku, San Francisco 097098
Kikusui Handicraft Museum, Kawanishi 028619
Kikuta, Sendai 111399
Kikuya, Kyoto 081853
Kilátó, Budapest 109162
Kilback Bros, Vancouver 128474
Kilby Store and Farm, Harrison Mills 005872
Kilchmann & Martín, México . . . 112036
Kilchmann, Peter, Zürich 116903
Kilchoer, Olivier, Fribourg 134084
Kilcock Art Gallery, Kilcock . . . 109656
Kildahl, Wenche, Tromsø 084216
Kildevang, Næstved 065930
Kildonan Museum, Taigh Tasgaidh Chill Donnain, Kildonan 044559
Kildonan Roofing, Winnipeg . . . 128488
Kilen Galleri, Hvasser 113261
Kilgarvan Motor Museum, Kilgarvan 024723
Kilian, François, Strasbourg . . . 105647
Kilian, Hans, Marburg 077225
Kiliansboden, Lund 086648
Kilim Arte & Antichità, Verona . . 081749
Kilin, Singapore 114634
Kiliński, Jacek, Warszawa 113945
Kilkenny Castle, Kilkenny 024725
Kilkivan Historical Museum, Kilkivan 001185
Kill City Crime Books, Prahran . 139914
Killarney Centennial Museum, Killarney 005967
Killen, David, New York 095346, 123023
Killerton House, Broadclyst . . . 043533
Killerton: Clyston Mill, Broadclyst 043534
Killerton: Markers Cottage, Broadclyst 043535
Killhope, the North of England Lead Mining Museum, Weardale . . . 046089
Killin Gallery, Killin 089493
Kilmacolm Antiques, Kilmacolm 089494, 134827
Kilmainham Gaol and Museum, Dublin 024647
Kilmallock Museum, Kilmallock . 024731
Kilmartin Museum, Kilmartin . . 044565
Kilmister, Masterton 133104
Kilmorack Gallery, Beauly 117393
Kilmore Old Wares, Kilmore . . . 061682
Kilmore Quay Maritime Museum, Kilmore Quay 024732
Kilshaw's Auctioneers Ltd., Victoria 125662
Kilsyth's Heritage, Kilsyth 044569
Kiltartan Gregory Museum, Gort 024710

Kim, Long Seng, Singapore 085274
Kim, Phuong, Ho Chi Minh City . 125401
Kim, San, Singapore 133398
Kim, Thye Lee, Singapore 085275
Kim, Tina, New York 123024
Kim, Yung Hee, New York 123025
Kimba and Gawler Ranges Historical Society Museum, Kimba 001186
Kimball Art Center, Park City . . 051829
Kimball House Museum, Battle Creek 046796
Kimbell Art Museum, Fort Worth 048863
Kimbell Art Museum, Publications Department, Fort Worth 138387
Kimball, Patsy, Buderim 061219
Kimber & Son, Malvern Link . . 090530, 135167
Kimberley, Bilbao 085695
Kimberley, Melbourne 099175
Kimberley District Heritage Museum, Kimberley 005968
Kimberley Mine Museum, Kimberley 038585
Kimberly's Fine Art, Dallas . . . 120895
Kimble County Historical Museum, Junction 049802
Kimcherova, New York 095348
Kimchi Field Museum, Pulmuone Gimchi Museum, Seoul 029831
Kime, Robert, Marlborough . . . 090568
Kimga, Yokohama 111550
Kimin, Singapore 085276
Kimjack, Calgary 064206
Kimmerich, Berlin 106307
Kimmerich, Horst, Düsseldorf . 075441
Kimmich, Klaus, Köln 107638
Kimo Bruks Museum and Gallery, Oravais 011029
Kimpfbeck, J., Nersingen 108241
Kimpton, K., San Francisco . . . 124562
Kimreeaa, Seoul 111722, 111723
KiMuncho, Singapore 114635
Kimura, Kyoto 081854
Kimura, San Francisco 124563
Kimyon, Adnen, Frankfurt am Main 075752
Kimyoungseob, Seoul 111724
Kimzey & Miller, Seattle 124802
Kin Liou, Paris 071479
Kina NZ, Taranaki 113104
Kina Slott, Drottningholm 040397
Kincaid Museum, Kincaid 005969
Kincová, Zlín 102713
Kincsem Múzeum, Tápiószentmárton 023668
Kind, Parisa, Frankfurt am Main 106970
Kindbom & Co, Olof, Karlsborg . 126822
Kinder- und Jugendmuseum, Nürnberg 020502
Kinder-Akademie Fulda gGmbH, Werkraum Museum, Fulda . . . 018289
Kinder Fine Arts, Christchurch . 112933
kinder museum frankfurt, Frankfurt am Main 018170
Kindergartenmuseum, Bruchsal . 017406
Kindergartenmuseum Nordrhein-Westfalen, Bergisch Gladbach . 016845
Kindermann, Thomas, Wiebelsdorf 078874
Kindermuseum Adlerturm, Dortmund im Mittelalter, Museum für Kunst und Kulturgeschichte, Dortmund 017724
Kindermuseum im FEZ-Berlin, Berlin 016969
Kindermuseum München, München 020183
Kindermuseum, Schaufenster, Schule und Kinderkunst e.V., Wuppertal 022400
Kindermuseum, Stadtgeschichtliches Museum Leipzig, Leipzig 019660
Kindersley and District Plains Museum, Kindersley 005970
Kinderwagenmuseum, Nieuwolda 032501

Kinderwagens van toen, Dwingeloo 032081
Kinderwelt Walchen, Vöcklamarkt 002802
Kindheitsmuseum, Marburg . . . 019933
Kindheitsmuseum, Schönberg, Holstein 021302
Kinenkan Mikasa, Yokosuka . . . 029555
Kineone, Istres 103806
Kinet, J., Bruxelles 063422
Kineya, Tokyo 081993
King, Cleveland 120714
King, Fort Worth 093293
King, Houston 093550
King, Salt Lake City 124217
King, San Antonio 096820
King & Co., San Francisco 124564
King, Wymondham, Norfolk . . . 091830
King & Chasemore, Midhurst . . 127229
King David Private Museum and Research Center, Tel Aviv . . . 025036
King Feng Arts, Hong Kong . . . 064997
King Griffin, San Diego 124386
King Hooper Mansion, Marblehead 050603
King House, Boyle 024543
King Island Historical Museum, Currie 001008
King John's Castle, Limerick . . 024751
King John's Hunting Lodge, Axbridge 043205
King Kamehameha V – Judiciary History Center, Honolulu . . . 049494
King Mac Craw, Trappes 073833
King Manor, Jamaica 049740
King-Prime Gallery, Bangalow . 098556
King Richard's, Atlanta 091985
King Saud University Museum, Riyadh 037932
King Sejong The Great Memorial Exhibition, Seoul 029832
King-Smith & Nutter, Stow-on-the-Wold 091327
King Street Antiques, Toledo . . 097445
King Street Curios, Melksham . . 090587
King Street Curios, Tavistock . . 091402
King Street Gallery, Darlinghurst 098802
King Street Gallery, Newcastle, Staffordshire 118980
King Street Gallery, Newtown, New South Wales 099317
King Township Historical Museum, King City 005971
King Tut, San Diego 124387
King Tut Egyptian Imports, Tampa 097401
King, A., San Antonio 127703
King, Ann, Bath 088165
King, Anthony, Stuttgart 078527
King, David H., Dallas 092986
King, Dennis, Enfield 079507
King, Donald, New York 095349, 136293
King, Erika, Miami 122095
King, Henry, New York 123027
King, John, London 090093
King, John K., Detroit 144876
King, John K., Ferndale 144885
King, Kevin, Dunedin 133094
King, Laurence, London 138277
King, Peter, Ti Tree 062310
King, Philip, Auckland 133988
King, Roger, Dallas 092987
King, Roger, Hungerford 089416
King, Shaun, Atherborough . . . 088088
Kingaroy Shire Art Gallery, Kingaroy 001188
Kingdom Antiques, Tralee 079603
Kingfisher Gallery, Cowbridge . 117794
Kinglake Gallery, Kinglake . . . 099055
Kingman County Historical Museum, Kingman 049932
Kingman Museum, Battle Creek 046797
Kingman Tavern Historical Museum, Cummington 048056
Kings Art Gallery, Vancouver . . . 101664

Knole, Sevenoaks 045739
Knoll Galerie Wien, Wien 100197
Knoll, Hans, Dillingen, Saar . . . 129948
Knollmayer, Othmar, Tulln 062830, 128147
Knollwood, New York 095351
Knoor, Rheurdt 078151
Knoor, Heiner, Issum . . 076568, 130388
Knop, Klaus, Görlitz 075982
Knopp, Klaus, Ohlsdorf 062730
Knops, C.J.M., Munstergeleen . . 132968
Knops, Michel, Sittard 112765
Knospe, Herrstein 076450
Knott House Museum,
 Tallahassee 053542
Knotty Pine Auction Gallery, West
 Swanzey 127760
Knous, Bill & Sue, Denver 093142
Knowles, Jeremy, London 118634
Known Space Books, Adelaide . . 139647
Knox, Denver 121016
Knox County Historical Society
 Museum, Edina 048436
Knox County Museum, Benjamin 046886
Knox County Museum, Knoxville 049956
Knox's Headquarters State Historic
 Site, Vails Gate 053798
Knoxville Museum of Art,
 Knoxville 049966
Knud Rasmussens Hus,
 Hundested 009989
Knudaheio – Garborgheimen,
 Undheim 033874
Knudsen, Erhardt, Odense 065964
Knudsen, Helle, Stockholm 115996
Knudsen, Lars, Millfield 099208
Knüpfer, Andrea, Halle 130239
Knüppel, Helga, Hamburg 107256
Knüttel, Kurt & Maria, Königstein im
 Taunus 130501
Knuf, Frits, Vendôme 141337
Knuht, A., Berlin 074803
Knust, Sabine, München 108149
Knuts, Bruxelles 063425
Knutsford Antiques Centre,
 Knutsford 089536, 134842
Knutsford Heritage Centre,
 Knutsford 044613
Knutsson, Stockholm 086831
Knutsson, Bo, Vänersborg 086949
Knyrim, Brigitte, Regensburg . . . 108471
Knysna Museum, Knysna 038594
Ko-Ra, Skopje 111937
Kô-Zen, Montréal 101285
KOA Art Gallery, University of Hawaii,
 Kapiolani Community College,
 Honolulu 049495
Koala Country Commodities, Port
 Macquarie 062086
Kóbányai Helytörténeti Gyüjtemény,
 Budapest 023179
Kobariški Muzej, Kobarid 038345
Kobe Doll Museum, Kobe 028658
Kobe Lamp Museum, Kobe 028659
Kobe Lampwork Glass Museum,
 Kobe 028660
Kobe Maritime Museum, Kobe . . 028661
Kobe-shi Fukushoku Hakabutsukan,
 Kobe 028662
Kobe-shi Kagakukan, Kobe 028663
Kobe-shiritsu Hakabutsukan,
 Kobe 028664
Kobeia, München 108150
Kobelius, E., Lassan 130546
Kober, Köln 076819
Kober, Wertheim 108897
Koberstein, E., Kleinostheim . . . 076755
Kobie – Serie Bellas Artes,
 Bilbao 139102
Kobijutsu Kaito, Kyoto 081856
Kobisenmühle, Sankt Georgener
 Museen, Sankt Georgen im
 Schwarzwald 021207
Kobo, Seattle 124804

Kobo Aya, Yokohama 082053
Kobold, Josef, Vilsbiburg 078717
Kobrine, Danièle, Paris 071482
Kobrossi, Mouna, Jounieh 111829, 142774
Kobs, Detlef, Ausacker 074438
Kobsik, Meersburg 077259
Kobsik, Oberstaufen 077800
Kocábek, Praha 065434
Kocaeli Devlet Güzel Sanatlar Galerisi,
 İzmit 042707
Kocaeli Müzeleri ve Örenyerleri,
 İzmit 042708
Kocal, A., Sandhausen 078269
Koch, Den Haag 132856
Koch, Wolfenbüttel 078966
Koch & Englert, Gießen 107086
Koch-McErlain, New York 095352
Koch-Westenhoff, Margot,
 Lübeck 107903
Koch, Anette von, Stockholm . . 086832
Koch, Carla, Amsterdam . . 112318
Koch, Horst, Idar-Oberstein 075630
Koch, Jean-Marie, Schlierbach . 073422
Koch, Jochen, Reichartshausen . 130945
Koch, Matthias, Duderstadt 075391
Koch, Michaela, Minden 130663
Koch, O., Braunschweig 075088
Koch, Peter, Suhl 131082
Koch, Richard, Münster 077590
Koch, Robert, San Francisco . . . 124565
Koch, Silvia, Berlin 129752
Koch, T., Nieheim 108290
Koch, Wilfried, Neubrandenburg 077637
Kochan, Pat, Dallas 120897
Kochan, W., Bremen 141579
Kochanek, Frank, Gelsenkirchen 075913
Kocher & Allemann, Selzach . . . 116727
Kochi Bungakukan, Kochi 028670
Kochi-ken Kaitokukan, Kochi . . . 028671
Kochi-kenritsu Bijutsukan, Kochi 028672
Kochi Liberty and People's Rights
 Museum, Kochi 028673
Kochinian Ovanes, San Francisco 097100, 124566
Kochukyo, Tokyo 081995
KochxBos Gallery, Amsterdam . . 112319
Kociol Artystyczny, Kraków . . . 113695
Kocken, Willi, Kevelaer 076703, 107536
Kockler, Paul, Le Luc 069240
Kocsimüzeum, Bábolna Nemzeti
 Ménesbirtok, Bábolna 023095
Kocsis-Seger, Illes, Stuttgart . . 131058
Kodai Orient Hakubutsukan,
 Tokyo 029347
Kodai Yuzen-en Bijutsukan,
 Kyoto 028757
Kodály Zoltán Emlékmúzeum és
 Archívum, Kecskemét 023403
Kodama Museum, Kagoshima . . 028559
Kodansha International, Tokyo . . 137882
Kodisjoen Kotiseutumuseo,
 Kodisjoki 010839
Koditek, Ursula, Emmerich am
 Rhein 106842
Kodner, Saint Louis . . . 096560, 124084
Kodolányi Emlékmúzeum, Vajszló 023769
Kodric, Friederike, Salzburg 062773
Kodymý, Miroslav, Praha 128590
Kö-Galerie am Kaisergarten,
 Siegen 108624
Koe, Lilian, Petaling Jaya 137911
Köbelin, Rainer, München 142042
København Museum for Moderne
 Kunst, København 010018
Københavns Antik, København . 065851
Københavns Antikcenter,
 København 065852
Københavns Auktioner,
 København 125726
Københavns Museum,
 København 010019
Köberle, Ulrich, Überlingen 078660, 078661

Købmands Gårdens Antik, Skive 066044
Koechlin, Dr., Basel 143827
Köchling, Marie-Theres, Münster 077591
Köck, Rückersdorf 062751
Köck, Günter Frank, Garmisch-
 Partenkirchen 107059
Köck, Günter Frank, München . . 130722
Köckert, Anne Marie, Bad Homburg
 v.d. Höhe 074480
Køge Museum, Køge 010039
Köhl, Peter H., Saarbrücken . . . 142188
Köhler, Wittlich 108970
Koehler & Amelang, Verlagsgruppe
 Seemann Henschel, Leipzig . 137518
Köhler Verlag, Linz 136858
Köhler, Christian,
 Mönchengladbach 107998
Köhler, Günther, Wien . 062957, 128200
Köhler, Heiko, Frankfurt (Oder) . 075717
Köhler, Josef, Erwitte 075613
Köhler, M., Naumburg (Saale) . . 077614
Köhlereimuseum, Hasselfelde . . 018792
Köhn, J., Eching, Kreis Freising . 075516
Köhn, Joachim, Neufahrn bei
 Freising 077650
Köhnlein, Werner, Reutlingen . . 108490
Köhrmann, G., Oldenburg 077853
Koek, T.H., Beverwijk 132819
Kölcsey Ferenc Emlékszoba,
 Szatmárcseke 023592
Köll, Karl-Heinz, Seefeld in Tirol 128130
Koeller, Frédéric, Beure 067095
Kölling, Torsten, Burg bei
 Magdeburg 075178
Köllisch, Nürnberg 077753
Köllner, Isabel, Weimar 142303
Köln International School of Design
 (KISD), Fachhochschule Köln,
 Köln 055556
Kölner Graphikwerkstatt, Köln . . 107641
Kölner Münzkabinett, Köln 076820
Kölner Münzstube, Köln 076821
Kölner Weinmuseum, Köln 019369
Kölnischer Kunstverein, Köln . . . 058907
Kölnisches Stadtmuseum, Köln . 019370
Koelsch, Houston 121354
Kölsch, Hans-Werner, Wuppertal 109010
Koeltz, Sven, Königstein im
 Taunus 141904
Kölzer, Arnold, Mastershausen . 077245
Koenders, M.C.J., Voorthuizen . 133039
Koendo, Iida, Tokyo 081996
Koenig, Bruxelles 063426
König, Darmstadt 075259
König, Großotheim 076055
Koenig, Pézenas 072098
König, Soest 078407
König Ludwig II.-Museum, Bayerische
 Verwaltung der staatlichen
 Schlösser, Gärten und Seen,
 Herrenchiemsee 018923
König, Andreas, Vetschau 131118
König, B & R., Ebersdorf bei
 Coburg 075514
König, Harry, Deckenpfronn 075270
König, Hartmut, Nauen 142076
Koenig, Hermann, Stuhr 078502
König, Johann, Berlin 106314
König, Johann, Waldfischbach-
 Burgalben 078751
Koenig, Leo, New York 123035
König, M., Leichlingen 076989
König, Marianne,
 Rednitzhembach 142166
König, O., Köln 076822
König, Ursula, Hanau 075514
König, Walther, Berlin . 141475, 141476, 141477
König, Walther, Bonn 141548
König, Walther, Dresden 141618, 141619
König, Walther, Frankfurt am
 Main 141687, 141688
Koenig, Walther, London 144399
König, Walther, Münster 142064

König, Walther, Nürnberg 142101
König, Walther, Stuttgart 142237
König, Wolfgang, Rhodt unter
 Rietburg 078152
Königliches Schloss Berchtesgaden:
 Schlossmuseum und Rehmuseum,
 Wildwissenschaftliche Sammlung
 von Herzog Albrecht von Bayern,
 Berchtesgaden 016833
Königshaus am Schachen, Bayerische
 Verwaltung der staatlichen Schlösser,
 Gärten und Seen, Garmisch-
 Partenkirchen 018318
Königshofer, Wien 062958
Königspesel, Hooge 019030
Königspfalz Freilichtmuseum,
 Tilleda 021756
Koenitz, Leipzig 107825
Koenitz, Heike, Wuppertal 131195
Könner, Neustadt am
 Rübenberge 077676
Koenraad Bosman Museum,
 Rees 020934
Könyvesbolt & Antikvárium,
 Szolnok 142408
Könyvtár és Múzeum – Borsodi Tájház,
 Muvelodési Központ, Edelény . 023288
Köpings Museum, Köping 040555
Koepp, Jeanne, Berlin 106315
Köppen, Bernd, Berlin 129753
Koerner, Ann, New Orleans 094954
Körner, Ralf, Olsberg 130860
Körnig, Uwe, Frankfurt am Main 141689
Köröndi, Budapest 109164
't Körrefke, Maastricht 083283
Kößler, Johannes, Babenhausen, Kreis
 Unterallgäu 074444
Köster, Braunschweig 075089
Köster, D.C.H., Kiel 076714
Köster, H., Hilden 076466
Kösters, Wilhelm, Münster 077592
Koether, Mario, Falkenstein,
 Vogtland 075680
Koetser, David, Amsterdam 112320
Koetser, David, Zürich 116904
Koetsudo, Tokyo 111465
Köyhän Maalarin Kehys- ja
 Taidekauppa, Tampere 066337
Köylion Torpparimuseo, Tuiskula 011251
Középkori O-Zsinagóga, Soproni
 Múzeum, Sopron 023566
Középkori Romkert – Nemzeti
 Emlékhely, Szent István Király
 Múzeum, Székesfehérvár . . . 023610
Középkori Zsidó Imaház, Budapesti
 Történeti Múzeum, Budapest . 023180
Közlekedési Múzeum, Budapest 023181
Közlekedési Múzeum – Kiskörösi
 Közúti Múzeum, Kiskörös . . . 023418
Központi Bányászati Múzeum,
 Sopron 023567
Központi Kohászati Múzeum, Országos
 Müszaki Múzeum, Miskolc . . . 023463
Kofalk, L., Solingen 078416
Koffie- en Theemuseum,
 Amsterdam 031775
Koffie- en Winkelmuseum,
 Pieterburen 032587
Koffie Verkeert, Rotterdam 112732
Koffiebanderij De Gulden Tas,
 Bree 003320
Koffler Centre School of Visual Arts,
 Toronto 055094
The Koffler Gallery, Toronto 007016
Kofukuji Kokuhokan, Nara 028963
Koga Masao Museum of Music,
 Tokyo 029348
Kogal, Bern 116235
Kogando, Osaka 081912
Koganei City Hakenomori Art Museum,
 Koganei 028687
Kogei Murata, Tokyo 111466
Kogire-Kai, Kyoto 126459
Koglin, Matthias, Hamburg 076198

Neustadt an der Aisch 020402
Kulturas Books, Washington .. 145376
Kulturbetrieb "WolkenSchachLankWal",
Leipzig 019661
Kulturbryggarna, Malmö 143703
Kulturbunker Mülheim, Köln ... 019372
Kulturcentrum i Ronneby,
Ronneby 040722
Kulturen Zivot, Skopje 138942
Kulturfabrik Hainburg, Hainburg an der
Donau 002020
Kulturforum Alte Post / Städtische
Galerie, Neuss 020393
Kulturforum Würth, Kolding ... 010042
Kulturgården på Lassfolk, Lillby 010940
Kulturgeschichtliches Museum
Bügeleisenhaus, Hattingen ... 018801
Kulturgeschichtliches Museum
Osnabrück, Osnabrück 020658
Kulturgut, Essen 075638
Kulturgut Höribach, Sankt Lorenz 002620
Kulturhalle Tübingen, Tübingen .. 021810
Kulturhaus der Otto-Hellmeier-Stiftung,
Raisting 020893
Kulturhistorie Aabenraa, Museum
Sønderjylland, Aabenraa 009836
Kulturhistorie Sønderborg
Slot, Museum Sønderjylland,
Sønderborg 010155
KulturhistorieTønder, Museum
Sønderjylland, Tønder 010176
Kulturhistorische Sammlung,
Iphofen 019111
Kulturhistorisches Museum /
Ringelnatz-Sammlung, Wurzen 022406
Kulturhistorisches Museum der
Hansestadt Stralsund, Stralsund 021608
Kulturhistorisches Museum
Franziskanerkloster, Städtische
Museen Zittau, Zittau 022467
Kulturhistorisches Museum
Mühlhausen, Mühlhäuser Museen,
Mühlhausen/Thüringen 020138
Kulturhistorisches Museum
Prenzlau im Dominikanerkloster,
Prenzlau 020850
Kulturhistorisches Museum Rostock,
Kloster zum Heiligen Kreuz,
Rostock 021108
Kulturhistorisches Museum Schloß
Merseburg, Merseburg 020034
Kulturhistorisches Museum,
Kaisertrutz, Reichenbacher Turm und
Barockhaus, Görlitz 018455
Kulturhistorisches Museum,
Magdeburger Museen,
Magdeburg 019870
Kulturhistoriska Museet i Bunge,
Fårösund 040424
Kulturhistoriska Museet 'Kulturen i
Lund', Lund 040611
De Kulturhistoriske Samlinger,
Bergen 033360
Kulturhuset, Stockholm 040810
Kulturkunststatt Prora, Binz,
Ostseebad 017169
Kulturlandschaft Deilbachtal,
Essen 018044
Kulturmodell, Künstlerhaus der Stadt
Passau, Passau 108376
Kulturmuseet Spinderihallerne,
Vejle 010188
Kulturno-obrazovatelnyj centr Škola
L.N. Tolstogo, Gosudarstvennyj Muzej
L.N. Tolstogo, Moskva 037143
Kulturno Povijesni Muzej, Dubrovački
Muzeji, Dubrovnik 008739
Kulturno-vystavočnyj Centr Raduga,
Samara 037535
Kulturno-vystavočnyj Centr Raduga,
Uljanovsk 037820
Kulturno-Vystavočnyj Kompleks
Sokolniki, Moskva 037144
Kulturnyj Centr Kazan, Kazan .. 036931

Kulturnyj Centr-muzej V.S. Vysockogo,
Moskva 037145
Kulturos Barai, Vilnius 142783
Kulturreich, Hamburg 107259
Kulturscheune, Mössingen 020103
Kulturschloß Reichenau, Reichenau an
der Rax 002526
Kulturspeicher im Schamuhn Museum,
Uelzen 021840
KulturStiftung Rügen, Putbus ... 020863
Kulturstiftung Schloss Britz,
Berlin 016976
Kulturverein Attendorn, Attendorn 058923
Kulturverein Landstrich,
Brunnenthal 138568
Kulturverkstedet, Mosjøen 113276
Kulturwerk des Berufsverband
Bildender Künstlerinnen und
Künstler Südbaden, Freiburg im
Breisgau 058924
Kulturwerk des Berufsverbandes
Bildender Künstler und Künstlerinnen
Berlins, Berlin 058925
KulturWerk-Stadt Sulz –
Nagelschmiede / Strickerei,
Sulz 041783
Kulturwissenschaftliche Fakultät,
Universität Bayreuth, Bayreuth 055396
Kulturzentrum der Aktion Lebensqualität,
München 108152, 142043
Kulturzentrum Hans-Reiffenstuel-Haus,
Pfarrkirchen 020756
Kulturzentrum Kolvenburg,
Billerbeck 017163
Kulturzentrum Oberschützen,
Oberschützen 002421
Kulturzentrum Ostpreußen,
Ellingen 017909
Kulturzentrum Schloß Bonndorf,
Bonndorf im Schwarzwald ... 017286
Kulturzentrum Schloss Borbeck,
Essen 018045
Kulturzentrum Sinsteden
des Rhein-Kreises Neuss,
Landwirtschaftsmuseum und
Skulpturenhallen Ulrich Rückriem,
Rommerskirchen 021085
Kulunkian-Joumier, Marie-Geneviève,
Saint-Cybardeaux 072682
Kulunkian, Charles, Saint-Yrieix-la-
Montagne 073296
Kulunkian, Stéphane, Garat 068576
Kulunqi Religion Museum, Kailu 007789
Kum, Hing, Hong Kong 064998
Kuma Bijutsukan, Kuma 028705
Kumagai Morikazu Museum,
Tokyo 029357
Kumaki, Tokyo 081998
Kumamoto Castle, Kumamoto .. 028706
Kumamoto-kenritsu Bijutsukan,
Kumamoto 028707
Kumamoto-kenritsu Gigei Bijutsukan,
Kumamoto 028708
Kumamoto Kokusai Mingeikan,
Kumamoto 028709
Kumamoto-shiritsu Gendai Bijutsukan,
Kumamoto 028710
Kumamoto-shiritsu Hakubutsukan,
Kumamoto 028711
Kumar Gallery, Delhi .. 079280, 109341,
137691
Kumar, Jain-Virendra, Delhi 079279,
109340
Kumar, Prakash, Bangalore ... 079248
Kumar, Sushil, Hyderabad 079286
Kumaya Bijutsukan, Hagi 029382
Kumbez, Almaty ... 137895, 138938
Kumbu Kumbu, Nairobi 111572
Kume Bijutsukan, Tokyo 029358
Kumer, Navin, New York 123045
Kumlehn, Inge, Sandhausen .. 130989
Kummer, Beat, Bern 087099
Kummer, Wolfram, Pattensen .. 130874
Kumon, Los Angeles 121803

Kumpf, Daniela, Wiesbaden ... 078897
Kumps, L., Antwerpen 063163
Kumquat, San Francisco 124568
Kumra & Co., Singapore 085278
KUMU Eesti Kunstimuuseum,
Tallinn 010508
Kun-Shan University Art Center,
Yongkang 042319
K'Un Sun, Bogotá 065122
Kun Zsigmond Lakásmúzeuma,
Óbudai Múzeum, Budapest .. 023185
Kunaicho Sannomaru Shozokan,
Tokyo 029359
Kundencenter der Stadtwerke
Strausberg, Strausberg 021615
Kunffy Lajos Emlékmúzeum,
Somogytúr 023561
Kung Long Mineral Museum,
Sincheng 042177
Kungajaktmuseet, Vargön 040956
Kungang Mei Ye Art Galley,
Shanghai 102086
Kungl. Akademien för de fria
Konsterna, Stockholm 056361
Kungl. Konsthögskolan,
Stockholm 056362
Kungl. Myntkabinettet, Sveriges
Ekonomiska Museum,
Stockholm 040811
Kungl. Vitterhets Historie och Antikvitets
Akademien, Stockholm 056363, 059809
Kungliga Akademien för de Fria
Konsterna, Stockholm 040812
Kungliga Slottet i Stockholm,
Stockholm 040813
Kungsantik, Stockholm 086835
Kungsbacka, Kungsbacka 077116
Kungsbutiken, Gävle 086496
Kungsholmens Antik och Kuriosa,
Stockholm 086836
Kungsstugan och Cajsa Wargs Hus,
Örebro 040694
Kungsudden Local Museum,
Kungsör 040569
Kungurskij Kraevedčeskij Muzej,
Kungur 037010
Kunigo Stanislovo Rimkaus Muziejus,
Laukuva 030235
Kunisaki-machi Rekishi Minzoku
Shiryokan, Kunisaki 028712
Kunitachi Bijutsu Kenkyujo,
Kokubunji 055958
Kunizakari Sake Museum, Handa 028427
Kunj Art Gallery, Karachi 113403
Kunozan-Toshogu-ji Homotsukan,
Shizuoka 029217
Künqû Böwùguǎn, Kunqu Opera
Museum, Shanghai 008050
Kunsch, Berlin 129760
Kunshan Painting Gallery,
Kunshan 102038
Die Kunskamer, Waterfront 114912
Kunst & Co., Amstelveen 112211
Kunst, Christchurch 112934
Kunst & Ko., Eindhoven 112546
Kunst, Tallinn 137065
Kunst – Werk, Utrecht 112794
Kunst- og Antikvitetshandler Ringen,
Farum 058524
Kunst- u. Verlagshaus A. de Bernardi,
Aachen 105894, 137295
Kunst- und Antiquitäten-Messe Bonn,
Bonn 098005
Kunst- und Antiquitäten-Messe
München, München 098006
Kunst- und Antiquitäten-Messe Sylt,
Wenningstedt 098007
Kunst- und Antiquitäten-Tage,
Münster 098008
Kunst- und Antiquitätenhandel in der
Orangerie, Berlin 098009
Kunst- und Antiquitätentage,
Braunschweig 098010
Kunst- und Auktionshaus Mag. Ingo

Schönpflug, Innsbruck 062629, 125534
Kunst- und Auktionshaus Ginhart,
Showroom Raubling, Raubling . 126328
Kunst- und Auktionshaus Henning Hille,
Bad Bevensen 074454, 126123,
129639
Kunst- und Auktionshaus Peter
Karbstein, Düsseldorf 126187
Kunst- und Auktionshaus Schloß
Hagenburg, Hagenburg 126210
Kunst- und Auktionshaus Tegernsee,
Tegernsee 126351
Kunst- und Auktionshaus Wilhelm M.
Döbritz, Frankfurt am Main ... 075755,
126199
Kunst- und Ausstellungshalle der
Bundesrepublik Deutschland GmbH,
Bonn 017275
Kunst- und Gewerbeverein
Regensburg, Regensburg 020951
Kunst- und Heimathaus,
Paderborn 020705
Kunst- und Kulturkontakt
Perchtoldsdorf, Perchtoldsdorf . 058243
Kunst- und Kulturkreis Rastede,
Rastede 058926
Kunst- und Kulturpädagogisches
Zentrum der Museen in Nürnberg,
Nürnberg 058927
Kunst- und Museumsbibliothek,
Museen der Stadt Köln, Köln .. 019373
Kunst- und Museumskreis, Bad
Essen 058928
Kunst- und Museumsverein
Starnberger See e.V., Feldafing 058929
Kunst- und Museumsverein Wuppertal
e.V., Wuppertal 022401
Kunst- und Rahmenhandlung Ernst,
Christine, Wien 100205
Kunst- und Skulpturenmuseum,
Heilbronn 018861
Kunst- und Wunderkammer Burg
Trausnitz, Zweigmuseum des
Bayerischen Nationalmuseums,
Landshut 019550
Kunst & Antiek Journaal,
Schiedam 138973
Kunst & Antiekrevue, Den Haag 138974
Kunst & Auktionshaus Eva Aldag,
Buxtehude 126172
Kunst & Beterschap, Amsterdam 112321
Kunst & Cotto, Sattledt 062800
Kunst & Cultuur, Bruxelles 138600
Kunst & Forum, Bad Wimsbach-
Neydharting 127982
Kunst & Kultur, Kulturpolitische
Zeitschrift der Ver.di, Tübingen 138759
Kunst & Kunst, Eindhoven 112547
Kunst & Kunst, Groningen 083112
Kunst & Kuriosa, Heidelberg .. 126230
Kunst & Vliegwerk, Hilversum .. 083214
Kunst & Vorm, Dordrecht 082998
Kunst & Werk, Ingelheim am
Rhein 107439
Kunst 7, Altendorf 116115
Kunst ab Werk, Miltach 107985
Kunst Adelt, Maastricht 137960
Kunst am Schützenhof, Bad Neuenahr-
Ahrweiler 106031
Kunst am Wall, Bremen 106582
Kunst Archiv Darmstadt,
Darmstadt 017594
Kunst aus Nordrhein-Westfalen,
Aachen 016247
Kunst aus NRW, in der ehemaligen
Reichsabtei Aachen – Kornelimünster,
Aachen 016248
Kunst-Buch, Leipzig 141936
Kunst-Design & Antiquitäten,
Hermagor 062611
KUNST-DRUCK(E), Leipzig ... 107827
Kunst en Vliegwerk, Voorburg .. 083505
Kunst-Event Noord Nederland,
Groningen 098108

Valmontone 081645
La Centrale Powerhouse Gallery,
Montréal 101286
La Chaumière de Granièr,
Thiézac 015732
La Criée Centre d'Art Contemporain,
Rennes (Ille-et-Vilaine) 014866
La Felce – Istituto Europeo d'Arte e
Cultura, Milano 055875
La Ferme de Gribelle, Gedinne . 082168
La Ferme Musée de Marcq,
Enghien 003499
La Galeria, Sant Cugat del Vallès 115506
LA galeria Arte Contemporáneo,
Bogotá 102248
La Galerie d'Art, Bowness-on-
Windermere 117504
La Hougue Bie Museum,
Grouville 044332
La Hune Brenner, Paris 104950
La Lanta Fine Art, Bangkok . . . 117031
La Loie Fuller, Paris 071491
La Maison Bleue, Craon 103591
La Maison Bleue, Tbilisi 105861, 105862
La Maison du Gruyère, Fromagerie
de Démonstration de Gruyère AOC,
Pringy 041602
La Malle des Indes, Metz 104177
La Part de l'Oeil, Bruxelles 138602
La Petite Galerie, Tampa 097404
La Piscine – Musée d'Art et
d'Industrie André Diligent,
Roubaix 014963
La Porte Étroite, Paris 141116
La Provence par Marc Ferrero,
Eze 103681
La Raza Galeria Posada,
Sacramento 052631
La Remise Musée de la Vie Rurale,
Offaing 003838
La Rocca, Leonardo, Palermo . . 110625
La Salle University Art Museum,
Philadelphia 051970
La Serre aux Papillons, La Queue-lèz-
Yvelines 013262
La Speranza, Luigi, Wien 100212
La Tibetaine, Paris 071492
La Tine, Troistorrents . 087661, 134259
La Trobe Street Gallery,
Melbourne 099177
La Trobe University Art Museum,
Bundoora 000913
La Trouvaille, Grône 087323
La vie des musées, Hornu 138603
Laakes, W., München 077480
Laarman, Goes 142956
Laat, H. de, 's-Hertogenbosch . . 083204
Laatzen, Hermann, Hamburg . . 141778
The Lab, San Francisco 052903
Labadie, Charles, Saint-Jean-de-
Luz 105490
Labaëre, Dourges 128826
Laban, Jean-Michel, Oloron-Sainte-
Marie 070732
Laband Art Gallery, Loyola Marymount
University, Los Angeles 050387
Labarre A, Saint-Germain-
Lembron 072770
Lábasház, Soproni Múzeum,
Sopron 023568
L'Abat Jour de Charme, Trouville-sur-
Mer 073853
Labatut, Paris 104951
Labbé, Armel, La Chartre-sur-le-
Loir 068930
Labet, Michel, Étiolles 068427
Labeyrie, Alain, Bordeaux 128735
Labeyrie, Pascal, Bordeaux . . . 128736
Labiche, Nicole, Montaure 070152
Labiche, Nicole, Rouen 072553
Il Labirinto, Milano 142542
Labirynt, Kraków 113697
Labirynt II, Kraków 113698
Labisch, Hubert, Unterpleichfeld 131107

Labonne, Albert-Claude, La
Réole 069005
Labor Fruit, Los Angeles 121804
Laboratário de Ensino de Ciências,
Faculdade de Filosofia, Ciências e
Letras de Ribeirão Preto, Ribeirão
Preto 004601
Il Laboratorio, Firenze 142498
Il Laboratorio, Roma 132337
Laboratorio Antiquariato, Milano 131849
Laboratório de Anatomia e
Identificação de Madeiras,
Manaus 004474
Laboratorio de Conservación y
Restauracion, Barcelona 133486
Laboratório de Demonstração do
Instituto de Fisica, Intituto de Fisica /
IF, São Paulo 004779
Laboratorio de Restauracion y
Enmarcacion, Barcelona 133487
Laboratorio del Legno, Verona . 132669
Laboratorio di Restauro, Milano 131850
Laboratorio di Restauro e
Manutenzione d'Arte Tessile,
Firenze 131589
Il Laboratorio di Restauro San
Prospero, Milano 131851
Laboratorio di Restauro Santo Stefano,
Bologna 131372
Laboratorio Lucidatura Mobili Antichi,
Milano 131852
Laboratorio per l'Arte Contemporanea,
Ospedaletto 110569
Laboratorio Restauri d'Arte,
Trieste 132605
Laboratorio Restauro Dipinti,
Parma 132115
Laboratorio Restauro e Conservazione,
Padova 132057
Laboratorios Dopla, Sevilla 133790,
. 133791
Labour of Love, Jacksonville . . 136006
Labrada, Cali 102315
Labrador Interpretation Centre, North
West River 006383
Labrador Straits Museum, L'Anse-au-
Loup 006038
Labråten, Asker Museum, Valstads
samlinger, Hvalstad 033505
Labre, Michael, Sassey 073385
L'Abri Pataud, Gisement Préhistorique
et Musée, Les Eyzies-de-Tayac-
Sireuil 013554
Labriffe, M., Marcq-en-Barœul . 069811
Labropoulou-Blumer, Labrini,
Schwäbisch Gmünd 131009
Labrouche, Montendre 070183
Labrouche, Line & Michel,
Messac 070028
Labry, Dominique-Mathieu,
Montpeyroux 070268
Laburnum, Poole 090881, 135289
Laburnum Antiques, Richmond . 096394
Laburnum Cottage Antiques, Eye 089032
Labyrint, Praha 137042, 138659
Labyrint, Eggenstein-
Leopoldshafen 075530
Labyrinth, Valletta 082257
Labyrinth Kindermuseum Berlin,
Berlin 016987
Labyrinthos, Firenze 138883
Lac Cardinal Regional Pioneer Village
Museum, Grimshaw 005812
Lac-Du-Bonnet and District
Historical Society Museum, Lac-Du-
Bonnet 006017
Lac-La-Hache Museum, Lac-La-
Hache 006018
Lac Lagorio Arte Contemporanea,
Brescia 109923
Lac Qui Parle County Historical
Museum, Madison 050526
Lac Sainte-Anne Historical Society
Pioneer Museum, Rochfort

Bridge 006665
Lac, Hong, Ho Chi Minh City . . . 125402
Lac, Isabelle du, Toulouse 073743
Lacam, Nice 070570
Lacarin, Madeleine, Montluçon . 070218
Lacaze, Alain, Québec 101367
L'Accent Sud, Saint-Tropez 073274
Laccroix, Jean-Claude, Lorient . 069583
LACE – Los Angeles Contemporary
Exhibitions, Los Angeles 050388
Lace Antiguidades, Rio de
Janeiro 064017
Lace House Museum, Black
Hawk 046991
Lace Market Gallery, New College
Nottingham, Nottingham 045357
The Lace Museum, Sunnyvale . . 053491
Lacerba, Ferrara 110034
Lacerte, Madeleine, Québec . . . 101368
Lacewing Fine Art, Winchester . 119649
Lacey Historical Society Museum,
Forked River 048735
Lach, Grzegorz, Kraków 133210
Lachaert, Sofie, Tielrode 100681
Lachaux, Alain, Beaune 066966
Lachaux, Jean-Christophe, Paris 071493
Lachaux, Jean-Pierre, Beaune . . 066967
Lachenaud, Jean-Luc, Tours . . . 105718
Lacher-Biene, Silvia, Müllheim . 077372
Lachin, Venezia 081681, 081682
Lachin Antichità, Esposizione Vendita
Restauro, Venezia 081683
Lachman, Dušan, Praha 128595
Lachmund, U., Abbenrode 074312
Lachmuth, Wolfgang,
Schopfheim 078311
Lacidogna, Michele, Torino 081549
Lackagh Museum and Heritage Park,
Turloughmore 024816
Låckereds Gård Antik,
Vänersborg 086950
Lackey, Oklahoma City 095820
Lackey, David, Houston 093557
Lackey, Hugh, San Antonio . . . 096821
Lackham Museum of Agriculture and
Rural Life, Lacock 044618
Lackmann-Wisskirchen, L.,
München 077481
Lackmann, Sabine, Essen 075640
Lackner, G., Salzburg 062775
Lackus, H., Kraichtal 076884
Lacombe, Claudine, Auneau . . . 066755
Lacombe, Eric, Bordeaux 125805
Lacombe, Jean-Pierre, Rodez . . 072472
Lacoste, Jacques, Paris 104952
Lacote, Philippe, Beaune 066968
Lacour, Guy, Goven 068635
Lacour, Jean-Marc, Bruz 067470,
. 128765
Lacour, Jean-Marie, L'Isle-sur-la-
Sorgue 069519
Lacour, Josette, Genève 087284, 116422
Lacour, Pierre, Fourdrain 068545
Lacourbas, Hélène et Romain,
Bellenaves 067019
Lacourt, Maurice, Charmes 067796
The Lacquer Chest, London . . . 090104
Lacquerware Museum, Pagan . . 031650
Lacrimosa, Osaka 081913
Lacroix, Québec 101369
Lacroix, Alexandre, Paris 104953
Lacroix, Serge, Saint-Julien-en-
Genevois 072825
The Lacrosse Museum and National
Hall of Fame, Baltimore 046721
Lacruz, Valencia 133821
Lacueva, Eduardo, Buenos Aires 139607
Lacy, London 090105, 118637
Lacy, West Hollywood 125257
Lacy Road Gallery, London 118638
Lacy Scott & Knight, Bury Saint
Edmunds 127039
Lacy Scott & Knight, Stowmarket 127316

Lacydon, Marseille . . . 104134, 137110
Laczkó Dezső Múzeum,
Veszprém 023714
Ladakh, Delhi 109342
Ladbyskibsmuseet, Kerteminde . 010002
Laden für Nichts, Leipzig 107829
Ladenburger Spielzeugauktion,
Ladenburg 126262
Ladengalerie Berlin, Berlin 106332
Laderer, Pittsburgh 123807
Ladeuille, Roger, Lamorlaye . . . 069097
Ladevèze, Michel, Cormeilles . . 068097
Ladew Manor House, Monkton . 050918
Ladics-ház, Corvin János Múzeum,
Gyula 023351
Ladner, Hubert & Helma, Urbar . 078683
Ladoucette, Marc de, Paris 104954
Ladrière, Sandrine, Paris 071494
Lads, Osaka 111374
Ladson, Malvern, Victoria 127907
Ladstätter, Markus, Wien 128203
Ladue Antique Galleries, Saint
Louis 096561
Lady and the Tramp Antiques Mall,
Saint Paul 096669
Lady Cant Bis, Antwerpen 063164
Lady Denman Maritime Museum,
Huskisson 001159
Lady Di Régiségbolt, Budapest . 079163
Lady Franklin Gallery, Lenah
Valley 001215
Lady Jane, Rotterdam 083390
Lady Lever Art Gallery, Wirral . . 046192
Lady Matilda Gallery, Nana Glen 099286
Lady of the Lake, Austin 092080
Lady of the Sea Gallery, Norfolk 095698
Lady Piú, Torino 081550
Lady Steptoe, Orange 062021
Lady Waterford Hall, Berwick-upon-
Tweed 043336
Lady Wilson Museum,
Dharampur 023930
Ladybug, San Diego 124388
Ladyship Oils, Killurin 109663
Ladysmith Railway Museum,
Ladysmith 006026
Läänemaa Muuseum, Haapsalu 010436
Läänikvalteri Aschanin Talo,
Heinola 010639
Läckö Slott, Lidköping 040582
Lähetysmuseo, Helsinki 010670
Lährm, Gerhard, Salzburg 062776
Lækkert, Børre, Oslo 084167
Lämmle, B., Vaihingen an der
Enz 108821
Lände, Kressbronn am Bodensee 019465
Ländliche Bildergalerie,
Dischingen 017676
Längelmäen Kirkkomuseo,
Längelmäki 010891
Längelmäen Korsumuseo,
Länkipohja 010892
Längelmäen Pellavamuseo,
Länkipohja 010893
Länsmuseet Gävleborg, Gävle . . 040439
Länsmuseet Halmstad, Halmstad 040487
Länsmuseet Västernorrland,
Härnösand 040481
Länsmuseet Varberg, Varberg . . 040951
Laeremans, Philippe & Lisa,
Bruxelles 100488
Lærken, Nykøbing Falster 102881
Læsehesten, Aalborg 140511
Læsehesten, Frederikshavn . . . 140539
Læsehesten, Silkeborg 140618
Læsehesten Kolding Antikvariat,
Kolding 140585
Læsø Museum, Læsø 010051
Lafarge, Jean-Pierre, Cognac . . 068003
Lafaurie, Bénédicte de, Paris . . 071495
Lafay, Benoît, La Bégude-de-
Mazenc 128875
Lafayette, Cleethorpes 144112
Lafayette, Saint-Ouen 073086

Lignum, Prato 132164
Ligozat, André, Gap 068574
Ligüerre, Pablo, Zaragoza ... 133858
Liguori Editore, Napoli 137803
Ligures, Bordighera 138884
Lihula Muuseum, Lihula 010463
Liicht, Nei, Dudelange 111877
Liinelot, Helsinki 066275
Liisa's Antiikki, Helsinki 066276
Liiwimaa Antiik, Kanepi 066204, 128644
Lijiang Museum, Lijiang 007814
Lijiang Publishing House, Guilin 136997
Lijiashan Bronze Museum,
 Jiangchuan 007736
Lijn 3, Den Haag 112483
Lik, Peter, Aspen 119808
Lik, Peter, La Jolla 121602
Lik, Peter, Noosa Heads 099328
Like Before, Cagliari 079819
Likeio Ton Ellinidon Collection,
 Rethymno 022895
Likha Antiques and Crafts Inc.,
 Manila 084310
Liki Rossii, Sankt-Peterburg ... 138024
Likin, Sandanski 100997
Likovni Klub Scena Crnjanski,
 Beograd 114504
Lil-Tob-Lou, Los Angeles 094225
Lila Chrif, Casablanca 082384
Lila Laden, Bonn 075038
Lile & Lav, Beograd 114505
L'Ile au Trésor, Annecy 066585
L'Ile au Trésor, Saint-Dizier ... 072700
Lilfords, New Milton 118974
Lilian, Andrée, Riehen 116679
Lilian's Fine Collectables, Toronto 064638
Lilias Lane, Nelson 083862
Lilienhof, Lilienthal 019733
Lilienthal-Centrum Stölln,
 Gollenberg 018481
Liliesleaf Gallery, Rosebank ... 114898
Liling Museum, Liling 007815
Liliput, Köln 141899
Liljendal Hembygdsmuseum,
 Liljendal 010939
Liljevalchs Konsthall, Stockholm 040815
Lilla Galleriet, Sölvesborg 115916
Lilla Galleriet, Umeå 116065
Lilla Galleriet Helsingborg,
 Helsingborg 115782
Lilla Hönsahuset, Lund 086649
Lilla Huset Antikt, Skövde 086752
Lilla Konstgalleriet, Kalmar ... 115800
Det Lille Antikvariat, Århus ... 140520
Den Lille Butik, Fanø 065579
Det Lille Galleri, Haderslev ... 102784
Det Lille Galleri, Holstebro ... 102809
Det Lille Galleri, Kristiansand ... 113268
Det Lille Galleri, Vejle 066121
Lille Heddinge Rytterskole, Rødvig
 Stevns 010117
Lille Métropole Musée d'Art Moderne,
 d'Art Contemporain et d'Art Brut,
 Villeneuve-d'Ascq 016049
Lillebonne, Nancy 104273, 137114
Lillehammer Kunstmuseum,
 Lillehammer 033568
Lillesand By-og Sjøfartsmuseum,
 Lillesand 033572
Lillian and Albert Small Jewish
 Museum, Washington 054006
Lillian and Coleman Taube Museum of
 Art, Minot 050882
Lillian Stevenson Nursing Archives
 Museum, Saint John's 006748
Lillie Art Gallery, East Dunbartonshire
 Museums, Milngavie 045197
Lilliput, Pittsburgh 096140, 136473
Lilliput Antique Doll and Toy Museum,
 Brading 043474
Lillooet District Museum, Lillooet 006069
Lillstreet Art Center, Chicago .. 120461
Lilly's Art, Boston 120170
Lil's Treasure, Mulgoa 061918

Liltorp, Elin, Aalborg 065517
Lily White, Portland 096269
Lilydale Antique Centre, Lilydale 061728
Lily's Antiques, Maryborough,
 Queensland 061788
Lily's Antiques, Pittsburgh 096141
Lim Antiqua, Lucca ... 137761, 142520
Lim, Raywin, Whitianga 084066
Lima Hembygdsgård, Lima 040585
L'Image-en-Provence, Marseille . 104136
Limardo, Buenos Aires 127798
Limassol District Museum,
 Lemesos 009268
Limassol Municipal Art Gallery,
 Lemesos 009269
Limb, R.R., Newark-on-Trent .. 090658
Limbažu Muzejs, Limbaži 029982
Limberlost State Historic Site,
 Geneva 049030
Limbrock, Gerd, Hemer 076426
Limbrock, J., Rhede 108498
Limburg, Den Haag 082912
Limburgs Miniatuurmuseum, Sint
 Geertruid 032690
Limburgs Museum, Venlo 032801
Limburgs Openluchtmuseum
 Eynderhoef, Nederweert Eind . 032484
The Lime Tree, Fort William ... 118000
Lime Tree Antiques, Hadlow ... 089204
Lime Tree Gallery, Bristol 117586
Lime Tree Gallery, Stanhope .. 119411
Limelight Gallery, Surry Hills .. 099611
Limerick City Gallery of Art,
 Limerick 024752
Limerick Museum, Limerick .. 024753
Limesmuseum Aalen, Zweigmuseum
 des Archäologischen
 Landesmuseums Baden-
 Württemberg, Aalen 016258
Limfjordsmuseet, Løgstør 010059
Limhamns Auktionsbyrå,
 Trelleborg 126900
Limhamns Museum, Malmö ... 040629
Liming Fine Arts Gallery,
 Qingdao 102053
Limingan Kotiseutumuseo,
 Liminka 010943
Limited, London 138279
Limited Edition Contemporary
 Graphics, Pershore 138331
Limited Edition Mint, Philadelphia 095965
Limited Editions, Ashburton ... 143086
Limited Editions, Mobberley .. 090610,
 135193
LIMN Gallery, San Francisco .. 124575
Limon Heritage Museum, Limon 050229
Limongelli, Michelangelo, Torino 132541
Limousine Bull Artists Collective,
 Aberdeen 060126
Limpsfield Watercolours,
 Limpsfield .. 089631, 118342, 134874
Lin & Keng, Beijing 101841
Lin An-Tai Historical Home,
 Taipei 042245
Lin Art, Košice 085394
Lin Liu-Hsin Puppet Theatre Museum,
 Toa-Thiu-Thia Puppet Centre,
 Taipei 042246
Lin Yuan Simplicity Art Museum,
 Yuchi 042327
Lin Yutang House, Taipei 042247
Lin, Anthony, Hong Kong 065006
Lin, Peter, Los Angeles 136078
Lin, Polly, Los Angeles 094226
Linard, Eric, La Garde-Adhemar 103839
Linardi & Risso, Montevideo .. 145388
Linares, Palma de Mallorca ... 086183
Lina's Antiques, Fresno 093340
Linc Real Art, San Francisco .. 124576
Linchuan Museum, Linchuan .. 007816
Linckersdorff, München 077485
Linckersdorff, von, Berlin 074826
Linckh, Andrea, Bamberg 129672
Lincoln, Buffalo 092375

Lincoln Antique Mall, Chicago .. 092575
Lincoln Arts Council, Lincoln ... 060563
Lincoln Cathedral Treasury,
 Lincoln 044711
Lincoln Children's Museum,
 Lincoln 050242
Lincoln County Historical Museum,
 Davenport 048120
Lincoln County Historical Society,
 Lincoln 050231
Lincoln County Historical Society
 Museum, North Platte 051528
Lincoln County Historical Society
 Museum of Pioneer History,
 Chandler 047487
Lincoln County Pioneer Museum,
 Hendricks 049405
Lincoln Home, Springfield 053337
Lincoln Homestead, Springfield . 053344
Lincoln Log Cabin, Lerna 050169
Lincoln Memorial Shrine,
 Redlands 052399
The Lincoln Museum, Fort
 Wayne 048855
Lincoln Parish Museum, Ruston 052613
Lincoln Park Historical Museum,
 Lincoln Park 050256
Lincoln School of Art and Design,
 University of Lincoln, Lincoln . 056505
The Lincoln-Tallman Restorations,
 Janesville 049751
Lincoln Tomb, Springfield 053338
Lincoln Train Museum,
 Gettysburg 049054
Lincoln, Ebrahimzadeh,
 Saarbrücken 078252
Lincolns House, Los Angeles ... 094227
Lincoln's New Salem Historic Site,
 Petersburg 051917
Lincolnshire Fine Arts, Grimsby . 118089
Lincolnshire Road Transport Museum,
 Lincoln 044712
Lind, David, Louisville 121934
Lind, Gregory, San Francisco .. 124577
Linda Durham Contemporary Art,
 Santa Fe 124714
Linda Gallery, Beijing 101842
Linda Gallery, Jakarta 109544
Linda Gallery, Shanghai 102900
Linda Gallery, Singapore 114642
Linda Loves Lace, San Antonio . 096825
Lindale Art Gallery, Paraparaumu 113074
Lindart, Birmingham 120085
Lindas, Mallow 079562
Linda's Antiques, Kinsale 079543,
 142430
Lindas Gamle Skap, Fauske ... 084091
Lindås Skulemuseum, Isdalstø . 033509
Linda's Treasures, Dallas 092996
Lindbeck, Vera, Isernhagen ... 107453
Lindberg & Persson, Björkö ... 143627
Lindberg & Persson, Täby 143786
Lindberg, B. & M., Helsinki ... 066277
Linde Auktionstjänst, Lindesberg 126831
Linde-Schöpfli, Winterthur 087710
Linde, de, Aalst 063118
Lindemann, Dülmen 075396
Lindemann, Dorothea,
 Hildesheim 130351
Lindemann, Felix, Altenrhein .. 116117
Lindemann, Oliver, Hamburg .. 107265
Lindemann, Winfried,
 Schermbeck 078283
Lindemanns, H., Stuttgart 142241
Linden, Bilambil 098599
Linden, Tampa 124912
Linden – Saint Kilda Centre for
 Contemporary Arts, Saint Kilda,
 Victoria 001468
Linden Art Center, Birmingham . 120086
Linden House Antiques,
 Leominster 089613, 134865
Linden House Antiques, Stansted
 Mountfitchet 091267

Linden-Museum Stuttgart, Staatliches
 Museum für Völkerkunde,
 Stuttgart 021645
Linden Railroad Museum, Linden 050260
Linden, Peter, Dalkey 079403
Lindenau-Museum, Altenburg . 016338
Lindenauer, Isak, San Francisco 097105
Lindenberg, Rotterdam 143031
Lindenfelser Museum, Lindenfels 019751
Linder, Gisèle, Basel 116187
Linder, Lars, Hedesunda 126807
Linder, Reinhard, Gummersbach 076072
Linderholm, Lena, Stockholm . 116000
Lindesbergs Museum,
 Lindesberg 040587
Lindesnes Bygdemuseum, Sør-
 Audnedal 033777
Lindgaard Thomsen, Jimmy,
 Skagen 066041
Lindgren, Lisa, Dragør 065565
Lindholm, Göteborg 133883
Lindholm, Stelle 078472
Lindholm Høje Museet,
 Nørresundby 010075
Lindig, Beatrice,
 Oberschleißheim 130848
Lindigtmühle am Lindenvorwerk,
 Kohren-Sahlis 019426
Lindinger & Schmid, Berlin ... 137339
Lindisfarne Priory, Holy Island . 044456
The Lindisfarne Room,
 Gateshead 118013
Lindkvist & Sjöberg, Stockholm . 086838
Lindleinturm-Museum,
 Creglingen 017553
Lindner, Stuttgart 078532
Lindner, Wien 100216
Lindner, Andreas, Wien 062974
Lindner, Hans, Mainburg 141970
Lindner, Johannes, Radebeul . 130918
Lindner, Konrad, Bernried, Kreis
 Deggendorf 129836
Lindner, Ramon, Essen 075641
Lindner, U., Callenberg 075198
Lindorf, Hans-Karl, Kiel 076715
Lindquist, Solveig, Helsinki ... 128656
Lindsay, Den Haag 142927
Lindsay, London 090129
Lindsay Gallery, Lindsay 006071
Lindsay Wildlife Museum, Walnut
 Creek 053921
Lindsay, Burns & Co., Perth ... 127261
Lindsay, Duff, Columbus 120781
Lindsay, Lillian, Oberon 062014
Lindsay, Robert, Melbourne ... 099178
Lindsay's Antiques, Invercargill . 083804
Lindsell Art Gallery, Lindsell .. 118349
Lindsey, Nashville 094846
Lindsey Antiques, North Berwick 090702
Lindsey Court Architectural,
 Horncastle 089391
Lindskoug, Mats, Lund 133903
Lindstrand-Bengtsson, Ginger,
 Mjölby 126852
Lindströms, Kenth, Stockholm . 086839
Line Gallery, Beijing 101843
The Line Gallery, Linlithgow ... 118350
La Linea d'Ombra, Roma 142644
Linea, Marina, Wien 062975
LINEART, the Art Fair, Gent ... 097887
Lineaverde, Vomero 138885
Linecker, Leopold, Schalchen . 128126
Lines, D. & J., Wychbold 091828,
 135621
Linfen Museum, Linfen 007818
Linfen Zone Museum, Linfen .. 007819
Linga Longa, Tirau 113122
Lingao Museum, Lingao 007820
Lingard, Ann, Rye 091014
Lingbeek & Van Daalen, Haarlem 132899
Lingen, Axel, Recklinghausen . 078074
Lingenauber, Eckard, Monaco .. 112079
Lingenauber, Eckart, Düsseldorf 075446
Lingnan Fine Arts Museum, Academia

Macroom Museum, Macroom .. 024765
Macrorie House Museum,
Pietermaritzburg 038621
Macrorie Museum, Macrorie ... 006111
Macrosun, Saint Louis 124090, 124091
MAC's – Musée des Arts
Contemporains, Hornu 003634
Mac's Antique Car Museum,
Tulsa 053725
McSpadden & Haskell, Chicago . 092578
McSwain, Charlotte ... 092448, 135744
McSweeney, Gerald, Midleton .. 142431
McTague, Harrogate 089237
McTague of Harrogate, Harrogate 118119
McTear's, Glasgow 127119
Macula, Paris 137235
Macula, Santa Cruz de Tenerife 115519
McVeigh & Charpentier, London 090147,
135048
McWane Science Center,
Birmingham 046974
McWhirter, James, London 090148
Maczulat, E., Braunschweig ... 141568
Mad Art, Saint Louis 124092
Mad Booking, Nashville 145035
Mad Dog and the Pilgrim Booksellers,
Lander 144939
Mad-Elf-Art, Stockholm 116004
MAD Gallery, Lancefield 099078
Mad Musée, Liège 003718
Madaba, Paris 105010
Madaba Archaeology Museum,
Ajloun 029575
Madách Imre Emlékmúzeum, Nógrádi
Történeti Múzeum, Csesztve .. 023264
Madaire, Thierry, Sainte-Agathe-la-
Bouteresse 073299
Madalyn, Norfolk 095700
Madam Blå Antik, Hadsund ... 065655
Madam Blå Brukt og Antikk,
Drammen 084087
The Madam Brett Homestead,
Beacon 046813
Madam Olsen, Bergen 084077
Madame Tussaud's, London ... 044936
Madame Tussaud's Amsterdam,
Amsterdam 031778
Madame Tussaud's Wax Museum,
New York 051334
Madames, Mice & More,
Indianapolis 093738
Madang Museum, Madang 034011
Madara Nacionalen Istoriko-
archeologičeski Rezervat,
Madara 004993
Madcap Antiques, Toronto 064646
Maddermarket Antiques, Norwich 090733,
135235
Maddick, Chicago 120469
Maddi's Gallery, Charlotte ... 120280
Made By Hand, Ashbourne 117323
Made From Australia Galleries,
Deakin 098817
Made Gallery, Carlton North .. 098721
Made in France, Houston 093568
Made in France, Nashville 094848
Made in Greenwich, London ... 118658
Made in Japan, Hyde Park 061636
Made in Nippon, Auckland 083622
Made in the Murray Mallee, Swan
Hill 062262
Madec, Eliane, Fécamp 125861
Madel, Pierre, Paris 071560
La Madeleine, Bouin 067328
La Madeleine, Cabourg 067489
Madeline & Laupin, Toulon-sur-
Arroux 105674
Madeline Island Historical Museum, La
Pointe 049999
Mader, Milwaukee 122212
Madera County Museum, Madera 050518
Maderas Gallery, Tucson 125000
Madert, Mehring 107971
Madhavan Nair Foundation,

Edapally 023936
Madhouse, Rotorua 113088
Madhouse Fun Furnishings,
Buffalo 092378
Madhya Pradesh Tribal Research and
Development Institute, Bhopal . 023857
Madison, Atlanta 119867
Madison Avenue Antique Mall,
Memphis 094482
Madison Avenue Galleries,
Toledo 097448
Madison Children's Museum,
Madison 050535
Madison County Historical Museum,
Edwardsville 048447
Madison County Historical Society
Museum, Winterset 054375
Madison Fine Art, New York ... 095391
Madison Historical Society Museum,
Madison 050519
Madison-Morgan Cultural Center
Collection, Madison 050521
Madison Museum of Contemporary
Art, Madison 050536
Madison Press Books, Toronto . 136981
Madonas Novadpētniecības un
Mākslas Muzejs, Madona ... 029985
Madonna House Museum,
Combermere 005532
Madonna Massimo, Palermo ... 080884
Madoura, Vallauris 105764
Madras Christian College Museum,
Chennai 023885
MADRE – Museo d'Arte Donnaregina,
Napoli 026828
Madres Dominicanas – Monasterio
Sancti Spiritus, Toro 040062
Madrières, Olivier, Laguepie ... 069086
La Madrileña, Madrid 086035
Madron, Chicago 120470
Madsack, Denise, Stuttgart ... 131062
Madsen, Lisbeth, Herning 065683
Madureira, Maria, Porto Alegre . 100848
Madurodam, Den Haag 032003
Mäder, Bern 087105
Mädi's Antiquitätenlädeli, Aeschlen ob
Gunten 086996
Maeght, Barcelona 115016
Maeght, Paris 105011, 137236
Maeght Musée, Paris 114469
Mähler, Katharina, Wolfenbüttel . 131176
Mährisch-Schlesisches
Heimatmuseum, Klosterneuburg 002175
Maejima Memorial Museum,
Joetsu 028551
Maek-Hyang, Daegu 111611
Maekawa, Luana, Firenze 131594
Mäkelänkadun Antikvariaatti,
Helsinki 140675
Maels.L, Floriane, Eze 103684
Mälsåkers Slott, Stallarholmen . 040786
Die Männer von Brettheim, Rot am
See 021113
Mäntsälän Kotiseutumuseo,
Mäntsälä 010959
Mäntyharjun Museo, Mäntyharju 010962
Mäntyviidan Kijakauppa, Helsinki 140676
Märchenhaus und Heimatmuseum
Ottenschlag, Ottenschlag ... 002438
Märchenhorn,
Fachmuseum Gußeiserne
Öfen/Feuerstättenmuseum, Neu-
Ulm 020327
Maere, Jan de, Bruxelles 063442,
100499
Märkisches Glasmuseum,
Stechlin 021566
Märkisches Museum, Kulturforum
Witten, Witten 022284
Märkisches Museum, Stadtmuseum
Berlin, Berlin 016994
Märkisches Ziegelei-Museum Glindow,
Werder 022156
Märklin-Museum, Göppingen .. 018452

Maertzdorf, Doetinchem 082983
Märzgalerie, Berlin 106356
Maerzgalerie, Leipzig 107832
Maes, Knokke-Heist .. 100608, 128321
Maese, Lewis, Houston 093569
Mäsinge Antik och Konsthantverk,
Båstad 086455
Maessen, Bad Kissingen 074496, 074497
Maessen, Petra, Bad Kissingen . 074498
Mästerby Antik, Stockholm ... 086841
Mätzelt, R., Hörstel 076482
Mafe, São Paulo 100963
Maffart, Guy, Rennes (Ille-et-
Vilaine) 072399, 129433
Maffei, São Paulo 100964
Maffei, Giorgio, Torino 142685
Maffra Sugarbeet Museum,
Maffra 001237
Mafikeng Museum, Mafikeng . 038601
Mafra & Mafra, Lisboa 133304
Mag, Miami 139454
Mag Presse, Brignoles 140767
Maga Magò, Trieste 142698
Magadanskij Oblastnoj Kraevedčeskij
Muzej, Magadan 037040
Magan Sangrahalaya Samiti,
Wardha 024214
Magana Gallery, Windsor, Ontario 101721
Magapa, Granada 133626
Magasin, Duisburg 075505
Le Magasin, Haarlem 083151
Magasin – Centre National d'Art
Contemporain, Grenoble 012988
Magasin 3 Stockholm Konsthall,
Stockholm 040817
La Magasin de Cadres, Lille ... 069439,
128918
Magasin de Collection Privée,
Genève 087287
Magasin Eclair, Angers 066552
Le Magasin Pittoresque, Nice . 140961
Magatani, Tokyo 111471
El Magatzem, La Bisbal
d'Empordà 085726
Het Magazijn, Amsterdam 082614
Het Magazijn, Gent 063593
Magazin 4, Bregenzer Kunstverein,
Bregenz 099834
Magazin Etalon, Bucureşti ... 084925
The Magazine Antiques, New
York 139455
Magazine Arcade Antiques, New
Orleans 094960
Magazine Street Gallery, New
Orleans 122445
Magazinul Colectiilor, Bucureşti . 084926
Magazyn MM, Warszawa 084560
Magazyn Sztuki + Obieg,
Gdańsk 139013
Magazzino d'Arte Moderna,
Roma 110834
Il Magazzino di Aristide, Milano . 080429
Magdalen College Museum,
Wainfleet 046045
Magdalene Gallery, Taunton ... 119489
Magdalenen-Verlag Clemens Kopp
OHG, Holzkirchen 137471
Magdeburger Antiquariat,
Magdeburg 141968
Magdeburger Museen, Museum für
Naturkunde und Kulturhistorisches
Museum, Magdeburg 019873
Magellan Trading, Tucson 097509
Magenta, Florida 138541
Magenta, Nijmegen 112694
Magenta, Roermond 112708
Magenta Fine Arts, West Kirby . 119613
Magers & Quinn, Minneapolis . 145018
Magersfontein Battlefields Museum,
McGregor Museum, Kimberley 038587
Mages, Christian de, Nice 070578
Magevney House, Memphis ... 050715
Maggi, Gabriella, Trieste 132606
Maggia, Giovanni, Verona 081753

Maggie L. Walker National Historic
Site, Richmond 052456
Maggie May's, North Shields .. 090706,
135227
Maggie's Book Bazaar, Highgate
Hill 139799
Maggies Place, Columbus 092868
Il Maggiolino, Bari 079665
Maggs Bros., London 144401
Magg's Shipping, Liverpool ... 089663
Maggs, John, Falmouth 134698, 144183
Al-Maghraby, Khan, Cairo 102997
Magi Arte, Milano 110389
Magi, Cezar, New Orleans 122446
Magia Imagem, Lisboa 114129
Magic Art Corporation, Tshwane 085500
Magic Dragon, Los Angeles ... 121831
Magic Faces, Buffalo 120241
Magic Flute Artworks, Lower
Swanwick 118856
Magic House-Saint Louis Children's
Museum, Saint Louis 052707
Magic Lantern Castle Museum, San
Antonio 052840
Magic Lanterns, Saint Albans . 091026
Magic Moments, Albuquerque . 091907
Magic of Quimper, Littlehampton 089656
Magic Oriental Antiques, Abu
Dhabi 087919
Magic Shop, Columbus 092869
Magica, Beograd 114506
Magical Artroom, Tokyo 111472
Le Magicien, Orchies 070746
La Magie du Verre, La Tour-de-
Peilz 116762
Magill Antiques and Art Gallery,
Magill 061748
Magin, Liège 140212
Magis, J.-J., Paris 141192
Magistrati, Sandro, Milano 131860
Magistri, Roma 081268, 132350
Magli, Ettore, Bologna 131375
Maglio, Davide, Torino 132546
Magliocchetti, Roma 132351
Magloire, Philippe & Claude,
Paris 071561
Magma, Christchurch 112939
Magna, Coimbra 114053
Magna Gallery, Oxford 090782, 144518
Magnan, Alberto, New York ... 123088
La Magnanerie du Coudray, Maison
de la Soie d'Anjou, Le Coudray-
Macquard 013430
Magnanerie Muséalisée de la Roque,
Molezon 013996
Magne, Michel, Rouen 141283
Magne, René, Saint-Julien-de-
Jordanne 072819
Magnesitmuseum, Radenthein . 002507
Magnet, Wilfried, Wien 100217, 140084
Magnetawan Historical Museum,
Magnetawan 006113
Magnificat, Imola 080138
Magnifico, Albuquerque 119762
Magnin, François, Paris 141193
Magnino, Mondeville 070106
Magnitogorskaja Kartinnaja Galereja,
Magnitogorsk 037042
Magnitogorskij Kraevedčeskij Muzej,
Magnitogorsk 037043
Magnolia Editions, Oakland ... 138491
Magnolia Grove House Museum,
Greensboro 049210
Magnolia Manor Museum, Cairo 047306
Magnolia Mound Plantation, Baton
Rouge 046789
Magnolia Plantation, Charleston 047519
Magnolias, Houston 121365
Des Magnolias comme Autrefois,
Paris 071562
Magnoni, Massimo, Roma 132352
Magnum Ars, Moskva . 085020, 114359,
133374, 143456
Magnus Antikt, Alingsås 086441

Mann, John, Canonbie 088550, 134523
Mann, Mina, New York 095397
Mann, Robert, New York 123091
Mann, Thomas, New Orleans . 122447
Mann, Vincent, New Orleans . 094963
Manna, Den Haag 082916
Manna Gum Gallery, Dromana . 098835
Manna, Emilia, Napoli 080729
Mannamine, Nordingrå 040673
Manneken-Pis-Museum,
 Geraardsbergen 003571
Mannenzaal van het Sint Pieters en
 Bloklands Gasthuis, Amersfoort 031734
Mannerheim museo, Helsinki . 010677
Mannerheimintien Antiikki,
 Helsinki 066282
Manners, E. & H., London . . . 090154
Manneschi, Rovigo, Firenze . . 131597
Johannes Mannhardt & Matthias
 Ruhdorfer, Rottach-Egern . . . 078216
Mannhart, Buchs (Sankt Gallen) 087150
Mannhaupt, Mario, Luckenwalde 107883,
 130591
Mannheimer Kunstverein e.V.,
 Mannheim 059096
Mannies Arts, Kathmandu . . . 112153
Manning Park Visitor Centre, Manning
 Park 006127
Manning Regional Art Gallery,
 Taree 001561
Manning, K., San Francisco . . 145300
Manning, Oliver, Canterbury . . 134528
Manning, Shedd, Atlanta 135666
Manningham Gallery, Doncaster 098828
Mannsfeld, Colmar 103571
Mannum Old Wares and Curios,
 Mannum 061780
Manny, Chicago 092582, 135768
Del Mano, Los Angeles 121832
Mano, Seoul 111737
Mano, Jose M. de la, Madrid . 086036,
 115339
Manoel Theatre and Museum,
 Valletta 030574
Le Manoir, Rabat 082418, 112127
Manoir Automobile, Lohéac 013658
Manoir de Folie Vallée, Pont-de-
 l'Arche 072206
Manoir de Folie Vallée, Rouen . 072559
Manoir de Kernault, Mellac . . . 013918
Manoir de la Ville de Martigny,
 Martigny 041482
Manoir de Veygoux, Scénomusée
 des Combrailles, Charbonnières-les-
 Varennes 012266
Le Manoir de Villedoin, Velles . . 105776
Manoir de Villers, Saint-Pierre-de-
 Manneville 105310
Manoir du Huis Bois-Maison P.N.R. du
 Boulonnais, Le Wast 013523
Manoir Leboutillier, Anse-au-
 Griffon 005245
Manoir Mauvide-Jenest, Saint-
 Jean 006725
Manolaki, Thessaloniki 109105
Manoni, Goffredo, Milano 080434
Manor Antiques, Adare 079327
Manor Antiques, Gravesend . . 089162
Manor Antiques, Nottingham . . 090745
Manor Antiques, Wilstead . . . 091711,
 135584
Manor Barn, Skipton 091200
The Manor Bindery, Fawley . . . 134704
Manor Cottage Heritage Centre,
 Southwick 045823
Manor Farm, Bursledon 043583
Manor Farm and Country Park,
 Bursledon 043584
Manor Farm Antiques, Standlake 091265
Manor Fine Arts, Banbridge . . 117349
Manor Gallery, Gravesend 118073
Manor House, Donington-le-
 Heath 043923
Manor House, Sandford Orcas . 045706

Manor House Antique Mall,
 Indianapolis 093739
Manor House Antiques,
 Blackheath 061152
The Manor House Antiques,
 Brasted 088362
Manor House Antiques,
 Fishguard 089070
Manor House Antiques,
 Sacramento 096471, 136531
Manor House Art Gallery and Museum,
 Ilkley 044490
Manor House Auctions, Heckfield 127144
Manor House Gallery,
 Cheltenham . 088617, 117716, 134554
Manor House Museum, Kettering 044551
Manor Museum, Manor 006128
Manorism, Atlanta 091990
Manos, Denver 121020
Manos Faltaits Museum, Skyros 022928
Las Manos Gallery, Chicago . . 120475
Las Manos Magicas, Houston . . 121366
Manou, Ronchamp . . . 072489, 105413
Manoukian Noseda, Giacomo,
 Milano 080435, 131863
Manrique, Martin, Los Angeles . 136081
Manro-Classic – Auto & Musik
 Museum, Koppl 002190
Le Mans Collections, Le Mans . 069251
La Mansarda, Medellín 065205
La Mansarde, Dampierre-en-
 Yvelines 068211
Mansart Rémy, Bruxelles 063447
Mansell, G., Hoylake 089401
Mansell, William C., London . . 135050
Mansers Antiques, Shrewsbury . 091183,
 135396
Mansfeld-Museum Hettstedt,
 Hettstedt 018937
Mansfelder Bergwerksbahn e.V.,
 Benndorf 016823
Mansfield, Deloraine 061388
Mansfield Art Center, Ohio State
 University, Mansfield 050593
Mansfield Fine Arts Guild,
 Mansfield 060574
Mansfield Gallery, Mansfield . . 099142
Mansfield Historical Society Museum,
 Storrs 053439
Mansfield Museum and Art Gallery,
 Mansfield 045142
Mansfield Park Gallery, Glasgow 118046
Mansfield State Historc Site,
 Mansfield 050591
Mansfield, Louise, Stillorgan . . 109705
Manship House Museum,
 Jackson 049707
Manshodo, Hiroshima 081809
Mansion Antique House,
 Singapore 085292
La Mansión del Fraile,
 Bucaramanga 065147
Mansion House, London 044938
Mansion House, Warkworth . . . 033164
Mansions, Lincoln 089637
Manske, D., Bernburg 074915
Mansky, Claudia, Rotenburg an der
 Fulda 078203
Manson, Edward, Woodbridge . . 091782,
 135609
Manson, Yves, La Flèche 125878
Mansour, Cairo 102999
Mansour Bros., Damascus . . . 087837
Mansour, London . . . 090155, 118659
Al-Mansour Gallery, Cairo 103001
Mansour, Ahmed, Cairo 103000
Manten, W., Vreeland 133040
Manthey, Berlin 074831
Manthey, Cornelia, Hamburg . . 141785
Manthey, Gerhard, Hamburg . . 130280
Manthey, Gerhard, Kiel 076716
Mantler, Wolfgang, Wien 140085
Manton, F.T., Uxbridge 135528
Mantra, Torino 111010

Mantu, N., Galați 114254
Manu, Breda 082811
Manualidades, La Paz 100703
Manuel L. Quezon Memorial Shrine
 Museum, Quezon City 034416
Manuelian, Georges, Nice 070580
Manuella, Nice 070581
Manufacture Robert Four,
 Aubusson 066736, 128693
Manufaktur der Träume, Sammlung
 Erika Pohl-Ströher, Annaberg-
 Buchholz 016394
Manufakturgalerie Eva Brosché,
 Berlin 106357
Manujlivs'kyj Literaturno-memorialnyj
 Muzej O.M. Gor'kogo, Verchnja
 Manujlivka 043052
Manuka, Fisher 061456
Manurewa Community Arts Centre,
 Auckland 032973
Manus, Männedorf 138145
Manus Presse, Stuttgart 108724
Manyung Gallery, Mount Eliza . 099262
Manzanal, Donostia-San
 Sebastián 133612
Manzano, Juan B., Sevilla 086281
Manzione, Punta del Este 125318
Manzke, Dipl. Gemäldesrestaurator
 Holger, Potsdam 130904
Manzo, Oklahoma City 095826, 136397
Manzoni Villa, Musei Civici,
 Lecco 026423
Maoling Museum, Xingping . . . 008278
Maoming Museum, Maoming . . 007881
The Map House of London,
 London 144402
Map World, London 144403
MAP, Publika, Kuala Lumpur . . 111960
Mapes, David W., Vestal 127750
Mapes, Shirley K., Omaha 145140
Maple Antiques, Surbiton 091363
Maple Europe, Paris 071580
Maple Leaf Furniture Refinishing,
 Toronto 128460
Maple Ridge Art Gallery, Maple
 Ridge 006135
Maple Ridge Museum, Maple
 Ridge 006136
Maple Street Book Shop, New
 Orleans 145053
Maple Syrup Museum, Saint
 Jacobs 006722
Maple Valley Historical Museum,
 Maple Valley 050598
Maples, Mosta 082235
Maplewood Antique Mall, Saint
 Louis 096568
Maplewood Farm, North
 Vancouver 006379
Mappa Mundi and Chained Library,
 Hereford 044432
Il Mappamondo, Milano 110390
Mappamundi, Knokke-Heist . . . 100609,
 140200
Mapungubwe Museum, Tshwane 038666
Maqdisi, Damascus 087838
Maqi, Tbilisi 105865, 105866
Maqueda Abreu, Maria Luisa,
 Granada 115180
La Mar, Denia 085786
Mar Pau, Viña del Mar 101790
Mar, Grup d'Art Escolà,

Barcelona 115017
Mara Muizniece Riga School of Art,
 Riga 056057
Marabini, Bologna 109862
Maragall, Barcelona . . 085615, 115018,
 126725, 138054
Maragheh Museum, Maragheh . 024413
Marais Des Cygnes Memorial Historic
 Site, Pleasanton 052112
Marais, Jean-Claude, Pezou . . 072104
Maraldi, Walter, Roma 142645
Maralt, Kyra, Berlin 106358
Maramec Museum, The James
 Foundation, Saint James 052674
Marani, Ferny Creek 061455
Marani, Roma 081270
Maraninchi, Marseille 129014
Maraş Ikon Müzesi, Gazimağusa 033278
Marat Art, Bratislava 114736
Maratha History Museum, Deccan
 College, Pune 024141
Marathon County Historical Society
 Museum, Wausau 054115
Maraut, Michèle & Didier, Saint-Jean-
 Cap-Ferrat 072793
Maraux, Patrick, Nevers 070490
Marazzani Visconti Terzi Arte,
 Piacenza 110667
Marazzi, Loris, Venezia 111157
Marbach, Jean, Mulhouse 070342,
 104264
Mårbacka Manor, Home of Selma
 Lagerlöf, Östra Ämtervik 040706
Marbeau, Paris 105021
Marbella, New York 123092
Marbella, David, New Orleans . . 094964
Marble Arts, Richmond 096395
Marble Crafts Museum, Pirgos . 022872
Marble Hill Gallery, Twickenham 091532
Marble Hill House, Twickenham 046019
Marble Historical Museum,
 Marble 050601
Marble Moon, Glenelg 098942
Marble Mountain Library and Museum,
 West Bay 007198
Marble Palace, Houston 093571
Marble Palace Art Gallery and Zoo,
 Kolkata 024050
Marble Springs State Historic
 Farmstead Governor John Sevier
 Memorial, Knoxville 049968
Marblehead Arts Association,
 Marblehead 060575
Marblehead Museum and J.O.J. Frost
 Folk Art Gallery, Marblehead . . 050604
Marbles Kids Museum, Raleigh . 052354
La Marbrerie, Lille 069440
Marbrier, Thierry, Mauregny-en-
 Haye 069956
Marbs, Uwe, Baden-Baden . . . 074600
Marburger Kunstverein, Marburg 059097
Marburger Kunstverein e.V.,
 Marburg 059098
Marburger Universitätsmuseum
 für Kunst und Kulturgeschichte,
 Marburg 019934
Marc, Fougères (Ille-et-Vilaine) . 086542
Marc Chagall Galeria de Arte, Rio de
 Janeiro 100910
Marc Chagall Kunsthuis,
 Amsterdam 031779
Marc Jancou Contemporary, New
 York 123093
Marc, Jean-Louis, Paris 105022
Marc, Philip, Chantenay Saint-
 Imbert 067773
Marca Puig, Maria Teresa,
 Barcelona 085616
Marcar'art, Albi 066457
Marcazzan, Fabien, Monferran-
 Saves 070110
Marce, Jean Philippe,
 Montpellier 129046
Marceau, Paris 071581

Meier-Za, E., Oftringen 087526, 134200
Meier-Za, E., Zofingen 087724
Meier, Anthony, San Francisco . 124587
Meier, Anton, Genève 116425
Meier, Astrid, Castrop-Rauxel . . 106618
Meier, Bernard, Kapellen 063635,
128318
Meier, Christophe, Bruyères le
Châtel 128764
Meier, Corina, Kammerstein . . . 130396
Meier, David, San Antonio 136604
Meier, Dr. Helmut, Arth 116129
Meier, Erich-Franz, Hannover . . . 130317
Meier, Gisela, München 077493, 108168
Meier, H., Gutenzell-Hürbel 076081
Meier, Horst Dieter, Freiburg im
Breisgau 107021, 141711
Meier, Jack, Houston 121369
Meier, Karin, Mantel 077221
Meier, Michael Th., Bad Münder am
Deister 129655
Meierhofer, Arnulf, Salzburg . . . 128115
Meierhoff, Kansas City 093918
Meierimuseet, Institutt for
Næringsmiddelfag, Ås 033332
Meierische Museumboerderij,
Heeswijk-Dinther 032261
Meigle Gallery, Meigle 118926
Meigle Museum of Sculptured Stones,
Meigle 045163
Meignen, Christian, Gent 128307
Meigs County Museum, Pomeroy 052140
Meijer, Amsterdam 132788
Meijer, Utrecht 112796
Meijerimuseo, Saukkola 011165
Meijerink & Zoon, G.A.,
Enschede 083064, 132881
Meijerink, T., Visvliet 133034
Meiji, Tokyo 111474
Meiji-Daigaku Hakubutsukan,
Tokyo 029365
Meiji-Daigaku Kouko Hakubutsukan,
Tokyo 029366
Meiji-Daigaku Shouhin Hakubutsukan,
Tokyo 029367
Meiji Jingu Homotsuden, Tokyo . 029368
Meiji Memorial Picture Gallery,
Tokyo 029369
Meiji Shobo, Tokyo 142750
Meile, Urs, Luzern 116566
Meili, Herbert, Horgen 116475
Meincke Danielsen, Lone,
Gentofte 065622
Meindl & Sulzmann, Wien 140086
Meindl, P., Hofheim in
Unterfranken 076493, 130364
Meineche, Flemming, Ringkøbing 065996
Meinema, A., Enschede 083065
Meiners, Enschede 083066
Meinong Hakka Museum,
Meinong 042119
Meintzinger, Frickenhausen am
Main . 075850
Meir Dizengoff Museum, Tel Aviv 025039
Meire, Belo Horizonte 063855
Meire, Jean-Marie & Dominique,
Brugge 063226
Meirelles, Mauricio, Belo
Horizonte 063856, 128351
Meirelles, Miguel, Malvern,
Victoria 127908
Meise, Brigitta, Hamburg 141786
Meisel, Louis K. & Susan P., New
York . 123113
Meishan Farming Village Museum,
Meishan 042120
Meisinger, Helmut, Stadl-Paura . 062813,
128137
Meisnitzer, Heinz, Wien 128211
Meiso, Sendai 111400
Meissen Galerie, Berlin 106364
Meißener-Porzellan- und Christofle
Tafelsilber-Ausstellung- Schloß
Weyer, Gmunden 001940

Meissener Porzellan-Sammlung Sigrid
Pless, Bad Soden am Taunus . 016667
Meißener Porzellan-Sammlung
Stiftung Ernst Schneider,
Zweigmuseum des
Bayerischen Nationalmuseums,
Oberschleißheim 020568
Meissl, Gerhard, Bad Sauerbrunn 127981
Meissl, Gerhard, Rohrbach bei
Mattersburg 128100
Meissner, Praha 065438, 140489
Meissner & Neumann, Praha . 065439,
125695
Meissner, Hans, Meilen 116584
Meissner, Rose, Söhrewald 108638
Meißner, W., Tännesberg 078582
Meissner's Auction Service, New
Lebanon 127599
Gebr. Meister, Koblenz 076773
Meister-Götz, Brigitte, Hettstadt 107403
Meister, Michael, Ludwigsburg . 077095
Meisterhäuser Dessau, Dessau-
Roßlau 017633
Le Meitour, Portland . . 096273, 123890
Meiwald, Ingrid & Uwe,
München 108169
Meixner, Klaus, Würzburg 142339
Meja, Renate, Wenden 078834
Méjanès, Claude, Auzits 066800
Mejean, Christine & Gilles,
Perpignan 072046
Mejia Vallejo, Roxana, Medellín . 065209
Mejia, José Manuel, Medellín . . 065207
Mejia, Roxana, Medellín 065208
Mekaanisen Musiikin Museo,
Varkaus 011318
Mekanik, Antwerpen . . 100361, 140123
Mekong Gallery, Singapore 114651
Mel Fisher Maritime Heritage Museum,
Key West 049913
La Mela e il Serpente, Padova . 080824
La Melagrana, Massa 110224
Melaleuca Gallery, Anglesea . . . 098499
Melanchthonhaus Bretten,
Bretten 017392
Melanchthonhaus Wittenberg, Stiftung
Luthergedenkstätten in Sachsen-
Anhalt, Lutherstadt Wittenberg 019862
Melandie, Palermo 080890
Melanin, Baltimore 120033
Mélanson, Chantal, Annecy 103200
Melberg, Jerald, Charlotte 120281
Melbourne, London . . . 090173, 135057
Melbourne Antique Prints and Maps,
Camberwell 061249
Melbourne Art Fair, Melbourne . 097858
Melbourne Clocks Museum,
Hampton 001134
Melbourne Contemporary Arts,
Melbourne 118927
Melbourne Fine Art Gallery,
Melbourne 061815, 099180
Melbourne Hall, Melbourne 045164
Melbourne Maritime Museum, Home
of Polly Woodside, Southbank . 001506
Melbourne Museum of Printing,
Footscray 001073
Melbourne Museum, Museum Victoria,
Carlton South 000946
Melbourne Studio of Painting and
Drawing, Fitzroy 098884
Melbourne Tank Museum, Narre
Warren North 001340
Melbourne's Living Museum of the
West, Maribyrnong 001252
Melcher, Dirk, Monheim am
Rhein 077348
Melcher's, Gernot, München . . . 077494
Melchior, F., Merseburg 077287
Melchior, Karin, Kassel 117524
Melchiori, Anna, Genova 131719
Meldal Bygdemuseum, Trøndelag
Folkemuseum, Meldal 033596
Meldrum House, Whangarei . . . 084065

Melelli, Fernando, Trieste 081629
Melesi, Lecco 110178
Melet, Laurent, Macornay 069745
Meletta, Eric, München 077495
Melford Antique Warehouse, Long
Melford 090465
Melford Fine Arts, Long Melford 118846
Melford Hall, Sudbury, Suffolk . 045907
Melfort and District Museum,
Melfort 006160
Melgarejo Peñuela, Alonso,
Bucaramanga 102297
Melgosa Sanchez, Martin Sergio,
México 112042
Méli-Mélo, Minneapolis 094765
Meli-Melo, Montréal 101297
Méli-Melo, Saint-Macaire 072865
Meli-Melo Artist's Alliance, Hong
Kong . 058469
Melich-Mautner, Daniela, Wien . 062982
Melicharovo vlastivědné muzeum,
Unhošť 009774
Melin, Malmköping 086654
Melindre, São Paulo 064139
Melissa Publishing House,
Athinai 137673
Melk, Frans, Hilversum 142985
Melkowska, Grażyna, Szczecin . 113868
Mellado, San Lorenzo de El
Escorial 133776
Mellado Lopez, Jose Antonio,
Badalona 133448
Mellat Museum, Sa'd-Abad Museum,
Tehrān 024461
Melle & Sowada, Twistringen . . 078654
Mellemværftet, Nordmøre Museum,
Kristiansund 033546
Mellendorf, Peter, Lübeck 077119
Meller Merceux Gallery, Oxford . 119088
Meller Merceux Gallery, Witney . 119664
Mellerstain House, Gordon 044292
Mellette House, Watertown 054096
Melli Museum, Tehrān 024462
Mellier, Jean-Louis, Castillon-la-
Bataille 067662
Mellilän Museoriihi, Mellilä 010973
Mellilän Radio- ja Puhelinmuseo,
Mellilä 010974
Melling, K., Burnley 117626
Mellon Financial Corporation's
Collection, Pittsburgh 052078
Mellors & Kirk, Nottingham . . . 127247
Mellow, Honolulu 093395
Melngalvju nams, Rīga 111813
Melnick House Gallery, Ascot . . 117321
Melnikow, M., Heidelberg 076392
Meloche, Monique, Chicago . . . 120482
Melodia, Vincenzo, Firenze 131608
Mélodie du Temps, Paris 071607
Melody Art, Alresford 117300
Melody Art Studio, Tugun 099704
Melody's Antique, Chester 088645
Meløy Bygdemuseum, Ørnes . . . 033638
Meloni, Mauro, Cagliari 131468
Melori & Rosenberg, Venezia . . 111163,
111164
La Meloria, Livorno 080160
Meloun, Karel, Klášterec nad
Ohří . 102571
Melrose Abbey Museum,
Melrose 045168
Melrose Courthouse Museum,
Melrose 001281
Melrose House, Tshwane 038667
Melrose Lightspace, Los Angeles 121835
Melrose Plantation Home Complex,
Melrose 050707
Melrose Vintage, Phoenix 096060
Mel's Antiques, Baltimore 092179
Mel's Antiques, Kitchener 064282
Melse & Rietema, Groningen . . . 083114
Melsheimer, Hubertus, Köln . . . 076831
Melson, R., Kiel 076717
Melting Art, Limoges 069470

Melton Antiques, Woodbridge . . 091783
Melton Art Reference Library Museum,
Oklahoma City 051643
Melton Carnegie Museum, Melton
Mowbray 045170
Melton Park Gallery, Oklahoma
City . 123539
Meltons, London 090174
Meltzer, Neal, New York 123114
Melun Encheres, Melun 125917
Melusine, Asnières-sur-Seine . . 066702
Melville Discovery Centre,
Applecross 000799
Melville Heritage Museum,
Melville 006163
Melville Railway Museum,
Melville 006164
Melvin Art Gallery, Florida Southern
College, Dept. of Art, Lakeland 050047
Melvin B. Tolson Black Heritage
Center, Langston 050083
Melwood Photography Gallery,
Pittsburgh 123812
Melzer, Michael, Lüdenscheid . 141963
Mem-Erie Historical Museum,
Erie . 048555
Members Calender, New York . . 139461
Membrado, Buenos Aires 060905
Meme et Moi, Los Angeles 094240
Memelink, Alfred, Petone 113077
Memento Park Budapest, a
kommunista diktatúra gigantikus
emlékei, Budapest 023204
Memi Pasa Fürdoje, Pécs 023521
Mémin, Gilles, Le Mans 069252
Memme-Taadi Kamber, Karksi . . 010454
Memmed Seid Ordubadinin Xatire
Muzeyi, Memorial Museum of
Mammad Said Ordubady, Bakı 003083
Memmel, Fritz, Speyer 078442
Mémoire de la Nationale 7,
Piolenc 014674
Mémoire de la Photo, Donzère . 012626
Mémoire de Saumon, Petite Camargue
Alsacienne, Saint-Louis-la-
Chaussée 015225
Mémoire d'Enfance, Cannes . . . 067588
Mémoire du Livre, Paris 141205
Mémoire du Rhin, Petite Camargue
Alsacienne, Saint-Louis-la-
Chaussée 015226
La Mémoire du Temps, Bruxelles 063449
Mémoire du Temps, Byblos 082128
Mémoires, Rouen 141284
Memoires Antiguidade, Rio de
Janeiro 064029
Mémoires de Grenier, Vincennes 074207
Mémoires de Greniers, Fargues-Saint-
Hilaire 068450
Les Mémoires d'Obersoultzbach,
Obersoultzbach 014347
Memoirs of the American Academy in
Rome, New York 139462
Memoirs of the American Academy in
Rome, Roma 138887
Memoli Numismatica e Antiquariato,
Milano 080444
Memorabilia di Andrea Balloni,
Milano 080445
Memorable Treasures, Atlanta . . 119871
Memorear Antiguidades, Rio de
Janeiro 064030
Mémorial 1939–1945, Fort de
la Cité d'Alet, Saint-Malo (Ille-et-
Vilaine) 015238
Memorial Art Gallery of the University
of Rochester, Rochester 052518
Memorial Day Museum, Waterloo 054087
Le Mémorial de Caen, Caen . . . 012091
Mémorial de la Shoah, Musée,
Centre de Documentation Juire
Contemporaine, Paris 014478
Memorial de Sergipe, Aracaju . . 004228
Mémorial de Vendée, Musée du Logis

Memorijalna Zbirka Maksimilijana
Vanke, Hrvatska akademija Znanosti
i Umjetnosti, Korčula 008764
Memorijalni Muzej Džuro Jakšić,
Srpska Crnja 038069
Memorijalnyj Budinok-muzej D.
Javornic'kogo, Dnipropetrovskyj
deržavnij istoričnij muzej im
Javornic'kogo, Dnipropetrovs'k 042884
Memorium Nürnberger Prozesse,
Museen der Stadt Nürnberg,
Nürnberg 020508
Memory House Antiques, San
Francisco 097117
Memory Lane, Southwell 091239
Memory Lane, Sowerby Bridge . 091246
Memory Lane, Wellington 084042
Memory Lane Antique, Los
Angeles 094241
Memory Lane Antiques, Ascot
Vale 061055, 127833
Memory Lane Antiques, Great
Bookham 089165
Memory Lane Antiques, London 064298
Memory Lane Antiques, Lower
Stondon 090483
Memory Lane Antiques, Pomona 062078
Memory Lane Antiques, Regina . 064501
Memory Lane Antiques, San
Jose 097206
Memory Lane Antiques & Collectibles,
Malahide 079560
Memory Lane Collection,
Goodwood 061529
Memory Lane Museum at Seattle
Goodwill, Seattle 053122
Memory Lane Photographics,
Hastings 098968
Memory Lane Upholstery,
Calgary 128403
Memory Market, Oklahoma City 095829
Memoryville USA, Rolla 052568
Mempel, Dagmar, Vieselbach . . 108835
Memphis, Cairo 066179
Memphis Antique Market,
Memphis 094486
Memphis Belle B17 Flying Fortress,
Memphis 050717
Memphis Brooks Museum of Art,
Memphis 050718
Memphis Coin Gallery, Memphis 094487
Memphis College of Art,
Memphis 057383
Memphis College of Art Gallery,
Memphis 050719
Memphis Pink Palace Museum,
Memphis 050720
Memphis Plating Works,
Memphis 136132
Menage A Trois, Christchurch . 083708
Ménager, Benoît, Mürs-Erigné . 070351
La Ménandière, Alpe-d'Huez . . 066482
Menard Art Museum, Komaki . . 028694
Menard, Henri, Marseille 069897
Ménard, Hervé, La Chapelle-Saint-
Mesmin 068924
Menardi, Uta, Leiden 083250
Menarini, Giampiero, Bologna . 142457
Menart, Aude, Monpazier 104197
Menat, Roma 081285
Mencendorfa Nams – Rīdzinieku Māja-
Muzejs, Rīga 030034
Menczer Museum of Medicine and
Dentistry, Hartford 049347
Mende-Kohnen, Susanne,
Wiesbaden 131160
Mende, B. & F., Havixbeck . . . 107360
Mende, P., Binzen 074957
Mendel-Antiquariat, Berlin . . . 141484
Mendel Art Gallery, Saskatoon . 006817
Mendes, São Paulo . . . 140273, 140274
Mendès, Martial, Toulouse . . . 073745
Mendez, Vezin-le-Coquet 129570
Méndez, Marvia, Caracas 097825

Mendez, Oscar, Barcelona 133495
Mendl, Reinhard, Bad
Reichenhall 074533
Mendo, Amsterdam 112336
Mendocino Art Center,
Mendocino 057384
Mendocino Art Center Gallery,
Mendocino 050727
Mendocino County Museum,
Willits 054302
Mendoza, Caracas 125336
Mendoza Rodriguez, Hector,
Bogotá 065125, 065126
Menec, Helsinki 140677
Meneghel, Susanne, Wien 062983
Menem, Alex, Paris 105045
Ménendez, Claude, Fontiers-
Cabardès 068525
Ménendez, Pierre, Fontiers-
Cabardès 068526
Menez, Marie-Françoise, Aurillac 066768
Menezes, Gessy Geyer De, Porto
Alegre 100849
Menezes, Roberto, Miami 094601,
136149
Meng, Singapore 133400
Mengelmoes, Arnhem 082756
Menges, A., Oldenburg 077855
Menges & Söhne, Aloys,
Hannover 076323
Mengès, Christophe, Monbalen . 070099
Mengès, Gérard, Monbalen . . . 070100
Mengzhou Museum, Mengzhou . 007886
Menhir, Bern 143850
Menier Gallery, London 118670
Menikos, Menikou, Paphos . . . 065266
The Menil Collection, Houston . 049542
Menim Restorations, Langport . 134844
Las Meninas, Barcelona 085621, 085622
Menine, Millau 070069
Měnínská Brána, Muzeum města Brna,
Brno 009309
Menka-s Antiques, Clifton Hill . 061335
Menke, Chr.-Peter, Dortmund . 075342,
129961
Menkhaus, Antonius,
Georgsmarienhütte 107074
Mennello Museum of American Folk
Art, Orlando 051715
Mennickheim, Kassel 130422
Mennink, L.J., Amsterdam 082620
Mennitti, Guido, Firenze 131609
Mennonite Heritage Center,
Harleysville 049319
Mennonite Heritage Museum,
Goessel 049104
Mennonite Heritage Museum,
Rosthern 006677
Mennonite Heritage Village,
Steinbach 006906
Mennonite Historical Society of British
Columbia, Abbotsford 005205
Mennonite Library and Archives
Museum, North Newton 051524
Mennour, Kamel, Paris 105046
Menocal, Nina, México 112043
Menominee County Heritage Museum,
Menominee 050729
Menomonee Falls Antiques,
Milwaukee 094707
Menories Antiguidades, Rio de
Janeiro 064031
Menotti, Baden bei Wien 099827
Menotti, Croix 068190
Menozzi, Dr. Valeria, Modena . 131967
Menrad, W., Ladenburg 076928, 107766
Menssen, Norderstedt 108296
Menßen, J., Esens 075619
Mentjes, Meike, Berlin 129773
Mentlhof-Bergbauernmuseum,
Heiligenblut 002048
Mentor Graham Museum, Blunt 047030
Mentougou Huayang Antique,

Beijing 064947
MenTouGou Museum, Beijing . . 007444
Menu, Jean, Saint-Calais 072661
Menuiserie au Fil du Temps, Evaux et
Menil 068433
Menuiserie Claude, Giromagny . 128851
Menuiserie-Ebénisterie d'Art
Retrouvailles, Stadtbredimus . 082206,
132715
Menyea, Los Angeles 094242
Menzel, Christa & Werner,
Fürstenwalde 107041
Menzel, Galerie Nordafrika, Wien 062984
Menzel, Hermann, Hamburg . . 076218
Menzel, Manfred, Bad Honnef . 074491
Menzer Heimatstube, NaturParkHaus
Stechlin, Stechlin 021567
Menzerath, A., Simmerath 078394
Menzoyan, Marc, Saint-Andeol-le-
Château 072627
Meopham Windmill, Meopham . 045172
Mephisto Antiquariat, Paderborn 142139
Meppener Kunstkreis e.V.,
Meppen 059103
Mer & Découvertes, Bonifacio . 067230
La Mer les Bateaux, Noirmoutier-en-
l'Ile 070686
Mer Terre et Soleil, Sète 073475
Mera, Jaime, Santiago de Chile 101778
Meråker Bygdemuseum, Meråker 033597
Meramec Antiques, Saint Louis . 096573
Merano Arte – Kunst Meran, Galleria
d'Arte Contemporanea, Merano 026601
Merc & Cia, Sevilla 086283
Mercadante, Antonio, Torvilliers . 073652
Mercadé, Richard, Céret 067693
Mercader, Houston 093576
El Mercader de Venecia,
Badalona 085532
El Mercadillo de Salado, Sevilla 086840
Mercado, Brasilia 100778
Mercado das Pulgas Antiguidades, Rio
de Janeiro 064032
Mercado de Tesouros de Objetos Antigos,
Rio de Janeiro 064033, 128366
El Mercado del Mueble Usado, La
Plata 060938
Mercado Negro Antiguidades, Porto
Alegre 063929
Mercado Puerta de Toledo,
Madrid 115346
Mercador da Sé, Lisboa 084746
Il Mercante, Napoli 080732
Il Mercante d' Oriente, Verona . 081756
Il Mercante di Stampe, Milano . 142550
Mercantile Arts Centre Kintyre,
Tarbert 045943
Mercatino dell'800 e del '900,
Napoli 080733
Mercato dell'Antiquariato,
Brescia 079779, 142476
Mercato d'Epoca, Miami 094602
Mercato, Roberto, Claro 087188
Mercator, Utrecht 143057
Mercator Museum, Sint-Niklaas 003939
Mercatorfonds, Bruxelles 136939
Mercators Schrijn – Graventoren,
Rupelmonde 003909
Mercatu Arte, Belo Horizonte . 100755
La Merced, Bilbao 085703, 133555
Merced County Courthouse Museum,
Merced 050735
Mercedes-Benz Museum,
Stuttgart 021646
Mercer Art Gallery, Harrogate . 044370
Mercer County Genealogical and
Historical Society, Princeton . 052271
Mercer County Historical Museum,
The Riley Home, Celina 047458
Mercer County Museum, Mercer 050736
Mercer Gallery, Monroe Community
College, Rochester 052519
Mercer Museum of the Bucks County
Historical Society, Doylestown . 048328

Mercer Street Books and Records,
New York 145093
Mercer Union – Centre for
Contemporary Visual Art,
Toronto 007021
Mercer, Noel, Long Melford . . . 090466
Mercer, Thomas, London 090175
The Merchandise Mart International
Antiques Fair, Chicago 098293
Merchant Adventurers' Hall, York 046256
Merchant Gate Gallery, Glasgow 118048
Merchant House Antiques,
Honiton 089377
Merchant House Antiques,
Ipswich 089457
The Merchant of Welby, Welby . 062407
Merchant's House Museum, New
York 051338
Merchant's House Museum,
Plymouth 045472
Merchat, Gérard, Besançon . . . 067072
Merchionne, Loano 110204
Merchionne, Patrizia, Pietra
Ligure 110672
Mercier & Cie., Lille 125889
Mercier & Kalck, Paris 126013
Mercier Press, Blackrock, Cork . 137700
Mercier, Chantal, Clermont-
Ferrand 067976
Mercier, Gaëtan, Aubigny-sur-
Nère 066733
Mercier, Jean-Marie, Biarritz . . 067147
Mercier, Jean-Yves, Cholet . . . 067928
Mercier, Josiane, Saint-Geniez-
d'Olt 072752
Mercier, Michel, Marseille 069898
Mercièr, Thierry, Paris 105047
Merck hoe Sterck, Rotterdam . 133001
Mercorelli, Fabrizio, Roma 132360
Mercure, Toulon (Var) 073683
Mercuri & Talarico, Roma 132362
Mercuri, Giuseppe, Roma 132361
Mercurio Arte, Milano 110397
Mercurio Arte, Palermo 110629
Mercurio Arte, Rapallo 110714
Mercurio Arte Contemporanea,
Viareggio 111222
Mercurio, Th., Levallois-Perret . 069389
Mercurius, Almelo 082446
Mercury, London 090176
Mercury Bay and District Museum,
Whitianga 033190
Mercury Gallery, Boston 120174
Mercury Signs, Houston 121371
Merdøgård, Arendal 033328
Mere Antiques, Topsham 091471
Mere Museum, Mere 045173
Meredith, Baltimore 120034
Meredith Gallery, Baltimore . . . 046727
Meredith Palmer Gallery, New
York 123115
Merello, Massimo, Genova . . . 080103
Merenwijk, Leiden 112644
Mereside Books, Macclesfield . 135164,
144481
Merge, Auckland 112877
Mergen, G., Steinfurt 078466
Mergenthaler, Gerd, Wiesloch . 078916
Mergenthaler, Walter, Arnstein . 141367
Mergozzi, Ursula, Bad Wurzach . 129663
Merhaba, Ankara 087878
Meri-Valentino, Sofia 140289
Meriden Historical Society Museum,
Meriden 050738
Meridian Galerie, Zürich 087790, 134308
Meridian Gallery, San Francisco 124588
Meridian Gallery at Artstore,
Boston 117492
Meridian International Center – Cafritz
Galleries, Washington 054011
Meridian Museum of Art,
Meridian 050740
Meridian Street Antiques,
Indianapolis 093742

Lázních, Mariánské Lázně 009532
Mestské Múzeum v Pezinku,
 Pezinok 038240
Městské Muzeum ve Stříbře,
 Stříbro 009737
Městské Muzeum, Jihomoravské
 Muzeum Znojmo, Moravský
 Krumlov 009547
Městské Muzeum, Muzeum T.G.M.
 Rakovník, Nové Strašecí 009565
Městské Muzeum, Muzeum v Bruntále,
 Krnov 009492
Městské Muzeum, Odděleni Oblastni
 Muzeum Jihovýchodni Moravy,
 Napajedla 009553
Městské Muzeum, Okresní muzeum
 Kroměřížska, Holešov 009407
Městské Muzeum, Okresni Vlastivědné
 Muzeum Nový Jičín, Bilovec .. 009291
Městské Muzeum, Okresni Vlastivědné
 Muzeum Nový Jičín, Příbor ... 009692
Městské Vrbasovo Muzeum,
 Ždánice 009817
Mestský Vlastivedný Dom,
 Žitnoostrovné Múzeum Dunajská
 Streda, Šamorín 038263
Mesuret, Claude, Lesparre-
 Médoc 069383
Mesureur, Karine, L'Isle-sur-la-
 Sorgue 069525
Met Room, Barcelona 115025
Meta-Aesthetix, Port Melbourne 099455
La Métairie, Paris 071610
Metais, Claude, Compiègne ... 128810
Métais, Henri, Rouen . 072563, 141285
Metal, Warszawa 113953
Metal Art Company, San
 Francisco 136672
Metal Art Studio, New York 095413,
 136304
Metal Arts, Vestavia Hills ... 136774
The Metal Arts Guild, Toronto . 101526
Metal at Edge Hill Station,
 Liverpool 060138
Metal Maddness Art Gallery, Salt Lake
 City 124222
Metallhandwerksmuseum, Steinbach-
 Hallenberg 021576
Metallmuseum, Tullnerbach-
 Lawies 002782
Metalocus, Madrid 139106
Metamora Courthouse,
 Metamora 050752
Metamorforse, Amsterdam 142865
Metamorphis, Ashburton 117326
Metamorphosis Church Museum,
 Meteora 022804
Metaphores, Nijmegen 083328
Metaphysical Art Gallery, Taipei . 117005
Metaphysical Book Store Center,
 Denver 144868
Metára, Rio de Janeiro 100911
Metaux Précieux, Aix-en-
 Provence 066411
Métaux Précieux, Carpentras .. 067638
Métayer, Jean-Jacques, Mérignac
 (Charente) 070018
Métayer, Marie-Antoinette, Paris 071611
Metcalfe-Hofmann, Deal 117834
Metchosin School Museum,
 Victoria 007153
Meteor Crater, Museum of
 Astrogeology, Winslow 054360
Meteorkrater-Museum, Steinheim am
 Albuch 021585
Methe, Reiner, Ringgau 078160
Methil Heritage Centre, Methil . 045179
Methmann & Co., Hamburg ... 076219
Metiers d'Art Sant Roch, Céret . 012199
Les Métiers du Champagne, Musée
 de la Cave des Champagnes de
 Castellane, Épernay 012688
Metis, Amsterdam 112337
Metivier, Nicholas, Toronto 101527

Metlewicz, Dr. Thomasz, Wien . 062985
Métra, Raoul, Autun 066779
Metras, Rene, Barcelona 115026
Métraux, Raynald, Lausanne .. 116518
Metro 5 Gallery, Armadale,
 Victoria 098516
Metro Antiques, New York 095414
Metro Antiques, Philadelphia ... 095973
Metro Art, New York 123118
Metro Arts, Brisbane 000888
Metro Furniture, Mumbai 079298
Metro Gallery, New York 095415
Metro Pictures, New York 123119
Metro Retro, Dallas 093009
Metrocoins, Pirmasens 077971
Metroform, Tucson 125004
Metrolina Antiques, Charlotte .. 092450
Metrònom, Barcelona 115027
Metrònom, Fundació Rafael Tous d'Art
 Contemporani, Barcelona ... 038882
Metropolart, Paris 105048
Metropole Gallery, Folkestone .. 044186
Metropolis, Bordeaux 067289
Métropolis, Lyon 104069
Métropolis, Paris 071612, 105049
Metropolis M, Utrecht 138976
Metropolitan Antique Gallery,
 Denver 093152
Metropolitan Antiques, New York 095416
Metropolitan Arts Centre MAC,
 Belfast 117422
Metropolitan Arts Institute,
 Phoenix 057638
Metropolitan Gallery, Austin ... 119963
Metropolitan Garage Door,
 Milwaukee 094708
Metropolitan Graphic Art Gallery, New
 York 123120
Metropolitan Home, Vancouver . 064793
The Metropolitan Museum of Art, New
 York 051339
Metropolitan Museum of Art Bulletin,
 Middle Village 139464
Metropolitan Museum of Art Journal,
 New York 139465
Metropolitan Museum of Art, Special
 Publications, New York 138460
Metropolitan Museum of Manila,
 Manila 034367
Metropolitan Pavilion, New York 095417
Metropolitan Police Heritage Centre,
 London 044944
Metropolitana Leiloeira, Porto . 126676
Métrot, André, Paris . 071613, 071614
Metsamor Museum, Metsamor . 016195
Metsers, G.L., Den Haag 112487
Metta, Madrid 115348
Mettchen, Dieter, Darmstadt .. 075260
Mettlach Steinzeugsammler e.V.,
 Rehlingen-Siersburg 059104
Metz Collection, Pierrevillers .. 072118
Metz de Benito, München 077496
Metz-Noblat, Bertrand de, Nancy 070375
Metz von Tessin'sche
 Kutschensammlung, Starzach . 021560
Metz, Hilde, Antwerpen 100362
Metz, J. & M., Heidelberg ... 076393,
 126231
Metze, Manfred, Blankenrath .. 129849
Metzen, T., Tübingen 078641
Metzgalerie, Koblenz 107561
Metzger, A., Kielce 143274
Metzger, Jean-Pierre, Prunières . 072278
Metzger, Marcel, Pouancé 072252
Metzgermuseum Zunft zum Widder,
 Zürich 041936
Metzner, Bernd, Seevetal 108612
Metzner, Eberhard, Mainz 077180
Meubelmakerij G. de Reus,
 Amsterdam 132789
Meubles & Cie, Orvault 129114
Les Meubles d'Antan, Mehun-sur-
 Yèvre 069987
Meubles d'Art, Pully 087546

Meubles d'Art Chartres, Ribérac 072415
Meubles d'Autrefois, Augy 066751
Meubles d'Autrefois, Besançon . 067073
Meubles Décennies 30'a 70',
 Québec 064484
Meubles d'Hier et d'Aujourd'hui,
 Poilley 072172
Meubles et Objets en Périgord, Piegut-
 Pluviers 072112
Meubles la Merisière, Fréjus ... 068550
Meubles Oubliés, Vanier 064846, 128480
Meubles Ray, Québec 064485
Meubles Style Restauration,
 Bonne 128717
Meubl'Occase, Montpellier 070256
Meugnier, Jean-Louis, Cordes-sur-
 Ciel 068094
Meunier, Franck, Ferney-Voltaire 103689
Meunier, Jacqueline, Saint-Martin-de-
 Gurson 072892
Meunier, Jean-Jacques, Jarnac . 068840
Meunier, Marie-Yolande,
 Toulouse 129533
Meunier, Patrice, Bordeaux .. 128738
Le Meur, Dijon 140793
Meurier, Jocelyne, Nîmes 070649
Meuron, Anita, Honolulu 121231
Meurs, I.J.A., Leiden 142994
Meuschel, Konrad, Bad Honnef . 141378
Meuseu d'Historia de València,
 Palacio del Marqués de Campo,
 Valencia 040113
Meux Home Museum, Fresno .. 048943
Mevagissey Fine Art, Mevagissey 118935
Mével, Jacques, Plouech 072167
Mével, Jacques, Trébeurden .. 073834
Mevel, Jean-Pierre, Toulon (Var) 073684
Mevlânâ Müzesi, Konya 042738
Mevlevi Tekke Müzesi, Lefkoşa . 033300
Mewes, Lübeck 077120
Mews, Dallas 093010, 093011
Mews Antique Emporium, Holt,
 Norfolk 089355
Mews Antiques, Bromsgrove .. 088466
Mexic-Arte Museum, Austin ... 046665
Mexican Gallery, Dallas 120907
The Mexican Museum, San
 Francisco 052905
México en el Tiempo, Miguel
 Hidalgo 138958
Mey, Jürgen, Geldern 107063
Meyer, Aesch 143815
Meyer, Ahaus 074323
Meyer, Marseille 104139
Meyer, Paris 071615, 105050
Meyer, Recklinghausen 078075
Meyer & Deubert, Neustadt an der
 Weinstraße 108270
Meyer Boswell, San Francisco . 145301
Meyer-Buhr, Ute, Nürnberg ... 130834
Meyer-Dommert, M., Berlin ... 129775
Meyer-Lindenberg, Reinhard,
 Lehrte 076987
Meyer-Oceanic Art, Berlin 071619
Meyer Riegger GmbH, Karlsruhe 107503
Meyer, Alexander, Sankt Martin . 078275
Meyer, Antje & Andreas,
 Artlenburg 074388
Meyer, Claude, Paris 071616
Meyer, Don, Dallas 093012
Meyer, Dr. Claus-Peter, Aachen 074305
Meyer, Françoise, Hamburg .. 076220
Meyer, H. Jürgen, Lüneburg ... 107918
Meyer, Harald, Passau 142143
Meyer, Harry, Hamburg 076221
Meyer, Harry, Reinbek 078106
Meyer, Jean-Claude, Paris ... 071617
Meyer, Jutta, Lüneburg 107919
Meyer, Karlheinz, Karlsruhe ... 107502
Meyer, Marion, Paris 105051
Meyer, Martin, Nürnberg 130833
Meyer, Michel, Nice 140963
Meyer, Michel, Paris 071618
Meyer, Philippe, Vevey 143932

Meyer, Rainer F., Berlin 141486
Meyer, Rolf, Marienberg 077234
Meyer, Thomas, Regensburg .. 142168
Meyer, Thomas V., San Francisco 097118
Meyerdiercks, Peter, Hamburg . 076222
Meyerhof Scheeßel, Scheeßel .. 021246
Meyerovich, San Francisco 124589
Meyerowitz, Ariel, Long Island
 City 121694
Meyniel, Georges, Laval
 (Mayenne) 069148
Meynier, Maria-Hélène, Toulouse 073746,
 129534
Meysenburg, Ulrich F., Essen .. 141660
Meysey-Thompson, Sarah,
 Woodbridge 091784
Meystre, Catherine Noëlle, Zürich 116916
Meža Muzejs Boju Piļi, Aizpute . 029923
Mézaute, Michel, Lalinde 069090
Meždunarodna Restavracija,
 Ruse 100996
Meždunarodnaja Chudožestvennaja
 Jarmarka, Moskva 098127
Meždunarodnaja Vystavka Architektury
 i Sredovovo Disajna, Moskva . 098128
Meždunarodnaja Vystavka-Prodaža
 Živopisi, Grafiki, Skulptury i Izdelij
 Dekorativno-Prikladnogo Iskusstva,
 Perm 098129
Meždunarodnyj Centr-Muzej im. N.K.
 Rericha, Moskva 037170
Meždunarodnyj Muzejno-vystavočnyj
 Centr, Primorskij gosudarstvennyj
 muzej im. V.K. Arseneva,
 Vladivostok 037859
Mèze, Yoland, Tavel 073592
Mézédes emlékeink – Mézeskalácsos,
 Cukorka- és Gyertyakészíto Múzeum,
 Szekszárd 023623
Mézerac, Arnaud de, Caen 103436
Mezőgazdasági Tájmúzeum – Holland-
 ház, Dég 023277
Mezőföldi Tájház, Dég 023278
Mezogazdasági és Élelmiszeripari
 Szakképzo Intézet,
 Szabadkígyós 023585
Mezogazdasági Eszköz- és
 Gépfejlodéstörténeti Szakmúzeum,
 Szent István Egyetem, Gödöllő 023322
Mezőgazdasági Gépmúzeum,
 Mezőkövesd 023454
Mezogazdaságtudományi Kar Történeti
 Múzeum, Nyugat-Magyarországi
 Egyetem, Mosonmagyaróvár .. 023476
Mezohegyesi Állami Ménes
 Kocsimúzeuma, Mezőhegyes .. 023451
Mezquita Catedral de Córdoba,
 Córdoba 039116
Mezzacqui, Costante e Tino,
 Modena 080641, 142571
Mezzani, Giuseppe, Verona ... 081757
Mezzanin, Wien 100219
Mezzanine, Cleveland 092789
La Mezzanine, Montréal 101298
The Mezzanine Gallery, The
 Metropolitan Museum of Art, New
 York 051340
Mezzomonaco, Pascal, Lyon .. 128958
MFA Circle Gallery, Maryland
 Federation of Art, Annapolis .. 119806
MFA City Gallery, Maryland Federation
 of Art, Baltimore 120035
MFF, Saint-Paul-de-Vence 105548
MFK Mund- und Fußmalende Künstler
 Verlag GmbH, Stuttgart 137631, 138777
MG Artes, Fortaleza 063891
MGJ Jewellers, Wallingford .. 091569
MGM Galeria, Warszawa 113954
MGM Münzgalerie München,
 München 077497
MGM Studio, Roma 110843
MGS & NSI, Minneapolis 094766
MH, Châteaurenard (Bouches-du-
 Rhône) 067841

Lauingen 019605
Mineralienschau, Vohenstrauß . . 021938
Mineralienzentrum Steinstadel,
Aggsbach Dorf 001684
Mineralogical Museum of Harvard
University, Cambridge 047330
Mineralogical Museum of Kamarzia,
Attica 022628
Mineralogical Museum of Lavrio,
Lavrio 022777
Mineralogičeskij Muzej im. A.E.
Fersmana Rossijskoj Akademii Nauk,
Moskva 037171
Mineralogičeskij Muzej im. A.V.
Sidorova, Irkutsk 036855
Mineralogičeskij Muzej Moskovskoj
Geologorazvedyvatelnoj Akademii,
Moskva 037172
Mineralogičeskij Muzej, Geologičeskij
institut Kol'skogo naučnogo centra
RAN, Apatity 036686
Mineralogické muzeum – PřF-UK,
Přírodovědecká fakulta Univerzity
Karlovy v Praze, Praha 009644
Mineralogisch-Geologisch Museum,
Delft 031983
Mineralogisch-Geologische Gesteins-
Sammlung, Schwarzenfeld . . . 021378
Mineralogisch Museum, Grou . . 032207
Mineralogisch Museum, Academy for
Mineralogy, Merksem 003787
Mineralogisch-petrographische
Sammlung der Universität Leipzig,
Leipzig 019665
Mineralogische Sammlung,
Tübingen 021813
Mineralogische Sammlung der
TU Bergakademie Freiberg,
Freiberg 018203
Mineralogisches Museum (Kristalle
und Gesteine), Universität Münster,
Münster 020251
Mineralogisches Museum am
Steinmann-Institut, Universität Bonn,
Bonn 017279
Mineralogisches Museum der Philipps-
Universität Marburg, Marburg . 019935
Mineralogisches Museum der
Universität Hamburg, Hamburg 018712
Mineralogisches Museum der
Universität Würzburg, Würzburg 022373
Mineralogisches Museum Oberkirchen,
Freisen 018233
Mineralogy Museum, Bangkok . 042392
Mineralovodskij Kraevedčeskij Muzej,
Mineralnye Vody 037053
Mineralų Muziejus, Geologijos ir
geografijos institutas, Vilnius . . 030363
Minerva, Trieste 111074
Minerva Antik, Malmö 086669
Minerva Antiques, London 090184
Minerva Editrice, Assisi 137714
Minerva Quilt Centre, Llanidloes 118374
Minerva Restauri, Milano 131870
Minerva, The International Review
of Ancient Art and Archaeology,
London 139237
Minerva's Antiques, Birmingham 092257
Minerve, Toulon (Var) 073686
Minervini, Giorgio, Roma 081288
Mines d'Asphalte de la Presta,
Travers 041807
Mines de Sel de Bex, Bex 041125
Minet Frères, Woluwe-Saint-
Pierre 140229
Ming, Cincinnati 120639
Ming, Honolulu 093397
Ming, Shenzhen 102132
Ming Art, Bad Zwischenahn . . . 074584
Ming Art Gallery, Beijing 101845
Ming-Ching, Singapore 085295
Ming Direct, Waikato 083995
Ming Direct, Weikato 084019
Ming Furniture, New York 095420

Ming Gallery, Louisville 094409
Ming-K'I, Waardamme 063798
Ming Mai, Santa Monica 097218
Ming og Qing, Charlottenlund . . 065560
Ming Qing Antiques, Shanghai . 065058
Ming Qu Antique House, Ipoh . 082213
Ming Qu Antique House, Klang . 082214,
082215
Ming Things, Ottawa 064455
Ming Tong, Lille 103962
Mingardi, Gianfranco, Brescia . 131437
Mingazzini, Michela, Roma . . . 081289
Mingboy, Singapore 085296
Mingcheng Yuan Shi Museum,
Nanjing 007914
Mingei, Atlanta 091994
Mingei International Museum, San
Diego 052861
Mingei International Museum, North
County Satellite, Escondido . . 048567
Mingenback Art Center Gallery,
Lindsborg 050265
Mingenew Museum, Mingenew . 001296
Ming's Gallery, Hong Kong . . . 101979
Mingshan Chashi Museum,
Mingshan 007890
Mingus, Praha 140490
Mingus, Umeå 143793
Mingxi Museum, Mingxi 007891
Minh, Chau, Ha Noi 125365
Minhauzena Muzejs, Dunte . . . 029946
Minhe Hui Tuzu Self-Rule Museum,
Minhe 007892
Minhwa, Paris 071630
Mini-Château, Amboise 011440
Mini Galeria Destellos, San
Salvador 103044
Mini-Mint of Tucson, Tucson . . 097512
Mini-Musée, Habsheim 013033
Mini-Musée Architectural,
Charnat 012274
Mini Musée des Miniatures,
Sospel 015636
Mini Print International de Cadaqués,
Cadaqués 098151
Mini Rastro Casavella, Vigo . . . 086387
Miniaci Art Gallery, Milano 110400
Miniatur Wunderland Hamburg,
Hamburg 018713
Miniaturbuchverlag Leipzig,
Geschäftsbereich der Wartelsteiner
GmbH, Simbach am Inn 137618
Miniature Books Museum, Bakı . 003084
Miniature Magic, Austin 092087
Miniatures, Lyon 128959
Miniatures Museum of Taiwan,
Taipei 042250
Miniaturmuseum Arikalex, Berlin 017001
Miniaturpark Klein-Erzgebirge,
Oederan 020595
Miniatuur Walcheren, Middelburg 032470
Miniatuurstad, Antwerpen 003213
Minigallery.Co.Uk, Thornton
Heath 119504
Minilista, F., Miami 122108
Minimotor Muzejs, Rīga 030035
Minimundus, Klagenfurt 002162
Minimuseum, Groningen 032202
The Mining Museum, Platteville . 052104
Minion, Kyoto 081861
Miniota Municipal Museum,
Miniota 006196
Minischeepvaartmuseum,
Ouwerkerk 032578
Minisink Valley Historical Society
Museum, Port Jervis 052161
Minjasafn Austurlands,
Egilsstaðir 023751
Minjasafn Egils Ólafssonar,
Patreksfjörður 023768
Minjasafnið Burstarfelli,
Vopnafjörður 023802
Minjasafnið á Akureyri, Akureyri 023740

Minkler, Thomas, New York 095421,
145095
Minlaton National Trust Museum,
Minlaton 001297
Minle Museum, Minle 007893
Minna Street Gallery, San
Francisco 124592
Minnamoora, Wanniassa 062396
Minneapolis College of Art and Design,
Minneapolis 057420
Minneapolis Institute of Arts,
Minneapolis 050876
Minneapolis Institute of Arts. Annual
Report, Minneapolis 139467
Minneapolis Uptown Antiques,
Minneapolis 094768
Minnedosa and District Museum,
Minnedosa 006197
Minnenas Bod, Göteborg 086526
Minnesota Air National Guard
Museum, Saint Paul 052744
Minnesota Association of Museums,
Minneapolis 060589
Minnesota Children's Museum, Saint
Paul 052745
Minnesota Historical Society Museum,
Saint Paul 052746
Minnesota Museum of American Art,
Saint Paul 052747
Minnesota Pioneer Park Museum,
Annandale 046465
Minnesota State Capitol Historic Site,
Saint Paul 052748
Minnesota Transportation Museum,
Saint Paul 052749
Minnette, Los Angeles 094246
Minnick, Honolulu 135929
Minnie's Thirteen Forty One,
Jacksonville 093849
Minnilusa Pioneer Museum, Rapid
City . 052377
Mino, Alain, Beinheim . 067006, 128708
Mino, Alvaro, Roma 081290
Minokamo-shiritsu Hakubutsukan,
Minokamo 028842
Minoletti, Gianfranco, Genova . 080104,
131721
Minoletti, Marco, Genova 131722
Minoriten Galerien, Graz 099874
Minority Arts Resource Council Studio
Art Museum, Philadelphia . . . 051976
Minot, Paris 071631
Le Minotaure, Alger 060824
Le Minotaure, Paris . . . 071632, 105054
Minotauro, La Spezia 101172
Minotauro, Roma 081291, 132363
Minouche, Marin-Epagnier 116579
Minqin Museum, Minqin 007894
Minqing Museum, Minqing 007895
Minski, H., Gummersbach 076073
Minsky, Paris 105055
Minssen, Ile-Tudy 103801
Minster Abbey Gate House Museum,
Minster-in-Sheppey 045205
Minster Abbey Gatehouse Museum,
Sheerness 045745
Minster Books, Wimborne
Minster 135587, 144666
Minster Gate Bookshop, York . 135626,
144683
Mint Museum, Osaka 029067
Mint Museum of Art, Charlotte . 047539
Mint Museum of Craft and Design,
Charlotte 047540
Mint, Franklin, Las Vegas 093997
Mintage, Mumbai 109471
Mintai Tieshi Museum, Quanzhou 008013
Minten, Kees, Beers bij Cuyk . 132815
Minter Field Air Museum, Shafter 053165
Mintmaster, Atlanta 091995
Minto Museum, Minto 006198
Minton, Damien, Newcastle . . . 099300
Minton, Joseph, Dallas 093015
Mintsas, Theodoros, Athinai . . . 079079

Les Minuscules, Marseille 069899
Minusinskaja Chudožestvennaja
Kartinnaja Galereja, Minusinsk 037056
Minusinskij Regionalnyj Kraevedčeskij
Muzej im. N.M. Martjanova,
Minusinsk 037057
Minut Init Art Space, Petaling
Jaya 111978
Minute Man, National Historical Park,
Concord 047916
Minx, Dr. Rainer, Wünsdorf . . . 142336
Minxi Revolution History Museum,
Minxi 007896
Minymaku Arts, Amata 060987
Minzoku Shiryokan, Miyama . . . 028855
Miqueleiz, Pamplona . . 086217, 143598
Mir, Sankt-Peterburg 143479
MIR Appraisal Services, Chicago 092586
Mir Dizajna, World of Design, Sankt-
Peterburg 139055
Mir-Emad Calligraphy Museum, Sa'd-
Abad Museum, Tehrān 024464
Mir i Muzej, Tula 139056
Mir Iskusstv, Moskva 085022
Mir Iskusstv, Vinnycja 117230
Mir Russki, Linlithgow 089645
Mira Antique, Bucureşti 084930
Mira Fine Art Gallery, Melbourne 061816
Mirabeau, Houston 093580
Mirabeau, Paris 105056, 129320
Mirabella, Giacomo, New York . 136307
Mirabella, Patrizia, Napoli 080734
Mirabilia, Roma 110845
Mirabilia, Venezia 111165
Miracle Metal, Cleveland 135820
Miracle of America Museum,
Polson 052139
Mirage, Douglas 139468
Mirage, Kraków 113704
Mirage Art Gallery, Delhi 109346
Mirage Studio, Cleveland 120719
Miraglia, Salvador, Lyon 140886
Mirakhore, Esther, Les Acacias . 086994
Mirakov, Jurij, Moskva 114361
Miralles Guillen, Vicente H.,
Valencia 133823
Miramar Zeemuseum, Vledder . 032811
Miramichi Natural History Museum,
Miramichi 006200
Miramón Kutxa Espacio de la Ciencia,
Donostia-San Sebastián 039162
Miramont Castle Museum, Manitou
Springs 050583
Miramont, Céline, Les Ternes . . 069376
Miranda Libreria, Madrid 143583
Miranda Sáchez, Santiago de
Chile 064923, 128497
Miranda, Dino, Roma 081292
Miranda, Jorge, Paris 129321
Miranda, Miguel, Madrid 143582
Miranda, Roberto, San Isidro . . 060951
Mirandas, Carmen, Salt Lake
City . 096743
Mirande, Bernard, Fortaleza . . . 100814
Mirani, Bucureşti 084931
Mirari, Windsor, Ontario 101722
Miras, Moskva 114362
Miras, Ufa 114455
Mira's Antik, Ingelheim am Rhein 076544
Mirasaka Peace Museum of Art,
Mirasaka 028843
Mirate, Francesco, Venezia . . . 081693
Mire, New Orleans 094966
Mirehouse, Keswick 044548
Mirer, R., Obersaxen Affeier . . . 116640
Mireuksa Temple Museum, Iksan 029774
Mireya, Buenos Aires 139619
Miri Antique, Berlin 074837
MIRI-Antiquitäten, Berlin 074838
Miri Interior, Berlin 074839
Miriam and Ira D. Wallach Art Gallery,
New York 051341
Miriam Switching Post, Saint
Louis 096577

Miyandoab Museum, Miyandoab 024419
Miyashita, Sapporo 111390
Miyawaki, Ichiro, Kyoto 111316
Miyazaki-ken Sogo Hakubutsukan,
 Miyazaki 028858
Miyazaki-kenritsu Bijutsukan,
 Miyazaki 028859
Miyazawa Kenji Kinenkan,
 Hanamaki 028422
Miyoshi, Kobe 081829
Miyuki, Tokyo 111481
MIZ, Seoul 111740
Mizel Museum, Denver 048229
Mizener, Hamilton 064269
Mizener, Toronto 064651
Mizon, Maree, Paddington, New South
 Wales 099396
Mizu-to-Midori-no Fureaikan,
 Okutama 029040
Mizuhomachi Kyodo Hakubutsukan,
 Mizuho 028863
Mizuma, Tokyo 111482
Mizunami-shi Kaseki Hakubutsukan,
 Mizunami 028864
Mizunami Toji Shiryokan,
 Mizunami 028865
Mizuno, West Hollywood 125262
Mizzi, Marsa 082232
Mjellby Konstmuseum, Halmstad 040488
MJM Antiques, Hungerford 089417
MJM Arte Antigo, São Paulo . . . 128376
MJM Global Arts, Bruxelles 063452
Mjölby Hembygdsgård, Mjölby . . 040647
Mjøssamlingene, Minnesund . . . 033598
Mjs Antiques, Tauranga 083962
MK Fine Art, New York 123139
MK Galerie, Rotterdam 112739
MK Kunst Galerie, Mülheim an der
 Ruhr 108020
MKG Art Management, Houston . 121377
MKJ Art Gallery, New York 123140
MKM – Museum Küppersmühle für
 Moderne Kunst, Duisburg . . . 017819
Mkrtchyan, A.H., Yerevan 098455
MLA West Midland, Regional Council
 for Museums, Libraries and Archives,
 Birmingham 060140
Mladinska Knjiga, Ljubljana 138036,
 143505
MLD, Saint-Ouen 073115
Mleczko, Andrzej, Kraków 113705
MM Galerie, Grebenstein 107114
MM Project, Karlsruhe 107504
MME Fine Art, New York 095426
MMK – Museum für Moderne Kunst
 Frankfurt am Main, Frankfurt am
 Main 018171
MMK 2 – Museum für Moderne Kunst
 Frankfurt am Main, Frankfurt am
 Main 018172
MMK 3 – Zollamt, Museum für
 Moderne Kunst Frankfurt am Main,
 Frankfurt am Main 018173
MMST Galerie, Thessaloniki . . . 109106
MNAC Publications, Barcelona . 138057
MNATP – Musée National des Arts et
 Traditions Populaires, Alger . . 000038
MO-Artgallery, Amsterdam 082621
Mo Lan, Beijing 101846
Mo Tu Uv – Museum of Mechanical
 Toys, Ulaanbaatar 031545
Mo Yuan Ge, Beijing 101847
MOA, Paju 111637
MOA Bijutsukan, Atami 028313
Moanalua Gardens Foundation,
 Honolulu 049498
Moat Park Heritage Centre,
 Biggar 043361
Moatti Fine Arts, London 118676
Moatti, Alain, Paris . . 071634, 105058
Moatti, Emmanuel, Paris 105059
Moaven Al- Molk Museum,
 Kermanshah 024405
Moba, Bruxelles 100503

Mobach Keramiek Museum,
 Utrecht 032765
Mobbs, Annette, Sandgate 091092
Mobèche, Pablo, La Tine 087652
Moberg, Kristinehamn 086606
Moberg, Bert, Borås 143629
Mobilart C & R, Montréal 128431
Mobile Books, Lomma 143690
Mobile Medical Museum, Mobile 050905
Mobile Museum of Art, Mobile . 050906
Mobiles Kindermuseum im
 Freizeitheim Vahrenwald,
 Hannover 018762
Mobili & Oggetti della Nonna,
 Roma 081294
Mobilia-Auto- ja Tiemuseo,
 Kangasala 010782
Mobilia International, Verona . . . 081758
Mobilier des Vallées de l'Himalaya,
 Aussois 066771
Mobilus, Strasbourg 129499
Mobius, Boston 120178
Mobius Gallery, Boston 047088
Mobles Monthy, Sabadell 115494
Mobydick Antiquités, Saint-Malo (Ille-
 et-Vilaine) 072880
MOCA Museum of Contemporary Art,
 Bangkok 042393
Mocenni, M., Den Haag 082918
Mockbeggar Plantation,
 Bonavista 005336
Mockler, Stephen,
 Berchtesgaden 129683
Mocko, H., Esslingen 075663
Mocny, L., Lindlar 107869
Moda, Buffalo 092382
Moda, San Francisco 097121
Modalen Skulemuseum, Modalen 033601
ModAnOn.de – Modernes Antiquariat
 Online, Hannover 141812
Mode Moderne, Philadelphia . . . 095976
Modelbouwmuseum, Wassenaar 032845
Modell Ältre, Stockholm 086844
Modellbahnmuseum-Muggendorf,
 Wiesenttal 022230
Modellbaumuseum, Büdingen . . 017436
Modello, A., Paris 105060
Modellpark Mönichkirchen,
 Mönichkirchen 002364
Modell's Restoration, New
 Orleans 136212
Modemuseum Feigel, Ehingen . . 017862
Modemuseum im Schloss
 Ludwigsburg, Landesmuseum
 Württemberg, Ludwigsburg . . 019794
Modemuseum Provincie Antwerpen,
 Antwerpen 003214
Modemuseum Schloss Meyenburg,
 Meyenburg 020057
Moder Nena, Santiago de Chile . 064924
Modern & Antique Clock Repair,
 Dallas 135861
Modern Art, Argelès-sur-Mer . . . 103221
Modern Art, Chicago 092587
Modern Art, Mechelen 100652
Modern Art, Tokyo 111483
Modern Art and Showbusiness
 Academy, Tbilisi 055376
Modern Art Auctions, London . . 127204
The Modern Art Gallery, Belfast . 117423
Modern Art Gallery, Karlsruhe . . 107505
Modern Art Gallery, Los Angeles 121838
Modern Art Gallery, Singapore . . 114655
Modern Art Gallery, Taichung . . 116971
Modern Art Gallery, Trondheim . 113389
Modern Art Museum of Fort Worth,
 Fort Worth 048865
Modern Art Oxford, Oxford 045399
Modern Art Oxford Bookshop,
 Oxford 144519
Modern Art Products, Hong Kong 101980
Modern Art Research Institute, Academy
 of Arts of the Ukraine, Kyiv . . 056452,
 138191

Modern Artifacts, San Francisco 097122
Modern Artist Gallery, Whitchurch-on-
 Thames 119629
Modern at Sundance Square, Fort
 Worth 121159
Modern Day, Miami 136150
Modern Fuel Artist – Run Centre,
 Kingston 005984
Modern Gallery, Hyderabad . . . 109380
Modern House, Cleveland 092790,
 120721
Modern Hut, Houston 093581
The Modern Institute, Glasgow . 118049
Modern Magyar Képtár I, Janus
 Pannonius Múzeum, Pécs . . . 023522
Modern Magyar Képtár II, Janus
 Pannonius Múzeum, Pécs . . . 023523
Modern Masters Gallery, San
 Francisco 124594
Modern Mural Arts Institute,
 Atami 111256
Modern Painters, London 139238
Modern Painting & Framing,
 Ottawa 101340
Modern Primitive Gallery, Atlanta 119872
Modern Sculpture.com, San
 Francisco 124595
Modern Studio, Bruxelles 063453
Modern Time Antique, Vancouver 064795
Modern Times, Chicago 092588
Modern Woodworking, Louisville 136110
Moderna Galerija, Ljubljana . . . 038369
Moderna Galerija, Podgorica . . . 031578
Moderna Galerija, Valjevo 038074
Moderna Galerija, Zagreb 008878
Moderna Möbelklassiker, Malmö 086670
Moderna Museet, Stockholm . . . 040822
Moderna Museet Butik,
 Stockholm 138105, 143764
Modernaire, Oakland 095738
Modernariato, Milano 110401
Moderne, Amsterdam 112338
Moderne Antiques, Los Angeles 094247
Moderne Galerie im Museum Krems,
 Krems 002202
Moderne Gallery, Philadelphia . . 095977,
 123673, 145155
Modernism, Saint-Ouen 073116
Modernism, San Francisco 124596
Modernism Gallery, Miami 094608
Modernism, A Century of Art and
 Design, New York 098298
Il Modernista, Bologna 131381
Modernista, Praha 065441
Modernity, New York 123141
Modernpast, San Francisco 097123
Modernt och Antikt, Järfälla . . . 086569
Modes & Dugardyn, Bruxelles . . 063454
Modestie, Deauville 068227
Modified Art Gallery, Phoenix . . 052028
Modified Arts, Phoenix 052029
Modique Antiques, Vancouver . . 064796
Modjopahit, Amsterdam 142866
Modoc County Historical Museum,
 Alturas 046393
Modschiedler, Hamburg 076225
Modulo, Lisboa 114130
Modulo, Porto 114185
Modus, Paris 105061
Modus, Rotterdam 112740
Modus Vivendi, Baden-Baden . . 074601
Modus Vivendi, Carentan 067625
Modus Vivendi Gallery, Lemesos 102507
Moe Historical Museum, Moe . . 001300
Moebel Angèle, Bartenheim . . . 066897
Möbelberget Antik Storvik,
 Storvik 086896
Möbelflicker, Baden bei Wien . . 127983
Möbelgruppen, Hägersten 086541
Der Möbelhof, Lehrberg 076984
Möbelkällaren, Enskede 086476
Möbelklassikeren Randers,
 Randers 065981
Möbelklinik Beckers, Jüchen . . . 130392

Møbelverkstedet Restaurering,
 Oslo 133156
Moebli, Nürnberg 077755
Möcking, Ingo, Bielefeld 129844
Mödlinger Künstlerbund, Mödling 058263
Mödlinger Stadtverkehrsmuseum,
 Mödling 002358
Möhkön Ruukki, Ilomantsin
 Museosäätiö, Möhkö 010987
Möhring, Dortmund 075343
Møllenberg, Trondheim 084221
Möllenhoff, Irmgard, Porta
 Westfalica 077989
Møller, Lemvig 102870
Möller, Ostercappeln 077908
Möller, Waibstadt 078742
Møller Andersen, Aksel & Eva,
 Herning 065684
Moeller Fine Art Ltd., New York 123142,
 138462
Møller Witt, Århus 102741
Möller-Wolff, Melissa, Bad
 Aibling 129635
Moeller, Dr. Martin, Hamburg . . 076227
Möller, Frank-C., Hamburg 076226
Møller, Hanne, Svaneke 066077
Möller, Herbert, Hagen 076095
Möller, J., Dortmund . . 075344, 106687
Möller, Lothar, Neufra 108249
Möller, Robert & Co., Kiel 076718
Möller, Sibylle Karola, Bad Soden am
 Taunus 106040
Møller, Susanne, Haderslev 065652
Möller, Ulrike-S., Warnemünde . 108861
Möllering, Beate, München 108171
Möllers, Dr. Doris, Münster 108231
Möllers, K., Birkenau 106508
Möllner Museum Historisches Rathaus,
 Mölln 020090
Mölndals Antik, Mölndal 086684
Mölndals museum, Mölndal . . . 040650
Mølsteds Museum, Dragør 009873
Moelv Auksjonsforretning, Moelv 126570
Moementum, Wien 100220
Mönchehaus Museum Goslar,
 Goslar 018489
Mönchehaus Museum Goslar, Verein zur
 Förderung moderner Kunst e.V. Goslar,
 Goslar 059105, 137436
Mönchguter Museen im Ostseebad
 Göhren, Göhren, Ostseebad . . 018446
Mönchhof Galerie, Kilchberg
 (Zürich) 116480
Mönikes jun., F., Steinheim,
 Westfalen 078470
Möniste Muuseum, Mõniste . . . 010467
Møns Museum, Stege 010160
Mønsted Antik og Ting, Viborg . 066134
Møntergården, Odense 010096
Mørch Jensen, Palle,
 Frederiksberg 065602
Moerchen, Anne, Hamburg 107272
Møre Auksjonsforretning, Tornes I
 Romsdal 126604
Mörfelden Museum, Mörfelden-
 Walldorf 020098
Mörgeli Bilderrahmen, Zürich . . 087791,
 116917, 134310
Mörike-Gedenkstube Wermutshausen,
 Niederstetten 020446
Mörike Museum Cleversulzbach,
 Neuenstadt am Kocher 020347
Mörikehaus Ochsenwang, Bissingen
 an der Teck 017181
Mörmann, Elmar, Rothenburg ob der
 Tauber 078209
Mörner, Axel, Stockholm 116007
Mörsbacher Museum, Mörsbach 020101
Mörth, Wien 140087
Moervarststede, Wachtebeke . . 004041
Moes, Anny, Bar-le-Duc 066881
Kuno Mösch & Marianne Baumann,
 Balgach 116150
Moesgaard, Faaborg 065577

Moriah, New York 095433, 095434
Moriani, Milena, Pisa 110684
Moriarty, Madrid 115349
Moriarty, Salt Lake City 096745
Moriarty Historical Museum,
Moriarty 050986
Móricz Zsigmond Emlékház,
Prügy 023540
Móricz Zsigmond Emlékház, Jósa
András Múzeum, Tiszacsécse . 023684
Morigi & Figlio, G., Bologna . . 131382
Morija Museum, Morija 030119
The Morikami Museum and Japanese
Gardens, Delray Beach 048194
Morikuma, Saitama 081923
Morillas, Donostia-San Sebastián 133614
Morin, Claude, Saint-Paul-de-
Vence 105550
Morin, Jacques, Saint-Brieuc . . 072659
Morin, Jean, Plougonven 072158
Morin, Jean-Yves, Sainte-Pience 073323
Morin, Michel André, London . . 090193
Morin, Thierry, Lyon 069714
Morini, Lucio, Brescia 079781
Morioka City Local Hall, Morioka 028870
Morion, Helsinki 066284
Morisco, Federico, Roma 132371
Morisco, Gianfranco, Roma 081299
Morishita Bijutsukan, Hinase . . 028446
Morisot, Patrick, Colombey-les-
Belles 068050
Morita, Tokyo 082007
Morita-mura Rekishi Mingeikan,
Morita 028871
Moritz, E., Goslar 076007
Morlan Gallery, Lexington 050197
Morley College, London 056524
Morley Gallery, London . 044946, 118677
Morley, David, Twickenham . . . 091533
Morley, Patrick & Gillian,
Warwick 091603
Morley & Co, Robert, London . 090194,
135064
Morlock, Barbara, Schenefeld . . 108562
Mormon Station Museum, Genoa 049037
Mormon Visitors Center,
Independence 049627
Mormors Antik och Kuriosa,
Ljusdal 086636
Mormors Källare, Vadstena . . . 086947
Mormors Prylar, Norrtälje 086702
Mormors Skattkista, Stockholm . 086846
Mormors Spegel Antik,
Stockholm 086847
Mormorsgrufwans Antik,
Åtvidaberg 086449
Mornet-Tristan, Colette, Oloron-Sainte-
Marie 070733
Morning Glory Antiques, Kansas
City 093920
Morning Mountain Arts, Berry . . 061140
Morning Star Antiques, Tucson . 097513
Morning Star Traders, Tucson . 125006
Morningside Antiques,
Albuquerque 091908
Morningside Antiques, Miami . . 094611
Morningside Art, Houston 121377
Morningside Gallery, Edinburgh . 117919
Morningside Nature Center,
Gainesville 048966
Mornington Peninsula Regional Gallery,
Mornington 001310
Moro de Venecia, Valencia . . . 086350
Morohashi Kindai Bijutsukan,
Kitashiobara 028647
Moromi Mingeikan, Okinawa . . 029038
Moroni, Renzo, Roma 081300
Moroni, Umberto, Roma 081301
Morosini, Padova 080825
Morpeth Art Studio, Morpeth . . 099247
Morpeth Chantry Bagpipe Museum,
Morpeth 045227
Morpeth Gallery, Morpeth 099248
Morpeth Trading Post, Morpeth . 061881

Morph, Denver 121026
Morphets, Harrogate 127138
Morphett's Enginehouse Museum,
Burra 000917
Morpho Gallery, Chicago 092589, 120489
Morpurgo, J.M., Amsterdam . . 082624
Morra Arte Studio, Napoli 110553
Morrab, Truro 119537
Morrab Studio, Penzance 119121
Morrin, Dublin 079466
Morrin Centre, Literary and Historical
Society of Quebec, Québec . . 006583
Morring, Robert, Atlanta 091997
Morrinsville Antiques,
Morrinsville 083835
Morrinsville Museum,
Morrinsville 033066
Morris, Södertälje 143728
Morris & Bricknell, Ross-on-Wye 127272
Morris and District Centennial
Museum, Morris 006294
Morris and Helen Belkin Art Gallery,
University of British Columbia,
Vancouver 007114
Morris Belknap Gallery, Dario
Covi Gallery and SAL Gallery,
Louisville 050438
Morris-Butler House Museum,
Indianapolis 049653
Morris Graves Museum of Art,
Eureka 048587
Morris-Jumel Mansion, New York 051344
Morris Marshall & Poole,
Llanidloes 127181
Morris Marshall & Poole,
Montgomery 127232
The Morris Museum, Morristown 050993
Morris Museum of Art, Augusta 046632
Morris, Chris, Sassafras 062184
Morris, Darlene, Tucson 097514
Morris, Donald, New York 123148
Morris, Frances, Enniskillen . . . 117949
Morris, M.A.J., Burton-upon-
Trent 088514, 144061
Morris, Peter, Bromley 088464
Morris, Robert Lee, New York . 123149
Morrison, Chicago 120490
Morrison & West, Lyttelton 083820
Morrison Museum of the Country
School, Islay 005924
Morrison, D. J., Christchurch . . 133086
Morrison, David, Portland 145196
Morrison, Guy, London 090195
Morrison, Jan, Bristol 088441
Morrison & Son, Robert, York . 091848
Morrison, Thomas, Dallas 093017,
135863
Morristown National Historical Park,
Morristown 050994
Morro Bay State Park Museum of
Natural History, Morro Bay . . . 051000
Morrow Mountain State Park Museum,
Albemarle 046321
Mors Doré, Paris 129323
Morsak Verlag, Grafenau, Kreis
Freyung-Grafenau 137439
Morse Museum, Morse 006296
Morse Road Antique Center,
Columbus 092872
Morseburg, West Hollywood . . . 125263
Morsink, Jan, Amsterdam 082625
Morsink, Saskia, Enschede . . . 083067
Morskoj Muzej-Akvarium,
Tichookeanskij naučno-
issledovatelskij centr rybolovstva,
Vladivostok 037860
Morskoj Muzej, Karelskij morskoj
istoriko-kulturnyj centr i
morskoj klub Poljarnyj Odissej,
Petrozavodsk 037481
Morslands Historiske Museum,
Nykøbing Mors 010083
Morsø Kunsthandel, Thisted . . 066089
Mortehoe Museum, Mortehoe . . 045228

Morten, Eric J., Manchester . . . 144485
Mortensen, Anna, Toreby 102935
Mortgage, Portland 123893
Morthland, Sarah, New York . . . 123150
Mortier-Valat, Joëlle, Paris . . . 105070
Mortimer, Brian, Exeter 089023
Morton, Fort Worth 093299
Morton & Co, Timaru 083975
Morton Grove Historical Museum,
Morton Grove 051001
Morton Homestead, Prospect
Park 052282
Morton House Museum, Benton
Harbor 046894
Morton J. May Foundation Gallery,
Maryville University, Saint Louis 052710
Morton Lee, J., Hayling Island . 089288,
118144
Morton Museum of Cooke County,
Gainesville 048974
Morton Square Antiques,
Nashville 094851
Morton, John, Dublin 079467
Morton, Louis C., Guadalajara . 082284
Morton, Louis C., México 082296
Morton, Louis C., Monterrey . . 082308
Morueco Rodriguez, Luis, Madrid 086047
Moruzzi Numismatica, Roma . . 081302
Morvan, Alain, München 077498
Morven, Timaru 083976
Morven Gallery, Barvas 117365
Morven Historical Museum,
Morven 001312
Morven Park Museum, Leesburg 050164
Morwellham Quay Historic Port &
Copper Mine, Morwellham . . . 045229
Mory-Wydeven, Ann M.,
Milwaukee 122215
Mo's Gallery, Tucson 125007
Mosaic (St. Petersburg), Saint
Petersburg 139471
Mosaic Gallery, Amman 029593
Mosaic Museum, Beiteddine Palace,
Beiteddine 030102
Mosaic Planet, Blackheath . . . 061153
Il Mosaico, Udine 111088
Mosaico Gal Arte, Porto Alegre . 100852
Mosaïque, Briançon 103419
Mosaique Gallery, Chicago . . . 120491
Mosaïque Gallo-Romaine, Amou 011455
Mosarm, Liège 063718
Moscatelli, Claudio, London . . . 135065
Moschakeion, International Museum of
Marine Research, Moschato . . 022814
Moscow Art Magazine, Moskva . 139057
Moscow Business Plaza Gallery,
Moskva 114363
Mose, Odense 065966, 102894
Mose Toidze House Museum,
Tbilisi 016219
Mosebach, Rainer, Halle, Saale . 076113
Mosel & Tschechow, Galerie und Verlag,
München 108172, 137564
Mosel-Weinmuseum, Bernkastel-
Kues 017110
Moseley Emporium, Birmingham 088260,
134431
Moseley Violins, Birmingham . . 088261,
134432
Moser & Klang, Stockholm . . . 086848
Eva Moser-Seiberl & Wilfried Moser,
Bad Aussee 127979
Moser, Andreas, Wien 140090
Moser, Charlotte, Genève 116427
Moser, Michael, Osnabrück . . . 077896
Moser, Paul, Mittelbiberach . . . 077893
Moser, Roland, Simbach am Inn 142210
Moser, Theo, Oberau 128087
Moser, Walter, Wien 062990
Moses, Dallas 120910
Moses Lake Museum & Art Centre
(MAC), Moses Lake 051006
Moses Lake Museum and Art Center,
Moses Lake 051007

Moses Myers House, Norfolk . . 051492
Moses Saidian, Tehrān 079320
Moses, Dexter, Croydon Park . . 061373
Moses, Manuel, München 130732
Moses, Nancy, Philadelphia . . . 123675
Mosher, Alexandra, Hamilton . . 100692
Mosie & Midge, Baltimore 092183
Moskat, Walter, Wolfurt 063072
Moskovskaja Gosudarstvennaja
Kartinnaja Galereja A. Šilova,
Moskva 037173
Moskovskaja Gosudarstvennaja
Specializirovannaja Škola Akvareli
Sergeja Andrijaki, Moskva . . . 056233
Moskovski Dom Knigi, Moskva . 143457
Moskovskij Akademičeskij
Chudožestvennyj Licej, Rossijskaja
Akademija Chudožestv, Moskva 056234
Moskovskij Centr Iskusstva,
Moskva 037174
Moskovskij Dom Fotografii,
Moskva 037175
Moskovskij Dom Skulptorov,
Moskva 114364
Moskovskij Dvor Art-Agentstvo,
Moskva 114365
Moskovskij Gosudarstvennyj Muzej
S.A. Esenina, Moskva 037176
Moskovskij Gosudarstvennyj
Universitet Kultury i Isskustv,
Chimki 056217
Moskovskij Gosudarstvennyj
Vystavočnyj Zal Novyi Manež,
Moskva 037177
Moskovskij Literaturnyj Muzej-centr
K.G. Paustovskogo, K.G. Paustovsky
Museum-Centre of Literature,
Moskva 037178
Moskovskij Meždunarodnyj Salon
Isjaščnych Iskusstv, Moskva . . 098130
Moskovskij Muzej Sovremennogo
Iskusstva, Moskva 037179
Moskovskij Muzej-usad'ba Ostankino,
Moskva 037180
Mosman Art Gallery, Mosman . . 099254
Mosnier, Laure, Montpellier . . . 129047
Moss, Cheltenham 144096
Moss, New Orleans 094969
Moss & Co., Washington 097686
Moss Antikvariat, Moss 143202
Moss Antikvitets- og Auksjonsforretning,
Moss 084125, 126572
Moss End Antique Centre,
Warfield 091584, 135542
Moss Kunstgalleri, Moss 113280
Moss Mansion Museum, Billings 046953
Moss-Thorns Gallery of Arts,
Hays 049375
Moss, Alan, New York 095435
Moss, Brendan M., Vancouver . 064797
Moss, Ralph & Bruce, Baldock . 088109
Moss, Sydney L., London 090196
Moss, Tobey C., Los Angeles . . 121840
Mossakowski, Marek, Warszawa 084565,
084566, 143340, 143341
Mossbank and District Museum,
Mossbank 006297
Mossette, Fresno 093341
Mossini, Massimo, Mantova . . . 080178
Mossman Gallery, Mossman . . . 099260
Most čerez Stiks – Pons per Styx,
Muzej Nonkonformistskogo Iskusstva,
Sankt-Peterburg 037585
Most, Peter, Berlin 129779
MostBirnHaus Stift Ardagger,
Ardagger 001711
Mostböck-Huber, Edith, Wien . . 128215
Mosteiro de S. Martinho de Tibães,
Mire de Tibães 035690
Mosteiro de Santa Clara-a-Velha,
Instituto Português do Património
Arquitectónico, Coimbra 035451
Mosteiro de São João de Tarouca,
São João de Tarouca 035845

Whyalla 001635
Mount Manaia Art Gallery,
Whangarei 113197
Mount Mary College Costume
Museum, Milwaukee 050852
Mount Morgan Historical Museum,
Mount Morgan 001317
Mount Pleasant Antiques Centre, Market
Weighton 090562, 135180
Mount Pleasant Furniture,
Vancouver 064798
Mount Pleasant Historical Society
Museum, Mount Pleasant 051026
Mount Pleasant, Philadelphia Museum
of Art, Philadelphia 051977
Mount Prospect Historical Society
Museums, Mount Prospect . . . 051029
Mount Pulaski Courthouse, Mount
Pulaski 051030
Mount Rainier National Park Museum,
Ashford 046531
Mount Royal College Gallery,
Calgary 005421
Mount Rushmore National Memorial,
Keystone 049920
Mount Saint Vincent University Art
Gallery, Halifax 005840
Mount Stewart House,
Newtownards 045322
Mount Street Gallery, Brecon . . 117516,
144031
Mount Vernon Hotel Museum, New
York 051345
Mount Vernon Museum of
Incandescent Lighting,
Baltimore 046729
Mount Victoria and District Historical
Museum, Mount Victoria 001318
Mount Victoria Antiques and Book Shop,
Mount Victoria 061915, 139872
Mount Washington Museum, North
Conway 051515
Mountain Art, Llanberis 118369
Mountain Bookstore, Hamilton . 140313
Mountain Farm Museum,
Cherokee 047569
Mountain Gateway Museum, Old
Fort 051660
Mountain Heritage Center, Western
Carolina University, Cullowhee . 048051
Mountain Life Museum, London 050312
Mountain Lodge Pottery and Art
School, Newport 055805
Mountain Mills Museum, Saint
Catharines 006705
Mountain Peaks Antiques, Salt Lake
City 096746
Mountain-Plains Museums Association,
Littleton 060594
Mountain Resort Museum,
Chengde 007506
Mountain View Doukhobor Museum,
Grand Forks 005793
Mountain View Furniture Centre,
Stratford 083947
Mountain View Gallery, Highfields 098988
Mountain View Museum, Olds . . 006409
Mountaineering Museum,
Darjeeling 023896
Mountaineering Museum,
Hanamaki 028423
Mountbatten Exhibition, Romsey 045603
Mounted Branch Museum, East
Molesey 044032
Mountford, Michael, Boyle 079355,
131232
Mountmellick Museum,
Mountmellick 024772
Moura, Mariana, Recife 100864
Mourad, Cairo 103006
Mouradian, Hélène, Paris 105073
Mouret, Gilbert, Marseille 069900,
129016
Mourlot, J.L., Marseille 104140

Mourmans, Knokke-Heist 100611
Mourne, Letterkenny 079544
Mouseio Akropoleos, Athinai . . . 022578
Mouseio Elinikis Laikis Technis,
Athinai 022579
Mouseio Elinikis Paidikis Tehnis,
Athinai 022580
Mouseio Ethnikon Archaiologikon,
Athinai 022581
Mouseio Isrorias tis Ellinikis
Endymasias, Athinai 022582
Mouseio Kerameikos, Athinai . . 022583
Mouseio Kompologiou, Nafplion . 022830
Mouseio Laikon Organon, Athinai 022584
Mouseio Mpenaki, Athinai 022585
Mouseio Trenon, Athinai 022586
Mouseio Vorre, Paiania 022848
Mouseio Zakynthou, Zakynthos . 022998
Mouseion Goulandri Fysikis Istorias,
Kifissia 022748
Mousley Museum of Natural History,
San Bernardino County Museum,
Yucaipa 054480
Moussa Castle Museum,
Beiteddine 030103
Mousse, Milano 137785, 138888
Moussé, Claude, Toulouse 129536
Mousseau, Séverine, Chef-
Boutonne 067895
Mousset, Daniel, Lyon 128961
Moussion, Paris 105074
Moust, J., Brugge 063228
Moustache & Trottinette,
Montpellier 140928
Mout- en Brouwhuis De Snoek,
Alveringem 003188
Mouthon, Sylvain, Faverges . . . 068455
Mouton, Michel, Lanester 069109
Mouvances, Paris 105075
Mouvement Socio-Culturel de la
Tuque, La Tuque 006015
Mouvements Modernes, Paris . . 071648
Mouysset, Francine, Rodez 072474
Mouzannar, Pierre, Beirut 082108
Moveis, Alvinus, Rio de Janeiro 064035
Movelanjos, Rio de Janeiro 064036
Movements in the Arts, Westport 139472
Movie Arts Posters, San Jose . . 124702
The Movie Museum, Owosso . . . 051767
Movie Shop, Norwich . 090735, 144507
Movieland Wax Museum of the Stars,
Niagara Falls 006345
Movilla, Leichhardt 127902
Movimiento Artistico del Rio Salado,
Phoenix 060595
Moving Image Centre, Auckland 112881
Mowbray Gallery, Port Douglas . 099446
Mowhay Gallery, Trebetherick . . 119528
Moxhams Antiques, Bradford-on-
Avon 088343
Moy Antique Pine, Moy 090635
Moy Antiques, Moy 090636
Moy, J., London 135066
Moy, Jakob Graf von, Salzburg . 062780
Moyano, Barcelona 085627
Moyano 21, Madrid 086048
Moyard, Morges 087490, 134183
Moycullen Village Antiques,
Moycullen 079568
Moyle Mubarek Library Museum,
Toshkent 054594
Moylurg, Castletownsend 079370
Moynihan & Riehlman, Morser 123153
Moyse's Hall Museum, Bury Saint
Edmunds 043594
Mozaik Müzesi, İstanbul 042681
Mozart Antiquités, Paris 071649
Mozart Wohnhaus, Internationale
Stiftung Mozarteum, Salzburg . 002576
Mozarthaus St.Gilgen, Sankt
Gilgen 002607
Mozarthaus Vienna, Wien 002955
Mozarthaus, Kunstsammlungen und
Museen Augsburg, Augsburg . 016467

Mozarts Geburtshaus, Internationale
Stiftung Mozarteum, Salzburg . 002577
MPA Studio, Winnipeg 101751
Mpellos, Agios Dimitrios 109024
MPF Gallery, Philadelphia 123676
MPG Contemporary, Boston . . . 120180
MPG Town Gallery, Odiongan . 034391
MPLS Numisatics, Minneapolis . 094769
MPM Dizajn, Ohrid 111929
MPP 83, Pleven 128388
MPR International Committee
for Museums Marketing and PR,
Malmö 059811
Mr Antiguedades, Estepona 085817
Mr Bigglesworthy, Auckland . . . 083626
Mr Mod, Christchurch 083709
Mr Phoenix, Levin 083814
Mr Pickwicks Trading Company,
Christchurch 083710, 143118
Mr. George, Luzern 087451
Mr. Lucky, San Francisco 097124
Mr. Paint Stripper, Los Angeles . 136082
Mr. Yeste, Barcelona . . 085628, 133497
Mramornyj Dvorec, Gosudarstvennyj
Russkij Muzej, Sankt-Peterburg 037586
Mronz, Ute, Köln 107657
Mrs Mills Antiques, Ely 088989
Mrugalla, Peter, Regensburg . . . 078090
MRW Antiguidades, Rio de
Janeiro 064037
MS Art, Praha 102673
MS Libros, Buenos Aires 139620
Ms. B Art Gallery, Oklahoma City 123540
MSA Limited, Saint Louis 096580
MSCC Forsyth Center Galleries,
Texas A & M University, College
Station 047836
Msvar, Tampa 097414
MTA Briefings, Washington 139473
MTA Tabiat Tarihi Müzesi, Ankara 042555
Mtengatenga Postal Museum,
Namaka 030481
Mtskheta Museum, Mtskheta . . 031500
MU – De Witte Dame, Eindhoven 112549
Mu-Zee-Um, Oostende 003850
Mu.ZEE – Kunstmuseum aan Zee,
Oostende 003851
Muang Sing Exhibitions Museum,
Muang Sing 029909
muba – Museum für Baukultur,
Neutal 002406
MUBAG – Museo de Bellas Artes
Gravina, Alicante 038759
Mucciaccia, Lucio, Roma 110854
Muccioli, Detroit 121091
MuCEM, Musée des Civilisations de
l'Europe et de la Méditerranée,
Marseille 013846
Much Wenlock Museum, Much
Wenlock 045237
Much, Ado, Atlanta 091998
Mucha, La Rochelle 069036
The Muchnic Gallery, Atchison . 046560
Muchovo muzeum, Praha 009645
Muci, Caracas 125337
Muck, Stefan, Windach 131167
Muckel, Ratingen 078055
Muckenhofer, Robert, Trieben . . 128146
Muckenthaler Gallery and Mansion
Museum, Fullerton 048957
Muckleburgh Collection, Holt,
Norfolk 044455
Muckross House Gardens and
Traditional Farms, Killarney . . 024728
Mücsarnok, Budapest 023208
mudac – Musée de Design et
d'Arts Appliqués Contemporains,
Lausanne 041420
Mudanya Mutareke Evi Müzesi,
Mudanya 042759
Mudde, A.M., Haarlem 083156
Muddi's Antik, Horsens 065728
MudFire Pottery Center, Atlanta . 119874
Mudfish Pottery, Albuquerque . . 119767

Mudgee Colonial Inn Museum,
Mudgee 001319
Mudhead, Denver 121027, 121028
MUDIA – Museo Diocesano Agrigento,
Agrigento 025085
Mudrány Kúria, Jósa András Múzeum,
Szabolcs 023587
Mü-Terem, Budapest . 079165, 109172,
126371
La Mueblería, Medellín 065210
Muebles Baque, Barcelona 085629
Muebles la Ganga, Fuengirola . . 085822
Muebles Usados el Callejón,
Medellín 065211
Muebles y Ceramicas Colombia,
Barranquilla 128501
Mück, Brombachtal 075154
Mühl, Regensburg 078091
Mühl, Dieter, Kempten 141867
Mühlan, Adelheid & Michael, Landau
in der Pfalz 141923
Mühlbauer, Peter, Pocking 077983
Mühlbauer, Stephan, Regensburg 130938
Mühlberger, Gudrun, Pichl bei
Wels 128094
Mühlberger, Michael, Zapfendorf 079039
Mühlberger, Wolfgang, Wien . . . 140091
Mühlburger, Werner, Lienz 062686
Die Mühle, Eberswalde 017842
Mühle Laar, Zierenberg 022455
Mühlen- und Landwirtschaftsmuseum,
Fehmarn 018086
Mühlen- und Landwirtschaftsmuseum,
Jever 019154
Mühlen- und Mennonitenmuseum
Bettinger Mühle, Schmelz . . . 021291
Mühlenbeck, Holger, Wuppertal . 079017
Mühlenbein-Schelkle, Berlin . . . 129780
Das Mühlendorf, Ottenhöfen im
Schwarzwald 020680
Mühlenfachmuseum "Stiftsmühle",
Aurich 016483
Mühlengalerie, Großefehn 107133
Mühlenhof Altkalen, Altkalen . . . 016349
Mühlenhof-Freilichtmuseum Münster,
Münster 020252
Mühlenmuseum, Haren (Ems) . . 018774
Mühlenmuseum, Oberkrämer . . 020551
Mühlenmuseum, Rheinsberg . . . 021027
Mühlenmuseum Brüglingen,
Münchenstein 041528
Mühlenmuseum Katzbrui,
Apfeltrach 016402
Mühlenmuseum Mitling-Mark
mit Sammlung Omas Küche,
Westoverledingen 022186
Mühlenmuseum Moisburg,
Moisburg 020104
Mühlenmuseum Teichmühle,
Steinwiesen 021590
Mühlenmuseum und Mühlenweg
Maria Luggau, Maria Luggau . . 002317
Mühlerama, Museum in der Mühle
Tiefenbrunnen, Zürich 041940
Mühlfeld + Stöhrer, Frankfurt am
Main 106978
Mühlhaus, Alena, Wiesbaden . . 108938
Mühlich & Neumann, Berlin 129781
Mühlschlegel, Bärbel G.,
Taunusstein 108769
Mühlviertler Keramikwerkstätte
Hafnerhaus, Leopoldschlag . . . 002263
Mühlviertler Schlossmuseum Freistadt,
Oberösterreichische Landesmuseen,
Freistadt 001894
Mühlviertler Vogelkundeweg,
Gutau 002006
Mühlviertler Waldhaus, Windhaag bei
Freistadt 003036
Mülheimer Kunstverein e.V., Mülheim
an der Ruhr 059106
Mülhens-Molderings, Barbara,
Köln 130483
Müllauer, Thomas Franz, Krems 062668

Mundy, C.W., Indianapolis 121484
Mundy, Ewan, Glasgow 089129, 118050,
 134719
Muné, Jean-Philippe, Paris 071651
Muné, Mercédès, Saint-Quentin
 (Aisne) 126082
Muñeca, Barniz de, Alcalá de
 Henares 085510, 133437
Muñecas, Madrid 126758
Munerotto, Gianfranco, Venezia . 132635
Munganbana Aboriginal Art Gallery,
 Cairns 098697
Munich Contempo, München . . . 098017
Municipal Art Gallery, Molyvos . 022812
Municipal Art Gallery,
 Thessaloniki 022958
Municipal Art Gallery of Xanthi,
 Xanthi 022995
Municipal Art Society, New York 051346
Municipal Art Society of New York,
 New York 060596
Municipal d'Arts Plastiques, La
 Menuiserie, Choisy-le-Roi 012378
Municipal Gallery of Athens,
 Athinai 022587
Municipal Gallery of Corfu,
 Kerkyra 022743
Municipal Gallery of Herakleion,
 Iráklion 022705
Municipal Gallery of Lamia,
 Lamia 022772
Municipal Gallery of Livadia,
 Livadia 022788
Municipal Gallery of Piraeus,
 Peiraias 022860
Municipal Gallery of Piraeus,
 Piraeus 022867
Municipal Gallery of Samos,
 Samos 022907
Municipal Gallery of Volos, Volos 022988
Municipal Museum Gwalior,
 Gwalior 023965
Municipal Museum of Kavala,
 Kavala 022739
Municipality Museum, Hebron . . 033980
Municipalnaja Chudožestvennaja
 Galereja g. Kostromy, Kostroma 036984
Municipalnyj Muzej Anna
 Achmatova – Serebrjannyj vek,
 Sankt-Peterburg 037587
Municpal'nyj Muzej Pryvatnych
 Kollekcij im. O. Bleščunova,
 Odesa 043006
Munier, Rodolphe, Paris 129326
Munkácsy Mihály Emlékház,
 Békéscsaba 023125
Munkácsy Mihály Múzeum,
 Békéscsaba 023126
Munkeborg, Saltsjö-Boo 086736, 133915
Munkkiniemen Antiikkipuuseppä,
 Helsinki 066285
Muñoz Antiguedades, Málaga . . 086124
Muñoz Jimenez, Alfredo, Estella 126735
Muñoz Turégano, Valencia 086351
Muñoz, Carlos, San José 102412
Muñoz, Jose, Estepona 085818
Munro, Vera, Hamburg 107276
Munroe, Victoria, Boston 120181
Munro's Mill Antique Centre,
 Tamworth 062294
Munsala Hembygdsmuseum,
 Munsala 010993
Munsin Museum, Masan 029793
Munson-Williams-Proctor Arts Institute
 Museum of Art, Utica 053792
Munson-Williams-Proctor Arts Institute.
 Bulletin, Utica 139474
Munster Literature Centre, Cork 024588
Munt- en Penningkabinet van
 de Spaar- en Voorschotbank,
 Surhuisterveen 032729
De Muntkoerier, Apeldoorn 082739,
 138977
Muntwisselkantoor, Apeldoorn . . 082740

Munzi, Gabriella, Roma 081303
Muonion Kotiseutumuseo,
 Muonio 010994
Le Mur Vivant, London 090198, 118680
Mura Clay Gallery, Newtown, New
 South Wales 099319
Mura-Todesco, Béatrice, Dijon . 068282
Murad, Mohammed Isam,
 Damascus 087840
Murakami Folk Museum,
 Murakami 028877
Murakami Hojido, Tokyo 082008
Muraki, Ebetsu 081791
Mural da História, Lisboa 133305
Muramooto, Akiko, Hong Kong . 065011
Murari, Max, Villeneuve-sur-Lot . 074132
Murarka's Art Gallery, Kolkata . . 109418
Murat, Pamplona 086219
Murat-David, Philippe, Paris . . . 071652
Murata & Friends, Berlin 106369
Murator, Warszawa 137999
Murauchi Bijutsukan, Hachioji . . 028397
Al-Murbati, Manama 063101
Murch, Jill, Moonta 099238
Murchison Falls National Park
 Museum, Murchison Falls 042845
Murchison Museum, Murchison . 033068
Murchison Settlement Museum,
 Mullewa 001321
Murdaca, Natale, Milano 131873
Murder by the Book, Cranston . . 144842
Murder by the Book, Denver . . . 144869
Murder by the Book, Houston . . 144910
Murder by the Book, Portland . . 145197
Murder Ink, New York 145097
Murdocca, Vincenzo, Roma 132372
Murdoch & Barclay, Moorabbin . 127916
Murdoch McLennan, Auckland . . 043627
Muré, Robert, Toulouse 073748, 129537
Mureau, Dreux 128828
Murer, Milano 080457
Murgtal-Museum, Forbach 018121
Murias Numismatica, A Coruña . 085779
Murie Museum, Kelly 049871
Muriel, Boris, West Hollywood . . 125264
Murillo, Edmonton 128414
Murillo, Lisboa 114134
Murino, Mario, Milano 131874
Murmanskij Oblastnoj
 Chudožestvennyj Muzej,
 Murmansk 037354
Murmanskij Oblastnoj Kraevedčeskij
 Muzej, Murmansk 037355
Les Murmures du Temps,
 Crémieu 068177
Murney Tower Museum,
 Kingston 005985
Il Muro di Tessa, Milano 142552
Muroran-shi Seishonen Kagakukan,
 Muroran 028879
Muroran-shi Tontenkan, Muroran 028880
Muros Vivos, Bucaramanga 102298
Murphy, Los Angeles 136083
Murphy, Jan, Fortitude Valley . . 098909
Murphy, Jennifer, Charlotte 120282
Murphy, John,
 Newtownshandrum 079578
Murphy, Michael, Tampa 124915
Murphy, Roger, Kingston 061687
Murphy's Furniture, Cork 079394
Murphy's Loft, Cleveland 120722
Murr, Gabriele, Bamberg 074626
Murr, Renate, Esslingen 141665
Murray Charteris Art Gallery, Hervey
 Bay 061609, 098986
Murray Hill Art, Cleveland 120723
Murray-Lindsay Mansion,
 Lindsay 050262
Murray, Guy, New York 123155
Murray, Kevin, Armadale, Victoria 061033
Murray's Motorcycle Museum,
 Laxey 044646
Murrell Home, Oklahoma Historical
 Society, Park Hill 051831

Murrer, Werner, München 077500,
 130733
Murrough, H. O'Brien, Portland . 145184
Murrumburrah-Harden Historical
 Museum, Murrumburrah 001325
Murrurundi Museum, Murrurundi 001326
Mursia, Ugo, Milano 137786
Murston House, Geelong 098930
Murtada, Abdul Khaliq Najwani,
 Muttrah 084238
Murtoa Water Tower Museum,
 Murtoa 001327
Murtovaaran Talomuseo, Valtimo 011306
Murtuz, Moskva 114366
Mus-Olles Museum, Nälden . . . 040671
Musa Art Gallery, Aberdeen . . . 117276
MUSA Collections Centre, Museum of
 the University of Saint Andrews,
 Saint Andrews 045646
Musa Heritage Gallery, Kumbo-
 Nso . 005197
MUSA Museum Startgalerie Artothek,
 Wien . 002957
MUSAC, Museo de Arte
 Contemporáneo de Castilla y León,
 León . 039366
Musaem Chontae Dhún na nGall,
 Letterkenny 024745
Músaem Chorca Dhuibhne, Chorca
 Dhuibhne Regional Museum,
 Ballyferriter 024534
Musafir-Khana Palace, Cairo . . . 010376
Musandi, Chipo, Berlin 106370
La Musardiére, Plauzat 105313
Musardière, Renescure 072375
Musashi-murayama-shi Rekishi
 Minzoku Shiryokan, Musashi-
 murayama 028881
Musashino Art University Museum and
 Library, Kodaira 028681
Musashino Bijutsu Daigaku,
 Tokyo 055997
Al-Musbahi, Jeddah 085129
Muscarelle Museum of Art, College of
 William and Mary, Williamsburg 054289
Muscariello, Giuseppe, Napoli . . 132020
Muscariello, Mario, Napoli 080735
Muscariello, Pasquale, Napoli . . 132021
Muscariello, Vincenzo, Napoli . . 080736
Muscat Gate Museum, Muscat . . 033918
Muscatine Art Center, Muscatine 051063
Muschel- und Schneckenmuseum,
 Norden 020461
Muschel, Carolin, Obfelden 134199
Muschelkalkmuseum Hagdorn,
 Ingelfingen 019094
Muschi & Licheni, Trieste 081630
Muschietti, Walter, Udine 081644
Muschik, Aschaffenburg 105964
Muschter, A., Berlin 074843
Le Muse, Milano 080458
MUSE – Museo delle Scienze di
 Trento, Trento 027991
Muse Art Gallery, Philadelphia . . 051978
Muse Gallery, Jackson 049721
Muse Gallery, Philadelphia 123677
The Muse Gallery, Milawa 099204
MUSE-O, Stuttgart 021647
Muse Studio, Point Lonsdale . . . 099432
Museactron, Maaseik 003756
Muséal Adolphe Pégoud,
 Montferrat 014061
Musée, Aigues-Mortes 011368
Musée, Bages (Pyrénées-
 Orientales) 011682
Musée, Bischwiller 011864
Musée, Brignon 012043
Musée, Chaillac 012213
Musée, Chazé-sur-Argos 012351
Musée, Cransac 012524
Musée, Cruzy 012541
Musée, Evolène 041252
Musée, Frontignan-la-Peyrade . . 012874
Musée, Gramat 012952

Musée, Joinville (Haute-Marne) . 013132
Musée, Kampong Thom 005183
Musée, Le Landeron 041403
Musée, Laragne-Montéglin 013381
Musée, Lisieux 013633
Musée, Livry 013645
Musée, Lupiac 013719
Musée, Moyen 014174
Musée, Orainville 014370
Musée, Plouay 014700
Musée, Quiberon 014881
Musée, Saint-Hilaire-en-Lignière 015160
Musée, Tauriers 015717
Musée 1900, Arpaillargues-et-
 Aureillac 011555
Musée 1900, Cauterets 012187
Musée 1900 Arts et Techniques,
 Champlitte 012250
Musée 2ème Guerre Mondiale,
 Ambleteuse 011435
Musée 39–45, Roscoff 014955
Musée 39–45 du Grand Blockhaus,
 Batz-sur-Mer 011724
Musée 40–44, Monceau-
 Imbrechies 003796
Musée à Flot de l'Escorteur d'Escadre,
 Musée Naval Maillé Brézé,
 Nantes 014215
Musée à Flot du Galion,
 Plouharnel 014710
Musée à la Ferme de Rome, Bézu-la-
 Forêt . 011842
Musée à la Mémoire des Combattants
 et de Victimes de Guerre,
 Mâcon 013759
Musée a la Recherche du Temps
 Perdu, Bricquebec 012035
Musée A la Rencontre des Vieux
 Métiers, Bouray-sur-Juine 011958
Musée Aal Braaneburg,
 Brandenbourg 030396
Musée Abbaye d'Airvault,
 Airvault 011377
Musée-Abbaye de Charroux,
 Charroux 012278
Musée-Abbaye Saint-Germain,
 Auxerre 011639
Musée Abbé Deletoille, Fondation
 Boudenoot, Fruges 012875
Musée Abbé Jules Lemire, Vieux-
 Berquin 016006
Musée Acadien, Archigny 011527
Le Musée Acadien, Caraquet . . . 005451
Musée Acadien, Cheticamp 005504
Musée Acadien de Pubnico-Ouest,
 West Pubnico 007200
Musée Acadien du Québec,
 Bonaventure 005333
Musée Acadien, Prince Edward Island
 Museum and Heritage Foundation,
 Miscouche 006204
Musée Acadien, Université de
 Moncton, Moncton 006219
Musée Accous-Fermiers Basco-
 Béarnais, Accous 011355
Musée Adam Mickiewicz, Paris . 014480
Musée Adja Swa, Yamoussoukro 008713
Musée Adjaman Mihiin Raphaël,
 Vavoua 008712
Musée Adrien Mentienne, Bry-sur-
 Marne 012065
Musée Adzak, Paris 014481
Musée Aéronautique, La Baule-
 Escoublac 013173
Musée Aérorétro, Albon 011405
Musée Africain, Ile-d'Aix 013093
Musée Africain, Lyon 013734
Musée Africain de Namur,
 Namur 003816
Musée Agathois, Agde 011356
Musée Agricole, Coffrane 041198
Musée Agricole, Villy-le-
 Maréchal 016093
Musée Agricole Bras de Brosne,

Marville 013878
Musée d'Art Haïtien du Collège Saint Pierre, Port-au-Prince 023075
Musée d'Art Inuit Brousseau, Québec 006585
Musée d'Art Islamique, Marrakech 031601
Musée d'Art Islamique de Rakkada, Rakkada 042494
Musée d'Art Islamique Raqqada, Kairouan 042479
Musée d'Art Juif, Paris 014498
Musée d'Art Juif J.C. Katz, Colmar 012441
Musée d'Art Local, Oisemont . 014358
Musee d'Art Mercian Karuizawa, Miyota 028862
Musée d'Art Militaire, Vincey . . . 016096
Musée d'Art Moderne, Céret . . . 012200
Musée d'Art Moderne, Troyes . . 015847
Musée d'Art Moderne – Museum voor Moderne Kunst, Koninklijke Musea voor Schone Kunsten van België, Bruxelles 003380
Musée d'Art Moderne de la Ville de Paris, Paris 014499
Musée d'Art Moderne de Saint-Étienne Métropol, Saint-Priest-en-Jarez 015320
Musée d'Art Moderne et Contemporain, Strasbourg 015671
Musée d'Art Moderne et Contemporain, Les Abattoirs, Toulouse 015783
Musée d'Art Moderne et d'Art Contemporain, Liège 003725
Musée d'Art Moderne et d'Art Contemporain, Nice 014282
Musée d'Art Moderne Grand-Duc Jean, Luxembourg 030413
Musée d'Art Moderne Jean Peské, Collioure 012433
Musée d'Art Moderne Richard Anacréon, Granville 012962
Musée d'Art Moderne, Donation Maurice Jardot, Belfort . . . 011786
Musée d'Art Naïf, Lasne-Chapelle-Saint-Lambert 003697
Musée d'Art Naïf, Nice 014283
Musée d'Art Nègre, Yaoundé . . . 005200
Musée d'Art Populaire, Le Monastier-sur-Gazeille 013474
Musée d'Art Populaire du Hauran, Musée d'Antiquites de Bosra, Bosra 041977
Musée d'Art Populaire Religieux, Saint-Julien-Molhesabate 015201
Musée d'Art Religieux, Blois . . 011895
Musée d'Art Religieux, Castelnau-Magnoac 012170
Musée d'Art Religieux, Fréland . 012863
Musée d'Art Religieux, Marsal . 013837
Musée d'Art Religieux, Vermand 015966
Musée d'Art Roger Quilliot, Clermont-Ferrand 012408
Musée d'Art Rustique, Musée de la Poupée et du Jouet Edouard Wolff, Vianden 030428
Musée d'Art Sacré, Dijon 012595
Musée d'Art Sacré, Hambye . . 013036
Musée d'Art Sacré, Le Monêtier-les-Bains 013476
Musée d'Art Sacré, Le Revest-les-Eaux 013503
Musée d'Art Sacré, Le Val . . . 013515
Musée d'Art Sacré, Lectoure . . 013528
Musée d'Art Sacré, Lorgues . . 013676
Musée d'Art Sacré, Saint-Béat . 015034
Musée d'Art Sacré, Saint-Cirq-Lapopie 015063
Musée d'Art Sacré, Senez 015563
Musée d'Art Sacré, Viviers-en-Ardèche 016109
Musée d'Art Sacré – Francis Poulenc,

Rocamadour 014913
Musée d'Art Sacré de Fourvière, Lyon 013736
Musée d'Art Sacré de Rostilas Loukine, Arsonval 011567
Musée d'Art Sacré du Gard, Pont-Saint-Esprit 014745
Musée d'Art Sacré, Trésor de la Cathédrale Notre-Dame, Paris . 014500
Musée d'Art Singulièr Raymond Reynaud, Sénas 015562
Musée d'Art Urbain, Montréal . . 006253
Musée d'Artisanat Monuments en Allumettes et Sciences Naturelles, Fontet 012834
Musée d'Arts Africains, Langonnet 013366
Musée d'Arts Décoratifs, Saint-Géoire-en-Valdaine 015129
Musée d'Arts et de Traditions Populaires, Amélie-les-Bains-Palalda 011444
Musée d'Arts et de Traditions Populaires, Cervione 012210
Musée d'Arts et de Traditions Populaires, Palinges 014412
Musée d'Arts et de Traditions Populaires, Poncé-sur-le-Loir . 014727
Musée d'Arts et de Traditions Populaires, F. Arnaudies, Saint-Paul-de-Fenouillet 015291
Musée d'Arts et de Traditions Populaires, Musée André Voulgre, Mussidan 014195
Musée d'Arts et d'Histoire du Donjon, Niort 014310
Musée d'Arts et Traditions Populaires, Cancale 012123
Musée d'Arts et Traditions Populaires, La Guérinière 013241
Musée d'Arts et Traditions Populaires, Marmoutier 013828
Musée d'Arts et Traditions Populaires, Yssingeaux 016155
Musée d'Arts et Traditions Populaires de Castellane et du Moyen Verdon, Castellane 012168
Musée d'Arts et Traditions Rurales, Saint-Alban-Auriolles 015008
Musée d'Arts Populaires, Laroque-des-Albères 013384
Musée d'Arts Populaires de Lille-Sud, Lille 013609
Musée d'Arts Reliquex, Verdelais 015958
Musée d'Assier, Feurs 012789
Musée Daubigny, Auvers-sur-Oise 011633
Musée Dauphinois, Grenoble . . 012991
Musée David, Angers 011470
Musée David et Alice Van Buuren, Bruxelles 003381
Musée d'Avions Montélimar, Montélimar 014052
Musée de Baalbeck, Baalbeck . . 030094
Musée de Bagnes, Le Châble . . 041181
Musée de Basse-Navarre et des Chemins de Saint-Jacques, Institut Culturel Basque, Saint-Palais (Pyrénées-Atlantiques) 015289
Musée de Bastia, Bastia 011722
Musée de Bataille, Mutzig 014197
Musée de Béjaïa, Béjaïa 000050
Musée de Beni Abbès, Bechar . 000049
Musée de Bible et Terre Sainte, Paris 014501
Musée de Bibracte, Saint-Léger-sous-Beuvray 015217
Musée de Biot, Musée d'Histoire et de Céramique Biotoise, Biot . . . 011859
Musée de Boinchoux, Besse-et-Saint-Anastaise 011826
Musée de Bonoua, Bonoua . . . 008705
Musée de Borda, Dax 012559
Musée de Bordj Moussa, Béjaïa 000051

Musée de Bouxwiller et du Pays de Hanau, Bouxwiller 011996
Musée de Bretagne, Rennes (Ille-et-Vilaine) 014867
Musée de Bulla Regia, Jendouba 042478
Musée de Cahors Henri-Martin, Cahors 012104
Musée de Calès, Lamanon . . . 013348
Musée de Calligraphie et Epigraphie Arabe, Damascus 041979
Musée de Carouge, Carouge . . 041176
Musée de Castel-Merle, Sergeac 015572
Musée de Centre Social, Luzy . . 013730
Musée de Cerdagne, Sainte-Léocadie 015413
Musée de Cerdagne d'Eyne, Eyne 012754
Musée de Cerisiers La Grange a Janou, Cerisiers 012203
Musée de Cervières, Cervières . 012209
Musée de Charlevoix, La Malbaie 006010
Musée de Charroux et de son Canton, Charroux-d'Allier 012279
Musée de Château, Durtal 012660
Musée de Château Guillaume, Lignac 013601
Musée de Châtillon-Coligny, Châtillon-Coligny 012326
Musée de Chauny, Chauny . . . 012345
Musée de Cherchell, Cherchell . 000053
Musée de Chine, China Museum Scheut – Anderlecht, Bruxelles 003382
Musée de Circonscription Archéologique, Sétif 000071
Musée de cire, Lourdes 013697
Musée de Cire de l'Historial, Sainte-Anne-d'Auray 015400
Musée de Cire et Salle de Documents Historiques, Perros-Guirec 014651
Musée de Cire-Historial de la Haute-Auvergne, Aurillac 011618
Musée de Cire Historique, Byblos 030107
Musée de Cires, Historial des Princes de Monaco, Monaco 031532
Musée de Citadelle, Sisteron . . 015612
Musée de Clichy et Société Historique, Clichy 012417
Musée de Cohennoz, Cohennoz 012427
Musée de Cox, Cox 012523
Musée de Dar Jamaï, Meknès . 031604
Musée de Diamare, Maroua . . . 005198
Musée de Djelfa, Djelfa 000056
Musée de Dol, Dol-de-Bretagne 012611
Musée de Domaine de Lacroix-Laval, Marcy-l'Étoile 013815
Musée de Drummond Castle, Ile-de-Molène 013097
Musée de Enchanteurs, Antrain-sur-Couesnon 011509
Musée de Faïences Christine Viennet, Béziers 011837
Musée de Faykod, Aups 011611
Musée de Ferroviaire à Orient-Express, Sospel 015637
Musée de Figurines Végétales, Basse-Pointe 030596
Musée de Flandre, Cassel 011693
Musée de Folklore, Nismes . . . 003831
Musée de Folklore de la Chée, Heiltz-le-Maurupt 013057
Musée de Folklore et d'Histoire Armand Pellegrin, Ancienne Ecole Communale des Garçons, Opheylissem 003854
Musée de Folklore Flamand Jeanne Devos, Wormhout 016149
Musée de France de Berck-sur-Mer, Berck-sur-Mer 011804
Musée de Fresques, Blain 011869
Musée de Gajac, Villeneuve-sur-Lot 016067
Musée de Géologie, Lozanne . . 013714
Musée de Géologie Botanique – Espace Geologique, La

Bourboule 013178
Musée de géologie René-Bureau, Sainte-Foy 006793
Musée de Germigny et Grange Germignonne, Germigny-des-Prés 012907
Musée de Glozel, Ferrières-sur-Sichon 012785
Musée de Grenoble, Grenoble . . 012992
Musée de Groesbeeck de Croix, Namur 003818
Musée de Guérin, Guérin 005818
Musée de Hottemme, Barvaux . 003260
Musée de Jean Chouan, Saint-Ouen-des-Toits 015284
Musée de Jouet et da la Poupée Ancienne, L'Isle-sur-la-Sorgue . 013640
Musée de Jouques, Musée d'Art et d'Histoire, Jouques 013141
Musée de Jules Gounon-Loubens, Loubens-Lauragais 013684
Musée de Kabgayi, Kabgayi . . . 037911
Musée de Kamouraska, Kamouraska 005940
Musée de Kent, Bouctouche . . . 005343
Musée de Kerhinet, Saint-Lyphard 015230
Musée de la Baleine, Port-la-Nouvelle 014769
Musée de la Bande Dessinée et Musée Municipal, Angoulême . 011480
Musée de la Banderette, Travers 041808
Musée de la Banque Nationale de Belgique, Bruxelles 003383
Musée de la Basilique et des Thermes Romains, Arlon 003243
Musée de la Bataille, Fontenoy-en-Puisaye 012831
Musée de la Bataille, Rocroi . . . 014929
Musée de la Bataille de Tilly sur Seulles 1944, Tilly-sur-Seulles 015762
Musée de la Bataille des Ardennes, Clervaux 030397
Musée de la Bataille des Ardennes, La Roche-en-Ardenne 003689
Musée de la Bataille du 6 Août 1870, Woerth 016148
Musée de la Bataille Mai-Juin 1940, Semuy 015561
Musée de la Batellerie, Briennon 012040
Musée de la Batellerie, Conflans-Sainte-Honorine 012470
Musée de la Batellerie de l'Ouest, Redon 014843
Musée de la Batellerie d'Offendorf, Offendorf 014350
Musée de la Batellerie et du Plan Incliné, Saint-Louis-Arzviller . 015224
Musée de la Batterie de Merville, Merville-Franceville-Plage 013948
Musée de la Bécane à Grand-Père, Sault-lès-Rethel 015510
Musée de la Bendrologie, Manéga 005174
Musée de la Bière, Armentières 011552
Musée de la Bière, Sankt Vith . . 003918
Musée de la Bière, Stenay 015658
Musée de la Blanchisserie Artisanale Joseph Gladel, Craponne (Rhône) 012526
Musée de la Bohème, Yviers . . 016158
Musée de la Boissellerie, Bois-d'Amont 011908
Musée de la Boite à Biscuits, Opheylissem 003855
Musée de la Boîte en Fer Blanc Lithographiée, Grand-Hallet . . 003579
Musée de la Bonneterie et du Négoce de la Toile, Quevaucamps . . . 003874
Musée de la Bonneterie, Musée de Vauluisant, Troyes 015848
Musée de la Boulangerie, Bonnieux 011920
Musée de la Boulangerie Rurale, La

Musée de Saxon, Saxon 041693
Musée de Schirmeck, Schirmeck 015542
Musée de Sétif, Sétif 000072
Musée de Sismologie et Magnétisme
Terrestre, Strasbourg 015677
Musée de Site, Sare 015483
Musée de Site Galloromain Villa
Loupian, Musée Archéologique et
Historique, Loupian 013693
Musée de Site Le Bazacle,
Toulouse 015786
Musée de Skikda, Skikda 000074
Musée de Sologne, Cheverny . 012366
Musée de Sologne, Moulin
du Chapitre, Romorantin-
Lanthenay 014943
Musée de Sonis, Bataille du 2
Décembre 1870, Loigny-la-
Bataille 013659
Musée de Sonvilier, Sonvilier . . 041754
Musée de Souvigny, Souvigny . . 015654
Musée de Spéléologie, Ecomusée du
Gouffre, Fontaine-de-Vaucluse . 012816
Musée de Statues d'Enfants, Musée
Schoenenberger, Les Mages . . 013560
Musée de Sucy, Sucy-en-Brie . . 015686
Musée de Suresnes René Sordes,
Suresnes 015691
Musée de Tabarka, Tabarka . . . 042506
Musée de Tahiti et des Iles – Te Fare
Manaha, Punaauia 016174
Musée de Tauroentum, Saint-Cyr-les-
Lecques 015079
Musée de Tautavel-Centre Européen
de la Préhistoire, Tautavel 015718
Musée de Tazoult, Tazoult 000076
Musée de Téboursouk,
Téboursouk 042508
Musée de Temouchent, Ain
Temouchent 000036
Musée de Tessé, Le Mans 013465
Musée de Tigran, Champvoux . . 012254
Musée de Timgad, Timgad-Batna 000078
Musée de Tipasa, Tipasa 000079
Musée de Tissage, Chauffailles . 012337
Musée de Tlemcen, Tlemcen . . 000080,
000081
Musée de Tourisme et d'Artisanat,
Lys-Saint-Georges 013758
Musée de Traditions Populaires et
d'Archéologie, Chauvigny 012346
Musée de Ua Huka, Musée
Archeologique, Vaipaee 016175
Musée de Ventabren, Musée
Archéologique La Calade,
Ventabren 015955
Musée de Verrières-le-Buisson,
Verrières-le-Buisson 015974
Musée de Vieux Cormeilles,
Cormeilles-en-Parisis 012487
Musée de Vieux-la-Romaine, Vieux-la-
Romaine 016007
Musée de Vieux-Lavaux, Cully . 041208
Musée de Vieux Logis, Sainte-
Enimie 015408
Musée de Vieux Sallèles, Sallèles-
d'Aude 015453
Musée de Voitures Anciennes et
Sellerie, Menetou-Salon 013929
Musée de Voitures Hippomobiles
Anciennes, Tour-en-Sologne . 015798
Musée de Vulliod Saint-Germain,
Pézenas 014661
Musée de Wanne, Trois-Ponts . 004012
Musée de Warcoing, Warcoing . 004047
Musée de Waterloo, Waterloo . . 004054
Musée de Zarzis, Zarzis 042518
Musée d'Eben, Eben-Emael . . 003487
Musée d'Egyptologie, Villeneuve-
d'Ascq 016052
Musée d'El-Oued, El-Oued 000060
Musée Delphinal, Beauvoir-en-
Royans 011775
Musée d'Enfidha, Enfidaville . . . 042472

Musée d'Ennery, Paris 014534
Musée Dentaire de Lyon, Lyon . 013738
Musée d'Entomologique,
Chaveyriat 012349
Musée d'Entrecasteaux,
Entrecasteaux 012683
Musée Départemantal des Sapeurs-
Pompiers de l'Orne, Bagnoles-de-
l'Orne 011686
Musée Départemental, Baume-les-
Messieurs 011729
Musée Départemental Albert Kahn,
Boulogne-Billancourt 011951
Musée Départemental Alexandre
Franconie, Cayenne 016163
Musée Départemental Breton,
Quimper 014822
Musée Départemental d'Archéologie,
Hastingues 013042
Musée Départemental d'Archéologie,
Montrozier 014117
Musée Départemental d'Art Ancien et
Contemporain, Épinal 012698
Musée Départemental d'Art
Contemporain de Rochechouart,
Rochechouart 014919
Musée Départemental d'Art Religieux,
Digne-les-Bains 012583
Musée départemental d'art religieux,
Sées 015548
Musée Départemental d'Art Sacré
Contemporain, Saint-Pierre-de-
Chartreuse 015307
Musée Départemental de Flandre,
Musée d'Art et d'Histoire,
Cassel 012164
Musée Départemental de la Bresse –
Domaine des Planons, Saint-Cyr-sur-
Menton 015080
Musée Départemental de la
Préhistoire, Le Grand-Pressigny 013444
Musée Départemental de la
Résistance, Le Teil 013507
Musée Départemental de la
Résistance en Vercors, Vassieux-en-
Vercors 015929
Musée Departemental de la
Résistance et de la Déportation,
Forges-les-Eaux 012838
Musée Departemental de la
Résistance et de la Déportation,
Lorris 013682
Musée Départemental de la
Résistance et de la Déportation,
Manneville-sur-Risle 013791
Musée Départemental de la
Résistance et de la Déportation,
Tulle 015855
Musée Départemental de la
Résistance et de la Déportation Jean
Philippe, Toulouse 015787
Musée Départemental de la Tapisserie,
Aubusson 011597
Musée Départemental de la Vigne et
des Pressoirs, Champlitte 012251
Musée Départemental de l'Abbaye de
Saint-Riquier, Saint-Riquier . . . 015348
Musée Départemental de l'École
Publique, Chevregny 012367
Musée Départemental de l'École
Publique, Saint-Clar-de-
Lomagne 015066
Musée Départemental de l'Ecole
Publique, Vergne 015965
Musée Départemental de l'Éducation,
Saint-Ouen-l'Aumône 015285
Musée Départemental de l'Oise,
Beauvais 011773
Musée Départemental de Préhistoire,
Solutré-Pouilly 015629
Musée Départemental de Préhistoire
Corse, Sartène 015498
Musée Départemental de Saint-
Antoine, Saint-Antoine-l'Abbaye 015022

Musée Départemental del'Ariège,
Château des Comtes de Foix,
Foix 012810
Musée Départemental des Antiquités
de la Seine-Maritime, Rouen . . 014966
Musée Départemental des Arts et
Traditions Populaires de la Haute-
Loire et du Massif Central, Saint-
Didier-en-Velay 015091
Musée Départemental des Arts et
Traditions Populaires du Perche,
Saint-Cyr-la-Rosière 015077
Musée Départemental des Hautes-
Alpes, Gap 012889
Musée Départemental des Pays de
Seine-et-Marne, Saint-Cyr-sur-
Morin 015083
Musée Départemental des Sapeurs-
Pompiers, Sciez 015543
Musée Départemental des Sapeurs-
Pompiers du Val-d'Oise, Osny . 014397
Musée départemental du Bugey-
Valmorey, Lochieu 013651
Musée départemental du Revermont,
Treffort 015828
Musée Départemental du Sel,
Marsal 013838
Musée Départemental du Textile,
Lavelanet 013408
Musée Départemental Georges de La-
Tour, Vic-sur-Seille 015992
Musée Départemental Hébert, La
Tronche 013311
Musée Départemental Ignon-Fabre,
Mende 013925
Musée Départemental Jérôme-
Carcopino, Aléria 011410
Musée Départemental Maurice Denis,
Saint-Germain-en-Laye 015141
Musée Départemental Pascal Paoli,
Morosaglia 014139
Musée Départemental Stéphane
Mallarmé, Vulaines-sur-Seine . 016127
Musée départemental Victor
Schœlcher, Pointe-à-Pitre 023029
Musée des 18 Jours-Mémoires de
Guerre, Pipaix 003868
Musée des 4 Saisons,
Generagues 012898
Musée des Abénakis, Odanak . . 006399
Musée des Affiches Léonetto-
Cappiello, Épernay 012692
Musée des Alambics, Saint-Romain-
de-Benet 015352
Musee des Allues, Maison Bonnevie,
Meribel 013940
Musée des Alpilles, Saint-Rémy-de-
Provence 015341
Musée des Amis de Castrum Vetus,
Châteauneuf-les-Martigues . . . 012308
Musée des Amis de Montmélian,
Montmélian 014080
Musée des Amis de Thann,
Thann 015724
Musée des Amis du Vieux Corbie,
Corbie 012479
Musée des Amis du Vieux Donzère,
Donzère 012627
Musée des Amis du Vieux Guérigny,
Guérigny 013018
Musée des Amis du Vieux Lormont,
Lormont 013679
Musée des Amis du Vieux
Montrichard, Musees du Donjon,
Montrichard 014114
Musée des Amis du Vieux Nolay,
Nolay 014327
Musée des Amis du Vieux
Saint-Étienne, Saint-Étienne . 015105
Musée des Amoureux,
Werentzhouse 016140
Musée des Anciens Enfants de Troupe,
Autun 011626
Musée des Anciens Outils Agricoles,

Saint-Mathurin 015258
Musée des Années 30, Boulogne-
Billancourt 011952
Musée des Antiquités Nationales,
Saint-Germain-en-Laye 015142
Musée des Appareils Photographiques
et de Cinéma d'Amateurs,
Marsilly 013868
Musée des Archives, Saint-
Hubert 003914
Musée des Archives Départementales
de l'Aveyron, Conseil Général de
l'Aveyron, Rodez 014930
Musée des Armes, Tulle 015856
Musée des Arômes de Provence,
Saint-Rémy-de-Provence 015342
Musée des Arômes et du Parfum,
Graveson 012983
Musée des Art et Tradition, Reulle-
Vergy 014879
Musée des Arts Africains, Océaniens,
Amérindiens, Marseille 013855
Musée des Arts Anciens du Namurois,
Namur 003819
Musée des Arts Asiatiques, Nice 014286
Musée des Arts Décoratifs,
Bordeaux 011930
Musée des Arts Décoratifs, Lyon 013739
Musée des Arts Décoratifs, Paris 014535
Musée des Arts Décoratifs,
Strasbourg 015678
Musée des Arts Décoratifs et de
la Modernité, Gourdon (Alpes-
Maritimes) 012946
Musée des Arts Décoratifs Sabatier
d'Espeyran, Montpellier 014096
Musée des Arts du Cognac,
Cognac 012424
Musée des Arts et de l'Enfance,
Fécamp 012771
Musée des Arts et des Meubles,
Poilley 014717
Musée des Arts et des Sciences,
Sainte-Croix 041663
Musée des Arts et d'Histoire,
Locronan 013653
Musée des Arts et Metiers, Paris 014536
Musée des Arts et Métiers, Saint-
Gildas-de-Rhuys 015149
Musée des Arts et Métiers de la Vigne
et du Vin, Moulis-en-Médoc . . 014163
Musée des Arts et Tradition Apicoles,
Fontan 012825
Musée des Arts et Traditions
Populaires, Djerba 042470
Musée des Arts et Traditions
Populaires, Ermont 012703
Musée des Arts et Traditions
Populaires, Esse 012721
Musée des Arts et Traditions
Populaires, Le Sel-de-Bretagne 013505
Musée des Arts et Traditions
Populaires, Saint-Arnoult-en-
Yvelines 015029
Musée des Arts et Traditions
Populaires, Saint-Esprit 030602
Musée des Arts et Traditions
Populaires, Treignac 015833
Musée des Arts et Traditions
Populaires, Wattrelos 016138
Musée des Arts et Traditions
Populaires 'Dar Ben Abdallah' de
Tunis, Tunis 042514
Musée des Arts et Traditions
Populaires de la Haute-Loire,
Lavaudieu 013405
Musée des Arts et Traditions
Populaires de la Vallée de la Cère,
Arpajon-sur-Cère 011557
Musée des Arts et Traditions
Populaires de Moyenne Provence,
Draguignan 012647
Musée des Arts et Traditions
Populaires, Abbaye de Valbonne,

Musée des Arts et Traditions Populaires, Musée Municipal, –
Musée des Métiers et des Légendes de la Forêt d'Orléans,

Index of Institutions and Companies

Musée d'Histoire et d'Archéologie, Vannes (Morbihan) –
Musée du Château des Ducs de Bretagne, Château des Ducs de

Index of Institutions and Companies

Ménerbes 013926
Musée du Tissage et de la Soierie,
Bussières 012072
Le Musée du Tisserand Dauphinois,
La Batie-Montgascon 013171
Musée du Touage et Canal de Saint-
Quentin, Riqueval 014901
Musée du Touquet, Le Touquet-Paris-
Plage 013510
Musée du Tour Automatique
et d'Histoire de Moutier,
Langdrehautomaten- und
Geschichtsmuseum, Moutier . . 041522
Musée du Tour de France, Arvieux-en-
Queyras 011572
Musée du Tourneur, Cinquétral . 012387
Musée du Train, Clairac 012392
Musée du Train à Vapeur, Sainte-Foy-
l'Argentière 015411
Musée du Train et de la Miniature,
Musée de la Vie Rurale, Saint-
Sauves-d'Auvergne 015356
Musée du Train et des Equipages
Militaires, Tours 015817
Musée du Train et du Jouet,
Arpaillargues-et-Aureillac . . . 011556
Musée du Transmanche, Escalles 012706
Musée du Transport Urbain Bruxellois,
Bruxelles 003404
Musée du Travail, Montfermeil . . 014059
Musée du Travail Charles Peyre,
Montfermeil 014060
Musée du Trégor, Guimaec 013023
Musée du Tribunal Révolutionnaire,
Tinchebray 015763
Musée du Trièves, Mens 013930
Musée du Valois, Vez 015984
Musée du Valois et de l'Archerie,
Crépy-en-Valois 012531
Musée du Veinazès, Lacapelle-del-
Fraisse 013327
Musée du Vélo, Cormatin 012486
Musée du Vélo, Fenneviller 012779
Musée du Vélo, Periers 014628
Musée du Vélo et de la Moto,
Domazan 012615
Musée du Vélo Le Belle Échappée, La
Fresnaye-sur-Chédouet 013229
Musée du Vélocipède, Cadouin . 012090
Musée du Veneur, Céré-la-Ronde 012198
Musée du Verre, Blaye-les-Mines 011886
Musée du Verre, Marcinelle . . . 003770
Musée du Verre, Sars-Poteries . 015497
Musée du Verre, Musées
d'Archéologie et d'Arts Décoratifs,
Liège 003731
Musée du Verrier, Saint-Prex . . 041659
Musée du Vieaux Château,
Bricquebec 012036
Musée du Vieil Argenteuil,
Argenteuil 011537
Musée du Vieil Auvillar, Auvillar 011635
Musée du Vieil Eygalières,
Eygalières 012749
Musée du Vieil Outil Hastière,
Hastière 003608
Musée du Vieux-Baulmes,
Baulmes 041086
Musée du Vieux Biarritz, Musée
Historique, Biarritz 011845
Musée du Vieux Bourg, Mimizan 013978
Musée du Vieux Brest, Brest . . . 012024
Musée du Vieux-Château, Collections
d'Art Naïf, Laval (Mayenne) . . 013399
Musée du Vieux-Cimetière,
Soignies 003954
Musée du Vieux Clairac, Clairac 012393
Musée du Vieux Courseulles,
Courseulles-sur-Mer 012514
Musée du Vieux Figeac, Figeac . 012791
Musée du Vieux Granville,
Granville 012963
Musée du Vieux Lambesc,
Lambesc 013351

Musée du Vieux L'Arbresle,
L'Arbresle 013382
Musée du Vieux Marseille,
Marseille 013862
Musée du Vieux Mazères, Hotel
d'Ardouin, Mazères (Ariège) . . 013904
Musée du Vieux Merville,
Merville 013947
Musée du Vieux-Monthey,
Monthey 041507
Musée du Vieux Montpellier,
Montpellier 014100
Musée du Vieux-Moudon, Château du
Rochefort, Moudon 041520
Musée du Vieux Moulin, Villar-
Loubière 016013
Musée du Vieux Moulin à Vent,
Vensac 015954
Musée du Vieux Nîmes, Nîmes . 014307
Musée du Vieux Nimy, Mons . . . 003805
Musée du Vieux Pays,
Dieulouard 012581
Musée du Vieux-Pays d'Enhaut,
Château-d'Oex 041184
Musée du Vieux Pérouges,
Pérouges 014639
Musée du Vieux-Phare, Matane . 006147
Musée du Vieux Plassac, Plassac 014686
Musée du Vieux Pommiers, Pommiers-
en-Forez 014726
Musée du Vieux Pressoir et de la
Vigne, Coulanges-la-Vineuse . 012500
Musée du Vieux Sisteron, Musée
Municipal, Sisteron 015614
Musée du Vieux Toulon, Toulon
(Var) 015775
Musée du Vieux Toulouse,
Toulouse 015790
Musée du Vieux-Tréport, Le
Tréport 013512
Musée du Vieux Warcq, Warcq . 016132
Musée du Vigneron, Buxy 012076
Musée du Vigneron, Chaumont-le-
Bois 012343
Musée du Vigneron, Les
Marches 013561
Musée du Vigneron, Verdigny . . 015960
Musée du Vigneron Paul Coulon et
Fils, Rasteau 014839
Musée du Vigneron, Cave Vinicole du
Vieil Armand, Wuenheim 016150
Musée du Vignoble et des Vins
d'Alsace, Kientzheim 013160
Musée du Vignoble Nantais, Le
Pallet 013485
Musée du Village, Moknine 042490
Musée du Village, Saint-Sorlin-
d'Arves 015367
Musée du Vin, Cheignieu-la-
Balme 012354
Musée du Vin, Cissac-Médoc . . 012389
Musée du Vin, Ehnen 030407
Musée du Vin, Nissan-lez-
Ensérune 014313
Musée du Vin, Paris 014556
Musée du Vin, Saint-Hilaire-de-
Loulay 015157
Musée du Vin dans l'Art, Pauillac 014616
Musée du Vin de Bourgogne,
Beaune 011767
Musée du Vin de Cahors et de la
Table Lotoise, Cahors 012105
Musée du Vin de Champagne Piper-
Heidsieck, Reims 014855
Musée du Vin de la Batellerie et de la
Tonnellerie, Bergerac 011809
Musée du Vin et de Saint-Jacques de
Compostelle, Pomerol 014724
Musée du Vin-Mimoria di Vino,
Luri 013720
Musée du Vin, Cave Brotte,
Châteauneuf-du-Pape 012306
Musée du Vin, Gourmet Quercynois,
Saint-Cirq-Lapopie 015064

Musée du Vitrail, Curzac-sur-
Vonne 012546
Musée du Vitrail et du Verre,
Gordes 012942
Musée du Vivarais Protestant,
Pranles 014792
Musée du Zinc, Montpellier . . . 014101
Musée Ducal, Bouillon 003310
Musée Duhamel du Monceau,
Pithiviers-le-Vieil 014680
Musée d'Unterlinden, Colmar . . 012443
Musée Dupleix et Amas,
Landrecies 013358
Musée Dupuytren, Université Paris VI
Pierre et Marie Curie, Paris . . 014557
Musée d'Uxellodunum et Musée de
Martel, Martel 013872
Musée d'Yverdon-les-Bains et sa
Région, Yverdon-les-Bains . . . 041904
Musée E. Chenon, Château-
Meillant 012295
Musée Eclaté d'Arts et de Traditions
Populaires, Cardaillac 012149
Musée-Ecole de Broderie, Cilaos 036014
Musée École de la Perrine, Laval
(Mayenne) 013400
Musée-École du Grand Meaulnes,
Épineuil-le-Fleuriel 012699
Musée Ecole Publique en Charente,
Saint-Fraigne 015125
Musée-École, Centre d'Etudes et des
Patrimoines, Saint-Christophe-en-
Brionnais 015059
Musée Écologique Vanier, Laval 006047
Musée EDF Electropolis, L'Aventure de
l'Électricité, Mulhouse 014180
Musée Edgar Melik, Cabriès . . . 012084
Musée Edgard Clerc, Musée
Précolombien, Le Moule 023028
Musée Edith Piaf, Paris 014558
Musée Edmond Rostand, Cambo-les-
Bains 012115
Musée Edouard Branly, Paris . . 014559
Musée Edouard Mahé, Retiers . 014874
Musée Éducatif de Préhistoire,
Villeneuve-la-Comtesse 016059
Musée Éducatif d'Entomologie de
Levens, Levens 013586
Musée Église Catholique de
l'Assomption, Rosenwiller . . . 014957
Musée El Kobba des Arts et Traditions,
Sousse 042505
Musée Elise Rieuf, Massiac . . . 013882
Musée Emile Aubry, Béjaïa 000052
Musée Emile Chénon,
Châteaumeillant 012304
Musée Émile Guillaumin, Musée du
Folklore, Ygrande 016154
Musée Émile Jean, Villiers-sur-
Marne 016092
Musée Émile Verhaeren,
Honnelles 003630
Musée Emir Abdelkader, Miliana 000067
Musée Emmanuel de la Villéon,
Fougères (Ille-et-Vilaine) 012845
Musée en Herbe, Paris 014560
Musée en Piconrue, Bastogne . . 003266
Musée en Plein Air de Sculptures
Contemporaines, Étiolles 012737
Musée en Plein Air du Sart-
Tilman, Centre d'Animation et
d'Intégration des Arts Plastiques
de la Communauté française de
Belgique, Liège 003732
Musée Entomologique, Musée des
Papillons, Saint-Quentin (Aisne) 015326
Musée Ermitage John Io Scorpione,
Saint-Ame 015015
Musée Ernest Cognacq, Saint-Martin-
de-Ré 015250
Musée Espace Bérenger Saunière,
Rennes-le-Château 014870
Musée Espéranto a Gray, Gray . 012986
Musée Estève, Bourges 011981

Musée Estienne de Saint-Jean, Aix-en-
Provence 011382
Musée Estrine, Saint-Rémy-de-
Provence 015343
Musée et Atelier d'Art Animalier, La
Chapelle-Thouarault 013196
Musée et Centre de Transmission
de la Culture Daniel Weetaluktuk,
Inukjuak 005914
Musée et du Vieux Chinon,
Chinon 012374
Musée et Jardins botaniques
cantonaux, Lausanne 041427
Musée et Maison des Vins,
Bandol 011701
Musée et Parc Archéologiques de
Montauban, Musées Gaumais,
Buzenol 003427
Musée et Plaisir du Chocolat,
Biarritz 011846
Musée et Salon Permanent de
l'Automobile de Sport Prestige et
Collection, Chauffailles 012338
Musée et Site Archéologiques de Nice-
Cimiez, Nice 014288
Musée et Site Gallo-Romains de Saint-
Romain-en-Gal – Vienne, Saint-
Romain-en-Gal 015353
Musée et Temple des Bastides,
Labastide-d'Armagnac 013319
Musée et Trésor de l'Hospice, Bourg-
Saint-Pierre 041149
Musée Ethnographique,
Chefchaouen 031589
Musée Ethnographique, Mouans-
Sartoux 014147
Musée Ethnographique, Tétouan 031625,
031626
Musée Ethnographique Alexandre
Senou Adande, Porto-Novo . . 004106
Musée Ethnographique de la Région
Maritime, Aného 042459
Musée Ethnographique de l'Olivier,
Cagnes-sur-Mer 012100
Musée Ethnographique des Oudaïa,
Rabat 031613
Musée Ethnographique du Donjon,
Niort 014312
Musée Ethnographique du Peuple
Basque, Isturitz 013113
Musée Ethnographique Regional,
Bouar 007319
Musée Ethnologique Intercommunal
du Vermandois, Vermand 015967
Musée Etienne-Jules Marey,
Beaune 011768
Musée Étienne Martin, Noyal-sur-
Vilaine 014333
Musée Etival dans le Temps, Ferme-
Musée, Etival-Clairefontaine . . 012738
Musée Eudore-Dubeau, Montréal 006268
Musée Eugène Boudin, Honfleur 013081
Musée Eugène Burnand, Moudon 041521
Musée Eugène Farcot, Saclère . 015441
Musée Eugène Le Roy et Vieux
Métiers, Montignac 014069
Musée Européen de Sculptures
Contemporaines en Plein Air, Musée
à Ciel, Launstroff 013392
Musée-Expo de la Grange
aux Abeilles, Giffaumont-
Champaubert 012914
Musée Expo Forêt, Gérardmer . 012904
Musée Extraordinaire Georges-
Mazoyer, Ansouis 011499
Musée Fabre, Montpellier 014102
Musée Faniahy, Musée de l'Université
de Fianarantsoa, Fianarantsoa . 030473
Musée Fantastique de la Bête
du Gévaudan, Saugues-en-
Gévaudan 015503
Musée Faure, Musée Municipal, Aix-
les-Bains 011386
Musée Fayet, Béziers 011840

Chatrian, Phalsbourg 014664
Musée Historique et Lapidaire, Isle-
Aumont 013106
Musée Historique et Logis Thiphaine,
Le Mont-Saint-Michel . . 013479
Musée Historique et Militaire,
Freyming-Merlebach 012870
Musée Historique et Militaire,
Huningue 013085
Musée Historique et Militaire,
Mémorial du Finistère, Brest . . 012025
Musée Historique et Préhistorique Van
den Steen, Jehay-Amay 003663
Musée Historique, Institut National des
Jeunes Aveugle, Paris 014566
Musée Hofer-Bury, Lavérune . . . 013409
Musée Honoré Mercier,
Sabrevois 006685
Musée Horlogerie Automates Yves
Cupillard, Morteau 014144
Musée Horreum Romain,
Narbonne 014233
Musée Horta, Hortamuseum,
Bruxelles 003406
Musée Hospitalier, Charlieu 012271
Musée Hospitalier – Apothicairerie,
Hôtel-Dieu, Bourg-en-Bresse . 011970
Musée Hospitalier et Apothicairerie,
Louhans 013689
Musée-Hôtel Bertrand,
Châteauroux 012317
Musée-Hôtel de Beaumont,
Valognes 015907
Musée Hôtel de la Dentelle,
Brioude 012047
Musée-Hôtel de Ville, Thann . . . 015725
Musée-Hôtel Granval-Caligny,
Valognes 015908
Musée-Hôtel Lallemand, Bourges 011982
Musée-Hôtel Le Vergeur, Reims 014856
Musée Humoristique Albert Dubout,
Palavas-les-Flots 014411
Musée Huperel de l'Histoire Cathare,
Minerve 013980
Musée Huppy Autrefois, Huppy . 013087
Musée Hydrogéologique,
Chaudfontaine 003438
Musée Ianchelevici, La Louvière 003688
Musée Impérial de la Miniature,
Verneuil-sur-Avre 015971
Musée in Situ des Bains Romains, Aix-
les-Bains 011387
Musée Industriel Corderie Vallois,
Notre-Dame-de-Bondeville . . . 014329
Musée Industriel du Val-de-Travers,
Fleurier 041258
Musée Industriel et d'Ethnologie,
Lille 013615
Musée Ingres, Montauban 014030
Musée Ingres: Bulletin,
Montauban 138696
Musée Intercommunal d'Histoire et
d'Archéologie, Louvres 013712
Musée International d'Art Naïf,
Vicq 015997
Musée International d'Art Naïf Yvon-M.
Daigle, Magog 006114
Musée International d'Arts Modestes,
Sète 015584
Musée International de Akum,
Bamenda 005192
Musée International de la Base
Aérienne de Chièvres, Chievres 003441
Musée International de la Chasse,
Gien 012913
Musée International de la Chaussure,
Romans-sur-Isère 014940
Musée International de la Croix-Rouge
et du Croissant-Rouge, Genève 041306
Musée International de la Faune,
Argelès-Gazost 011532
Musée International de la Faune,
Québriac 014816
Musée International de la Marionnette,

Internationaal Marionettenmuseum
Peruchet, Bruxelles 003407
Musee International de la Miniature,
Lyon 013750
Musée International de la Parfumerie,
Grasse 012972
Musée International de la Reforme,
Genève 041307
Musée International de Mobilier
Miniature, Vendeuvre 015948
Musée International des Hussards,
Tarbes 015713
Musée International des Polices
et des Gendarmeries, Charvieu-
Chavagneux 012286
Musée international d'horlogerie,
Institut l'Homme et le Temps, La
Chaux-de-Fonds 041188
Musée International du Carnaval et du
Masque, Binche 003286
Musée International du Coquillage,
Saint-Barthélemy 023032
Musée International, Pétanque
et Boules, Saint-Bonnet-le-
Château 015039
Musée Isérables, Fondation Pro
Aserablos, Isérables 041376
Musée Itinérant d'Art Byzantin,
Montréal 006269
Musée Ivan Tourguéniev,
Bougival 011947
Musée Ivanoff, La Borne 013176
Musée J. Armand Bombardier,
Valcourt 007094
Musée J.-E. Blanche, Offranville 014351
Musée J.-F. Leyraud, La Roche-sur-le-
Buis 013275
Musée J.B. Mathon et André Durand,
Neufchâtel-en-Bray 014252
Musée Jacquemart-André, Fontaine-
Chaalis 012813
Musée Jacquemart-André, Paris 014567
Musée Jacques Cartier à Saint-Malo,
Manoir de Limoelou, Saint-Malo (Ille-
et-Vilaine) 015240
Musée Jacques Pellan, Giverny . 012927
Musée Jadis Allevard, Allevard-les-
Bains 011419
Musée-Jardin Paul Landowski,
Boulogne-Billancourt 011953
Musée Jean Aicard, Solliès-Ville 015628
Musée Jean Aicard – Paulin Bertrand,
La Garde 013231
Musée Jean-Charles Cazin,
Samer 015468
Musée Jean Cocteau, Menton . . 013937
Musée Jean de La Fontaine, Château-
Thierry 012299
Musée Jean Gabin, Mériel 013941
Musée Jean-Henri Fabre, Saint-
Léons 015220
Musée Jean-Honoré Fragonard,
Grasse 012973
Musée Jean-Jacques Rousseau,
Genève 041308
Musée Jean-Jacques Rousseau,
Montmorency 014083
Musée Jean-Jacques Rousseau,
Môtiers 041518
Musée Jean-Lurçat, Angers 011475
Musée Jean Lurçat, Saint-Laurent-les-
Tours 015213
Musée Jean Macé, Beblenheim 011778
Musée Jean-Marie Somet, Villars
(Loire) 016018
Musée Jean-Marie Souplet, Musée
Minéralogique et Paléontologique,
Engis 003501
Musée Jean-Mermoz, Aubenton 011587
Musée Jean-Moulin, Paris 014568
Musée Jean Racine, La
Ferté-Milon 013220
Musée Jeanne d'Aboville, La
Fère 013216

Musée Jeanne d'Arc, Chinon . . 012375
Musée Jeanne d'Arc, Rouen . . . 014969
Musée Jeanne d'Arc, Sainte-Catherine-
de-Fierbois 015403
Musée Jenisch, Cabinet Cantonal
des Estampes, Centre national du
dessin, Fondation Oskar Kokoschka,
Vevey 041844
Musée Joachim du Bellay, Liré . 013631
Musée Johannique, Vaucouleurs 015931
Musée Joseph Abeilhe, Marciac 013808
Musée Joseph Denais, Beaufort-en-
Vallée 011755
Musée Joseph Durand, Saint-Clément-
des-Baleines 015068
Musée Joseph Filion, Sainte-
Thérèse 006800
Musée Joseph Lhoménède, Frugières-
le-Pin 012876
Musée Joseph Vaylet, Espalion . 012715
Musée Jouenne, Saint-Rémy-de-
Provence 015344
Musée Judéo-Alsacien,
Bouxwiller 011997
Musée Juif Comtadin, Cavaillon 012191
Musée Juif de Belgique-Joods
Museum van België, Bruxelles 003408
Musée Juin 1944, L'Aigle 013343
Musée Jules Desbois, Parçay-les-
Pins 014417
Musée Jules Destrée, Charleroi . 003437
Musée Jules Garinet, Châlons-en-
Champagne 012223
Musée Jules Romains, Saint-Julien-
Chapteuil 015196
Musée Jules Verne, Nantes 014223
Musée Jurassien d'Art et d'Histoire,
Delémont 041214
Musée Jurassien des Arts,
Moutier 041523
Musée Juste pour Rire, Montréal 006270
Musée Kasba, Tanger 031622
Musée Kateri Tekakwitha,
Kahnawake 005933
Musée Kaysone Phomvihane,
Vientiane 029915
Musée Kio-Warini, Loretteville . . 006094
Musée Kotama, Jijel 000065
Musée Kwok-On, Paris 014569
Musée La Batterie d'Azeville,
Azeville 011676
Musée La Diana, Montbrison . . 014044
Musée la Faïencerie, Ancy-le-
Franc 011459
Musée La Ferme Forézienne, Saint-
Bonnet-les-Oules 015040
Musée la Magie des Automates, Lans-
en-Vercors 013373
Musée la Main et l'Outil, Pannes 014414
Musée La Maison du Bucheron,
Pourcy 014782
Musée La Maison du Passé, Royat-les-
Bains 014986
Musée la Maison du Pêcheur et "Le
Hope", Saint-Gilles-Croix-de-Vie 015150
Musée la Muse, Mérindol 013943
Musée la Perçée du Bocage 1944,
Saint-Martin-des-Besaces . . . 015251
Musée La Pouponnière, Bourg-
Charente 011967
Musée la Taille de Pierre, Saint-
Antoine-l'Abbaye 015023
Musée la Vie des Jouets,
Mauleon 013889
Musée la Villa Aurélienne, Fréjus 012862
Musée Labasso, Bangassou . . . 007317
Musée l'Abeille Vivante, Le
Faouët 013440
Musée Labenche d'Art et d'Histoire,
Brive-la-Gaillarde 012051
Musée Lacoune, Lacaune 013328
Musée Laennec, Nantes 014224
Musée Lamartine, Mâcon 013761
Musée Lamartine, Pierreclos . . . 014668

Musée Lambinet, Versailles 015977
Musée Lamothe-Cadillac, Saint-
Nicolas-de-la-Grave 015277
Musée Langlois, Beaumont-en-
Auge 011763
Musée Languédocien,
Montpellier 014104
Musée Lapérouse, Albi 011402
Musée Lapidaire, Aire-sur-
l'Adour 011376
Musée Lapidaire, Avignon 011656
Musée Lapidaire, Baume-les-
Messieurs 011731
Musée Lapidaire, Morlaàs 014128
Musée Lapidaire, Saint-Germain-
Laval 015145
Musée Lapidaire, Saint-Guilhem-le-
Désert 015155
Musée Lapidaire, Saint-Ursanne 041661
Musée Lapidaire, Villeveyrac . . . 016086
Musée Lapidaire de l'Abbaye, Savigny
(Rhône) 015529
Musée Lapidaire de l'Abbaye Saint-
Pierre, Maillezais 013773
Musée Lapidaire de Mozac,
Mozac 014175
Musée Lapidaire du Cloître de
l'Ancienne Cathédrale, Vaison-la-
Romaine 015881
Musée Lapidaire et d'Art Religieux,
Société des Amis des Arts,
Charlieu 012272
Musée Lapidaire et Exposition
Permanente sur la Restauration,
Carcassonne 012147
Musée Lapidaire, Palais des
Archevêques, Narbonne 014234
Musée Larrey, Beaudean 011754
Musée L'Art en Marche Hauterives
Art Brut, Neuve Invention,
Hauterives 013051
Musée L'Art en Marche Lapalisse Art
Brut, Lapalisse 013379
Musée Laumonier de la Locomotive à
Vapeur, Vierzon 016004
Musée Laurier, Victoriaville 007159
Musée Lautrecois, Lautrec 013396
Musée Le Grenier de l'Histoire,
Lèves 013587
Musée Le Jacquemart, Langeac 013362
Musée Le Masque en Liberté,
Nibelle 014275
Musée le Mémoire d'Oyé, Oyé . 014403
Musée Le Minerve, Yzeures-sur-
Creuse 016161
Musée Le Mont-Saint-Michel, Le
Mont-Saint-Michel 013480
Musée Le Patrimoine du Sapeur-
Pompier, Beaune 011769
Musée Le Petit Lourdes, Lourdes 013704
Musée Le Petit Louvre, La
Pacaudière 013257
Musée Le Petit Mont-Saint-Michel,
Saint-Marcan 015242
Musée Le Pionnier, Saint-Malo . 006765
Musée Le Secq des Tournelles –
Musée de la Ferronnerie,
Rouen 014970
Musée Le Soum, Saint-Véran . . 015384
Musée le Temple du Soleil, Saint-
Michel-en-l'Herm 015268
Musée Le Vieux Cormenier,
Champniers-en-Vienne 012253
Musée Leblanc-Duvernoy,
Auxerre 011640
Musée Leclerc Briant, Épernay . 012693
Musée Lella Hadria, Midoun . . . 042489
Musée Lénine, Paris 014570
Musée Leon de Smet, Deurle . . 003464
Musée Léon Dierx, Saint-Denis . 036016
Musée Léon Marès, Lovagny . . . 013713
Musée Les 3 Salles, Lectoure . . 013529
Musée Les Amis de l'Outil,
Bièvres 011854

Musée Protestant de la Grange de
Wassy, Wassy 016137
Musée Provençal des Arts et
Traditions Poplaires, Donzère . 012628
Musée Provençal des Transports
Urbains et Régionaux, La
Barque 013168
Musée Provençal du Costume et du
Bijou, Grasse 012974
Musée Provençal et Folklorique
Taradeau, Les Arcs 013541
Musée Provincial de Douala,
Douala 005195
Musée Provincial de la Forêt,
Namur 003823
Musée Provincial du Houet, Bobo-
Dioulasso 005171
Musée Provincial du Poni, Gaoua 005172
Musée Provincial du Sanmatenga,
Kaya 005173
Musée Provincial Félicien Rops,
Namur 003824
Musée Prytanée Militaire, La
Flèche 013225
Musée Pyrénéen de Niaux, Niaux 014274
Musée Québécois de Culture
Populaire, Trois-Rivières 007076
Musée Quentovic, Etaples 012733
Musée Rabelais, Seuilly 015587
Musée Raimu, Cogolin 012425
Musée Rambouritain, Rambouillet 014835
Musée Raoul Dastrac, Collection
d'Arts et de Traditions Populaires,
Aiguillon 011371
Musée Rath, Genève 041309
Musée Raymond Lafage, Lisle-sur-
Tarn 013642
Musée Raymond Peynet, Brassac-les-
Mines 012009
Musée Raymond Poincaré,
Sampigny 015470
Musée Raymond Rochette, Saint-
Sernin-du-Bois 015361
Musée Réattu, Arles 011548
Musée Reflet Brionnais,
Iguerande 013092
Musée Regards sur le Passé,
Hourtin 013084
Musée Régimentaire les Fusiliers
de Sherbrooke, Sherbrooke,
Québec 006862
Musée Regional, Kisangani 008675
Musée Régional André Grenard
Matsoua, Kinkala 008680
Musée Régional d'Ethnologie,
Béthune 011829
Musée Regional d'Argenteuil, Saint-
André-d'Argenteuil 006694
Musée Régional d'Arras, Mutzig 014198
Musée Régional d'Arts et de
Traditions Populaires, Grimaud 013008
Musée Régional d'Auvergne,
Riom 014898
Musée Régional de Fouras,
Fouras 012848
Musée Régional de Géologie Pierre
Vetter, Decazeville 012562
Musée Régional de la Côte-Nord,
Sept-Îles 006844
Musée Régional de la Poterie bas
Normande, Ger 012903
Musée Régional de la Résistance et
de la Déportation, Thionville . . 015735
Musée Régional de la Sagne, La
Sagne 041654
Musée Régional de la Vigne et du Vin,
Montmélian 014081
Musée Régional de l'Air, Groupement
Préservation Patrimoine
Aéronautique, Marcé 013800
Musée Régional de l'Alsace Bossue,
Sarre-Union 015493
Musée Régional de l'Orléanais,
Beaugency 011756

Musée Regional de Mahdia,
Mahdia 042485
Musée Régional de Préhistoire,
Orgnac-l'Aven 014380
Musée Régional de Rimouski,
Rimouski 006654
Musée Régional de Sikasso,
Sikasso 030559
Musée Régional de Sokadé,
Sokadé 042462
Musée Régional de Vaudreuil-
Soulanges, Vaudreuil-Dorion . 007132
Musée Régional de Zinder,
Zinder 033232
Musée Régional des Arts de la Table,
Ancien Hospice Saint-Pierre du XVIIe
s, Arnay-le-Duc 011553
Musée Régional des Enrôles de Force,
Dudelange 030404
Musée Régional des Métiers, La
Cheze 013201
Musée Régional des Mines de
Malartic, Malartic 006122
Musée Régional des Savanes,
Dapaong 042460
Musée Régional des
Télécommunications en Flandres,
Marcq-en-Barœul 013813
Musée Régional d'Histoire et
d'Archéologie, Musée de Visé,
Visé 004035
Musée Régional d'Histoire et
d'Artisanat du Val-de-Travers,
Môtiers 041519
Musée Régional d'Histoire et
d'Ethnographie, Fort-de-France 030598
Musée Régional du Cerel,
Toamasina 030476
Musée Régional du Chemin de Fer,
Rosny-sous-Bois 014962
Musée Régional du Chemin de Fer
Nord-Pas-de-Calais, Denain . . 012568
Musée Régional du Cidre et du
Calvados, Valognes 015909
Musée Régional du Machinisme
Agricole, La Ferté-Milon 013221
Musée Régional du Sahel, Gao . 030558
Musée Régional du Timbre et de la
Philatélie, Le Luc 013460
Musée Régional Dupuy-Méstreau,
Saintes 015436
Musée Régional Ex-Dixième Riaom,
Thiès 037944
Musée Régional Ma-Loango Diosso,
Pointe-Noire 008681
Musée Relais du Cheval de Trait
Comtois, Levier 013589
Musée Religieux d'Art Franciscain,
Nice 014293
Musée Religieux Franco-Canadien,
Tours 015818
Musée Remember 39–45, Léhon 013532
Musée Remise aux Outils Champenois,
Dormans-en-Champagne . . . 012630
Musée Renaudot, Loudun 013687
Musée René Davoine, Charolles 012276
Musée Renoir, Cagnes-sur-Mer . 012101
Musée Requien, Avignon 011658
Musée Rêve Auto-Jeunesse,
Mosnac 014145
Musée Rêve et Miniatures,
Brantôme 012006
Musée Revoir le Passé, Les Loges-
Marchis 013559
Musée Ribauri, Lasne-Chapelle-Saint-
Lambert 003698
Musée Rignault, Saint-Cirq-
Lapopie 015065
Musée Rizla Croix, Mazères-sur-
Salat 013907
Musée Rochelais d'Histoire
Protestante, La Rochelle 013293
Musée Rodava, Cercle Historique et
Archéologique, Rêves 003883

Musée Rodriguez Huguette, Saint-
Macaire 015233
Musée Roger Thières, Payrac . . 014619
Musée Rolin, Musées Municipaux,
Autun 011627
Musée Romain, Avenches 041042
Musée Romain, Nyon 041561
Musée Romain de Lausanne-Vidy,
Lausanne 041431
Musée Romain de Vallon, Vallon 041831
Musée Romand de la Machine
Agricole, Gingins 041315
Musée Ronsard, La Riche 013269
Musée Rosine Perrier,
Villargondran 016015
Musée Royal de l'Armée et d'Histoire
Militaire, Koninklijk Museum van het
Leger en de Krijgsgeschiedenis,
Bruxelles 003413
Musée Royal de Mariemont,
Morlanwelz-Mariemont 003811
Musée Royaume de l'Horloge,
Villedieu-les-Poêles 016032
Musée Roybet Fould, Courbevoie 012508
Musée Rude, Dijon 012601
Musée Rue Etienne Lenoir, Mussy-la-
Ville 003815
Musée Rupert de Chièvres,
Poitiers 014719
Musée Rural, Foucherans 012841
Musée Rural, Saint-
André-d'Embrun 015019
Musée Rural Berry-Marche,
Boussac 011992
Musée Rural d'Arts et Traditions
Populaires La Combà, Autrafé, La
Combe-de-Lancey 013206
Musée Rural d'Auris-en-Oisans
des Choses d'Autrefois, Auris-en-
Oisans 011621
Musée Rural de la Sologne
Bourbonnaise, Beaulon 011760
Musée Rural de l'Educations dans les
Côtes d'Armor, Saint-Nicolas-du-
Pelem 015279
Musée Rural des Art Populaires,
Laduz 013332
Musée Rural du Bois, Coupiac . 012505
Musée Rural du Champsaur, Bénévent-
et-Charbillac 011801
Musée Rural du Porzay,
Plomodiern 014698
Musée Rural du Porzay, Saint-Nic-
Pontrez 015275
Musée Rural Jurassien, Les
Genevez 041313
Musée Rural, Écomusée des Monts du
Forez, Usson-en-Forez 015870
Musée Ruzo, Montreux 041511
Musée Sabatier, Saint-Bonnet-de-
Joux 015038
Musée Sabatier d'Eyspéran,
Montpellier 014105
Musée Saharien de Ouargla,
Ouargla 000070
Musée Sahut, Simiane-Collongue 015609
Musée Saint-Brieux, Saint Brieux
Museum, Saint-Brieux 006704
Musée Saint-Étienne, Honfleur . 013082
Musée Saint-Euxpéry, Laàyoune 031597
Musée Saint-François-Régis, La
Louvesc 013248
Musée Saint-Jacques, Moissac . 013995
Musée Saint-Jean, Anneyron . . 011491
Musée Saint-Jean, La Rochette
(Savoie) 013295
Musée Saint-Joachim, La
Broquerie 006008
Musée Saint-Joseph, Saint-
Joseph 006757
Musée Saint-Loup, Troyes 015850
Musée Saint-Martin, Tours 015819
Musée Saint-Nicolas, Vitré 016104
Musée Saint-Pierre Fourier,

Mattaincourt 013884
Musée Saint-Raymond, Musée des
Antiques de Toulouse, Toulouse 015794
Musée Saint-Remi, Reims 014857
Musée Saint-Sauveur Nibelle Autrefois,
Nibelle 014276
Musée Saint-Simon, La
Ferté-Vidame 013223
Musée Saint-Vic, Saint-Amand-
Montrond 015013
Musée Sainte Bernadette,
Lourdes 013705
Musée Sainte-Croix, Poitiers . . 014720
Musée Sainte-Jeanne-Antide-Thouret,
Sancey-le-Long 015472
Musée Sainte-Martine, Sainte-
Martine 006799
Musée Salies, Musée des Beaux-Arts,
Bagnères-de-Bigorre 011683
Musée-Salle Communale, Yvoire 016159
Musée Salle Documentaire, Coucy-le-
Château-Auffrique 012498
Musée Santons du Monde, Huilerie,
Clermont-l'Hérault 012412
Musée Sarret de Grozon, Arbois 011522
Musée Saturnin Garimond, Fons 012812
Musée Savoisien, Chambéry . . 012234
Musée Schœlcher, Pointe-à-Pitre 023031
Musée Scout Baden-Powell,
Sisteron 015615
Musée Sculpture sur Bois, Lans-en-
Vercors 013374
Musée Sellier, Cogolin 012426
Musée Serret, Saint-Amarin . . . 015014
Musée Servie de Santé des Armées
au Val-du-Grâce, Paris 014591
Musée Sherlock Holmes, Lucens 041455
Musée Sidi Ben-Aissa, Le Kef . . 042480
Musée Sidi Bou Saïd, Sidi Bou
Saïd 042503
Musée Sidi Mohamed Ben Abdellah,
Essaouira 031591
Musée Sidi Zitouni, Houmt Souk 042476
Musée Simon-Segal, Aups 011612
Musée Site Départemental
d'Archéologie de Bavay, Bavay 011734
Musée Skolig al Louarn, Skolig al
Louarn, Plouvien 014714
Musée Sobirats, Carpentras . . 012158
Musée Somme 1916, Albert . . . 011397
Musée Souleïado Charles Demery,
Musée du Tissu Provençal, Tarascon
(Bouches-du-Rhône) 015706
Musée Sous-Glaciaire, La Grave 013239
Musée Sous Marin Pays Lorient,
Lorient 013677
Musée souterrain de la Poterie,
Hospices de la Madeleine,
Saint-Émilion 015099
Musée Souterrain de l'Outil,
Chacé 012212
Musée Souvenir du Dirigeable R101,
Beauvais 011774
Musée Spadois du Cheval, Spa . 003962
Musée Spectacle de Musiques du
Monde, Montoire-sur-le-Loir . . 014087
Musée Spitfire, Florennes 003525
Musée Sterna de l'Armée et des Trois
Guerres, Seynod 015601
Musée Stewart au Fort de Île Sainte-
Hélène, Montréal 006276
Musée Suffren et du Vieux Saint-
Cannat, Saint-Cannat 015049
Musée Suisse de la Figurine
Historique, Morges 041516
Musée Suisse de la Machine à
Coudre, Fribourg 041274
Musée Suisse de la Marionnette,
Fribourg 041275
Musée suisse de la Mode, Yverdon-
les-Bains 041905
Musée Suisse de l'Appareil
Photographique, Vevey 041845
Musée Suisse de l'Orgue, Schweizer

Museo A. Lia, La Spezia 026377
Museo A. Murer, Falcade 026028
Museo A. Ricci dei Minerali Elbani,
Rio nell'Elba 027352
Museo A. Versace, Bagnara
Calabra 025271
Museo A.R. Giorgi, Reggiolo ... 027332
Museo Abarth, Marietta 050612
Museo Abel Santamaría, La
Habana 008984
Museo Abel Santamaria, Santa
Clara 009169
Museo Abraham González, Vicente
Guerrero 031464
Museo Acacia, La Habana 008985
Museo Academia de Historia Leonardo
Tascón, Buga 008482
Museo Ada e Giuseppe Marchetti,
Fumone 026204
Museo ADIAC, Museo Indígena de
Sutiaba, León 033206
Museo Adolfo López Mateos, Atizapán
de Zaragoza 030657
Museo Adolfo Lozano Sidro, Priego de
Córdoba 039782
Museo Adriano Bernareggi,
Fondazione Adriano Bernareggi,
Bergamo 025329
Museo Aeronáutico, Baradero . 000140
Museo Aeronáutico, Montevideo 054512
Museo Aeronautico Caproni di Taliedo,
Roma 027398
Museo Aeronautico Caproni-Taliedo,
Vizzola Ticino 028237
Museo Aeronáutico Colonel Luis
Hernan Paredes, Maracay ... 054699
Museo Aeronáutico del Perú,
Lima 034148
Museo Aeronáutico Municipalo, Los
Alcázares 038737
Museo Aeronáutico Torreón de Gando,
Museo del Aire, Telde 040024
Museo Aeronautico y del Espacio,
Quito 010302
Museo Aerospaziale Monte di Apollo,
Perugia 027087
Museo Africano, Roma 027399
Museo Africano, Verona 028167
Museo Africano Mundo Negro,
Madrid 039439
Museo Afro Antillano de Panamá,
Ciudad de Panamá 033991
Museo Agrario Tropicale, Istituto
Agronomico per l'Oltremare,
Firenze 026112
Museo Agrarista de Tzurúmutaro,
Pátzcuaro 031182
Museo Agrícola El Patio, Teguise 040020
Museo Agricola, Ronco Briantino 027491
Museo Agricolo Brunnenburg,
Landwirtschaftsmuseum, Tirolo di
Merano 027913
Museo Agricolo della Civiltà Contadina
L. Carminati, San Giuliano
Milanese 027587
Museo Agricolo e del Vino Ricci
Curbastro, Capriolo 025614
Museo Agricolo e Museo dell'Arte
Conciaria, Castelfranco Veneto 025676
Museo Agro-Forestale San Matteo,
Erice 026008
Museo Agro-Pastorale dell'Area
Ellenofona, Bova Marina 025465
Museo Agrumeria, Reggio
Calabria 027319
Museo Aguilar y Eslava, Cabra . 038989
Museo Alberto Arvelo Torrealba,
Barinas 054641
Museo Alberto Mena Caamaño,
Quito 010303
Museo Alcamese d'Arte Sacra,
Alcamo 025111
Museo Alcázar de Colón, Santo
Domingo 010218

Museo Alejandro Otero, Caracas 054651
Museo Alejo Carpentier,
Camagüey 008924
Museo Alfar, Santa Elena de
Jamuz 039910
Museo Alfieriano, Centro Nazionale di
Studi Alfieriani, Asti 025240
Museo Alfonsiano, Pagani 026997
Museo Alfonso López Pumarejo,
Honda 008535
Museo Alfredo Ramírez de Arellano &
Rosello, San Germán 035980
Museo All'Aperto di Storia
dell'Agricoltura, Facoltá di Agraria,
Sassari 027690
Museo Almacén El Recreo,
Chivilcoy 000302
Museo Almafuerte, La Plata ... 000404
Museo Alpino Duca degli Abruzzi,
Courmayeur 025944
Museo Alpujarreño de Costumbre
Populares, Capileira 039037
Museo Alta Valle Scrivia, Sezione
Etnologica, Valbrevenna 028071
Museo Altar de la Patria, Ixcateopan
de Cuauhtémoc 030888
Museo Alternativo Remo Brindisi,
Comacchio 025892
Museo Alto Bierzo, Bembibre . 038936
Museo Amano, Lima 034149
Museo Amazigh, Melilla 039553
Museo Ambientale del W.W.F.,
Centro di Educazione Ambientale,
Orbetello 026928
Museo Ambientalistico Madonita,
Polizzi Generoso 027213
Museo Ambiente Cubano, Gibara 008960
Museo Amedeo Bocchi, Parma . 027041
Museo Americanista, Lomas de
Zamora 000427
Museo Americanistico Federico
Lunardi, Genova 026243
Museo Amparo, Puebla 031192
Museo Anatomico, Siena 027776
Museo Anatómico, Valladolid ... 040139
Museo Anatomico G. Tumiati,
Università di Ferrara, Ferrara . 026052
Museo Anatómico Pedro Ara,
Córdoba 000317
Museo Anatomico Veterinario,
Pisa 027180
Museo Anconetani del Acordeón,
Buenos Aires 000164
Museo Andrés Avelino Cáceres,
Lima 034150
Museo Andrés Cué, Amancio .. 008900
Museo Anenecuilco, Ayala 030661
Museo Anestesiológico y Biblioteca
Histórica de la Asociación de
Anestesiología de Buenos Aires,
Buenos Aires 000165
Museo Angel Orensanz y Artes de
Serralbo, Instituto de Cultura y Arte
Contemporáneo, Sabiñánigo . 039841
Museo Antártico, Montevideo . 054513
Museo Antártico en Buenos Aires,
Buenos Aires 000166
Museo Antica Miniera di Talco
Brunetta, Cantoira 025594
Museo Antico Tesoro della Santa Casa,
Loreto 026465
Museo Antiguo Colegio de San
Ildefonso, México 030977
Museo Antiguo Cuartel de Caballería
del Ejército Español, Camagüey 008925
Museo Antiguo Palacio de la Medicina
Mexicana, México 030978
Museo Antimperialista, Nueva
Gerona 009106
Museo Antiquarium Archeologico,
Falerone 026029
Museo Antón, Candás 039028
Museo Anton García de Bonilla,
Ocaña 008577

Museo Antoniano, Padova 026976
Museo Antonio Lussich, Punta
Ballena 054546
Museo Antonio Maceo, San
Pedro 009157
Museo Antonio Manuel Campoy,
Cuevas del Almanzora 039150
Museo Antonio Raimondi, La
Merced 034128
Museo Antonio Raimondi, Lima . 034151
Museo Antonio Ricaurte, Villa de
Leyva 008658
Museo Antrológico, Cereté ... 008502
Museo Antropologia e Historia de San
Pedro Sula, San Pedro Sula .. 023086
Museo Antropologia e Historia,
Universidad Autónoma de
Tamaulipas, Victoria 031467
Museo Antropológico de Iquique,
Iquique 007335
Museo Antropológico de Tunja,
Tunja 008649
Museo Antropológico Montané, La
Habana 008986
Museo Antropológico Reina Torres de
Aráuz, Ciudad de Panamá 033992
Museo Antropológico Shuar,
Quito 010304
Museo Antropológico Tairona, Santa
Marta 008622
Museo Antropológico, Universidad del
Tolimo, Ibagué 008537
Museo Antropológico, Universidad
Mayor, Real y Pontifica de San
Francisco Xavier, Sucre 004160
Museo Antzetik Ta Jtelum,
Zinacantán 031522
Museo Anzoátegui, Pamplona . 008581
Museo Aperos de Labranza,
Lerdo 030930
Museo Apistico Didattico,
Bregnano 025472
Museo Archaeologico di Santa
Restituta, Lacco Ameno 026383
Museo Archeologica, Savignone 027709
Museo Archeologico, Acqualagna 025069
Museo Archeologico, Amelia .. 025147
Museo Archeologico, Arborea .. 025183
Museo Archeologico, Artena .. 025214
Museo Archeologico, Atri 025249
Museo Archeologico, Bonorva .. 025440
Museo Archeologico,
Caltanissetta 025552
Museo Archeologico, Camaiore . 025557
Museo Archeologico, Castello di
Godego 025687
Museo Archeologico, Cesena . 025771
Museo Archeologico, Dorgali .. 025991
Museo Archeologico, Enna ... 026002
Museo Archeologico, Fermo .. 026044
Museo Archeologico, Frosinone . 026200
Museo Archeologico, Isola della
Scala 026362
Museo Archeologico, Lentini .. 026430
Museo Archeologico, Marianopoli 026552
Museo Archeologico, Molfetta .. 026709
Museo Archeologico, Montelupo
Fiorentino 026783
Museo Archeologico, Ostiglia .. 026961
Museo Archeologico, Palazzuolo sul
Senio 027003
Museo Archeologico, Povegliano
Veronese 027260
Museo Archeologico, Priverno . 027283
Museo Archeologico, Pula 027285
Museo Archeologico, Rocca di
Mezzo 027366
Museo Archeologico, San Miniato 027609
Museo Archeologico, Santadi . 027651
Museo Archeologico, Santorso 027672
Museo Archeologico, Scansano . 027723
Museo Archeologico, Venafro . 028111
Museo Archeologico, Ventotene 028155
Museo Archeologico, Veroli .. 028163

Museo Archeologico, Vetulonia . 028178
Museo Archeologico, Villasimius 028216
Museo Archeologico al Teatro Romano,
Verona 028168
Museo Archeologico Antiquarium
Arborense, Oristano 026938
Museo Archeologico Antonio Santarelli,
Forlì 026170
Museo Archeologico Aquaria,
Soncino 027806
Museo Archeologico Attrezzato e
Cattedrale di San Zeno, Pistoia 027187
Museo Archeologico Baglio Anselmi,
Marsala 026557
Museo Archeologico Civico,
Carassai 025619
Museo Archeologico Civico,
Forlimpopoli 026178
Museo Archeologico Civico-Diocesano
G. B. Leopardi, Penne 027075
Museo Archeologico Comprensoriale,
Teti 027908
Museo Archeologico Comunale,
Vicchio 028185
Museo Archeologico Comunale di
Artimino, Carmignano 025626
Museo Archeologico dei Campi Flegrei,
Bacoli 025266
Museo Archeologico del Finale, Finale
Ligure 026085
Museo Archeologico del Territorio,
Cupra Marittima 025969
Museo Archeologico del Territorio di
Populonia, Piombino 027168
Museo Archeologico del Territorio,
Antiquarium Suasanum, San Lorenzo
in Campo 027594
Museo Archeologico della Badia,
Badia di Licata, Licata 026436
Museo Archeologico della Lucania
Occidentale, Padula 026996
Museo Archeologico della Valle Sabbia,
Gavardo 026224
Museo Archeologico dell'Abruzzo,
Crecchio 025945
Museo Archeologico dell'Agro
Nocerino, Nocera Inferiore ... 026874
Museo Archeologico dell'Alto Adige,
Bolzano 025432
Museo Archeologico dell'Alto
Canavese, Cuorgnè 025968
Museo Archeologico dell'Antica,
Alife 025128
Museo Archeologico dell'Antica Capua,
Santa Maria Capua Vetere ... 027643
Museo Archeologico dell'Arte della
Lana, Consorzio Sistena Museale
Valle de Liri, Arpino 025209
Museo Archeologico di Calatia,
Maddaloni 026507
Museo Archeologico di Casteggio,
Casteggio 025660
Museo Archeologico di Himera,
Termini Imerese 027897
Museo Archeologico di Morgantina,
Aidone 025089
Museo Archeologico di Naxos, Giardini
Naxos 026282
Museo Archeologico di Sepino,
Sepino 027747
Museo Archeologico di Vallecamonica,
Cividate Camuno 025865
Museo Archeologico di Villa Sulcis,
Carbonia 025621
Museo Archeologico e Antiquarium,
Sala Consilina 027529
Museo Archeologico e Antiquarium
Nazionale, Formia 026180
Museo Archeologico e d'Arte della
Maremma, Grosseto 026318
Museo Archeologico e della Collegiata,
Casole d'Elsa 025655
Museo Archeologico e della via
Flaminia, Cagli 025521

Museo Arqueológico de Tepeapulco,
Tepeapulco 031356
Museo Arqueológico de Tilcara,
Tilcara 000638
Museo Arqueológico de Tizatlán,
Tizatlán 031386
Museo Arqueológico de Tonalá, Tonalá,
Chiapas 031419
Museo Arqueológico de Tula Jorge R.
Acosta, Tula de Allende 031432
Museo Arqueológico de Úbeda, Casa
Mudéjar, Úbeda 040089
Museo Arqueológico de Venustiano
Carranza, Venustiano Carranza 031458
Museo Arqueológico de Xochimilco,
México 030980
Museo Arqueológico d'Eivissa i
Formentera, Eivissa 039171
Museo Arqueológico del Banco Central
de Bahia, Bahia de Carácluez . 010248
Museo Arqueológico del Centro de
Estudios Histórico Sociales Julio
Espejo Nuñez, Jauja 034123
Museo Arqueológico del Cerro de la
Estrella, México 030981
Museo Arqueológico del Cesar,
Valledupar 008655
Museo Arqueológico del Colegio Juan
XXIII, Lima 034153
Museo Arqueológico del Huila,
Neiva 008573
Museo Arqueológico del Instituto
de Arqueología y Etnología,
Mendoza 000448
Museo Arqueológico del Sinú,
Tierralta 008645
Museo Arqueológico del Soconusco,
Tapachula 031326
Museo Arqueológico Dr. Román Piña
Chan, Tenango del Valle 031347
Museo Arqueológico e Histórico de
Andahuaylas, Andahuaylas . . . 034034
Museo Arqueológico Etnográfico, San
Pedro del Pinatar 039879
Museo Arqueológico-Etnológico
Gratiniano Baches, Pilar de la
Horadada 039752
Museo Arqueológico Etnológico
Municipal, Guardamar de
Segura 039291
Museo Arqueológico Frederico Galvez
Durand, Huancayo 034103
Museo Arqueológico Gregorio Aguilar
Barea, Juigalpa 033203
Museo Arqueológico Guamuhaya,
Trinidad 009209
Museo Arqueológico Horacio Urteaga,
Universidad Nacional de Cajamarca,
Cajamarca 034054
Museo Arqueológico José Casinelli,
Santa Inés 034232
Museo Arqueológico José María
Morante de la Universidad Nacional
de San Augustín de Arequipa,
Arequipa 034036
Museo Arqueológico Juan Sepúlveda y
Museo Eduardo Ruiz, Uruapán 031444
Museo Arqueológico Julio César
Cubillos, Cali 008485
Museo Arqueológico Julio César
Cubillos, San Agustín 008620
Museo Arqueológico La Bagatela, Villa
del Rosario 008661
Museo Arqueológico La Encomienda,
Fundación Emilio Pérez Piñero,
Calasparra 039008
Museo Arqueológico La Merced,
Cali 008486
Museo Arqueológico Luis G. Urbina,
México 030982
Museo Arqueológico Marco Fidel
Micolta, Guamo 008532
Museo Arqueológico Mesoamericano,
Tijuana 031379

Museo Arqueológico Municipal,
Alcúdia (Baleares) 038748
Museo Arqueológico Municipal,
Burriana 038987
Museo Arqueológico Municipal,
Cartagena 039049
Museo Arqueológico Municipal,
Cehegín 039071
Museo Arqueológico Municipal,
Crevillente 039139
Museo Arqueológico Municipal,
Elda 039183
Museo Arqueológico Municipal, Jerez
de la Frontera 039339
Museo Arqueológico Municipal,
Lorca 039406
Museo Arqueológico Municipal,
Marchena 039533
Museo Arqueológico Municipal,
Montoro 039593
Museo Arqueológico Municipal, San
Fulgencio 039867
Museo Arqueológico Municipal
Alejandro Ramos Folqués, Palacio de
Altamira, Elche 039176
Museo Arqueológico Municipal Antonio
Ballester, Callosa de Segura . . 039015
Museo Arqueológico Municipal
Camilo Visedo Molto, Museu d'Alcoi,
Alcoy 038743
Museo Arqueológico Municipal
Cayetano Mergelina, Yecla . . . 040239
Museo Arqueológico Municipal de
Alhambra, Alhambra 038758
Museo Arqueológico Municipal de
Obulco, Porcuna 039771
Museo Arqueológico Municipal
José María Soler, Edificio de
Ayuntamiento, Villena 040220
Museo Arqueológico Municipal y
Centro de Interpretación del Mar,
Águilas 038710
Museo Arqueológico Municipal y
Museo Municipal Miguel Justino
Ramírez, Piura 034217
Museo Arqueológico Municipal, Casa
de la Cultura, Santaella 039919
Museo Arqueológico Municipal, Iglesia
de la Soledad, Caravaca de la
Cruz 039038
Museo Arqueológico Nacional,
Madrid 039440
Museo Arqueológico Nacional Brüning,
Lambayeque 034129
Museo Arqueológico Padre Martín
Recio, Estepa 039199
Museo Arqueológico-Paleontológico
Municipal de Rojales, Rojales . 039822
Museo Arqueológico Pío P. Díaz,
Cachi 000283
Museo Arqueológico Provincial,
Alicante 038760
Museo Arqueológico Provincial,
Badajoz 038849
Museo Arqueológico Provincial,
Huesca 039310
Museo Arqueológico Provincial,
Ourense 039667
Museo Arqueológico Provincial, San
Salvador de Jujuy 000599
Museo Arqueológico Provincial,
Sevilla 039975
Museo Arqueológico Provincial
Andalgalá, Andalgalá 000122
Museo Arqueológico Provincial Condor
Huasi (interim), Belén 000145
Museo Arqueológico Provincial Samuel
A. Lafone Quevedo, Andalgalá . 000122
Museo Arqueológico R.P. Gustavo
Le Paige S.J., San Pedro de
Atacama 007346
Museo Arqueológico Regional, Alcalá
de Henares 038729
Museo Arqueológico Regional Anibal

Montes, Río Segundo 000534
Museo Arqueológico Regional Guane,
Floridablanca 008522
Museo Arqueológico Regional Inca
Huasi, La Rioja 000413
Museo Arqueológico San Miguel de
Azapa, Arica 007326
Museo Arqueológico-Torre del Agua,
Osuna 039665
Museo Arqueológico y Colonial, Fuerte
Quemado 000371
Museo Arqueológico y Etnográfico,
Betancuria 038945
Museo Arqueológico y Etnológico
Córdoba, Consejería de Cultura Junta
de Andalucia, Córdoba 039117
Museo Arqueológico y Etnológico de
Granada, Granada 039276
Museo Arqueológico y Etnológico de
Lucena, Palacio Castillo del Moral,
Lucena 039410
Museo Arqueológico y Etnologico
Municipal Dámaso Navarro,
Petrer 039751
Museo Arqueológico y Paleontológico
de Guane, Baricharà 008420
Museo Arqueológico, Cueva de Siete
Palacio Barrio de San Miguel,
Almuñécar 038780
Museo Arqueológico, Fundación Cueva
de Nerja, Nerja 039627
Museo Arqueológico, Museo de la
Naturaleza y el Hombre-Antiguo
Hospital Civil, Santa Cruz de
Tenerife 039906
Museo Arqueológico, Universidad
Estatal de Cuenca, Cuenca . . . 010258
Museo Arqueológico, Universidad
Mayor de San Simón,
Cochabamba 004123
Museo Arqueoloógico y Etnográfico,
Ibarra 010288
Museo Arqueolóxico e Histórico, A
Coruña 039130
Museo Arquidiocesano, Santiago de
Cuba 009180
Museo Arquidiocesano de Arte
Religioso, Pamplona 008582
Museo Arquidiocesano de Arte
Religioso de Popayán, Popayán 008602
Museo Arquitectura de Trinidad,
Trinidad 009210
Museo Arrese, Corella 039124
Museo Art Nouveau-Art Déco,
Fundación Manuel Ramos Andrade,
Salamanca 039847
Museo Arte Tempo (MAT),
Clusone 025876
Museo Artequin, Santiago de
Chile 007347
Museo Artes Decorativas, Gibara 008961
Museo Artes Plásticas, Pinar del
Río 009122
Museo Artes y Costumbres Populares
Alto Guadalquivir, Cazorla 039070
Museo Artesanal de Gualaceo,
Gualaceo 010275
Museo Arti e Mestieri di un Tempo,
Cisterna d'Asti 025848
Museo Arti e Tradizioni Popolari del
Gargano Giovanni Tancredi, Monte
Sant'Angelo 026752
Museo Artístico de Roncesvalles,
Roncesvalles 039826
Museo Artistico della Bambola,
Suvereto 027869
Museo Artistico Industriale F. Palizzi,
Istituto d'Arte di Napoli, Napoli 026830
Museo Arturo Michelena,
Caracas 054653
Museo Arxiu Capitular, Tortosa . 040074
Museo Astronomico e Copernicano,
Osservatorio Astronomico di Roma,
Roma 027401

Museo Astronomico e Geofisico,
Modena 026691
Museo Atelier Antonio Ortiz Echagüe,
Carro Quemado 000293
Museo Audiovisual, Caracas . . 054654
Museo Augustín Landívar,
Cuenca 010259
Museo Augusto Righi, Montese . 026799
Museo Aurelio Castelli, Siena . . 027778
Museo Aurelio Espinosa Polit,
Cotocollao 010256
Museo Aurelio Espinoza Pólit,
Quito 010305
Museo Aurelio Marena, Bitonto . 025357
Museo Austral de Pintura Primitiva
Moderna Naif, Esquel 000366
Museo Auto d'Ecopa, San
Marino 037920
Museo Azuayo del Folklore,
Cuenca 010260
Museo B. Gigli, Recanati 027315
Museo Badia di San Gemolo,
Valganna 028077
Museo Bagatti Valsecchi, Milano 026635
Museo Bahía de los Angeles,
Ensenada 030786
Museo Balaa Xte Guech Gulal,
Teotitlán del Valle 031354
Museo Balear Ciencies Naturals,
Sóller 039998
Museo Balseros del Mar del Sur,
Salango 010334
Museo Baluarte de Santiago,
Veracruz 031459
Museo Banco Central de Reserva del
Perú, Lima 034154
Museo Banco del Pacifico,
Guayaquil 010277
Museo Bandini, Fiesole 026072
Museo Barjola, Gijón 039246
Museo Baroffio e del Santuario
del Sacro Monte sopra Varese,
Varese 028098
Museo Barovier e Toso, Venezia 028122
Museo Barracco, Roma 027402
Museo Beata Camilla Battista Varano,
Camerino 025561
Museo Beata P. Morosini, Albino 025103
Museo Beato Angelico, Vicchio . 028186
Museo Beato Angelo, Acri 025075
Museo Belisario Porras, Las
Tablas 034002
Museo Bellapart, Santo Domingo 010219
Museo Bello Piñeio, Centro Cultural
Antigo Hospital da Caridade,
Ferrol 039208
Museo Benalauría, Benalauría . 038938
Museo Benedettino e Diocesano
d'Arte Sacra, Nonantola 026882
Museo Benigno Malo, Cuenca . 010261
Museo Benito Hortiz, Sancti-
Spíritus 009158
Museo Benito Juárez, José
Azueta 030908
Museo Benito Juárez, Casa del
Benemérito de las Américas, La
Habana 008988
Museo Berenziano, Seminario
Vescovile, Cremona 025948
Museo Bernabé de las Casas,
Mina 031093
Museo Bernardino Caballero,
Asunción 034017
Museo Bernardo de Muro, Tempio
Pausania 027890
Museo Bernardo Martínez Villegas,
Bácum 030665
Museo Berrocal, Vilanueva de
Algaidas 040197
Museo Bersano delle Contadinerie
e Stampe antiche del Vino, Nizza
Monferrato 026871
Museo Biblioteca Comunale,
Etroubles 026014

Museo Castillo Serrallés, Ponce 035972
Museo Catcco, Ollantaytambo . . 034210
Museo Catedral, Palma de
Mallorca 039697
Museo Catedral de La Plata, La
Plata 000405
Museo Catedralicio, Almería . . . 038776
Museo Catedralicio, Badajoz . . . 038850
Museo Catedralicio, Baeza . . . 038856
Museo Catedralicio, Burgo de
Osma 038976
Museo Catedralicio, Burgos . . . 038979
Museo Catedralicio, Cádiz 039000
Museo Catedralicio, Ciudad Real 039099
Museo Catedralicio, Cuenca . . . 039143
Museo Catedralicio, Guadix 039290
Museo Catedralicio, Jaén 039333
Museo Catedralicio, Málaga . . . 039510
Museo Catedralicio, Ourense . . . 039668
Museo Catedralicio, Santo Domingo
de la Calzada 039952
Museo Catedralicio, Segovia . . . 039963
Museo Catedralicio, Sigüenza . . 039989
Museo Catedralicio, Zamora . . . 040241
Museo Catedralicio de La Seo de
Zaragoza, Zaragoza 040250
Museo Catedralicio de Tui, Tui . . 040086
Museo Catedralicio Diocesano, Ciudad
Rodrigo 039105
Museo Catedralicio-Diocesano,
León 039367
Museo Catedralicio Diocesano,
Pamplona 039718
Museo Catedralicio-Diocesano,
Valencia 040115
Museo Catedralicio, Iglesia Catedral,
Palencia 039682
Museo Catedralico y Giralda,
Sevilla 039977
Museo Católica de Santa María,
Cercado 034068
Museo Católico Peninsular,
Mérida 030952
Museo Cavour, Santena 027668
Museo Cemento Rezola, Donostia-San
Sebastián 039163
Museo Cemí, Jayuya 035966
Museo Centenario Norte de Santander
y Ciudad de Cúcuta, Cúcuta . . 008509
Museo Centrale del Risorgimento,
Roma 027405
Museo Centrale dell'Istituto Storico
della Resistenza, Imperia 026350
Museo Centro Cultural Pachamama,
Amaicha del Valle 000120
Museo Centro de Cultura Mayo de el
Júpare Blas Mazo, Huatabampo 030873
Museo Centro de Interpretacion de
Monesterio, Monesterio 039574
Museo Centro de la Imagen,
México 030991
Museo Centro Studi A.G. Barrili,
Carcare 025623
Museo Centro Taurino Potosino, San
Luis Potosí 031269
Museo Cerezo Moreno,
Villatorres 040218
Museo Cerlogne, Saint Nicolas . 027525
Museo Cerralbo, Madrid 039441
Museo Cerro de la Campana,
Santiago Suchilquitongo 031310
Museo Cerro de los Huizaches, San
Pablo Huixtepec 031289
Museo Cervantino, El Toboso . . 040037
Museo Cervi, Gattatico 026223
Museo Chairama, Santa Marta . 008624
Museo Chiaramonti e Braccio
Nuovo, Musei Vaticani, Città del
Vaticano 054621
Museo Chihuahuense de Arte
Contemporáneo, Chihuahua . . 030698
Museo Chileno de Arte Precolombino,
Santiago de Chile 007348
Museo Chillida Leku, Hernani . . 039299

Museo Chorotega-Nicarao llamado
"Enrique Berio Mántica Deshon",
Chinandega 033196
Museo Chorro de Maita,
Yaguajay 009228
Museo Christiano, Cividale del
Friuli 025864
Museo Ciénaga de San Pedro,
Madera 030938
Museo Ciencias Naturales, Nueva
Gerona 009107
Museo Ciencias Naturales Carlos de la
Torre, Sancti-Spíritus 009160
Museo Ciudad de Baeza, Baeza 038857
Museo Ciudades del Mundo, La
Habana 009004
Museo Civico, Aci Castello 025066
Museo Civico, Airola 025091
Museo Civico, Alatri 025095
Museo Civico, Amalfi 025140
Museo Civico, Apice 025177
Museo Civico, Ariano Irpino 025201
Museo Civico, Asolo 025228
Museo Civico, Atina 025247
Museo Civico, Avola 025265
Museo Civico, Baranello 025281
Museo Civico, Bardonecchia . . . 025285
Museo Civico, Barga 025288
Museo Civico, Bassano del
Grappa 025305
Museo Civico, Belluno 025317
Museo Civico, Bisacquino 025351
Museo Civico, Bolzano 025433
Museo Civico, Borgo Velino . . . 025451
Museo Civico, Bormio 025455
Museo Civico, Cabras 025519
Museo Civico, Campagnano di
Roma 025574
Museo Civico, Campochiaro . . . 025583
Museo Civico, Caprino Veronese 025613
Museo Civico, Casale Monferrato 025641
Museo Civico, Casamicciola
Terme 025647
Museo Civico, Castel Bolognese 025661
Museo Civico, Castelleone 025684
Museo Civico, Castelnovo
Bariano 025690
Museo Civico, Castelnuovo
Scrivia 025696
Museo Civico, Castelraimondo . . 025697
Museo Civico, Castroreale 025712
Museo Civico, Centuripe 025749
Museo Civico, Cerchio 025752
Museo Civico, Champdepraz . . . 025791
Museo Civico, Cittadella 025858
Museo Civico, Conversano 025912
Museo Civico, Cori 025922
Museo Civico, Crema 025946
Museo Civico, Crotone 025960
Museo Civico, Cuneo 025966
Museo Civico, Erba 026005
Museo Civico, Feltre 026040
Museo Civico, Ferentino 026043
Museo Civico, Foggia 026156
Museo Civico, Fondi 026166
Museo Civico, Fornovo San
Giovanni 026183
Museo Civico, Fratta Polesine . . 026196
Museo Civico, Fucecchio 026202
Museo Civico, Garessio 026221
Museo Civico, Gibellina 026285
Museo Civico, Guardiagrele 026330
Museo Civico, Iesi 026340
Museo Civico, Larciano 026406
Museo Civico, Larino 026408
Museo Civico, Lodi 026453
Museo Civico, Lucignano 026485
Museo Civico, Luino 026492
Museo Civico, Maddaloni 026508
Museo Civico, Magliano Sabina . 026512
Museo Civico, Manerbio 026532
Museo Civico, Mattinata 026588
Museo Civico, Mazara del Vallo . 026588
Museo Civico, Medicina 026592

Museo Civico, Mirandola 026684
Museo Civico, Mondavio 026721
Museo Civico, Monsampolo del
Tronto 026732
Museo Civico, Montelparo 026782
Museo Civico, Noto 026887
Museo Civico, Osimo 026953
Museo Civico, Patrica 027054
Museo Civico, Pegognaga 027071
Museo Civico, Piedimonte
Matese 027140
Museo Civico, Pieve di Cento . . 027152
Museo Civico, Pistoia 027189
Museo Civico, Pizzighettone . . . 027200
Museo Civico, Pontecorvo 027230
Museo Civico, Putignano 027286
Museo Civico, Ragogna 027295
Museo Civico, Rende 027334
Museo Civico, Rieti 027341
Museo Civico, Riva del Garda . . 027360
Museo Civico, Rovereto 027507
Museo Civico, San Bonifacio . . . 027554
Museo Civico, San Cesario di
Lecce 027560
Museo Civico, San Ferdinando di
Puglia 027571
Museo Civico, San Gimignano . . 027575
Museo Civico, San Severo 027625
Museo Civico, Sanremo 027634
Museo Civico, Santa Giusta . . . 027639
Museo Civico, Sesto Calende . . 027762
Museo Civico, Sulmona 027855
Museo Civico, Susa 027863
Museo Civico, Taverna 027884
Museo Civico, Terrasini 027906
Museo Civico, Tolfa 027929
Museo Civico, Trevignano
Romano 028001
Museo Civico, Trinitapoli 028035
Museo Civico, Troia 028039
Museo Civico, Vasanello 028104
Museo Civico, Viterbo 028227
Museo Civico "Castello Ursino",
Catania 025718
Museo Civico A. Giacomelli, Castel
San Zeno, Montagnana 026739
Museo Civico A. Klitsche de la Grange,
Allumiere 025129
Museo Civico A. Parazzi, Viadana 028179
Museo Civico A. Tubino, Masone 026564
Museo Civico A.E. Baruffaldi, Badia
Polesine 025267
Museo Civico Ala Ponzone,
Cremona 025949
Museo Civico Albano, Albano
Laziale 025098
Museo Civico Alta Val Brembana,
Valtorta 028089
Museo Civico Antiquarium,
Nettuno 026863
Museo Civico Antiquarium Platina,
Piadena 027130
Museo Civico Antonino Olmo e
Gipsoteca, Savigliano 027705
Museo Civico Antonio Cordici,
Erice 026009
Museo Civico Archeologica e
Quadreria, Monterubbiano 026797
Museo Civico Archeologico,
Angera 025161
Museo Civico Archeologico,
Anzio 025170
Museo Civico Archeologico,
Arona 025207
Museo Civico Archeologico, Barbarano
Romano 025282
Museo Civico Archeologico, Bene
Vagienna 025321
Museo Civico Archeologico,
Bergamo 025330
Museo Civico Archeologico,
Bologna 025374
Museo Civico Archeologico,
Camerino 025562

Museo Civico Archeologico, Canosa di
Puglia 025592
Museo Civico Archeologico,
Castelfranco Emilia 025673
Museo Civico Archeologico,
Castelleone di Suasa 025685
Museo Civico Archeologico, Castro dei
Volsci 025711
Museo Civico Archeologico,
Castrovillari 025714
Museo Civico Archeologico, Cavaion
Veronese 025733
Museo Civico Archeologico,
Chiomonte 025824
Museo Civico Archeologico, Ciró
Marina 025846
Museo Civico Archeologico, Cologna
Veneta 025890
Museo Civico Archeologico, Concordia
Sagittaria 025907
Museo Civico Archeologico,
Fiesole 026073
Museo Civico Archeologico, Gazzo
Veronese 026229
Museo Civico Archeologico,
Gottolengo 026301
Museo Civico Archeologico, Grotte di
Castro 026324
Museo Civico Archeologico,
Latronico 026414
Museo Civico Archeologico,
Marciana 026548
Museo Civico Archeologico, Massa
Marittima 026573
Museo Civico Archeologico, Mel 026595
Museo Civico Archeologico,
Mondragone 026724
Museo Civico Archeologico, Montalto
Marche 026743
Museo Civico Archeologico, Nepi 026861
Museo Civico Archeologico,
Nicotera 026867
Museo Civico Archeologico,
Norma 026884
Museo Civico Archeologico,
Padria 026995
Museo Civico Archeologico,
Pitigliano 027195
Museo Civico Archeologico,
Ramacca 027300
Museo Civico Archeologico,
Remedello 027333
Museo Civico Archeologico,
Roccagloriosa 027368
Museo Civico Archeologico, Rosignano
Marittimo 027498
Museo Civico Archeologico,
Rutigliano 027519
Museo Civico Archeologico, Santa
Marinella 027646
Museo Civico Archeologico,
Sarteano 027687
Museo Civico Archeologico,
Tolentino 027922
Museo Civico Archeologico, Treia 027987
Museo Civico Archeologico,
Verucchio 028175
Museo Civico Archeologico "Francesco
Savini", Teramo 027893
Museo Civico Archeologico Antonio De
Nino, Corfinio 025921
Museo Civico Archeologico Arsenio
Crespellani, Bazzano 025313
Museo Civico Archeologico C. Cellini,
Ripatransone 027353
Museo Civico Archeologico della Val
Tenesi, Manerba del Garda . . 026531
Museo Civico Archeologico di
Fregellae, Ceprano 025751
Museo Civico Archeologico e
Paleobotanico, Perfugas 027078
Museo Civico Archeologico Eno Bellis,
Oderzo 026911
Museo Civico Archeologico Etnologico,

Museo Civico, Sezione Paleontologica, Bojano 025364
Museo Civico, Villa Colloredo Mels, Recanati 027316
Museo Civico, Villa Pallavicino, Busseto 025514
Museo Civicodi Scienze Naturali, Randazzo 027302
Museo Civicodi Storia Naturale, Villa Gardella, Stazzano 027837
Museo Clarisse Coulombie de Goyaud, Ituzaingó 000388
Museo Clemente Rospigliosi, Pistoia 027190
Museo Coahuila y Texas, Monclova 031100
Museo Colección de Veterinaria Militar, Madrid 039442
Museo-Colección del Observatorio Astronómico Nacional, Madrid . 039443
Museo-Colección Específico del Suboficial, Tremp 040079
Museo-Colección Específico Militar El Desnarigado, Ceuta 039083
Museo Colecciones ICO, Instituto de Crédito Oficial, Madrid 039444
Museo Colonial, El Tocuyo 054686
Museo Colonial Charcas, Universidad Mayor de San Francisco Xavier, Sucre 004162
Museo Colonial de Acolman, Acolman 030627
Museo Colonial del Conde de Sierra Gorda, Santander Jiménez . . . 031307
Museo Colonial e Histórico, Complejo Museográfico Enrique Udaondo, Luján 000430
Museo Coltzin, Culiacán 030755
Museo Comandancia La Plata, Santo Domingo 009202
Museo Comarcal, Zalduondo 040240
Museo Comarcal da Fonsagrada, A Fonsagrada 039214
Museo Comarcal de Arte Sacro de Peñafiel, Iglesia de Santa María, Peñafiel 039738
Museo Comarcal Velezano Miguel Guirao, Hospital Real, Vélez Rubio 040166
Museo Come Eravamo, Borgamanero 025444
Museo Comercial, Hellín 039297
Museo Comico Verscio, Verscio . . 041839
Museo Comité Olímpico, México 030992
Museo Communale Antiquarium, Atena Lucana 025246
Museo Complesso della Collegiata, Castiglione Olona 025709
Museo Comunal de Chañar Ladeado, Chañar Ladeado 000297
Museo Comunal Pedro Bargero, Emilio Bunge 000361
Museo Comunal Regional de San Guillermo, San Guillermo 000572
Museo Comunale, Montaione . . . 026740
Museo Comunale, Nova Ponente 026888
Museo Comunale, Praia a Mare 027263
Museo Comunale, Roggiano Gravina 027375
Museo Comunale A. Mendola, Favara 026038
Museo Comunale Archeologico, Viddalba 028199
Museo Comunale d'Arte Contemporanea, Polignano a Mare 027211
Museo Comunale d'Arte Moderna, Ascona 041033
Museo Comunale della Ceramica, Cutrofiano 025975
Museo Comunale della Manifattura Chini, Borgo San Lorenzo 025449
Museo Comunale della Valle dei Nuraghi, Torralba 027969

Museo Comunale della Valle del Sarno, Sarno 027682
Museo Comunale E. Durio, Civiasco 025862
Museo Comunale Storico, Acquaviva delle Fonti 025071
Museo Comunale Trappeto Maratea, Vico del Gargano 028196
Museo Comunale, Cassero, Monte San Savino 026751
Museo Comunidad Las Terrazas, San Cristobal 009151
Museo Comunitario, Mineral del Monte 031095
Museo Comunitario, Puente de Ixtla 031219
Museo Comunitario Altagracia de Arauz, Ensenada 030787
Museo Comunitario Amuzgo de Xochistlahuaca, Xochistlahuaca 031491
Museo Comunitario Colonia Vicente Guerrero, Colonia Vicente Guerrero 030719
Museo Comunitario Concuemitl, Cuencamé 030747
Museo Comunitario Coronela Amelia La Güera Robles, Xochipala . . 031490
Museo Comunitario Crónica y Arte Agropecuario de la Sierra Gorda, Landa de Matamoros 030924
Museo Comunitario Cuarenta Casas, Valentín Gómez Farías 031447
Museo Comunitario de Antropología e Historia, Apatzingán 030650
Museo Comunitario de Atoyac, Atoyac 030659
Museo Comunitario de Carrillo Puerto, Alvaro Obregón 030645
Museo Comunitario de Ciudad Lerdo, Lerdo 030931
Museo Comunitario de Estación Coahuila, Mexicali 030961
Museo Comunitario de Historia de San José de Gracia, San José de Gracia 031258
Museo Comunitario de Huitzapula, Huitzapula 030881
Museo Comunitario de Ixtlahuacán, Ixtlahuacán 030892
Museo Comunitario de la Ballena, La Paz 030916
Museo Comunitario de la Sal, Armería 030656
Museo Comunitario de las Varas, Compostela 030728
Museo Comunitario de Pejelagartero, Huimanguillo 030879
Museo Comunitario de Pipillola, Españita 030795
Museo Comunitario de San Andrés Mixquic, México 030993
Museo Comunitario de San Nicolás Zoyatlán, San Nicolás Zoyatlán 031287
Museo Comunitario de San Rafael del Sur, San Rafael del Sur 033229
Museo Comunitario de Santa Eulalia, Santa Eulalia 031304
Museo Comunitario de Santa Martha, Mulegé 031133
Museo Comunitario de Tototepec, Tototepec 031431
Museo Comunitario de Villa El Salvador, Villa El Salvador . . . 034252
Museo Comunitario de Villa Regina, Villa Regina 000676
Museo Comunitario de Xalisco, Xalisco 031485
Museo Comunitario de Xolalpan, Ixtacamaxtitlán 030890
Museo Comunitario del Valle de Guadalupe, Ensenada 030788
Museo Comunitario el Asalto a las Tierras, Mexicali 030962
Museo Comunitario El Rosario, El

Rosario 030781
Museo Comunitario Felipe Carrillo Puerto, Motul 031131
Museo Comunitario Francisco I. Madero, Francisco I. Madero, Coahuila 030798
Museo Comunitario General Francisco Villa, Durango 030768
Museo Comunitario Hicupa, Tehuacán 031343
Museo Comunitario Hitalulu, San Martín Huamelulpan 031279
Museo Comunitario Huitza Chilin, San Pedro 031291
Museo Comunitario Iluikatlachiyalistli, Yahualica 031494
Museo Comunitario Inti Raymi, Lima 034155
Museo Comunitario Ismael Girón González, Pánuco, Zacatecas . 031178
Museo Comunitario Itzmal Kauil, Izamal 030894
Museo Comunitario Ji, Ocosingo 031160
Museo Comunitario Jna Niingui, San Miguel Tequixtepec 031284
Museo Comunitario Joyonaque, Tuxtla Gutiérrez 031436
Museo Comunitario Juan García Aldama de la Comunidad Cucapá, El Mayor Indígena 030779
Museo Comunitario Kumkuy Ys Untzi, Copainalá 030731
Museo Comunitario Maika, Poanas 031190
Museo Comunitario Note Ujía, Santa María Asunción Tlaxiaco 031305
Museo Comunitario Nu-kuiñe, Cuquila 030761
Museo Comunitario Raramuri, Guachochi 030813
Museo Comunitario Rubén Jaramillo, Tlaquiltenango 031399
Museo Comunitario Serafín Olarte, Papantla 031179
Museo Comunitario Shan-Dany, Santa Ana del Valle 031297
Museo Comunitario sin Paredes Colonia Orizaba, Mexicali 030963
Museo Comunitario Snuuvico, San Juan Mixtepec Juxtlahuaca . . 031267
Museo Comunitario Tejamen, Nuevo Ideal 031146
Museo Comunitario Tzakualli, Zacualpan 031511
Museo Comunitario Unidad Indígena Emiliano Zapata, Hueyapan de Ocampo 030877
Museo Comunitario Unión y Progreso, Cuatrocienegas 030744
Museo Comunitario Xiximes, Gómez Palacio 030809
Museo Comunitario Xolalpan Calli, Hueyapan 030876
Museo Comunitario Ya Nfädi Yu Nohño Los Conocimientos de los Otomíes, Tolimán 031407
Museo Comunitario Yucu-Iti, Santa María Yucu-Iti 031306
Museo Comunitario Ze Acatl Topiltzin Quetzalcoatl, Tepoztlán 031370
Museo Concha Ferrant, La Habana 009005
Museo Conchiliologico e della Carta Moneta, Bellaria Igea Marina . 025316
Museo Contadino, Montalto Pavese 026745
Museo Contadino, Varese Ligure 028102
Museo Contadino della Bassa Pavese, San Cristina e Bissone 027567
Museo Contadino Foiano – Bauernmuseum Völlan, Lana . . 026391
Museo Contalpa de Nombre de Dios, Nombre de Dios 031145
Museo Contemporaneo, Montelupo

Fiorentino 026784
Museo Contisuyo, Moquegua . . 034205
Museo Convento de San Diego, Quito 010309
Museo Convento de Santa Clara, Salamanca 039848
Museo Convento del Desierto de la Candelaria, Ráquira 008613
Museo Convento Santo Ecce Homo, Sutamarchán 008642
Museo Conventual de las Carmelitas Descalzas de Antequera, Monasterio de San José de Carmelitas Descalzas, Antequera 038790
Museo Conventual de Santa Paula, Sevilla 039978
Museo Cooperativo Eldorado, Eldorado 000358
Museo Coronel Félix Luque Plata, Guayaquil 010278
Museo Corpus Domini o Chiesa della Santa, Bologna 025378
Museo Correale di Terranova, Sorrento 027819
Museo Correr e Biblioteca d'Arte e Storia Veneziana, Musei Civici Veneziani, Venezia 028124
Museo Costumbrista de Sonora, Alamos 030641
Museo Costumbristá Juan de Vargas, La Paz 004129
Museo Coyug-Curá, Pigüé 000488
Museo CRA Unità di Ricerca di Apicoltura e Bachicoltura, Bologna 025379
Museo Criollo de los Corrales, Buenos Aires 000176
Museo Cristero Ing. Efrén Quezada, Encarnación de Díaz, Jalisco . . 030785
Museo Cristero Señor Cura Cristóbal Magallanes, Totatiche 031428
Museo Cristóbal Mendoza, Trujillo 054711
Museo Cruz Herrera, La Línea de la Concepción 039378
Museo Cuartel de Emiliano Zapata, Tlaltizapán 031394
Museo Cuartel Zapatista, México 030994
Museo Cuevas de Las Maravillas, La Romana 010210
Museo Cultura Antigua Ribera del Bernesga, Cuadros 039142
Museo Cultura e Musica Popolare dei Peloritani, Messina 026612
Museo Cultura y Tradición de Jalcomulco, Jalcomulco 030896
Museo Cultural del Instituto Geografico Militar, Quito 010310
Museo Cultural Iijdio Guaranga, Guaranga 010276
Museo d'Arte e Scienza, Milano 026638
Museo D. Agostinelli, Roma . . . 027407
Museo D. Chalonge, Erice . . . 026010
Museo da Terra de Melide, Melide 039552
Museo Dantesco, Ravenna . . . 027310
Museo d'Art Contemporani, Elche 039177
Museo d'Arte "Costantino Barbella", Chieti 025819
Museo d'Arte Antica, Milano . . 026639
Museo d'Arte Cinese ed Etnografico, Parma 027044
Museo d'Arte Contemporanea D. Formaggio, Teolo 027892
Museo d'Arte Contemporanea di Roma – MACRO, Roma 027408
Museo d'Arte Contemporanea di Villa Croce, Genova 026246
Museo d'Arte della Città di Ravenna, Ravenna 027311
Museo d'Arte dello Splendore, Giulianova 026293
Museo d'Arte e Ammobiliamento,

Register der Institutionen und Firmen

Museo de Arte en Ciudad Juárez, Instituto Nacional de Bellas
– Museo de Calcos y Esculturas Comparda Ernesto de La Cárcova,

Gallegos 000526
Museo de Arte en Ciudad Juárez,
Instituto Nacional de Bellas Artes,
Juárez 030911
Museo de Arte Español Enrique
Larreta, Buenos Aires 000181
Museo de Arte Francisco Oller,
Bayamón 035953
Museo de Arte Gauchesco La Recova,
San Antonio de Areco 000558
Museo de Arte Gráficas Juan Pablos,
México 030998
Museo de Arte Guillermo Ceniceros,
Durango 030770
Museo de Arte Habana, La
Habana 009008
Museo de Arte Hispanoamericano
Isaac Fernández Blanco, Buenos
Aires 000182
Museo de Arte Ibérico El Cigarralejo,
Palacio de Menahermosa, Mula 039602
Museo de Arte Italiano, Lima . . 034161
Museo de Arte José Luis Bello y
Zetina, Puebla 031198
Museo de Arte Moderno, Cuenca 010262
Museo de Arte Moderno, Mérida 054703
Museo de Arte Moderno, México 030999
Museo de Arte Moderno, Santiago de
Chile 007351
Museo de Arte Moderno, Santo
Domingo 010220
Museo de Arte Moderno de
Barranquilla, Barranquilla 008423
Museo de Arte Moderno de Bogotá,
Bogotá 008441
Museo de Arte Moderno de Bogotá II,
Bogotá 008442
Museo de Arte Moderno de
Bucaramanga, Bucaramanga . . 008479
Museo de Arte Moderno de Buenos
Aires, Buenos Aires 000183
Museo de Arte Moderno de Durango,
Gómez Palacio 030810
Museo de Arte Moderno de la Casa
de la Cultura Ecuatoriana, Quito 010313
Museo de Arte Moderno de Medellín,
Medellín 008554
Museo de Arte Moderno del Estado de
México, Toluca 031408
Museo de Arte Moderno Jesús Soto,
Ciudad Bolívar 054680
Museo de Arte Moderno La Tertulia,
Cali . 008487
Museo de Arte Moderno Ramírez
Villamizar, Pamplona 008584
Museo de Arte Olga Costa,
Guanajuato 030844
Museo de Arte Oriental, Ávila . . 038835
Museo de Arte Polular, México . 031000
Museo de Arte Popular Americano,
Santiago de Chile 007352
Museo de Arte Popular de la
Universidad, Puebla 031199
Museo de Arte Popular de la
Universidad Nacional San Cristóbal
de Huamanga, Ayacucho 034046
Museo de Arte Popular de Quinua,
Quinua 034227
Museo de Arte Popular de San
Bartolo de Coyotepec, San Baltazar
Chichicapan 031247
Museo de Arte Popular José
Hernández, Buenos Aires 000184
Museo de Arte Popular Petare,
Caracas 054659
Museo de Arte Popular Poblano y
Museo de Artesanías, Puebla . 031200
Museo de Arte Popular Tlajomulco,
Tlajomulco de Zúñiga 031391
Museo de Arte Popular Venezolano,
Juangriego 054693
Museo de Arte Precolombino,
Cusco 034084
Museo de Arte Prehispánico,

Mascota 030944
Museo de Arte Prehispánico Carlos
Pellicer, Tepoztlán 031371
Museo de Arte Prehispánico de
México Rufino Tamayo, Oaxaca 031150
Museo de Arte Religioso, La
Habana 009009
Museo de Arte Religioso,
Huaquechula 030871
Museo de Arte Religioso Cardenal
Luque, Tenjo 008644
Museo de Arte Religioso Colonial,
Ciudad de Panamá 033995
Museo de Arte Religioso Colonial,
Comayagua 023081
Museo de Arte Religioso Concepción,
Riobamba 010330
Museo de Arte Religioso Convento de
San Francisco, Cajamarca 034055
Museo de Arte Religioso de Girón,
Girón 008526
Museo de Arte Religioso de la
Catedral, Lima 034162
Museo de Arte Religioso de
la Catedral de San Nicolás,
Rionegro 008615
Museo de Arte Religioso de Monguí,
Monguí 008568
Museo de Arte Religioso de Piura,
Piura 034219
Museo de Arte Religioso de San Gil,
Atienza 038831
Museo de Arte Religioso de Santa
Mónica, Puebla 031201
Museo de Arte Religioso Ex Convento
Franciscano, Huejotzingo 030874
Museo de Arte Religioso i
Palenteológico de San Bartolomé,
Atienza 038832
Museo de Arte Religioso Juan de
Tejeda, Córdoba 000321
Museo de Arte Religioso Julio Franco
Arango, Duitama 008512
Museo de Arte Religioso la
Concepción, Baños 010250
Museo de Arte Religioso Presbítero
Antonio María Franco, Supía . . 008641
Museo de Arte Religioso Santo
Domingo de Porta Coeli, San
Germán 035981
Museo de Arte Religioso Tiberio de J.
Salazar y Herrera, Parroquia de la
Catedral de Sonsón, Sonsón . . 008638
Museo de Arte Religioso y Colonial,
Cali . 008488
Museo de Arte Religioso, Cusco . 034085
Museo de Arte Sacra das Clarisas,
Convento das Clarisas, Monforte de
Lemos 039576
Museo de Arte Sacra de Iria Flavia,
Casa Rectoral de Iria, Padrón . 039678
Museo de Arte Sacra de Santa Clara,
Allariz 038764
Museo de Arte Sacra de Santa María
do Campo, Museo de Arte Sacro de
la Colegiata, A Coruña 039132
Museo de Arte Sacra de Vilanova,
Lourenzá 039409
Museo de Arte Sacro, Betancuria 038946
Museo de Arte Sacro, Castrojeriz 039067
Museo de Arte Sacro, Chihuahua 030700
Museo de Arte Sacro, León . . . 033208
Museo de Arte Sacro de La Rioja, La
Rioja 000414
Museo de Arte Sacro de Tineo,
Tineo 040034
Museo de Arte Sacro San Francisco,
Salta 000550
Museo de Arte Sacro San Miguel,
Oruro 004148
Museo de Arte Sacro Santiago de los
Caballeros, Gáldar 039232
Museo de Arte Sacro, Iglesia Colegial,
Osuna 039666

Museo de Arte Sacro, Iglesia
Parroquial de San Esteban,
Huete 039314
Museo de Arte Sacro, Monasterio de
San Pelayo de Anteltares, Santiago
de Compostela 039931
Museo de Arte San Miguel Arcángel,
Mula 039603
Museo de Arte Taino, San Felipe de
Puerto Plata 010212
Museo de Arte Universidad Nacional
de Colombia, Bogotá 008443
Museo de Arte Virreinal de Santa
Teresa, Arequipa 034037
Museo de Arte Virreinal de Taxco,
Taxco de Alarcón 031328
Museo de Arte y Artesanía de Linares,
Linares 007338
Museo de Arte y Diseño
Contemporáneo, San José . . . 008689
Museo de Arte y Tradiciones
Populares, Bogotá 008444
Museo de Arte, Historia y Cultura
Casa Alonso, Vega Baja 036004
Museo de Arte, Universidad del
Magdalena, Santa Marta 008625
Museo de Artes Decorativas de
Palacio Salcines, Guantánamo . 008967
Museo de Artes e Industrias
Populares, Pátzcuaro 031183
Museo de Artes Gráficas, Imprenta
Nacional de Colombia, Bogotá 008445
Museo de Artes Plásticas,
Madonado 054497
Museo de Artes Plásticas Eduardo
Sívori, Buenos Aires 000185
Museo de Artes Populares, Tepic 031365
Museo de Artes Visuales Aramara,
Tepic 031366
Museo de Artes y Artesanías Enrique
Estrada Bello, Santo Tomé . . . 000623
Museo de Artes y Costumbres
Populares, Sevilla 039979
Museo de Artes y Costumbres
Populares e internacional de Arte
Naif, Jaén 039334
Museo de Artes y Costumbres
Populares, Fundacón Unicaja,
Málaga 039511
Museo de Artes y Costumbres
Populares, Museo Monográfico del
Castro de Viladonga, Pedrafita do
Cebrero 039731
Museo de Artes y Oficios,
Monóvar 039580
Museo de Artes y Tradiciones
Populares, Espinal 008518
Museo de Artes y Tradiciones
Populares, Madrid 039448
Museo de Artes y Tradiciones
Populares de Ráquira, Ráquira 008614
Museo de Artes y Tradiciones
Populares de Tlaxcala, Tlaxcala 031400
Museo de Artes y Tradiciones
Populares, Instituto Riva-Agüero,
Universidad Católica del Perú',
Lima 034163
Museo de Artes y Tradiciones
Populares, Universidad Popular, San
Sebastián de los Reyes 039885
Museo de Artesanía Iberoamericana,
La Orotava 039662
Museo de Artesanías del Mundo,
Silvia 008631
Museo de Artesanías Tradicionales
Folklóricas, Corrientes 000343
Museo de Astronomía y Geodesia,
Universidad Complutense de Madrid,
Madrid 039449
Museo de Atoyac, Atoyac de
Alvarez 030660
Museo de Autos y del Transporte
Humberto Lobo Villarreal,
Monterrey 031106

Museo de Ávila, Ávila 038836
Museo de Aviones Históricos en Vuelo,
Fundación Infante de Orleans,
Madrid 039450
Museo de Ayutla, Ayutla de los
Libres 030662
Museo de Bahía de Cochinos, Playa
Girón 009131
Museo de Baltasar Lobo, Zamora 040242
Museo de Baracoa, Baracoa . . . 008906
Museo de Bardados del Paso Azul,
Lorca 039407
Museo de Barquisimeto,
Barquisimeto 054642
Museo de Batopilas, Francisco I.
Madero, Coahuila 030799
Museo de Belas Artes da Coruña, A
Coruña 039133
Museo de Bellas Artes, Asunción 034018
Museo de Bellas Artes, Badajoz 038851
Museo de Bellas Artes,
Comayagüela 023082
Museo de Bellas Artes, Córdoba 039118
Museo de Bellas Artes, Valencia 040116
Museo de Bellas Artes, Viña del
Mar . 007371
Museo de Bellas Artes Agustin Araujo,
Treinta y Tres 054555
Museo de Bellas Artes al Aire Libre
Caminito, Buenos Aires 000186
Museo de Bellas Artes Bonaerense,
La Plata 000407
Museo de Bellas Artes Ceferino
Carnacini, Villa Ballester 000662
Museo de Bellas Artes Claudio León
Sempere, Burzaco 000282
Museo de Bellas Artes de Álava,
Palacio Augustin, Vitoria-
Gasteiz 040231
Museo de Bellas Artes de Asturias,
Palacio Verlarde, Oviedo 039672
Museo de Bellas Artes de Caracas,
Caracas 054660
Museo de Bellas Artes de Castellón,
Castellón de la Plana 039061
Museo de Bellas Artes de Granada,
Granada 039277
Museo de Bellas Artes de la Boca
Quinquela Martín, Buenos Aires 000187
Museo de Bellas Artes de Murcia,
Murcia 039606
Museo de Bellas Artes de Santander,
Santander 039921
Museo de Bellas Artes de Sevilla,
Sevilla 039980
Museo de Bellas Artes de Toluca,
Toluca 031409
Museo de Bellas Artes Departamental
de San José, San José de
Mayo 054553
Museo de Bellas Artes Domingo
Faustino Sarmiento, Mercedes 000456
Museo de Bellas Artes Franklin
Rawson, San Juan 000579
Museo de Bellas Artes Juan Yapari,
Posadas 000493
Museo de Bellas Artes Laureano
Brizuela, San Fernando del Valle de
Catamarca 000565
Museo de Bellas Artes Octavio de la
Colina, La Rioja 000415
Museo de Bermejillo, Bermejillo 030668
Museo de Bomberos, Madrid . . 039451
Museo de Bordados Paso Blanco,
Lorca 039408
Museo de Buenos Aires,
Tacotalpa 031319
Museo de Burgos, Casa Miranda,
Burgos 038980
Museo de Cáceres, Cáceres . . . 038994
Museo de Cádiz, Cádiz 039001
Museo de Calcos y Esculturas
Comparda Ernesto de La Cárcova,
Buenos Aires 000188

Museo dell' Antica Civiltà Locale,
Bronte 025496
Museo della Badia Benedettina, Cava
dei Tirreni 025732
Museo della Badia di San Salvatore,
Vaiano 028069
Museo della Barca Lariana, Pianello
del Lario 027133
Museo della Basilica, Gandino . . 026218
Museo della Basilica, Grotte di
Castro 026325
Museo della Basilica di San Nicola,
Bari 025291
Museo della Basilica di San Pancrazio,
Roma 027415
Museo della Basilica di San Venanzio,
Camerino 025563
Museo della Basilica di Santa Maria
della Passione, Milano 026646
Museo della Basilica Patriarcale
di Santa Maria degli Angeli,
Porziuncola 027255
Museo della Basilica Patriarcale Santa
Maria degli Angeli, Assisi 025234
Museo della Battaglia, San Martino
della Battaglia 027599
Museo della Battaglia, Vittorio
Veneto 028234
Museo della battaglia del Senio,
Alfonsine 025123
Museo della Battaglia di San Martino,
Desenzano del Garda 025982
Museo della Beata Vergine di San
Luca, Bologna 025382
Museo della Biblioteca Maldotti,
Guastalla 026334
Museo della Bilancia,
Campogalliano 025584
Museo della Bonifica, San Donà di
Piave 027569
Museo della Bonifica, Ecomuseo di
Argenta, Argenta 025198
Museo della Calzatura, Sant'Elpidio a
Mare 027667
Museo della Calzatura d'Autore di
Rossimoda, Strá 027846
Museo della Calzatura P. Bertolini,
Vigevano 028202
Museo della Canzone e
della Riproduzione Sonora,
Vallecrosia 028083
Museo della Carrozza, Macerata 026498
Museo della Carta, Amalfi 025141
Museo della Carta e della Filigrana,
Fabriano 026016
Museo della Carta e della Filigrana,
Pioraco 027173
Museo della Cartolina S. Nuvoli,
Isera 026358
Museo della Casa Carnica, Prato
Carnico 027278
Museo della Casa Carsica,
Monrupino 026731
Museo della Casa Contadina,
Bolognetta 025426
Museo della Casa Contadina,
Corciano 025917
Museo della Casa Trevigiana, Casa da
Noal, Treviso 028005
Museo della Casina delle Civette, Villa
Torlonia, Roma 027416
Museo della Cattedrale, Bari . . . 025292
Museo della Cattedrale, Barletta 025300
Museo della Cattedrale, Chiusi
Città 025830
Museo della Cattedrale, Fossano 026186
Museo della Cattedrale di San Pietro,
Bologna 025383
Museo della Centuriazione,
Cesena 025774
Museo della Ceramica,
Castellamonte 025678
Museo della Ceramica, Fiorano
Modenese 026087

Museo della Ceramica, Forlì . . . 026172
Museo della Ceramica, Montelupo
Fiorentino 026785
Museo della Ceramica, Patti . . . 027057
Museo della Ceramica del Castello,
Castello Arechi, Salerno 027533
Museo della Ceramica di Castelli,
Palazzo Comunale, Castelli . . . 025686
Museo della Ceramica G. Roi,
Bassano del Grappa 025308
Museo della Certosa, Certosa di
Pavia 025762
Museo della Certosa, Serra San
Bruno 027750
Museo della Chiesa di San Francesco,
Mercatello sul Metauro 026607
Museo della Chiesa di San Lorenzo,
Portovenere 027254
Museo della Città, Ancona 025154
Museo della Città, Aquino 025182
Museo della Città e del Territorio,
Monsummano Terme 026736
Museo della Città, Musei Comunali,
Rimini 027346
Museo della Civiltà Contadina,
Acri 025076
Museo della Civiltà Contadina,
Aliano 025126
Museo della Civiltà Contadina,
Amandola 025143
Museo della Civiltà Contadina,
Andrate 025158
Museo della Civiltà Contadina,
Ateleta 025245
Museo della Civiltà Contadina,
Barolo 025302
Museo della Civiltà Contadina,
Bastiglia 025311
Museo della Civiltà Contadina,
Borghi 025445
Museo della Civiltà Contadina, Borgo
San Lorenzo 025450
Museo della Civiltà Contadina,
Calvisano 025556
Museo della Civiltà Contadina,
Castelfranco Emilia 025674
Museo della Civiltà Contadina,
Cavenago d'Adda 025736
Museo della Civiltà Contadina,
Cervia 025767
Museo della Civiltà Contadina,
Copparo 025915
Museo della Civiltà Contadina,
Curtatone 025973
Museo della Civiltà Contadina,
Fabriano 026017
Museo della Civiltà Contadina, Figline
Valdarno 026078
Museo della Civiltà Contadina,
Filottrano 026082
Museo della Civiltà Contadina, Loreto
Aprutino 026468
Museo della Civiltà Contadina,
Maierato 026515
Museo della Civiltà Contadina,
Mairano 026518
Museo della Civiltà Contadina, Moio
della Civitella 026708
Museo della Civiltà Contadina,
Mombaroccio 026715
Museo della Civiltà Contadina,
Montechiaro d'Acqui 026763
Museo della Civiltà Contadina,
Montefiore dell'Aso 026773
Museo della Civiltà Contadina,
Novellara 026902
Museo della Civiltà Contadina,
Roscigno 027494
Museo della Civiltà Contadina, San
Nicola La Strada 027612
Museo della Civiltà Contadina,
Sappada 027676
Museo della Civiltà Contadina,
Sassocorvaro 027696

Museo della Civiltà Contadina,
Serrastretta 027755
Museo della Civiltà Contadina, Sesto
Fiorentino 027763
Museo della Civiltà Contadina,
Spinetoli 027828
Museo della Civiltà Contadina,
Teggiano 027886
Museo della Civiltà Contadina,
Todi 027918
Museo della Civiltà Contadina, Torre
Pallavicina 027974
Museo della Civiltà Contadina,
Verdello 028160
Museo della Civiltà Contadina,
Zibello 028250
Museo della Civiltà Contadina A.
Marsiano, Niscemi 026869
Museo della Civiltà Contadina D.
Bianco, Sammichele di Bari . . 027544
Museo della Civiltà Contadina del
Cilento, Montecorice 026766
Museo della Civiltà Contadina del
Mendrisiotto, Stabio 041760
Museo della Civiltà Contadina dell'Alto
Monferrato e della Bassa Langa,
Castagnole delle Lanze 025659
Museo della Civiltà Contadina e
Artigianale d'Enza, Montecchio
Emilia 026761
Museo della Civiltà Contadina e della
Canapa G. Romagnoli, Argelato 025196
Museo della Civiltà Contadina e
Tradizioni Popolari, Tuglie . . . 028043
Museo della Civiltà Contadina ed
Artigiana, Monterosso Calabro . 026795
Museo della Civiltà Contadina ed
Artigiana, Cripta Chiesa San Filippo,
Ripatransone 027355
Museo della Civiltà Contadina Friulana,
Farra d'Isonzo 026035
Museo della Civiltà Contadina in Val
Vibrata, Controguerra 025911
Museo della Civiltà Contadina L.
Rubat, Piscina 027186
Museo della Civiltà Contadina
Masseria Lupoli, Crispiano . . . 025955
Museo della Civiltà Contadina
nell'Area, Montefalcone di Val
Fortore 026769
Museo della Civiltà Contadina Valle
dell'Aniene, Roviano 027511
Museo della Civiltà Contadina,
Castello De Vargas, Perdifumo 027077
Museo della Civiltà Contadina, Istituto
Agrario A. Motti, Castelnovo no'
Monti 025691
Museo della Civiltà Contadina,
Pastorale, Artigianale e della Miniera,
Seui 027769
Museo della Civiltà Contadina, Villa
Smeraldi, Bentivoglio 025324
Museo della Civiltà del Lavoro,
Campiglia Marittima 025575
Museo della Civiltà Locale, Buseto
Palizzolo 025512
Museo della Civiltà Locale – Raccolta
d'Arte di San Francesco, Complesso
Museale, Trevi 027998
Museo della Civiltà Messapica,
Poggiardo 027206
Museo della Civiltà Montanara,
Sestola 027767
Museo della Civiltà Romana,
Roma 027417
Museo della Civiltà Rupestre,
Zungri 028256
Museo della Civiltà Rurale,
Altamura 025131
Museo della Civiltà Rurale del
Vicentino, Cantina Sociale Val Leogra,
Malo 026524
Museo della Civiltà Salinara,
Cervia 025768

Museo della Civiltà Solandra,
Malé 026521
Museo della Civiltà Valligiana, Fortezza
di Bardi, Bardi 025284
Museo della Civitella, Chieti . . . 025820
Museo della Collegiata,
Castell'Arquato 025681
Museo della Collegiata, Chianciano
Terme 025797
Museo della Collegiata di Santa Maria
a Mare, Maiori 026517
Museo della Collegiata di Sant'Andrea,
Empoli 026001
Museo della Collegiata, Stiftsmuseum
Innichen, San Candido 027557
Museo della Collezione Gambarotta,
Piozzo 027174
Museo della Comunicazione "Mille
Voci . . . mille suoni", Bologna 025384
Museo della Comunità Ebraica,
Venezia 028126
Museo della Confraternita della
Misericordia, Anghiari 025163
Museo della Congregazione
Mechitarista dei Padri Armeni,
Venezia 028127
Museo della Corte, Porto Viro . . 027245
Museo della Croce Rossa Italiana,
Campomorone 025585
Museo della Cultura Alpina del
Comelico, Comelico Superiore . 025896
Museo della Cultura Arbereshe, San
Paolo Albanese 027613
Museo della Cultura Mezzadrile, Morro
d'Alba 026819
Museo della Cultura Popolare e
Contadina, Carrega Ligure . . . 025638
Museo della Donna, Angrogna . 025165
Museo della Donna E. Ortner,
Merano 026602
Museo della Esposizione Permanente,
Milano 026647
Museo della Farmacia Picciola,
Trieste 028025
Museo della Figurina, Modena . 026696
Museo della Figurina di Gesso
e dell'Emigrazione, Coreglia
Antelminelli 025920
Museo della Filigrana, Campo
Ligure 025577
Museo della Flora, Fauna e
Mineralogia, Auronzo di Cadore 025257
Museo della Fondazione Horne,
Firenze 026118
Museo della Fondazione Mandralisca,
Cefalù 025740
Museo della Fondazione Querini
Stampalia, Venezia 028128
Museo della Fondazione Ugo da Como,
Lonato 026459
Museo della Frutticoltura Adofo
Bonvicini, Massa Lombarda . . 026569
Museo della Gente dell'Appennino
Pistoiese, Cutigliano 025974
Museo della Geotermia,
Pomarance 027217
Museo della Grancia, Serre di
Rapolano 027758
Museo della Guerra, Castel del
Rio 025662
Museo della Guerra Adamellina,
Spiazzo 027826
Museo della Guerra Bianca,
Temù 027891
Museo della Guerra Bianca,
Vermiglio 028161
Museo della Guerra, Il Vittoriale degli
Italiani, Gardone Riviera 026220
Museo della Linea Gotica, Montefiore
Conca 026771
Museo della Liquirizia, Rossano 027501
Museo della Liuteria, Arpino . . . 025210
Museo della Macchina da
Scrivere P. Mitterhofer,

Estrada Torres, Azua 010199
Museo Histórico y de la Tradiciones
 Populares de la Boca, Buenos
 Aires . 000243
Museo Histórico y Natural de Lavalle,
 Lavalle Villa Tulumaya 000424
Museo Histórico y Numismático del
 Banco Central de la República
 Argentina "Dr. José Evaristo Uriburu",
 Buenos Aires 000244
Museo Histórico y Numismático del
 Banco de la Nación Argentina,
 Buenos Aires 000245
Museo Histórico y Regional Pico
 Truncado, Pico Truncado 000487
Museo Histórico y Tradicional de
 Barracas al Sud, Avellaneda . . 000129
Museo Histórico, Colonial y de
 Bellas Artes y Museo de Ciencias
 Naturales Regional Mesopotámico,
 Mercedes 000457
Museo Histório de Aspe, Aspe . 038823
Museo Hotel Marquetá, Mariquita 008551
Museo Houssay de Historia de la
 Ciencia y la Técnología, Universidad
 de Buenos Aires, Buenos Aires 000246
Museo Huehuetla-tolli, Comala . 030722
Museo Hunucmá de Sisal,
 Hunucmá 030882
Museo I Luoghi del Lavoro Contadino,
 Buscemi 025511
Museo I. Nievo, Fossalta di
 Portogruaro 026185
Museo I. Salvini, Cocquio
 Trevisago 025878
Museo Ibleo delle Arti e Tradizioni
 Popolari – Guastella, Modica . 026705
Museo Iconográfico del Quijote,
 Guanajuato 030850
Museo Icticola del Beni, Universidad
 Técnica del Beni, Trinidad . . . 004172
Museo Ideale Leonardo da Vinci,
 Vinci . 028219
Museo Iglesia del Salvador, Oña 039644
Museo Iglesia San Juan de Dios,
 Murcia 039612
Museo Ignacio Zuloaga, Pedraza de la
 Sierra 039733
Museo Igneológico del Cuerpo Ofical
 de Bomberos, Bogotá 008467
Museo Illichiano, Castell'Arquato 025683
Museo Iloilo, Iloilo 034316
Museo Imágenes de la Frontera,
 Dajabón 010204
Museo in Erba, Bellinzona 041091
Museo In Situ, Sulmona 027860
Museo Inca de la Universidad
 Nacional San Antonio Abad,
 Cusco 034093
Museo Independencia, Córdoba . 000329
Museo Indígena de Colombia Ethnia,
 Bogotá 008468
Museo Indígena de Guatavita,
 Guatavita 008533
Museo Indígena Regional Enin,
 Mitú . 008565
Museo Indigenista, Esquel 000367
Museo Industrial de Santa Catarina El
 Blanqueo, Santa Catarina 031301
Museo Inés Mercedes Gómez Álvarez,
 Universidad Ezequiel Zamora,
 Guanare 054691
Museo Inka, Cusco 034094
Museo Instituto Cultural México Israel,
 México 031050
Museo Insular de la Palma, Santa
 Cruz de la Palma 039904
Museo Inter-étnico de la Amazonía,
 Florencia 008521
Museo Interactivo de Ciencia,
 Tecnología y Medio Ambiente Sol del
 Niño, Mexicali 030964
Museo Interactivo de Ciencias
 Naturales, Ituzaingó 000389

Museo Interactivo de Ciencias-Puerto
 Ciencia, Universidad Nacional de
 Entre Ríos, Paraná 000483
Museo Interactivo de la Música,
 Málaga 039513
Museo Interactivo del Centro de
 Ciencias de Sinaloa, Culiacán . 030759
Museo Interactivo del Medio Ambiente,
 México 031051
Museo Interactivo El Rehilete,
 Pachuca 031172
Museo Interactivo La Avispa,
 Chilpancingo 030707
Museo Interattivo delle Scienze,
 Foggia 026158
Museo Internacional de Arte
 Contemporáneo, Arrecife 038812
Museo Internacional de Arte Naïf,
 Jaén . 039336
Museo Internacional de Electrografía,
 Cuenca 039149
Museo Internacional del Folklore e
 Civiltà Contadina, Atina 025248
Museo Internazionale del Presepio,
 Morrovalle 026820
Museo Internazionale della Campana,
 Agnone 025082
Museo Internazionale della Caricatura,
 Tolentino 027926
Museo Internazionale della Croce
 Rossa, Castiglione delle Stiviere 025706
Museo Internazionale della
 Fisarmonica, Castelfidardo . . . 025670
Museo Internazionale delle Ceramiche,
 Fondazione, Faenza 026023
Museo Internazionale delle Marionette
 A. Pasqualino, Palazzo Fatta,
 Palermo 027020
Museo Internazionale dell'Etichetta,
 Cupramontana 025971
Museo Internazionale dell'Immagine
 Postale, Belvedere Ostrense . . 025319
Museo Internazionale e Biblioteca
 della Musica, Bologna 025408
Museo Interparroquial de Alaejos,
 Alaejos 038717
Museo Interparroquial de Arte Sacro,
 Iglesia de Santa María de Mediavilla,
 Medina de Rioseco 039548
Museo Irineo Germán, Azoyú . . . 030663
Museo Irpino, Avellino 025259
Museo Irureta, Tilcara 000639
Museo Isabel Rubio, Isabel Rubio 009061
Museo Isidro Fabela,
 Atlacomulco 030658
Museo It Akean, Kalibo 034323
Museo Italgas, Torino 027957
Museo Italoamericano, San
 Francisco 052907
Museo Itinerante de Arte
 Contemporáneo del Mercosur,
 Buenos Aires 000247
Museo Ittico, Pescara 027106
Museo Ittico Augusto Capriotti, San
 Benedetto del Tronto 027549
Museo Ixchel del Traje Indígena,
 Guatemala 023053
Museo Jacinto Guerrero, Ajofrín 038716
Museo Jacinto Jijón y Caamaño,
 Quito 010323
Museo Jacobo Borges, Caracas 054671
Museo Jarocho Salvador Ferrando,
 Tlacotalpan 031388
Museo Jesuítico de Sitio, Yapeyú 000678
Museo Jesuitico Nacional de Jesus
 María, Concepción 000330
Museo Jesútico Nacional de Jesús
 María, Jesús María 000390
Museo Joaquín Peinado de Ronda,
 Ronda 039830
Museo Jorge Eliécer Gaitán, Puerto
 Gaitán 008609
Museo Jorge Pasquini López, San
 Salvador de Jujuy 000601

Museo José Antonio Páez,
 Acarigua 054634
Museo José de Jesús Almaza,
 Xicoténcatl 031487
Museo José Domingo de Obaldía,
 David 033999
Museo José Fernando Ramírez,
 Durango 030774
Museo José Guadalupe Posada,
 Aguascalientes 030634
Museo José Luis Cuevas, Colima 030713
Museo José Luis Cuevas, México 031052
Museo José Manuel Estrada,
 Suipacha 000628
Museo José María Luis Mora,
 Ocoyoacac 031163
Museo José María Morelos y Pavón,
 Cuautla 030746
Museo José María Velasco,
 Toluca 031417
Museo José Martí, La Habana . 009023
Museo José Natividad Correa Toca
 Teapa, Teapa 031335
Museo José Ortega, Arroba de los
 Montes 038813
Museo José y Tomás Chávez Morado,
 Silao . 031316
Museo Juan Cabré, Calaceite . 039005
Museo Juan Carlos Iramáin, San
 Miguel de Tucumán 000593
Museo Juan Lorenzo Lucero,
 Pasto 008588
Museo Juan Manuel Blanes,
 Montevideo 054524
Museo Juárez del Jardín Borda,
 Cuernavaca 030750
Museo Juárez e Historia de Mapimí y
 Ojuela, Mapimí 030943
Museo Juarista de Congregación
 Hidalgo, Entronque Congregación
 Hidalgo 030793
Museo Judío de Buenos Aires Dr.
 Salvador Kibrick, Buenos Aires 000248
Museo Julio Romero de Torres,
 Córdoba 039120
Museo Kan Pepen, Teabo 031334
Museo Kartell, Noviglio 026904
Museo Ken Damy di Fotografia
 Contemporanea, Brescia 025485
Museo Kusillo, Fundación Cultural
 Quipus, La Paz 004138
Museo L. Garaventa, Chiavari . 025806
Museo L. Minguzzi, Milano . . . 026654
Museo la Antigua Casa del Agua,
 Hunucmá 030883
Museo La Casa del Libro, San
 Juan 035997
Museo La Chole, Petatlán 031185
Museo La Cinacina, San Antonio de
 Areco 000560
Museo La Flor de Jimulco,
 Torreón 031425
Museo La Fudina, Comelico
 Superiore 025897
Museo La Isabelica, Santiago de
 Cuba 009198
Museo La Pesca, Benito Juárez 030667
Museo La Vieja Estación, María
 Teresa 000445
Museo La Vigía, Matanzas 009092
Museo-Laboratorio, Vernio . . . 028162
Museo Laboratorio del Tessile, Soveria
 Mannelli 027821
Museo Laboratorio di Archeologia,
 Monsampolo del Tronto 026733
Museo Laboratorio di Arte
 Contemporanea, Università La
 Sapienza, Roma 027447
Museo Laboratorio Santa Barbara,
 Mammola 026527
Museo Ladino di Fassa, Pozza di
 Fassa 027261
Museo Ladino-Fodom, Livinallongo del
 Col di Lana 026441

Museo Laguna del Caimán, Tlahualilo
 de Zaragoza 031390
Museo Lapidario, Urbino 028063
Museo Lapidario Civico, Ferrara 026063
Museo Lapidario del Duomo di
 Sant'Eufemia, Grado 026306
Museo Lapidario e del Tesoro del
 Duomo, Modena 026699
Museo Lapidario Estense,
 Modena 026700
Museo Lapidario Maffeiano,
 Verona 028173
Museo Lapidario Marsicano,
 Avezzano 025263
Museo Lara, Ronda 039831
El Museo Latino, Omaha 051677
Museo Lázaro Galdiano, Madrid 039477
Museo Legado Hermanos Álverez
 Quintero, Utrera 040095
Museo Legislativo los Sentimientos de
 la Nación, México 031053
Museo Leonardiano, Palazzina Uzielli
 & Castello dei Conti Guidi, Vinci 028220
Museo Leoncavallo, Brissago . . 041156
Museo Leoniano, Carpineto
 Romano 025634
Museo L'Iber, Museo de los Soldatitos
 de Plomo, Valencia 040125
Museo Libisosa, Lezuza 039374
Museo Lítico de Pucara, Pucara 034223
Museo Local de Acámbaro, Dolores
 Hidalgo 030767
Museo Local de Antropología
 e Historia de Compostela,
 Compostela 030729
Museo Local de Valle de Santiago,
 Valle de Santiago 031451
Museo Local Tuxteco, Santiago
 Tuxtla 031312
Museo Locale, Termeno 027896
Museo Lodovico Pogliaghi, Santa
 Maria del Monte, Varese 028099
Museo Lombardo di Storia
 dell'Agricoltura, Sant'Angelo
 Lodigiano 027658
Museo López Claro, Santa Fé . . 000610
Museo Lorenzo Coullaut-Valera,
 Marchena 039535
Museo Loringiano, Málaga 039514
Museo Los Amantes de Sumpa,
 Guayaquil 010284
Museo Luciano Rosero, Pasto . . 008589
Museo Lucio Balderas Márquez,
 Landa de Matamoros 030926
Museo Luigi Ceselli, Subiaco . . 027854
Museo Luigi Varoli, Cotignola . 025943
Museo Luis A. Calvo, Agua de
 Dios 008406
Museo Luis Alberto Acuña, Villa de
 Leyva 008660
Museo Luis Donaldo Colosio,
 Francisco I. Madero, Coahuila . 030801
Museo M. Antonioni, Ferrara . . . 026064
Museo Madre Caridad Brader,
 Pasto 008590
Museo Madres Benedictinas,
 Sahagún 039845
Museo Maestro Alfonso Zambrano,
 Pasto 008591
Museo Malacologico, Erice 026011
Museo Malacologico delle Argille,
 Cutrofiano 025976
Museo Malacologico Piceno, Cupra
 Marittima 025970
Museo Malvinas Argentinas, Río
 Gallegos 000528
Museo Manoblanca, Buenos
 Aires 000249
Museo Manuel de Falla, Alta
 Gracia 000119
Museo Manuel F. Zárate,
 Guarraré 034000
Museo Manuel López Villaseñor,
 Ciudad Real 039103

Museo Municipal de Bayamo, Bayamo 008912
Museo Municipal de Baza, Baza 038924
Museo Municipal de Bellas Artes, Bahía Blanca 000135
Museo Municipal de Bellas Artes, La Calera 000394
Museo Municipal de Bellas Artes, La Paz 000402
Museo Municipal de Bellas Artes, Tandil 000633
Museo Municipal de Bellas Artes de Valparaíso, Valparaíso 007369
Museo Municipal de Bellas Artes Dr. Genaro Perez, Córdoba 000333
Museo Municipal de Bellas Artes Dr. Genaro Pérez, Río Cuarto 000525
Museo Municipal de Bellas Artes Dr. Urbano Poggi, Rafaela 000511
Museo Municipal de Bellas Artes Juan B. Castagnino, Rosario 000542
Museo Municipal de Bellas Artes Juan Manuel Blanes, Montevideo .. 054527
Museo Municipal de Bellas Artes Lucas Braulio Areco, Posadas . 000496
Museo Municipal de Bellas Artes Prof. Amelio Ronco Ceruti, Metán .. 000460
Museo Municipal de Bellas Artes, Antiguo Convento de San Francisco, Santa Cruz de Tenerife . 039909
Museo Municipal de Bolivia, Bolivia 008916
Museo Municipal de Boyeros, La Habana 009030
Museo Municipal de Buey Arriba, Buey Arriba 008917
Museo Municipal de Cabaiguán, Cabaiguán 008918
Museo Municipal de Cabana, Cabana 034051
Museo Municipal de Cacomun, Cacomun 008919
Museo Municipal de Caibarién, Caibarién 008920
Museo Municipal de Caimanera, Caimanera 008921
Museo Municipal de Calahorra, Calahorra 039007
Museo Municipal de Calimete, Calimete 008923
Museo Municipal de Camajuaní Hermanos Vidal Caro, Camajuaní 008929
Museo Municipal de Campechuela, Campechuela 008930
Museo Municipal de Candelaria, Candelaria 008931
Museo Municipal de Carlos Manuel de Céspedes, Carlos Manuel de Céspedes 008933
Museo Municipal de Cauto Cristo, Cauto Cristo 008934
Museo Municipal de Cerámica, Paterna 039728
Museo Municipal de Chambas, Chambas 008936
Museo Municipal de Chancay, Chancay 034072
Museo Municipal de Chincha, Chincha Alta 034074
Museo Municipal de Ciencias, Bahía Blanca 000136
Museo Municipal de Ciencias Naturales, Valencia 040126
Museo Municipal de Ciencias Naturales Carlos Ameghino, Mercedes 000459
Museo Municipal de Ciencias Naturales Carlos Darwin, Punta Alta 000505
Museo Municipal de Ciencias Naturales Lorenzo Scaglia, Mar del Plata 000443
Museo Municipal de Cifuentes,

Cifuentes 008945
Museo Municipal de Ciro Redondo, Ciro Redondo 008946
Museo Municipal de Colón José R. Zulueta, Colón 008948
Museo Municipal de Consolación del Sur, Consolación del Sur 008949
Museo Municipal de Contramaestre, Contramaestre 008950
Museo Municipal de Corralillo, Corralillo 008951
Museo Municipal de Cruces, Cruces 008952
Museo Municipal de Cueto, Cueto 008954
Museo Municipal de Cumanayagua, Cumanayagua 008955
Museo Municipal de Daimiel, Daimiel 039152
Museo Municipal de El Trébol, El Trébol 000357
Museo Municipal de Eldorado, Eldorado 000359
Museo Municipal de Esmeralda, Esmeralda 008956
Museo Municipal de Estepona, Estepona 039201
Museo Municipal de Etnografía, Villadiego 040205
Museo Municipal de Etnología, Castellón de la Plana 039063
Museo Municipal de Florencia, Florencia 008957
Museo Municipal de Florida, Florida 008958
Museo Municipal de Fomento, Fomento 008959
Museo Municipal de Gibara, Gibara 008962
Museo Municipal de Guamá, La Plata 009071
Museo Municipal de Guane, Guane 008965
Museo Municipal de Guantánamo – Antigua Cárcel, Guantánamo . 008969
Museo Municipal de Guayaquil, Guayaquil 010285
Museo Municipal de Guisa, Guisa 008970
Museo Municipal de Habana del Este, La Habana 009031
Museo Municipal de Historia, Necolí 008572
Museo Municipal de Historia del Arte, Montevideo 054528
Museo Municipal de Historia Malitzin de Huiloapan, Huiloapan de Cuauhtémoc 030878
Museo Municipal de Historia Natural, General Alvear 000373
Museo Municipal de Historia Natural, San Rafael 000598
Museo Municipal de Historia y Arqueología, González 030811
Museo Municipal de Historia y Arqueología, Rivera 054550
Museo Municipal de Huaytará, Huaytará 034113
Museo Municipal de Imías, Playitas y Cajobabo, Cajobabo 008922
Museo Municipal de Jagüey Grande, Jagüey Grande 009063
Museo Municipal de Jesús Menéndez, Jesús Menéndez 009066
Museo Municipal de Jiguaní, Jiguaní 009067
Museo Municipal de Jovellanos Domingo Mujica, Jovellanos .. 009070
Museo Municipal de la Ciudad de Carcarañá, Carcarañá 000289
Museo Municipal de la Ciudad de Rosario, Rosario 000543
Museo Municipal de la Lisa, La Habana 009032

Museo Municipal de La Sierpe, La Sierpe 009206
Museo Municipal de La Yaya, La Yaya 009232
Museo Municipal de Lajas, Lajas 009072
Museo Municipal de Los Arabos Clotilde García, Los Arabos ... 009073
Museo Municipal de Los Palacios, Los Palacios 009074
Museo Municipal de Madrid, Madrid 039479
Museo Municipal de Maisí, Maisí 009076
Museo Municipal de Majagua, Majagua 009077
Museo Municipal de Majibacoa, Majibacoa 009078
Museo Municipal de Manatí Jesús Suárez Gayol, Manatí 009079
Museo Municipal de Manicaragua, Manicaragua 009080
Museo Municipal de Mantua, Mantua 009081
Museo Municipal de Manuel Tames, Manuel Tames 009082
Museo Municipal de Manzanillo, Manzanillo 009085
Museo Municipal de Marianao, La Habana 009033
Museo Municipal de Martí, Martí 009086
Museo Municipal de Mayarí, Mayarí 009095
Museo Municipal de Media Luna, Media Luna 009097
Museo Municipal de Minas, Minas 009098
Museo Municipal de Minas de Matahambre, Minas de Matahambre 009099
Museo Municipal de Moa, Moa . 009100
Museo Municipal de Morón, Morón 009102
Museo Municipal de Najasa, Sibanicú 009204
Museo Municipal de Nazca y Casa Museo María Reiche, Nazca .. 034208
Museo Municipal de Niceto Pérez, Niceto Pérez 009103
Museo Municipal de Niquero, Niquero 009104
Museo Municipal de Nuevitas, Nuevitas 009114
Museo Municipal de Palma Soriano, Palma Soriano 009116
Museo Municipal de Pedro Betancourt, Pedro Betancourt 009118
Museo Municipal de Perico, Perico 009119
Museo Municipal de Pilón, Pilón 009120
Museo Municipal de Pintura, Villadiego 040206
Museo Municipal de Placetas, Placetas 009130
Museo Municipal de Poblado de Jimaguayú, Jimaguayú 009068
Museo Municipal de Ponteareas, Ponteareas 039768
Museo Municipal de Porteña, Porteña 000492
Museo Municipal de Primero de Enero, Primero de Enero 009132
Museo Municipal de Quemado de Güines, Quemado de Güines .. 009136
Museo Municipal de Rafael Freyre, Rafael Freyre 009137
Museo Municipal de Ranchuelo, Ranchuelo 009138
Museo Municipal de Río Cauto, Río Cauto 009141
Museo Municipal de Rodas, Rodas 009142
Museo Municipal de Sagua de Tánamo, Sagua de Tánamo ... 009143

Museo Municipal de Sagua la Grande, Sagua la Grande 009144
Museo Municipal de San Cristobal, San Cristobal 009152
Museo Municipal de San Juan y Martínez, San Juan y Martínez 009154
Museo Municipal de San Luis 29 de Abril, San Luis 009155
Museo Municipal de San Miguel del Padrón, La Habana 009034
Museo Municipal de San Telmo, Donostia-San Sebastián 039165
Museo Municipal de Sandino, Sandino 009166
Museo Municipal de Santa Cruz del Sur, Santa Cruz del Sur 009176
Museo Municipal de Santiponce, Antiguo Matadero, Santiponce . 039950
Museo Municipal de Santo Domingo, Santo Domingo 009203
Museo Municipal de Sibanicú, Sibanicú 009205
Museo Municipal de Sierra de Cubitas, Cubitas 008953
Museo Municipal de Taguasco, Taguasco 009208
Museo Municipal de Trinidad, Trinidad 009212
Museo Municipal de Unión de Reyes Juan G. Gómez, Unión de Reyes 009214
Museo Municipal de Urbano Noris, Urbano Noris 009215
Museo Municipal de Varadero, Varadero 009216
Museo Municipal de Vedado, La Habana 009035
Museo Municipal de Venezuela, Venezuela 009217
Museo Municipal de Vertientes, Vertientes 009218
Museo Municipal de Vigo Quiñones de León, Vigo 040185
Museo Municipal de Viñales Adela Azcuy Labrador, Pinar del Río . 009126
Museo Municipal de Yaguajay, Yaguajay 009229
Museo Municipal de Yara, Yara 009230
Museo Municipal de Yateras, Yateras 009231
Museo Municipal del Cerro, La Habana 009036
Museo Municipal del Deporte, San Fernando del Valle de Catamarca 000567
Museo Municipal del III Frente, Santiago de Cuba 009199
Museo Municipal del Teatro, Lima 034191
Museo Municipal Dr. Rodolfo Doval Fermi, Sastre 000626
Museo Municipal Dreyer, Dreyer 034097
Museo Municipal Eduard Camps Cava, Guissona 039294
Museo Municipal Elisa Cendrero, Ciudad Real 039104
Museo Municipal Emilio Daudinot, San Antonio del Sur 009150
Museo Municipal Estados del Duque, Malagón 039520
Museo Municipal Fernando García Grave de Peralta, Puerto Padre 009135
Museo Municipal Forte de San Damián, Ribadeo 039810
Museo Municipal Francisco Javier Balmaseda, Santa Clara .. 009173
Museo Municipal Histórico Fotográfico de Quilmes "Gerónima Irma Giles y Gaete de Mayol", Quilmes .. 000508
Museo Municipal Histórico Regional Almirante Brown, Bernal 000147
Museo Municipal Histórico Regional Santiago Lischetti, Villa Constitución 000669

Pesca, Racines 027294
Museo Provinciale della Ceramica,
Raito di Vietri sul Mare 027299
Museo Provinciale della Vita
Contadina, San Vito al
Tagliamento 027627
Museo Provinciale delle Miniere,
Vipiteno 028222
Museo Provinciale delle Tradizioni
Popolari Abbazia Cerrate, Lecce 026419
Museo Provinciale di Storia Naturale,
Foggia 026159
Museo Provinciale di Storia Naturale,
Livorno 026446
Museo Provinciale Sigismondo
Castromediano, Lecce 026420
Museo Pucciniano, Torre del
Lago . 027973
Museo Pueblo de Luis, Trelew . 000643
Museo Puertorriqueño del Deportes,
Salinas 035979
Museo Quattroruote, Rozzano . . 027515
Museo Quezaltenango,
Quezaltenango 023060
Museo Quinta Amalia Simoni,
Camagüey 008928
Museo Quinta Casa de Juan Montalvo,
Ambato 010245
Museo Quinta de San Pedro
Alejandrino, Fundación Museo
Bolivariano, Santa Marta 008630
Museo Quinta Juan Leon Mera,
Ambato 010246
Museo R. Campelli,
Pievebovigliana 027158
Museo R. Cassolo, Mede 026590
Museo R. Cuneo, Savona 027718
Museo R. De Cesare, Spinazzola 027827
Museo Rabelo, La Habana 009047
Museo-Raccolta di Fisica, Bari . 025297
Museo Radiofónico de la Ciudad de
Boulogne, Boulogne 000148
Museo Rafael Coronel, Zacatecas 031505
Museo Rafael Escriña, Santa Clara de
Saguier 000604
Museo Rafael Zabaleta, Quesada 039797
Museo Raffaello Pagliaccetti,
Giulianova 026294
Museo Raíces, Jesús María . . . 008542
Museo Raíces de Satevó, Satevó 031313
Museo Rainis e Aspazija, Casa Carlo
Cattaneo, Castagnola 041179
Museo Ralli, Marbella 039532
Museo Ralli, Punta del Este . . . 054548,
060809
Museo Ralli, Santiago de Chile . 007361
Museo Ramón Gaya, Casa Palarea,
Murcia 039614
Museo Ramón López Velarde,
México 031070
Museo Ramón Pérez Fernández,
Rivadavia 000536
Museo Ramos Generales, Villa
María 000674
Museo Ratti dei Vini d'Alba, La
Morra 026375
Museo Rauzi, Palmira 000479
Museo Rayo, Roldanillo 008617
Museo Real Colegiata de San Isidoro,
Panteón, Biblioteca, Museo, Claustro,
León . 039372
Museo Recoleto, Quezon City . . 034417
Museo Regional, San Juan Bautista
Tuxtepec 031260
Museo Regional Amazónico,
Iquitos 034122
Museo Regional Aníbal Cambas,
Posadas 000497
Museo Regional Arqueológico
Rossbach, Chichicastenango . . 023047
Museo Regional Carlos Funes Derieul,
Coronel Dorrego 000339
Museo Regional Castelli, Castelli 000296
Museo Regional Cayetano Alberto

Silva, Venado Tuerto 000657
Museo Regional Comunitario
Altepepialcalli, México 031071
Museo Regional Cuauhnáhuac,
Cuernavaca 030751
Museo Regional Daniel Hernández
Morillo, Huancavelica 034102
Museo Regional de Acambay,
Acambay 030620
Museo Regional de Actopán,
Actopán 030628
Museo Regional de Aldama,
Aldama 030642
Museo Regional de Antropología,
Resistencia 000523
Museo Regional de Antropología
Carlos Pellicer Cámara,
Villahermosa 031478
Museo Regional de Antropología e
Historia de Baja California Sur, La
Paz . 030919
Museo Regional de Antropología J.
Jesús Figueroa Torres, Sayula . 031315
Museo Regional de Arqueología,
Huamanga 034101
Museo Regional de Arqueología de
Junin, Chupaca 034078
Museo Regional de Arqueología de
Tuxpan, Tuxpan de Rodríguez
Cano . 031434
Museo Regional de Arte e Historia,
Jerez de García Salinas 030904
Museo Regional de Arte Moderno
MURAM, Cartagena 008498
Museo Regional de Arte Popular La
Huatápera, Uruapán 031445
Museo Regional de Atacama,
Copiapó 007334
Museo Regional de Bolillo,
Cartagena 039054
Museo Regional de Campeche,
Campeche 030676
Museo Regional de Casma Max Uhle,
Casma 034066
Museo Regional de Chiapas, Tuxtla
Gutiérrez 031441
Museo Regional de Cinco Saltos,
Cinco Saltos 000305
Museo Regional de Claromecó,
Balneario Claromecó 000138
Museo Regional de Cuetzalan,
Cuetzalán 030753
Museo Regional de Desamparados
Joaquín García Monge, San
José . 008696
Museo Regional de Durango y Museo
del Niño, Universidad Juárez,
Durango 030775
Museo Regional de Guadalajara,
Guadalajara 030835
Museo Regional de Guanajuato
Alhóndiga de Granaditas,
Guanajuato 030851
Museo Regional de Guerrero,
Chilpancingo 030708
Museo Regional de Hidalgo,
Pachuca 031173
Museo Regional de Historia de
Aguascalientes, Aguascalientes 030635
Museo Regional de Historia de Colima,
Colima 030714
Museo Regional de Historia de
Tamaulipas, Victoria 031468
Museo Regional de Historia,
Universidad de Sonora,
Hermosillo 030861
Museo Regional de Ica María Reiche
Gross Newman, Ica 034116
Museo Regional de Iguala, Iguala de
la Independencia 030886
Museo Regional de Iquique,
Iquique 007336
Museo Regional de la Araucania,
Temuco 007364

Museo Regional de la Arqueológico de
Tiwanaku, Tiwanaku 004169
Museo Regional de la Cerámica,
Tlaquepaque 031398
Museo Regional de la Ciudad de La
Paz, La Paz 000403
Museo Regional de la Laguna,
Torreón 031427
Museo Regional de las Culturas
Occidente, Guzmán 030856
Museo Regional de Mascota,
Mascota 030945
Museo Regional de Nayarit,
Tepic . 031368
Museo Regional de Nuevo León,
Monterrey 031114
Museo Regional de Pigüé, Pigüé 000489
Museo Regional de Pintura José
Antonio Terry, Tilcara 000640
Museo Regional de Puebla,
Puebla 031215
Museo Regional de Querétaro,
Querétaro 031228
Museo Regional de Río Verde, Río
Verde 031232
Museo Regional de Sacanta,
Sacanta 000547
Museo Regional de San Carlos, San
Carlos 054551
Museo Regional de San Martín,
Moyobamba 034206
Museo Regional de Sinaloa,
Culiacán 030760
Museo Regional de Sonora,
Hermosillo 030862
Museo Regional de
Telecomunicaciones Tomás Guzmán
Cantú, La Paz 030920
Museo Regional de Tierra Caliente,
Coyuca de Catalán 030739
Museo Regional de Tlaxcala,
Tlaxcala 031402
Museo Regional de Ucayali,
Pucallpa 034221
Museo Regional de Yucatán,
Mérida 030958
Museo Regional del Valle del Fuerte,
Ahome 030637
Museo Regional Doctor Leonardo
Oliva, Ahualulco de Mercado . . 030638
Museo Regional Dr. Adolfo Alsina,
Carhué 000290
Museo Regional Dr. Federico Escalada,
Río Mayo 000533
Museo Regional Dr. José Luro, Pedro
Luro . 000485
Museo Regional El Fuerte, El
Fuerte 030777
Museo Regional Francisco Mazzoni,
Maldonado 054500
Museo Regional Guayupe de Puerto
Santander, Puerto Santander . . 008610
Museo Regional Huasteco, Valles 031454
Museo Regional José G. Brochero,
Santa Rosa de Río Primero . . . 000617
Museo Regional Las Varillas, Las
Varillas 000423
Museo Regional Lázaro Cárdenas,
Tlapehuala 031396
Museo Regional Luciano Márquez,
Zacatlán 031510
Museo Regional Malargüe,
Malargüe 000438
Museo Regional Maracó, General
Pico . 000376
Museo Regional Michoacano,
Morelia 031128
Museo Regional Municipal de El
Calafate, El Calafate 000356
Museo Regional Particular Epifanio
Saravia, Santa Catalina 000603
Museo Regional Patagónico,
Comodoro Rivadavia 000310
Museo Regional Potosino, San Luis

Potosí 031278
Museo Regional Provincial Padre
Manuel Jesús Molina, Río
Gallegos 000530
Museo Regional Rescate de Raíces,
Ahualulco de Mercado 030639
Museo Regional Rincón de Vida, Villa
Mirasol 000675
Museo Regional Rufino Muñiz Torres,
Ocampo 031159
Museo Regional Rumi Mayu (Río de
Piedra), Sanagasta 000602
Museo Regional Salesiano de Rawson,
Rawson 000515
Museo Regional Salesiano Maggiorino
Borgatello, Punta Arenas 007344
Museo Regional Trevelin, Trevelin 000647
Museo Regional Valcheta,
Valcheta 000655
Museo Regional Valparaíso,
Valparaíso 031455
Museo Regional y de Arte Marino,
Puerto San Julián 000504
Museo Regionale, Messina 026613
Museo Regionale della Ceramica,
Caltagirone 025551
Museo Regionale della Ceramica,
Deruta 025979
Museo Regionale delle Centovalli e
del Pedemonte, Intragna 041375
Museo Regionale di Camarina,
Ragusa 027298
Museo Regionale di Scienze Naturali,
Saint Pierre 027526
Museo Regionale di Scienze Naturali,
Affiliation Regione Piemonte,
Torino 027962
Museo Religioso de Guatavita,
Guatavita 008534
Museo Religioso Santo Domingo,
Bolívar 010252
Museo Religioso y Colonial de San
Francisco, Cali 008493
Museo Renacimiento Indígena,
Huamuxtitlán 030870
Museo Renato Brozzi,
Traversetolo 027986
Museo Revoltella e Galleria d'Arte
Moderna, Comune di Trieste,
Trieste 028031
Museo Ricardo J. Alfaro, Bella
Vista . 033987
Museo Richard Ginori della
Manifattura di Doccia, Sesto
Fiorentino 027764
Museo Ripley, México 031072
Museo Risorgimentale,
Montichiari 026807
Museo Risorgimentale, Pieve di
Cadore 027151
Museo Rivarossi dei Treni in Miniatura,
Como 025900
Museo Roca, Buenos Aires . . . 000270
Museo Rocsen, Nono 000474
Museo Rodera Robles, Casa del
Hidalgo, Segovia 039967
Museo Rodolfo Valentino,
Castellaneta 025679
Museo Rognoni Salvaneschi,
Novara 026896
Museo Romagnolo del Teatro,
Forlì . 026175
Museo Romano, Tortona 027980
Museo Romano de Astorga,
Astorga 038827
Museo Romano Oiasso, Irún . . 039326
Museo Romántico, Madrid 039493
Museo Romántico, Trinidad . . . 009213
Museo Romántico – Casa de
Montero, Museo Histórico Nacional,
Montevideo 054536
Museo Rómulo Raggio, Vicente
López 000658
Museo Ron Arehucas, Arucas . . 038822

Sineu, Sineu 039993
Museu Parroquial de Santa Maria la
 Major d'Inca, Inca 039323
Museu Parroquial dels Sants Joans,
 Estivella 039203
Museu Parroquial, Parròquia Sant
 Martí, Altafulla 038782
Museu Particular del Pastor Joaquim
 Gassó, Fornells de la Muntanya 039219
Museu Patrício Corrêa da Câmara,
 Universidade da Região da
 Campanha, Bagé 004243
Museu Pau Casals, El Vendrell . 040172
Museu Paulista da Universidade de
 São Paulo, São Paulo 004824
Museu Paulo Firpo, Dom Pedrito 004364
Museu Paulo Machado de Carvalho,
 São Paulo 004825
Museu Pedro Cruz, Pedrógão
 Grande 035738
Museu Pedro Ludovico, Goiânia 004393
Museu Picasso, Barcelona 038917
Museu Pinacoteca, Igarassu . . . 004406
Museu Pio XII, Braga 035406
Museu-Poblat Ibèric, Tornabous 040060
Museu Popular Beatriz Costa,
 Malveira 035678
Museu Postal, Ordino 000102
Museu Postal e Telegráfico da ECT,
 Brasília 004287
Museu Professor Hugo Machado da
 Silveira, Patrocínio 004542
Museu Rafael Bordalo Pinheiro,
 Lisboa 035650
Museu Regional Abade de Baçal,
 Bragança 035411
Museu Regional Carlos Machado,
 Ponta Delgada 035753
Museu Regional D. Bosco, Campo
 Grande 004312
Museu Regional da Fauna e Flora do
 Itatiaia, Itatiaia 004417
Museu Regional da Huila,
 Lumbango 000112
Museu Regional d'Artá, Artà . . 038815
Museu Regional de Arqueologia D.
 Diogo de Sousa, Braga 035407
Museu Regional de Arqueologia e
 Etnografia de Arganil, Arganil . 035368
Museu Regional de Cabinda,
 Cabinda 000105
Museu Regional de Etnografia do
 Lobito, Lobito 000107
Museu Regional de Leiria, Leiria 035584
Museu Regional de Olinda,
 Olinda 004525
Museu Regional de Oliveira de
 Azeméis, Oliveira de Azeméis . 035716
Museu Regional de Paredes de Coura,
 Paredes de Coura 035734
Museu Regional de São João Del Rei,
 São João Del Rei 004753
Museu Regional de Sintra, Sintra 035873
Museu Regional do Alto Uruguai,
 Erechim 004365
Museu Regional do Huambo,
 Huambo 000106
Museu Regional do Sul de Minas,
 Campanha 004300
Museu Regional Dr. Alípio de Araújo
 Silva, Rio Preto 004698
Museu Regional Manuel Nobre,
 Azambujeira 035376
Museu Regional Olívio Otto,
 Carazinho 004322
Museu Renato Lobo Garcia,
 Colares 035469
Museu Republicano Convenção de Itu,
 Universidade de São Paulo, Itu 004421
Museu Restauração, Lisboa . . . 035651
Museu Rocaguinarda de Terrissa dels
 Països Catalans, Oristà 039659
Museu Rodrigues Lapa, Anadia . 035359
Museu Romàntic Can Llopis,

Sitges 039996
Museu Romantic Can Papiol, Vilanova
 i la Geltrú 040195
Museu Romàntic Delger, Caldes de
 Montbui 039013
Museu Romântico da Quinta da
 Macieirinha, Porto 035785
Museu Rondon, Universidade Federal
 de Mato Grosso, Cuiabá 004341
Museu Rural, Alcáçovas 035314
Museu Rural – Centro de Arte e
 Cultura, Reguengo Grande . . . 035807
Museu Rural da Casa do Povo de
 Santa Maria, Estremoz 035503
Museu Rural de Beringel,
 Beringel 035391
Museu Rural de Boticas, Boticas 035400
Museu Rural de Vila Franca do
 Campo, Vila Franca do Campo 035924
Museu Rural de Villa-Lobos,
 Borba 035397
Museu Rural do Grupo dos Amigos de
 Estremoz, Estremoz 035504
Museu Rural e do Vinho do Concelho,
 Cartaxo 035435
Museu Rural e Etnográfico, São João
 da Ribeira 035844
Museu S. Pedro da Palhaça,
 Palhaça 035728
Museu Sacro da Igreja de São
 Sebastião, Araxá 004236
Museu Sacro São José de Ribamar,
 Aquiraz 004227
Museu Sala de Armas, Almeida 035341
Museu Salles Cunha, Rio de
 Janeiro 004682
Museu Salvador, Instituto Botánico de
 Barcelona, Barcelona 038918
Museu Santa Casa da Misericórdia,
 Coimbra 035467
Museu Santa Maria Rosa Molas,
 Jesús 039344
Museu Santos Barosa da Fábrica do
 Vidro, Marinha Grande 035681
Museu São João Batista,
 Caratinga 004321
Museu São Norberto, Pirapora do
 Bom Jesus 004559
Museu Sargento Edésio de Carvalho,
 Sousa 004836
Museu Sebastião da Gama, Vila
 Nogueira de Azeitão 035925
Museu Sitio Arqueológico Casa dos
 Pilões, Rio de Janeiro 004683
Museu Sobre a Pesca do Atum,
 Tavira 035884
Museu Solar Monjardim, Vitória 004872
Museu Sub-Tenente António
 Bernardino Apolónio Piteira,
 Arraiolos 035370
Museu Tauri, Barcelona 038919
Museu Taurino, Alcochete 035324
Museu Teatro, Rio de Janeiro . . 004684
Museu Técnico-Científico do
 Instituto Oscar Freire, Faculdade de
 Medicina / FM, São Paulo . . . 004826
Museu Temático do Vinho,
 Almeirim 035344
Museu Tempostal, Salvador . . . 004723
Museu Teresa Bernardes Adami
 de Carvalho, Santo Antônio do
 Monte 004735
Museu Territorial do Amapá,
 Macapá 004463
Museu Théo Brandão de Antropologia
 de Folclore, Maceió 004469
Museu Theodormiro Carneiro Santiago,
 Itajubá 004412
Museu Tinguí-Cuera, Araucária . 004233
Museu Torre Balldovina, Santa Coloma
 de Gramenet 039903
Museu-Tresor Parroquial, Esglesia de
 Sant Esteve, Olot 039642
Museu Universitário, Campinas . 004308

Museu Universitário de Arte,
 Uberlândia 004860
Museu Universitário Gama Filho, Rio
 de Janeiro 004685
Museu Universitário Professor
 Oswaldo Rodrigues Cabral,
 Florianópolis 004376
Museu Valencia del Joguet, Ibi . 039317
Museu Valencià d'Etnologia,
 Valencia 040132
Museu Valencià d'Història Natural,
 Valencia 040133
Museu Víctor Balaguer, Vilanova i la
 Geltrú 040196
Museu Victor Meirelles,
 Florianópolis 004377
Museu Viladomat d'Escultura,
 Escaldes-Engordany 000092
Museu Villa-Lobos, Rio de
 Janeiro 004686
Museu Vivo da Comutação Manual,
 Vilar 035944
Museu Vivo da Memória Candanga,
 Brasilia 004288
Museu Vivo de Vilar do Pinheiro, Vilar
 do Pinheiro 035945
Museu von Martius, Teresópolis 004849
Museu Vulcano-Espeleológico
 Machado Fagundes, Angra do
 Heroísmo 035364
Museu Zé Didor, Campo Maior . 004313
Museu Zoobotânico Augusto Ruschi,
 Passo Fundo 004541
Museu Zoológico, Coimbra . . . 035468
Museu Zoológico, Pombal 035750
O Museu, Faculdade de Belas Artes
 da Universidade do Porto, Porto 035767
Museum, Bagheria 025269
Museum, Coswig 017538
The Museum, Dunwich 044002
The Museum, Greenwood 049238
Museum, Großpösna 018573
Museum, Mühlacker 020132
The Museum, Newton Stewart . 045313
Museum, Wettin-Löbejün 022190
Museum, Zofingen 041915
Museum – Begegnung der Kulturen,
 Krenglbach 002208
Museum – Herberg de Ar,
 Westerbork 032857
Museum – Treasures from the
 National Archives, Kew 044554
Museum "Alte Schule",
 Georgenthal 018366
Museum "Burg Wendelstein",
 Vacha 021882
Museum "Kaffeemühle", Wolgast 022331
Museum "Währungsreform 1948"
 und Konklave in Rothwesten,
 Fuldatal 018292
Museum "Werkstatt Plaumer",
 Öhringen 020600
Museum 1806, Institut zur
 militärgeschichtlichen Forschung
 Jena 1806 e.V., Jena 019143
Museum 1915–1918 "Vom Ortler bis
 zur Adria", Kötschach-Mauthen 002189
Museum 1940–1945, Dordrecht 032071
Museum 3. Dimension,
 Dinkelsbühl 017669
Museum '40-'45, Slochteren . . . 032703
Museum aan de Ijzer, Diksmuide 003472
Museum aan de Stroom (MAS),
 Antwerpen 003215
Museum Aargau, Lenzburg . . . 041434
Museum Abdij Mariënlof, Kerniel 003672
Museum Abdij van Egmond, Egmond
 Binnen 032102
Museum Abdijkerk, Thorn 044253
Museum Abodiacum, Denklingen 017623
Museum ABRI Satriamandala,
 Jakarta 024262
Museum Abtei Liesborn, Museum des
 Kreises Warendorf, Wadersloh . 021946

Museum Abteiberg,
 Mönchengladbach 020095
Museum Abtsküche,
 Heiligenhaus 018868
Museum Adam Malik, Jakarta . . 024263
Museum Adorf, Adorf 016278
Museum Affandi – Museum Seni,
 Yogyakarta 024367
Museum Africa, Johannesburg . 038576
Muséum Agricole et Industriel de
 Stella Matutina, Piton-Saint-Leu 036015
Museum Aguntum, Verein Curatorium
 pro Agunto, Dölsach 001813
Museum Albert van Dyck,
 Schilde 003923
Museum Ald Slot, Wergea 032854
Museum Alex Mylona, Athinai . 022588
Museum Alexandrowka, Potsdam 020827
Museum Alpin Pontresina,
 Pontresina 041592
Museum Alte Brettersäge,
 Rappottenstein 002518
Museum Alte Kirche, Reken . . . 020980
Museum Alte Lateinschule,
 Großenhain 018564
Museum Alte Münze, Südharz . 021671
Museum Alte Pfefferküchlerei,
 Weißenberg 022117
Museum Alte Textilfabrik, Weitra 002841
Museum alte Ziegelei Westerholt,
 Wardenburg 022015
Museum Altes Bad Pfäfers, Bad
 Ragaz 041043
Museum Altes Gymnasium,
 Schweinfurt 021385
Museum Altes Land, Jork 019162
Museum Altes Rathaus,
 Leingarten 019633
Museum Altes Rathaus,
 Pirmasens 020775
Museum Altes Zeughaus,
 Wehrhistorisches Museum,
 Solothurn 041749
Museum 'Altes Zollhaus',
 Baltrum 016730
Museum Altomünster,
 Altomünster 016363
Museum Alzey, Alzey 016367
Museum am Burghof, Lörrach . 019761
Museum am Dom, Würzburg . . 022375
Museum am Dom (Bischöfliches Dom-
 und Diözesanmuseum), Trier . 021791
Museum am Lindenplatz, Weil am
 Rhein 022054
Museum am Markt, Schiltach . . 021260
Museum am Maxplatz, Rehau . . 020961
Museum am Meer, Büsum 017447
Museum am Modersohn-Haus,
 Worpswede 022355
Museum am Odenwaldlimes,
 Elztal 017927
Museum am Ostwall im Dortmunder
 U, Dortmund 017728
Museum am Schloss, Raesfeld . 020887
Museum am Schölerberg, Natur
 und Umwelt-Planetarium,
 Osnabrück 020660
Museum am Thie e.V., Göttingen 018470
Museum am Widumhof, Urbach 021873
Museum Amager, Dragør 009874
Museum Amandinhuis, Herk-de-
 Stad 003619
Museum Amden, Amden 041013
Museum Amelinghausen
 mit Zinnfigurenausstellung,
 Museumsverein für das Fürstentum
 Lüneburg, Amelinghausen . . . 016372
Museum Amtspforte Stadthagen,
 Stadthagen 021552
Museum an der Krukenburg, Bad
 Karlshafen 016590
Museum an der Münze,
 Neuleiningen 020364
Museum Anatomicum, Marburg 019936

Museum de Zwarte Tulp, Lisse . 032421
Museum Delfzijl, Delfzijl 031989
Museum der 50er und 60er Jahre,
 Vaihingen an der Enz 021885
Museum der Alltagskultur – Schloss
 Waldenbuch, Außenstelle des
 Landesmuseums Württemberg,
 Waldenbuch 021967
Museum der Anthropologie, Universität
 Zürich-Irchel, Zürich 041942
Museum der Arbeit, Hamburg . . 018714
Museum der Arbeit, Hann.
 Münden 018751
Museum der Barbarossastadt
 Gelnhausen, Gelnhausen 018348
Museum der Barlachstadt Güstrow,
 Güstrow 018600
Museum der Bayerischen Könige,
 Hohenschwangau 019005
Museum der Belgischen Streitkräfte in
 Deutschland, Soest 021493
Museum der Berliner Bürgerbräu
 Brauerei, Berlin 017008
Museum der bildenden Künste Leipzig,
 Leipzig 019667
Museum der Brikettfabrik
 Herrmannschacht, Zeitz 022430
Museum der Brotkultur, Ulm . . . 021853
Museum der Cistercienserinnen-Abtei
 Lichtenthal, Baden-Baden 016709
Museum der Deutschen
 Binnenschifffahrt, Duisburg . . . 017820
Museum der Deutschen
 Spielzeugindustrie, Neustadt bei
 Coburg 020411
Museum der deutschen
 Sprachinselorte bei Brünn, Erbach,
 Alb-Donau-Kreis 017977
Museum der Donauschwaben,
 Herbrechtingen 018898
Museum der Firma Hartmann, Bad
 Berleburg 016526
Museum der Freiwilligen Feuerwehr,
 Heiligenhaus 018869
Museum der Freiwilligen Feuerwehr,
 Laxenburg 002246
Museum der Göttinger Chemie,
 Göttingen 018471
Museum der Grafschaft Mark,
 Altena 016329
Museum der Grafschaft Rantzau,
 Barmstedt 016754
Museum der Granitindustrie,
 Haselbachtal 018785
Museum der Havelländischen
 Malerkolonie, Schwielowsee . . 021409
Museum der Heimatvertriebenen,
 Vöcklabruck 002801
Museum der Heimatvertriebenen,
 Stadtmuseum Wels-Burg, Wels 002850
Museum der historischen
 Waschtechnik, Ostbevern 020664
Museum der Katakombenstichting,
 Valkenburg, Limburg 032783
Museum der Klosterruine mit
 Lapidarium, Rüeggisberg 041647
Museum der Kommunikationstechnik
 und Bürogeschichte, Bamberg 016738
Museum der Kulturen Basel,
 Basel 041071
Museum Der Kunststall, Dahlem 017574
Museum der Landschaft, Saanen 041651
Museum der Landschaft Eiderstedt,
 Sankt Peter-Ording 021220
Museum der Landschaft Hasli,
 Meiringen 041491
Museum der Landsmannschaft
 Ostpreußen, Gelsenkirchen . . . 018354
Museum der Landtechnik, Land- und
 Forstwirtschaftliche Fachschule,
 Knittelfeld 002182
Museum der Marktgemeinde Sankt
 Johann in Tirol, Sankt Johann in
 Tirol . 002614

Museum der Mechitharisten-
 Congregation, Wien 002959
Museum der Moderne Salzburg –
 Mönchsberg, Salzburg 002578
Museum der Moderne Salzburg –
 Rupertinum, Salzburg 002579
Museum der Natur und Umwelt
 Cottbus, Cottbus 017543
Museum der Natur, Stiftung Schloss
 Friedenstein Gotha, Gotha 018496
Museum der Oberzent,
 Beerfelden 016806
Museum der Photographie,
 Fischamend 001880
Museum der Schildbürger, Belgern-
 Schildau 016815
Museum der Schwalm,
 Schwalmstadt 021365
Museum der Schweizer
 Kapuzinerprovinz, Sursee 041785
Museum der Seefahrt,
 Geiselhöring 018335
Museum der Staatlichen Münze Berlin,
 Berlin 017009
Museum der Stadt Alfeld (Leine),
 Stadtmusem und Tiermuseum,
 Alfeld 016310
Museum der Stadt Bad Gandersheim,
 Bad Gandersheim 016570
Museum der Stadt Bad Ischl, Bad
 Ischl . 001741
Museum der Stadt Bad Neuenahr-
 Ahrweiler, Bad Neuenahr-
 Ahrweiler 016623
Museum der Stadt Bad Schwartau,
 Bad Schwartau 016662
Museum der Stadt Bad Staffelstein,
 Bad Staffelstein 016670
Museum der Stadt Bensheim,
 Bensheim 016828
Museum der Stadt Bludenz,
 Bludenz 001777
Museum der Stadt Boppard,
 Boppard 017291
Museum der Stadt Borna, Borna 017300
Museum der Stadt Butzbach
 im Solms-Braunfelser Hof,
 Butzbach 017479
Museum der Stadt Calw, Calw . 017489
Museum der Stadt Dommitzsch,
 Dommitzsch 017690
Museum der Stadt Eberbach,
 Eberbach 017829
Museum der Stadt Eschborn,
 Eschborn 018022
Museum der Stadt Ettlingen,
 Ettlingen 018068
Museum der Stadt Friedland,
 Friedland 018254
Museum der Stadt Füssen,
 Füssen 018280
Museum der Stadt Gladbeck,
 Stadtgeschichte und Computerkunst,
 Gladbeck 018425
Museum der Stadt Grafing, Grafing
 bei München 018511
Museum der Stadt Gronau (Leine),
 Gronau, Leine 018547
Museum der Stadt Hagenow,
 Hagenow 018633
Museum der Stadt Kapfenberg,
 Kapfenberg 002129
Museum der Stadt Ketzin/Havel,
 Ketzin, Havel 019279
Museum der Stadt Korneuburg,
 Korneuburg 002192
Museum der Stadt Lahnstein im
 Hexenturm, Lahnstein 019517
Museum der Stadt Lahr, Villa Jamm
 im Stadtpark, Lahr 019523
Museum der Stadt Langen, Langen,
 Hessen 019560
Museum der Stadt Lennestadt,
 Lennestadt 019700

Museum der Stadt Ludwigsfelde,
 Ludwigsfelde 019797
Museum der Stadt Lünen, Lünen 019848
Museum der Stadt Mittweida "Alte
 Pfarrhäuser", Mittweida 020084
Museum der Stadt Nauen,
 Nauen 020287
Museum der Stadt Neu-Isenburg Haus
 zum Löwen, Neu-Isenburg . . . 020322
Museum der Stadt Neustadt an
 der Weinstraße, Neustadt an der
 Weinstraße 020408
Museum der Stadt Neustrelitz,
 Neustrelitz 020420
Museum der Stadt Neutraubling,
 Ortsgeschichtliche Dokumentation,
 Neutraubling 020421
Museum der Stadt Parchim,
 Parchim 020716
Museum der Stadt Pasewalk und
 Künstlergedenkstätte Paul Holz,
 Pasewalk 020720
Museum der Stadt Pegau, Pegau 020731
Museum der Stadt Ratingen,
 Ratingen 020909
Museum der Stadt Schkeuditz,
 Schkeuditz 021263
Museum der Stadt Schopfheim,
 Schopfheim 021324
Museum der Stadt Schwaz auf Burg
 Freundsberg, Schwaz 002682
Museum der Stadt Steyr, Steyr . 002726
Museum der Stadt Troisdorf,
 Bilderbuchmuseum, Troisdorf . 021801
Museum der Stadt Villach,
 Villach 002795
Museum der Stadt Vils, Vils . . . 002798
Museum der Stadt Weinheim,
 Weinheim 022105
Museum der Stadt Worms im
 Andreasstift, Worms 022344
Museum der Stadt Zerbst mit
 Sammlung Katharina II., Zerbst 022444
Museum der Stadtgeschichte
 im Zeughaus, Lutherstadt
 Wittenberg 019863
Museum der Stadtpfarrkirche
 St. Xaver – museum sacrum,
 Leoben 002256
Museum der Stadtwerke,
 Pirmasens 020776
Museum der Stille, Berlin 017010
Museum der Trauerarbeitsplätze,
 Institut für Philosophie und
 Gruppendynamik, Klagenfurt . . 002163
Museum der unerhörten Dinge,
 Berlin 017011
Museum der Universität Tübingen
 MUT – Alte Kulturen, Sammlungen
 im Schloss Hohentübingen,
 Tübingen 021814
Museum der Verbandsgemeinde
 Speicher, Speicher 021529
Museum der VG-Eich im
 Storchenschulhaus, Gimbsheim 018421
Museum der Völker, Museum
 für Kunst und Ethnographie,
 Schwaz 002683
Museum der Votivkirche, Wien . 002960
Museum der Westlausitz Kamenz,
 Kamenz 019181
Museum der Winterthur-
 Versicherungen, Winterthur . . . 041888
Museum des Augustiner
 Chorherrenstifts, Reichersberg 002529
Museum des Blindenwesens,
 Wien . 002961
Museum des Chorherrenstifts
 Klosterneuburg, Klosterneuburg 002176
Museum des ehemaligen Kreises
 Stuhm/Westpr., Bremervörde . . 017389
Museum des Geschichtsvereins
 Keltisches Noreia, Mühlen 002373
Museum des Haager Landes, Haag in

Oberbayern 018616
Museum des Handwerks, Bad
 Bederkesa 016508
Museum des Kreises Plön mit
 norddeutscher Glassammlung,
 Plön . 020798
Museum des Landes Glarus,
 Näfels 041542
Museum des Nötscher Kreises, Nötsch
 im Gailtal 002413
Museum des Saarländischen
 Aberglaubens, Gersheim 018390
Muséum des Sciences Naturelles de
 Belgique, Bruxelles 003416
Museum des Stiftes Admont,
 Admont 001680
Museum des Teltow, Zossen . . 022475
Muséum des Volcans, Aurillac . . 011619
Museum des Wiener Männergesang-
 Vereins, Wien 002962
Museum des Zisterzienserstifts
 mit Margret Bilger-Galerie,
 Schlierbach 002664
Museum Development Service, Suffolk
 County Council, Ipswich 060143
Museum Dewantara Kirti Griya,
 Yogyakarta 024370
Museum Dharma Wiratama,
 Yogyakarta 024371
Muséum d'Histoire Naturell,
 Auxerre 011641
Muséum d'Histoire Naturelle,
 Autun 011629
Muséum d'Histoire Naturelle,
 Bagnères-de-Bigorre 011684
Muséum d'Histoire Naturelle,
 Blois . 011898
Muséum d'Histoire Naturelle,
 Chartres 012285
Muséum d'Histoire Naturelle,
 Grenoble 012997
Muséum d'Histoire Naturelle, Le
 Havre 013456
Muséum d'Histoire Naturelle,
 Lyon . 013756
Muséum d'Histoire Naturelle,
 Marseille 013865
Muséum d'Histoire Naturelle,
 Neuchâtel 041552
Muséum d'Histoire Naturelle,
 Nice . 014294
Muséum d'Histoire Naturelle,
 Perpignan 014646
Muséum d'Histoire Naturelle,
 Rouen 014974
Muséum d'Histoire Naturelle, Saint-
 Denis 036017
Muséum d'Histoire Naturelle,
 Troyes 015851
Muséum d'Histoire Naturelle de
 Bordeaux, Bordeaux 011936
Muséum d'Histoire Naturelle de la
 Ville de Bayonne, Bayonne . . . 011743
Muséum d'histoire naturelle de la Ville
 de Genève, Genève 041310
Muséum d'Histoire Naturelle de
 Toulouse, Toulouse 015795
Muséum d'Histoire Naturelle de Tours,
 Tours 015820
Muséum d'Histoire Naturelle
 Fauniscope, Gras 012966
Muséum d'Histoire-Naturelle, Museum
 Parc Emanuel Liais, Cherbourg-
 Octeville 012364
Muséum d'Histoire Naturelle, Vivarium,
 Dijon . 012602
Museum Dhondt-Dhaenens,
 Deurle 003465
Museum Dingolfing-Herzogsburg,
 Dingolfing 017667
Museum Diponegoro, Magelang 024303
Museum Dirgantara Mandala,
 Yogyakarta 024372
Museum DKM, Duisburg 017821

Museum für Schriftguss, Satz und Druckverfahren, Darmstadt . . 017595
Museum für Seenotrettungsgeräte, Neuharlingersiel 020352
Museum für Sepulkralkultur, Kassel 019228
Museum für Stadtgeschichte, Alpirsbach 016321
Museum für Stadtgeschichte, Breisach am Rhein 017350
Museum für Stadtgeschichte, Freiburg im Breisgau 018217
Museum für Stadtgeschichte, Höhr-Grenzhausen 018979
Museum für Stadtgeschichte, Neuenburg am Rhein 020341
Museum für Stadtgeschichte Dessau, Dessau-Roßlau 017635
Museum für Stadtgeschichte im Adam- und-Eva-Haus, Paderborn . . 020707
Museum für Stadtgeschichte Templin, Templin 021725
Museum für Stadtgeschichte und Volkskunde, Heppenheim . . 018893
Museum für Thüringer Volkskunde Erfurt, Erfurt 017995
Museum für Uhren und mechanische Musikinstrumente, Oberhofen . 041563
Museum für Uhren und Schmuck, Frankfurt am Main 018176
Museum für Unterwasserarchäologie, Sassnitz 021230
Museum für Ur- und Frühgeschichte, Stillfried 002733
Museum für Ur- und Frühgeschichte, Wieselburg an der Erlauf 003026
Museum für Ur- und Frühgeschichte Thüringens, Weimar 022086
Museum für Ur- und Frühgeschichte, Willibaldsburg, Eichstätt 017878
Museum für Urgeschichte, Koblach 002184
Museum für Urgeschichte(n), Zug 041974
Museum für verfolgte Kunst-Israel, Ashdod 024840
Museum für visuelle Kommunikation, Köln 019377
Museum für Völkerkunde, Burgdorf 041172
Museum für Völkerkunde, Wien 003012
Museum für Völkerkunde Hamburg, Hamburg 018720
Museum für Volkskultur, Spittal an der Drau 002708
Museum für Volkskunst, Haslach 022038
Museum für Vor- und Frühgeschichte, Garching an der Alz 018313
Museum für Vor- und Frühgeschichte, Gunzenhausen 018611
Museum für Vor- und Frühgeschichte, Langenau 019568
Museum für Vor- und Frühgeschichte sowie Stadtgeschichte, Egeln . 017854
Museum für Vor- und Frühgeschichte, Stiftung Saarländischer Kulturbesitz, Saarbrücken 021168
Museum für Waage und Gewicht, Balingen 016726
Museum für Waffentechnik, Ausrüstung, Uniformen und Auszeichnungswesen, Vilshofen 021929
Museum für Wattenfischerei, Wremen 022361
Museum für Weinbau und Stadtgeschichte, Edenkoben . . 017850
Museum für Weinkultur, Deidesheim 017612
Museum für Westfälische Literatur, Oelde 020604
Museum für Wohnkultur des Historismus und des Jugendstils, Hiltrefingen 041364
Museum für Zeit – Pfälzisches

Turmuhrenmuseum, Rockenhausen 021059
Museum für Zeitgenössische Glasmalerei, Langen, Hessen . 019561
Museum Fürstenfeldbruck, Fürstenfeldbruck 018273
Museum Fundreich, Thalmässing 021742
Museum Furthmühle, Pram . . . 002482
Muséum Gallery, Albi 103171
Museum Gayo, Aceh Tengah . . 024215
Museum Gedong Kirtya, Singaraja 024344
Museum Gedung Arca, Gianyar 024253
Museum Gedung Joang '45, Jakarta 024269
Museum Geelvinck Hinlopen Huis, Amsterdam 031783
Museum gegenstandsfreier Kunst, Otterndorf 020685
Museum Geiserschmiede, Bühlertal 017440
Museum Gelnhausen, Gelnhausen 018349
Museum-Gemaal de Hoogte, Nieuwolda 032502
Museum Gensungen, Felsberg . 018097
Museum Geologi, Bandung . . . 024226
Museum Georg Schäfer, Schweinfurt 021386
Museum Gesigt van't Dok, Hellevoetsluis 032278
Museum GGZ-Drenthe, Assen . 031860
Museum Giersch der Goethe-Universität, Frankfurt am Main 018177
Museum Goa Bala Lompoa, Sungguminasa 024349
Museum Goch, Goch 018442
Museum Godshuis Belle, Ieper . 003649
Museum Göltzsch, Rodewisch . . 021065
Museum Goldener Steig, Waldkirchen 021980
Museum Goldenes Dachl, Innsbruck 002104
Museum Griesheim, Griesheim . 018533
Museum Grootseminarie, Brugge 003338
Museum Grossauheim, Hanau . 018744
Museum Großkrotzenburg, Großkrotzenburg 018568
Museum Gülden Creutz, Leinefelde-Worbis 019627
Museum Gugging, NÖ Museum Betriebs GmbH, Maria Gugging 002316
Museum Gula, Klaten 024300
Museum Gunnar-Wester-Haus, Schweinfurt 021387
Museum Gust de Smet, Deurle . 003466
Museum Gustavianum, Uppsala 040916
Museum H.R. Giger, Gruyères . . 041344
Museum haarundkamm, Mümliswil 041525
Museum Haldensleben, Haldensleben 018654
Museum Halle, Kindheits- und Jugendwerke bedeutender Künstler, Halle / Westfalen 018660
Museum Hameln, Hameln 018732
Museum Harsefeld, Harsefeld . . 018778
Museum Haus Cajeth, Heidelberg 018840
Museum Haus Dix, Gaienhofen . 018308
Museum Haus Esters, Kunstmuseen Krefeld, Krefeld 019461
Museum Haus Hövener, Brilon . 017399
Museum Haus Kast, Gaggenau . 018305
Museum Haus Kasuya, Yokosuka 029556
Museum Haus Lange, Kunstmuseen Krefeld, Krefeld 019462
Museum Haus Löwenberg, Gengenbach 018359
Museum Haus Ludwig für Kunstausstellungen, Saarlouis . 021176
Museum Haus Martfeld, Schwelm 021391
Museum Havezate Mensinge, Roden 032613

Museum Hedendaagse Glaskunst, Museums Vledder, Vledder . . 032812
Museum Hedendaagse Grafiek, Museums Vledder, Vledder . . . 032813
Museum Heimathaus Irmintraut, Ottersberg 020687
Museum Heineanum, Museum für Vogelkunde, Halberstadt 018649
Museum Henriette Polak, Zutphen 032937
Museum Heraldiek Benelux, Temse 003972
Museum Herbarium Bogoriensis, Bogor 024240
Museum Herisau, Herisau 041362
Museum Herman De Cuyper, Blaasveld 003289
Museum Herzogsburg, Braunau am Inn 001782
Museum Hessenstube, Baunatal 016761
Museum Het Gebied van Staden, Staden 003965
Museum Het Groot Graffel, Warnsveld 032841
Museum Het Oude Raadhuis, Megen 032465
Museum Het Petershuis, Gennep 032510
Museum Het Prinsenhof, Delft . . 031984
Museum Het Rembrandthuis, Amsterdam 031784
Museum Het Schip, Amsterdam 031785
Museum het Tramstation, Schipluiden 032679
Museum Het Valkhof, Nijmegen 032508
Museum Het Verscholen Dorp, Vierhouten 032806
Museum Heylshof, Stiftung Kunsthaus Heylshof, Worms 022345
Museum Highlights, Wickenburg 139475
Museum Hindeloopen, Hindeloopen 032309
Museum Historische Verzameling Nederlandse Politie, Zaandam . 032895
Museum Historischer Bierkrüge, Hainfeld 002022
Museum Hitzacker (Elbe), Das Alte Zollhaus, Hitzacker 018966
Museum HochQuellenWasser Wildalpen, Wildalpen 003028
Museum Höxter-Corvey, Höxter . 018983
Museum Hoffmann'sche Sammlung, Kohren-Sahlis 019427
Museum Hofmühle, Immenstadt im Allgäu 019090
Museum Hohenau an der March, Hohenau an der March 002071
Museum Hohenzollern in Franken, Plassenburg Castle, Bayerische Verwaltung der staatlichen Schlösser, Gärten und Seen, Kulmbach . . 019501
Museum Holstentor, Die Lübecker Museen, Lübeck 019825
Museum Huelsmann, Kunst + Design, Bielefeld 017154
Museum Hüsli-Sammlung Schwarzwälder Volkskunst, Grafenhausen 018507
Museum Humanum, Waldkirchen an der Thaya 002826
Museum Humpis-Quartier Ravensburg, Ravensburg 020923
Museum Huta Bolon Simanindo, Pematangsiantar 024329
Museum Huta Bolon Simanindo, Samosir 024336
Museum Huthaus Einigkeit, Brand-Erbisdorf 017319
Museum Huthaus Zinnwald, Altenberg 016337
Museum Idar-Oberstein, Idar-Oberstein 019071
Museum Illingen, Illingen, Kreis Neunkirchen 019080

Museum im Adler, Benningen am Neckar 016827
Museum im alten Brauhaus, Homberg (Ohm) 019026
Museum im alten Pfarrhaus, Wiedensahl 022207
Museum im Alten Rathaus, Bad Brückenau 016538
Museum im Alten Rathaus, Mönchberg im Spessart 020093
Museum im Alten Rathaus, Neckargemünd 020302
Museum im Alten Rathaus, Waghäusel 021953
Museum im Alten Schloß, Altensteig 016344
Museum im Alten Schloß, Neckarbischofsheim 020301
Museum im alten Zeughaus, Bad Radkersburg 001750
Museum im Ammes Haus, Hatzfeld 018807
Museum im Amtshaus, Grünsfeld 018588
Museum im Amtshausschüpfla, Erlangen 018012
Museum im Astorhaus, Walldorf 021991
Museum im Ballhaus, Imst . . . 002090
Museum im Bellpark, Kriens . . . 041398
Museum im Bierlinghaus, Bad Bayersoien 016506
Museum im Blaahaus am Unteren Römerweg, Kiefersfelden 019283
Museum im Bock, Leutkirch im Allgäu 019716
Museum im Boyneburgischen Schloß, Sontra-Wichmannshausen 021520
Museum im Burgturm, Neuleiningen 020365
Museum im Deutschhof, Städtische Museen Heilbronn, Heilbronn . 018861
Museum im Dorf, Wittingen . . . 022287
Museum Im Dorf, Außenstelle des Heimatmuseums Reutlingen, Reutlingen 021005
Museum im 'Fressenden Haus' – Burgkasten Weißenstein, Regen 020935
Museum im Frey-Haus, Brandenburg an der Havel 017326
Museum im Fürstenstöckl, Ebenau 001822
Museum im Gerberhaus, Bretten 017393
Museum im Goldschmiedehaus, Ahlen 016284
Museum im Gotischen Haus, Bad Homburg v.d. Höhe 016582
Museum im Graulturm, Gau-Algesheim 018324
Museum im Greuterhof, Islikon . 041377
Museum im Grünen Haus, Reutte 002541
Museum im Heimathaus, Traunstein 021773
Museum im Herrenhaus, Hausach 018811
Museum im Hexenturm, Markdorf 019944
Museum im Hirsch, Remshalden 020993
Museum im Hollerhaus, Dietfurt an der Altmühl 017659
Museum im Jost-Sigristen-Haus, Ernen 041245
Museum im Kaisertrakt, Benediktinerstift Göttweig, Furth bei Göttweig 001904
Museum im Kastenturm, Bischofshofen 001773
Museum im Kleihues-Bau, Museen der Stadt Kornwestheim, Kornwestheim 019444
Museum im Klösterle, Peiting . . 020736
Museum im Kloster – Museum des Landkreises Osnabrück, Bersenbrück 017120
Museum im Kloster Grafschaft,

Museum of Veterinary Science,
Agricultural University,
Guwahati 023961
Museum of Victorian Reed Organs and
Harmoniums, Shipley 045764
Museum of Vision Science and
Optometry, Waterloo 007185
Museum of Vision, Foundation of the
American Academy of Ophthalmology,
San Francisco 052910
Museum of Waldensian History,
Valdese 053800
Museum of Weapons, Gjirokastër 000015
Museum of Wellington, City and Sea,
Wellington 033174
Museum of Welsh Cricket,
Cardiff 043658
The Museum of Western Art,
Kerrville 049900
Museum of Western Australian Sport,
Claremont, Western Australia . . 000967
Museum of Western Colorado, Grand
Junction 049145
Museum of Wisconsin Art, West
Bend 054166
Museum of Witchcraft, Cornwall 043812
Museum of Wonders, Imbil . . 001161
Museum of Woodcarving, Shell
Lake 053187
Museum of Woodwork and
Ornamental Turning, Ashburton 032956
Museum of Worcester Porcelain,
Worcester 046221
Museum of Works by Theophilos,
Lesbos 022780
Museum of World Religions,
Yungho 042329
Museum of Yachting, Newport . 051449
Museum of Yarmouth History,
Yarmouth 054443
Museum of Yarmukian, Kibbutz Shaar
Hagolan 024967
Museum of Yilan Government History,
Yilan 042313
Museum of Yokohama Urban History,
Yokohama 029537
Museum of York County, Rock
Hill 052525
Museum of Yorkshire Dales Lead
Mining, Earby 044015
Museum of Zoology, University of
Michigan, Ann Arbor 046462
Museum Olbernhau, Olbernhau . 020627
Museum on Main Street,
Pleasanton 052110
Museum on the Boyne, Alliston . 005217
Museum on the Mound,
Edinburgh 044078
Museum on the Seam,
Jerusalem 024917
Museum Ons' Lieve Heer op Solder,
Amsterdam 031786
Museum Ons Mijnverleden,
Houthalen 003639
Museum Oorlog en Vrede, Breda 031927
Museum Orth, Orth an der
Donau 002436
Museum Orvelte, Orvelte 032554
Museum Oskar Reinhart,
Winterthur 041890
Museum Osterzgebirgsgalerie im
Schloß, Dippoldiswalde 017673
Museum Osthusschule, Bielefeld 017155
Museum Otto Ludwig, Eisfeld . 017902
Museum Otto Schäfer, Buchkunst,
Graphik, Kunsthandwerk,
Schweinfurt 021388
Museum Otzberg, Sammlung zur
Volkskunst in Hessen, Otzberg 020697
Museum Oud-Asperen, Asperen 031855
Museum Oud Overschie,
Rotterdam 032632
Museum Oud-Rijnsburg,
Rijnsburg 032605

Museum Oud Soest, Soest 032711
Museum Oud Vriezenveen,
Vriezenveen 032829
Museum Oud Westdorpe,
Westdorpe 032856
Museum Oude Boekdrukkunst,
Almen 031724
Museum Ovartaci, Kunstmuseum /
Psykiatrisk Historisk Museum,
Risskov 010115
Museum Pachen, Rockenhausen 021060
Museum Pachten, Dillingen, Saar 017666
Museum Palagan, Ambarawa . . 024219
Museum Palthehof, Nieuwleusen 032500
Museum Pancasila Sakti, Jakarta 024278
Museum Pangeran Diponegoro,
Yogyakarta 024374
Museum Pankow – Standort
Heynstraße, Berlin 017027
Museum Papageorgiou,
Limenaria 022786
Museum Papiermühle Homburg, Markt
Triefenstein 019956
Museum Passeier – Andreas Hofer,
San Leonardo in Passiria 027592
Museum Pater Valentinus Paquay-
Heilig Paterke, Hasselt 003604
Museum Paul Delvaux, Sint-
Idesbald 003934
Museum Paul Tétar Van Elven,
Delft 031987
Museum Pemirintah Daerah Grobogan,
Purwodadi Grobogan 024334
Museum Pendidikan Islam,
Yogyakarta 024375
Museum Penzberg – Sammlung
Campendonk, Penzberg 020741
Museum Perjuangan, Bogor . . . 024243
Museum Perjuangan, Yogyakarta 024376
Museum Perjuangan Bukit Barisan,
Medan 024312
Museum Pers, Surakarta 024354
Museum Pers Antara, Jakarta . . 024279
Museum Petersberg, Petersberg bei
Halle, Saale 020747
Museum Pfalzgalerie Kaiserslautern
(mpk), Kaiserslautern 019171
Museum Pfleggerichtshaus,
Anras 001709
Museum Plagiarius, Solingen . . 021501
Museum Plantin-Moretus /
Prentenkabinet, Antwerpen . . . 003217
Museum Polling, Polling 020807
Museum Pos & Giro, Bandung . 024229
Museum Prabu Geusan Ulun,
Yayasan Pangeran Sumedang,
Sumedang 024347
Museum Practice, London 139242
Museum Pregarten, Pregarten . . 002488
Museum Priesterhäuser, Zwickau 022487
Museum Professionals Group,
Duxford 060145
Museum Prüm, Prüm 020859
Museum Pugung Ulago Sembah,
Donggala 024252
Museum Pura Mangkunegara,
Surakarta 024355
Museum Purbakala Mojokerto,
Mojokerto 024314
Museum Purbakala Trowulan,
Mojokerto 024315
Museum Puri Lukisan, Gianyar . 024254
Museum Quality Finishes, New
York 136310
Museum Quintana – Archäologie in
Künzing, Künzing 019492
Museum Raabe-Haus,
Eschershausen 018024
Museum Radio-Wereld, Diever . 032049
Museum Radya Pustaka,
Surakarta 024356
Museum Ratna Wartha, Gianyar 024255
Museum Ravensburger,
Ravensburg 020924

Museum Region Neulengbach,
Neulengbach 002396
Museum Regional, Savognin . . . 041691
Museum Regional Surselva Casa
Carniec, Ilanz 041374
Museum Reich der Kristalle,
Mineralogische Staatssammlung
München, München 020204
Museum Reichenau, Reichenau 020966
Museum Reichenfels,
Hohenleuben 019000
Museum Rekor Indonesia Jamu Jago,
Semarang 024343
Museum Reksa Artha, Jakarta . 024280
Museum René de Clercq,
Deerlijk 003456
Museum Retz, Stadtsammlung und
Südmährische Galerie, Retz . . 002537
Museum Rietberg Zürich, Zürich 041945
Museum Rijn- en Binnenvaart,
Antwerpen 003218
Museum Rijswijk Het Tollenshuis,
Rijswijk, Zuid-Holland 032608
Museum Ritter, Sammlung Marli
Hoppe-Ritter, Waldenbuch . . . 021968
Museum Roemervilla, Bad Neuenahr-
Ahrweiler 016624
Museum Römervilla, Grenzach-
Wyhlen 018528
Museum Rolf Werner, Bansin,
Seebad 016751
Museum Root, Root 041639
Museum Rosenegg, Kreuzlingen 041394
Museum Rudolf Wachter, Neues
Schloß Kißlegg, Kißlegg 019316
Museum Rufferdinge,
Bezoekerscentrum Rufferdinge,
Landen 003696
Museum Ruman Bolon,
Pematang 024328
Museum Rungehaus, Wolgast . . 022332
Museum Rupelklei, Terhagen . . 003974
Museum Sacrum, Tiel 032742
Museum Sächsisch-Böhmisches
Erzgebirge, Marienberg 019940
Museum Saet en Cruyt, Andijk . 031828
Museum Saigerhütte Olbernhau-
Kupferhammer, Olbernhau 020628
Museum Salzbütte, Huttwil 041373
Museum Sammlung Rosengart Luzern,
Luzern 041471
Museum Sankt Blasien, Sankt
Blasien 021203
Museum Sankt Dionys, Mittelalterliche
Ausgrabungen, Esslingen 018063
Museum Sankt Leon-Rot, Sankt Leon-
Rot 021215
Museum Sankt Veit/Glan, 1 Museum –
7 Themen, Sankt Veit an der
Glan 002648
Museum Sankt Wendel, Mia-Münster-
Haus, Sankt Wendel 021225
Museum Saoraja Lapawowoi,
Watampone 024366
Museum Sarganserland, Sargans 041686
Museum Sasmita Loka,
Yogyakarta 024377
Museum Sasmita Loka A. Yani,
Jakarta 024281
Museum Satria Mandala, Jakarta 024282
Museum Scheuerle, Backnang . 016492
Museum Schietkamp-Harskamp,
Harskamp 032238
Museum Schillerhaus, Reiss-
Engelhorn-Museen, Mannheim 019913
Museum Schleitheimertal,
Schleitheim 041703
Museum Schlösschen im Hofgarten,
Wertheim 022173
Museum Schloß Adelsheim,
Volkskundliches Museum,
Berchtesgaden 016834
Museum Schloss Bernburg,
Bernburg 017107

Museum Schloss Bruck, Museum der
Stadt Lienz, Lienz 002270
Museum Schloß Burgk, Burgk . . 017466
Museum Schloss Colditz, Colditz 017534
Museum Schloß Ehrenstein,
Ohrdruf 020625
Museum Schloss Fasanerie, Hessische
Hausstiftung, Eichenzell 017873
Museum Schloss Fellenberg,
Kulturstiftung für den Landkreis
Uerzig-Wadeln, Merzig 020042
Museum Schloss Friedrichsfelde,
Berlin 017028
Museum Schloß Glücksburg,
Römhild 021075
Museum Schloss Hardenberg,
Velbert 021898
Museum Schloss Hellenstein,
Heidenheim an der Brenz 018856
Museum Schloss Herzberg, Herzberg
am Harz 018931
Museum Schloß Hohenlimburg,
Hagen 018629
Museum Schloss Homburg,
Nümbrecht 020483
Museum Schloß Klippenstein,
Radeberg 020879
Museum Schloss Kuckuckstein,
Liebstadt 019730
Museum Schloss Kyburg, Kyburg 041401
Museum Schloß Lackenbach,
Lackenbach 002223
Museum Schloss Lembeck,
Dorsten 017714
Museum Schloss Lichtenberg,
Fischbachtal 018110
Museum Schloß Moritzburg,
Zeitz 022431
Museum Schloss Netzschkau,
Netzschkau 020320
Museum Schloss Neuenburg, Freyburg
(Unstrut) 018242
Museum Schloss Oberschwappach,
Knetzgau 019338
Museum Schloß Ortenburg,
Ortenburg 020651
Museum Schloss Ottersbach,
Großklein 001989
Museum Schloss Peigarten,
Dobersberg 001810
Museum Schloß Ratibor, Roth . . 021118
Museum Schloß Rochlitz,
Rochlitz 021057
Museum Schloß Rochsburg,
Lunzenau 019855
Museum Schloss Schönebeck,
Bremen 017368
Museum Schloss Schwarzenberg,
Schwarzenberg 021377
Museum Schloss Steinau an
der Straße mit Brüder-Grimm-
Gedenkstätte, Steinau an der
Straße 021573
Museum Schloss Steinheim –
Museum für regionale Vor- und
Frühgeschichte, Hanau 018745
Museum Schloss Tenneberg,
Waltershausen 022001
Museum Schloß und Festung
Senftenberg, Senftenberg 021443
Museum Schloss und Gut Liebenberg,
Löwenberger Land 019764
Museum Schloß Weesenstein,
Müglitztal 020131
Museum Schloss Wilhelmsburg,
Schmalkalden, Kurort 021285
Museum Schloss Wolfenbüttel,
Wolfenbüttel 022314
Museum Schloss Wolkenstein,
Wolkenstein 022334
Museum Schmelzra, Scuol 041720
Museum Schneggli, Reinach
(Aargau) 041620
Museum Schnütgen, Museen der

Register der Institutionen und Firmen

Muzej-Archiv D.I. Mendeleeva, Sankt-Peterburg
– Muzej Istorii Moskovskogo Gosudarstvennogo Universiteta im.

Tavrijs'kyj, Sevastopol 043028
Nacional'nyj Zapovidnyk Chorticja,
Zaporižžja 043058
Nack, Saitama 111383
Nacke, Dieter, Bartenshagen-
Parkentin 106067
Nad Niprem, Bielsko-Biała 084320
NADA Art Fair Miami, Miami
Beach 098299
NADA New York, New York 098300
Al-Nada, Katr, Cairo 103007
Nadaï, Michel de, Toulouse 129538
Nadalini, Gianpaolo, Paris 129327
Nádasdi Ferenc Múzeum, Sárvár 023551
Nádasdy-Kastély, Nádasdladány 023477
Nadbaltyckie Centrum Kultury w
Gdansku, Gdańsk 034575
Nadeau, Windsor 127764
Nadelburgmuseum, Lichtenwörth 002267
Nadelmann, Johann, Berlin 141488
Nader Mausoleum, Mashad 024417
Nader, Gary, Miami 122109
Nadi Gallery, Jakarta 109545
Nadiani, Antonio, Roma 081306, 132373
Nadia's Antiques, Toronto 064654
Nadir, Annecy 103201
Nadja Brykina Gallery, Moskva . 114367
Nadja Brykina Gallery, Zürich . . 116920
Nadkarni, R.P., Mumbai 131225
Nadlerhaus, Stützengrün 021618
Nadrag, Nikolaus, Bielefeld 074941
NAEA News, Reston 139480
Nääs Slott & Slöjdseminarium,
Floda 040431
Naegele, Amyas, New York . . . 123159, 136311
Nähmaschinen-Museum,
Steckborn 041770
Nähmaschinen-Museum Gebrüder
Mey, Sammlung Albrecht Mey,
Albstadt 016301
Näitustesaal Rotermanni Soolalaos,
Eesti Kunstimuuseum, Tallinn . 010511
Näkövammaismuseo, Jiris 010742
Närkekonservatorerna, Kumla . . 133895
Næs Jernverksmuseum,
Tvedestrand 033867
Naesa, Singapore 114658
Naeshirogawa Minkan-yaki Bijutsukan,
Higashi-Ichiki 028434
Naeslund, Malmö 086671
Nässjö Auktionshall, Malmbäck . 034922
Næstved Antikvariat, Næstved . . 140590
Næstved Museum, Næstved . . . 010069
Naffouj, Landstuhl 107781
Nafplion Folklore Museum,
Nafplion 022831
Naftalina, Porto Alegre 063930, 128537
Naga, New York 095437
Naga, Singapore 085299
Nagai, Tokyo 111486
Nagano-ken Shinano Bijutsukan,
Higashiyama Kaiikan, Nagano . 028889
Nagano-kenritsu Rekishi
Hakubutsukan, Chikuma 028329
Nagaoka Gear Museum,
Nagaoka 028891
Nagaoka Municipal Science Museum,
Nagaoka 028892
Nagaoka-shiritsu Hakubutsukan,
Nagaoka 028893
Nagaoka-shiritsu Kogyo Hakurankai,
Nagaoka 028894
Nagasaki Atomic Bomb Museum,
Nagasaki 028910
Nagasaki-ken Bijutsukan,
Nagasaki 028911
Nagasaki Kite Museum,
Nagasaki 028912
Nagasaki Rekishi no Bunka
Hakubutsukan, Nagasaki 028913
Nagasaki Science Museum,
Nagasaki 028914
Nagasaki-shiritsu Hakubutsukan,

Nagasaki 028915
Nagasaki-shiritsu Nyokodo Nagai
Kinenkan, Nagasaki 028916
Nagashima Museum, Kagoshima 028562
Nagatoro Kyukokan, Nagatoro . . 028920
Nagel, Beijing 125671
Nagel, Bruxelles 125591
Nagel, Hong Kong 125675
Nagel, Phoenix 096062
Nagel, Santiago de Chile 064926
Nagel, Tokyo 126464
Nagel, Verona 126458
Nagel Auktionen, Nagel Auctions,
Stuttgart 126345
Nagel, B., West Hollywood 097746
Nagel, Brigitta, Hamburg 076228
Nagel, Daniel, Neustadt an der
Weinstraße 108271
Nagelmuseum, Löchgau 019760
Nagelschmiedemuseum, Brandstätter
Hammer, Losenstein 002303
Naghi, New Orleans 094970
Nagi-cho Gendai Bijutsukan,
Nagi 028922
Nagi Museum, Cairo 010384
Nagon, Los Angeles 094250
Nagornaja Galereja, Moskva . . . 114368
Nagoya-Boston Museum of Fine Arts,
Nagoya 028935
Nagoya City Hideyoshi and Kiyomasa
Memorial Museum, Nagoya . . 028936
Nagoya Gallery, Nagoya 111340
Nagoya Geijutsu Daigaku,
Nishiharu 055971
Nagoya-shi Bijutsukan, Nagoya . 028937
Nagoya-shi Daigaku Hakubutsukan,
Nagoya 028938
Nagoya-shi Hakubutsukan,
Nagoya 028939
Nagoya-shi Kagakukan, Nagoya . 028940
Nagoya Zokei Geijutsu Daigaku,
Okusa 055973
Nagswood, El Paso 121117
Nagtegaal, Hans Peter,
Apeldoorn 132804
Nagtegaal, Roos, Bruntinge 132840
Nagu Hembygdsmuseum/Nauvon
Kotiseutumuseo, Local Heritage
Museum of Nagu/Nauvo, Nauvo 011005
Nagy Ferenc Galéria, Tab 023663
Nagy István Képtár, Türr István
Múzeum, Baja 023101
Nagy Lajos Emlékkiállítás,
Apostag 023091
Nagy László Emlékház, Iszkáz . . 023375
Nagy, Michael, Woollahra 099782
Nagy, Richard, London 118682
Nagy, Tibor de, New York 123161
Nagyházi, Budapest . . 109173, 126372
Nagykunsági Tájház, Györffy István
Nagykun Múzeum, Karcag . . . 023394
Nagytétényi Kastélymúzeum,
Iparművészeti Múzeum,
Budapest 023209
Naharro, Madrid 133718
Naharro Reyes, Luis, Zaragoza . 086425
Naharro, José-Luis, Lausanne . . 087386
Nahas, Sharjah 087962
Nahkl Fort Museum, Nahkl 033922
Nahmad, Helly, London 118683
Nahmad, Helly, New York 123161
Nahmani, Daniel, Mont-de-
Marsan 070121
Nahnella, São Paulo 064141
Nahum Goldmann Museum of the
Jewish Diaspora, Tel Aviv 025013
Nahum Gutman's Museum, Tel
Aviv 025042
Naicam Museum, Naicam 006306
Naïfs du Monde Entier, Paris . . . 105078
Naigai, Tokyo 142751
Nail, Kathy, Seattle 124821
Naim, Anne-Maria, Paris 071657
Naim, Pascal, Paris 105079

Naimeh, Yousef, Damascus 087841
Nain Museum, Nain 006307
Naini, Cockayne Hatley 117766
Nairn Museum, Nairn 045245
Naismith Memorial Basketball Hall of
Fame, Springfield 053349
Naito Kinen Kusuri Hakubutsukan,
Kawashima 028626
Naiv Antikvarnaja Galereja, Sankt-
Peterburg 085082
Naive art museum of Latvia,
Rīga . 030038
Najana, Warszawa 113961
Nájera Núñez, Rosa, Alajuela . . 102366
Naka Contemporary Art Gallery,
Bali . 109528
Nakagawa Chaini-zu Kindai Bijutsukan,
Fukuyama 028379
Nakagawa Photo Gallery, Kyoto . 028784
Nakama-shiritsu Minzoku
Hakubutsukan, Nakama 028949
Nakambale Museum, Ondangwa 031673
Nakamiya Gallery, Osaka 111376
Nakamura Kinen Bijutsukan,
Kanazawa 028590
Nakamura Kogei, Kyoto 081863
Nakamura, Kobijutsu, Hiroshima 081813
Nakano Historical Museum,
Tokyo 029376
Nakano-shi Rekishi Minzoku
Shiryokan, Nakano 028953
Nakanoshima Bijutsu Gaikun,
Osaka 055974
Nakao Shosen-do, Osaka 142727
Nakao Shoten, Osaka 142728
Nakashian-O'Neil, Saint Paul . . . 096678
Nakata Bijutsukan, Onomichi . . . 029052
Nake, Erich, Wehrheim 108866
Naked Art, Birmingham 120089
Naked Eye Gallery, Brighton . . . 117560
Nakhchivan Autonomous Republic
Djalil Mammadkulizade Literature
Museum, Naxçivan 003109
Nakhchivan Carpet Museum,
Naxçivan 003110
Nakhchivan State History Museum,
Naxçivan 003111
Nakkilan Kotiseutumuseo ja
Juustomeijerimuseo, Nakkila . . 011003
Nakota Curios, Hastings 089271
Nakusp & District Museum,
Nakusp 006308
Nalbandian & Son, Loutfic,
Beirut 082110
Nalbandian, Serge & Gaby,
Beirut 082111
Nall, George, Louisville 121940
Nalšios Muziejus, Švenčionys . . 030314
Nam June Paik Art Center,
Yongin 029887
Nam Nao, Petchabun 042439
Nam, Phuong, Ho Chi Minh City 125409
Nam & Co., Thye, Singapore . . . 085300
Namarook Antiques, Windsor,
Victoria 062428
Namaste, Fort Worth 093301
Namban Bunkakan, Osaka 029069
Nambara Arts & Crafts,
Nhulunbuy 061963
Nambrok Antiques, Sale 062173
Nambu Toji Denshokan,
Ishidoriya 028514
Namgyal Institute of Tibetology,
Gangtok 023941
Namık Kemal Zindanı ve Müzesi,
Gazimağusa 033279
Namikawa Banri Bukkyo Bijutsu
Shashin Gallery, Hiroshima . . . 028471
Namikawa Cloisonne Museum of
Kyoto, Kyoto 028785
Namiraz, Monaco 082338
Namjin Art Museum, Imhoe 029775
Namoc-National Art Museum of China,
Beijing 007448

Namsdalsmuseet, Namsos 033622
Namsskogan Bygdatun,
Namsskogan 033624
Namy-Caulier, Martine, Paris . . . 105080, 137243
Namyslok, Aschersleben 105969
Nanaimo Art Gallery, Nanaimo . 006312
Nanaimo District Museum,
Nanaimo 006313
Nan'ao Coast Defence City Museum,
Nan'ao 007899
Nanao-shiritsu Bijutsukan, Nanao 028956
Nana's Imported Arts, Milwaukee 122217
Nana's Treasures and Antiques, El
Paso 093244
NANB Nursing History Centre,
Fredericton 005731
Nanba Bijutsu Gakuin, Osaka . . 055975
Nanbando, Tokyo 082009
Nanbooks, Settle 091117
Nance Museum, Lone Jack 050315
Nancéide, Nancy 140938
Nanchang Museum, Nanchang . 007901
Nanchang Uprising Museum,
Nanchang 007902
Nancheng Museum, Nancheng . 007906
Nancy Antiquités, Montréal 064391
Nancy Island Historic Site, Wasaga
Beach 007178
Nancy's Christmas Collectibles,
Denver 093153
Nandan Museum-Vichittra and Art
Gallery, Santiniketan 024159
Nandewar Historical Museum,
Barraba 000825
Nanfa, Antonio, Firenze 131617
Nanfria, Leonardo, Genova 131725
Nanhai Museum, Nanhai 007907
Nanich Castañe, Maria Teresa,
Barcelona 085630
Naninck & Lengaigne, Saint-
Omer 072956
Naniwa-no Umino Jikukan,
Osaka 029070
Nanjiang Museum, Nanjiang . . . 007908
Nanjing Calligraphy and Painting
Gallery, Nanjing 102045
Nanjing Children's Painting and
Calligraphy Association, Nanjing 058470
Nanjing College of Fine Arts,
Nanjing 055159
Nanjing Folklorish Museum,
Nanjing 007915
Nanjing International Culture and Arts
Exchange Center, Nanjing 007916
Nanjing Museum, Nanjing 007917
Nanjing Museum, Nanjing,
Zhangzhou 007922
Nanjing Museum of Palaeontology,
Nanjing 007918
Nanjingdi Zhi Museum, Nanjing 007919
The Nanking Porcelain &Co.,
London 090201
Nanni, Milano 080459
Nanni, Manuela, Milano 110403
Nanning Museum, Nanning 007925
Nanny's Web, Bentleigh East . . . 139673
Nanortallip Katersugaasivia,
Nanortalik 023010
Nanping Museum, Nanping 007926
Nan's Hands, Indianapolis 093745
Nanshan Painting Gallery,
Shenzhen 102133
Nansong Guanstove Museum,
Hangzhou 007649
Nantais, Darryl, Linton 118351
Nantclwyd y Dre, Ruthin 045624
Nante, Eggenfelden 075529
Nantenshi, Tokyo 111487
Nantgarw China Works Museum,
Nantgarw 045246
Nanto, Nara 081900
Nanton Lancaster Air Museum,
Nanton 006315

Jose 052928
Nat'Antic, Menton 070010
Natchez Trace Parkway, Tupelo . 053730
Nategh, Basel 087064
Natesan, Bangalore 079251
Nathan Arts d'Asie, Saint-Ouen . 073121
Nathan Denison House, Forty
Fort 048869
Nathan Fine Art GmbH, Berlin . . 106373
Nathan Fine Art, Dr. Johannes Nathan,
Berlin 106372
Nathan Fine Art, Dr. Johannes Nathan,
Zürich 116921
Nathan Manilow Sculpture Park,
University Park 053772
Nathan, Ann, Chicago 120492
Nathan, John, Exeter . 089024, 134693
Nathanaelle, Neffe, Honfleur . . 103789
Nathaniel W. Faison Home and
Museum, La Grange 049991
Nathaniel, Byron, Dallas 093019
Nationaal Ambulance- en Eerste
Hulpmuseum, Kampen 032357
Nationaal Archief, Den Haag . . . 032015
Het Nationaal Autominiaturen Museum,
Asperen 031856
Nationaal Baggermuseum,
Sliedrecht 032699
Nationaal Beiaardmuseum, National
Carillon Museum, Asten 031863
Nationaal Bevrijdingsmuseum
1944–1945, Groesbeek 032196
Nationaal Borstelmuseum,
Izegem 003657
Nationaal Brandweermuseum,
Hellevoetsluis 032279
Nationaal Brilmuseum Amsterdam,
Amsterdam 031793
Nationaal Coöperatie Museum,
Schiedam 032673
Nationaal Fietsmuseum Velorama,
Nijmegen 032510
Het Nationaal Gevangenismuseum,
Veenhuizen 032794
Nationaal Glasmuseum, Leerdam 032389
Nationaal Historisch Orgelmuseum
Elburg, Elburg 032119
Nationaal Houtambachtenmuseum De
Wimpe, Herenthout 003618
Nationaal Jenevermuseum,
Hasselt 003606
Nationaal Landschapskundig Museum,
Dordrecht 032073
Nationaal Likeur- en
Frisdrankenmuseum Isidorus Jonkers,
Hilvarenbeek 032305
Nationaal Luchtvaart-Themapark
Aviodome, Schiphol 032678
Nationaal Modelspoor Museum,
Sneek 032708
Nationaal Monument Kamp Vught,
Vught 032833
Nationaal Museum en Archief
van Douane en Accijnzen,
Antwerpen 003225
Nationaal Museum Historisch
Landbouwtechniek,
Wageningen 032838
Nationaal Museum van de Speelkaart,
Turnhout 004016
Nationaal Museum van Speelklok tot
Pierement, Utrecht 032769
Nationaal Museum Verpleging en
Verzorging, Zetten 032915
Nationaal Oorlogs- en Verzetsmuseum,
Overloon 032581
Nationaal Reddingmuseum Dorus
Rijkers, Den Helder 032032
Nationaal Rijtuigmuseum, Leek . 032385
Nationaal Ruimtevaart Museum,
Lelystad 032412
Nationaal Scheepvaartmuseum,
Antwerpen 003226
Nationaal Schoeiselmuseum,

Izegem 003658
Nationaal Schoolmuseum,
Rotterdam 032635
Nationaal Scoutsmuseum,
Leuven 003709
Nationaal Sleepvaart Museum,
Maassluis 032441
Nationaal Smalspoormuseum –
Stoomtrein Valkenburgse Meer,
Valkenburg, Zuid-Holland 032785
Nationaal Tabaksmuseum,
Tabaksmuseum, Wervik 004064
Nationaal Tinnen Figuren Museum,
Ommen 032537
Nationaal Vakbondsmuseum De
Burcht, Amsterdam 031794
Nationaal Veeteelt Museum, Beers bij
Cuyk 031877
Nationaal Visserijmuseum van
Oostduinkerke, Oostduinkerke . 003843
Nationaal Vlas-, Kant- en
Linnenmuseum, Kortrijk 003681
Nationaal Vlechtmuseum,
Noordwolde 032523
Nationaal Volkssportmuseum voor
de Vinkensport, Vinkenmuseum,
Harelbeke 003598
Nationaal Wielermuseum,
Roeselare 003893
National 1798 Rebellion Centre,
Enniscorthy 024696
National Aboriginal Cultural Centre,
Harbour 061586
National Academy Museum, New
York 051358
National Academy of Arts, Seoul 056050
National Afro-American Museum and
Cultural Center, Wilberforce . . . 054277
The National Agricultural Center and
Hall of Fame, Bonner Springs . 047051
National Air and Space Museum,
Smithsonian Institution,
Washington 054014
National Alliance for Media Arts &
Culture, San Francisco 060603
National Antique and Art Dealers
Association of America, New
York 060604
National Antique Centre,
Mornington 061878
National Apple Museum,
Biglerville 046952
National Archives of Zambia,
Lusaka 054769
National Army Museum, London 044963
National Army Museum Sandhurst
Departments, Sandhurst,
Berkshire 045708
National Army Museum, Sandhurst
Outstation, Camberley 043623
National Army Museum, Te Mata Toa,
Waiouru 033150
National Art Association of Denver,
Denver 060605
The National Art Centre, Tokyo,
National Museum of Art, Tokyo 029377
National Art Connection,
Minneapolis 122292
National Art Education Association,
Reston 060606
National Art Gallery, Bhaktapur . 031692
National Art Gallery, Colombo . . 040281
National Art Gallery, Dhaka . . . 003149
National Art Gallery, Islamabad . 033936
National Art Gallery, Kabul 000004
National Art Gallery of Armenia –
Sisian Branch, Sisian 000708
National Art Gallery of Namibia,
Windhoek 031686
National Art League, Douglaston 060607
National Art Museum of Sport,
Indianapolis 049654
National Art School, Darlinghurst 054831
National Artists Equity Association,

Pacific Grove 060608
National Arts Club, New York . . 051359
National Arts Coalition, Newtown 059735
National Arts Education Archive,
University od Leeds, Wakefield 046048
National Arts Strategies,
Washington 060609
National Assembly of State Arts
Agencies, Washington 060610
National Association for the Visual
Arts, Woolloomooloo 058172
National Association of Artists
Organizations – NAAO,
Birmingham 060611
National Association of Decorative and
Fine Arts Societies, London . . 060154
National Association of Fine Arts,
Kathmandu 059505
National Association of Miniature
Enthusiasts, Carmel 047398
National Association of Schools of Art
and Design, Reston 060612
National Association of Women Artists,
New York 060613, 139481
National Association of Women Artists
Gallery, New York 051360
National Atomic Museum,
Albuquerque 046336
National Automobile Museum of
Tasmania, Launceston 001210
National Automobile Museum, Harrah
Collection, Reno 052412
National Automotive and Truck
Museum of the United States,
Auburn 046619
National Baseball Hall of Fame and
Museum, Cooperstown 047939
National Birendra Art Gallery,
Kathmandu 031697
National Border Patrol Museum and
Memorial Library, El Paso 048474
National Broadcasting Museum,
Minsiong 042123
National Bronze Art Museum,
Lalitpur 031703
National Building Museum,
Washington 054015
National Campaign for the Arts,
London 060155
National Canal Museum, Easton 048417
National Capital Trolley Museum,
Silver Spring 053226
National Cartoonists Society, Winter
Park 060614
National Center for the American
Revolution, Valley Forge 053811
National Central University Art Center,
Jhongli 042067
National Cheng Kung University
Museum, Tainan 042210
National Chengchi University Museum
of Ethnology, Taipei 042258
National Chiang Kai-shek Memorial
Hall, Taipei 042259
National Chiao Tung University Art
Center, Hsinchu 042058
National Children's Museum,
Delhi 023913
National Children's Museum,
Washington 054016
National Chung Hsing University Art
Center, Taichung 042197
National Civil Rights Museum,
Memphis 050722
National Coal Mining Museum for
England, Wakefield 046049
National Coin and Stamp Company,
Omaha 095889
National College of Art and Design,
Dublin 055801
National College of Arts, Lahore 056159
National Commission for Museums
and Monuments, Abuja 059569
National Conference of Artists,

Detroit 060615
National Coracle Centre, Cenarth 043696
National Corvette Museum, Bowling
Green 047123
National Council of Science Museums,
Kolkata 059290
National Council on Education for the
Ceramic Arts, Erie 060616
National Cowboy and Western
Heritage Museum, Oklahoma
City 051644
National Cowgirl Museum and Hall of
Fame, Fort Worth 048866
National Cryptologic Museum, Fort
Meade 048803
National Cultural History Museum,
Northern Flagship Institute,
Tshwane 038670
National Culture and Arts Foundation,
Taipei 059899
National Cycle Collection, Llandrindod
Wells 044756
National Czech and Slovak Museum,
Cedar Rapids 047454
National D-Day Museum, New
Orleans 051227
National Dairy Museum, Ashurst,
Southampton 043196
National Dinosaur Museum,
Nicholls 001356
National Dr. Sun Yat-sen Memorial
Hall, Taipei 042260
National Dragonfly Biomuseum,
Ashton, Oundle 043192
National Endowment for the Arts,
Washington 060617
National English Literary Museum,
Grahamstown 038547
National Exhibits by Blind Artists,
Philadelphia 051983
National Fairground Archive, University
of Sheffield, Sheffield 045752
National Farm Toy Museum,
Dyersville 048377
National Firearms Museum,
Fairfax 048626
National Fishing Heritage Centre,
Great Grimsby 044318
National Folk Art Museum of Armenia,
Yerevan 000742
National Folk Museum, Seoul . . 029851
National Folk Museum of Lesbos,
Mytilini 022825
National Folklore Collection,
Dublin 024651
National Football Museum,
Canton 047375
National Football Museum,
Preston 045528
National Fresh Water Fishing Hall of
Fame, Hayward 049382
National Frontier Trails Center,
Independence 049628
National Gallery, Bangkok 042399
National Gallery, London 044964
National Gallery Bulawayo,
Bulawayo 054775
National Gallery Company,
London 138285
National Gallery of Armenia,
Yerevan 000743
National Gallery of Armenia – Alaverdi
Branch, Alaverdi 000682
National Gallery of Art,
Washington 054017
National Gallery of Australia,
Canberra 000937
National Gallery of Canada,
Ottawa 006451
National Gallery of Corfu,
Skripero 022926
National Gallery of Ireland
Publications, Dublin 137703
National Gallery of Ireland, Gailearaí

Society Museum, Sunbury ... 053488
Northumberland Fisheries Museum,
 Pictou 006503
Northumbria Pine, Whitley Bay . 091694
Northwest Antiques, San Antonio 096842
Northwest Architectural Salvage, Saint
 Paul 096680
Northwest Arctic Heritage Center,
 Kotzebue 049974
Northwest Art Center, Minot State
 University, Minot 050883
Northwest Camera, Portland ... 096283
Northwest Collectibles and Antique
 Paper, Portland 096284
Northwest Gallery and Sinclair Gallery,
 Northwest College, Powell 052250
Northwest Museum of Arts and
 Culture, Spokane 053326
Northwest Pastel Society, Gig
 Harbor 060647
Northwest Railway Museum,
 Snoqualmie 053255
Northwest Tribal Art, Seattle .. 124824
Northwest Watercolor Society,
 Bellevue 060648
Northwestern Mutual Art Gallery,
 Cardinal Stritch University,
 Milwaukee 050853
Northwestern Ontario Sports Hall of
 Fame, Thunder Bay 006975
Northwich Auction, Antiques and
 Collectables, Northwich 090720,
 127243
Northwind Arts Center, Port
 Townsend 052168
Northwood, Bournemouth 117499
Northwood Art Space, Columbus 047903
Norton & Roberts, London 144414
Norton Antiques, Twyford,
 Norfolk 091538
Norton Conyers, Ripon 045592
Norton Museum of Art, West Palm
 Beach 054194
Norton Priory Museum, Runcorn 045622
Norton Simon Museum of Art,
 Pasadena 051843
Norton, Pauline, Bridgnorth 117522
Norton, Richard, Chicago 092590,
 120498
Norton & Co., W.W., London .. 138288
Norton's Fine Art Studios, Saint
 Louis 124098
Norup, Næstved 102875
Norway Art, Minneapolis 122296
Norwegian Laft Hus, Red Deer . 006607
Norwich and District Museum,
 Norwich 006389
Norwich Antique Clock Shop,
 Norwich 090736, 135236
Norwich Arts Council Gallery,
 Norwich 051563
The Norwich Decorative and Fine Arts
 Society, Norwich 060172
Norwich Gallery, Norwich 045344
Norwich Historical Society,
 Norwich 051569
Norwich School of Art and Design,
 Norwich 056547
Norwich Studio Art Gallery,
 Norwich 119032
Norwich University Museum,
 Northfield 051549
Norwood Historical Association
 Museum, Norwood 051570
Norwood Museum, Holm 044453
Norwood Park Artists Guild, Des
 Plaines 060649, 121073
Norwood, John, New York 095452
Nosaka O-tomatto Hakubutsukan,
 Ito 028526
Nosbaum & Reding, Luxembourg 111913
Nosbüsch, Manfred, Euskirchen 141670
Nose Creek Valley Museum,
 Airdrie 005210

Nosel, Doug, Jamestown 127535
Nosorog, Beograd 085168, 114511
Nossereau-Hauff, Christine, L'Isle-sur-
 la-Sorgue 069528
Nossi College of Art,
 Goodlettsville 057101
Nosta, Bruxelles 063459
Nostalga Kunst- und Antiquitätentage,
 mit Mineralien- und Edelsteinbörse,
 Oldenburg 098019
Nostalgi Haderslev, Haderslev .. 065653
Nostalgia, Aix-en-Provence 066412
Nostalgia, Annecy 066589
Nostalgia, Blackpool 088277
Nostalgia, Budapest 079166
Nostalgia, Cairo 103010
Nostalgia, Christchurch 083712
Nostalgia, Clevedon 088712
Nostalgia, Dubai 087939
Nostalgia, Los Angeles 094256
Nostalgia, Nelson 118973
Nostalgia, Nijmegen 083329
Nostalgia, Solna 086761
Nostalgia, Stockport 091298
Nostalgia Antik, Offenburg 077833
Nostalgia Antiques, Moonee
 Ponds 061870
Nostalgia Antiques, Porthcawl . 090886,
 135292
Nostalgia Factory, Kangaroo
 Valley 061661, 139814
Nostalgia Factory, Manly 061778
Nostalgia Gallery, Teddington . 119492
Nostalgia Möbler och Ting, Falun 086487
Nostalgia on 19th Street,
 Houston 093591
Nostalgia Schmuck, Pforzheim . 108390
Nostalgia Shop, Saint Louis ... 096585
Nostalgia Shoppe, Toledo 097449
Nostalgia Traders, Mittagong .. 061858
Nostalgia World, Memphis 094493
Nostalgiaville, Miami 094614
Nostalgie, Pont-a-Marcq 072194
Nostalgie, Tilburg 083433
Nostalgie, Winterthur 087711
Nostalgie & Cottage, Buchholz in der
 Nordheide 075165
Nostalgie Antique, Hamburg ... 076232
Nostalgie auf Rädern –
 Fahrzeugmuseum, Großklein .. 001990
Nostalgipalatset, Stockholm ... 086851
Nostalgirundan, Varberg 086967
Nostalgoteket, København 065866
Nostell Priory, Wakefield 046050
Nostitz, Charles von, New York . 136314
Nostradamus Antiques,
 Weybridge 091668
Nostradamus II, East Molesey .. 088926
Nostromo Books, Auckland 143103
Noszlopy Kúria, Újvárfalva 023696
Nosztalgia, Budapest 142390
Not Just Antiques, Tetbury ... 091433
Not Just Dolls, Dallas 093023
Not Just Silver, Weybridge ... 091669
Nota, La Paz 100706
Nota Bene, Düsseldorf 075455
Notable Accents, Dallas 093024
Notaphilie Dresden, Dresden .. 075377
Notari, Otello, Roma 132379
Notarishuis Arnhem, Arnhem ... 126493
Notburga-Museum, Eben am
 Achensee 001820
Notebaart, P.C., Bussum 142915
De Notelaer, Hingene 003623
Nothe Fort Museum of Coastal
 Defence, Weymouth 046129
Nothelfer, Georg, Berlin 106382
Nothing Definite, Saint Louis ... 096586
Nothing in Stone, Cardiff 117680
Nothing Trivial, Calgary 064208
Notions Antique Centre,
 Grantham 089157, 134731
Notizie da Palazzo Albani, Urbino 138896
Notizie degli Scavi di Antichità,

Roma 138897
Notodden Auksjonsforretning,
 Notodden 126576
Notodden Brukt og Antikk,
 Notodden 084130
Notojima Glass Art Museum,
 Notojima 029014
Notranjski Muzej Postojna,
 Postojna 038411
Notre Dame of Jolo College Museum,
 Sulu Culture Museum, Jolo ... 034319
Nottbohm Galerie & Kunsthaus,
 Göttingen 107106
Nottingham Antiques, Atlanta . 092000
Nottingham Castle, Nottingham . 045363
Nottingham Contemporary,
 Nottingham 060173
Nottingham Society of Artists,
 Nottingham 060174
Nottingham Transport Heritage Centre,
 Ruddington 045615
Nottingham Trent School of Art and
 Design, Nottingham Trent University,
 Nottingham 056549
Nottingham University Museum of
 Archaeology, Nottingham 045364
Nou Cents, Barcelona 085633
Nouchka, La Bastide-des-
 Jourdans 068887
Nougues, Henri, Pontorson ... 072232,
 129407
Nouh, Damascus 087846
Noujaim, Juliette, Paris 071670
Noujaim, Paul, Paris 071671
Nouna R, Bruxelles 063460
Nouri-Lokoschus, Ellen, Potsdam 078000
Nourisson, Philippe, Vern-sur-
 Seiche 129563
Nourry-Joannès, Claudine, Verneuil-
 sur-Avre 073993
Noury, Jacques, Tours 105720
Noûs-Verlag, Dusslingen 137399, 141643
Nousbaum, Marie-France,
 Campagne 067565
Nousiaisten Kotiseutumuseo
 ja Topoisten Ulkomuseoalue,
 Nousiainen 011016
Nouveaux Brocanteurs, La Chapelle-
 en-Serval 068918
Nouvelle Arche de Noë Editions,
 Paris 137246
Nouvelle Art, Oslo 113335
Nouvelle Galerie, Grenoble ... 103741
Nouvelle revue d'esthétique,
 Paris 138698
Nouvelle Saison, Grenoble ... 140812
Nouvelle Tendance, Paris 129331
Nouvelles de l'Estampe, Paris .. 138699
Nouvelles Galeries de Paris,
 Bruxelles 125592
Nouvelles Hybrides, Courbevoie . 068130
Nouvelles Images, Den Haag .. 112488
Nouvelles Images, Paris 105091, 137247
Nouvelles Images, Villemandeur 105823,
 137291
Nouvellet, Olivier, Paris 105092
Nova Conservação, Lisboa 133308
A Nova Eclética, Lisboa 143399
Nova Gallery, Calgary 101115
Nova Jewelry, Chiang Mai 117057
Nova Kodl, Praha 102675
Nova Morada, Porto 084868
Nova Rúa, Lugo 115217
Nova Scotia College of Art and Design,
 Halifax 055065
Nova Scotia Museum, Halifax .. 005841
Nova Scotia Museum of Natural
 History, Halifax 005842
Nova Scotia Printmakers Association,
 Centreville 058424
Nova Terra Antiek, Apeldoorn . 082741
Novagraphics, Tucson 125011
Novaja Galereja, Moskva 114370
Novaja Galereja, Ufa 114456

Novak, Ljubljana 085438, 114803
Novak-Spurny, Irma, Salzweg .. 108554
Novak, C. & B., Gomaringen ... 076003
Novák, Karel, Kralupy nad
 Vltavou 140442
Novalis-Literaturgedenkstätte,
 Weißenfels 022131
Novalis-Museum, Forschungsstätte für
 Frühromantik, Wiederstedt .. 022209
Novanta Nove, Amsterdam ... 112346
Novantatrè, Bologna 109864
Novarese, Domenico, Torino .. 081571
Novaria Restauri, Genova 131726
Novarino, Enrico, Torino 081572
Novarino, Fabien, Cassis 103489
Novato History Museum, Novato 051573
Novecento, Barcelona 085634
Il Novecento, Manfredonia 110213
Novecento, Modena 131968
Novecento, Padova 080827
Novecento, Rovereto 110901
Novecento & Dintorni, Roma .. 081312
Il Novecento di Pandora, Firenze 080010
Novecento Editrice, Palermo .. 137810
Novellan, Hondarribia 115188
Novello, Michele, Venezia 111168
Novelty Art, Mumbai 079301
The Noverre Gallery, Norwich .. 119033
Noves, Laure de, La Ciotat 068937
Novgorod, Kouvola 140697
Novgorod-Siverskyj Istoriko-kulturnyj
 Muzej-zapovidnyk Slovo o Polku
 Igorevim, Novgorod-Sivers'kyj . 043003
Novgorodskij Gosudarstvennyj Muzej-
 zapovednik, Velikij Novgorod . 037840
Novi Hram, Sarajevo 100726
Novi, Marco, Bologna 131383
Novità Bibliografiche, Roma ... 138898
Novo Arts, New York 123176
Novo Galería de Arte, Palma de
 Mallorca 115457
Novo Século, Lisboa 114136
Novočerkasskij Muzej Istorii Donskich
 Kazakov, Novočerkassk 037399
Novodevičij Monastyr, Gosudarstvennyj
 istoričeskij muzej, Moskva ... 037310
Novoe Prostranstvo, Odesa ... 117226
Novohradská Galéria, Lučenec . 038204
Novohradské Múzeum, Lučenec 038205
Novohradsky, Wolfgang,
 Freigericht 075838
Novokuzneckij Chudožestvennyj Muzej,
 Novokuzneck 037402
Novokuzneckij Kraeveďeskij Muzej,
 Novokuzneck 037403
Novorossijskij Gosudarstvennyj
 Istoričeskij Muzej Zapovednik,
 Novorossijsk 037404
Novosibirskaja Architekturno-
 chudožestvennaja Akademija,
 Novosibirsk 056240
Novosibirskaja Kartinnaja Galereja,
 Novosibirsk 037407
Novosibirskij Muzej Prirody,
 Novosibirsk 037408
Novosibirskij Oblastnoj Kraevedčeskij
 Muzej, Novosibirsk 037409
Novotroickij Istoriko-kraevedčeskij
 Muzej, Orenburgskij oblastnoj
 kraevedčeskij muzej,
 Novotroick 037412
Nový Antik Bazar, Praha 065444
Nový Zámok Banská Štiavnica,
 Banská Štiavnica 038107
Novyj Ėrmitaž, Moskva 085023
Now & Again, Auckland 083629
Now & Again, Baltimore 092184
Now & Again at 57th Street,
 Sacramento 096473
Now & Forever Images,
 Christchurch 112943
Now & Then, Pittsburgh 096151
Now & Then, Vancouver 064800
Now & Then Collectibles, Miami 094615

Bergamo 055815, 137719
Nuovo Liceo Artistico di Venezia e
Mestre, Venezia 055943
Nuovo Museo Provinciale Sannitico,
Campobasso 025581
Nuovo Segno, Forlì 110096
Nur, Sarajevo 063814
Nurihiko, Tokyo 111491
Nurkkaus, Ranskalainen, Helsinki 066290
Nurmeksen Museo, Nurmes . . . 011019
Nurmon Museo, Nurmo 011020
Nurom Hat Museum, Suame . . . 022516
Nurse Bennett Heritage House,
Daniel's Harbour 005569
NUS Museum, Singapore 038093
Nusraty, New York 095454
Nussbaum, Louisville 121941
Nussbaum, Zeist 112813
Nussbaum, Scott F., Louisville . . 094410,
144985
Nusser & Baumgart, München . . 077510,
108173, 137565
Nusser, Ursula, München 126296
Nussknackermuseum, Neuhausen /
Erzgebirge 020356
Nussle, Sarah, Paris 071672
Nussli Restauratoren, Bern . . . 134036
The Nut Point Gallery,
Christchurch 112944
Nutcote Museum, Home of May Gibbs,
Neutral Bay 001346
Nuti Loredana, Roma 081314
Nutida Art, Stockholm 116014
Nutida Svenskt Silver, Stockholm 116015
Nutley Antiques, Nutley 090749
Nutmeg, West Hartford 127758
Nuttall, Pennant Hills 062060
Nuwaubian, London 144415
NVA Museum Prora in der
Kulturkunststatt Prora, Binz,
Ostseebad 017172
Nvo Millenium, Scorzè 110945
Ny Ålesund By- og Gruvemuseum,
Ny-Ålesund 033636
NY Arts, New York 139497
NY Arts Beijing, Beijing 101848, 138647
Ny Carlsberg Glyptotek,
København 010027
Nya Kalmar Konst- och Antikvitetsaffär,
Kalmar 086583
Nya och Gamla Ting i Lövånger,
Lövånger 126836
Nyabinghi African Gift Shop, New
York 123177
Nyahokwe Ruins Site Museum,
Inyanga 054782
Nyaman Gallery, Bali 109529
Nyborg, Oslo 084173
Nyborg Antik, Nyborg 065936
Nyborg og Omegns Museer,
Nyborg 010078
Nye Galleri 22, Trøgstad 084213
NYFA Quarterly, New York 139498
Nyfors Antik och Kuriosa,
Ludvika 086639
Nygatans Antik och Kuriosa,
Örebro 086719
Nyhuis, Emlichheim 075559
Nyírségi Erdészeti Zrt. Debreceni
Erdészet – Bánki Tájház,
Debrecen 023273
NYIT Finearts, New York Institute of
Technology, Old Westbury . . . 057576
NYK Kaiun Hakubutsukan,
Yokohama 029539
Nykarleby Museum och
Konstsamlingen Kalevala,
Nykarleby 011023
Nykjær, Bent, Vejle 066124
Nylander Museum, Caribou 047389
Nýlistasafnið Nýló, Reykjavík . . . 023786
Nymans, Haywards Heath 044404
Nymindegab Museum, Nørre
Nebel 010073

Nymindegab Redningsbådsmuseum,
Nørre Nebel 010074
Nynäs Konst och Hantverk,
Nynäshamn 115884
Nynäs Slott, Tystberga 040897
Nynäshamns Järnvägsmuseum,
Nynäshamn 040690
Nynorsk Antikvariat, Oslo 143222
Nyoirin-ji Homotsukan, Yoshino . 029563
Nyons Antic, Nyons 070718
Nysä, Paris 071673
Nyslotts Landskapsmuseum,
Nyslott 011024
Nyströmska Gården, Köpings Museum,
Köping 040556
Nyt Nordisk Forlag, København . 137052
Nyugat, Budapest 142391
Nyúzó Gáspár Fazekas Tájház, Kiss
Pál Múzeum, Tiszafüred 023686
NZ Art Online, Christchurch . . . 112945
NZ Arts, Auckland 112886
NZH Vervoers Museum, Noord-
Zuid-Hollandsche Stoomtramweg,
Haarlem 032217
O', Milano 059395
O, Wanju 111798
O & O, Amsterdam 082631
La O Antiquités, Sallanches . . . 073345
O Bijutsukan, Tokyo 029390
O Museu do Marajó, Cachoeira do
Arari 004295
O-Won, Daejeon 111620
O. Henry Museum, Austin 046667
O. Kelaptrishvili Museum, Tbilisi 016224
O.C.C.M.P, Bordeaux 067292
O.G.N, Paris 071674
O.H.M.M. Impex, Bucureşti 084933
O3 Gallery, Oxford 045402
Oak & Kauri, Kumeu 083811
Oak Apple Art Gallery,
Northampton 119020
Oak Creek Pioneer Village, Oak
Creek 051578
Oak Hall, Niagara Falls 106347
Oak House Museum, West
Bromwich 046107
Oak Ridge Art Center, Oak Ridge 051584
Oakdale Museum and History Center,
Oakdale 051585
Oakenshawe, Baltimore 092185
Oakes & Son, G., Darwen 088823
Oakham Castle, Rutland County
Museum, Oakham 045373
Oakhurst Cottage, Godalming . . 044283
Oakland Antiques, Belfast 088210
Oakland Aviation Museum,
Oakland 051595
Oakland Coin and Jewelry,
Oakland 095741
Oakland Museum of California,
Oakland 051596
Oaklander, Irving, New York . . . 145099
Oaklands Historic House Museum,
Murfreesboro 051056
Oakleaf Antiques, Taupo 083952
Oakleigh and District Museum,
Oakleigh 001377
Oakleigh House Museum, Mobile 050908
Oakley Antique Mall, Cincinnati . 092716
Oakley Gallery, Ben, London . . . 118690
Oakley Interiors, Chicago 135770
Oakridge, El Paso 093245
Oakridge, Louisville 094411
Oaks House Museum, Jackson . . 049713
Oaktree Antiques, Lubenham . . 090485
Oakville Galleries, Centennial,
Oakville 006395
Oakville Galleries, Gairloch,
Oakville 006396
Oakville Museum at Erchless Estate,
Oakville 006397
Oakwell Hall Country Park,
Birstall 043400
Oakwood Antiques, Hinuera . . . 083793

Oakwood Gallery, Edwinstowe . . 117936
Oakwood Gallery, Leeds 089574, 134853
Oakwood House Gallery, Maldon 118888
Het Oale Meestershuus,
Slagharen 032698
Oale Smederie, Hellendoorn . . . 032276
OAN-Oceanie Afrique Noire Books,
New York 145100
Oasen, Valby 140631
Oasi Antichità, Roma 081315
Oasis, Manawatu 113025
Oasis, Seattle 097311
Oasis Antique, Sharjah 087964
Oasis Art Gallery, Portland 123894,
127677
Oasis Gallery, Marquette 050642
Oasis Superette, Tauranga 143163
Oatlands, Leesburg 050165
Ob-Art, Barcelona 115035
Ob Luang, Chiang Mai 042418
Obadia, Nathalie, Paris 105093
Obalne Galerie – Galerija Loža,
Koper 038347
Obalne Galerie – Mestna Galerija,
Piran 038406
Obam, Toulon (Var) 105672
Oban Antiques, Oban 090755
Oban Art Gallery, Oban 119058
Oban War and Peace Museum,
Oban 045376
Obara-mura Kami no Bijutsukan,
Obara 029016
Obecné múzeum a Galéria Jana Hálu,
Galéria Petra Michala Bohúňa
Liptovský Mikuláš, Važec . . . 038299
Obecní Dům, Praha 009671
Obedinenie Fotografov Aserbaidžana,
Bakı 058314
Obelisk Antiques, Petworth 090850,
135280
Obelisk Antiques, Warminster . . 091593
Obelisk Museum, Al-Mataryia . . 010341
Obelisque, Oslo 084174
Obéniche, Honfleur 103791
Oberacker, Rolf, Wiesbaden . . . 078903
Oberammergau Museum,
Oberammergau 020531
Oberdiek, H., Melle 077274
Oberdiek, Harald, Melle 077275
Oberer Torturm-Ausstellung, Marbach
am Neckar 019924
Oberfränkisches Bauernhofmuseum,
Zell, Oberfranken 022438
Oberfränkisches Bauernhofmuseum
Kleinlosnitz, Zell im
Fichtelgebirge 022436
Oberfränkisches Feuerwehrmuseum,
Schauenstein 021243
Oberfränkisches Textilmuseum,
Helmbrechts 018882
Oberharzer Bergwerksmuseum,
Museum für Technik- und
Kulturgeschichte, Clausthal-
Zellerfeld 017517
OberhausMuseum, Passau 020725
Oberkärntner Brauchtums- und
Maskenmuseum, Oberdrauburg 002414
Oberländer, Heike, Berlin 074852
Oberländer, Konrad, Augsburg . . 105982
Oberlander, Eberhard,
Wurmannsquick 131199
Oberlausitzer Kunstverein e.V.,
Zittau 059140
Oberlausitzer Sechsstädtebund-
und Handwerksmuseum Löbau,
Löbau 019759
Oberle, Aline, Feldkirchen in
Kärnten 127998
Oberle, Frieder, Bad
Schussenried 074552
Oberlé, Gérard, Montigny-sur-
Canne 140920
Oberlin College Gallery,
Cleveland 047781

Oberlin Heritage Center, Oberlin 051604
Obermaier, R., Altötting 074363
Obermair, Rudolf, Wels 062842, 128156
Obermayr, Axel, Aumühle 074435
Obermayr, Günther, Piberbach . . 128093
Obermeier, Rosemarie & Johann,
Poing 077986
Obermeier, Rudolf, Regensburg . 130939
Obermeyer & Reschke, Bonn . . . 075042
Obermoser, J., Kitzbühel 062642
Oberösterreichische Fotogalerie,
Linz 002287
Oberösterreichische Landesmuseen,
Linz 002288
Oberösterreichischer Künstlerbund,
Dornach 058268
Oberösterreichischer Kunstverein,
Linz 058269, 099975
Oberösterreichischer Steingarten,
Vorchdorf 002811
Oberösterreichisches Burgenmuseum
Reichenstein, Tragwein 002767
Oberösterreichisches
Feuerwehrmuseum St. Florian, Sankt
Florian 002597
Oberösterreichisches Jagdmuseum,
Schloß Hohenbrunn, Sankt
Florian 002598
Oberösterreichisches Literaturmuseum
und Literatur-Galerie im StifterHaus,
Adalbert-Stifter-Institut des Landes
Oberösterreich, Linz 002289
Oberösterreichisches Schulmuseum,
Bad Leonfelden 001745
Oberpfälzer Fischereimuseum,
Tirschenreuth 021757
Oberpfälzer Flußspat-
Besucherbergwerk /
Bergbaumuseum Reichhart-Schacht,
Stulln 021621
Oberpfälzer Freilandmuseum Neusath-
Perschen, Nabburg 020278
Oberpfälzer Handwerksmuseum,
Rötz 021079
Oberpfälzer Künstlerhaus,
Schwandorf 021367
Oberpfälzer Volkskundemuseum,
Burglengenfeld 017468
Oberrheinische Narrenschau,
Kenzingen 019275
Oberrheinisches Bäder- und
Heimatmuseum, Bad Bellingen 016510
Oberrheinisches Tabakmuseum,
Mahlberg 019879
Oberschlesisches Landesmuseum,
Ratingen 020910
Oberschwäbische Barockgalerie,
Ochsenhausen 077813
Oberschwäbisches Museumsdorf
Kürnbach, Bad Schussenried . . 016658
Obersimmentaler Heimatmuseum,
Heimathus am Chilchstalden,
Zweisimmen 041975
Oberto, Martino, Genova 131727
Oberweger, Renate, Schruns . . . 100061
Oberweißbacher Bergbahn,
Mellenbach-Glasbach 020014
Oberwelt, Stuttgart 108729
Oberwemmer, Günter, Hamburg 130283
Obieg, Warszawa 139016
Obinitsa Põhikooli Muuseum,
Obinitsa 010471
Obir-Tropfsteinhöhlen, Bad
Eisenkappel 001729
Objectif Lune, Paris 071675
Objects of Bright Pride, Seattle . 124825
Objects of Desire, Louisville . . . 121942
Objdinenie Fotocentr Sojuza
Žurnalistov, Moskva 037311
Objdinennyj Muzej Pisatelej Urala,
Ekaterinburg 036821
Objektief, Enschede 112564
L'Objet Curieux, Genève 087298
Objet Trouvé, Stuttgart 078540

O'Malley, C.H., Baltimore 092186
Oman, Dublin 079471
Oman Museum, Muscat 033919
Oman Natural History Museum,
Muscat 033920
Oman, James & Angela, Dublin 079472
Omani-French Museum Bait Fransa,
Muscat 033921
Omani Heritage Gallery, Al-
Qurum 084233
Omar, Cairo 103013
Omar, Knaresborough . 089528, 134839
Omaruru Museum, Omaruru ... 031671
Oma's Schatzkammer, Bad Homburg
v.d. Höhe 074485
Ó'Mathúna Pádraig, Caiseal
Mumhan 109574
Ombalantu Baobab Tree Heritage Site,
Ombalantu 031672
Ombre et Lumière, Orléans ... 104381
Ombre et Lumière, Saint-Malo (Ille-et-
Vilaine) 105507
Ombres & Lumières, Paris 071684
Ombretta, Gardella, Genova ... 080108
Ome Kimono Museum, Ome ... 029043
Ome-shiritsu Bijutsukan, Ome .. 029044
Ome-shiritsu Hakubutsukan,
Ome 029045
Omega, Newport, Essex 090689, 135222
Omega, Warszawa 143342
Omega Antykwariat, Poznań ... 084475
Omega Art Expo, New York 123184
Omega Gallery, Carson-Newman
College, Jefferson City 049763
Omell, Ascot 088058, 134356
Omell 5060 N.R., London 118698
Omell Galleries, Ascot 117322
O'Melveny, Don, West Hollywood 125267
Omenka, Lagos 033259
Omi Natural History Museum,
Omi 029047
Omilos Dimitreli, Thessaloniki .. 055690
Het Ommelander Antiquariaat,
Appingedam 142897
Omni Art, Dallas 120913
Omni Chinatown, Singapore ... 085302
Omni Gallery, Portland 123896
Omni-Trading, Apeldoorn 082742,
137945
Omni View, Chicago 120504
Omnia, Sappemeer 126514
Omniarte, Catania 131491
Omnipod, Cardiff 088568
Omoide Museum, Kyoto 028789
Oms, Odile, Céret 033501
Omskij Gosudarstvennyj Istoriko-
kraevedčeskij Muzej, Omsk .. 037420
Omskij Gosudarstvennyj Literaturnyj
Muzej im. F.M. Dostoevskogo,
Omsk 037421
Omskij Oblastnoj Muzej
Izobrazitelnych Iskusstv im. M.A.
Vrubelja, Omsk 037422
Omuletz, Wilma, Eisenstadt 062541
Omuta-shi Tanko oyo Kagakukan,
Omuta 029050
On a Shoestring, Birmingham .. 092262
On Aura Tout Vu, Paris 105096
On Canvass, Sydney 099652
On Deck, Oklahoma City 095834
On-Line Gallery, Southampton . 119388
On Paper, Providence 123955
On Porpoise, San Diego 124397
On Sight, Toronto 101535
On the Air, Hawarden . 089279, 134764
On the Avenue, Buffalo 092384
On the Hill Cultural Arts Center,
Yorktown 054464
On the Plaza Gallery, San
Antonio 124303
On the Shelf, Wagga Wagga ... 139976
On the Wild Side, Minneapolis . 122298
On Yedinci Yüzyıl Osmalı Evi,
Bursa 042594

Onas, Bolzano 079731
The ONCA Trust and Gallery,
Brighton 060175
Once a Tree, Portsmouth 090892,
135295
Once Again, Wellington 084043
Once Read Books, Long Beach . 144945
Once Upon A Child, Canal
Winchester 144764
Once Upon a Crime, Minneapolis 145020
Once Upon a Time, Auckland .. 083632
Once Upon a Time, Clarkesville . 127446
Once upon a Time, Miami 094620
Once Upon a Time, New York .. 095465
Onda, Portland 123897
Ondar-Bide, Donostia-San
Sebastián 085804
Onde, Danielle, L'Isle-sur-la-
Sorgue 069529
Onder de Sint Maarten,
Zaltbommel 143078
Ondergronds Museum, Kanne .. 003669
't Onderhuys, Nieuw Beijerland . 132970
Onderwijskundig, Hilversum ... 142986
Onderwijsmuseum Educatorium,
Ootmarum 032551
One and J, Seoul 111746
One Bell, Lavenham 089555
One Club for Art & Copy, New
York 060656
One Eye Gallery, Wellington ... 084044
One-Forty-Eight Shop, Hamilton . 064271
One Home, Denver 093156
One of a Kind Antiques, San
Diego 096951
One Off Contemporary Art Gallery,
Nairobi 111575
One Price Store, Singapore 085303
One Step Back, Bungay 088480
One Stop Antiques, Clayfield ... 061329
One Stroke, San Jose 124704
One To Z, Delft 112449
One Tree Two Bears Trading Post,
Long Beach 094048
One Twenty Eight, New York ... 123185
Oneida Community Mansion House,
Oneida 051684
Oneida County Historical Society
Museum, Utica 053793
Oneida Nation Museum, De Pere 048146
O'Neil, R.A., Toronto 064661
O'Neill, Tam, Denver 093157
Onesti, Olivia, Reims 072356
Oneten, Houston 121384
Ongakudori, Yokohama 111551
Ongerup and Needilup District
Museum, Ongerup 001380
Onggi Folk Museum and Institute,
Seoul 029853
ONI Gallery, Boston 120189
Onichimiuk, Halina, Amiens 066521,
128680
Onion Museum, Checheng 042006
Oniris, Rennes (Ille-et-Vilaine) .. 105395
Onishi Seiwemon Museum,
Kyoto 028790
Oniśko, Jan, Warszawa 113967
Online Exhibits, Earl Shilton .. 117876
Only Collectables, Saint Paul ... 096681
The Only Place for Pictures,
London 118699, 118700
Onnen, Ewald, Bamberg 129673
Ono, Nagoya 111343
Ono, Tokyo 111493
Onomato Kunstverein, Düsseldorf 059142
Onomichi-shiritsu Bijutsukan,
Onomichi 029053
Onondaga Historical Association
Museum, Syracuse 053521
Oñoro-Ortiz 1890, Madrid 133719
Onrust, Amsterdam 112347
Ons Museum, Giessenburg ... 032169
Ons Museum, Wintelre 032873
Ons Winkeltje, Hilversum 083218

Onsberg, Ulf, Malmö 115863
Onset Contemporary Art, Chester 117726
Onslow, Stourpaine 127315
Onslow Antiques, Shenton Park 062195
Onslow County Museum,
Richlands 052433
Onslow Goods Shed Museum,
Onslow 001381
Ontario Association of Art Galleries,
Toronto 058425
Ontario College of Art & Design,
Toronto 055095
Ontario County Historical Society
Museum, Canandaigua 047361
Ontario Electric Railway Museum,
Milton 006190
Ontario Museum Association,
Toronto 058426
Ontario Police College Museum,
Aylmer 005266
Ontario Provincial Police Museum,
Orillia 006413
Ontario Science Centre, Toronto 007024
De Ontdekhoek Kindermuseum,
Rotterdam 032640
Ontem & Hoje, Rio de Janeiro .. 064043
Ontmoetingscentrum de Veldkei,
Expositie, Havelte 032243
Ontonagon County Historical Society
Museum, Ontonagon 051695
Onyang Minsok Pakmulgwan,
Asan 029713
Onyx Images, Indianapolis 121487
Le Onze, Paris 071685
Ooblik, Lyon 104073
OÖ Kulturquartier, Linz 002290
Ooltewah Auction, Ooltewah .. 127646
Oomes, P., Hilversum 132921
Oorlogs- en Verzetsmuseum Johannes
Post, Ridderkerk 032603
Oorlogsverzetsmuseum Rotterdam,
Rotterdam 032641
Oost-Indisch Huis, Amsterdam . 031798
Oost Leeshal, Amsterdam 142870
Oostends Historisch Museum De Plate,
Oostende 003852
Oosterkade Kunstonderneming,
Groningen 112583
Oosterlaar, Johan, Luttenberg .. 132950
Het Oosters Antiquarium, Leiden 142995
De Oostindische Compagnie,
Schoten 063771
Oostplein Antiek, Rotterdam ... 083397
Op de Beeck, J., Mechelen ... 100654
Op de MuurEN, Deventer 059533
Op den Berghe, Deventer 082973
OPA Graphics, New Orleans ... 122462
Opal Antik och Auktion, Umeå . 086929
Opalescences, Saint-Ouen ... 073122
L'Opaline, Perros-Guirec 072063
Opaline, Tarbes 073588
Opaline Rose, Tehrān 079321
Opatska Riznica Sv. Marka,
Korčula 008767
Opbouw, Amsterdam 142871
Opbouw, Rotterdam 143033
Opcje, Katowice 139019
OPD Restauro, Rivista dell'Opificio
delle Pietre Dure e Laboratori di
Restauro di Firenze, Firenze .. 138902
Opelousas Museum, Opelousas . 051698
Opelousas Museum of Art,
Opelousas 051699
Open Air Museum of Ethnography,
Tbilisi 016225
Open-Air Water-Power Museum,
Dimitsana 022657
Open Art, Prato 110711
Open Art Galerie, Borken,
Westfalen 106549
Open Art Gallery, Brighton 117562
Open Atelier, Leiden 083252
The Open Book, Wellington ... 143181
Open Books a Poem Emporium,

Seattle 145333
Open Care, Milano 131880
Open Door Studio, Los Angeles . 094262
The Open Eye Gallery, Edinburgh 088972,
117921, 134677
Open Eye Gallery, Liverpool ... 044741
Open Haven Museum,
Amsterdam 031799
Open Hunt, New York 095466
Open Museum, Migdal-Tefen .. 024976
Open Museum, Omer 024983
Open Museum of Photography, Tel
Hai 025050
Open Press, Denver 138385
Open Space Gallery, Victoria ... 007154
Open Studio, Toronto 007025
Openart, Cormano 109992
Openbaar Vervoer Museum,
Doetinchem 032057
Openbaar Vervoer Museum,
Rotterdam 032642
OpenHand OpenSpace Gallery,
Reading 119202
Opening Night Gallery,
Minneapolis 122299
Openlucht Laagveenderij Museum
Damshûs, Nij Beets 032503
Openluchtmuseum Bachten de Kupe,
Alveringem 003189
Openluchtmuseum De Duinhuisjes,
Rockanje 032611
Openluchtmuseum Ellert en Brammert,
Schoonoord 032685
Openluchtmuseum Erve Kots,
Lievelde 032420
Openluchtmuseum Front Line Hooghe,
Ieper 003650
Openluchtmuseum Het Hoogeland,
Warffum 032840
Openluchtmuseum Nieuw Amsterdam,
Nieuw Amsterdam 040306
Openluchtmuseum Ootmarsum,
Ootmarsum 032552
OpenSpace Bae, Busan 111597
Opera Galeria, Warszawa 113968
Opera Gallery, Beirut 111826
Opera Gallery, Dubai 117249
Opera Gallery, Genève 116430
Opera Gallery, Hong Kong 101984
Opera Gallery, London 118701
Opera Gallery, Miami 122114
Opera Gallery, Monaco 112085
Opera Gallery, New York 123186
Opera Gallery, Paris 105097
Opera Gallery, Seoul 111747
Opera Gallery, Singapore 114662
Opera Laboratori Florentini,
Firenze 131624
Opferkuch, Rolf, Stuttgart 078541
Ophelia's Art Gallery,
Birmingham 120092
Ophey, Norbert, Geldern 075909
Opifex et Artifex, Milano 131881
Opificio delle Arti Tessili, Milano 080478
Opitz, H, Brühl 075161
Opitz, Jörg, Greiz 076030, 076031
Opitz & Geschw., Manfred, Greiz 076032
Opium, Ajaccio 066439
Opium, Warszawa 084570
Opium Antik, København 065869
Opleiding Kunstgeschiedenis,
Leiden 056121
Oplenova Hiša, Gorenjski Muzej,
Srednja Vas v Bohinju 038440
Het Oplettende Lezertje,
Bredevoort 142912
De Oplichterij, Rotterdam 112742
O'Plus, Anglet 066564
Opolski Rocznik Muzealny, Opole 139020
La Oportunidad, Buenos Aires . 060910
Opos, Milano 059396
Opotiki Museum, Opotiki 033085
Oppdal Bygdemuseum, Oppdal . 033644
Oppenberg, Bärbel, Dinslaken . 106666

Oppenheimer, Joel, Chicago . . . 092597,
120505, 135773, 138375, 144788
Opper, Uwe, Kronberg im Taunus 107746
Opposite, Paris 071686
Oprandi, Boltiere 109886
Opravy & Renovace, Opatovice nad
Labem 128575
Opravy Starožitnosti, Svitavy . . . 065490,
128610
Oprechte Veiling Haarlem,
Haarlem 126504
Oprescu, Ion, Timişoara 133372
Opsis, Seoul 111748
Opsmuk, Amsterdam 082632
De Opsteker, Amsterdam 112348
Opti Art Galerie, Boppard 106542
Optica, Montréal 101302
Optik Industrie Museum,
Rathenow 020908
Optima Gestion, Madrid 133720
Optimum Fine Arts, Hornchurch . 118215
Option Art, Oostende 063762
Optisches Museum der Ernst-Abbe-
Stiftung Jena, Jena 019144
Opulent Era Gallery IV, Miami . . 094621
Opus, Wrocław 114035
Opus 21, Paris 071687
Opus 39 Gallery, Lefkosia 102489
Opus 39 Gallery, Lemesos 102509
Opus 40 and the Quarryman's
Museum, Saugerties 053047
Opus 57, Charlottenlund 065562
Opus Gallery, Ashbourne 117324
Opus II, Kitchener 101191
Opus One Gallery, Atlanta 119876
Opus Restauri, Parma 132120
Opus Zwei, Sankt Gallen 087588
Opuscula Pompeiana, Roma . . . 138903
Õpusztaszeri Nemzeti Történeti
Emlékpark, Opusztaszer 023491
Oquendo, Madrid 086054
Or & Bleu, Rouen . . . 072565, 129441
L'Or du Temps, Amiens 140725
L'Or du Temps, Paris 141213
L'Or en Décor, Paris 129332
Or et Change, Bayonne 066919
Or et Change Comptoir des Minerais
Précieux, Tarbes 073589
Or et Monnaies Bordeaux,
Bordeaux 067293
L'Or Limousin, Limoges 069473
Oracle Junction, Buffalo 144759
Al-Oraifi, Rashid, Manama 100303
Orana Googars CDEP, Dubbo . . 061403
Orandajin, 's-Hertogenbosch . . 083206
Orang Asli Museum, Melaka . . . 030539
Orange, Los Angeles 094263
Orange Bleue Mogador, Le Havre 103899
Orange County Historical Museum,
Hillsborough 049443
Orange County Museum of Art,
Newport Beach 051458
Orange County Museum of Art –
Orange Lounge, Costa Mesa . . 047988
Orange County Regional History
Center, Orlando 051716
Orange Empire Railway Museum,
Perris 051901
Orange Group, New York 095467
Orange Regional Gallery, Orange 001383
Orange Street Gallery,
Uppingham 119570
Orange Tree Antiques,
Jacksonville 093855
Orangedale Railway Museum,
Orangedale 006412
De Orangerie, Delft 082848
Orangerie, 's-Hertogenbosch . . 032295
Orangerie Belvedere, Klassik Stiftung
Weimar, Weimar 022089
Orangerie im Englischen Garten,
Bayerische Verwaltung der
staatlichen Schlösser, Gärten und
Seen, München 020209

Orangerie-Reinz, Köln 107660
Orangerie, Kunstsammlung Gera,
Gera 018371
Orangerieschloss und Turm, Stiftung
Preußische Schlösser und Gärten
Berlin-Brandenburg, Potsdam . 020835
Orangeriet Antik Trädgårdskonst,
Lund 086651
Orangetown Historical Museum, Pearl
River 051867
Oranien-Nassau-Museum, Diez . 017662
Oranien-Nassauisches Museum, im
Wilhelmsturm, Dillenburg 017663
Oranmore Antiques, Dallas 093025
Oravská Galéria, Dolný Kubín . . 038165
Oravská Galéria, Námestovo . . . 038227
Oravské Múzeum Pavla Országha
Hviezdoslava, Dolný Kubín . . . 038166
Orawski Park Etnograficzny, Zubrzyca
Górna 035303
Orban & Streu, Frankfurt am
Main 141694
Orbán Ház, Szilvásvárad 023650
Orbel, Torino 132559
Orbel Art, Sofia 101032
Orbetello, Los Angeles 121846
Orbicon, Cáceres 133579
Orbital Arts, Toronto 101536
Orblin, Ivan, Reims 072357
Orbost Gallery, Dunvegan 117874
ORCA Aart Gallery, Chicago . . . 120506
Orcas Island Historical Museum,
Eastsound 048419
Orcel, Jean-Paul, Vouvray 074243
Orchard Gallery, Londonderry . . 045062
Orchard Gallery, New York 123187
Orchard Gallery, Singapore 114663
Orchard House, Concord 047918
Orchard Park Historical Society
Museum, Orchard Park 051708
Orchid Art Gallery, Dallas 120914
Orchid Pavilion Art Gallery,
Singapore 114664
Orci, Bucaramanga 102300
Ordemann, D., Schwalmstadt . . 108594
Orden und Militaria, Hamburg . . 076233
Die Ordenssammlung-Historia
Antiquariat, Berlin 141492
Ordronneau, Yolande, Allouis . . 066481
Ordrupgaard, Charlottenlund . . 009869
Ordsall Hall Museum, Salford . . 045696
Ordu Devlet Güzel Sanatlar Galerisi,
Ordu 042770
Ordu Etnografya Müzesi, Ordu . 042771
Ordubad Regional History Studies,
Ordubad 003114
Les Oréades, Bagnères-de-
Luchon . . 066851, 103269, 103270,
103271, 137075
Les Oréades, Moskva 114371
Les Oréades, Paris 105098
Les Oréades, Toulouse 073749, 105705,
129359
Oredaria, Roma 110858
O'Regan, Donal, Cork 079397
O'Regan's, Carmel, Gortnamona
Schull 126391
Oregon Air and Space Museum,
Eugene 048584
Oregon Coast History Center,
Newport 051443
Oregon College of Arts and Craft,
Portland 057671
Oregon Electric Railway Historical
Society Museum, Lake Oswego 050035
Oregon Electric Railway Museum,
Salem 052793
Oregon Gallery, Portland 123898
Oregon Historical Society,
Portland 052206
Oregon-Jerusalem Historical Museum,
Oregon 051709
Oregon Museum of Science and
Industry, Portland 052207

Oregon Museums Association,
Portland 060657
Oregon Scenics, Portland 123899
Oregon Sports Hall of Fame and
Museum, Portland 052208
Oregon Trail Museum, Gering . . 049048
Oregon Trail Regional Museum, Baker
City 046685
O'Reilly, Dublin 126387
O'Reilly & Co., William, New
York 123188
Orellana, Luis, Santiago de Chile 064927
Orelya, Paris 071688
Orenburgskij Oblastnoj Kraevedčeskij
Muzej, Orenburg 037435
Orenburgskij Oblastnoj Muzej
Izobrazitelnych Iskusstv,
Orenburg 037436
Orense Esculturas, Rio de
Janeiro 128368
Orenstein, Reed, New York 145103
Oresome Gallery, Kingston-upon-
Hull 118268
Orez, Den Haag 112489, 137948
Orfèo, Luxembourg 111914
Organ Pipe Cactus Museum, Ajo 046297
Organisationen Danske Museer,
København 058528
Organization of Independent Artists,
New York 060658
Organization of Military Museums of
Canada, Gloucester 058427
Organization of Museums, Monuments
and Sites of Africa OMMSA,
Accra 059240
Orgel-Art-Museum Rhein-Nahe,
Windesheim 022263
Orgelbaumuseum, Schloss Hanstein,
Ostheim vor der Rhön 020674
Orgelmuseet i Fläckebo,
Salbohed 040736
Orgelmuseum Borgentreich,
Borgentreich 017293
Orgelmuseum Kelheim, Kelheim 019259
Orginalen Antikk, Førde 084093
Orhan Kemal Müzesi, İstanbul . . 042682
Oriamu Museum, Izumiotsu . . . 028544
Oriande, Bruxelles 063461
Oricchio, Fausto, Roma 081318
Oricha, Los Angeles 121847
Oriel, Dublin 109625
Oriel Canfas Gallery, Cardiff . . . 060176
Oriel Ceri Richards Gallery, Taliesin
Arts Centre, Swansea 045929
Oriel Davies Gallery, Newtown,
Powys 045318
Oriel Gallery, Ascot 098523
Oriel Gallery, Mold 045213
Oriel Gallery, Picton 113079
Oriel Glanymor Gallery, Fishguard 117993
Oriel Mostyn Gallery, Llandudno 044761
Oriel Myrddin Gallery,
Carmarthen 043668
Oriel Newydd, Llanerchymedd . . 118372
Oriel Plas Glyn-Y-Weddw,
Llanbedrog 118368
Oriel Plas Glyn-y-Weddw,
Pwllheli 045536
Oriel Washington Gallery, Penarth 119110
Oriel Wrecsam, Wrexham Arts Centre,
Wrexham 046232
Oriel-y-Felin Gallery, Trefin 119529
Oriel y Park Gallery and Visitor Centre,
Saint Davids 045655
Oriel Ynys Môn, Llangefni 044767
Orient-Antiquariat, Schönried . 143922
Orient Antiques, Bruxelles 063462
Orient Express, Cairo 066184
The Orient Express, Richmond,
Victoria 062137
Orient Express the apartment,
Cairo 103014
Orient Expressed Imports, New
Orleans 094973

Orient House, Glebe 061516
Orient Interiör, Göteborg 086528
Orient Longman Private,
Hyderabad 137693
Orient-Occident, Paris 071689
Orient-Teppich, Sankt-Peterburg 085085
Orient USA, New York 095468
Oriental Antique, Dallas 093026
Oriental Antique Gallery, Armadale,
Victoria 061034
Oriental Antique House,
Singapore 085304
Oriental Antiques, Abu Dhabi . . 087920
Oriental Antiques Center, Dubai . 087940
Oriental Art, Amsterdam 082633
Oriental Art, Cairo 103015
Oriental Art, Milano 080479
Oriental Art Gallery, San
Francisco 124607
Oriental Arts, Chennai 079271
Oriental Arts, Saint Louis 124099
Oriental Bazaar, Tokyo 082015
Oriental Bronzes, Paris 071690
Oriental Ceramic Society,
Cambridge 060177
The Oriental Collection, Ottawa . 064457
Oriental Danny, Dallas . 093027, 093028
Oriental Decorations, New York . 095469
Oriental Furniture and Arts,
London 090220, 135069
Oriental Furniture Repair, San
Diego 136635
Oriental Gallery, Vancouver 064802
Oriental Handicrafts Exhibition,
Manama 063103
The Oriental Haveli, Bangalore . 079252
Oriental Heritage, Los Angeles . 094264
Oriental House, Riyadh 085145
Oriental Imports, Oklahoma City 095835
Oriental Institute Museum, University
of Chicago, Chicago 047650
Oriental Interiors, Vancouver . . . 064803
Oriental International Fine Arts, New
York 095470
Oriental Museum Durham,
Durham 044009
Oriental Rug Gallery, Eton 089009
Oriental Rug Gallery, Guildford . 089196
Oriental Rug Gallery, Oxford . . . 090783
Oriental Rug Gallery, Sacramento 096475
Oriental Rug Gallery, Saint
Albans 091027
Oriental Rug House and Custom
Furniture Center, Jacksonville . 093856,
136013
Oriental Rug Shop, Sheffield . . . 091141
Oriental Rug Treasures, Long
Beach 094049
Oriental Shop, Nashville 094854
Oriental Treasure Box, San Diego 096952
Oriental Treasures, Dallas 093029
Oriental Treasures, Singapore . . 085305
Oriental Vista Art Collections,
Shanghai 102093
The Orientalia Journal, Little
Neck 139502
Orientalisches Münzkabinett Jena
(OMJ), Lehrstuhl für Semitische
Philologie und Islamwissenschaft der
Universität Jena, Jena 019145
Orientalist, London . . . 090221, 135070
l'Orientaliste, Marrakech 082408
L'Orientaliste, Thônex 087649
Orientalna, Warszawa 113969
Orientation, London 090222
Orientations, Hong Kong 138648
Orientations, San Francisco 097133
Oriente, Pradamano 110704
Origami, Paris 105099
Origen, Budapest 079168
Origin, Dublin 109606
Original- und Abgußsammlung der
Universität Trier, Trier 021793
Original & Authentic Aboriginal Art,

Melbourne 061817
Original & Authentic Aboriginal Art,
 Sydney 062287
The Original Aboriginal Art Company,
 Narangba 061931
Original Architectural Salvage,
 Dublin 079473
Original Art, Indianapolis 121488
Original Art Galleries, Subiaco . . 099591
The Original Art Shop, Colchester 117773
Original Art Shop, Stoke-on-Trent 119423
The Original Art Shop, Truro . . . 119539,
 135506
The Original Artshop,
 Manchester 118903
Original Baltimore Antique Arms Show,
 Timonium 098304
Original Design, Colmar 068036
The Original Dreamtime Art Gallery,
 Alice Springs 098489
The Original Dreamtime Art Gallery,
 Cairns 061241
Original Gallery, Nice 104331
Original Garo, Sapporo 081930
Original Miami Beach Antique Show,
 Miami Beach 098305
Original Oz Art Gallery, Mount
 Martha 099269
The Original Wall Art, Langley . . 118295
Originality, Totnes 119524
Originals, Bridgnorth 117523
Original's in Glass, Tampa 136730
Origine, Beauvais 066996
Origine – Kunst Antiek Design,
 Haarlem 138979
Origines, Houdon . . 068787, 140818
Origini, Verona 081762
Origins, Oostende 063763
Origrafica Konsthandel, Malmö . 086672
Orillia Museum of Art and History,
 Orillia 006414
Orima, Stockholm 086855
Orimattilan Kotiseutumuseo,
 Orimattila 011031
Orimattilan Pullomuseo,
 Orimattila 011032
Orimattilan Taidemuseo,
 Orimattila 011033
Orinasukan, Kyoto 028791
Oriol, Barcelona 085635, 115036
Orion, Miami 094622
Orion Antique, Dallas 093030
Orion Antique, Oklahoma City . . 095836
Orion Book Store, Toronto . . 104378
Orion Press, Tokyo . . . 137886, 142754
The Orion Publishing Group,
 London 138289
Oriot, Jean-Marcel, Bagnoles-de-
 l'Orne 066855
Oripään Kotiseutumuseo, Oripää 011035
Oriskany Battlefield, Oriskany . . 051712
Orissa, Milano 080480
Orissa State Museum,
 Bhubaneshwar 023862
Orit Art Gallery, Tel Aviv 109737
Oriti Niosi, Paolo Franco, Cagliari 079826
Oriveden Paltanmäen Museo,
 Orivesi 011036
Orkdal Bygdemuseum, Svorkmo 033826
Orkney Gallery, Kirkwall 118279
Orkney Museum, Kirkwall 044604
Orkney Wireless Museum,
 Kirkwall 044605
Orland Historical Museum,
 Orland 051713
Orlandini, Mauro, Torino 132560
Orlando & Almeida, Lisboa . . 084763
Orlando Brown House, Liberty Hall
 Museum, Frankfort 048892
Orlando Museum of Art, Orlando 051717
Orlando Science Center, Orlando 051718
Orlando, John Baptist, Tarxien . 132727
Orlaque, Paris 129333
Orleans, Toronto 064662

Orleans House Gallery, London . 044971
Orlické Muzeum, Choceň 009361
Orlogsmuseet, Nationalmuseet,
 København 010028
Orlovskij Gosudarstvennyj Institut
 Iskusstv i Kultury, Orël 056243
Orlovskij Oblastnoj Kraevedčeskij
 Muzej, Orël 037432
Orlovskij Oblastnoj Muzej
 Izobrazitelnych Iskusstv, Orël . 037433
Ormesby Hall, Middlesbrough . . 045189
Ormond Memorial Art Museum,
 Ormond Beach 051724
Ornabi, São Paulo 140275
Ornament, Vista 139503
Ornament and Crime, Los
 Angeles 094265
Ornamet Connection, Austin . . 092094
Ornatto, Porto Alegre . 063931, 063932,
 063933
Ornis Jagt- & Naturbøger, Skjern 140620
Ornunga Museum, Vårgårda . . . 040954
Oro de Monte Alban, San
 Antonio 096845
Oro e Colore, Firenze 131625
ORO Fine Art Gallery,
 Albuquerque 119774
Oro Fino, Düsseldorf . 106772, 130031
Oro Gema, Valencia . . 086352, 126771
Oro Incenso e Mirra, Milano . . 080481
Oro y Plata, Sevilla 086287
Orobs, Toledo 124943
Orologio, Antwerpen 063172
Orono Museum of Art, University of
 Maine, Bangor 046748
Orońsko, Orońsko 139021
Oroszlányi Bányász Múzeum
 Alapítvány, Központi Bányászati
 Múzeum, Oroszlány 023498
Oroville Chinese Temple, Oroville 051730
Orphan Blues Magazine, Detroit 121093
Orphée, Paris 071691
Orpiment, Paris 071692
Orplid, Icking 076530
Orr, San Diego 096953
Orr, C., Minneapolis 145021
Orr, Michael, Columbus 120786
Orrill, J., Los Angeles 127559
Orrú, Salvatore, Lippstadt 107872
Orsa Auktionsbyrå, Orsa 126862
Őrségi Népi Műemlékegyüttes –
 Szalafo-Pityerszer, Savaria Múzeum
 Szombathely, Szalafő 023588
Orsi, Carlo, Milano 080482
Orsi, Francesco, Varese 081648
Orsini Arte e Libri, Milano . . . 080483,
 142554
Orsini, Alessandro, Roma 081319
Orsini, Roberto, Milano 142553
Orskij Istoriko-kraevedčeskij Muzej,
 Orsk 037437
Orssich, Paul, London 144419
Országos Földtani Múzeum,
 Budapest 023216
Országos Pedagógiai Könyvtár és
 Múzeum, Budapest 023217
Országos Széchényi Könyvtár,
 Budapest 023218
Országos Színháztörténeti Múzeum és
 Intézet, Budapest 023219
Orta Dogu Teknik Universitesi Sanat
 Galleri, Ankara 042557
Orta Oyunlari Sanat Gösteri Yan,
 İstanbul 117150
Ortega, Jacksonville 093857
Ortega, Santander 086252
Ortega, Sevilla 086288
Ortega Machuca, Jose Ramon,
 Madrid 115353
Ortega Motilla, L., Denia 115131
Ortega Ortega, Enrique, Córdoba 133589
Ortega Ruiz, Manuel, Barcelona 085636
Ortega, Alfonso, Alicante 114920
Ortega, Gilbert, Phoenix 123753

Ortega, Lola, Sevilla 086289
Ortega, Marie-Cristina, Versailles 074027
Ortega, Morales, Sevilla 086290
Orteu, Jacques, Saint-Girons . . 105483
Orth, Seattle 124827
Orth & Thierfeld, Lohmar 077088
Orth, Peter J., Bonn 106536
Orthopedics Museum, Chulalongkorn
 University, Bangkok 042402
Ortiz & Bello, Miami 094623
Ortiz & Dagenbela, San Antonio 124304
Ortiz Aragon, Alicia, Granada . 115182
Ortiz Comas, Adriano Santiago,
 Madrid 115354
Ortiz un Mundo Diferente, León 115201
Ortiz, Pierre, Calvisson 067553
Ortiz, Rafael, Sevilla 115549
Ortmann, Jan-Stefan, Paris . . . 129334
Ortodoks Antik, Moskva 085024
Ortodoksinen Kirkkomuseo,
 Kuopio 010880
Ortodox Egyházművészeti Gyűjtemény,
 Kecskemét 023408
Ortolan, Giuseppe, Padova . . . 080829
Orton Geological Museum, Ohio State
 University, Columbus 047906
Orton, Stephen, Watlington . . . 091618,
 135549
Orts – und Tabakpfeifenmuseum
 Ruhla, Ruhla 021154
Orts- und Wohnmuseum,
 Marthalen 041479
Orts Vidal, Alfredo, Alicante . . . 085522
Orts, Gérard, Paris 071693
Orts, Gérard, Pau 072004
Ortsgeschichtliche Sammlung,
 Bovenden 017305
Ortsgeschichtliche Sammlung,
 Oberrieden 041565
Ortsgeschichtliche Sammlung
 Rebstein, Ortsmuseum Spritzenhaus,
 Rebstein 041615
Ortsgeschichtliches Museum,
 Siegenburg 021456
Ortskundliches Museum Jois,
 Jois 002124
Ortsmusem Wittenbach im Schloss
 Dottenwil, Wittenbach 041898
Ortsmuseum, Amriswil 041015
Ortsmuseum, Andwil 041019
Ortsmuseum, Bergün 041096
Ortsmuseum, Binningen 041133
Ortsmuseum, Brachwitz-
 Saalkreis 017308
Ortsmuseum, Bülach 041165
Ortsmuseum, Bütschwil 041168
Ortsmuseum, Häggenschwil . . 041348
Ortsmuseum, Kaltbrunn 041380
Ortsmuseum, Laax 041402
Ortsmuseum, Merenschwand . 041500
Ortsmuseum, Nackenheim . . . 020280
Ortsmuseum, Nürensdorf 041557
Ortsmuseum, Opfikon 041578
Ortsmuseum, Rafz 041606
Ortsmuseum, Roggwil 041636
Ortsmuseum, Schänis 041694
Ortsmuseum, Thalwil 041796
Ortsmuseum, Unterengstringen . 041817
Ortsmuseum, Untersiggenthal . 041821
Ortsmuseum, Vnä 041851
Ortsmuseum, Wängi 041853
Ortsmuseum, Walenstadt 041856
Ortsmuseum Albisrieden, Zürich 041948
Ortsmuseum Altstetten,
 Altstetten 041012
Ortsmuseum Beringen, Beringen 041097
Ortsmuseum Brittnau, Brittnau . 041157
Ortsmuseum Diessenhofen,
 Diessenhofen 041218
Ortsmuseum Dietikon, Dietikon . 041220
Ortsmuseum Dürstelerhaus,
 Ottikon 041583
Ortsmuseum Eglisau, Eglisau . 041229
Ortsmuseum Erlenbach,

Erlenbach 041242
Ortsmuseum Frenkendorf,
 Frenkendorf 041266
Ortsmuseum für Heimatkunde,
 Schlieren 041705
Ortsmuseum Gaiserwald, Altes
 Pfarrhaus, Sankt Josefen . . 041678
Ortsmuseum Grächen, Grächen . 041329
Ortsmuseum Haus zum Torggel,
 Berneck 041120
Ortsmuseum Hinwil, Hinwil . . . 041365
Ortsmuseum Höngg, Zürich . . . 041949
Ortsmuseum Kefiturm, Belp . . . 041094
Ortsmuseum Kilchberg, Kilchberg
 (Zürich) 041383
Ortsmuseum Küsnacht, Küsnacht 041399
Ortsmuseum Lindengut Flawil,
 Flawil 041257
Ortsmuseum Mollis, Mollis . . . 041504
Ortsmuseum Mühle, Museen Maur,
 Maur 041490
Ortsmuseum Neunkirch,
 Neunkirch 041553
Ortsmuseum Oberes Bad,
 Marbach 041478
Ortsmuseum Oberuzwil,
 Oberuzwil 041567
Ortsmuseum Oetwil, Oetwil am
 See 041569
Ortsmuseum Pratteln, Jacquard-Stübli,
 Pratteln 041599
Ortsmuseum Rüschlikon,
 Rüschlikon 041648
Ortsmuseum Schmitten,
 Schmitten 041707
Ortsmuseum Spreitenbach,
 Spreitenbach 041759
Ortsmuseum Steinmaur, Sünikon 041781
Ortsmuseum Sust, Horgen . . . 041370
Ortsmuseum Trotte, Arlesheim . 041029
Ortsmuseum und Sammlung Karl-
 Jauslin, Muttenz 041541
Ortsmuseum und Stadtscheune,
 Mellingen 041495
Ortsmuseum Urdorf, Urdorf . . . 041823
Ortsmuseum Ursulastift,
 Gerstetten 018393
Ortsmuseum Vechigen, Boll . . . 041143
Ortsmuseum Wallisellen,
 Wallisellen 041857
Ortsmuseum Weiach, Weiach . . 041862
Ortsmuseum Weikertschlag,
 Weikertschlag 002834
Ortsmuseum Wetzikon, Wetzikon 041868
Ortsmuseum Wiediкon, Zürich . 041950
Ortsmuseum Wiesendangen,
 Wiesendangen 041871
Ortsmuseum Wila, Wila 041874
Ortsmuseum Wilchingen,
 Wilchingen 041875
Ortsmuseum Wollishofen, Zürich 041951
Ortsmuseum Zollikon, Haus zum
 Felsengrund, Zollikon 041916
Ortsmuseum zur Farb, Stäfa . . 041762
Ortssammlung Wettelsheim,
 Treuchtlingen 021784
Ortsstube, Bolligen 041144
Orstein, Bremerhaven 075147
Ortus, Bonnieux 103359
Orugoru no Chiisana Hakubutukan,
 Tokyo 029392
Orust, Henån 086558
Oružejnaja Palata, Gosudarstvennyj
 muzej-zapovednik Moskovskij Kreml,
 Moskva 037313
Orvieto Photo, Milano 080484
Orville-Fasid, C., San Antonio . 096846
Orvos- és Gyógyszerészettörténeti
 Kiállítás, Katona József Múzeum,
 Kecskemét 023409
Orvostörténeti és Patikakiállítás,
 Karcag 023395
Orwell Corner Historic Village, Prince
 Edward Island Museum and Heritage

Památník Zapadlých Vlastenců, Krkonošské Muzeum, Paseky nad Jizerou 009592
Památník Životické Tragedie, Muzeum Těšínska, Havířov 009394
Pambasang Museo ng Pilipinas, Manila 034373
Pambianco, Alberto, Milano 131883
Pamer, Irene, Grimma 130217
Pamětní Síň Jana Ámoše Komenského, Brandýs nad Orlicí 009299
Pametnik na Kulturata Zemenski Manastir, Zemen 005166
Pami Antichitá, Roma 081325
Pammer, Evelyn, Wien 063000
Pampa Centro de Artes y Diseño, Buenos Aires 060911
Pampaloni, Paolo, Firenze 131628, 142502
Pampaloni, Roberto, Firenze . . . 131629
Pampeana, Buenos Aires 139625
Pampille, Bernay 067052
Pamplin Historical Park and the National Museum of the Civil War Soldier, Petersburg 051922
Pamukbank Fotoğraf Galerisi, İstanbul 117151
Pan African Art Gallery, Long Beach 121684
Pan American Gallery, Dallas . . . 120916
PAN Amsterdam, Amsterdam . . . 098111
Pan-Art, Hong Kong 101988
Pan-Dan, Moskva 114372
PAN kunstforum niederrhein, Emmerich am Rhein 017942
Pan-o-Rama, Bremen 141581
Panache, Los Angeles 094269
Panache, West Hollywood 097750
Panache Antiques, Vancouver . . 064806
Panachrantos Monastery, Andros 022539
Panaddaman-Cagayan State University Museum, Tuguegarao 034442
Panalba International, Marseille . 104142
Panamericana-Escola de Arte e Design, Campus Angelica, São Paulo 055041
Panamericana-Escola de Arte e Design, Campus Groenlândia, São Paulo 055042
Panamin Museum, Philippine Museum of Ethnology, Pasay City 034399
Panarcadic Archaeological Museum of Tripolis, Tripoli 022975
Panasia Gallery, Davos Platz . . . 087204, 116335
Panasia Gallery, Zürich 087795
Panay, Gérard, Bormes-les-Mimosas 067313
Panayi, Nicolas, Lefkosia 055228, 102490
La Pancarte, Nort-sur-Erdre . . . 070696
La Panchetta, Bari 109782
Pancho Lepina, Vigo 086390
Pancrazi, Jean-François, Toulon (Var) 129518
Panda, Smederevo 114542
Pandanus Palace, Noosaville . . . 061970
Pandiani, Mario, Torino 132561
Pandiris, André, Paris 071704
'␣t Pandje, Utrecht 112797
Pandolfini Casa d'Aste, Firenze . 126409
Pandolfino, Daniele, Roma 132382
Pandora, Antwerpen 136918
Pandora Decor, Firenze 080013
Pandora Galéria, Budapest 109175
Pandora Old Masters, New York . 095481
Pandora's Box, Totnes 091481
Pandoras Gallery, Calgary 101116
Pánek, Bohumil, Říčany u Prahy 128609
Panerių Memorialinis Muziejus, Valstybinis Vilniaus Gaono Žydų Muziejus, Vilnius 030366
Panevėžio, Panevėžys 111846

Panevėžio Kraštotyros Muziejus, Panevėžys 030270
Pangloss Antikvariat, Visby 143813
Panhandle-Plains Historical Museum, Canyon 047377
Panhellenic Union of Antiquities and Art Object Restorers, Athinai . . 059248
De Panhoeve, Berlicum 132818
Panicali, Carla, Roma 110859
Panico, Rocco, Kemmelbach . . . 062638
Panier, Francine, Saint-Tropez . . 073276
Panini, Franco Cosimo, Modena 137799
Panini, Luca, Modena 142572
Panisa, Chiang Mai 117058
Panizza, Enrico Enzo, Milano . . . 080490
Pankhurst Centre, Manchester . 045136
Panlong Art Cooperative, Shanghai 102095
Pannemann, K. & H., Westerstede 108905
Panneterie, Saint-Ouen 073124
Pannetier, Gérard, Malemort-sur-Corrèze 069773
Pannhuis, Harald, Gummersbach 076074
Pannon Antik, Budapest 079172
Pannonhalmi Főapátság Gyűjteménye, Pannonhalma 023505
Pannonisches Heimatmuseum, Neusiedl am See 002405
Christiane von Pannwitz & Carolin Zuber, Berlin 129787
Panoptikum, Gelsenkirchen 075914
Panorama, Exeter 117965
Panorama, Wien 100222, 136903
Panorama Antiquariat, Lüneburg 141965
Panorama Antiques, Saint Louis 096591
Panorama Art Gallery, Warszawa 126637
Panorama de la Bataille de Waterloo, Braine-l'Alleud 003313
Panorama Galleries, New York . 095482
Panorama Großantiquariat, Wiesbaden 142321
Panorama Kreuzigung Christi, Einsiedeln 041232
Panorama Mesdag, Den Haag . . 032018
Panorama Museum, Bad Frankenhausen 016562
Panorama Museum, Salzburg Museum, Salzburg 002581
Panorama Numismatique, Paris . 071705
Panorama Oborona Sevastopolja 1854–1855 rr., Muzei geroičnoï oborony i vyzvolennja Sevastopolja, Sevastopol 043030
Panorama Plevenska Epopeja 1877, Pleven 005022
Panorama Racławicka, Muzeum Narodowe, Wrocław 035267
Panorama Šturm Sapun-gori 7 Travnja 1944 r., Muzei geroičnoï oborony i vyzvolennja Sevastopolja, Sevastopol 043031
Panorama, Salisbury University, Salisbury 139506
Panos Aravantinos Theatrical Museum of Painting and Stage Design, Piraeus 022870
Pansarmuséet, Axvall 040359
Pansi, Heinrich u Anita, Schwanberg 100062
Panssarimuseo, Parola 011061
Państwowa Galeria Sztuki w Sopocie, Sopot 035045
Państwowe Muzeum Archeologiczne, Warszawa 035210
Państwowe Muzeum Etnograficzne, Warszawa 035211
Państwowe Muzeum im. Przypkowskich, Jędrzejów . . 034627
Państwowe Muzeum na Majdanku, Lublin 034835
Państwowe Muzeum Stutthof, Sztutowo 035096
Państwowe Muzeum Stutthof w

Sztutowie, Sopot 035046
Państwowe Zbiory Sztuki, Zamek Królewski na Wawelu, Sułoszowa 035064
Panta Rei Antiek, Leeuwarden . 083232
Panta-Res, Milano 131884
Panta Rhei, Madrid 143586
Pantaleón Rodríguez, Isabel, Salamanca 133773
Pantano, Grazia, Modena 131969
Pantazi, Agni & Georgiou, Piraeus 079104
Panteão da Pátria Tancredo Neves, Brasília 004289
Pantechnicon Art Gallery, Daylesford 098814
Pantelejmonovskij, Sankt-Peterburg 085086, 143483
Panter & Hall, London 118712
Panter, Verena, Köln 130485
Pantera Roz, Bucureşti 114239
Pantet, René, Genève 126930
Panthéon, Paris 014597
Pantheon Arte, Roma 110860
Pantheon Books, New York . . . 138470
Pantheon Gallery, Lefkosia 102491
Panther Decor, Vancouver 064807
Pantiles Antiques, Tunbridge Wells 091513
Pantiles Oriental Carpets, Tunbridge Wells 091514, 135514
Pantiles Spa Antiques, Tunbridge Wells 091515, 135515
Pantoja, Eliseo, Santiago de Chile 101783
Pantokrátor, Budapest 079173
Panton, Milano 080491, 137788
Panton, Praha 137043
Panzano, Gian Carlo, Genova . . 080110
Panzano, Mario, Genova 080111
Pao & Moltke, Toronto . 064664, 101539
Pao Galleries at Hong Kong Art Centre, Hong Kong 007693
Paola Shop, Lima 084297
Paolella, Fabio, Napoli . . 080744, 132022
Paoletti, Paolo, Firenze 080014
Paoli, Anna Loretta, Prato 081008
Paoli, de, Windsor, Ontario . . . 101723
Paoli, Enrico, Prato 110712
Paolo, Cincinnati 120644
Paolucci Numismatica, Padova . 080831
Pap, Mária, Budapest 131215
Papa Re, Roma 132383
Papadam, Nikos, Thessaloniki . 109108
Papadato, Roma 081326
Papadopol's Art, Constanţa . . . 084947
Papadopoulos Picture Gallery, Evangelistria Holy Foundation, Tinos 022971
Papadopoulos, Charis, Thessaloniki 079117
Papadopoulos, Georgios, Thessaloniki 109109
Papadopoulos, Kleanthis, Thessaloniki 109110
Papadopoulos, Stephan, Kornwestheim 130510
Papagena, Le Vésinet 103927
Papageno, Oviedo 086156
Papakura and District Historical Society Museum, Papakura . . . 033099
Papakura Art Gallery, Auckland . 112889
Papaleo, Vincenzo, Roma 132384
Papamoa Art Gallery, Tauranga . 113113
Papazian, Paris 071706
Pape, Barbara, Rinteln 078163
Pape, Hans-Werner, Berlin 129788
Papelaria Moderna, Lisboa 143401
Papeler, Heinz, Krefeld 076899
Paper Antiquities, San Diego . . 096954, 145263
The Paper Bag Princess, West Hollywood 097751
Paper Chain, Mackay 139841

Paper Conservation Studio, New York 136318
The Paper Conservator, Upton-upon-Severn 139247
Paper Heart Gallery, Phoenix . . 123757
Paper Moon, Portland 145200
Paper Peddlers Out-Of-Print Book, South Euclid 145346
Paper-Rock-Scissors, Baltimore 120041
Paper Sculpture, San Francisco . 124610
Paper-Weight, Łódź 084444
Paperback Trading Post, Buffalo 144760
Paperbark Gallery, Evans Head . 098868
Papergraphica, Christchurch . . . 083713
Paperimuseo, Espoo 010604
Paperworks Gallery, Vancouver . 101680
Paphos District Archaeological Museum, Paphos 009276
De Papieren Korf, Gent 063596, 140192
Papiergeschichtliche Sammlung, Stiftung Zanders, Bergisch Gladbach 016848
Papiermacher- und Heimatmuseum, Frankeneck 018137
Papiermachermuseum, Steyrermühl 002732
Papiermolen de Schoolmeester, Westzaan 032861
Papiermuseum Düren, Düren . . 017783
Papiers d'Antan, Bruxelles 063465, 140162
Papilio Starozitnosti, Brno 065283
Papiliorama-Nocturama Foundation, Kerzers 041381
Papillon, Bern 116240
Papillon, Los Angeles 094270
Papillon, Joël & Paulette, Le Fidelaire 069211
Papiri Brignoni, Adriana, Lugano 087429, 087430
Papiri, Antonello, Ponte Capriasca 134204
Papiro, Palermo 132094
Papiros, Denia 133597
Papita, Dubai 117250
Papon, Jean, Vevey 087684
Papp, Dr. Magdalene, Wien . . . 100223, 128218
Papp, Florian, New York 095483
Papp, Th., Niddatal 108279
Pappabello, Cleveland 092798
Pappalardo, Valentina, Catania . 109966
Pappe, Bernd, Bern 134037
Papplewick Pumping Station, Ravenshead 045551
Pappot, Peter, Amsterdam 082635
Pappy, Richmond 096398
Paprsek, Kutná Hora 102573
Papua New Guinea Display Centre, Crafers 000996
Papua New Guinea National Museum and Art Gallery, Boroko 034007
Papunya Tula Artists, Alice Springs 098491
Papworth, Barry, Lymington . . . 090505, 135162
Papworth, Chris L., Kelvedon . . 089473
Papyrud Secret, Cairo 066186
Papyrus, Brugge 063230
Papyrus, Bruxelles 140163
Papyrus, Voorburg 143069
Papyrus Antique Shop, San Diego 096955
Papyrus Books, New York 145106
Papyrus Salus, Heukelom 132917
papyrus Zeitungsantiquariat, Wuppertal 142353
Papyrusmuseum und Papyrussammlung, Österreichische Nationalbibliothek, Wien 002983
Le Paquebot, La Flotte 068980
Paquebot, Saint-Ouen 073125
Para-Börse, Basel 087065

Perey, Wollongong 139990
Perez, London 090245, 135079
Perez, San Antonio 136607
Perez & Pires, Porto Alegre 100854
Perez Arrans, Jose Antonio,
 Sevilla 086294
Pérez Barón, Elias, Bogotá 065131
Perez Carrasco, Tomas, Madrid . 086058
Perez Cejas, Alberto, Montevideo 136811
Perez de Albeniz, Moises,
 Pamplona 115485
Perez Gonzalez, Rafael,
 Valladolid 115625
Perez-Hita Cugat, Pedro,
 Barcelona 085643
Perez Paya, Valencia 086353
Pérez-Paya, Valencia 143615
Perez Perez, Guillermo, Zaragoza 133862
Pérez Sanleón, Antonio, Valencia 086354
Pérez, Andrés, Sevilla 086352
Perez, Ildefonso Lorite, Almeria . 114928
Pérez, Luis, Bogotá 102257
Perez, Mickael, Les Ulmes 069380
Pérez, Roberto, Medellín 065214, 128550
Pérez, Trinidad de, Bogotá 065130
Perfect Touch, Philadelphia 123689
Perfecto Da Lama, Saint-Pey-
 d'Armens 073214
Perfekta, Kraków 084421
Perform Arte Contemporanea, La
 Spezia 110173
Performance Space, Eveleigh . . 001067
Performing and Creative Arts
 Department, College of Staten Island
 Cuny, Staten Island 057904
Performing and Visual Arts
 Department, Marian College,
 Indianapolis 057195
Performing and Visual Arts
 Department, Wagner College, Staten
 Island 057905
Performing Arts Collection of South
 Australia, Adelaide 000772
Performing Arts Collection, The Arts
 Centre, Melbourne 001279
Perfume Museum, Niagara-on-the-
 Lake 006355
Pergamentum, Granada 133627
Pergamino, Madrid 086059
Pergamon, Bredevoort 142913
Pergamon Antique, Spišská Nová
 Ves . 085418
Pergamonmuseum –
 Antikensammlung, Staatliche Museen
 zu Berlin – Stiftung Preußischer
 Kulturbesitz, Berlin 017051
Pergamonmuseum – Museum für
 Islamische Kunst, Staatliche Museen
 zu Berlin – Stiftung Preußischer
 Kulturbesitz, Berlin 017052
Pergamonmuseum – Vorderasiatisches
 Museum, Staatliche Museen zu
 Berlin – Stiftung Preußischer
 Kulturbesitz, Berlin 017053
Perge Müzesi, Aksu 042534
Perhirin, Jacques, Le Relecq-
 Kerhuon 069293
Perhon Kotiseutumuseo, Perho . 011067
Peribo, Mount Kuring-Gai 136820
Pericoi, Nathalie, Saint-Ouen . . 073128
Perides, Maria, Newstead 099312
Perier, Antoine de, Nantes 140949
Périer, Charles, Le Chesnay . . . 069194
Périès, Jean-Claude, Montauban 070146,
 070147
Perimeter Gallery, Chicago 120509
Perine, Paris 071725
Perini, Alberto & Marcus, Verona 142706
Perini, Maurizio, Milano 131887
Period Classics, Singapore 085310
Period Collections, Houston 121388
Period Features, Leek 089590
Period Fireplaces, Bristol 088444,
 134484

Period Furniture Showrooms,
 Beaconsfield 088189, 134399
Period Gallery, Omaha 123587
Period Picture Company,
 Washington 125197
Period Style Lighting, Enfield . . . 088999
Perkey, Cheryl, Los Angeles . . . 121851
Perkin, Bruce, Cork 079398
Perkins Bull Collection,
 Peterborough 006493
Perkins Center for the Arts,
 Moorestown 050972
Perkins County Historical Society
 Museum, Grant 049166
Perkins History Museum,
 Watertown 054092
Perkins, Bryan, Wellingborough . 091628,
 135551
Perkins, R.G., Toronto 064667
Perkins, Steve, Whangarei 133140
Perkinson Gallery, Millikin University,
 Decatur 048165
La Perla, Buenos Aires 060913
La Perle des Puces, Cagnes-sur-
 Mer . 067533
Perler & Co., Wabern . 087690, 134273
Perlerin, Alain, Saint-Valéry-sur-
 Somme 073285
Perles & Terres, Cannes 103471
Perlès, Christophe, Paris 071726
Perlin, Amy, New York 095493
Perlinger, Magarethe, München . 108178
Perlini Arte, Reggio Calabria . . . 110722
Perlman, Trelleborg 086918
Perlo, Jean-Louis, Reims 072359
Perlow Rich, Katharina, New
 York . 123215
Permanenten Vestlandske
 Kunstindustrimuseum, Bergen . 033364
Permanenze Centro di Restauro,
 Milano 131888
Permskaja Gosudarstvennaja
 Chudožestvennaja Galereja,
 Perm 037471
Permskij Gosudarstvennyj Institut
 Iskusstv i Kultury, Perm 056244
Permskij Oblastnoj Kraevedčeskij
 Muzej, Perm 037472
Pernáth, Praha 102680
Perner, Udo, Hof 141838
Pernes, Civray 067936
Pernès, Michel, Beaune 103305
Pernička, Vojtěch, Brno 128563
Perniön Museo, Perniö 011068
Pernod, Jean-Pierre, Saint-Martin-du-
 Fresne 072907
Pernot, Alain, Vic-sur-Seille 074063
Pero, Beograd 114513
Péroline, L'Hospitalet 069399
Peron, Los Angeles 094276
Peron – Galerie Českého Umění,
 Praha 102681
Perpetuum Art, Kostroma 114269
Perpignan Numismatique,
 Perpignan 072049
Perplies, Aachen 105896
Perquier, Jacques, Pont-Audemer 072199
Perra, Andrea, Catania 079875
Perramond, Alain, Tain-
 l'Hermitage 073574
Perranzabuloe Folk Museum,
 Perranporth 045439
Perras, Bernard, Paris 071727
Perrault, Gilles, Paris . . 071728, 129341
Perrault's Museum, Val Marie . . 007093
Perreau-Saussine, Paris 071729
Perreau, Patrick, Châteauroux . . 128791
Perret, Gustave, Saint-Ouen . . . 073129
Perret, Paul, Saint-Just-Saint-
 Rambert 072835
La Perrichola, Buenos Aires 060914
Perrier, Jean-Claude, Laval
 (Mayenne) 069149
Perrier, Michel, La Boisse 068899

Perrier, Suzanne, Régny 072331
Perrin, Montbéliard 104203, 140919
Perrin, Jacqueline, Nice 070597, 104334
Perrin, Jacques & Philippe, Paris 071730
Perrin, Josiane, Aix-les-Bains . . 066424
Perrin, Marie-Jo, Lyon 069717
Perrin, Michelle, Tournus 073791
Perrin, Noël, Jasseron 068842
Perrin, Patrick, Paris 071731
Perrins Art Gallery, London 118719
Perritaz, Christian, Fribourg 134086
Perron, Ralph, Saint-Jeoire 072816,
 129466
Perrone, Antonio, Biel . 087134, 134046
Perrot, Bernard, Châteauneuf-en-
 Thymerais 067836
Perrotin, Emmanuel, Miami 122116
Perrotin, Emmanuel, Paris 105113
Perrusson, Christian, Sennecey-le-
 Grand 073453
Perry, Charlotte 092453
Perry, Jacksonville 121539
Perry & Nicole, Memphis 121985
Perry & Phillips, Bridgnorth 127030
Perry County Lutheran Historical
 Society, Altenburg 046388
Perry-Downer House and Costume
 Gallery, Monterey 050943
Perry, George, Tauranga 113114
Perryman, Ian & Belinda,
 Woollahra 062470, 127971
Perry's Cider Mills, Ilminster . . . 044491
Perry's Mart Masterton,
 Masterton 083831
Perry's Victory and International Peace
 Memorial, Put in Bay 052326
Perryville Battlefield Museum,
 Perryville 051906
Per's Afsyring og Antik, Roskilde 066022
Persano, Giorgio, Torino 111018
Persaù, Ralf, München 130739
Persault, Michel, Albertville 066443
Il Perseo, Palermo 080897
Persepolis, Isfahan 079313
Persépolis, Palma de Mallorca . 086186,
 133766
Persian and Oriental Rug Gallery,
 Pittsburgh 096154
Persian Antiques Exhibition, Abu
 Dhabi 087921
Persian Arts & Crafts, Vancouver 064811
Persian Carpet Gallery of Petworth,
 Petworth 090852
Persian Carpet Museum, Raas . 029892
The Persian Carpet Studio, Long
 Melford 090467, 135149
Persian Carpets and Antiques, Abu
 Dhabi 087922
Persian Gallery, Boston 092323
Persian Gallery, New York 095494
Persian Shop, New York 095495
La Persiana, Palermo 110630
Persico Rosalba, Milano 080502
Persico, Didier, La Valette-du-Var 069057
Persico, Didier, Pignans 072121
Persmuseum, Amsterdam 031800
Person, Catherine, Seattle 124829
Personal Museum, Paris 105114
Personal Touch, Toledo 124944
Persone, Maria Adele, Bari 131320
Personé, Maria Adele, Bari 079668
Perspective Art, Ottawa 101342
Perspective Gallery, Blacksburg . 046997
Perspective, Art in Architecture,
 London 118720
Perspectives, Pont-Aven 105339
Persson, Malmö 143704, 143705
Persson, Åke, Piteå 126865
Persson, Lennart, Falun 133878
Persson, Oskar H., Helsingborg . 115783
Perth Antiques, Perth 062070
Perth Bookshop, Perth 144533
Perth Galleries, Subiaco 099592
Perth Institute of Contemporary Arts,

Northbridge, Western Australia 001365
Perth Museum, Perth 006486
Perth Museum and Art Gallery,
 Perth 045442
Perthuis, Serge, Saint-Arnoult-des-
 Bois . 072637
Perticaro, Gaetano, Genova 131730
Perttelin Kotiseutumuseo, Inkere 010732
Peruggi, Andrea, Padova 110593
Pesbar, Barbate 126712
Pesca, Nashville 094856
Pescali, Daniele, Milano 110413
Pesce Maurizio, Genova 080113
Pesce, Elena, Genova 080112
Pesce, Sabrina, Bari 079669
Pescetta, Verona 081763, 132678
Pescetta, Alessandro, Verona . . 081764
Pescetto, Rosa, Genova 080114
Peschar, Hannah, Ockley 119059
Pescheteau-Badin, Paris 126021
Peschke, J., Paderborn 077929
Pesciaioli, Luciano, Roma 081332
Pesenti, Bruno, Rochefort (Charente-
 Maritime) 072458
Peshawar Museum, Peshawar . 033963
Peshtigo Fire Museum, Peshtigo 051913
Peshwa Satishchandra, Paris . . 071732
Pešková, Jitka, Český Krumlov . 065306
Pesnel, Francette, Montgeron . . 070194
Pessah, Daniel, Fuengirola 085823
Pessin, Marc, Saint-Laurent-du-
 Pont . 105498
Peštera Rabiša Muzej,
 Belogradčik 004894
Pesterzsébeti Múzeum, Budapest 023221
Petach Tikva Museum of Art, Petah
 Tikva 024987
Petalax Hembygdsmuseum,
 Petalax 011070
Petalouda Gallery, Naxos 109088
Petaluma Wildlife and Natural Science
 Museum, Petaluma 051914
Pete and Susan Barrett Art Gallery,
 Santa Monica College, Santa
 Monica 053019
Peter, Buxtehude 075195
Peter & Martine, L'Isle-sur-la-
 Sorgue 069531
Peter Anson Gallery, Buckie . . . 043561
Peter Benoitmuseum, Harelbeke 003599
Peter Bichsel Fine Books GmbH,
 Zürich 143968
Peter Chapman Antiques & Restoration,
 The Studio, London . . 090246, 135080
Peter Conser House, Oklahoma
 Historical Society, Heavener . . 049387
Peter et Martine, Beaumettes . . 066942
Peter Hill Fine Art Gallery,
 Sheffield 119345
Peter J. McGovern Little League
 Baseball Museum, South
 Williamsport 053302
Peter Kiefer, Buch- und
 Kunstauktionshaus, Pforzheim . 126320,
 142152
Péter Pál Polgárház, Koszta József
 Múzeum, Szentes 023640
Peter Pan's Bazaar, Gosport . . . 089150
Peter Paul Luce Gallery, Cornell
 College, Mount Vernon 051032
Peter Raczeck Fine Art, New
 York . 123216
Peter Rice Homestead, Marlboro 050635
Peter Rosegger-Geburtshaus,
 Alpl . 001694
Peter Rosegger-Museum,
 Krieglach 002210
Peter Scott Gallery, Lancaster . . 044627
Peter Van den Braken Centrum,
 Sterksel 032725
Peter Wentz Farmstead,
 Worcester 054423
Peter Whitmer Farm, Waterloo . 054088
Peter-Wiepert-Museum, Fehmarn 018087

Piedmont, Charlotte 135745
Piedmont Arts Museum, Piedmont
 Arts Association, Martinsville . 050662
Piedmont Lane Gallery, Oakland 123513
Piedra Lumbre Visitors Center, Ghost
 Ranch Living Museum, Abiquiu 046282
Piedrahita, Felipe, Bogotá 065132
Piehet, Ray J., New Orleans .. 094978
Piel, Michel, Cabourg 103429
Pielaveden Kotiseutumuseo,
 Pielavesi 011073
Pielisen Museo, Lieksa 010936
Pien, Amersfoort 082468
Pienmäen Talomuseo,
 Niemisjärvi 011007
Piepo & Partner, Hannover 130319
The Pier-2, Art District Kaohsiung,
 Kaohsiung 042088
Pier 21, Halifax 005843
Pier Arts Centre, Stromness .. 045900
Pier One Imports, Houston .. 093598
Pier Pander Museum,
 Leeuwarden 032395
Pierce Art Center, Minneapolis . 122301
Pierce Manse, Concord 047924
Pierce's, Houston ... 093599, 127520
't Pierement, Leiden 083254
't Pierement, Middelburg 083312
Pierhuff, Indianapolis 093751
Pierides-Marfin Laiki Bank Museum,
 Larnaka 009249
Pierides Museum of Ancient Cypriot
 Art, Athinai 022620
Pierina Lutti, Buenos Aires ... 060915
Pierini, Aldarin, Firenze 080019
Pierini, Filippo, Firenze 131635
Pierini, Robert, Biot 103346
Piero, Yokohama 111552
Pierogi, Leipzig 107835
Pierogi 2000, Brooklyn 120224
Pierogi 2000, Leipzig 107836
Pieroth, Heinz, Frankfurt am
 Main 075764
Pierre, 's-Hertogenbosch 112615
Pierre & Nicolas, Cannes 103472
Les Pierre Antiques, New York . 095497
Pierre aux Loups, Cheval de Bois,
 Conflans-Sainte-Honorine 068077
Pierre d'Agate, Reims 072360
Pierre Gildesgame Maccabi Sports
 Museum, Ramat Gan 024998
Pierre Menard Home, Ellis Grove 048516
Pierre Michel D., Paris 105124
Pierre, Alain, Paris ... 129342, 129343
Pierre, Isabelle, Monaco 082339
The Pierrepoint Gallery, Bridport 117528
Pierrepont, Oxford 119089
Pierrepont Museum, Canton 047370
Pierres et Vestiges, Suresnes .. 073570
Pierres Passion, Vic-le-Comte .. 074059
Pierres Précieuses, Strasbourg . 073556
Pierron, Laurent, Saint-Georges-du-
 Bois 072759
Le Pierrot, Saint-Pierre-de-
 Clages 143914
Pierrot, Warszawa 113975
Piers Pisani Antiques, Sherborne 091158,
 135384
Pierson, Marie-Françoise, Villers-la-
 Chèvre 074141
Pierson, Pat, Sainte-Foy-la-
 Grande 073309
Piert-Borgers, Barbara, Köln ... 130486
Piesk, Friedrich, Wiesbaden .. 142322
Pietarin Radan Museo, Lahti ... 010900
Pieter Vermeulen Museum,
 IJmuiden 032342
Pieternel, Deventer 082974
Pieters, Herzogenrath 076455
Pieters, Guy, Knokke-Heist .. 100618
Pieters, Guy, Saint-Paul-de-
 Vence 105553
Pieters, Luc, Knokke-Heist .. 100619
Pietershuis, Haarlem 112600

La Pietra d'Agata, Milano 080506
Piętro Wyżej, Górnośląskie Centrum
 Kultury, Katowice 034654
Pietroforte, Manlio, Roma 132397
Pifaçanes, Barcelona 133502
Piffl, Markus, Graz ... 062582, 128017
The Pig Yard Gallery, Wexford .. 109716
Pigeon Valley Steam Museum,
 Nelson 033073
Pigeon & Co, Lomas, Chelmsford 134546
Piggelmee, Zwolle 083551
Pigmalion, Postojna 114822
Pignatelli, Domenic R., North
 Providence 136384
Pignede, Yves, Maisons-Laffitte . 069764
Pignolo, Giuliana, Milano 131891
Pigot, Jean-Michel, Sens 073460
Pig's Wings Bookshop of Dragon Hill,
 Coolangatta 139732
Pihan, Jenny, Frankston 098915
Pihay, Georgette, Québec 101379
Pihlajaveden Kotiseutumuseo,
 Keuruu 010824
Pihlmark, Århus 102742, 140521
Pihtiputaan Kotiseutumuseo,
 Pihtipudas 011074
Pijpenkabinet & Smokiana,
 Amsterdam 031802
Pikaflor, Honfleur 068774
Pikakannu Põhikooli Muuseum,
 Pikakannu 010480
Pikari, Helsinki 066295
Pike County Museum, Milford .. 050827
Pikes Peak Pastel Society, Colorado
 Springs 060682
Pikinasso, Roanne 105408
Pikto Galerija, Zagreb 102464
Piktogram, Warszawa 139022
Piktúra Galéria, Budapest 109179
Pikture, Bangkok 117037
Pila Museum, Pila 034401
Pilar Martí, Barcelona 085645
Pilar Parra & Romero, Madrid .. 115359
Pilardus, Cannes 103473
Pilat, Bianca, Chicago 120512
Pilat, Bianca, Milano 110415
Pilatushaus, Oberammergau .. 020533
Pilchuck Glass School, Seattle . 057858
Pile, Ronald, Ely 117943
Pilegaard, Aalborg ... 065519, 140512
Pilgrim Antiques, Ampthill 088043,
 134350
Pilgrim Antiques, Honiton 089379
Pilgrim Books, Calgary 140302
Pilgrim Hall Museum, Plymouth . 052119
Pilgrim Monument and Provincetown
 Museum, Provincetown 052306
Pilgrims Antique Centre, Dorking 088878
Pilgrims Antiques Centre,
 Gainsborough 089109
Pilgrim's Rest Museum, Pilgrim's
 Rest 038626
Pili, Rosetta, Cagliari 079827
Pilies Muziejus, Mažosios Lietuvos
 Istorijos Muziejus, Klaipėda ... 030222
Pilkington, Yelvertoft 138350
Pillantás, Budapest 109180
Pillars, Lyneham 090511
Pillars & Pomegranates, Fresno . 093345
Piller & Assoc., Stanley M.,
 Oakland 095743
Piller, Yves, Corminboeuf 087194
Pillet, Lyons-la-Forêt 069734
Pilling Handelsgesellschaft mbH,
 Detmold 075295
Pillon, Trieste 081632
Pilloni, Nunzia & C., Cagliari .. 079828
Pilloni, Rosaria, Cagliari 131470
Pillsbury, Michel, Houston 110341
Pillu, François, Paris 105125
Pilney, Saint Paul 096684
Pilonova Galerija Ajdovščina,
 Ajdovščina 038311
Pilorgé, Jean, Carnac 067631

Pilotgalerie, Galerie für Junge Kunst &
 Edition, Luzern 116567, 138142
Pilots Cottage Museum, Kiama . 001184
Pils, Erich, Krems 062669
Pils, John, Saint Louis 124104
Pilsen, Chicago 092603, 135774
Pilton Art Gallery, Barnstaple .. 117361
Piltzer, Gerald, Barbizon 103284
Piltzer, Gérald, Macherin 104091
Piltzer, Gérald, Paris 105126
Piltzer, Gérald, Roma 110864
Pilz, Evelyn, Münster 077598
Pilz, Roman J., Mainburg 130611
Pilzmuseum Taura, Belgern-
 Schildau 016816
Pilzner, Fred, Hannover 107347
Pim, Heerlen 083184
Pima Air and Space Museum,
 Tucson 053711
Pimeria Alta Historical Society
 Museum, Nogales 051484
Pimlico, Chicago 092604
Pimlico Books, London 144424
Le Pin Bleu, Beaune 066973
Le Pin Perdu, Carcassonne ... 067618
Pin, Xuan Ge, Singapore 114668
Pin.Arte, Torino 111019
Pina, C., Charleroi 063549
La Pinacoteca, Barcelona 115037
La Pinacoteca, Bogotá 102258
Pinacoteca, Chiomonte 025825
Pinacoteca, Córdoba 000336
Pinacoteca, Milano 026665
La Pinacoteca, Napoli 080750
Pinacoteca, Teramo 027894
Pinacoteca Ambrosiana, Milano . 026666
Pinacoteca Andrea Alfano,
 Castrovillari 025716
Pinacoteca Barão de Santo Ângelo,
 Universidade Federal do Rio Grande
 do Sul, Porto Alegre 004580
Pinacoteca Benedicto Calixto,
 Santos 004738
Pinacoteca Cantonale Giovanni Züst,
 Rancate 041607
Pinacoteca Carmelita del Convento del
 Carmen, Trujillo 034250
Pinacoteca Cascella, Museo Civico
 d'Arte Contemporanea, Ortona 026946
Pinacoteca Chiesa di San Giovanni,
 Pieve Torina 027157
Pinacoteca Chiesa di San Tomaso
 Becket, Padova 026994
Pinacoteca Civica, Abano Terme 025061
Pinacoteca Civica, Ascoli Piceno 025224
Pinacoteca Civica, Baiardo 025279
Pinacoteca Civica, Cento 025748
Pinacoteca Civica, Cepagatti .. 025750
Pinacoteca Civica, Crotone 025962
Pinacoteca Civica, Fermo 026049
Pinacoteca Civica, Iesi 026341
Pinacoteca Civica, Imperia 026353
Pinacoteca Civica, Pieve di Cento 027154
Pinacoteca Civica, San
 Gimignano 027579
Pinacoteca Civica, Santarcangelo di
 Romagna 027665
Pinacoteca Civica, Savona 027719
Pinacoteca Civica, Spello 027824
Pinacoteca Civica A. Ricci, Monte San
 Martino 026750
Pinacoteca Civica Amedeo Modigliani,
 Follonica 026164
Pinacoteca Civica Bruno Molajoli,
 Fabriano 026018
Pinacoteca Civica d'Arte Moderna,
 Latina 026413
Pinacoteca Civica e Gipsoteca U. Gera,
 Ripatransone 027358
Pinacoteca Civica F. Duranti,
 Montefortino 026776
Pinacoteca Civica Francesco Podesti,
 Ancona 025157
Pinacoteca Civica G. Cattabriga,

Bondeno 025439
Pinacoteca Civica Melozzo degli
 Ambrogi, Forlì 026177
Pinacoteca Civica Tosio Martinengo,
 Brescia 025487
Pinacoteca Civica, Museo di San
 Domenico, Imola 026349
Pinacoteca Civica, Palazzetto del
 Podestà, Montelupone 026787
Pinacoteca Civica, Villa Grappallo,
 Vado Ligure 028068
Pinacoteca Comunale, Assisi ... 025237
Pinacoteca Comunale, Bevagna 025341
Pinacoteca Comunale, Bosa ... 025458
Pinacoteca Comunale, Castiglion
 Fiorentino 025704
Pinacoteca Comunale, Cesena . 025781
Pinacoteca Comunale, Città di
 Castello 025856
Pinacoteca Comunale, Deruta . 025980
Pinacoteca Comunale, Faenza .. 026026
Pinacoteca Comunale, Manciano 026529
Pinacoteca Comunale, Massa
 Fermana 026567
Pinacoteca Comunale, Massa
 Marittima 026578
Pinacoteca Comunale, Matelica . 026584
Pinacoteca Comunale, Narni ... 026857
Pinacoteca Comunale, Ostra ... 026963
Pinacoteca Comunale, Quistello . 027290
Pinacoteca Comunale, Ripe San
 Ginesio 027359
Pinacoteca Comunale, San Benedetto
 del Tronto 027550
Pinacoteca Comunale, San Severino
 Marche 027624
Pinacoteca Comunale, Sarnano . 027681
Pinacoteca Comunale, Spoleto . 027833
Pinacoteca Comunale, Verucchio 028176
Pinacoteca Comunale A. Moroni, Porto
 Recanati 027243
Pinacoteca Comunale Alberto Martini,
 Oderzo 026912
Pinacoteca Comunale Casa Rusca,
 Locarno 041448
Pinacoteca Comunale D. Stefanucci,
 Cingoli 025841
Pinacoteca Comunale E. Giannelli,
 Parabita 027033
Pinacoteca Comunale F. Galante
 Civera, Margherita di Savoia . 026551
Pinacoteca Comunale Foresiana,
 Portoferraio 027250
Pinacoteca Comunale Francesco
 Cozza, Stilo 027844
Pinacoteca Comunale Vincenzo Bindi,
 Giulianova 026295
Pinacoteca D. Inzaghi, Budrio .. 025506
Pinacoteca Dantesca Fortunato
 Bellonzi, Torre de Passeri 027971
Pinacoteca d'Arte Antica, Gemona del
 Friuli 026232
Pinacoteca d'Arte Contemporanea,
 Smerillo 027799
Pinacoteca d'Arte Francescana,
 Lecce 026421
Pinacoteca d'Arte Moderna,
 Avezzano 025264
Pinacoteca d'Arte Moderna e
 Contemporanea "AM International",
 Bivongi 025359
Pinacoteca Davide Bergh, Calice al
 Cornoviglio 025545
Pinacoteca de la Escuela Provincial de
 Bellas Artes Dr. Figueroa Alcorta,
 Córdoba 000337
Pinacoteca de la Facultad de Bellas
 Artes, Manizales 008549
Pinacoteca de la Universidad de
 Concepción, Concepción ... 007333
Pinacoteca de Nuevo León,
 Monterrey 031116
Pinacoteca dei Cappuccini,
 Voltaggio 028244

Piopio and District Museum,
 Piopio 033106
Pio's Antiques, Victoria 082263
Pip Antiques, Virginia 062385
Pipaongo Etnografia Museoa, Museo
 Etnográfico de Pipaón, Pipaón . 039754
Pipat & Morier, Blaye . 067184, 067185
Pipat & Morier, Bordeaux 067296
La Pipe, Oostende 063765
La Pipe Eric, Bruxelles 063473
Piper Antiques, Auckland 083634
Piper Aviation Museum, Lock
 Haven 050299
Piper Barn, Kyneton 061703
Piper-Wölbert, Ulrike Margarete,
 Stuttgart 131063
Piperaud, Pascale, Saint-Ouen . 073131
Pipestone County Historical Museum,
 Pipestone 052055
Pipino, Vincenzo, Napoli 132023
Pippa, Luigi, Roma 132398
Pippa's Art Gallery, Whangarei . 113199
Pippi, Firenze 080020
Pippin, Clayfield 061330
Pippin, Kenneth, Baltimore 092190
Piqua Historical Area State Memorial,
 Piqua 052056
Pique-Puces, Bruxelles 140165
Piquet, Coudekerque-Branche . . 068119
Piqueux, Pierre, La Rochette . . . 069040
Piraino, Pietro, Palermo 080898
Piramal Gallery, Mumbai 109476
Pirâmide, Lisboa 114141
La Piramide, Milano 080507
Piramidon, Centre d'Art Contemporani,
 Barcelona 115038
Piras, Maria Giovanna, Torino . . 111021
Pirate, Denver 121034
Pirate Contemporary Art Oasis,
 Denver 048234
Piratenamüseum, Wilhelmshaven 022248
Pirate's Alley, Oklahoma City . . 123544
Pirie, George, Edinburgh 088973
Pirmoradi, Hamburg 076236
Piro, Hélène, Martel 069930
La Pirogue Museum, Cheticamp 005506
Pirontidi, Ernesto, Barcelona . . . 085647
La Pirouette, Hyères 068805
Pirovano, Fabio, Magliaso 087462,
 134174
Pirovano, Fabio, Pura 087547
Pirra, Stefano, Torino 111022
Pirri, Angela, Roma 081340
Pisanelli, Tiziana, Roma 081341
Pischetola, Giuseppe, Torino . . . 081581
Piskarevskoe Memorialnoe Kladbišče –
 Muzej, Sankt-Peterburg 037640
Pismo, Denver 121035
Pisonero Ortega, Eduard,
 Barcelona 133503
Pistil, Seattle 145335
Piston, Hyman E., New York . . . 095499
Pistone, Mario Giuseppe, Catania 131492
Pistor, Lorenz, Rodenbach 142178
Pisu, Giovanni, Cagliari 079829, 131471
Pit 21, Milano 110416
Pitäjämseun ja Nymann Talo ja
 Apteekkimuseo, Tohmajärvi . . 011244
Pitäjäntupa-Museo, Joutseno . . 010750
Pitcairn, Scott 2207 Second Av,
 Seattle 124835
Pitchal, Virginie, Paris 105127
Pitcher, Nicholas S., London . . . 090255
Piteå Museum, Piteå 040716
Piteå Sparkmuseum, Piteå 040717
Pitfield, David, Sunninghill Ascot 119455
Piti Arte Ibiza, Eivissa 115149
Pitkänpellon Talomuseo,
 Kangasniemi 010785
Pitlochry and Moulin Heritage Centre,
 Moulin 045233
Pitlochry Festival Theatre Art Gallery,
 Pitlochry 045465
Pitmedden Furniture Workshop,

Ellen . 088985
Il Pitocchetto, Brescia 109928
Piton, Miriam, Saint-Raphaël . . . 073249
Pitot House Museum, New
 Orleans 051233
Pitow, Bruck an der Mur 099837
Pitre, Honolulu 121243
Pitrelli, Vincenzo, Milano 131892
Pitsch & Geissbühler, Zofingen . 116825
Pitstone Green Farm Museum,
 Pitstone 045466
Pitt Meadows Museum, Pitt
 Meadows 006507
Pitt Rivers Museum, Oxford 045406
Pittarello, Gastone, Venezia 132638
Pittencrieff House Museum,
 Dunfermline 043987
Pittera, Jean, Marseille 129018
Pitti, Monaco 082340
Pittock Mansion, Portland 052209
Pitton, Fabrizio, Torino 081582
Pittsburg State University Natural
 History Museum, Pittsburg . . . 052060
Pittsburgh Antique Mall,
 Pittsburgh 096156
Pittsburgh Center for the Arts,
 Pittsburgh 052080
Pittsburgh Children's Museum,
 Pittsburgh 052081
Pittsburgh Pastel Artists League,
 Pittsburgh 060683
Pittsburgh Plating and Lamp Service,
 Pittsburgh 136476
Pittsburgh Print Group,
 Pittsburgh 060684
Pittsburgh Society of Illustrators,
 Monroeville 060685
Pittsford Historical Society Museum,
 Pittsford 052095
Pittsworth Pioneer Historical Museum,
 Pittsworth 001407
Pitz, Ludwig, Stolberg, Rheinland 078483,
 108680
Pitzen, Christoph, Esslingen . . . 130113
Pitzhanger Manor-House and Gallery,
 London 044976
Piumaccio d'Oro, Firenze 131636
Piva & C, Milano 080510
Piva, Francesco, Milano 080508
Piva, Giuseppe, Milano 080509
Pivano, Pietro, Torino 132564
Pivot, Bernard, Basel 134000
Pivotal Galleries, Richmond,
 Victoria 099499
Pivovarské Muzeum, Plzeň 009602
Pivovarski Muzej, Ljubljana 038374
Pixel Gallery – Pixel Galerie, Frankfurt
 am Main 106982
Pixel Place, Hamilton 101185
Pixelprojekt_Ruhrgebiet,
 Gelsenkirchen 018355
Pixi & Cie., Paris 105128
Pixian Juan Calligraphy and Painting
 Gallery, Chengdu 101884
Pixian Museum, Pixian, Sichuan 007966
Pixis, Christian, München 108181
Pixtory, Marseille 069906, 104144,
 137111
Pizhou Museum, Pixian, Jiangsu 007965
Piziarte, Teramo 110966
Pizorno Azuara, Laura, Ourense 086149
Pizzi, Amilcare, Cinisello
 Balsamo 137735
Pizzi, Gabrielle, Melbourne 099182
Pizzinelli, Gianfranco, Roma . . . 132399
Pizzini, Rovereto 110902
Pjatigorskij Kraevedčeskij Muzej,
 Pjatigorsk 037486
Pjazza Antiques, San Gwann . . . 082247
Pjóðmenningarhúsið, Reykjavík . 023787
Pjóðminjasafn Íslands, Reykjavík 023788
Pjotr, Tilburg 112772
PKM, Seoul 111753
PLA Naval Museum, Qingdao . . 007983

Pla, Alfons, Barcelona 133504
Plaar, Jonas, Zürich . 087798, 134312
Plaaswinkel, Tshwane 085505
Plac-Art, Bremen 075136
Plac Zamkowy, Warszawa 113976
PLACE, Belfast 060183
The Place Antiques, Golden
 Square 061528
Place Concore Antiquario, Rio de
 Janeiro 064049
Place des Arts, Paris . . 105129, 137252,
 141223
Place des Vosges, New York . . . 123223
La Place du Soleil, San
 Francisco 097141
Place Royale, Montréal 101304
placeMAK, Seoul 111754
Placemaker, Miami 122120
Placencio, Francisco, Santiago de
 Chile 064929
Placentia Area Museum,
 Placentia 006508
Placentia Arte, Piacenza 110670
Places and Spaces, London . . . 090256
Plachot, Christian, Ypreville-
 Biville 074274, 129587
Plada, Maribor 085445
Pladeck, F., Bielefeld 074944
Plages, Boulogne-Billancourt . . . 138702
Plain Farm Workshop, Alton . . . 134342
Plains Art Museum, Fargo 048659
Plains Indians and Pioneers Museum,
 Woodward 054412
Plains Vintage Railway and Historical
 Museum, Ashburton 032958
Plainsman Museum, Aurora 046648
Plaisio, Lagkadikia 109084
Plaisir d'Antan, La Roche-Guyon 069009
Plaisirs d'Intérieur, Saint-Jean-de-
 Luz . 072805
PlakART am Dreiecksplatz, Kunst-
 Drucke-Rahmen, Kiel 076722
Plakat am Markt, Seligenstadt . . 108687
Plakity, Michael, Dresden 075378
Plamondon and District Museum,
 Plamondon 006511
Plan 2 B, Portland 139906
Plan Incliné de Ronquières,
 Ronquières 003901
Plan-Weseritzer Heimatstuben mit
 Archiv, Tirschenreuth 021758
Plan.d.-Produzentengalerie,
 Düsseldorf 106776
Plana, Ricard, Terrassa 115563
Planage, Binoist, Rouen 072569
La Plancha, Heerlen 083186
Plane Space, New York 123224
Plane Tree, Christchurch 083714
Planet Anime, Houston 093601
Planet Art, Cape Town 114854
Planet Art, Miami 122121
Planet Bazaar, London 090257
Planet Corroborce, Byron Bay . . 061235
Planet Earth Museum, Newhaven 045293
Planet Publishing, New Orleans . 122466
Planet Rugs, Houston 093602
Planetario, Trieste 111075
Planète Bordeaux, Beychac-et-
 Caillau 011832
Planète de la Découverte, Musée des
 Sciences pour Enfants, Beirut . 030101
Planetron – Aards Paradijs,
 Dwingeloo 032082
Il Planisfero, Seriate 110948
Plank, Wien 100224
Planque, Claudine, Lausanne . . . 116521
Planšarski Muzej, Gorenjski Muzej
 Kranj, Bohinjsko Jezero 038316
Plantard, Guer 068701
Plantation Agriculture Museum,
 Scott 053092
Plantation Antiques, Toronto . . . 064671
Plantation Furniture & Antiques,
 Calgary 064211

Plantation Historical Museum,
 Plantation 052102
Plantation of Ulster Visitor Centre,
 Draperstown 043948
Plantation Shop, Atlanta 092006
Planteau du Maroussem, Eric, Aix-en-
 Provence 103153, 128670
Plantener Pedersen, Tine, Holte 065719
Planter, Singapore 085311
Plantier, Le Cheylard 069195
Plantijn, Breda 142907
Planting, Eduard, Amsterdam . . 112351
Plantiques, San Antonio 096850
Plantureux, Serge, Paris 141224
Plas Mawr, Conwy 043804
Plas Newydd,
 Llanfairpwllgwyngyll 044766
Plas Newydd, Llangollen 044776
Plas yn Rhiw, Pwllheli 045537
Plasberg, Ralf, Nürnberg 077758
Plasma, Prahran 062108
Plassard, Yves, Paris 071744
Plassart, Ch., Poitiers 126054
Plasse, Agnès, Boulogne-
 Billancourt 067337
Plassenburg, Bayerische Verwaltung
 der staatlichen Schlösser, Gärten
 und Seen, Kulmbach 019502
Plassmann, Mignon, Attendorn . 105972
Plast-Art, Černigiv 117170
Plastic Club, Philadelphia 051993
Plastics Historical Society,
 Sidcup 060184
Plastique Kinetic Worms,
 Singapore 114669
Plastyka, Kraków 113715
Plastyka, Warszawa 113977
Plat Art, Buenos Aires 127802
Plat, B., Hardegarijp 132904
Plat, Jean-Louis, Tours 073819
El Plata, Sevilla 086298
De Plataan, Heerlen 083187
Plâté, Colombo 086435, 115663
Plateau, Seoul 111755
Plateaux Gallery, London 118723
Platenhäuschen, Erlangen 018013
Platero, Buenos Aires 139627
Platform – Centre for Photographic
 and Digital Arts, Winnipeg . . . 007270
Platform 1 Heritage Farm Railway,
 Littlehampton 001223
Platform Artists Group,
 Melbourne 099183
Platform Gallery, Clitheroe 117761
Plati Galeria, Wrocław 114037
Plating, JB, London 135085
Platini, Sylvie, Portland 123906
Platini, Sylvie, Veyrier-du-Lac . . 105806
Platinum Collectibles, Las Vegas 094002
Platou, Bærums Verk 126551
Platt and Borstein Galleries, American
 Jewish University, Los Angeles 050405
Platt R. Spencer Memorial Archives
 and Special Collections Area,
 Geneva 049033
Platt, Alan Quentin, Chicago . . . 120513
Platt, Kevin, Padstow 119100
Platt, Susan, Seattle 124836
Platt, Trevor, Wynnum 099790
Platte, E. & H., Preußisch
 Oldendorf 108419
Platten, Frank, Suderburg 131080
Platter og Kunst, Viborg 066135
Plattner, Nicolas & Marianne,
 Liestal 087404
Plattner, Rosina, Schladming . . . 100058
Plattsburgh Art Museum, State
 University of New York,
 Plattsburgh 052108
Platz, Danielle, Baden-Baden . . 129667
Platzer, Georg-Gustav, Oberhofen am
 Irrsee 099996
Plauener Spitzenmuseum, Plauen 020787
Play-Gallery for still and motion

Polak, R., Den Haag 112490
Polanco, San Francisco 124614
Polansky & Assoc., New York . 123227
Polar Art, Stockholm 116017
Polar Arts of Asia, Singapore . . 085312
Polar, Pascal, Bruxelles 100510
Polaris, Paris 105133
Polarmuseet, Andenes 033324
Polarmuseet i Tromsø, Tromsø . 033848
Polarolo & Sons, E., New York . 136322
Poldark Mine and Heritage Complex,
 Helston 044420
Polder, J.A., Borne . . 112432, 132827
Poldermuseum, Antwerpen . . . 003230
Poldermuseum, Puttershoek . . . 032592
Poldermuseum de Hooge Boezem
 Achter Haastrecht, Haastrecht . 032224
Poldermuseum Den Huijgen Dijck,
 Heerhugowaard 032253
Poldermuseum Het Grootslag –
 Nationaal Saet en Cruytmuseum,
 Andijk 031829
Poldowrian Museum of Prehistory,
 Coverack 043823
Polemiko Mouseio, Athinai . . . 022621
La Polena, Genova 110142
Polenmuseum Rapperswil,
 Rapperswil 041612
Poleschi Arte, Forte dei Marmi . 110097
Poleschi Arte, Lucca 110207
Poleschi Arte, Milano 110419
Polesden Lacey House, Dorking 043934
Poleski Ośrodek Sztuki, Łódź . . 113767
Poletti, Carlos, Milano 131893
Poley, Dennis, Alreswas 088027
Polgár, Budapest 079178, 109181,
 126373
Poli Museo della Grappa, Bassano del
 Grappa 025310
Poli, Eugenio, Firenze 131637
Poli, Paolo, Firenze 131638
PoliArt Studio d'Arte, Milano . . 110420
Poliarts 2000, Milano 080512
Polibinskij Memoralnyj Muzej-usadba
 S.V. Kovalevskoj, Polibino . . . 037491
The Police Museum, Belfast . . . 043319
Police Museum, Hong Kong . . . 007695
Police Museum, Imphal 023993
Police Station and Courthouse
 Collections, Auburn 000810
Polidori, Alberto, Perugia 132147
Poliester, Cuauhtémoc 138961
Il Polifilo, Milano 142558
Polifroni, Felice, Torino 132566
Poligrafa, Barcelona 138060
Polimento e Restauraçoes São
 Domingos, São Paulo 128379
Polish American Museum, Port
 Washington 052172
Polish Association of Members of the
 Museum Professions, Kraków . 059619
Polish Cultural Institute, London 044977
Polish Museum of America,
 Chicago 047655
Polish Sculpture, Orońsko 139024
Polisher, Tulsa 136769
Polishistoriska Museet,
 Stockholm 040832
Polistekniska Museet, Solna . . . 040779
Politeama Gallery, Roma 110865
Politechničski Muzej, Moskva . . 037322
Political Life Museum, Amman . 029594
Political Memorbilia Marketplace, Las
 Vegas 094003
Political Museum, Shanghai . . . 008057
Politie-Petten Museum,
 Slochteren 032704
Politiemuseum Oudaan,
 Antwerpen 003231
Politiemuseum Provincie Antwerpen,
 Wommelgem 004074
Politimuseet i Oslo, Oslo 033682
Polizeihistorische Sammlung Berlin,
 Berlin 017054

Polizeimuseum, Basel 041079
Polk County Heritage Gallery, Des
 Moines 048246
Polk County Historical Museum,
 Bartow 046774
Polk County Historical Museum,
 Cedartown 047457
Polk County Historical Museum,
 Osceola 051734
Polk County Historical Society, Des
 Moines 048247
Polk County Memorial Museum,
 Livingston 050295
Polk County Museum, Balsam
 Lake . 046693
Polk County Museum, Crookston 048034
Polk Museum of Art, Lakeland . 050048
Polk Place Antiques, Nashville . 094858
Polkadot Gallery, Exeter 117966
Poll, Eva, Berlin 106392
Pollak, Tel Aviv 142436
Pollak, Patrick, South Brent . . . 144593
Polland, Günther, Wien 140095
Pollard, Indianapolis 093752
Poller Media GmbH, Frankfurt am
 Main 106983, 137424
Pollet & Desrumeaux, Lille 069446
Pollet Thiollier, Guy, La Clusaz . 068942
Pollheide, Gerhard, Sayalonga . . 115534
Pollinger, Roger, Turtmann . . . 087663,
 134260
Pollismolen, Bos-en Pijpenmuseum,
 Bree . 003321
Pollmächer, Dr. Stefan, Bad
 Zwesten 106050
Pollock, Los Angeles 094280
Pollock Gallery, Southern Methodist
 University, Dallas 048086
Pollock, Charles, West Hollywood 097754
Pollock's Toy Museum, London . 044978
Pollok House, Glasgow 044251
Polloni & C., Guido, Firenze . . . 131639
Polly, Venlo 112804
Polnecq, Catherine, Paris 129348
Polnische Buchhandlung – Ksiegarnia
 Polska, Wien 140096
The Polo Gallery, Galway 119646
Polo-Lodge Antiques, Tulsa . . . 097589
Polokwane Art Museum,
 Polokwane 038627
Polonia Art, Katowice . 084367, 126616
Polos, Brunswick Heads 061216
Polplakat, Warszawa 113980
Polska Federacja Fotograficznych
 i Audiowizualnych Stowarzyszeń
 Twórczych, Wrocław 059620
Polska Izba Artystów Konserwatorów
 Dzieł Sztuki, Warszawa 059621
Polskie Foto, Wrocław 139025
Polskie Towarzystwo Archeologiczne
 i Numizmatyczne Zarzad Główny,
 Warszawa 059622
Polson Park and Museum,
 Hoquiam 049514
Polstjernan Antik, Stockholm . . 086858
Poltavs'kyj Chudožnij Muzej,
 Poltava 043017
Poltavs'kyj Krajeznavčyj Muzej,
 Poltava 043018
Poltavs'kyj Literaturno-memorial'nyj
 Muzej I.P. Kotljarevskogo,
 Poltava 043019
Poltavs'kyj Literaturno-memorial'nyj
 Muzej Panasa Myrnogo, Poltava 043020
Poltavs'kyj Literaturno-memorial'nyj
 Muzej V.G. Korolenka, Poltava . 043021
Poltavs'kyj Muzej Aviaciï ta
 Kosmonavtiki, Poltava 043022
Pôltsamaa Muuseum, Pôltsamaa 010481
Poluch, J., Livinské 133414
Poluschkin, S., Much 108015
Pôlva Talurahvamuuseum,
 Karilatsi 010452
Polvere di Stelle, Padova 110595

Polvo Art Studio, Chicago 047656
Polvo Magazine, Chicago 139509
Poly Art Museum, Beijing 007455
Poly International Auction,
 Beijing 125672
Poly Produzentengalerie e.V.,
 Karlsruhe 107507
Poly, M.D., Floirac 103696
Polyedre, Antwerpen 063176
Polygnotos Vagis Museum,
 Thassos 022942
Polygraphicum, Eberbach 075511,
 141644
Polylustre, Fortaleza 063894
Polynesian Cultural Center, Laie 050019
Polyphon, Heemstede 142978
Polytechnique, Bruxelles 140166
Polyteekkarimuseo, Espoo 010605
Polzin, Saskia Gesa, Paderborn . 130871
Pom Pom, Los Angeles 094281, 094282
Poma, Paolo, Morcote 116603
O Pomar dos Artistas, Lisboa . . 133313
Pomar, Maria, Palma de Mallorca 115459
Pomares Esparza, J., Pamplona 115486
Pomarium Anglicum Obstmuseum,
 Sörup 021489
Pomarkun Kotiseutumuseo,
 Pomarkku 011085
Pomázer Heimatstube, Sinsheim 021481
Pomegranate Europe, Warwick . 138346
Pomeroy Living History Farm,
 Yacolt 054437
Pomes Penyeach, Newcastle-under-
 Lyme 144498
Pomez, Olivier, Paris 071749
Pomfret Gallery, Pontefract . . . 119162
Pomier, Lyon 069719
Pomiès, Yveline, Toulouse 129541
Pomme d'Ambre, Nancy 070377
Pomme de Pin, Bergerac 067047
La Pomme d'Or, Genève 087304
Pommerat, Gérard, Toulouse . . 073754
Pommersches Bettenmuseum,
 Flugplatzmuseum Peenemünde,
 Peenemünde 020729
Pommersches Landesmuseum,
 Greifswald 018525
Pommier, Gérard, Ferney-Voltaire 068468,
 103690
Pommois, Isabelle, Paris 071750
Pomona College Museum of Art,
 Claremont 047719
Pomone, Lutry 116554
Pomorski i povijesni muzej Hrvatskog
 primorja, Rijeka 008809
Pomorski Muzej, Zadar 008857
Pomorski muzej Orebić, Orebić . 008791
Pomorski Muzej Sergej Mašera,
 Piran 038407
Pomorski Muzej u Kotoru, Kotor 031570
Pomorski Muzej, Dubrovački Muzeji,
 Dubrovnik 008745
Pomorskie Muzeum Wojskowe,
 Bydgoszcz 034506
Pompallier Mission and Printery,
 Russell 033124
Pompei, Franco, Roma 132400
Pompejanum, Bayerische Verwaltung
 der staatlichen Schlösser, Gärten
 und Seen, Aschaffenburg 016426
Pompey Museum of Slavery and
 Emancipation, Nassau 003132
Pompous Peasant, Tampa 097418
Pomskizillious Museum of Toys,
 Xaghra 030592
Ponca City Art Association, Ponca
 City . 060688
Ponce DeLeon Inlet Lighthouse, Ponce
 Inlet . 052143
Ponce, Raquel, Madrid 115360
Ponceblanc, Jouannin, Saint-Rambert-
 en-Bugey 073244
Poncelet, David, Cambrai 067559
Poncet, Michel, Essertines-sur-

Yverdon 087229
Pond, London 118726
Pond Cottage Antiques,
 Stillington 091279
Pond, Lily, Geelong 061504
Pondicherry Museum,
 Pondicherry 024131
Pongauer Heimatmuseum im Schloß
 Goldegg, Goldegg 001944
Pongnoi Community Art Space, Chiang
 Mai . 117059
Pongratz, Alois, Zwiesel 079061
Pongratz, Wolfgang, Graschuh . 128007
Poniger Clocks and Watches,
 Armadale, Victoria 061037
Ponitrianske Múzeum, Nitra . . . 038230
Pons, Chantal & Patrick, Lyon . . 069720,
 128964
Ponse, Charenton-le-Pont 067782
Ponsford, A.J. & R.L., Barnwood 088138,
 134386
Ponshu-kan-Echigo Sake Museum,
 Yuzawa 029571
Pont & Plas, Gent 100563
Pont-Dépôt Ventes, Pont-Saint-
 Esprit 072219
Le Pont des Arts, Narbonne . . . 104300
Le Pont du Diable, Céret 067694
Le Pont Traversé, Paris 141226
Pont, Michel, Biarritz 067153
De Pont, Museum voor Hedendaagse
 Kunst, Tilburg 032748
Pont, Philippe, Saint-Loubès . . . 072856
Ponte, Beograd 085170
A Ponte – Galeria de Arte, São
 Paulo 100969
Il Ponte Contemporanea, Roma . 110866,
 137839
Il Ponte, Casa d'Aste, Milano . . 080513,
 110421, 126426
Pontecorboli, Angelo, Firenze . . 137752
Ponteduro Antichità, Bologna . . 079718,
 131389
Pontefract Castle Museum,
 Pontefract 045479
Pontefract Museum, Pontefract . 045480
Ponterio & Assoc., San Diego . . 096959
Ponti, Alessio, Roma 110867
Ponti, Francesco, Roma 142650
Ponticq, Michèle, Duras 068363
Ponticq, Michèle, Monpazier . . . 070117
Pontifical Biblical Institute Museum,
 Jerusalem 024921
Pontiki Thalia, Lefkosia 102495
Pontis'Antic, Valbonne 073897
Ponto de Antiguidades, Porto
 Alegre 128358
Pontremoli, Milano 142559
Pontual, Mauricio, Rio de Janeiro 100918
Pontypool and Blaenavon Railway,
 Blaenavon 043419
Pontypool Museum, Pontypool . 045483
Pontypridd Museum, Pontypridd 045484
Pony Express Museum, Saint
 Joseph 052686
Ponyhof Artclub, München 108184
Ponziani – Lo Studiolo, Firenze . 131640
Pool Dickynson, Madrid 133723
Poole, Douglas, Toronto 064673
Poor Man's Gallery, Virginia
 Beach 125089
Poor Richard's Auctions, Tacoma 127737
Poor Richard's Books, Felixstowe 144186
Poorhosaini, S.N., Darmstadt . . 075261
Poorter, Johanna de, Antwerpen 100366
Pop and Contemporary Fine Art,
 Singapore 114671
Pop Angel House Museum,
 Tryavna 005129
Pop Antik, Helsinki 066296
Pop-Art, Čačak 114529
Pop Culture Classics, Phoenix . . 096070
Pop Indiana, Indianapolis 121494
pop/off/art, Berlin 106393

Portret na Życzenie, Warszawa . 113981
Portretgalerie, Den Haag 112491
Portrush Antiques, Nelson 083863
Portsea Island Decorative and Fine
 Arts Society, Portsmouth 060187
Portsmouth & Hampshire Art Society,
 Porstmouth 060188
Portsmouth Athenaeum,
 Portsmouth 052222
Portsmouth Auctions, Portsmouth 127268
Portsmouth Museum, Portsmouth 052228
Portsmouth Museum of Military
 History, Portsmouth 052235
Portsoy Salmon Bothy Museum,
 Portsoy 045521
Portsteffen, Prof. Hans, Köln . . 130487
The Portstewart Galleries,
 Portstewart 119182, 119183
Portugall, Dieter, Koblenz 107563
Portuondo Wakonigg, Jorge,
 Bilbao 085705
Portuondo Wakonigg, Ramón,
 Madrid 086065
Portz, Sascha, Niederzissen . . . 077704
Porvoon Museo, Porvoo 011096
Porzelan-Klinik, Hamburg 130286
Porzellan Klinik Leipzig, Leipzig . 130568
porzellan museum frankfurt,
 Kronberger Haus, Frankfurt am
 Main 018180
Porzellanikon Hohenberg, Hohenberg
 an der Eger 018996
Porzellanikon Selb, Selb 021433
Porzellanmuseum Reichmannsdorf,
 Reichmannsdorf 020971
Porzellansammlung, Staatliche
 Kunstsammlungen Dresden,
 Dresden 017766
Porzellanwerkstatt, Freiburg im
 Breisgau 130161
Porzellanwerkstatt, Köln 130488
Pos-Art, Montréal 101306
Posada Alvarez, María Teresa,
 Medellín 102359
Posada Art Books, Bruxelles . . 140167
Posadovský, Bedřich, Praha . . . 128600
Posavski Muzej Brežice, Grad Brežice,
 Brežice 038318
Posch, Gabriele, Birkfeld 062523
Posion Kotiseutumuseo, Posio . . 011100
Posipal, Veit, Dresden 129994
Positive, Dijon 068287
Positive Images Art, Austin . . . 119970
Positive Negative Visual Gallery,
 Bali 109530
POSK Gallery, London 044979
Pospieszczyk, Jürgen,
 Regensburg 078093
Pospišil, Josef, Kutná Hora . . . 128570
Pospíšilová, Dr. Marie, Praha . . 102683,
 128601
Poßegger, Stefan, Trautenfels . . 062829
Posselt, M. I., Bonn 106537
Posset, 's-Hertogenbosch 112616
Possibilities, Jacksonville 093861
Possibilities, New Orleans 094979
Possum Art Gallery, Beenleigh . 098575
Possum Brush Gallery, Taree . . 099672
Post, Enschede 083069
Post, Los Angeles 121854
Post & Tele Museum, København 010029
Post 10 Antiques, Oklahoma City 095837
Post-Archaeological Institute,
 Jackson 049716
Post Art, Amsterdam 082639
Post Fine Arts, Wilfried Post, Freiburg
 im Breisgau 107022
Post Gallery, Houston 121394
Post Horn Books, Settle 144573
Post House Antiques,
 Bletchingley 088286
Post Museum, Fort Leavenworth
 Historical Society, Fort
 Leavenworth 048792

Post Rock Museum, Rush Co
 Historical Society, La Crosse . . 049981
Post Script Antiques, London . . 090261
Post Scriptum, Bologna 131390
Post, Bert, Noorden 137961
Post, Emmanuel, Berlin 106394
Post, J.G., Breda 132836
Post, L.A., Benningbroek 132816
Postakürt Galéria, Miskolc 023468
Postal Museum, Amman 029595
Postal Museum, Cairo 010387
Postal Museum, Cheonan 029728
Postal Museum, Shanghai 008058
Postal Museum, Taipei 042265
Postal Museum and Philatelic Library,
 Manila 034376
Postal Museum Botswana,
 Gaborone 004213
Postamúzeum, Balatonszemes . . 023110
Postamúzeum, Budapest 023223
Postamúzeum, Hollókő 023371
Postamúzeum, Nagyvázsony . . . 023484
Postamúzeum, Opusztaszer . . . 023492
Postapalota, Pécs 023526
La Poste d'Antan, Paris 071754
La Poste d'Autrefois, Paris 141227
Poste de Traite Chauvin,
 Tadoussac 006957
Poste du Village, Rennes (Ille-et-
 Vilaine) 141275
Poster Art, Buffalo 120244
Poster Art, San Diego 124403
Poster Art Gallery, Genève 116433
Poster Art Place, San Antonio . . 124306
Poster Arts, Los Angeles 121855
Poster Dizajn, Moskva 114375
Poster-Galerie, Hamburg 107284
Poster Galerie, Innsbruck 099915
Poster Galerie Wien beim
 Hundertwasserhaus, Wien . . . 100225
Poster Gallery, Albuquerque . . . 119778
Poster Gallery, Kansas City . . . 121589
Poster Planet, Sacramento 124026
Poster Plus, Chicago 120517
Poster Portfolio, New York 123230
Poster Restoration Studio, Los
 Angeles 136088
The Poster Shack, Norfolk 123486
Poster Shoppe Gallery, Columbus 120788
Poster Source, San Francisco . . 124615
Poster Store, San Diego 124404
Poster World, Phoenix 123761
Postergalerie, Dortmund 106688
Postergalerie Flensburg,
 Flensburg 106924
Posteritati, New York 123231
Posterity Graphics, Toronto 101545
Posterman, Louisville 121944
Posteroptics, Windsor, Ontario . . 101725
Posterplanet, Portland 123908
Posters, Abu Dhabi 117233
Posters, San Antonio 124307
Posters and Frames, San Diego 124405
Posters Etc, Toronto 101546
Posters Posters, Atlanta 119881
Posterworld, Saint Louis 124107
Postgeschichtliches Museum,
 Recklinghausen 020932
Posthoorn, Rotterdam 083399
Postimuseo, Helsinki 010681
Postmark Gallery, Kansas City . . 121590
Postmasters, New York 123232
Póstminjasafn Íslands,
 Hafnarfjörður 023758
Le PostMusée, Luxembourg . . . 030420
Postmuseum, Stockholm 040833
Postmuseum des Fürstentums
 Liechtenstein, Vaduz 030139
Postmuseum Mettingen,
 Mettingen 020051
Postmuseum Rheinhausen,
 Oberhausen-Rheinhausen 020546
Il Posto delle Briciole, Milano . . 080517
Postojannaja Požarno-techničeskaja

Vystavka, Sankt-Peterburg . . . 037641
Postons, Neil, Leominster 134866
Poštové Múzeum Banská Bystrica,
 Banská Bystrica 038100
Poštovní Muzeum, Praha 009677
Poštovní Muzeum, Poštovní Muzeum
 Praha, Vyšší Brod 009807
Postrotemuseet, Storby 011195
Postville Courthouse Museum,
 Lincoln 050230
Le Potager, Jacksonville 093862
Potala Art Gallery, Kathmandu . . 112158
Potamianos, Johann, München . 077520
Potard, Simone, Dierre 068244
Potashnik, David, Coulsdon . . . 088764,
 134613
Potboard Antiques, Tenby 091413
Potburys, Sidmouth 127301
Potchefstroom Museum,
 Potchefstroom 038631
Le Poteau Rose, Lambersart . . . 103867
Potennec, Jean-Claude, Verdun
 (Meuse) 073983
Potereau, Châteauroux 103534
Poterie Dubois-Musée la Grange aux
 Potiers, Boulffioulx 003307
Pothmann, Willi, Siegen 078386
't Pothuis, Haarlem 083161
't Pothuis, Zutphen . . . 083540, 133052
Potiron, Marc, Saint-Sébastien-sur-
 Loire 073266
Potland Museum, Basildon 043263
Potluck, Nashville 094859
Potomac Fiber Arts Gallery,
 Alexandria 119802
Potoroo, South Melbourne 099564
Potpourri, Lörrach 077085
Potpourri, Pittsburgh 123818
Potrebny, H. & M., Horb am
 Neckar 076511
Potrony, Miami 122122
Potsdam-Museum, Forum für Kunst
 und Geschichte, Potsdam . . . 020836
Potsdam Public Museum,
 Potsdam 052239
Potstada, Heike, Kiel 076723
Pottenbakkerij De Brinksteen,
 Dwingeloo 112533
Pottenbakkerij Het Ovenhuis,
 Ruinerwold 032658
Pottenbakkerij Museum,
 Kattendijke 032360
Potter, Houston 093603
Potter, Lewes 089623, 134872
Potter, Merredin 127912
Potter, Vancouver 064813
Potter Art Gallery, Missouri Western
 State University, Saint Joseph . 124040
The Potter Clarke Gallery, Saint Ives,
 Cornwall 119283
Potter County Historical Society
 Museum, Coudersport 047996
Potter, Barry, Stockton-on-Tees . 127311
Potter, Jonathan, London 144428
Potter, Nick, London 118729
Potter & Son, W.G., Axminster . 088096,
 134364
Potteries Antique Centre, Stoke-on-
 Trent 091306
The Potteries Museum and Art Gallery,
 Stoke-on-Trent 045870
Potteries Specialist Auctions,
 Cobridge 127069
Potters, Gladstone 098935
Potter's Antiques and Coins,
 Bristol 088445
Potters Bar Museum, Potters Bar 045523
Potters Cottage Gallery,
 Warrandyte 099723
Potter's Guild of San Diego, San
 Diego 060689
Potters, Chelsea, Auckland 112893
Potterton, New York 145108
Potterton, Thirsk 144623

Pottery Art Cooperative, Wuxi . . 058471,
 102155
The Pottery Buying Centre, Stocke-on-
 Trent 091290
Pottery Northwest Seattle Center, 305
 Harrison St, Seattle 124837
Pottery Stall, Hong Kong 101992
Pottery Studio, Seattle 124838
Pottery Workshop, Hong Kong . 101993
Pottier, Jean-Roger, Vitteaux . . . 074227
Potton, Craig, Nelson 137976
Pott's Antiques, London 090262
Potts Inn Museum, Pottsville . . . 052242
Potts, Ludovic, Ely 134681
Pottsgrove Manor, Pottstown . . 052241
Potuguesa, Tostedt 108781
Potzmann, Franz, Litzelsdorf . . . 128078
Pou d'Art, Sant Cugat del Vallès 115508
Pou, Aura & S., Barcelona 133505
Poubeau, Anne, Sancerre 073362
Pouce Coupe and District Museum,
 Pouce Coupe 006551
Pouch Cove Museum, Pouch
 Cove 006552
Pouch, M., Český Krumlov 140430
Pouffier, Elisabeth, Dijon 068288
Pouillier, Michel, Saint-Maixme-
 Hauterive 072870
Pouillon, François, Versailles . . . 074029
Poulain, Emile, Baud 066906
Poulain, Pierre, Paris 071755
Le Poulbot, Porto-Vecchio 072248
Poulin, Steve & Jeannine,
 Fairfield 127485
Poulmarch, Armelle, Brest 103416
Poulsen, Kolding 065903
Poulsen, Margit, Fanø 065580
Poulsen, Svend, Silkeborg 066037
Poulter & Son, H.W., London . . 090263,
 135087
Pound Gallery 1216 10th Av,
 Seattle 124839
Pound Ridge Museum, Pound
 Ridge 052249
Pound Sreat Gallery, Carshalton 117690
Pounder Kone Art Space, Los
 Angeles 121856
Pounder, Nicholas, Double Bay . 139747
Pounds, Linda, Houston 093604
Poupard, Marguerite, Sers 073471
Poupée Merveilleuse, Marcy . . . 069816
Poupée Passion, Longueil 128930
Poupées Retrouvées, Paris 071756,
 129349
Pourhossein, Hossein, Darmstadt 075262
Pourny, Christian, Fayence 068462
Pourrier, Nathalie, Arras 066681
Pouryun Museum, Guanyun . . . 007626
Pousse-Cornet, Marie-Edith,
 Blois 125793
Poussier, Charles, Nanterre . . . 070386
La Poussière du Temps, Paris . . 141228
Poussières, Bruxelles 063474
Poussières d'Empires, Paris . . . 071757
Poussin Gallery, London 118730
Poutrain, Pascal, Douai 068337
Poutsma, J., Kampen 142988
Pouvreau, Cathy, Lille 103964
Pouyet, Gérard, Cluses 067996
Považská Galéria Umenia, Žilina 038304
Považské Múzeum, Žilina 038305
Povijesni i pomorski muzej Istre,
 Pula 008805
Powder Magazine, Beechworth . 000840
Powder Magazine, Charleston . . 047522
Powderham Castle, Kenton 044544
Powderhouse Antiques, New
 York 095502
Powell, Chicago 144790, 144791,
 144792
Powell, Columbus 092875, 120789
Powell Bros. & Sons, Salt Lake
 City 096751, 136580
Powell County Museum, Deer

Ränkimäen Ulkomuseo, Lapua . 010922
Rätisches Museum, Archäologische, historische und volkskundliche Sammlungen Graubündens, Chur 041195
Rättviks Antik och Auktion, Rättvik 086731, 126866
Rättviks Konstmuseum och Naturmuseum, Rättvik 040719
Rätzel, Georg, Gießen . 075941, 107088
Rätzer, Meißen 077269
Rätzer, Thomas, Dresden 075379
Raevangla Fotomuuseum, Tallinna Linnamuuseum, Tallinn 010516
Rafael, New York 123245
Rafael, Tehrān 079322
Rafael, Marc, Paris 071768
Rafanelli, Fabio, Genova 110145
Rafanelli, Luca, Firenze 131641
Rafelman, Marcia, Toronto . . . 101556
Rafer, Aline, Saint-Étienne 072731
Raff, Erwin, Denkendorf 129935
Raffael-Verlag, Ittigen 138132
Raffaelli, Giordano, Milano . . . 110427
Raffaello, Providence 123958
Raffaghello, Sabrina, Ovada . . 110570
Raffan & Kelaher, Leichardt . . 125487
Raffenel, Jean-Pierre, Domagné 068314
Raffety & Walwyn, London . . . 090269
Raffin, Jean-François, Paris . . . 071769
Raffles, Singapore . . . 114674, 126699
Rafo Antigüedades, Lima 084298
Raft Artspace, Parap 099415
Rag and Bone Books, Minneapolis 145023
La Rage, Lyon 104078
Råger's Antik, Malmö 086673
Rageth, Jürg, Riehen 116681
Ragged School Museum, London 044986
Raggedy, Anne, Oklahoma City . 095838
Raggl-Thurner, Schönwies 128128
Ragici, Dr. Luigi, Milano . . . 080528
Ragini Art Village, Lalitpur . . . 112174
Ragione e Sentimento, Roma . . 081351
Raglan and District Museum, Raglan 033116
Raglan Castle and Visitor Centre, Raglan 045541
Raglan Dealers, Raglan 083920
Raglan Gallery, Cooma 098777
Raglan Gallery, Manly 099139
Raglan's Right Up My Alley, Raglan 083921
Ragley Hall, Alcester 043120
La Ragnatela, Milano 080529
La Ragnatela, Roma . . 081352, 132405
Ragona, Gioacchino, Palermo . 080901
Ragone, Vittorio, London 090270
Ragosta, Alfonso, Lecce 126416
Ragot, Jones, Paris 071770
Ragtime, Bari 079671
Ragusa, Valerio, Padova 080833
Raguseo, Edward, New York . . 095508
Rah-Coco, Providence 096348
Raha- ja Mitalikokoelma, Helsinki 010682
Rahäuser, H., Breisach am Rhein 075099
Rahardt, Mike, Leipzig 130569
Rahbarnia-La Persia, San Marino 133391
Al-Rahiq, Damascus 087849
Rahm-Nebling, Monika, Kaiserslautern 076600
Rahmanan, New York 095509
RahmenArt, Hamburg 107287
Rahmi M. Koç Müzesi, İstanbul . 042683
Rahn, C., Berlin 074859
Rahn, Dr. P., Leipzig 107837
Rahr West Art Museum, Manitowoc 050585
Raicri, Preto, Belo Horizonte . . 100765, 100766
Raiffeisenhaus, Flammersfeld . . 018114
Raigné, Raymond, Fourcès 068544
Raike, Tucson 097523

Rail Museum, Egyptian National Railways Museum, Cairo 010391
Rail Transport Museum, Bassendean 000827
Railings Gallery, London 118737
Railroad and Heritage Museum, Temple 053593
Railroad House Historical Museum, Sanford 052970
Railroad Memories, Denver 093164
Railroad Museum of Long Island, Riverhead 052490
Railroad Museum of Pennsylvania, Strasburg 053449
Railroad Sales Agent, Milwaukee 094712
Railroader's Memorial Museum, Altoona 046391
Rail's End Gallery – Haliburton Highlands Guild of Fine Arts, Haliburton 005826
Railway Age, Crewe 043841
Railway Bizarre, Ringwood . . . 062141
Railway Coastal Museum, Saint John's 006752
The Railway Exposition, Covington 048007
Railway Museum, Gorakhpur . . 023949
Railway Museum, Kalamata . . . 022712
Railway Museum, Livingstone . . 054766
Railway Museum, Mysore 024112
Railway Museum, Ravenglass . . 045548
Railway Museum, Saitama 029121
Railway Museum, Wylam 046237
Railway Preservation Society of Ireland, Whitehead 046145
Railway Square Antique Centre, Toowoomba 062324
Railway Station Gallery, Pomona 099437
Railway Station Museum, Castlegar 005473
Railway Station Museum, Uitenhage 038687
Railway Station Museum, Wonthaggi 001653
Railways to Yesterday, Rockhill Trolley Museum, Rockhill Furnace . . 052541
Railworld, Peterborough 045446
Raimbourg, Thierry, Barentin . . 066888
Raimo, Antonio, Atlanta 092010, 119883, 144709
Raimondi, Bassano del Grappa . 109792
Raimondi di Pettinaroli, Milano . 110428
Raimondo, Guglielmo, Palermo . 110633
Raimund-Gedenkstätte, Gutenstein 002007
Raimundo Requixa, Maria Concepcion, Alicante 085523
Rain Forest Art Gallery, Barrio Turnón 102367
Raiņa Literatūras un Mākslas Vēstures Muzejs, Rīga 030041
Raiņa Memoriālais Muzejs Jasmuiža, Preiļi 029997
Raiņa Muzejs Tadenava, Dunavas 029944
Raiņa un Aspazijas Māja, Rīga . 030042
Raiņa un Aspazijas Memoriālā Vasarnīca, Raiņa Literatūras un Mākslas Vēstures Muzejs, Jūrmala 029966
Rainbird Art Gallery, Montville . 099233
Rainbow Art, Tampa 124919
Rainbow Arts Gallery, Singapore 114675
Rainbow Books, Brighton 144038
Rainbow Books, Wellington . . . 143184
Rainbow Fine Art, New York . . . 123246
Rainbow Galerie, Riehen 116682
Raindre, Guy, Paris 071771
Raine, Harry, Consett 088752
Rainer-Regiments-Museum, Salzburg 002582
Rainforest Arts, Atherton 098525
Rainforest Gallery, Canungra . . 098718
Rainham Hall, Rainham 045542

Raintree Aboriginal Art Gallery, Darwin 098808
Raintree Abporiginal Art Gallery, Darwin 061380
Rainy Hills Pioneer Exhibits, Iddesleigh 005904
Rainy River District Women's Institute Museum, Emo 005672
Rainyday Gallery, Penzance . . . 119123
Rais Ali Delvary Museum, Bushehr 024385
Rait Village Antiques Centre, Rait 090915
Raitioliikennemuseo, Helsingin Kaupunginmuseo, Helsinki . . . 010683
Raiz, Donostia-San Sebastián . . 085806
Raj, Gent 063600, 063601
Raj, New York 095510
Raja Dinkar Kelkar Museum, Pune 024143
Rajabhat Institute, Bangkok . . . 056427
Rajaju, South Fremantle 099558
Rajalahden Talomuseo, Virrat . 011336
Rajamuseo, Imatra 010727
Rajcevic, Marinko, Neuwied . . . 077697
Rajesk Chitrakar, Lalitpur 112175
Rajic-Cretegny, Hélène, Genève . 087306
Rajkiya Sangrahalaya, Udaipur . 024196
Rajoloteca Salvador Miquel, Vallromanes 040158
Rajpol, Warszawa 084571
Rajputana Museum, Ajmer . . . 023812
Rajskij Sad, Moskva 114376
Rakennuskulttuuritalo Toivo ja Korsmanin talo, Pori 011088
Rakhine State Museum, Sitture . 031652
Rakhtshuy-Khaneh Museum, Zanjan 024490
Rakiura Museum, Stewart Island 033127
Rakkestad Bygdetun, Rakkestad 033705
Rákóczi Múzeum, Magyar Nemzeti Múzeum, Sárospatak 023547
Rákospalotai Múzeum, Budapest 023224
Rakstniecības un Mūzikas Muzejs, Rīga 030043
Rakstnieka Herberta Dorbes Māja-Muzejs Senču Puteķļi, Ventspils 030082
Raku, Singapore 114676
Raku Museum, Kyoto 028792
Rakushu Rakuchu Gallery, Kyoto 028793
Rakvere Linnakodaniku Muuseum, Rakvere 010482
Rakvere Linnus-Muuseum, Rakvere 010483
Rakvere Näitustemaja-Museum, Rakvere 010484
RAL Productions, Chicago 120527
Raleigh City Museum, Raleigh . . 052360
Raleigh Hill's Upholstery, Portland 136498
Ralf's Antiques, West Hollywood 097757
Sri Rallabandi Subbarao Government Museum, Rajahmundry 024149
Rallarmuseet, Moskosel 040656
Ralli Museum, Caesarea 024850
Ralls Historical Museum, Ralls . 052361
Ralls, Marsha, Washington . . . 125201
Ralph Allen Memorial Museum, Oxbow 006464
Ralph Foster Museum, College of the Ozarks, Point Lookout 052132
Ralph M. Chait Galleries, New York 095511, 123247
Ralph Milliken Museum, Los Banos 050416
Ralph Waldo Emerson House, Concord 047919
Ralph's Auctions, Greer 127501
Ram, Rotterdam 112745
Ram, Valencia 086355, 133824
Ram Art, Niš 114533
Ram Mala Museum, Comilla . . . 003138
Rama, Bangkok 079255
Rama IX Art Museum, Bangkok . 042406
Ramadier, Ludovic, Avignon . . . 066827

Ramage, Christiane, Longpré-Corps-Saints 069563
Ramakers, Den Haag 112493
Ramalhete, Lisboa 126665
Raman Science Centre, Nagpur . 024116
Ramani, Utrecht 083473
Ramania Art Emporium, Kathmandu 112159
Rambaldi, Paolo, Molinella 142574
Rambert, Michel, Lyon 125906
Rambling Rose Antiques, Fort Worth 093308
Rambo Antigüedades, Buenos Aires 060916
Rambourg, Eric, Bordeaux 128745
Le Rameau d'Or, Lyon 140890
Ramee, Washington 125202
Rameix, Christophe, La Celle-Dunoise 068908, 103827
Ramer, Andreas, Schnaitsee . . . 078301
Ramer, Andreas, Seefeld 078361
Ramesberger, Andrea, Steyr . . . 062818
Ramex Galerie, Kassel 076662
Ramez, Cairo 066189
Ramirez Perez-Lucas, Tomas, Madrid 115366
Ramirez, Angel, Miami 122127
Ramirez, Gabriel, Bogotá 128520
Ramirez, M., Phoenix 145170
Ramirez, Mario, Los Angeles . . 094286, 136089
Ramiro, Madrid 086068, 086069, 126759, 143588
Ramiro & Leitão, Lisboa 084774
Ramkema, Dik, Overveen 143022
Ramla Museum, Ramla 025003
Ramlingappa Lamture Museum, Osmanabad 024120
Rammal, Damascus 087850
Rammehåndværk, København . . 128635
Rammerscales, Lockerbie 044782
Ramón i Cabrera, Castello de la Plana 085755
Ramón Magsaysay Memorabilia Museum, Manila 034379
Ramona's Antiques, Atlanta . . . 092011
Ramondon, Guéthary 103754
Ramoneda Soler, Maria Rosa, Barcelona 133507
Ramoni, Roberto, Roma 081353
Ramon's Antique Store, Los Angeles 094287
Ramon's Antique Store, West Hollywood 097758
Ramos Iznata, Jose Luis, Málaga 086127
Ramos, Dário, Porto 114188
Ramos, Noémio Santos, Faro . . 114060
Ramose, Maastricht 083289
Rampa, Ivano, Almens 133967
Rampal, Jean-Jacques, Paris . . . 071772, 129355
Rampazzo, Luciana, Roma 132406
Rampouch, Jaroslav, Olomouc . 065365
Ramsauer, Angela, Geiselhöring . 130186
Ramsay, London 090271
Ramsay Cornish, Edinburgh . . . 127098
Ramsay Museum, Honolulu . . . 115487
Ramsay, Fred, Plamerston North 083917
Ramsay, John, Vancouver 101687
Ramsdell, Nowa Nowa 099357
Ramsden Morrison, San Diego . 124409
Ramsey, Saint Paul 124174
Ramsey Center for Arts, Shoreview 053200
Ramsey Garland, Philadelphia . . 095992
Ramsey House Museum Plantation, Knoxville 049969
Ramsey Rural Museum, Huntingdon 044481
Ramsey, Jeremy, Singapore . . . 114677
Ramsgate Maritime Museum, Ramsgate 045543
Ramsgate Museum, Ramsgate . . 045544
Ramunni, Francesco, Bari 079672

Raven & the Bear, Vancouver . . 101688
Raven Press Gallery, Dunvegan . 117875
Raven Row, London 118738
Ravenel, Saint Pierre 114460
Ravenel, Taipei 117008, 126975
Ravenna, Seattle 145336
Raven's Den Native Art Gallery,
Vancouver 101689
Raven's Nest Antiques,
Wellington 084046
Ravenswood, Chicago 092612
Raverty's Motor Museum,
Echuca 001047
Ravestijn, Amsterdam 082649
Ravet, Marc, Boiscommun 067214
Raveyre, Antoine, Saint-Étienne 072732
Ravier, Joëlle & Daniel, Corps-
Nuds 068105
Ravindra Art Palace, Delhi 109349
Ravintolamuseo, Lahti 010902
Ravizza, Norbert, Stuttgart 078544
Ravmuseet, Oksbøl 010101
Ravnsbjerghus Galleri, Viby 102954
Ravon, Ph., Saintes . . 073336, 141302
Ravon, Xavier & Philippe, Dax . . 068224
Raw Art Gallery, Berlin 106400
Raw Art Gallery, Chicago 120528
Raw Art UK, Chester 117727
Raw Vision, Radlett 139252
Rawhide Old West Museum,
Scottsdale 053096
Rawls Museum Arts, Courtland . 048004
Al-Rawwas, Mohammed Mwafaq,
Damascus 087852
Ray & Scott, Saint Sampson . . 091063,
135343
The Ray Drew Gallery, New Mexico
Highlands University, Las Vegas 050125
Ray E. Powell Museum,
Grandview 049164
Ray & Co, Harry, Welshpool . . . 127352
Ray, Janette, York 144684
Ray, Simon, London 118739
Raya, Singapore 114678
Raykova House Museum,
Tryavna 005130
Raym'Art, Les Sables-d'Olonne . 103939
Rayment, Derek & Tina, Barton,
Cheshire 088146, 134388
Raymond, Cincinnati 120649
Raymond Avenue Gallery, Saint
Paul 124175
Raymond M. Alf Museum of
Paleontology, Claremont 047720
Raymond, Christophe, Auterive . 066772
Raymond, Laurence, Persac . . . 072068
Raymond's Design Studio, New
York 136328
Raymore Pioneer Museum,
Raymore 006603
Raymundo's Art Gallery, Long
Beach 121685
Raynalds Mansion, Much
Wenlock 090638
Raynaud, Jean, La Roche-sur-
Yon 125879
Raynaud, Jean-Louis, Aix-en-
Provence 066413
Rayner, Port Macquarie 099454
Rayner, Michael, Cheltenham . . 144097
Raynham Hall Museum, Oyster
Bay 051786
Raynor, Tom, New Orleans 094982
Rayo Rojo, Buenos Aires 139628
Le Rayon Vert, Nantes 104294
Rayons Verts, Niort 104357
Ray's Antiques, Callington 061244
Ray's Hub, Long Beach 094056
Rayuela, Madrid 115367
Rayvec, Dallas 120926
Rayxart Invertigaciòn, Madrid . . 115368
Razstavna Galerija, Ljubljana . . 114804
Razstavna Galerija, Škofja Loka 114827
Razstavni Salon Rotovž, Maribor 038393

Razzano, Mario, Napoli 080756
Razzle Dazzle, Tucson 097524
RB Restauro Cose Antichi,
Verona 132680
RBM Fine Art Designs, Cincinnati 120650
RB's Settlers Antiques, Ulmarra . 062360
RBSA Gallery, Royal Birmingham
Society of Artists, Birmingham 043390
RC Arts, Poole 119165
RCAF Memorial Museum,
Trenton 007059
RCMP Centennial Celebration Museum,
Fairfield 005687
RCR Antique and Arts, New York 095515
RCS Libri, Milano 137791
RDS Diffusion, Paris 071779
Re-Art, Moskva 114377
Re Artú, Padova 080835
RE Create, Chicago 092613
Re Find, Cleveland 092801
Re Nova, Warszawa 133259
Re-Soul, Seattle 097324
Re-Vu, Lille 069448
Re, Francesco, Napoli 080757
Re.Ve.Ma., Torino 132571
Rea, Marcia, Freeman's Reach . 098916
Reactor, Nottingham 060194
Read Heeler, Echuca 139753
Read, Alan, Horncastle 089392
Read, John, Martlesham 090577, 135184
Reader's Book Shop, Regina . . . 140349
Readers Den, Windsor, New South
Wales 139988
Reader's Digest Art Gallery,
Pleasantville 052114
Readers Realm, Castle Hill 139723
Readers Rendezvous, Kingston . 139825
Readers Rest, Lincoln 144300
Readers Teahouse, Kenmore . . . 139818
Reader's Town, Mar del Plata . . 139637
Readers World, Birmingham . . . 144020
Reading Abbay Gateway,
Reading 045557
Reading Guild of Artists, Reading 060195
Reading Historical Society,
Reading 052392
Reading Historical Society Museum,
Reading 052386
Reading Public Museum and Art
Gallery, Reading 052390
Reading Railroad Heritage Museum,
Reading 052391
Reading Room Gallery, London . 118740
Read's, Johannesburg 085472
Read's Rare Book Shop,
Brisbane 139693
Readsboro Historical Society,
Readsboro 052394
Reaktion Books, London 138299
Real-73, Almeria 085528
Real Academia de Bellas Artes de la
Purísima Concepción, Valladolid 056349
Real Academia de Bellas Artes de
Nuestra Señora de las Angustias,
Granada 056317
Real Academia de Bellas Artes de San
Carlos, Valencia 056348
Real Academia de Bellas Artes
de San Fernando, Museo de la
Real Academia de Bellas Artes,
Madrid 056331
Real Academia de Bellas Artes de San
Telmo, Málaga 056333
Real Academia de Bellas Artes de San
Telmo, de Málaga, Málaga . . 056334
Real Academia de Bellas Artes de
Santa Isabel de Hungría, Sevilla 056346
Real Academia de Ciencias, Bellas
Artes y Buenas Letras "Luis Vélez de
Guevara", Écija (Sevilla) . . . 056316
Real Academia de Córdoba de
Ciencias, Bellas Letras y Nobles
Artes, Córdoba 056313
Real Academia de Nobles Artes de

Antequera, Antequera 056305
Real Academia de Nobles y Bellas
Artes de San Luis, Zaragoza . 056351
Real Art, Chicago 120529
The Real Art Gallery, Shrewsbury 119361
Real Cartuja, Valldemosa 040154
Real Cartuja de Miraflores,
Burgos 038985
Real Casa del Labrador, Aranjuez 038796
Real Fábrica de Tapices, Madrid 039501
Real Monasterio de San Jerónimo,
Granada 039283
Real Monasterio de Santa María de El
Puig, El Puig de Santa María . 039795
Real Mother Goose, Portland . . 123915,
123916
Real Museo Mineralogico, Napoli 026855
Real Pottery, Tring 139253
Real Reviews, Fort Worth 093310
Real TART Community Gallery, New
Plymouth 033079
Real Time, Auckland 083638
Real World Computer Museum,
Boothwyn 047062
Reale & Figli, Catania 131493
Reale, Carmelo, Catania 131494
Reali Arte Contemporanea,
Brescia 109929
Realidade Galeria de Arte, Rio de
Janeiro 100922
Die Realismusgalerie, Fuldatal . 107052
Realities Gallery, Toorak 099693
Really Cool Stuff, Portland 096301
Really Good Stuff, Portland 096302
The Realm Imports, Chicago . . . 120530
Rearasa, Zamora 086408, 133838
Reart, Bratislava 085381, 133407
Reart, Poprad 133418
Reason, C., Oxted 090787, 135261
Rebassa Guardiola, Gabriel, Palma de
Mallorca 086187
Rebbaumuseum am Bielersee-Musée
de la Vigne au Lac de Bienne,
Ligerz 041444
Rebecca Gallery, Toronto 101557
Rebecca Hossack Art Gallery,
London 118741, 118742
Rebecca Nurse Homestead,
Danvers 048105
Rebel, Marco, Luzern 134162
Rebel, Walter, Hamburg 141789
Rebelo, Antonio Silva, Lisboa . . 084776
Rebelo, Nuno A. Costa, Braga . 084611
Rebensburg, Bad Kreuznach . . . 129650
Rebillot, Jean-Louis, Nohant-Vic 070603
Reblandmuseum, Baden-Baden . 016713
Rebok, T.H., Observatory 133434
Rebolledo Cuerno, Maria Antonia,
Getxo 085834
Rebollini, Agnese, Genova 080117
Rebollo, Pepe, Zaragoza 115656
Reborn Antiques, Port Adelaide . 062081
Reborn Antiques, West
Hollywood 097759
Reboucas, Heriberto C., Fortaleza 063895
Reboul, Jean-Michel, Paris 071780
Reboul, Patrice, Paris . 071781, 071782
Rebound, Dunedin 143125
Rebound, Pittsburgh 096157
Rebourg, Claude, Neufchâteau . 070460
Rebours, Johann, Sainte-Croix-sur-
Aizier 073305
Rebuffel, Jean-Marie, Nice 070603
Rebuffel, Laurent, San Francisco 097144
Rebuttini, Sergio, Modena 131972
Le Recamier, Bruxelles 063479
Récamier, Nice 070604
Recasens Art, Barcelona 115043
Recchi, Nicoló, Roma 081356
Rech, Almine, Paris 105143
Rech, Manfred, Haan . 076087, 107152
Rechberger, Rainer, Altmünster . 139997
Rechem, Flandre van, Lille 128922
Rechnermuseum der Gesellschaft für

wissenschaftliche Datenverarbeitung,
Göttingen 018474
Rechnermuseum, Hochschule
Furtwangen Universität, Furtwangen
im Schwarzwald 018299
Rechnitzer, Berlin 129791
Rechtshistorisches Museum,
Karlsruhe 019207
Recinto Casa Benito Juárez,
Saltillo 031244
Reciprocity, Dallas 120927
Recke, Hilmar, Magdeburg 077161,
130609
Recker, H., Warendorf 078780
Recker, Michael, Mainz 130617
Reckermann, Köln 107664
Reckhaus, Rheda-Wiedenbrück . 108496
Recktenwald, L., Eppelborn 075576
Reclaimed, Seattle 097325
Le Recoin, Voiron 074237
Recollect Dolls Hospital, Burgess
Hill 088496, 134505
Recollection-Antiques, Los
Angeles 094288
Recollections, Brighton 088414, 134475
Recollections, Omaha 095891
Recollections, Poynton 090900
Recollections, Saint Paul 096686
Recollections Antiques,
Indianapolis 093753
Recollections Antiques, London . 090276
Recom, Ostfildern 137596
Recon, Dallas 093040
Record of the Princeton University Art
Museum, Princeton 139517
Record Office for Leicestershire,
Leicester and Rutland,
Leicester 044679
Re'creation, Céret 103502
Recto-Verso, Strasbourg 073558
Rector, Tulsa 125061
Rectory Bungalow Workshop,
Elton 134680
Recuerdos de Bacolod Arts and
Antiques, Bacolod 084305
Recuerdos Gallery, Zamboanga . 113512
O' Recuncho, A Coruña 085780
Recupero e Conservazione,
Milano 138910
Les Recyclables, Genève 143877
Red Arrow Gallery, Nashville . . . 122349
Red Art Gallery, Nelson 113050, 133105
Red Barn Antique Market,
Indianapolis 093754
The Red Barn Antiques,
Warkworth 084018
Red Barn Auction, Phoenix 127665
Red Barn Gallery, Belfast 117429
Red Barn Mall, Louisville 094416
Red Barn Museum, Morristown . 050996
Red Baron Antiques, Atlanta . . . 092013
Red Bay National Historic Site, Red
Bay 006604
Red Biddy Gallery, Shalford 119334
Red Brick Arts Centre and Museum,
Edson 005663
Red Bridge Antiques, Providence 096349
Red Bridge Books, Kansas City . 144934
Red Bridge Gallery, Shanghai . . 102099
Red Bull Hangar-7, Salzburg . . . 002583
Red Car Gallery, Milwaukee . . . 122224
Red Cedar Gallery, Montréal . . . 101308
Red Centre Art, Coolbinia 061354
Red Chair Antiques, Long Beach 094057
Red Cheery Art Gallery,
Singapore 114679
Red Clay State Historical Park,
Cleveland 047790
Red Cloud's Auction Barn,
Chicago 127433
Red Corner, Vancouver 064814
Red Corridor Gallery, Fulda 107051
Red Deer and District Museum, Red
Deer 006608

Wales's Own Regiment of Yorkshire, York 046258
Regimental Museum of The Royal Welsh (Brecon), Brecon 043486
Regimentals Antiques, Victor Harbor 062375
Régimódi bolt, Budapest 079182
Régimódi Lakberendezések boltja, Budapest 079183
Le Regina, Liège 063721
Regina, Seoul 111759
The Regina A. Quick Center for the Arts, Saint Bonaventure 052652
Regina Antiguidades, Rio de Janeiro 064056
Regina Firefighters Museum, Regina 006621
Regina Gallery, Moskva 114379
Regina General Hospital Museum, Regina 006622
Regina Gouger Miller Gallery, Carnegie Mellon University, Pittsburgh . . 052082
Regina Plains Museum, Regina . 006623
Reginald F. Lewis Museum of Maryland African American History and Culture, Baltimore 046736
Reginalde, Serrière-de-Briord . . 073470
Reginalds Tower, Waterford 024823
Regina's Gallery, Norfolk 095709
Régine Décors, Benfeld 067031
Regio Galerie, Basel 116193
Regio Galerie, Grenzach-Wyhlen 107118
Regional Museum 1940–1945 Schagen en Omstreken, Schagen 032666
Regionaal Natuurmuseum Westflinge, Sint Pancras 032696
Regional Arts and Culture Council, Portland 060702
Regional Galleries Association of Queensland, Fortitude Valley . . 058176
Regional Museum, Taraz 029675
Regional Museum of Natural History, Bhopal 023858
Regional Museum of Natural History, Mysore 024113
Regional Museum of Spartanburg County, Spartanburg 053312
Regional Museum of Yeghegnadzor, Yeghegnadzor 000714
Regional Science and Discovery Center, Horseheads 049518
Regional Science Centre, Bhopal 023859
Regional Science Centre, Guwahati 023962
Regional Science Centre, Tirupati 024189
Regional Science Centre and Planetarium, Kozhikode 024059
Regional Science Centre Bhubaneswar, Bhubaneshwar 023863
Regional Science City, Lucknow 024078
Regionale Heemmusea Bachten de Kupe, Openluchtmuseum, Izenberge 003659
Regionalen Istoričeski Muzej, Kardžali 004951
Regionalen Istoričeski Muzej, Kjustendil 004971
Regionalen Istoričeski Muzej, Pazardžik 005014
Regionalen Istoričeski Muzej, Pleven 005023
Regionalen Istoričeski Muzej, Ruse 005056
Regionalen Istoričeski Muzej, Stara Zagora 005104
Regionalen Istoričeski Muzej, Šumen 005111
Regionalen Istoričeski Muzej Varna, Varna 005146
Regionales Heimatmuseum für das Renchtal, Oppenau 020639
Regionalgeschichtliches Museum, Lutherstadt Eisleben 019858

Regionalmuseum, Bad Lobenstein 016609
Regionalmuseum Alsfeld, Alsfeld 016324
Regionalmuseum Alte Schule Kaufungen, Kaufungen 019252
Regionalmuseum Bad Frankenhausen, Bad Frankenhausen 016563
Regionalmuseum Binn, Binn . . . 041131
Regionalmuseum Burg Beeskow, Beeskow 016807
Regionalmuseum des Amtes Malliß, Neu Kaliß 020324
Regionalmuseum Eschenburg, Eschenburg-Eibelshausen . . . 018023
Regionalmuseum Fritzlar, Fritzlar 018266
Regionalmuseum Harkerode, Harkerode 018776
Regionalmuseum Langnau im Chüechlihus, Langnau im Emmental 041409
Regionalmuseum Leben und Arbeiten im Blauen Ländchen, Nastätten 020285
Regionalmuseum Neubrandenburg, Neubrandenburg 020329
Regionalmuseum Reichelsheim Odenwald, Reichelsheim 020965
Regionalmuseum Schlangenhaus, Werdenberg 041864
Regionalmuseum Schwarzwasser, Schwarzenburg 041715
Regionalmuseum Stockstadt, Stockstadt am Rhein 021602
Regionalmuseum Wolfhager Land, Wolfhagen 022315
Regionalna Izba Muzealna, Poddębice 034940
Regionalne Muzeum Młodej Polski – Rydlówka, Kraków 034744
Regionalni Muzej, Djakovica . . . 038015
Regionalni Muzej Doboj, Doboj . 004178
Regionální Muzeum, Český Krumlov 009353
Regionální Muzeum, Mělník . . . 009533
Regionální Muzeum, Mikulov na Moravě 009536
Regionální Muzeum, Náchod . . . 009552
Regionální Muzeum, Žďár nad Sázavou 009818
Regionální Muzeum a Galerie, Jičín . 009443
Regionální Muzeum K.A. Polánka, Žatec 009811
Regionální muzeum v Chrudimi, Chrudim 009371
Regionální Muzeum v Jílovém u Prahy, se specializací na zlato v ČR, Jílové u Prahy 009448
Regionální Muzeum v Kolíně, Kolín 009475
Regionální Muzeum v Teplicích, Teplice 009747
Regionální Muzeum ve Vysokém Mýtě, Vysoké Mýto 009805
Regionalnyj Muzej Severnogo Priladožja, Sortavala 037709
Regionmuseet Kristianstad, Kristianstad 040563
Regionmuseum Västra Götaland, Vänersborg 040932
Régipénz-Régiség Bolt, Pécs . . 079215
Régiposta Antiquitás, Budapest . 079184
Régis & Thiollet, Argenteuil 125771
Regis-Saunier, Laurence, Paris . 071787
Régis, Gilbert, Nice 070606
Régis, Jean-François, Paris 071786
Régiség & Használtcikk Kereskedés, Budapest 079185
Régiség & Műtárgy Kereskedés, Győr . 079206
Régiségbolt, Eger 079202
Régiségbolt, Mosonmagyaróvár . 079210
Regler, Thomas, München 130748
Regni, Daniela, Parma 132121
Régnier, Jean-Claude, Saint-

Ouen 073139
Regoli & Giorno, Brescia 079785
El Regreso del Sibarita, Salamanca 086239
Regresso Moveis Antigos, São Paulo 064147
Regroupement pour la Promotion de l'Art Imprimé, ARPRIM, Montréal 058436
Het Regthuijs, Abbekerk 031711
Regthuis Oudkarspel, Oudkarspel 032577
Regthuis t'Schou, Schipluiden . . 032680
Reguera Libreria, Sevilla 143604
Řeháček, Ivan, Hradec Králové . 128566
Rehbein, Thomas, Köln 107665
Rehberg, Dagmar, Horn 107425
Rehberger, R., Heidelberg 141820
Reheis, Erich, Rosenheim 130973
Rehhoff, Otterup 065974
Rehm, P., Ochsenhausen 108338
Rehn, Stockholm 086859
Rehnström, Mats, Stockholm . . 143768
Rehoboth Art League, Rehoboth Beach 052409
Rehoboth Museum, Rehoboth . . 031676
Rehs, New York 095519
Rei Desentupidora, Porto Alegre 063935
Reial Acadèmia Catalana de Belles Arts de Sant Jordi, Barcelona 038920, 138062
Reiartis Gestion, Valladolid 115626
Reiat-Museum, Thayngen 041797
Reibetanz, Herbert, Siegen 142209
Reich, Daniel, New York 123255
Reich, Dieter Bernd, Schärding . 062802
Reichard, Hermann, Wiesbaden . 108941, 131163
Reichardt, Lothar, Hilders 107405
Reichel, Pobershau 108401
Reichel, Robert, Nürnberg 077761, 130836
Reichelt, Braunschweig 075092
Reichelt, Eberhard & Karin, Gundelsheim, Oberfranken . . 130229
Reichenauer, Christoph, Wien . . 063011
Reichenbach, Jürgen, Freiburg im Breisgau 075823
Reichenbach, Peter, Essen 130105
Reichenberger, Theo, Kassel . . . 137480
Reicher, Arthur, Düsseldorf 075460
Reichert, A., Freiburg im Breisgau 075824
Reichert, Chr., Burghausen 075183
Reichert, Dr. Ludwig, Wiesbaden 137657
Reichert, Peter, Bad Staffelstein . 074566
Reichert, Siegmut, Kupferzell . . 107762
Reichert, Ulrike, Köln 130490
Reichl, Erich, Salzburg 128118
Reichlin, Ernst & Urs, Küssnacht am Rigi 087360, 116497, 134121
Reichmann, Alois, Wien 140097
Reichmuth, Bernhard, Ibach . . . 087342, 134111
Reichold, Gabriele, Haimhausen 076101, 130236
Reichold, Herman, Paderborn . . 108367
Reichsdorf-Museum Gochsheim, Gochsheim 018443
Reichskammergerichtsmuseum, Gesellschaft für Reichkammergerichtsforschung Wetzlar, Wetzlar 022198
Reichspräsident-Friedrich-Ebert-Gedenkstätte, Heidelberg 018841
Reichsstadtmuseum, Rothenburg ob der Tauber 021123
Reichsstadtmuseum im Ochsenhof, Bad Windsheim 016698
ReichsstadtMuseum Weißenburg, Weißenburg in Bayern 022122
Reichsstädtisches Museum, Bad Wimpfen 016694
Reichwald, Helmut F., Stuttgart . 131064
Reid Concert Hall Museum of

Instruments, Edinburgh University Collection of Historic Musical Instruments, Edinburgh 044088
Reid, Douglas, Kingston 111244
Reid, S., Nortrup 077728
Reidy, James, Houston 135964
Reif, Erkrath 075601
Reiff, Regstrup 102901
Reiffenstein, Wien 100227
Reigate Priory Museum, Reigate 045569
Reigate School of Art Design and Media, East Surrey College, Redhill 056560
Reijinsha, Osaka 137874
Reijnboek, Apeldoorn 142895
Reik, Karl, Göppingen 075978
Reilly, Ivan 079572
Reilly, Frances, Eumundi 098866
Reilly, Jenny, Rockhampton 062153
Reim, Susanne, Altenburg 129612
Reimann, Mühlhausen/Thüringen 077361
Reimann-Wehr, Cornelia, Werl . . 078841
Reimann, Detlef, Kirchzarten . . . 130445
Réimecher, Remich 082198
Reimer, Höör 143670
Reimer, W., Wolfsburg 078974
Reimers, Dresden 141623
Reimert, Irma, Groningen 112587
Reimex, Mülheim an der Ruhr . . 077370
Reims Décor, Reims 129426
Reimus, Dagmar, Essen 106891
Rein, Jacques, Paris 071788
Rein, Michel, Paris 105145
Reinart, Oss 112703
Reinberger Galleries, Cleveland Institute of Art, Cleveland 047782
Reinbold, Friederike, Berchtesgaden 129684
Reincarnation, Cleveland 092802
Reindeer Antiques, London 090280
Reindeer Antiques, Pottersbury . 090895
Reinders, J., Würselen 078985
Reindollar, Sheryl G., Charlotte . 092454
Reinecke, Gudrun, Hamburg . . . 130287
Reinecke, S., Bad Salzdetfurth . 074538
Reinegger, Peter, Fürstenfeldbruck 075866
Reineke-Fuchs-Museum, Friedrich von Fuchs, Linden-Leihgestern . . . 019748
Reinelt, Elisabeth & Wolfgang, Buxheim 106613
Reiner, Thomas, Reutlingen 130956
Reinfelder & Neumann, Nürnberg 077762
Reinhard, Helsingør . . . 065676, 102791
Reinhard-Blauth-Museum, Weilerbach 022067
Reinhard, Anita, Worms 108977
Reinhard, Susanne, Darmstadt . 075263
Reinhardt, Erich, Ravensburg . . 078066
Reinhardt, Harry, Korbach 076878
Reinhardt, J., Halle / Westfalen . 141753
Reinhardt, S., Rinteln 078164
Reinhardt, T., Extertal 075678
Reinhardt, Wilhelm, Bruchhausen-Vilsen 129894
Gebr. Reinher, Fußach . 062550, 128001
Reinhold, Emden 141652
Reining, N., Borken, Westfalen . 075064
Reinisch, Sabine, Wien 128222
Reinke, Stefan, Enger 106847
Reinkober, T., Winningstedt 078935
Reinold fils, Paris 071789, 129356
Reinshagen, W., Bad Oeynhausen 074525
Reinsma, Gabrielle, La Garenne-Colombes 068993
Reinstadler & Bebi, Küblis 087357
Reinwald, Joachim, Schwaigern 078334
Reipin Museo, Pirkkala 011077
Reis, Worms 108978
Reis Silverware, Edward, Marlborough 090571
Reis, Norbert, Hohenems 062619
Reis, Roland, Nürnberg 077763

Ribalta, Budapest 079187
Ribaux, Sankt Gallen 143918
Ribbentrop, Christiane von, Aschau im
 Chiemgau 074403
Ribbhagen, Kurt, Stockholm .. 086860
Ribblefort, Warton 119597
Ribbons, Delhi 079283, 109350
Ribchester Roman Museum,
 Ribchester 045579
Ribe Antikvariat, Ribe 140608
Ribe Kunstmuseum, Ribe 010109
Ribe Raadhussamling, Ribe 010110
Ribeiro de Sousa, Porto 084877, 126677
Ribeiro, Cecilia, Rio de Janeiro . 100923
Ribeiro, Manuel Santos, Porto .. 084876
Ribeli, Stefan, Bülach 087151
Ribeli, Stefan, Gräslikon 087320, 134100
La Ribera, Murcia 115408
Ribera Corona, Barcelona 133516
Ribes Garin, Salvador, Valencia . 086358,
 086359
Ribes Vikinger Museum, Ribe .. 010111
Ribes, Jean-Charles, Paris 071801
Ribière & Tuloup, Marseille 125914
Ribolzi, Adriano, Monaco 082343,
 112089
Ribot, Michel, Anglès (Brassac) . 066559
Rica Basagoiti, Bilbao 085708
Rica Basagoiti, Madrid 086074
Rica Basagoiti, Juan, Bilbao ... 085709
Ricard, Paul, Paris 105152
Ricart, Anna, Barcelona 085651, 115044
Ricaut, Guy, Pessac 072075
Riccadag Antiquities, Calgary .. 064213
Riccadonna, Monaco 112090
Riccardi Antichità, Assisi 079646
Riccardi, Angelo, Roma 081359
Riccardi, Maresca, Roma 142654
Ricchetto, Giuliana, Torino 142689
Ricci, Livorno 110202
Ricci, Anna, Roma 081360
Ricci, Corrado, Marzabotto 110223
Ricci, Jacques-André,
 Chapareillan 067777
Ricci, Jean, Soisy-sur-Ecole .. 073495
Ricci, Sara, Firenze 131650
Ricciardi, Lucienne, Grenoble .. 068683
Riccio Gallery, Edinburgh 117925
Ricciotti, Alain, Nice 070608
Riccius, Göteborg 086530
Ricco/Maresca Gallery, New York 123256
Rice, Denver 121038
Rice, Hamilton, New South
 Wales 139791
Rice, Houston 093612
Rice County Museum of History,
 Faribault 048660
The Rice Museum, Crowley ... 048042
Rice Museum, Dajia 042020
The Rice Museum, Georgetown . 049046
Rice University Art Gallery,
 Houston 049550
Rice, Harold B., Buffalo 092387
Ricerca d'Arte, Roma 110870
Ricerche Sul '600 Napoletano,
 Napoli 138912
Ricewolrd Museum, Los Baños . 034334
Rich, Den Haag 082935
Rich Man Poor Man, Sacramento 096479
Rich, David, Denmark 098824
Rich, Ernsting, Indianapolis ... 121495
Rich, Michael & Steven, London 090286,
 118747
Richard, Appledore, Kent 088050
Richard, Bevaix 087125
Richard, Houston 093613
Richard, Long Jetty 139837
Richard, Rio de Janeiro 064061
Richard Billinger-Gedenkraum, Sankt
 Marienkirchen bei Schärding . 002624
Richard-Brandt-Heimatmuseum
 Wedemark, Wedemark-
 Bissendorf 022035
Richard E. Peeler Art Center, DePauw

University, Greencastle 049198
Richard F. Brush Art Gallery and
 Permanent Collection, Saint
 Lawrence University, Canton .. 047371
Richard Gallery and Almond Tea
 Gallery, Cuyahoga Falls 048065
Richard H. Schmidt Museum of
 Natural History, Emporia State
 University, Emporia 048541
Richard-Haizmann-Museum, Museum
 für Moderne Kunst, Niebüll .. 020433
Richard Jefferies Museum, Coate 043780
Richard Koh Fine Art, Kuala
 Lumpur 111966
Richard Salter Storrs House,
 Longmeadow 050336
Richard-Simoncic-Museum,
 Volkskundemuseum,
 Rabensburg 002505
Richard Sparrow House,
 Plymouth 052122
Richard Wagner-Museum Luzern,
 Luzern 041474
Richard Wagner Museum mit
 Nationalarchiv und Forschungsstätte
 der Richard-Wagner-Stiftung
 Bayreuth, Bayreuth 016789
Richard-Wagner-Stätten Graupa,
 Pirna 020779
Richard, Anne, Bethancourt-en-
 Vaux 067090
Richard, C. & M., Neuchâtel ... 087509
Richard, F., Gent 100565
Richard, François, Saint-Ouen .. 073142
Richard, Jean-Luc & Takako,
 Paris 105153
Richard, Jean-Philippe, Mirabel-aux-
 Baronnies 104189
Richard, M., Cottenchy 068113
Richard, Marcel, Amiens 066522
Richard, Marie-Line, Saint-Pierre-
 Lafeuille 073222
Richard, Michel R., Montréal ... 064408,
 128432
Richard, Nicolet, Coustellet 103588
Richard, R. & F., Bruxelles 063481
Richards Antiques, Vancouver .. 064817
Richard's Oriental Rug Gallery,
 Pittsburgh 096159
Richards, D., Pittsburgh 145176
Richards & Sons, David, London 090287,
 135091
Richards, Glenn, Seattle 097329
Richards, J., Charlotte 120292
Richards, Lois, New York 123257
Richards, Margo, Sydney 062289
Richards, Richard, Hong Kong .. 101995
Richardson, Nantwich . 090646, 135203
Richardson & Kailas, London ... 090288
Richardson & Smith, Whitby ... 127356
Richardson-Bates House Museum,
 Oswego 051749
Richardson-Clarke, Boston 120196
Richardson, Nanette, San
 Antonio 124313
Richardsons, Bourne 127020
Richborough Castle – Roman Fort,
 Sandwich 045713
Richco, San Diego 124412
Riche, Cairo 103019
Richel, Philippe, Pessac 072076
Richelieu, Constanţa 084948
Richelieu, Gijón 085842, 126736
Richelieu Numismatique, Paris . 071802
Richens, Andrew, Toronto 064685
Riches, Cottonend 134612
Richet, Maurice, Tigy 073643
Richey Historical Society, Richey 052428
Richfield, New York .. 095522, 136332
Richibucto River Museum,
 Richibucto 006638
Richings, Allen, Southampton .. 119389
Richland County Historical Museum,
 Wahpeton 053902

Richland County Museum,
 Lexington 050209
Richland Fine Art, Nashville ... 122350
Richmond, London 118748
Richmond, Virginia Beach 125090
Richmond Antiques, Bowdon ... 088328
Richmond Antiques, Richmond,
 Tasmania 062133
Richmond Antiques and Curios,
 Richmond 083926
Richmond Art Center, Richmond 052435
Richmond Art Gallery, Richmond 006643
Richmond Art Museum,
 Richmond 052438
Richmond Art Society, Richmond,
 Surrey 060199
Richmond Book Shop, Richmond 145216
Richmond Castle and Exhibition,
 Richmond, North Yorkshire .. 045582
Richmond County Historical Society
 Museum, Melbourne 006158
Richmond Gaol Museum, Richmond,
 Tasmania 001446
Richmond Hill Gallery, Richmond,
 Surrey 119220
Richmond Main Mining Museum,
 Pelaw Main 001396
Richmond Museum, Richmond . 006644,
 038639
Richmond Museum of History,
 Richmond 052436
Richmond National Battlefield Park,
 Richmond 052459
Richmond Printmakers, Richmond,
 Surrey 060200
Richmond Railroad Museum,
 Richmond 052460
Richmond Relics, Richmond,
 Victoria 062138
Richmond River Historical Museum,
 Lismore 001221
Richmond Vale Railway Museum,
 Richmond Vale 001447
Richmond, David, Hyde Park ... 061637,
 127890
Richmond, David, Unley 062369
Richmondshire Museum, Richmond,
 North Yorkshire 045583
Richomme, New York 136333
Richon, Christian, Balma 066867
Rich's Antiques, Columbus 092878
Rich's Oldies and Goodies,
 Chicago 092616
Richter, Nashville 094865
Richter, Varel 108823
E. Richter & H. Graf,
 Lüdenscheid 107912
Dr. Richter & Kafitz, Bamberg .. 126129
Richter-Levsen, Martha, Wyk auf
 Föhr 079032
Richter Múzeum, Budapest ... 023228
Richter Verlag, Düsseldorf 137397
Richter, B. & J., Baden-Baden .. 141395
Richter, H., Braunshorn 075097
Richter, Helmuth, Weißenburg in
 Bayern 131144
Richter, Horace, Jaffa 109722
Richter, Jürgen, Willingshausen . 078930
Richter, K., Wolgast 078975
Richter, L., Lörrach 077086
Richter, M., Leverkusen 107853
Richter, Marianne, Hamburg ... 076238
Richter, Reiner, Nordhorn 077726
Richter, Roland, Rennerod 078127
Richter, U., Neustadt am
 Rübenberge 077678
Richtermeier, Ilona Marieluise,
 Berlin 129796
Richtermeier, Ilona Marieluise,
 Hamburg 130288
Richters, E., Hilden 076469
Richy, Pierre-Maurice, Chalon-sur-
 Saône 067726
Richy, Pierre-Maurice, Montbellet 070161

Rick, R., Frechen 075787
Rickard, Fred, Toledo . 097451, 136746
Ricke, Walter, Kottgeisering ... 141914
Ricker Pewter, Micheal, New
 Orleans 122471
Rickert, Hans, Stenten 108678
Rickett & Co., Shepperton 091151,
 135381
Ricketty Rix, Traralgon 062334
Rick's Furniture Refinishing, San
 Antonio 136609
Ricky's Galleria, Seattle 097330
Rico, Sainte-Foy-d'Aigrefeuille .. 129477
Ricochet, Toronto 064686
Ricoletto, Bogotá 102265
Riconti, Bernard, Paris 071803
Ricordi Rubati, Milano 131905
Il Ricordino, Napoli 080758
Ricordo, Porto Alegre 063936
Ricotta, Sergio, Roma . 081361, 132412
Ricour-Dumas, Christian, Paris . 071804
Ricros, Jean-Luc, Aurillac 066770
Ric's Art Boat, Bruxelles 003421
Rid, Katia, München 108190
Ridard, Claudine, Jossigny 068857
Ridard, Claudine, Saint-Mandé . 072886
Riddarholmskyrkan, Stockholm . 040835
Riddarhuset, Stockholm 040836
Riddell, Dallas 144856
Ridder, Thierry de, Saint-Ouen . 073143
Ridder, Willem de, Antwerpen .. 128259
Ridderhof Martin Gallery,
 Mary Washington College,
 Fredericksburg 048921
Ridderhofstad Gunterstein,
 Breukelen 031932
Riddoch Art Gallery, Mount
 Gambier 001315
Rideau Canal Museum, Smiths
 Falls 006886
Rideau District Museum,
 Westport 007206
Rideau Hall, Ottawa 006454
Ridelius, Visby 116097
Ridente, Nicola, Bari 131325
Rider University Art Gallery,
 Lawrenceville 050142
Ridge House Museum,
 Ridgetown 006648
Ridgeway Antiques, Westcliff-on-
 Sea 091655
The Ridgeway Gallery, Bakewell 117338
Ridglea, Fort Worth 093311
Ridi & Madon, Roma 132413
Riding Mountain National Park
 Interpretive Centre, Riding Mountain
 Historical Society, Wasagaming 007179
Ridna Chata, Kyїv 117214
Ridnik, Versailles 074031
Ridžina, Moskva 114380
Rieck, Wagersrott 078734
Riedel, Christa, Frankenthal,
 Pfalz 106930
Riedel, Friedrich, Marktl 130643
Riedel, Gerhard,
 Mühlhausen/Thüringen 077362
Riedenburger Bauernhofmuseum,
 Riedenburg 021040
Riedi, Ursula, Zürich 087801
Riedl-Seletzky, Wilhelm von,
 Wien 063014
Riedl, Lothar Joachim,
 Niederaichbach 130820
Riedmuseum, Stadtmuseum Rastatt,
 Rastatt 020902
Riefel, Joseph, Maria Enzersdorf am
 Gebirge 099981
Rieffel, Paris 141232
Riegamer, Dietbert, Hamburg .. 076239
Riegel, Gerhard, Nürnberg 077764
Rieger, New York 136334
Riegner, Miami 122130
Riehl, Franck, Guidel 068711
Riehle, Brigitte, Esslingen 130114

Ritchie, A. & R., Saint Helier . . . 091037
Ritchies, Toronto 125654
Rite-Way, Tampa 136733
Ritorna Moveis, São Paulo 064149
Ritorno, Casablanca 082396
Ritorto, Enzo, Roma 132415
Ritorto, Ferdinando, Roma 132416
Ritorto, Ivan, Roma 081362
Ritschard, M. & U., Bern 087110
Helga Ritscher-Sandmeier & Alexander
Sandmeier OHG, Berlin 074860
Rittenhouse, Philadelphia 123694
Ritter, Düsseldorf 075463
Ritter, Klagenfurt 136851
Ritter, New York 095524
Ritter & Temme, München 077525
Ritter & Zamet, London 118750
Ritter, C., Bruxelles 063482
Ritter, G., Rinteln 078166
Ritter, Hans-Dieter & Waltraud,
Jork . 107466
Ritter, Luc, Bruxelles 063483
Ritter, Marion, Hamburg 076240
Ritter, P., Marienheide 077235
Ritter, Patrice, Zürich 087803
rittergallery, Klagenfurt 099937
Rittergut Haus Laer, Bochum . . . 017220
Ritterhaus Bubikon, Bubikon . . . 041162
Ritthaler, Albert, Hamburg 107288
Rittman Historical Society Museum,
Rittman 052483
Ritu Creations, Mumbai 109482
Ritual Art Gallery, Kathmandu . . 112160
Ritums – Kulturas un Tautas Makslas
Centrs, Rīga 111816
Ritzenhoff, Chicago 092617
Ritzenthaler, Gassin 068582
Ritzy Bits, Auckland 083640
Rius Garrich, Claudio, Barcelona 085652
Riuttalan Talonpoikaismuseo,
Karttula 010793
Riva, Adriano, Padova 080836
Riva, Maria Patrizia, Firenze . . . 131652
RIVAA Gallery, Roosevelt Island Visual
Arts Association, New York . . . 123259
Rivals Renaud, Villenouvelle . . . 074134
Rivas Martin, Juan, Madrid 086075,
133738
Rivchun, Heide, Cleveland 092803,
135821
Rive de Sorgues, L'Isle-sur-la-
Sorgue 069535
Rive Gauche, Auxerre 066793
Rive Gauche, Den Haag 082938
Rive Gauche Galerie d'Art
Contemporain, Namur 100659
Rive, H., Düsseldorf 075464
Rivenburg, Nicholson 127633
Riveneuve, Marseille 140907
River and Rowing Museum, Henley-on-
Thames 044425
River Art Gallery, Limerick 109677
River Art Group, San Antonio . . 060704,
124314
River Arts Center, Clinton 047798
River Brink, The Samuel E. Weir
Collection, Queenston 006600
River City Antiques, Saint Paul . . 096689
River City Art and Antique Centre,
Bangkok 087867, 117038, 126978,
143982
River City Auction, Vicksburg . . 127751
River East Art Center, Chicago . . 120535
River Emporium, Woodburn 062440
River Findhorn Heritage Centre,
Forres 044197
River Gallery, Saint Paul 124176
River Heritage Museum, Paducah 051794
River Hills Park Museum,
Wildwood 054279
River House Antiques, Pittsburgh 096160
River House Antiques,
Washington 097690
River Legacy Living Science Center,

Arlington 046505
River Market Antique Mall, Kansas
City . 093927
River Museum, Wellsville 054155
River Read, Noosaville 139887
River Square Antiques, San
Antonio 096859
River Valley School Museum,
Virden 007167
Riverbank, Petworth 090854
Riverbank Antiques, Warrandyte 062400
Riverbank Studios, Spalding . . . 119399
Riverbend, Alderson 127384
Riverchase Antique Gallery,
Birmingham 092268
Riverchase Gallery, Birmingham 120097
Riverdale Mansion, Riverdale
Park . 052488
Rivère-Pagnon, Nicole, Saint-
Lizier 072854
Riverfront Arts Centre, Newport . 045299
Rivergum Art Gallery, Warrandyte 099724
Riverhouse, Steamboat Springs . 138527
Riverhouse Gallery, Saskatoon . 101413
Riverhurst F.T. Hill Museum,
Riverhurst 006656
Rivero Lake, Rodrigo, México . . 082299
Rivers Gallery, Nailsworth 118966
Riverside Antiques, München . . . 077526
Riverside Antiques,
Sawbridgeworth 091102
Riverside Architectural Antiques, Saint
Louis 096602
Riverside Art Museum, Riverside 052496
Riverside Book Company, New
York . 138476
The Riverside Gallery, Golant . . 118065
The Riverside Gallery, Inverness 118238
Riverside Gallery, Looe 118849
Riverside Gallery, Toronto 101559
Riverside Gallery, Uppermill . . . 119567
Riverside Municipal Museum,
Riverside 052497
Riverside Museum, Glasgow . . . 044254
Riverside Museum, La Crosse . . 049984
Riverside Museum at Blake's Lock,
Reading 045558
Riverside Violins, Newark-on-
Trent 090665
Riverstone, New Orleans 122473
Riverton Museum, Riverton 052500
Riverton Transportation & Heritage
Centre, Riverton 006659
Rivertown Galleries, London . . . 101211
Rivertown Gallery, Memphis . . . 121988
Riverview Antique Market,
Milwaukee 094713
Riverview at Hobson Grove, Bowling
Green 047124
Riverview Ethnographic Museum, Bear
River 005302
Riverwest Artists Association,
Milwaukee 060705
Riverwest Arts Center,
Milwaukee 122226
Rivet, Gabriele, Köln 107666
Rivett, Sue, Fakenham 089038
Rivi, Riccardo, Casalgrande . . . 079844
Riviera Books, Harleston 144212
Rivière & Desnoe, Saint-Leu . . . 133349
Rivière, Christophe, Tournai . . . 063793,
128341
Rivière, Colette, Maisons-Laffitte 069765
Rivière, Guy, Charmoy 067799
Rivière, Jean-Claude, Peujard . . 072078
Rivière, Michel, Toulon (Var) . . . 073690
Riviere, Roger, Peujard 072079
Rivilla Calvo, T., Segovia 115536, 115537
Rivington Arms, New York 123260
Rivista degli Studi Orientali,
Roma 138913
Rivista di Psicologia dell'Arte,
Roma 138914
Rivista di Storia della Miniatura,

Firenze 138915
Rivkind, Robert, Toronto 064688
Rivnens'kyj Krajeznavčyj Muzej,
Rivne 043023
Rivoli, Gladesville 061512
Rivoli, Howard, Neutral Bay . . . 061940
Rivollier Alain, Vienne 074079
Rivon, Alexandre, Parent 070802
Riyahi Gallery, London 090290
Riza, Sergiev Posad 037683
Rizal Technological and Polytechnic
Institute Museum, Morong . . . 034385
Rize Devlet Güzel Sanatlar Galerisi,
Rize . 042775
Rizeanu, Dardu, Craiova 133369
Rizhao Museum, Rizhao 008023
Riznica Franjevačkog Samostana Split,
Split . 008835
Riznica i Galerija Svetišta Majke
Gospe Trsatske, Rijeka 008811
Riznica Katedrale, Dubrovnik . . 008746
Riznica Katedrale Svetog Tripuna,
Kotor 031571
Riznica Samostana Svetog Frane,
Zadar 008858
Riznica Zagrebačke Katedrala,
Zagreb 008886
Riznica zlato i srebro grada Nina,
Nin . 008784
Rizo, Bernard, Nîmes 070653
Rizzato, Bruno, Venezia 132639
Rizzi, Arcangelo, Milano 131907
Rizzitiello, Pasquale, Milano . . . 131908
Rizzo Antiquari, Palermo 080904, 080905,
080906
Rizzo, Gaetano, Palermo 132098
Rizzo, Giovanni, Venezia 081702
Rizzoli, Milano 137792
Rizzotti, Stefania, Milano 142560
RJ Collectibles, Chicago 092618
Rjabov, Valentin, Moskva 114381
Rjazanskij Gosudarstvennyj Istoriko-
architekturnyj Muzej-zapovednik,
Rjazan 037515
Rjazanskij Oblastnoj Chudožestvennyj
Muzej im. I.P. Požalostina,
Rjazan 037516
Rjazanskij Zaočnyj Institut
Moskovskogo Gosudarstvennogo
Universiteta Kultury i Iskusstv,
Rjazan 056245
RL Fine Arts, New York 123261
RLB Kunstbrücke, Innsbruck . . . 002109
RM Antiquités, Pontoise 072231, 129406
RMA Institute, Bangkok 117039
RMIT Gallery & RMIT University's Art
Collection, Melbourne 001280
Ro Gallery, Long Island City . . . 121695,
127554
ROA Estudio, Madrid 133739
Roach Tackle Folk Art, Toronto . 101560
Road, Sendai 081946
Roadhouse Relics, Austin 119974
Roadshow Antique Jewellery, Nobby
Beach 061966
Roadshow Antiques, Southport . 062221
Roadside Antiques, Greystoke . . 089189
Roald Amundsens Hjem Uranienborg,
Svartskog 033823
Roald Amundsens Minne, Torp . 033842
Roan Bygdetun, Roan 033717
Roanoke Island Festival Park,
Homeport of the Elizabeth II,
Manteo 050595
Roar Gallery, Wellington 113177
Roaring Twenties Antique Car
Museum, Madison County . . . 050541
Rob Piercy Gallery, Porthmadog 119173
Rob Roy and Trossachs Victor Centre,
Callander 043618
Robache, Gérard, Vieille-Eglise . 074078
Robarick, Dorit, Lübbenau 140929
Robb Street Gallery, Bairnsdale . 098536
Robbe, M., Osnabrück 142130

Robben, Cincinnati 135801
Robben Island Museum, Robben
Island 038641
Robbins Hunter Museum, Avery-
Downer House, Granville 049174
Robbins Museum of Archaeology,
Middleborough 050787
Robbins, Ivelin & Craig, Miami
Beach 122164
Robbins, Martha, New Orleans . 122474
Robbins, Tucker, New York 095525
Robbinsville, Miami 094630
Roberson Museum and Science
Center, Binghamton 046965
Robert, Swansea 144616
Robert & Li, Tainan 116973
Robert A. Bogan Fire Museum, Baton
Rouge 046791
Robert A. Peck Gallery, Central
Wyoming College, Riverton . . 052501
Robert A. Vines Environmental
Science Center, Houston 049551
Robert and Mary Montgomery Armory
Art Center, West Palm Beach . 054195
Robert B. Ferguson Museum of
Mineralogy, Winnipeg 007272
Robert Brady Museum, Morelos 031130
Robert Burns Centre, Dumfries . 043965
Robert Burns House, Dumfries . 043966
Robert C. Williams American Museum
of Papermaking, Atlanta 046601
Robert Crown Center for Health
Education, Hinsdale 049451
Robert E. Lee Memorial Association,
Stratford 053456
Robert E. Wilson Art Gallery, Merillat
Centre for the Arts, Huntington 049573
Robert Edward Hart Memorial
Museum, Souillac 030617
Robert Frost Farm, Derry 048242
Robert Fulton Birthplace,
Quarryville 052333
Robert Galerie, Pöcking 108403
Robert Gordon University Art and
Heritage Collections, Aberdeen 043100
Robert Hull Fleming Museum,
Burlington 047291
Robert Hytha-Museum,
Sondermuseum Wildtiere der Welt,
Oberwölbling 002428
Robert-Koch-Museum, Berlin . . 017058
Robert Langen Art Gallery,
Waterloo 007186
Robert Louis Stevenson House,
Monterey 050944
Robert Louis Stevenson Memorial
Cottage, Saranac Lake 053031
Robert Louis Stevenson Museum,
Vailima 037917
Robert Louis Stevenson Silverado
Museum, Saint Helena 052670
Robert McLaughlin Gallery,
Oshawa 006424
Robert Mills Historic House and Park,
Columbia 047877
Robert Musil-Literatur-Museum,
Klagenfurt 002165
Robert Newell House, DAR Museum,
Saint Paul 052754
Robert O'Hara Burke Memorial
Museum, Beechworth 000841
Robert Owen Museum, Newtown,
Powys 045319
Robert R. McCormick Museum at
Cantigny, Wheaton 054241
Robert S. Kerr Museum, Poteau 052238
Robert S. Peabody Museum of
Archaeology, Phillips Academy,
Andover 046450
Robert-Schumann-Haus Zwickau,
Zwickau 022488
Robert Smail's Printing Works,
Innerleithen 044495
Robert-Sterl-Haus, Struppen . . . 021617

Regionální muzeum Český Krumlov, Horní Planá 009412
Rodolfo, Viola, Milano 110431
Rodon, Gent 063603
Rodrigue, New Orleans 122476
Rodrigue, Michel, Paris 071808
Rodrigues & Lopes, Lisboa 084780
Rodrigues, Alberto Dias, Lisboa . 114147
Rodrigues, Arnaldo, Rio de Janeiro 100924
Rodrigues, José Manuel, Lisboa 143403
Rodrigues, José Ribeiro, Lisboa 084779
Rodrigues, Luizandro A.G., Rio de Janeiro 064062
Rodrigues, Marco Antonio Silva, São Paulo 064150
Rodrigues, Maria Clara, Porto . . 084878
Rodriguez Alvarez, Sevilla 133795
Rodriguez Carballo, Avelina, Valencia 086360
Rodriguez Juarez, Ruben, Guadalajara 082285
Rodriguez, Albert, Saint-Ouen . . 073144
Rodríguez, Carlos Fernando, Bogotá 128522
Rodriguez, José, Zürich 087805
Rodriguez, Lilian, Montréal 101310
Rodriguez, Nancy, San Antonio . 096860
Roduner, Bruno, Wetzikon 087703,
087704
Rodziewicz, Andrzej, Wrocław . . 084600,
143357
Roe, Dallas 120931
Roe & Moore, London 144437
Roe, John, Islip 089460
Röbbig, München 077527
Röben, Wilhelmshaven 078926
Röber, Hamburg 076241
Roebling Hall, New York 123264
Roebourne Old Goal Museum, Roebourne 001455
de Roeck-Van Dijck, Antwerpen . 063177
Rød Bygdetunet, Uskedalen . . . 033876
Röda Bergets Antik, Stockholm . 086862
Röda Rummet, Uppsala 143802
Röda Stugans Antik, Torslanda . 086913
Roedde House Museum, Vancouver 007118
Røde Lade, Helsingør 065677
Röder & Coumont, Rodershausen 078171
Röder, Hermann, Rodershausen . 078170
Roeder, Margarete, New York . . 123265
Röder, Michael & Antje, Bergisch Gladbach 074690
Rödner, Helmut, Haarlem 142973
Roehr, Mirosław, Poznań 133226
Röhsska Museet, Göteborg 040463
Roelants, H., Genk 063566
Roelantsmuseum Oude Abdij Heemmuseum, Hemiksem . . . 003614
Røldal Bygdemuseum, Røldal . . 033718
Röling, Amsterdam 082653
Röll, Dr. Josef, Dettelbach 137381
Roellin, Christian, Sankt Gallen . 116707
Roelofs, Jan, Amsterdam 082654
Roelofsz, Charles, Amsterdam . . 082655
Roels, Rudolf, Gent 128308
Roemer- und Pelizaeus-Museum, Hildesheim 018949
Römer im Bajuwaren Museum Burg Kipfenberg, Kipfenberg 019299
Römer, Heidi, Zürich . . 087806, 116929
Römer, K. & J., Borna 075067
Römerbad, Schwangau 021370
Römerhalle, Museen im Rittergut Bangert, Bad Kreuznach 016597
Römerhaus Walheim, Walheim . 021989
Römerkastell Saalburg, Bad Homburg v.d. Höhe 016584
Römerkeller Ottmarsheimer Höhe, Mundelsheim 020264
Römermuseum, Heitersheim . . . 018879
Römermuseum, Mainhardt 019884
Römermuseum, Obernburg am

Main 020553
Römermuseum, Wien 002988
Römermuseum Bedaium, Heimat- und Geschichtsverein Bedaium in Seebruck e.V, Seebruck 021415
Römermuseum Favianis-Sankt Severin, Mautern 002336
Römermuseum Flavia Solva, Universalmuseum Joanneum, Wagna 002815
Römermuseum im Haus Isenburg, Eisenberg, Pfalz 017896
Römermuseum in der Schule, Ehingen 017864
Römermuseum Kastell Boiotro, Passau 020726
Römermuseum Mengen-Ennetach, Mengen-Ennetach 020026
Römermuseum Osterburken, Zweigmuseum des Archäologischen Landesmuseums Baden- Württemberg, Osterburken . . . 020667
Römermuseum Stettfeld, Ubstadt- Weiher 021831
Römermuseum Teurnia, Lendorf 002253
Römermuseum Tulln, Tulln 002781
Römermuseum Wallsee-Sindelburg, Wallsee 002828
RömerMuseum Weißenborg, Zweigmuseum der Archäologischen Staatssammlung München, Weißenborg in Bayern 022123
Römerpark Köngen, Köngen . . . 019391
Römersiedlung, Friesenheim . . . 018263
Römerstadt Carnuntum, Petronell 002457
Römerthermen Zülpich – Museum der Badekultur, Zülpich 022479
Römervilla e.V., Möckenlohe . . . 020086
Römerzeitliches Museum Ratschendorf, Ratschendorf . . 020937
Römhild, Jutta, Kleinkahl 130449
Römhild, Rolf Frank, Olpe 130859
Römisch-Germanisches Museum, Museen der Stadt Köln, Köln . . 019386
Römisch-Germanisches Zentralmuseum, Leibniz- Forschungsinstitut für Archäologie, Mainz 019895
Römische Badruine, Badenweiler 016717
Römische Badruine, Hüfingen . . 019050
Römische Bäder, Stiftung Preußische Schlösser und Gärten Berlin- Brandenburg, Potsdam 020837
Römische Baureste Am Hof, Wien Museum, Wien 002989
Römische Kalkbrennerei Iversheim, Bad Münstereifel 016618
Das Römische Kastell in Waldmüssingen, Schramberg . 021337
Römische Thermen, Weißenburg in Bayern 022124
Römische Villa Nennig, Stiftung Saarländischer Kulturbesitz, Perl- Nennig 020745
Römische Villa Urbana Longuich, Longuich 019777
Römischer Keller in Sulz am Neckar, Sulz am Neckar 021680
Römischer Weinkeller Oberriexingen, Zweigmuseum des Württembergischen Landesmuseums Stuttgart, Oberriexingen 020563
Römisches Freilichtmuseum, Hechingen 018826
Römisches Haus, Klassik Stiftung Weimar, Weimar 022092
Römisches Heiligtum für Isis und Mater Magna, mit Taberna archaeologica, Mainz 019896
Römisches Museum Remagen, Remagen 020983
Römisches Museum und Naturkunde- Museum, Zumsteinhaus, Kempten 019273

Römisches Museum, Kunstsammlungen und Museen Augsburg, Augsburg 016470
Roenland, Jevnaker 113262
Rønne, Palle, Næstved 065932
Rönnell, Stockholm 143769
Rönnquist & Rönnquist, Malmö . 115864
Röntgen-Gedächtnisstätte, Würzburg 022379
Roentgen-Museum, Neuwied . . 020424
Rörbäcksnäs Hembygdsgård, Lima 040586
Het Roerkopje, Ede 142943
Rørosmuseet, Røros 033721
Rörstrand Museum, Linköping . . 040593
Roerstreekmuseum, Sint Odiliënberg 032692
Rösch, Franz, Otting 077918
Roesch, Jane, Pittsburgh 096161
Roesch, Sonja, Houston 121399
Rösch, T., Gütersloh 076068
Röseler, Jutta, Niendorf bei Neuhaus, Elbe 077707
Rösener, Eva, Wuppertal 079018
Roesinger, Christa E., Köln 107667
Röske, Horst, Alfdorf 129604
Röske, Rainer, Berlin 106401
Rösler & Oswald, Wädenswil . . . 087691
Roesler, Nara, São Paulo 100972
Rösli Antiquitäten, Flaach 087234
Rösner, Duisburg 075508
Roess, Michel, Munster 070347, 129053
Rößig, Günter, Bad Blankenburg 105994
Rössler, Sankt Moritz 116716
Rößler Museum, Untermünkheim 021869
Rössler, Berthold, Ravensburg . . 108450,
108451
Rössli, Balsthal 116152
Rössli, Klosters 087352
Rösti, Andreas, Gümligen 087328,
134102
Rötger, Anton, Hamburg 130289
Röthel, M., Großpösna 130223
Röttges, Pforzheim 077963
Rötzel & Co., Frankfurt am Main 075766
Rötzer, Franz & Elke, Schwarzenbruck 078341
Röver, Ralf E., Donaueschingen . 075326
Röver, Sabine, Nürnberg 108318
Røyrvik Bygdatun, Limingen . . . 033573
Roffi, Tommaso, Bologna 142460
Rogai, Ennio, Roma 081364
Rogaland Bilmuseum, Vigrestad 033906
Rogaland Fiskerimuseum, Åkrehamn 033307
Rogaland Krigshistorisk Museum, Sola 033786
Rogaland Kunstmuseum, Stavanger 033802
Rogaland Kunstsenter, Stavanger 113373
Rogall, Wilma, Toronto 128464
Rogalla, F. & K., Heide 076368
Rogé, Emmanuel, Pertuis 105302
Rogendorfer-Ausstellung, Sonderausstellung des Museumsvereins, Pöggstall . . . 002472
Rogenhofer, Helmut, Wien 128224
Rogeon, Pierre-Marie, Paris . . . 126031
Roger, Den Haag 082939
Roger, Utrecht 112800
Roger Guffey Gallery, Kansas City 049846
Roger Raveelmuseum, Machelen 003758
Roger Tory Peterson Institute of Natural History Museum, Jamestown 049745
Roger Williams National Memorial, Providence 052304
Roger, Arthur, New Orleans . . . 122477,
122478
Roger, Claude-Henri, Dreuil-les- Amiens 068350
Roger, Hans-Peter, Neuss 130815
Rogers & Co, London 090293

Rogers Antikvariat, Malmö . . . 143706
Roger's Antiques Gallery, London 090295
Rogers de Rin, London 090296
Rogers Historical Museum, Rogers 052562
Rogers House Museum and Gallery, Ellsworth 048518
Rogers Jones & Co., Cardiff . . . 127045
Rogers Jones & Co., Colwyn Bay 127073
Roger's Upholstering, Pittsburgh 136478
Rogers, Alla, Washington 125205
Rogers, Anthony, Ebikon 116347
Rogers, Clive, London 090294
Rogers, Jolly, Hamilton 064274
Rogers, Robert D., Omaha 123589
Rogers, Wendy, Perth 062071
Rogg & Trachsler, Basel 087068
Rogge, Berlin 129797
Rogge, B., Berlin 129798
Roggenbuck & Schmid, Diedorf . 075305
Roggenbuck, Dr. Stefan, Gelsenkirchen 107070
La Roggia, Pordenone 110695
Rogier Lauriance, London 090297,
135093
Rogin, Frank, New York 095530
Rogner & Bernhard, Berlin 137348
Rogue Art Space, San Francisco 124626
Rogue Buddha Gallery, Minneapolis 122307
Rogue Gallery and Art Center, Medford 050693
Rogue Valley Art Association, Medford 060707
Rogues, Phoenix 096071
Rohain, Oostende 063767
Rohan, Landerneau 140824
Rohaut Delassus, Françoise, Blonville- sur-Mer 067205
Rohaut, Françoise, Honfleur . . . 068775
Dr. Rohde & Kornatz, Kassel . . . 076663
Rohde-Hehr, Patricia, Krempe . . 130524
Rohde, E., Potsdam 078002
Rohde, Eberhard, Sylt 108757
Rohe, Dr. Michael, München . . . 077528
Rohen, Karen, Hagen 130233
Rohleder, Ilona, Berlin 074861
Rohloff-Haluzán, V., Nürnberg . . 142102
Rohnstädter Heimatstube, Weilmünster 022070
Rohr, F., Bern 134039
Rohr, Hans, Bern 143851
Rohr, Susan, Luzern 134163
Rohrbach-Hugenberg, Rottach- Egern 078218
Rohrer, Fred, Zäziwil 087720
Rohrer, Ingrid, Konstanz 107711
Rohs, L., Brüe 106739
Le Roi David, Montauban 070148
Le Roi Fou, Paris 071809
Roider, Beatrix, München 130750
Roig, Barcelona 085653
Roig-Sabater, J., Mannheim . . . 077209
Roijen, J., Banholt 132813
Roinet, Jacques, Plouguenast . . 072162
Florence Rois, Granville 125865
Roiter, Marcio, Rio de Janeiro . . 064063
Roja, Warszawa 113986
Rojahn, Karl-Heinz, Bandenitz . . 141404
Rojas, Miami 136155
Rojas Jūras un Zvejniecības Muzejs, Roja 030056
Rojaus Kalnas, Vilnius 111861
Rojo Pinturas Española, Madrid . 086077
Rojstna Hiša Blaženega Antona Martina Slomška, Šentjur 038427
Rojstna Hiša Matije Čopa, Gornjesavski Muzej Jesenice, Žirovnica 038457
Rojstna Hiša Pesnika Dr. Franceta Prešerna, Gornjesavski Muzej Jesenice, Žirovnica 038458
Rojstna Hiša Pisatelja Frana Saleškega Finžgarja, Gornjesavski Muzej

La Rose des Vents, Le Cannet . 069178
Rose Fine Art and Antiques,
 Stillington 091280, 135433
Rose Galleries, Little Canada . . . 127552
Rose Gallery, Northampton 119022
Rose Gallery, Weedon 119604
The Rose Garden, Baltimore . . . 092194
Rose Hawk, Gainesville 127497
Rose Hill Manor Park & Children's
 Museum, Frederick 048909
Rose Hill Mansion, Geneva Historical
 Society, Geneva 049032
Rose Hill Museum, Bay Village . 046807
Rose Hill Plantation State Historic Site,
 Union 053767
Rose Lawn Museum, Cartersville 047411
Rose Museum at Carnegie Hall, New
 York 051379
Rose Passé, Troyes 073871
Rose Rose, São Paulo 064151
Rose Seidler House, Wahroonga 001609
Rose Street Gallery, Armadale,
 Victoria 098518
Rose Valley and District Heritage
 Museum, Rose Valley 006671
De Rose Winkel, Deventer 082975
Rose, Anthony, Yass 099806
Rose, Charles, Melbourne 061821
Rose, Dianne, Fort Worth 093312
Rose, Dr. Ulrich, Greifswald . . . 141746
Rose, Ekkehard, Krefeld 076900, 130521
Rose, Giovanni, Bayreuth 074655
Rose, Marjorie, Pittsburgh 123821
Rose, Marjorie, San Francisco . . 097150
Rose, Michael, London 090300, 090301,
 090302
Rose, Peter, New York 123268
Rose, R.L., Edinburgh 088975
Roseau County Historical Museum,
 Roseau 052578
Rosebery, Calgary 064214
Rosebery's, London 127209
Rosebud, El Paso 093248
Rosebud Centennial Museum,
 Rosebud 006672
Rosebud County Pioneer Museum,
 Forsyth 048737
Rosebud Studios, Surf Beach . . 099594
Rosebud's, Tampa 097420
Rosedale, Albany 112827
Rosedale Street Gallery, Dulwich
 Hill 098842
Rosefeld, Libbesdorf 077037
Rosegg, Sikoronja, Sankt
 Lamprecht 100051
Rosehr, Joachim, Kiel . 076725, 130438
Roseland Antiques, Toronto . . . 064692
Rosemann, Susanna & Frank,
 Vilseck 108837
Rosemary and Time, Thame . . 091450,
 135484
Rosemont Art Gallery, Regina . . 006624
Rosemont Plantation, Woodville . 054408
Rosemount Gallery, Aberdeen . 117280
Rosemount Lodge Art Gallery,
 Richmond, New South Wales . 099489
Rosemount Museum, Pueblo . . . 052317
Rosen & Chadick, New York . . . 136336
Rosen Kavalier, Houston 093615
Rosen, Andrea, New York 123269
Rosenbach Museum,
 Philadelphia 052000
Rosenbach, Detlev, Hannover . . 107348
Rosenbach, Louis, Dallas 093045
Rosenbad, Stockholm 143770
Rosenbaum, Dallas 120932
Rosenbaum, Houston 121400
Rosenberg, Höganäs 115786
Rosenberg, Mayen 077201
Rosenberg, Milano 110432
Rosenberg & Kaufman, New York 123272
Rosenberg Gallery, Goucher College,
 Baltimore 046737
Rosenberg, A., Bremerhaven . . . 075149

Rosenberg, Alex J., New York . . 123270
Rosenberg, C., Heswall 089326
Rosenberg & Co., Paul, New
 York 123271
Rosenblatt, Minna, New York . . 095534
Rosenblom, Mölndal 115873
Rosenborg Slot, Danske
 Kongers Kronologiske Samling,
 København 010031
Rosenbruch Wildlife Museum, Saint
 George 052667
Rosendahler Kunsthaus,
 Rosendahl 078191
Den Rosendahlske Bibelsamling,
 Esbjerg 009887
Rosendal, Durbanville 114866
Rosendals Slott, Stockholm . . . 040838
Roseneath Gallery, Armidale . . 061045
Rosenfeld, Bad Kissingen 106020
Rosenfeld, Philadelphia 123695
Rosenfeld, Tel Aviv 109739
Rosenfeld, Michael, New York . . 123273
Rosenfeld, Samuel, New York . . 123274
Rosengren, Hauge i Dalane . . . 113256
Rosenhagen, Johann, Öhringen . 077817
Rosenhahn, Willi, Daaden 075239
Rosenhauer, Ursula, Göttingen . 107107
Rosenheimer Verlagshaus GmbH & Co.
 KG, Rosenheim 137611
Rosenholm Slot, Hornslet 000981
Die Roseninsel, Künstler und
 Kunstfreunde am Starnberger See
 e.V., Starnberg 059153
Rosenkranz, Magdeburg 077162
Rosenkranz, Ilona & Stefan,
 Thiessow 108776
Rosenlew-museo, Pori 011089
Rosenlöfs Tryckerimuseum,
 Kungsgården 040568
Rosenmuseum, Bad Nauheim . . 016619
Rosenrod, Göteborg 086531
Rosenstock, Denver . . 121042, 121043,
 144872
Rosenthal, Berlin 106403
Rosenthal, Minneapolis 122309
Rosenthal, New Orleans 094990
Rosenthal Gallery of Art,
 Caldwell 047308
Rosenthal, Dennis, Chicago . . . 120538
Rosenthal, Ludwig,
 Leidschendam 143000
Rosenthal, Marcia, Pittsburgh . . 123822
Rosenthal, Marie-Eve, Saint-
 Ouen 073146
Rosenthal, Stan, Hastings 118128
Rosenvinge Kunst, Bergen 084080
Rosenwald-Wolf Gallery, University of
 the Arts, Philadelphia 052001
Rosenzweig, M., Bonn 106538
Rosequist, Tucson 125019
Rosersbergs Slott, Rosersberg . 040723
Rose's Bookshop, Hay-on-Wye . 144223
Rosetown & District Museum,
 Rosetown 006674
Rosetzky, Marion, Red Hill . . . 099480
Rosewall Memorial Shell Museum,
 Port Lincoln 001420
Rosewe, Klara & Fritz, Pforzheim 077964
Rosewood, Oakland 095746
Rosewood Antiques, Traralgon . 062335,
 127961
Rosewood Furniture, Melbourne 061822
Rosewood Scrub Historical Museum,
 Marburg 001249
Roseworthy Agricultural
 Museum, University of Adelaide,
 Roseworthy 001457
Rosgartenmuseum, Konstanz . . 019437
Rosh, West Hollywood 097764
Rosicrucian Egyptian Museum, San
 Jose 052929
Rosies från Gammalt till Nytt,
 Spånga 086765
Rosily Arts Museum, Taipei . . . 042268

Rosin, Douglas, Chicago 092620
Rosina's, Falmouth . . 089042, 134699
Rosing, H. & M., Bocholt 074987
Roskell, Plymouth 119156
Roski School of Fine Arts, University
 of Southern California, Los
 Angeles 057331
Roskilde Auktionshuss, Roskilde 125741
Roskilde Domkirkemuseum,
 Roskilde 010123
Roskilde Museum, Roskilde . . . 010124
Roskilde Museums Købmandsgård,
 Roskilde 010125
Roskildegalleriet, Roskilde 102909
Roslagens Sjöfartsmuseum,
 Väddö 040930
Roslagsmuseet, Norrtälje 040685
Roslavskij Istoriko-chudožestvennyj
 Muzej, Roslavl 037517
Roslyn Oxley9 Gallery, Paddington,
 New South Wales 099398
Rosmosegaard Antik, Gilleleje . . 065633
Rosoff, Charles, New York 123275
Rosot, Jean, Pont-Aven 072202
Rospo, London 090303
Rosrestavracija, Moskva 133376
Ross, Goulburn 061543
Ross, Washington 136801
Ross Abbey, Headford 079527
Ross Abbey Gallery, Sassafras . 099542
Ross Antiques, Ross 062161
The Ross C. Purdy Museum of
 Ceramics, Westerville 054211
Ross Castle, Killarney 024729
Ross County Historical Society
 Museum, Chillicothe 047683
Ross Farm Museum, New Ross 006334
Ross House Museum, Winnipeg 007273
Ross Memorial Museum, Saint
 Andrews 006698
Ross Museum, Foresters Falls . 005702
Ross Old Book and Print Shop, Ross-
 on-Wye 144548
Ross-on-Wye Antiques Gallery, Ross-
 on-Wye 090989
Ross-Thomson House Museum,
 Shelburne 006853
Ross, Bernie, San Jose 136694
Roß, Betina, Ellerau 130069
Ross, Douglas, Woburn 127365
Ross, Hardie, Chipping Campden 088664
Ross, Jane, Carlton South 061275
Ross, John, Tucson 097525
Ross, Luise, New York 123276
Ross, Marcus, London 090304
Ross, Morgan, Seattle 097331
Ross, Nancy, Chicago 092621
Ross, Simon, New York 095535, 136337
Rossaert, Antwerpen 140124
Rossberg, R., Bonn 075045
Roßberg, Reinhardt,
 Markkleeberg 130642
Rossberg, Werner, Davos Platz . 087205
Rossburn Museum, Rossburn . . 006625
Rosselli, John, New York 095536,
 095537
Rosselli, John, Washington 097692
Rossendale Footware Heritage
 Museum, Rawtenstall 045552
Rossendale Museum, Rossendale 045606
Rosseto, Volmir Luiz, Porto
 Alegre 100859
Rossetti, Luigi, Salsomaggiore
 Terme 110910
Rossetto, Roland, Chaumont (Haute-
 Marne) 067879
Rossfelder Heimatstuben,
 Crailsheim 017547
Rossi, Milano 131911
Rossi, San Francisco . 097151, 136680
Rossi, Sankt-Peterburg 114440
Rossi, Toulon (Var) 073691
Rossi & Rossi, London 090305
Rossi e Onesti, Assago 079645

Rossi, Carlo, Domodossola 079897
Rossi, D., Bad Honnef 074492
Rossi, Daniele, Firenze 131653
Rossi, Flora, Roma 081373
Rossi, Jean-Pierre, Saint-Michel-
 l'Observatoire 072942
Rossi, Julcir, São Paulo 064152
Rossi, Laura, Roma 132422
Rossi, Leopoldo, Milano 080536
Rossier, Pittsburgh 123823
Rossier, David & Colette,
 Rougemont 087562
Rossignol & Fils, Céret 128774
Rossignol, Daniel, Les Arcs . . . 140828
Rossignol, Gabriel, Paris 141234
Rossignol, Gérard, Paris 105158
Rossignol, Henri, Cannes 140775
Rossignoli Picotti, Giuseppina,
 Verona 132682
Rossijskij Antikvarnyj Salon,
 Moskva 098131
Rossijskij Ètnografičeskij muzej, Sankt-
 Peterburg 037642
Rossijskij Komitet Meždunarodnogo
 Soveta Muzeev (IKOM Rossii),
 Moskva 059692
Rossijskij Muzej Lesa, Moskva . 037325
Rossini, Paris 126032
Rossiters, Crescent Head 098789
Rossland Historical Museum,
 Rossland 006676
Rosslyn Chapel, Roslin 045605
Rosso, Fulvio, Trieste 081634
Rosso, Mano, Oakland 095747
Rosso, Sonia, Pordenone 110696
Rosso, Sonia, Torino 111024
Rosso, Yolande, Nice 070611
Rossolacca, Milano 080537
Rosson House Museum, Phoenix 052034
Ross's, Belfast 127010
Rost, Sebastian, Berlin 129800
Rosta-Buchladen, Münster 142069
Rosteck, Lemgo 077020
Rostellan Antiques, Midleton . . 079565
Rostovskij Filial Sankt-Peterburgskogo
 Gosudarstvennogo Universiteta
 Kultury i Iskusstv, Rostov-na-
 Donu 056246
Rostovskij Kreml – Gosudarstvennyj
 Muzej-zapovednik, Rostov . . . 037519
Rostovskij Oblastnoj Muzej
 Kraevedenija, Rostov-na-Donu 037522
The Rostra Gallery, Bath 117383
Rostropovich Museum, Bakı . . . 003091
Rostrum, South Petherton 091218,
 135412
Rostworowski, Dominik, Kraków 113722
Roswell Museum and Art Center,
 Roswell 052593
Rosy's Nostalgieladen, Zürich . . 087807
Roszkov, Budapest 109183
Rot-Kreuz-Museum, Regenstauf 020957
Rota, Nurieux-Volognat 070715
Rota, Bertram, London 144438
Rotary Museum of Police and
 Corrections, Prince Albert . . . 006564
Rotas de Arte, Lisboa 114148
Rotation, Los Angeles 094294
Rotch-Jones-Duff House and Garden
 Museum, New Bedford 051154
Rotenberg, Judi, Boston 120198
Rotenhahn, Rumohr 078233
Roter Hausberg, Wittwort 022300
Rotermund, Thole, Hamburg . . 076242,
 107289
Rotermundt, Amsterdam 082657
Rotes Antiquariat und Galerie C:
 Bartsch, Berlin 141495
Roth, Leipzig 077005
Roth, Minneapolis 122310
Roth Horowitz, West Hollywood 125272
Róth Miksa Emlékház, Budapest 129239
Roth, Andrew, New York 123277
Roth, Artur, Mainhardt 077166

Schwartz Heritage House, Altona 005225
Schwartz Judaica, San Diego . . 145269
Schwartz, Andrea, San Francisco 124635
Schwartz, Anna, Melbourne . . 099185
Schwartz, Carol, Philadelphia . 123697
Schwartz, Gabriele, Berlin 129809
Schwartz, Nancy, New York . . . 095563,
123303
Schwartzsche Villa, Berlin 017071
Schwarz, Philadelphia . 095995, 123698
Schwarz-Afrika-Museum,
Vilshofen 021930
Schwarz-Wrobel, Monika,
Bochum 075002
Schwarz, Barbara, Schorndorf . . 108581
Schwarz, Beat, Murten 087497
Schwarz, Hildegard, Sylt 108759
Schwarz, Hubert, Graz 128019
Schwarz, Karl & Barbara, Aarau 086987
Schwarz, Karl-Heinz, Tübingen . 078645
Schwarz, Linda, Cincinnati . . . 112655
Schwarz, M., Barßel 074639
Schwarz, Peter, Berlin 141502
Schwarz, Rudolf, Pfronten 077967
Schwarz, W., Altenkunstadt . . . 074359
Schwarz, Wolfgang, Weißensberg 078830
Schwarzacher, Gerhard, Sankt Jakob
am Arlberg 062794
Schwarzachtaler Heimatmuseum
Neunburg vorm Wald, Neunburg
vorm Wald 020376
Schwarzbach, Peter, Nürnberg . 077768
Schwarzberg, Mogens,
København 065879
Schwarzenberger Skulpturenpark,
Schwarzenberg am
Böhmerwald 002678
Schwarzer, Berlin 106422
Schwarzer, Düsseldorf 106788
Schwarzer Elefant, Köln 076841
Schwarzer, Dr. Rainer, Dresden . 075383
Schwarzer, Klaus, Düsseldorf . . 075471
Schwarzfischer, Rosenheim 142182
Schwarzkogler, Wolfgang, Wien . 128229
Schwarzmann, Peter, Starnberg 108669
Schwarzwälder Freilichtmuseum
Vogtsbauernhof, Gutach . . . 018614
Schwarzwälder Mühlenmuseum,
Grafenhausen 018508
Schwarzwälder Skimuseum,
Hinterzarten 018959
Schwarzwälder Trachtenmuseum,
Haslach im Kinzigtal 018789
Schwarzwald-Museum, Triberg im
Schwarzwald 021786
Schwarzweiss, Steinfurt 138795
Schwazer Silberbergwerk,
Schwaz 002684
Schweden, Oliver, München . . . 108199
Schwedenspeicher, Stade 021548
Schwedler, Holzgerlingen 076501
Schween, Bochum 129854
Schweig, Neil, Saint Louis 124116
Schweighofer, Bernd,
Marktoberdorf 130644
SchweineMuseum Stuttgart,
Stuttgart 021653
Schweinfurth Memorial Art Center,
Auburn 046622
Schweingruber, Firenze 142505
Schweins, Otto, Köln 107676
Schweinsteiger, Ilse, München . 077539
Schweißhelm, H., Hannover . . . 130321
Schweitzer, New York 123304
Schweitzer, Doris, Bonn 075049
Schweitzer, Lucien, Luxembourg 111916
Schweitzer, Lucien, Mondorf-les-
Bains 111924
Schweitzer, Rolf, Rothenburg ob der
Tauber 078210
Schweizer, Bad Homburg v.d.
Höhe 074487, 106016
Schweizer Finanzmuseum,
Zürich 041954

Schweizer Holzbildhauerei Museum,
Ausstellung der Schule für
Holzbildhauerei, Brienz (Bern) . 041154
Schweizer Kindermuseum,
Baden 041052
Schweizer Kunst – Art Suisse – Arte
Svizzera – Swiss Art, Zürich . 139137
Schweizer Museum für Wild und Jagd,
Utzenstorf 041826
Schweizer, Daniel, Cologny 087191
Schweizer, Dr. René,
Lampertheim 076937
Schweizer, Eglantine, Villars-le-
Terroir 116793
Schweizer, Jürgen, Bad
Fallingbostel 074470
Schweizer, Klaus, Konstanz . . . 076874,
107712
Schweizerische Gesellschaft Bildender
Künstlerinnen, Basel 059866
Schweizerische
Interessengemeinschaft zur
Erhaltung von Grafik und Schriftgut,
Vernate 059867
Schweizerische Nationalbibliothek,
Bern 041115
Schweizerische Theatersammlung,
Bern 041116
Schweizerischer Fachverband für
Glasmalerei, Romont 059868
Schweizerischer Kunstverein,
Zürich 059869
Schweizerischer Verband Bild und
Rahmen, Dübendorf 059870
Schweizerischer Verband der
Graveure, Zürich 059871
Schweizerischer Verband für
Konservierung und Restaurierung,
Bern 059872
Schweizerischer Verband Graphisches
Gewerbe, Bern 059873
Schweizerischer Werkbund,
Zürich 059874
Schweizerisches Agrarmuseum
Burgrain, Alberswil 041002
Schweizerisches Feuerwehrmuseum
Basel, Basel 041082
Schweizerisches Gastronomie-
Museum, Thun 041802
Schweizerisches Institut für
Kunstwissenschaft (SIK-ISEA),
Zürich 056408
Schweizerisches Militärmuseum Full,
Full 041278
Schweizerisches Nationalmuseum,
Landesmuseum Zürich, Zürich 041955
Schweizerisches Schützenmuseum,
Bern 041117
Schweizerisches Tanksäulenmuseum,
Gänsbrunnen 041279
Schwemmgut-Museum, Finsing 018107
Schwender, Jürgen, Münster . . . 077602
Schwenkfelder Library and Heritage
Center, Pennsburg 051888
Schwenkkros, A., Osten 077907
Schwerkolt Cottage Museum,
Mitcham 001298
Schwetz, Claude, Saint-Ouen . . 073156
Schwicker-Tosi, Firenze 110083
Schwickerath, Udo, Langenfeld . 076962
Schwilden, Bruxelles 140170
Schwind, Karlheinz, Frankfurt am
Main 106991
Schwindel, Rudolf, Augsburg . . 129630
Schwingruber, Markus, Luzern . 087452
Schwitter Verlag, Glattbrugg . . . 138130
Schwörer & Sohn, March 077230
Schwörer, Udo, Pforzheim 142153
Schwohn, D., Hörstel 076483
Schwules Museum, Berlin 017072
Schydt Fredensborg, Kirsten,
Holte 065720
Sci-Port Discovery Center,
Shreveport 053207

Sci-Tech Center of Northern New York,
Watertown 054094
Sciacca, Luigi, Messina 110240
Sciacchitano, Giulio, Torino . . . 132583
Sciacchitano, Pier Paolo, Torino 132584
Scianca, Luciano, Roma 081385
Sciarra, Raniero, Roma 081386
Sciascia, Salvatore, Caltanissetta 137731
Sciberras, B'Kara 082227
Sciboz-Cordier, Danielle, Nîmes . 070655
Scicali, Renata, Palermo 110636
Science & Technology Museum,
Beijing 007458
Science Activity Centre, Sirsa . . 024177
Science Activity Corner, Gwalior 023966
Science and Technology Museum of
Atlanta, Atlanta 046603
Science Center of Connecticut, West
Hartford 054182
Science Center of Iowa, Des
Moines 048249
Science Center of Pinellas County,
Saint Petersburg 052766
Science Center of Thessaloniki
and Technology Museum,
Thessaloniki 022963
Science Center of West Virginia,
Bluefield 047028
Science Center Spectrum, Berlin 017073
Science Centre, Birr 024542
Science Centre for Education,
Bangkok 042408
Science City Museum, Kolkata . 024054
Science Discovery Center of Oneonta,
Oneonta 051689
Science et Technologie de la
Conservation et de la Restoration
des Œuvres d'Art et du Patrimoine,
Puteaux 138708
The Science Factory Children's
Museum, Eugene 048585
The Science Fiction Museum and Hall
of Fame, Seattle 053131
Science Gallery, Dublin 024673
Science Hall of Penghu County,
Magong 042114
Science Imaginarium, Waterloo . 054084
Science Learning Center, Upton 053784
The Science Museum, Cebu . . . 034301
Science Museum, Dhaka 003150
Science Museum, Giza 010402
Science Museum of Long Island,
Manhasset 050572
Science Museum of Minnesota, Saint
Paul 052752
Science Museum of Virginia,
Richmond 052461
Science Museum of Western Virginia,
Roanoke 052504
Science Museum Wroughton, The
National Museum of Science &
Industry, Wroughton 046234
Science Museum, Bibliotheca
Alexandria, Alexandria 010353
Science Museum, The National
Museum of Science & Industry,
London 045009
Science North, Sudbury 006928
Science Spectrum, Lubbock . . . 050458
Science Station Museum, Cedar
Rapids 047455
Science Treasures, Oklahoma
City 095843
Sciencenter, Ithaca 049699
Scienceworks Museum, Museum
Victoria, Spotswood 001509
Scienicview, Reeth 119205
Scienze della letteratura, dell'arte e
dello spettacolo, Università degli
Studi di Pavia, Pavia 055895
Scipilliti, Liliana, Messina 110241
Scippa, Raffaele, Napoli 080766
Scirius, Mandelieu-la-Napoule . 104100
Scirocco & Koral Edizioni,

Terrasini 137843
Scisco, Vincent, Longwy 069569
Scitech, Aurora 046645
Scituate Historic Sites, Scituate 053085
Scituate Maritime and Irish Mossing
Museum, Scituate 053086
Sciworks, Winston-Salem 054369
Sclanders, Andrew, London . . . 144445
Scoazec, Jean-Louis, Pont-Aven 105340
Scognamiglio, Mimmo, Napoli . 110559
Scognamiglio, Rodolfo, Milano . 080553
Scohy, Serge, Antwerpen 100368
Scola Galleria, Oakland 123517
Scoles, Saskatoon 101414
Scollay Square Gallery, Boston . 047098
Scolton Manor Museum,
Haverfordwest 044393
Scone and Upper Hunter Museum,
Scone 001486
Scone Palace, Perth 045443
Scope Basel, Basel 098170
Scope Gallery, Alexandria 119804
Scope Hampton, Wainscott . . . 098316
Scope London, London 098235
Scope Miami, Miami Beach . . . 098317
Score, Stephen, Boston 092328
Le Scorpion, Les Baux-de-
Provence 103933
Lo Scorpione, Torino 111026
Scorrano, Carlo, Roma 081387
Scorza, Angela M., Rio de
Janeiro 100928
Scorza, Daniela Menezes, São
Paulo 100973
Scot, Paris 105180
Scotch Mist Gallery, Tucson . . . 125021
Scotch Whisky Experience,
Edinburgh 044094
Scotchtown, Beaverdam 046835
Scotia-Glenville Children's Museum,
Traveling Museum, Scotia . . . 053090
Scotia Museum, Scotia 053088
Scotland Art, Glasgow 118051
Scotland Heritage Chapel and
Museum, Scotland 053091
Scotland Street School Museum,
Glasgow 044260
Scotland Yard Antiques, Marburg 061783
Scotland's Secret Bunker, Saint
Andrews 045651
Scotney Castle, Tunbridge Wells 046012
Scots Antiques, Glasgow 089132
Scotsman, Saint Louis 096607
Scott, Atlanta 092018
Scott, Edmonton 101160
Scott & Co., Norfolk 127637
Scott Monument, Edinburgh . . . 044095
Scott Polar Research Institute
Museum, University of Cambridge,
Cambridge 043637
Scott, Lee, Atlanta 092019
Scott, Mike, Salisbury 135351
Scott, Richard, Holt, Norfolk . . 089357
Scott, Sarah, Sheffield 091145
Scotti, Emidio, Roma 132430
Scottie's Guns and Militaria,
Denver 093172
Scottish Antique, Doune 088888
Scottish Antique and Arts Centre,
Abernyte 087991, 134327
Scottish Art Gallery, Dunoon . . 117869
Scottish Arts Club, Edinburgh . . 117926
The Scottish Crannog Centre,
Kenmore 044543
Scottish Fisheries Museum,
Anstruther 043163
Scottish Football Museum,
Glasgow 044261
The Scottish Gallery, Edinburgh . 117927
Scottish Industrial Railway Centre,
Dalmellington 043868
Scottish Jewish Archives Centre,
Glasgow 044262
Scottish Maritime Museum,

Bruxelles 054941
Section Sciences Humaines, Lettres et
Arts, Université Charels-de-Gaulle
Lille 3, Villeneuve-d'Ascq 055370
Sector Ops Museum, Royal Air Force
Digby, Digby 043908
Sécula, Alain-Nicolas, Beaune . 066978
Sécula, Anthony, Beaune 066979
Sécula, Eric, Beaune 066980
Sécula, François, Beaune 066981
Sécula, Jacky, Beaune 066982
Sécula, Jean-Marc, Luzy 069621
Secula, Jean-Pierre, Saint-Ouen 073157
Sécula, Laurent, Beaune 066983
Sécula, Raymond, Beaune 066984
Sécula, Rodolphe, Beaune 066985
Sécula, Rodolphe, Paris 071848
Seculo XX Copacabana, Rio de
Janeiro 064069
Séculos Passados, Porto 084879
Secundo, Liège 063725
Secundus, Terhole 143042
Secwepemc Museum and Heritage
Park, Kamloops 005937
Sed Gallery, University of Georgia,
Athens 046566
Sedan Numismatique, Sedan . . 073428
Sederholmin Talo, Helsingin
Kaupunginmuseo, Helsinki . . . 010686
Seders, Francine, Seattle 124846
Sedgeberrow, Pershore 144532
Sedgewick Archives Museum and
Gallery, Sedgewick 006841
Sedgwick-Brooklin Historical Museum,
Sedgwick 053144
Sedgwick Museum of Earth Sciences,
Cambridge 043638
Sedlák, František, Praha 065452
Sedlak, Karl, Offenhausen 062729
Sedman, Bridlington 088385
Sedona Arts Center, Sedona . . . 053145
Šeduvos Kraštotyros Ekspozicija,
Daugyvenės kultūros istorijos
muziejus-draustinis, Seduva . . 030289
See Restoration, Atlanta 135668
See Science Museum,
Manchester 050567
See-Vogel-Museum Herbert Vargyas,
Rust 002560
Seebach, Jochen, Emkendorf . . 130074
Seeck, Mason City 127576
Seegalerie, Rottach-Egern 108533
Seeger, Braunschweig 106568
Seeger, Brigitte, Göppingen . . . 075979
Seeger, Burgel, Fellbach 075685
Seegers, Marie-Louise, Blies-
Ebersing 067189
Seekamp, Irina, Berlin 129810
Seekers Books, Toronto 140381
Seelackenmuseum, Sankt Veit im
Pongau 002650
Seeland Galerie, Jens . 116477, 134114
Seelhof, Ulrich, Dillenburg 129947
Seelhoff, Koblenz 076775
Seemann Verlag, Verlagsgruppe
Seemann Henschel, Leipzig . . 137521
Seemeyer, A., Sehnde 078371
Seemeyer, Adolf, Rehburg 078098,
130944

Seemuseum Kreuzlingen,
Kreuzlingen 041586
Seenot-Rettungskreuzer Georg
Breusing, Emden 017934
Seeshells Antiques, Las Vegas . 094009
Seethaphone, Bangalore 079256
Seething Control Tower Museum,
Seething 045730
Segal, Thomas, Baltimore 120049
Ségala, Badaroux 066845
Ségalen, Michel, Rennes (Ille-et-
Vilaine) 105399
Segantini-Museum, Sankt Moritz 041682
Segarra, Maria Fernandez,

Lisboa 084788
Segas, Gilbert, Paris 071849
Segedunum Roman Fort, Baths and
Museum, Wallsend 046055
Segesser, Jeannette von, Luzern 134166
Seggern, J. von, Bremen 075141
Seghers, P. & L., Oostende 100669
Il Segno, Milano 110443
Segno, Pescara 137817, 138919
Il Segno del Tempo, Milano . . . 080554,
080555
Sego Gallery, Salt Lake City . . . 124234
Segonds, Jean-Claude, Limoges 069477
Segontium Roman Museum,
Caernarfon 043613
Segovia, Marita, Madrid 086085, 115372
Segrelles del Pilar, Valencia . . . 115613
Seguin, Villeurbanne 129582
Séguin Poirier, Bernard, Montréal 101314
Seguin, Alain, Beaune 133306
Seguin, Patrick, Paris . 071850, 105182
Seguine-Burke Plantation, Staten
Island 053387
Seguinet, Arnaud, Duclair 125851
Seguins Cohorn, Michel de,
Fontainebleau 068512
Seguso Viro Srl, Venezia 111180, 111181
Sehara, Sarajevo 063817
Seharsch, Peter, Lich 107855
Sehgalerie, Bordesholm 106544
Şehir Müzesi, İstanbul 042688
Seian Zokei Daigaku, Otsu 055978
Seibert-Philippen, Gisela, Berlin 106423
Seibido, Nara 081903
Seibu, Tokyo 111499
Seidel & Sohn, Berlin . 074880, 074881
Seidel, Erfurt 075596
Seidel & Sohn, Potsdam 078003, 078004
Seidel & Richter, Kerstin, Berlin 141503
Seidel, Konrad, Witten 131173
Seidel, Stefan, Leipzig 130571
Seidel, Volker, Bochum 075003
Seidenberg, David, New York . . 095567
Seidenfaden, Max, Frederiksberg 102770
Seidl, Josef, München 077540
Seidl, Markus, Tiefenbach, Kreis
Passau 078595
Seidler, Christopher, London . . 090323
Seidler, Wilhelm, Linz . 062769, 099977
Seifert, Rüdersdorf bei Berlin . . 078229
Seifert, Edmund, Coburg 075218
Seifert, H., Köln 076842
Seifert, Rolf, Dresden 141624
Seiffer-Schulz, Ingrid, Haigerloch 107159
Seifudo, Kubo, Hiroshima 081814
Seigando, Jintsu, Tokyo 082020
Seigfred Gallery, Ohio University,
Athens 046570
Seigne, Eric, Boisset Saint-Priest 128715
Seigneur, J + M, Leipzig 077009
Seigneur, Jacques le, Ronchin . . 129440
Seiho, Tokyo 111500
Seiji, Honolulu 121247
Seiji Togo Memorial Sompo Japan
Museum of Art, Tokyo 029398
Seikado Bunko no Bijutsukan,
Tokyo 029399
Seiko, Sendai 111402
Seikosha, Osaka 081916
Seiler, Röslau 078183
Seiler Liepe, Ute, Berlin 129811
Seiler, Andreas, Wöschnau 087715
Seiler, Anton, Bonstetten 116261
Seiler, Thomas, Heilbronn 107382
Seiler, Werner, Basel 134001
Seillé, Carcès 067623
Seiller, Noirmoutier-en-l'Ile . . . 104365
Seima, Tourriers 073794
Seinäjoen Lehti- ja Kirjapörssi,
Seinäjoki 140707
Seinäjoen Luonto-Museo,
Seinäjoki 011170
Seinan Gakuin Daigaku Hakubutsukan,
Fukuoka 028367

Seinerzeit, Bünde 075172
Seippel, Dr. R.-P., Köln 107677
Seiryu-do, Fukuoka 081798
Seiryuden Bijutsukan,
Matsushima 028834
De Seis a Ocho, Gijón 085843
Seison-kaku, Kanazawa 028599
Seissian & Fils, Hagop, Beirut . . 132698
Seith, H., Kempten 076690
Seitou, Hiroshima 111278
Seitre, Simone, Saint-Martin . . . 109126
Seitz & Partner, Berlin 106424
Seitz, New York 095568
Seitz & Co., Saint Paul 096691
Seitz, K. & H., Rheinfelden 078148
Seitz, Werner, München 077541
Seiyo Inn, Sapporo 081932
Seize, Quimper 105374
Seize, Louis, Cairo 103023
Sejac, Poligny 129403
Sejallet, Jean, Saint-Rambert-
d'Albon 073243
Sejarah Mesjid Banten Museum,
Banten 024233
Sejong, Seoul 111762
Sejong College Museum, Seoul . 029857
Sejong Cultural Center Art Gallery,
Seoul 111763
Sejong Gallery, Seoul 111764
Sejul, Seoul 111765
Sekai Gangu Hakubutsukan, Bandai
Collection, Karuizawa 028599
Sekai Oota Kokaikan, Yokaichi . 029525
Sekaido, Sagamihara 081922
Sekaido, Tachikawa 081951
Sekaido, Tama 081953
Sekaido, Tokyo 082021, 082022, 082023
Sekcja, Warszawa 139031
Sekhmet, Vitoria-Gasteiz 143621
Sekido Bijutsukan, Tokyo 029400
Sekiguchi Koh Museum Yuzawa,
Yuzawa 029572
Sekisho Bijutsukan, Misumi . . . 028846
Sekisui Bijutsukan, Tsu 029472
Sekitan Kogyo Hakubutsukan,
Ube . 029483
Sekkeh Museum, Kerman 024404
Sekkeh Museum, Tehrän 024478
Sekken Museum, Sekken 033751
Sektor I, Górnośląskie Centrum
Kultury, Katowice 034656
Sekula, Sacramento 096482
Sekunda, Sankt-Peterburg 085095
Selano, Benedetto, Genève 116435
Selb, Lucie, Karlsruhe 130414
Selbu Bygdemuseum, Selbu . . . 033752
Selbu Strikkemuseum, Selbu
Bygdemuseum, Selbu 033753
Selby Gallery, Ringling School of Art
and Design, Sarasota 053036
Selch, Horst, Wörth am Main . . 108972
Selçuk Müzesi, Taş ve Istampa
Müzesi, Konya 042739
Seldom Seen Designs,
Cheltenham 117718
Selearte 1, Padova 110597
Select, Rotterdam . . . 083402, 133003
Select Art, Dallas 120935
Select Art, Utrecht . . . 083476, 143059
Select Miami, Miami Beach . . . 098321
Select New York, New York 098322
Select Stamp and Coin Studio,
Buffalo 092390
Selected Antiques & Collectables,
Barnstaple 088135, 134382
Selected Works, Chicago 144796
Selectionart, Torino 111027
Selections, Haarlem 083164
Selective Eye Gallery, Saint
Helier 091039, 119268, 135339,
144560
Selective Prints, Whitchurch . . . 119628
Selective Prints, Winsford 119659
Self Help Graphics and Art Gallery,

Los Angeles 050408
Seligmann, Maja, London 090324
Selims Antiques, Winnipeg 064880
Seling, Dr. H.W., München 077542
Seljuk, San Francisco 136681
Selkirk, Kambah 061655, 127893
Selkirk, Winnipeg 140402
Selkirk College Mansbridge Kootenay
Collection, Castlegar 005474
Sell, Forchheim 075711
Sell Antiques, Salt Lake City . . . 096756
Sellares, Alain, Montjoie-en-
Couserans 070208
Sellarione, Dario, Roma 081389
Sellerio, Palermo 137811
Sellers, Basil, Moruya 099250
Selli, Daniel, Gassin 068583
Selli, Daniel, Saint-Tropez 073279
Sellier, Eric, Neuilly-sur-Seine . . 070472
Sellier, Jean-Christian, Arras . . . 066682
Selliez, Domnique, Hardifort . . . 068734
Sellner Glashütte, Lohberg 019766
Sellos, Oscar B., Rio de Janeiro . 064070
Sellution Vintage Furniture,
Vancouver 064822, 064823
Sellwood Antique Collective,
Portland 096306
Sellwood Antique Mall, Portland 096307
Sellwood Coins, Portland 096308
Selly Manor Museum,
Birmingham 043392
Selmer, Chlodwig, Emsdetten . . 106846
Selonke, Hardebek 076343
Selons, R. & B., Cuckfield 134626
Sels, Clara Maria, Düsseldorf . . 106789
Selsey Lifeboat Museum, Selsey 045737
Selskar, Wexford 079615
Selskar Abbey Antiques, Wexford 079616
Selsor Gallery of Art, Safari Museum,
Chanute 047491
Šeltozerskij Vepsskij Ètnografičeskij
Muzej, Šeltozero 037678
Selva, Alberto, Milano 131922
Selvi, Carlo, Roma 081390
Selwoods, Taunton 091399
Selwyn, Marc, Los Angeles 121870
Selz, Beat, Perrefitte . . 116652, 138149
Selz, Dr. G., Freiburg im
Breisgau 075829
Şemaki Evi Müzesi, Yenisehir . . 042815
Semaphore Antique Centre,
Semaphore 062193
Semar, Rotterdam 112748
Sembritzki, Enno, Oldenburg . . 077860,
130855
Semed Vurğunun Ev-Muzeyi,
Bakı . 003094
Semenovskij Gosudarstvennyj
Kraevedčeskij Istoriko-
chudožestvennyj Muzej,
Semenov 037679
Semenzato, Patrizia, Venezia . . 081707
Semerád, Petr, Klatovy 140441
Semina Rerum, Zürich 116936
Seminar für künstlerisch-ästhetische
Praxis Menzel-Dach, Humboldt-
Universität zu Berlin, Berlin . . 055420
Seminar für Kunst Kunstpädagogik,
Universität Osnabrück,
Osnabrück 055617
Seminar für Kunst und Kirche,
Philosophisch-Theologische
Hochschule Sankt Georgen, Frankfurt
am Main 055480
Seminar für Kunst, Kunstgeschichte
und Kunstpädagogik, Carl
von Ossietzky Universität,
Oldenburg 055615
Seminar für Kunstgeschichte,
Universität Osnabrück,
Osnabrück 055618
Seminar für materielle und visuelle
Kunst, Carl von Ossietzky Universität,
Oldenburg 055616

Setor de Malacologia, Juiz de
Fora 004446
Setsuro Takahashi Bijutsukan,
Azumino, Azumino 028318
Setsuryosha Bijitsukan, Niigata . 028994
Setti Carraro, Giovanni Maria,
Milano 080559, 110448
Setti Lino & Figlio, Ozzano Taro 080788
Settlers Hardware, Houston 093623
Settlers Museum, Brewarrina .. 000882
Settlers Museum, Himeville 038558
Settlers Store Antiques, Mudgee 061917
Settlers West Galleries, Tucson . 125022
Settlers West Gallery, Tucson .. 125023,
145364
Setzer, Ortrud, München 108200
Seurasaaren Ulkomuseo, Helsinki 010687
Sevan Art Gallery Limited,
Toronto 101565
Sevas, Bucureşti 084937
Ševčenkivskyj Nacional'nyj
Zapovidnyk, Kaniv 042910
Sevek, Eze 103686
The Seven Art, Bangkok 117043
Seven Art, Helsinki 103108
Seven Oaks House Museum,
Winnipeg 007281
Seven Sanat Galerisi, İstanbul . 117155
Seven Sisters Antiques, Lanceston
South 061706
Sévene, Suresnes 073571
Sevenoaks Museum and Gallery,
Sevenoaks 045740
Seventeen O Eight, Richmond . 123991
Seventh Heaven, Chirk 088676
Seventh Inning, Buffalo 092391
Severance, Detroit 121094
Severiarte, Bologna 109872
Severin, Gisela & Peter, Friedberg,
Hessen 075854
Séverine, Oriot, Honfleur 068776
Severinhaus Basilika Sankt Laurenz,
Enns 001860
Severn River Auctions, Severna
Park 127723
Severn Valley Railway, Bewdley 043346
Severo-Kavkazskij Gosudarstvennyj
Institut Iskusstv, Nalčik 056237
Severo-Kazachstanskij Oblastnoj
Istoriko-Kraevedčeskij Muzej,
Petropavl 029660
Severo-Kazachstanskij Oblastnoj
Muzej Izobrazitelnogo Iskusstva,
Petropavl 029661
Severo-osetinskij Gosudarstvennyj
Obedinennyj Muzej Istorii,
Architektury i Literatury,
Vladikavkaz 037850
Severo-osetinskij Literaturnyj
Muzej im. K.L. Četagurova,
Vladikavkaz 037851
Severočeská Galerie Výtvarného
Uměni v Litoměřicich,
Litoměřice 009514
Severočeské Muzeum v Liberci,
Liberec 009508
Sevestre, Pascal, Cabourg 067490
Sévigné, Cesson-Sévigné 067698
Sévigné, Saint-Jean-sur-Vilaine . 072815
Sevilla Art Studio, New York ... 136344
Sevilla Decoracion, Sevilla 086302
Sevilla, Victor, Paris 105187
Seville Great House and Heritage Park,
Ocho Rios 028271
Sevniški Grad, Sevnica 038428
Sevret, René, Charenton-du-Cher 067779
Sewall-Belmont House,
Washington 054036
Seward County Historical Society
Museum, Goehner 049103
Seward House, Auburn 046623
Seward Museum, Seward 053160
Sewer, Ernest, Susten 087642
Sewerby Hall Art Gallery and

Museum, Museum of East Yorkshire,
Bridlington 043500
Sex Machines Museum, Praha . 009679
Sexmuseum Amsterdam Venustempel,
Amsterdam 031809
Sextius, Aix-en-Provence 103156
Sexton, Esther, Dublin 079480
Sexton, Robert, San Francisco . 124638
Sexton's Cottage Museum, Crows
Nest, New South Wales 001001
Seydoux, Paris 105188
Seyed-Ghaemi, Shamsadin,
Landshut 107779
Seyfarth, Thomas, Schwielowsee 131014
Seyfert, Gudrun, Stuttgart 108736,
108737
Seyhoun Art Gallery, Tehrān .. 109553,
109554
Seyitgazi Müzesi, Seyitgazi 042787
Seymour, Rutherglen 062166
Seymour, Vancouver 101695
Seymour, Waltersboro 127753
Seymour and District Historical
Museum, Seymour 001490
Seymour Art Gallery, North
Vancouver 006381
Seymour Community Museum,
Seymour 053163
Seymour, Jane, Morrinsville ... 083836
Seyun Iron Museum, Eumseong 029745
Seywald, Dr. Thomas, Salzburg . 100043
Sezam, Beograd 114518, 143490
Sezione Arte, Dipartimento di Scienza
della Letteratura e dell'Arte
Medioevale e Moderna, Pavia . 055895
Sezon Museum of Modern Art,
Karuizawa 028600
Sezoni, Sofia 101035
SFA Galleries, Stephen F. Austin State
University, Nacogdoches 051078
De Sfeer van Weleer, Rekken .. 032598
Sfeervol Wonen, Breda 082819
Sfeir-Semler, Beirut 111827
Sfeir-Semler, Dr. Andrée,
Hamburg 107295
La Sfinge, Parma 080962
SFMOMA Artist Gallery, San
Francisco 124639
Sforzini, Roma 142657
SG Kunst, Fredrikstad 084095
SGA Antiquités, Fontenay-sous-
Bois 068522
S'Galeriele, Göppingen 107099
Sgambati, Antonio, Modena .. 131979
Sgambato, Angelique,
Kaufbeuren 130427
Sganga, Giuseppina, Roma 081393
Sgarban, Giovanni, Milano 142562
Sgouros, Ioannis, Thessaloniki . 109112
Sgroi, Massimo, Palermo 080909
Sha Museum, Shaxian 008093
Shaanxi Chinese Painting Gallery,
Xian 008245
Shaanxi History Museum, Xian . 008246
Shaanxilong Books Museum,
Longxian 007847
Shab, Toronto 064699
Shaban, Yousef, Alexandria ... 066148
Shabby, Hattie, Tucson 097528
Shackerstone Railway Museum,
Shackerstone 045741
Shackleton, Anthony, David & Ann,
Snainton 091205, 135403
Shadeland Antique Mall,
Indianapolis 093759
Shades of Africa, Miami 122136
Shades of Afrika, Long Beach . 121687
Shades of Age, Clayfield 061332
Shades of Color, Portland 123923
Shades of the Past, Carbonear 005456
Shades of the Past, Philadelphia 095996
Shadi, Damascus 087854
Shadi Abdel Salam Museum,
Bibliotheca Alexandria,

Alexandria 010354
Shadicor Gallery, Cairo 103025
Shadowland, Richmond 145217
The Shadows-on-the-Teche, New
Iberia 051203
Shaffer, Portland 123924
Shafrazi, Tony, New York 123312
Shaftesbury Abbey Museum and
Garden, Shaftesbury 045742
Shaftesbury Town Museum,
Shaftesbury 045743
Shaftsbury Historical Society,
Shaftsbury 053166
Shah Alam Art Gallery, Shah
Alam 030554
Shah Charu, Dallas 120936
Shahd, V., Wendeburg 078833
Shaheed-e-Azam Bhagat Singh
Museum, Khatkar Kalan 024030
Shahinian, Zare, Damascus ... 087855
Shahnama, Mumbai 109489
Shahrastan Bros., Damascus .. 087856
Shahrood Museum, Semnan ... 024428
Shahryar Museum, Tabriz 024437
Shah's Arts Collection, Brighton,
Victoria 061196
Shahuji Chhatrapati Museum, New
Palace Museum, Kolhapur ... 024037
Shaiké I am Art Snir, Caulfield
South 061298
Shaikh & Son, London 090325
Shain, Charlotte 120293
Shainman, Jack, New York ... 123313
Shaka, Saint Louis 124117
Shake Rattle & Read Book Box,
Chicago 144797
Shaker Art, Milwaukee 122227
Shaker Heritage Society Museum,
Albany 046316
Shaker Historical Society Museum,
Shaker Heights 053167
Shaker Museum, New
Gloucester 051185
The Shaker Museum, Old
Chatham 051659
Shaker Museum at South Union,
South Union 053301
Shaker Square Antiques,
Cleveland 092807
Shaker Village of Pleasant Hill,
Harrodsburg 049341
Shakespeare & Co., München .. 142051
Shakespeare Birthplace Trust,
Stratford-upon-Avon 045892
Shakespeare Gallery, San José . 102415
Shakespeare's Globe Exhibition,
London 045012
Shakey, Philadelphia . 095997, 136445
Shakir Ali Museum, Lahore ... 033956
Al Shakma, Cairo 103026
Shakowi Cultural Center, Oneida 051685
Shakris, San Francisco 097157
Shakti Art Gallery, Mumbai ... 109490
Shalimar Palace, Dubai 043069
Shalini Ganendra Fine Art, Petaling
Jaya 111979
Shalom, Miami 136156
Shalom Construction &Co.,
Pittsburgh 136480
Shalovelo, Regina 128446
Shalva Amiranasvili Museum of
Art, Georgian National Museum,
Tbilisi 016226
Shamal, Villeurbanne 074189
Shaman, Bangkok 143983
Shambala, Hong Kong 065018
Shambhala, Boston 138363
Shambhala Librairie, Lyon 140892
Shambhu, Priti, Berlin 074882
The Shambles, Ashburton 088077
The Shambles, Hillsborough .. 118182
Shambles Antiques, Kendal ... 089479
Shambles Museum, Newent ... 045290
Shamburger, Richmond 096405

Shambyu Museum, Shambyu .. 031677
Shamian Gallery, Guangzhou .. 101900
Shammah, Suzy, Milano 110449
Shamrock and Cotehele Quay
Museum, National Maritime
Museum Outstation, Saint Dominick,
Cornwall 045659
Shamrock Museum, Shamrock . 006846
Shamwari, Oakland 123518
Shan State Museum, Taunggyi . 031653
Shan Xi, Shanghai 065059
Shan, Fenglin, Guangzhou 101901
Shand Galleries, Toronto 064700
Shand House Museum, Ferry Hill 005694
Shandong Academy of Fine Art,
Jinan 055154
Shandong Arts and Crafts College,
Tai'An 055176
Shandong Literature and Art
Publishing House, Jinan 137014
Shandong Painting Gallery, Jinan 007761
Shandong Provincial Museum,
Jinan 007762
Shandong Publishing House of
Literature and Art, Jinan 137014
Shandong Stone Inscription Art
Museum, Jinan 007763
Shandy Hall, Coxwold 043828
Shandy Hall, Geneva 049034
Shaner, Mark, Denver 121048
Shanez, Monaco 112092
Shang, Singapore 085324
Shangai, Bogotá 065139
ShangART Gallery, Shanghai ... 102101
Shanggao Museum, Shanggao . 008037
Shanghai Antiques and Curios Store,
Shanghai 065060
Shanghai Art Fair, Shanghai .. 097918
Shanghai Art Museum, Shanghai 008060
Shanghai Arts & Crafts,
Singapore 085325
Shanghai Arts and Crafts Museum,
Shanghai 008061
Shanghai Calligraphy and Painting
Publishing House, Shanghai .. 137019
Shanghai Children's Museum,
Shanghai 008062
Shanghai Corner, Los Angeles . 094305
Shanghai Curio, Shanghai 065061
Shanghai Duolun Museum of Moder
Art, Shanghai 008063
Shanghai Fine Arts Gallery,
Singapore 114684
Shanghai Former Residence of Soong
Ching Ling (Song Qingling Guju),
Shanghai 008064
Shanghai Gallery of Art,
Shanghai 102102
Shanghai History Museum,
Shanghai 008065
Shanghai Literature and Art Publishing
House, Shanghai 137020
Shanghai Museum, Shanghai .. 008066
Shanghai Museum of Contemporary
Art MOCA, Shanghai 008067
Shanghai Museum of Folk Collectibles,
Shanghai 008068
Shanghai Museum of Natural History,
Shanghai 008069
Shanghai Museum of Public Security,
Shanghai 008070
Shanghai Museum of the Chinese
Imperial Examination System,
Shanghai 008071
Shanghai Oil Painting and Sculpture
Academy, Shanghai 055169
Shanghai People's Fine Arts Publishing
House, Shanghai 137021
Shanghai Science & Technology
Museum, Shanghai 008072
Shanghai Spring Art Salon,
Shanghai 097919
Shanghai Urban Planning Exhibition
Hall, Shanghai 008073

Ottawa 006456
Skatkis, Paarl 085477
Skattkammaren, Kristinehamn . 086607
Skattkammaren, Stockholm . . . 040841
Skattkammaren – Uppsala Domkyrkas
 Museum, Uppsala 040918
Skaun Bygdamuseum, Børsa . . 033378
Skazka, Moskva 085034
Skeaping, Lydford 118863
Skeaping Gallery, Lydford 090500
Skeen, Joseph, Greenbank . . . 061567
Skellefteå Museum, Skellefteå . 040756
Skellgate Curios, Ripon 090969
Skelsey, K.L., Beverly Hills . . . 061143
Skepparn, Göteborg 086536
Skeppsvarvet Sjöfartsutställning,
 Sagalund Museum, Västanfjärd 011299
Skepsi on Swanston, Carlton,
 Victoria 098726
Skerries Mills, Fingal 024700
Skerryvore Museum, Story of
 Skerryvore Lighthouse, Hynish, Isle
 of Tiree 044485
Skestos, Gabriele, Chicago . . . 120549
Ski- und Heimatmuseum, Sankt Anton
 am Arlberg 002594
Ski- und Heimatmuseum Upfingen,
 Sankt Johann 021212
Skibbereen Heritage Centre,
 Skibbereen 024797
Skibinski, Josef, Ibbenbüren . . 076528
Skibinski, Marc, Montmirail . . . 070223
Skibsted, Struer 066073
Skidby Windmill and Museum of East
 Riding Rural Life, Skidby 045787
Skidt og Kanel, Frederikshavn . 065614
Skien Antikk, Skien 143232
Skiles, David, Louisville 094421
Skillbeck, Charlotte 120294
Skillen, Peter, Cockermouth . . 117769
Skilton, Charles, London 138306
Skimo Arte, Madrid 115374
Skimuseet, Oslo 033683
Skimuseum, Oberreute 020562
Skimuseum Fischinger Heimathaus,
 Fischen im Allgäu 018111
Skinkat, Sven, Flensburg 130132
Skinner, Boston 127410
Skinner Museum, Mount Holyoke
 College, South Hadley 053289
Skinner, Helen, Stockholm . . . 133932
Skipton Antiques Centre, Skipton 091201
Skiptvet Bygdemuseum, Skiptvet 033767
Skira, Milano 137794
Skirball Cultural Center, Hebrew Union
 College, Los Angeles 050409
Skirball Museum of Biblical
 Archaeology, Jerusalem 024931
Skirball Museum, Hebrew Union
 College-Jewish Institute of Religion,
 Cincinnati 047709
Skiri, Angela, München 077544
Skironio Centrum Kifissa, Skironio
 Museum Polychronopoulos, Néa
 Kifissia 022837
Skironio Museum Polychronopoulos,
 Megara 022801
Skissernas Museum, Lund 040616
Skive Museum, Skive 010143
Skivesset, Malmö 143709
Skjalm, H., København 065880
Skjern-Egvad Museum, Skjern . 010147
Skjern Malerier, Skjern 066051
Skjern Vindmølle, Skjern 010148
Skjold, Søren, Roskilde 066023
Skjoldborgs Hus, Vesløs 010190
Sklářská Muzeum Kamenický Šenov,
 Kamenický Šenov 009455
Sklářské Muzeum Moser, Karlovy
 Vary 009461
Sklářské Muzeum Nový Bor, Nový
 Bor 009566
Sklenka Muzeum v Železném Brodě,
 Městské Muzeum v Železném Brodě,

Železný Brod 009822
Sklep z Antykami, Poznań 084478
Sklep z Antykami, Warszawa . . 084576
Sklerijenn, Saint-Malo (Ille-et-
 Vilaine) 105510
Sklo, Seoul 111770
Sklorz, Martin, Ludwigsburg . . . 077097
Skobelev Park-muzej, Pleven . . 005024
Škoda Auto Museum, Mladá
 Boleslav 009541
Sköldberg, Karin, Göteborg . . . 133887
Skövde Konsthall och Konstmuseum,
 Skövde 040758
Skövde Stadsmuseum, Skövde . 040759
Skogsmuseet i Lycksele,
 Lycksele 040618
Skogsmuseum, Åsele 040351
Skogsmuseum, Sunne 040868
Skoindustrimuseet, Kumla 040566
Skokloster Motormuseum,
 Skokloster 040760
Skoklosters Slott, Skokloster . . 040761
Skol di Arte, Sint Nicolaas 054817
Škola Primijenjenih Umjetnosti,
 Sarajevo 054999
Skolen for Mediekunst, Kongelige
 Danske Kunstakademi,
 København 055251
Skolen for Mur og Rum, Kongelige
 Danske Kunstakademi,
 København 055252
Skolen for Tidsbaserede Medier,
 Kongelige Danske Kunstakademi,
 København 055253
Skolmuseet, Trolle Ljungby skola,
 Fjälkinge 040429
Skolmuseum Bunge, Fårösund . 040423
Skoob, Bath 144009
Skoob Russell Square, London . 144450
Skopia, Genève 116436
Skorianetz, Dr. Werner, Genève . 143878
Skoto, New York 123322
Skottvångs Gruva, Värdshus och
 Museum, Mariefred 040641
Skovbo Antique Export Denmark,
 Ringsted 066001
Skovgaard Jensen, Klippinge . . 065749
Skovgaard Museet i Viborg,
 Viborg 010193
Skovle & Skovle, København . . 140578
Skovs Antik, Silkeborg 066038
Skowhegan History House,
 Skowhegan 053247
Skowhegan School of Painting and
 Sculpture, New York 057526
Skowron, Michał, Poznań 084479,
 . 113835
Skowronek, Heinz, Insel Poel . . 107445
Skowronska, Thomas, Berlin . . 141504
Skrajewski, A., Dessau-Roßlau . 106655
Skrebowski, Justin F., London . . 090334,
 . 144451
Skrętowicz & Spółka, Kraków . . 133215
Skriaudžių Buities Muziejus, Prienų
 krašto muziejus, Skriaudžiai . . 030308
Skrifter och Tal, Stockholm . . . 143773
Skrobanek, E., Bruchköbel . . . 075155
Skrobek, Benedikta, Gaildorf . . 075883
Skrobek, Gerhard, Backnang . . 074446
Skrolsvik Fiskebruksmuseum, Midt-
 Troms Museum, Moen 033605
Skrotbua, Trondheim 084224
Skrypt, Kraków 143294
Skrypzak, Georg, Berne 129834
Skude Galleri og Kunstformidling,
 Haugesund 084104, 113259
Skude Galleri og Kunstformidling,
 Skudeneshavn 084198, 113358
Skufca, Dorothy, San Francisco . 136683
Skulptoriaus Broniaus Pundziaus
 Memorialinis Muziejus, Mažeikių
 Muziejus, Pieveniai 030275
Skulpturenhain vor Marleben,
 Trebel 108786

Skulpturenmuseum Glaskasten Marl,
 Marl, Westfalen 019967
Skulpturenmuseum im Hofberg,
 Stiftung Fritz und Maria Koenig,
 Landshut 019553
Skulpturenpark, Bad Nauheim . . 016620
Skulpturenpark Motzen,
 Mittenwalde 107992
Skulpturenpark Salzburger
 Freilichtskulptur, Salzburg 100044
Skulpturens Hus, Stockholm . . 040842
Skulpturensammlung, Staatliche
 Kunstsammlungen Dresden,
 Dresden 017770
Skulpturenweg, Emmendingen . 017940
Skulpturhalle Basel, Abguss-
 Sammlung des Antikenmuseums,
 Basel 041083
Skulptuuri Stuudio, Tauno Kangro,
 Tallinn 103066
Skultura Galeria de Arte, São
 Paulo 100975
Skuodo Muziejus, Skuodas . . . 030310
Skupin, Rudolf, Bremen 141583
Skupnost Muzejev Slovenije,
 Ljubljana 059723
Skuret Kulturpub, Oslo 113338
Skye and Lochalsh Archive Centre,
 Portree 060227
The Skye Museum of Island Life,
 Kilmuir 044567
Skyhawk Rugs, Albuquerque . . 091923
Skylark 2, London 118760
Skylark Gallery, London 118761
Skylark Studio, Cockermouth . . 117770
Skylark Studios, Tydd Gote . . . 119558
Skylight Galleries, Cape Town . . 114857
Skyline Books and Records, New
 York 145110
Skyscraper, New York 095578
Skyscraper Museum, New York . 051385
Skyttalan Museo, Parainen . . . 011057
Skywalk, Cincinnati 144816
Slaait'n Hoes, Onstwedde 032541
Slabsides, John Burroughs
 Association, West Park 054197
Slaby, Gerhard, Sankt Martin im
 Innkreis 062795
SLAC Kunstacademie, Stedelijke
 Academie voor Beeldende Kunst,
 Leuven 054963
The Slade Centre, Gillingham,
 Dorset 118021
Slade School of Fine Art, International
 University of Science and Culture,
 Ciudad de Panamá 056161
Slade School of Fine Art, University
 College London, London 056529
Slade, John, Saint-Christophe . . 072674
Slade, Michael, London 090335, 135099
Sládečkovo Vlastivědné Muzeum v
 Kladně, Kladno 009467
Sladmore Contemporary Gallery,
 London 090336, 118762, 135100
Sladmore Gallery, London 090337,
 118763, 135101
Slag van de Somme Museum,
 Schagen 032667
Slagelse Museum for Handel,
 Håndværk og Industri, Slagelse 010153
Slager, Mandy, Amsterdam . . . 132794
Slagterbutikken anno 1920, Roskilde
 Museum, Roskilde 010126
Sláma, Plzeň 065384
Slama, Franz, Wien 128230
Slama, Maria, Klagenfurt 062652,
 . 099938
Slama, Michael A., Portland . . . 096312
Slam's Boker och Skivor,
 Stockholm 143774
Śląski Dom Aukcyjny, Katowice . 126617
Śląski Salon Sztuki, Wrocław . . 084601
Slate Run Living Historical Farm,
 Ashville 046547

Slate Valley Museum, Granville . 049171
Slater, Indianapolis 093760
Slater, Sacramento 096483
Slater Memorial Museum,
 Norwich 051564
Slater Mill Historic Site,
 Pawtucket 051861
Slater Museum of Natural History,
 Tacoma 053532
Slater, Kathy, New Orleans . . . 095001
Slater, Phillip, Barnt Green . . . 134385
Slatkine, Genève 138129, 143879
Slaughter House Gallery,
 Pittsburgh 123824
Slaughter Ranch Museum,
 Douglas 048304
Slave Lodge, Iziko Museums of Cape
 Town, Cape Town 038506
Slavejkov Antikvariat, Sofia . . . 140290
Slaviero, Josilane, São Paulo . . 064155
Slavik, Renate, Wien 100235
Slavjanskij Dom, Moskva 114391
Slawenburg Raddusch, Vetschau 021909
Sledmere House, Driffield 043949
Sleeping Beauty Antique Beds,
 Brighton 088417, 134476
Sleepy Poet Stuff, Charlotte . . . 092460,
 . 092461
Slegers, P.T., Venlo 083503
Sleghem, Jacques & Sylvie, Lille 069449
De Slegte, Amersfoort 142823
De Slegte, Amsterdam 142880
De Slegte, Antwerpen . 140125, 140126
De Slegte, Arnhem 142899
De Slegte, Breda 142908
De Slegte, Bruxelles 140171
De Slegte, Den Haag 142932
De Slegte, Eindhoven 142947
De Slegte, Enschede 142950
De Slegte, Gent 140194
De Slegte, Groningen 142963
De Slegte, Haarlem 142974
De Slegte, Leiden 142997
De Slegte, Maastricht 143010
De Slegte, Rotterdam 143034
De Slegte, Tilburg 143047
De Slegte, Utrecht 143060
De Slegte, Zwolle 143085
Slegte, Roel de, Amsterdam . . . 082674
Sleigh Beds, Harriet Ann,
 Rolvenden 090980
Slein, Philip, Saint Louis 124122
Sleire Skulemuseum, Hosteland 033501
Slesvigske Vognsamling, Museum
 Sønderjylland, Haderslev 009936
Sleuth of Baker Street, Toronto . 140382
Slevogthof Neukastel, Sitz des
 Malers Prof. Max Slevogt mit
 Gemäldegalerie, Leinsweiler . . 019634
Slewe, Amsterdam 112365
Slezáček, Cecile Budějovice . . . 065303
Slezak, Marcella, Chicago 120550
Slezik, Sterling 127732
Slezské zemské muzeum, Opava 009575
Slezské zemské muzeum, Arboretum
 Nový Dvůr, Opava 009576
Slezské zemské muzeum, Areál čs.
 opevnění Hlučín-Darkovičky, Hlučín-
 Darkovičky 009403
Slezské zemské muzeum, Historická
 výstavní budova, Opava 009577
Slezské zemské muzeum, Památník II.
 světové války, Hrabyně 009417
Slezské zemské muzeum, Památník
 Petra Bezruče, Opava 009578
Slezské zemské muzeum, Srub Petra
 Bezruče, Ostravice 009585
Slidell Art Center, Slidell 053248
Slidell Museum, Slidell 053249
Sliedrechts Museum, Sliedrecht 032700
Slifer House, Lewisburg 050174
Sligo Art Gallery, Sligo 109703
Slim, R.T., Halesowen 144209
Slind Antikk og Auksjoner,

Sons of the American Revolution,
Roselle 052582
Sons of the American Revolution
Museum, Louisville 050441
Sonsbeek, Arnhem 112422
Sontg Hippolytus, Veulden 041840
The Sony Gallery for Photography,
Cairo 103030
Sony Wonder Technology Lab, New
York . 051388
Sonya Art, Brooklyn 047232
Sonya's Treasures, Indianapolis . 093763
Sonzogni, Luisa, Milano 080564
Soo, Seoul 111773
Soo Line Historical Museum,
Weyburn 007213
Soo San, London 090342
Soo Tze Oriental Antiques,
Prahran 062110
Soo Visual Arts Center,
Minneapolis 050879
Soobin Art International Pte. Ltd,
Singapore 114691
Sood Sangvichien Prehistoric Museum,
Bangkok 042410
Sooke Region Museum, Art Gallery
and Historic Moss Cottage,
Sooke 006890
Sookmyung Women's University
Museum, Seoul 029868
Sooner Collectibles, Oklahoma
City . 095847
Sooner Ga Museum, Dhaka . . . 003151
Sopel, Lyle, Vancouver 101697
Sopena, Ramón, Barcelona 138063
Sophia Antiquités, Saint-Ouen . . 073159
Sophia Gallery, München 108201
Sophia Wanamaker, Los Yoses . 102375
Sophie & Joe's Emporium, Saint
Paul . 096696
Sophie & Van Twist, Breda 082820
Sophienburg Museum, New
Braunfels 051164
Sophie's Books, Moss Vale 139868
Sophisticated Traveller, Zeist . . . 083527
Sopocki Dom Aukcyjny, Gdańsk 084340,
 126612
Sopocki Dom Aukcyjny, Kraków 084429,
 084430, 126624, 126625
Sopocki Dom Aukcyjny, Sopot . . 084494,
 126627
Sopot-Art, Sopot 113851
Soppa, U., Spangenberg 108654
Soproni Evangélikus Egyházközség
Múzeuma, Sopron 023574
Soproni Múzeum, Sopron 023575
Soproni Római Katolikus
Egyházművészeti Gyűjtemény,
Sopron 023576
Sorai, Kyoto 081867
Soranthe, Eindhoven 083041
Sorcha Dallas, Glasgow 118053
Sordes, Christian, Grenoble 068684
Sordini, Marseille 104150
Sordoni Art Gallery, Wilkes University,
Wilkes-Barre 054282
Sorecomodata, Porto . . 084880, 133340
Sorel, Portland 096313
Sorell Antique Centre, Sorell . . . 062209
Sorell Station Antiques, Sorell . . 062210
Soren, Christensen, New Orleans 122487
Soret, Hervé & Philippe, Saint-
Ouen 073160
Sorgato, David, Milano 080565
Sorgenfrei, Gisela, Bad
Schwartau 074555
Sorgenicht, Margarete, Berlin . . 074883
Soria, Asti 109770
Sorma, Sharjah 087971
Soro, Los Angeles 094311
Sorø Amts Museum, Sydvestsjællands
Museum, Sorø 010157
Sorokko, Serge, San Francisco . 124648,
 124649

Sorolla Galeria, Sevilla 115554
Soroptimist Book Shop, Port Pirie 139905
Soroptimist International, Kansas
City . 121593
Soroush, Tehrän 137699
Sorrentino, Amedeo, Napoli 132032
Sós, Budapest 142395
SOS Art, Bologna 131399
Sos Moveis, São Paulo 064156
Sosa-Carillo-Fremont House Museum,
Tucson 053712
Sosa, Lourdes, México 112056
Sósaiati, Coimbra 084621
Soseki Musem, London 045017
Soshoku Design, Tokyo 138937
Sosin & Sosin, Minneapolis 122313
Soskine, Michel, New York 123332
Sosnitza, Michael, Göttingen . . . 130210
Sosnovoborskij Chudožestvennyj
Muzei Sovremennogo Iskusstva,
Sosnovyj Bor 037711
Sosnowieckie Centrum Sztuki –
Zamek Sielecki, Sosnowiec . . . 035048
SoSo, Paju 111639
Sossdorf, Hans Georg, Lübeck . 077128
Sóstói Múzeumfalu,
Sóstógyógyfürdö 023579
SOTA Gallery, Witney 119665
Sota Zorraquin, Pedro de la,
Bilbao 115086
Sotamuseo, Helsinki 010689
Sotarns Antik och Auktion,
Ljungby 086633, 126834
Sotavallan Tuulimylly, Lempäälä 010929
Soteau, Christian, Souvigny 073518
Sotelo Salazar, Manuel, Lima . . 084301
Sotheby's, Amsterdam 126489
Sotheby's, Armadale, Victoria . . 125456
Sotheby's, Bangkok 126979
Sotheby's, Beverly Hills 127405
Sotheby's, Billingshurst 127014
Sotheby's, Boston 127411
Sotheby's, Buenos Aires 125451
Sotheby's, Caracas 127774
Sotheby's, Chicago 127434
Sotheby's, Constantia 126705
Sotheby's, Coral Gables 127454
Sotheby's, Dallas 127459
Sotheby's, Doha 126680
Sotheby's, Dublin 126388
Sotheby's, Edinburgh 127101
Sotheby's, Frankfurt am Main . . 126200
Sotheby's, Genève 126933
Sotheby's, Hamburg 126222
Sotheby's, Harrogate 127139
Sotheby's, Haverford . . 127505, 127506
Sotheby's, Hong Kong 125677
Sotheby's, Jakarta 126382
Sotheby's, Johannesburg 126707
Sotheby's, København 125709
Sotheby's, Köln 126253
Sotheby's, Kuala Lumpur 126474
Sotheby's, London 127211
Sotheby's, Los Angeles 127560
Sotheby's, Lugano 126942
Sotheby's, Madrid 126762
Sotheby's, McLeod 127579
Sotheby's, México 126481
Sotheby's, Milano 126428
Sotheby's, Montecito 127594
Sotheby's, München 126301
Sotheby's, New York 127624
Sotheby's, Newtownards 127240
Sotheby's, Oslo 126592
Sotheby's, Palm Beach 127649
Sotheby's, Paris 126042
Sotheby's, Praha 125698
Sotheby's, Rio de Janeiro 125631
Sotheby's, Roma 126445
Sotheby's, Saint-Geoire-en-
Valdaine 126076
Sotheby's, San Francisco 127711
Sotheby's, Santiago de Chile . . . 125666
Sotheby's, São Paulo 125632

Sotheby's, Shanghai 125683
Sotheby's, Singapore 126700
Sotheby's, Stockholm 126885
Sotheby's, Sydney 125517
Sotheby's, Taipei 126976
Sotheby's, Tel Aviv 126399
Sotheby's, Tiverton 127331
Sotheby's, Tokyo 126466
Sotheby's, Torino 126451
Sotheby's, Toronto 125655
Sotheby's, Towson 127744
Sotheby's, Ullenwood 127338
Sotheby's, Wien 125558
Sotheby's, Zürich 126970
Sotheby's at Auction, Bend 139524
Sotheby's Belgium SA, Bruxelles 125597
Sotheby's Monaco, Monaco . . . 126485
Sotheby's Restoration, New York 136352
Sotheran, Henry, London 090343,
 135105, 144452
Sotilasläaketieteen Museo, Lahti 010904
Sotiropoulos, Athinai 109058
Sotkamon Makasiinimuseo,
Sotkamo 011192
Soto, Boston 120203
Soto de Collins, Lucía, Bogotá . 065141
Soto Valle, Luis Miguel, Bilbao . 085711
Soto, Blanca, Madrid 115376
Sotscheck, Helmut, Potsdam . . . 130907
Sotterley Plantation Museum,
Hollywood 049472
Sotterranei dell'Arte, Monte
Carasso 041506
Sottocorno 9, Milano 110453
Sottopiano Beaux-Arts, Cagliari . 059402,
 109940, 137730
Sottoriva, Verona 081771
Sou, Sendai 111404
Soubizantik, Saint-Ouen 073161
Soubrier, Louis, Paris 071867
Souček, Vladislav, Plzeň 065385
Souchaud, Françoise, Lyon 104085
Soucheby's, Nelson . . . 083865, 113053
Souchet, Albert, Rennes (Ille-et-
Vilaine) 129436
Souchet, Fabien, Paris 129376
Souchko, Vladimir, Rouen 072577,
 129443
Souchon, Michel, Paris 071868
Souchot, Patrice, Cepoy 067689, 067690
Soudan Corners, Toronto 064701
Souders, Fort Worth 121167
Soudry-Tharaud, Annie, Carnac . 067633
Soufer, Mahboubeh, New York . . 133333
Souffle du Passé, Kfarhabab . . . 082140,
 142775
Soufir, Hélène, Maulette 069952
Souflard, Jean-Pierre, Ampuis . . 066526
Sougyo, Aoitori, Tokyo 082031
Souillac, Michel, Paris 071869
Soukaïna, Casablanca 082398
Soul 42, Bern 087115
Soul Art Space, Busan 111600
Soul Mates Adventures,
Amsterdam 112370
Soul of Africa, Vancouver 101698
Soul of Africa Museum, Essen . . 018056
Soulard, Saint Louis 124124
Soulard, Claude, Saint-Georges-de-
Montaigu 072756
Soulard, Jacqueline & Christian,
Flayosc 068481, 140799
Soulard, Marie-Hélène, Nantes . 129075
Soulas, Didier, La Roche-sur-Yon 069018
Soulflower, Bangkok 117046
Soulflower, Mumbai 109495
Soulié, Béatrice, Paris 105200
Soulié, Jacqueline, Finhan 068477
Soulie, José, Bourganeuf 067363
Soulier, Balthazar, Paris 129377
Soulier, Marc, Montpellier 070261
Soulières, Roger, Montréal 101315
Soulis, Dirk, Lone Jack 127553
soulofart.com, Leinfelden-

Echterdingen 076990
Soun Museum, Ashikaga 028305
Sound of the Century Museum,
Macau 007879
Sound School House Museum, Mount
Desert 051015
Sound Visitor Centre, Manx National
Heritage, Port Saint Mary 045494
Soundarte-Galería, Medellín . . . 102362
Soundiata, Seattle 124850
Sour, Patrick, Niort 070665
Sourbié, Didier, Sigean 073481
Source, Buffalo 092394
Source Antiques, Dubbo 061404
Source Antiques, Widcombe . . . 091703
Source aux Trouvailles, Nanterre 070387
Source Enterprises, Vancouver . 064832
Source Fine Arts, Kansas City . . 121594
Source: Notes in the History of Art,
New York 139525
Sourget, Patrick, Chartres 140785
Sourgnes, Michel, Ascot 098524
Source, Daniel, Vitry-sur-Seine . 074225
Sourillan International, Toulouse . 073763,
 105708
La Souris Verte, Paris 071870
Sourzat, Jean-Louis, Saint-Céré . 072669
Sous le Ciel Tibétain, Perpignan 072053
Sous-les-Toits-de-Paris, Paris . . 071871
Sousa & Filhos, Lisboa 084805
Sousa & Roquette, Lisboa 084806
Sousa, Aldo de, Buenos Aires . . 098426
Soussana, Jacques, Jerusalem . 109726,
 137712
Soustre, François, Saint-Hilaire-
Luc . 072787
Souter Johnnie's Cottage,
Kirkoswald 044603
Souterroscope des Ardoisières,
Caumont-l'Eventé 012186
South African Antique Dealers'
Association, Fontainebleau . . . 059736
South African Jewish Museum,
Gardens 038538
South African Mint Museum-Coin
World, Tshwane 038675
South African Museum, Iziko
Museums of Cape Town, Cape
Town 038508
South African Museums Association
(SAMA), Centrahil 059737
South African National Association for
the Visual Arts, Tshwane 059738
South African National Gallery, Iziko
Museums of Cape Town, Cape
Town 038509
South African National Museum of
Military History, Johannesburg 038580
South African National Railway &
Steam Museum, Auckland Park 038467
South African Police Service Museum,
Tshwane 038676
South Arkansas Arts Center, El
Dorado 048457
South Australian Aviation Museum,
Port Adelaide 001412
South Australian Maritime Museum,
Port Adelaide 001413
South Australian Museum,
Adelaide 000774
South Australian Police Museum,
Thebarton 001571
South Australian School of Art,
University of South Australia, Division
of Education, Arts and Social
Sciences, Adelaide 054819
South Bank Galleries, Pittsburgh 096163,
 123826
South Bank Printmakers, London 118764
South Bannock County Historical
Center, Lava Hot Springs 050133
South Bay Auctions, Long Island
City . 127555
South Bend Regional Museum of Art,

South Boston-Halifax County Museum of Fine Arts and History, –
Southwestern Saskatchewan Oldtimer's Museum, Maple Creek

Index of Institutions and Companies

Stadtmuseum Stadtoldendorf,
 Stadtoldendorf 021555
Stadtmuseum Steinfurt, Steinfurt 021582
Stadtmuseum Stolpen, Stolpen . 021606
Stadtmuseum Sulzbach-Rosenberg,
 Sulzbach-Rosenberg 021683
Stadtmuseum Teterow, Teterow 021732
Stadtmuseum Traiskirchen,
 Traiskirchen 002768
Stadtmuseum Traismauer,
 Traismauer 002769
Stadtmuseum Trostberg,
 Trostberg 021804
Stadtmuseum Tübingen,
 Tübingen 021817
Stadtmuseum und Fürstlich
 Starhembergisches Familienmuseum,
 Eferding 001830
Stadtmuseum und Glasmuseum
 Waldkraiburg, Waldkraiburg . . . 021983
Stadtmuseum und
 Tuchmachermuseum Pinkafeld,
 Pinkafeld 002461
Stadtmuseum Ungarturm Bruck an der
 Leitha, Bruck an der Leitha . . 001792
Stadtmuseum Vogtturm, Zell am
 See 003050
Stadtmuseum Warendorf,
 Warendorf 022018
Stadtmuseum Wasungen,
 Wasungen 022032
Stadtmuseum Wehr, Wehr 022041
Stadtmuseum Weilheim, Weilheim in
 Oberbayern 022069
Stadtmuseum Weimar, Weimar . 022096
Stadtmuseum Wendlingen,
 Wendlingen am Neckar 022149
Stadtmuseum Werne, Werne . . . 022163
Stadtmuseum Wiener Neustadt,
 Wiener Neustadt 003024
Stadtmuseum Wienertor Hainburg,
 Hainburg an der Donau 002021
Stadtmuseum Wil, Wil 041873
Stadtmuseum Wilhelm von Kügelgen,
 Ballenstedt 016729
Stadtmuseum Zehentstadel,
 Nabburg 020279
Stadtmuseum Zella-Mehlis, Zella-
 Mehlis 022440
Stadtmuseum Zistersdorf,
 Zistersdorf 003055
Stadtmuseum Zweibrücken,
 Zweibrücken 022483
Stadtmuseum Zwettl, Zwettl . . . 003059
Stadtmuseum, Städtische Museen
 Jena, Jena 019150
Stadtraum Vilshofen, Vilshofen . 021931
Stadtresidenz, Landshut 019554
Stadtschloss Weimar mit
 Schlossmuseum, Klassik Stiftung
 Weimar, Weimar 022097
Stadtteilmuseum Nowaweser
 Weberstube, Potsdam 020843
Stadtturmmuseum, Wehrheim . . 022042
Stadtturmgalerie, Gmünd,
 Kärnten 001931
Stadtverkehrs- und Kinomuseum,
 Klagenfurt 002168
Stäcker, Peter, Bischofszell 116256
Städel Museum, Frankfurt am
 Main 018183
Städelscher Museums-Verein e.V.,
 Frankfurt am Main 059161
Städtische Galerie, Dreieich . . . 017739
Städtische Galerie, Traunstein . . 021774
Städtische Galerie, Villingen-
 Schwenningen 021924
Städtische Galerie, Wurzen 022408
Städtische galerie ada Meiningen,
 Meiningen 020002
Städtische Galerie Bietigheim-
 Bissingen, Bietigheim-Bissingen 017161
Städtische Galerie Böblingen,
 Böblingen 017236

Städtische Galerie Bremen,
 Bremen 017371
Städtische Galerie Delmenhorst –
 Haus Coburg – Sammlung
 Stuckenberg, Delmenhorst . . . 017620
Städtische Galerie Die Fähre, Bad
 Saulgau 016650
Städtische Galerie Dresden –
 Kunstsammlung, Museen der Stadt
 Dresden, Dresden 017773
Städtische Galerie Eichenmüllerhaus,
 Lemgo 019693
Städtische Galerie Filderhalle,
 Leinfelden-Echterdingen 019632
Städtische Galerie Filderstadt,
 Filderstadt 018106
Städtische Galerie Fruchthalle Rastatt,
 Rastatt 020905
Städtische Galerie für Moderne Kunst,
 Wittlich 022288
Städtische Galerie Grimma,
 Grimma 018537
Städtische Galerie Haus Seel,
 Siegen 021455
Städtische Galerie im Alten Rathaus,
 Fürstenwalde 018274
Städtische Galerie im Alten Spital, Bad
 Wimpfen 016695
Städtische Galerie im Cordonhaus
 Cham, Cham 017499
Städtische Galerie im Königin-
 Christinen-Haus, Zeven 022453
Städtische Galerie im Kornhaus,
 Kirchheim unter Teck 019308
Städtische Galerie im Leeren Beutel,
 Museen der Stadt Regensburg,
 Regensburg 020955
Städtische Galerie im Lenbachhaus
 und Kunstbau München,
 München 020227
Städtische Galerie im Park,
 Viersen 021916
Städtische Galerie im Rathauspark,
 Gladbeck 018426
Städtische Galerie im Schloßpark
 Strünkede, Emschertal-Museum,
 Herne 018920
Städtische Galerie im Spital zum
 Heiligen Geist, Riedlingen . . . 021042
Städtische Galerie in der Alten Schule,
 Sigmaringen 021463
Städtische Galerie In der Badstube,
 Wangen im Allgäu 022008
Städtische Galerie in der Reithalle,
 Paderborn 020711
Städtische Galerie Iserlohn,
 Iserlohn 019120
Städtische Galerie Kaarst, Kaarst 019168
Städtische Galerie Karlsruhe,
 Karlsruhe 019211
Städtische Galerie Lehrte, Lehrte 019622
Städtische Galerie Liebieghaus,
 Liebieghaus Skulpturensammlung,
 Frankfurt am Main 018184
Städtische Galerie Lüdenscheid,
 Museen der Stadt Lüdenscheid,
 Lüdenscheid 019836
Städtische Galerie Neunkirchen,
 Neunkirchen, Saarland 020381
Städtische Galerie Nordhorn –
 Kunstwegen, Nordhorn 020475
Städtische Galerie Offenburg,
 Offenburg 020623
Städtische Galerie Ostfildern,
 Ostfildern 020673
Städtische Galerie Rastatt,
 Rastatt 020906
Städtische Galerie Reutlingen,
 Reutlingen 021008
Städtische Galerie Rosenheim,
 Rosenheim 021096
Städtische Galerie Sohle 1,
 Stadtmuseum Bergkamen,
 Bergkamen 016851

Städtische Galerie Stapflehus, Weil
 am Rhein 022056
Städtische Galerie Villa Streccius,
 Landau in der Pfalz 019539
Städtische Galerie Waldkraiburg,
 Waldkraiburg 021984
Städtische Galerie Wolfsburg,
 Wolfsburg 022327
Städtische Galerie, "Fauler Pelz",
 Überlingen 021834
Städtische Galerie, im Museum der
 Stadt Ettlingen, Ettlingen . . . 018069
Städtische Galerie, Museum alter
 lippischer Maler, Schieder-
 Schwalenberg 021254
Städtische Galerie, Sammlung des 20.
 Jahrhunderts, Füssen 020710
Städtische Gemäldegalerie,
 Füssen 018282
Städtische Kunstgalerie
 im Deutschordenshaus,
 Donauwörth 017701
Städtische Kunstgalerie Torhaus
 Rombergpark, Dortmund 017732
Städtische Kunsthalle, Museen
 der Stadt Recklinghausen,
 Recklinghausen 020933
Städtische Kunstsammlung,
 Murrhardt 020273
Städtische Kunstsammlung Schloß
 Salder, Salzgitter 021186
Städtische Museen Heilbronn –
 Kunsthalle Vogelmann,
 Heilbronn 018863
Städtische Museen Heilbronn –
 Museum im Deutschhof,
 Heilbronn 018864
Städtische Museen Wangen im Allgäu,
 Wangen im Allgäu 022009
Städtische Sammlungen Freital, auf
 Schloss Burgk, Freital 018237
Städtische Wessenberg-Galerie
 Konstanz, Konstanz 019438
Städtisches Heimatmuseum,
 Meßkirch 020048
Städtisches Heimatmuseum Höchstadt,
 Höchstadt an der Aisch 018973
Städtisches Heimatmuseum im
 Waldemarturm, Dannenberg . . 017584
Städtisches Heimatmuseum Landau,
 Landau in der Pfalz 019540
Städtisches Hellweg-Museum,
 Geseke 018402
Städtisches Kramer-Museum,
 Kempen 019267
Städtisches Kunstmuseum Spendhaus
 Reutlingen, Reutlingen 021009
Städtisches Lapidarium, Stuttgart 021657
Städtisches Museum,
 Aschersleben 016434
Städtisches Museum, Bruchsal . 017407
Städtisches Museum, Herborn . . 018896
Städtisches Museum, Kalkar . . . 019177
Städtisches Museum, Kitzingen . 019318
Städtisches Museum,
 Neunkirchen 002403
Städtisches Museum, Salzgitter 021187
Städtisches Museum, Schärding 002653
Städtisches Museum, Überlingen 021835
Städtisches Museum, Welzheim 022143
Städtisches Museum, Werl 022160
Städtisches Museum, Wiesloch . 022233
Städtisches Museum, Zeulenroda-
 Triebes 022449
Städtisches Museum Braunschweig,
 Altstadtrathaus, Braunschweig 017344
Städtisches Museum Braunschweig,
 Haus am Löwenwall,
 Braunschweig 017345
Städtisches Museum Engen und
 Galerie, Engen 017962
Städtisches Museum Fürstenwalde,
 Fürstenwalde 018275
Städtisches Museum Göppingen im

Storchen, Göppingen 018453
Städtisches Museum Göttingen,
 Göttingen 018477
Städtisches Museum Grevesmühlen,
 Museums- und Vereinshaus,
 Grevesmühlen 018532
Städtisches Museum Hann. Münden,
 Hann. Münden 018752
Städtisches Museum Haus Letmathe,
 Iserlohn 019121
Städtisches Museum im ehemaligen
 Heiliggeistspital, Munderkingen 020265
Städtisches Museum im Hospital,
 Nidderau 020430
Städtisches Museum im Kornhaus,
 Kirchheim unter Teck 019309
Städtisches Museum im Kornhaus Bad
 Waldsee, Bad Waldsee 016684
Städtisches Museum im Spiegelschen
 Palais, Halberstadt 018652
Städtisches Museum Kamen, Haus
 der Kamener Stadtgeschichte,
 Kamen 019179
Städtisches Museum Peterskirche,
 Vaihingen an der Enz 021886
Städtisches Museum Rosenheim,
 Rosenheim 021097
Städtisches Museum Saarlouis,
 Saarlouis 021177
Städtisches Museum Schloss Rheydt,
 Mönchengladbach 020096
Städtisches Museum Seesen,
 Seesen 021423
Städtisches Museum Wesel, Abt.
 Schill, Wesel 022177
Städtisches Museum Wesel,
 Festungsgeschichtliche Abteilung,
 Wesel 022178
Städtisches Museum Wesel, Galerie
 im Centrum, Wesel 022179
Städtisches Museum Zirndorf,
 Zirndorf 022465
Städtisches Museum, Abt.
 Stadtgeschichte, Städtische Galerie,
 Eisenhüttenstadt 017901
Städtisches Naturkundliches Museum,
 Göppingen 018454
Städtisches Ortsmuseum
 Schwamendingen, Zürich 041956
Städtisches Schulmuseum, Lohr am
 Main 019773
Städtligalerie, Wangen an der
 Aare 116804
Stähli, M. & M., Oberdiessbach . 116636
Stähli, Marc, Auvernier 133974
Stähli, Simon, Urdorf 143931
Stählin-Tschanz, Betli, Altendorf 087003
Stämpfli Verlag, Bern 138119
Ständerhaus, Buus 041174
Stærk, København 065886
Staetshuijs, Amsterdam 082677
Staetshuijs Antiquairs Meulendijks &
 Schuil, Amsterdam 082678
Staf, Antwerpen 063182
Staffanstorps Konsthall,
 Staffanstorp 040785
Staffelbach, Elisabeth, Aarau . . . 116104
Staffin Museum, Staffin 045833
Stafford, Barcelona 085664
Stafford Castle and Visitor Centre,
 Stafford 045837
Stafford Gallery, London 118770
Stafford, Ulla, Binfield 088242
Staffords, London 118771
Staffordshire House Antiques,
 Oakland 095749
Staffordshire Regiment Museum,
 Lichfield 044704
Stafforte, Andrea, Bern 087116
Stafsjö Bruksmuseum,
 Falkenberg 040417
Stage, Sapporo 081933
Stage & Screen, London 144455
Stage 21 Gallery, Tokyo 111514

Sternberg, Heinz, Hamburg 076258
Sternberg, Maurice, Chicago ... 120557
Šternberský Palác, Národní Galerie v
Praze, Praha 009681
Sterne-Hoya Museum,
Nacogdoches 051079
Sternenburg, Bonn 075052
Sternitzky, Hugues, Wasserbourg 074256
Sternmann, M., Crailsheim ... 075231
Šternová, Viera, Trenčín 114749
Sterr, F.X., Starnberg 131032
Sterrenburg, Drs. Marius,
Amsterdam 082682
Sterry, John Henry, Louisville ... 094425
Sterz, P. & I., Wolfsburg 108976
Sterzenbach, Mathias, Longeville-lès-
Metz 069558
Sterzik, Angelika & Heiko, Bernkastel-
Kues 106474
Stetten, Isabelle Anne, Paris ... 129378
Stettler Town and Country Museum,
Stettler 006908
Steuben House Museum, River
Edge 052485
Steuben Memorial State Historic Site,
Remsen 052411
Steuer, Helmut, Worms 078978
Stevenage Museum, Stevenage . 045850
Stevens, Houston 093636, 135969
Stevens & Son, Lubenham 090486,
135158
Steven's Art, Buffalo 120247
Stevens-Coolidge Place, North
Andover 051506
Stevens County Gas and Historical
Museum, Hugoton 049565
Stevens County Historical Society
Museum, Morris 050988
Stevens Furniture Restoration,
London 135110
Stevens Museum, Salem 052778
Stevens, Elliot, New York 123345
Stevens, John, Nashville 136200
Stevens, Larry, Baltimore 120053
Stevenson, Hamilton 064275
Stevenson Academy of Fine Arts,
Oyster Bay 057600
Stevenson Galleries, Tunbridge
Wells 119550
Stevenson-Hamilton Memorial
Information Centre, Skukuza .. 038648
Stevenson, Mandrake, Ibstock .. 089439,
134812
Stevenson, R.B., San Diego ... 124423
Steves Homestead Museum, San
Antonio 052850
Steveston Museum, Richmond . 006645
Stevington Windmill, Stevington 045851
Stew Gallery, Norwich 119035
Stewart, Bexhill-on-Sea 117444, 134420
Stewart, Eastbourne .. 088941, 134668
Stewart, Glenorie 061525
Stewart, Jacksonville 136015
Stewart Antiques, Los Angeles . 094423
Stewart Collection, Pocklington . 045476
Stewart Hay Memorial Museum,
University of Manitoba, Department
of Zoology, Winnipeg 007282
Stewart Historical Museum,
Stewart 006909
Stewart Indian Cultural Center, Carson
City 047408
Stewart M. Lord Memorial Museum,
Burlington 047284
Stewart, Charles, Atlanta 092024
Stewart, Cynthia, Tulsa 125065
Stewart, Dennis E., San Antonio 124321
Stewart, Inessa, Dallas 093055
Stewart, Laurie, London 090354
Stewart, Tabori & Chang, New
York 138481
Stewarton and District Museum,
Stewarton 045852
The Stewartry Museum,

Kirkcudbright 044600
Stevens, Palermo 110639
Stewner, Jochen, Lübeck 107907
Stey, Villemomble 074118
Steyaert, C., Bruxelles 063498
Steyaert, Claire, Minneapolis .. 094783
Steyning Museum, Steyning .. 045853
Steyrtal-Museumsbahn, Steyr .. 002728
Sticht, Uwe, Hagen 141750
Stichting Atlas Van Stolk,
Rotterdam 032646
Stichting De Appel, Center for
contemporary art, Amsterdam . 031812
Stichting De Brakke Grond,
Amsterdam 031813
Stichting George Grard,
Gijverinkhove 003576
Stichting Huis Bergh, 's-
Heerenberg 032249
Stichting Joden Savanna,
Paramaribo 040307
Stichting Kunst in Openbare Ruimte,
SKOR, Amsterdam 059537
Stichting Niggendijker, Groningen 112589
Stichting Noorderlicht, Groningen 112590,
137953
Stichting Oosterkerk, Amsterdam 031814
Stichting Outline, Amsterdam .. 112378
Stichting Santjes en Kantjes,
Maastricht 032452
Stichting tot Beheer Museum
Boijmans Van Beuningen,
Rotterdam 032647
Stichting Veranneman,
Kruishoutem 003684
Stichting Zeeuwse Schaapkudde,
Heinkenszand 032269
Stickan, Marion, Köln 076846
Stickereimuseum Eibenstock,
Eibenstock 017869
Stickereimuseum Lustenau,
Lustenau 002307
Stickmaskinsmuseum,
Glemminebro 040445
Sticks & Stones, Toronto 064703
Sticks and Stones, Christchurch 083721
Stida Eiendom, Oslo 084179
Stiebel, Gérald, New York 095599
Stiebeling, Klaus, Wuppertal .. 079024
Stiebner Verlag GmbH, München 137570
Stiefelhagen, Klaus, Lindlar ... 077066
Stiefelhagen, Kunibert, Siegburg 078833
Stiefelmachermuseum, Rechnitz 002525
Stiegemann-Schöpper, I., Rheine 078147
Stiegler & Co., New York 095600
Stiegler, Christa & Helmut,
Ansbach 105946
Stieglitz, Martha, Stuttgart ... 108738
Stiehl, Ralf, Twistetal 078653
Stieler, Breitenbrunn 075102
Stien, Daniel, San Francisco .. 097166
Stieren, San Antonio 124322
Stierhübelteichhaus, Trift- und
Holzfällermuseum, Karlstift .. 002133
Stierle, Heinz, Salzburg 140030
Sties, Paul, Kronberg im Taunus 107747,
107748
Stievano, Paolo, Padova 132066
Stiffkey, Norwich 090738
Stiffkey Antiques, Stiffkey 091277
Stiffkey Lamp Shop, Stiffkey .. 091278
Stift Fischbeck, Hessisch
Oldendorf 018935
Stift Herzogenburg,
Herzogenburg 002058
Stift Obernkirchen, Obernkirchen 020559
't Stift, Schatkamer en
Bezoekerscentrum, Susteren . 032730
Stiftelsen Militärfordons Museum,
Museet Malmahed, Malmköping 040625
Stiftelsen Musikkulturens Främjande,
Stockholm 040845
Stiftlandmuseum, Waldsassen . 021986
Stifts- und Heimatmuseum

Schloß Seeburg, Seekirchen am
Wallersee 002692
Stiftsbibliothek, Einsiedeln 041233
Stiftsbibliothek St. Gallen, Sankt
Gallen 041676
Stiftsgalerie Seitenstetten,
Seitenstetten 002694
Stiftsgården, Trondheim 033857
Stiftskirchenmuseum,
Himmelkron 018956
Stiftsmuseet, Museum Lolland-Falster,
Maribo 010065
Stiftsmuseum, Aschaffenburg .. 016431
Stiftsmuseum, Bad Buchau ... 016540
Stiftsmuseum, Garsten 001917
Stiftsmuseum, Zwettl 003060
Stiftsmuseum Mattsee, Mattsee 002334
Stiftsmuseum Millstatt, Millstatt 002349
Stiftsmuseum Praemonstratenser-
Chorherrenstift Schlägl, Aigen-
Schlägl 001686
Stiftsmuseum Schatzhaus Kärntens,
Sankt Paul 002635
Stiftsmuseum, Stiftsarchiv /
Stiftsbibliothek, Xanten 022418
Stiftssammlungen Lambach,
Lambach 002225
Stiftssammlungen Wilten,
Innsbruck 002112
Stiftung AutoMuseum Volkswagen,
Wolfsburg 022328
Stiftung B.C. Koekkoek-Haus,
Kleve 019325
Stiftung Belgisches Museum BSD im
Haus der Bildung und Erinnerung,
Soest 021493
Stiftung BINZ39, Zürich 116937
Stiftung Bohlenständerhaus Schrofen,
Amriswil 041017
Stiftung Brandenburgische
Gedenkstätten, Oranienburg .. 020646
Stiftung Bundeskanzler-Adenauer-
Haus, Bad Honnef 016586
Stiftung Domäne Dahlem, Landgut
und Museum, Berlin 017081
Stiftung Donauschwäbisches
Zentralmuseum, Ulm 021857
Stiftung Federkiel für zeitgenössische
Kunst und Kultur, Leipzig ... 107842
Stiftung für Konkrete Kunst,
Reutlingen 021010
Stiftung für Konkrete Kunst Roland
Phleps, Freiburg im Breisgau . 018222
Stiftung Fürst-Pückler-Museum, Park
und Schloß Branitz, Cottbus .. 017546
Stiftung Gerhart-Hauptmann-Haus,
Deutsch-osteuropäisches Forum,
Düsseldorf 017805
Stiftung Hubert Aratym,
Gutenstein 002008
Stiftung Käthe Kollwitz Haus,
Moritzburg 020122
Stiftung Keramion, Zentrum für
moderne und historische Keramik,
Frechen 018198
Stiftung Kloster Jerichow,
Jerichow 019152
Stiftung Kloster Michaelstein-Museum,
Blankenburg 017190
Stiftung Kohl'sche Einhorn-Apotheke,
Weißenburg in Bayern 022126
Stiftung Mecklenburg, Ratzeburg 020916
Stiftung Museum Kunstpalast,
Düsseldorf 017806
Stiftung Museum Schloss Moyland,
Sammlung und Archiv, Joseph
Beuys Archiv des Landes Nordrhein-
Westfalen, Bedburg-Hau 016800
Stiftung Naturschutzgeschichte,
Königswinter 019417
Stiftung Neue Synagoge Berlin –
Centrum Judaicum, Berlin ... 017082
Stiftung Opelvillen, Rüsselsheim 021152
Stiftung Phänomenta Lüdenscheid

Lüdenscheid 019837
Stiftung Preußische Schlösser
und Gärten Berlin-Brandenburg,
Potsdam 059162
Stiftung Römermuseum Homburg-
Schwarzenacker, Homburg .. 019029
Stiftung Sammlung E.G. Bührle,
Zürich 041957
Stiftung Scheibler-Museum Rotes
Haus Monschau, Monschau .. 020112
Stiftung Schleswig-Holsteinische
Landesmuseen Schloß Gottorf,
Schleswig 021273
Stiftung Schloss Ahrensburg,
Ahrensburg 016286
Stiftung Schloss Eutin, Eutin .. 018075
Stiftung Schloss Neuhardenberg,
Neuhardenberg 020350
Stiftung Schloss und Park Benrath,
Museum für Europäische
Gartenkunst, Museum Corps de
Logis (Hauptschloss), Museum
für Naturkunde, Orangerie, Park,
Düsseldorf 017807
Stiftung Simonshof, Gleisweiler . 018435
Stiftung Stadtmuseum Berlin,
Landesmuseum für Kultur und
Geschichte Berlins, Direktion und
Verwaltung, Berlin 017083
Stiftung Starke, Berlin 017084
Stiftung Stift Neuzelle, Neuzelle 020426
De Stijl, Dordrecht 083007
Stiklestad Nasjonal Kultursenter,
Verdal 033902
Stiko Karoliukai, Vilnius 111864
Stil, Beograd 085174
Stil Leben, Wermelskirchen ... 108893
Stilbruch, Oldenburg 077863
Still, Chicago 120558
Still National Osteopathic Museum,
Kirksville 049948
Stilla Nova, Maastricht 083294
Stille, Maastricht 143011
Stille-Nacht- und Heimatmuseum
Bruckmannhaus, Oberndorf bei
Salzburg 002417
Stille Nacht Galerie, Oberndorf bei
Salzburg 099997
Stille Nacht-Museum, Hallein .. 002029
Stille Nacht Museum Arnsdorf,
Lamprechtshausen-Arnsdorf .. 002226
Stille, D., Lienen 077045
Stillman, Georgie, San Diego .. 096970
Stills, Nijmegen 112699
Still's Corner, Timaru 113120
Stills Gallery, Edinburgh 044099
Stills Gallery, Paddington, New South
Wales 099403
Stillwater, Seattle 124852
STIM, Nesle-Hodeng 070458
Stima, Breda 112442
Stima, Bruxelles 100520
Stingray, Columbus 120794
Stingy Lu Lu's, Bridgetown ... 100320
Stinson, New Orleans 122490
Stinzenmuseum, Tsjerke en Uniastate
Beers, Beers 031876
Stirk Cottage, Kalamunda ... 001172
Stirling Antiques, Abinger
Hammer 087994
Stirling Smith Art Gallery and
Museum, Stirling 045859
Stirnemann, M.V., Zürich 143973
Stirt, James, Vevey 126955
Stith, Norfolk 136382
Stivanin-Bouquet, Céline, Castanet-
Tolosan 128770
Stix, W., Baden-Baden 074604
Stjepan Gruber Museum,
Županja 008895
Stjernsunds Slott, Askersund .. 040354
Stjørdal Museum KF, Stjørdal .. 033810
Stoani Haus der Musik, Gasen . 001919
Stobbe, Peter, Bochum 141536

Studio-Museo di Giuseppe Pellizza,
Istituto Giuseppe Pellizza,
Volpedo 028243
The Studio Museum in Harlem, New
York 051393
Studio National des Arts
Contemporains de Tourcoing,
Tourcoing 055366
Studio of Artists, Newtown, New
South Wales 099320
Studio of Contemporary Art,
Auckland 112899
Studio on J, Sacramento 124032
Studio on the Quay, Yarmouth . . 119702
Studio One, Cleveland 120738
Studio One, Honolulu 121249
Studio One Gallery, Mount
Gambier 099264
Studio Paul Nicholls, Milano . . 110476
Studio Per Il Restauro, Brescia . 131449
Studio Petrecca, Arte Contemporanea,
Torino 111031
Studio Plus, Geelong 098932
Le Studio PM, Montréal 101317
Studio Potter, Manchester . . . 139532
Studio Raffaelli, Trento 111056
Studio Reggiani, Milano 110477
Studio Restauro Formica, Milano 131928
Studio Restauro, Torino 132591
Studio Restauro Antichità,
Brescia 131450
Studio Restauro Santa Trinita,
Firenze 131665
Studio Ripetta, Roma 081406
Studio Roze Antiques, Rio de
Janeiro 128371
Studio S, Pune 109524
Studio S Arte, Roma 110880
Studio Saint-Sulpice, Paris 071877
Studio San Damiano, Milwaukee 122229
Studio San Giuseppe Art Gallery,
College of Mount Saint Joseph,
Cincinnati 047710
Studio Santo Spirito di Grossi & Lotti,
Firenze 131666
Studio Seven, Otley 119080
Studio Siro, Tiranë 098347
Studio Six Art, Oklahoma City . . 123547
Studio Sixteen Seventeen, Los
Angeles 121882
Studio Soligo, Roma 110881
Studio Solstone, Seattle 124854
Studio Suardo, Milano 131929
Studio Swiss, Tucson 136758
Studio Techne, Firenze 131667
Studio Ten, Saint Paul 124183
Studio Tommaseo, Istituto per la
Documentazione e la Diffusione delle
Arti, Trieste 059403
Studio Trisorio, Napoli 110561
Studio Trisorio, Roma 110882
Studio Västsvensk Konservering,
Göteborg 133889
Studio Venticinque, Milano 110478
Studio Wienblick, Wien 100242
Studio Wildflower Paintings,
Denmark 098825
Studio Windsor, Mumbai 109497
Studio Works Gallery, Nailsworth 118967
Studio X, Images de Presse,
Limours 137103
Studio za Umetničku Keramiku,
Aranđjelovac 114472
Studiogalerie Kaditzsch,
Denkmalschmiede Höfgen,
Grimma 018538
Studiolo, Milano 080570
Studios of Jack Richard Creative
School of Design, Cuyahoga
Falls 056929
Studios on High, Columbus 120798
Studo San Domenico, Milwaukee 122230
The Study Gallery, Bournemouth and
Poole College, Poole 045490

Stüber, Olaf, Berlin 106439
Stübiger, A., Grevenbroich 076034
Stührenberg, Christine, Usingen 131110
Stülpnagel, Karl-Friedrich von,
Leipzig 130572
Stuempfig, Anthony, Philadelphia 095999
Stümpges, V., Heidelberg 076398
Stützer, Thomas, Heiligenstadt,
Heilbad 130336
Stützle, Wolfram, Waldkirch . . . 131128
Stuff & Nonsense, Chesham . . . 088634
Stuff & Such, Houston 093639
Stuff Antiques, Phoenix 096077, 136463
Stuhlmann, Wedel 108864
Stuhr Museum of the Prairie Pioneer,
Grand Island 049143
Stumbaum, Regina, München . . 130769
Stumpf, Hong Kong 102005
Stumpf-Behrens, Karin, Kronberg im
Taunus 076913
Stumpf, Hermann,
Neckarsteinach 077620
Stumpf, Stephan, München . . . 108205
Stumpy Gully Antiques, Tyabb . . 062353
Stumvoll, Herbert, Hirschegg,
Kleinwalsertal 062615
Stundner, Salzburg 128119
Sturdivant Hall, Selma 053150
Stures Galleri, Tranås 116053
Sturgeon River House, Sturgeon
Falls 006923
Sturgis Station House Museum,
Sturgis 006924
Sturies, Dr. Andreas, Düsseldorf 126189
Sturm-Larondelle, Berlin 129819
Sturm, Michael, Stuttgart 098739
Sturm, von, Hamburg . 107296, 130295
Sturman, Hawes 089281
Sturmbaum, Regina, München . . 130770
Sturmflut Galerie, Hooge 107424
Sturmio, Sevilla 133797
Sturni, Daniela, Roma 132441
Sturt, Mittagong 099222
Sturt Street Antiques and Art,
Ballarat 061082
Stuteville, Seattle 097344, 136713
Stutsman County Memorial Museum,
Jamestown 049747
Stuttfeld, Köln 107679
Stuttgarter Antiquariat, Stuttgart 142247
Stuttgarter Antique & Art,
Stuttgart 098025
Stuttgarter Feuerwehr-Museum,
Stuttgart 021659
Stuttgarter Gesellschaft für Kunst und
Denkmalpflege, Stuttgart 059163
Stuttgarter Gesellschaft für Kunst und
Denkmalpflege, Studiensammlung
Möbel, Stuttgart 021660
Stuttgarter Künstlerbund e.V.,
Stuttgart 059164, 108740
Stuttgarter Kunstverein e.V.,
Stuttgart 021661
Stuttgarter Münzenmesse,
Stuttgart 098026
Stutzhäuser Brauereimuseum,
Luisenthal 019854
Stux, Stefan, New York 123351
Stuyck, Miguel, Madrid 133747
Styl, Pruszków 133228
Styl Antikvitás, Pécs 079216
Styl'Art, Monthey 116595
Style, Le Chambon-sur-Lignon . . 069190
Style 1900, Lambertville 139533
Style 25, Lausanne 087395
Style Art Publishing, Phoenix . . . 138493
Style D'Art, Rio de Janeiro 064073
Style Deco, München 077550
Style French Antiques, Los
Angeles 094315
Style French Antiques, West
Hollywood 097769
Style Gallery, London 090361

Style Junkies, Nelson 083866
Style, Denis, Bucureşti 114241
Styles of Stow, Stow-on-the-
Wold 091336, 135447
Styles Silver, Hungerford 089421,
134807
Styl'Vieil, Brignoles . . . 067441, 128762
Stypmann, David, New York . . . 095603
Styrge, Rouen 105436
Styrmannen Antik, Vaxholm . . . 086969
Styrsjöbo Stentryck, Leksand . . 115814
Su Ho Paper Museum, Taipei . . 042270
Su-no-sato Hakubutsukan,
Handa 028428
Suarez Doradores, Valencia . . . 133828
Suarez, Graciela, Miami 094640
Suarez, Pascal, Saint-Jean-de-la
Ruelle 072797
Suarsana, Putu & Nicole, Bad
Mergentheim 074510
Suau, Robert, Saint-Paulet-de-
Caisson 073209
Suaudeau, Marie-Pierre,
Montpellier 070262
Suay y Serra, Valencia 133829
Subak, Chicago 092632
Subak Museum, Banjar
Sanggulan 024231
Subal, Tony, Wien . . . 063032, 100243
Subalyuk-Múzeum, Cserépfalu . 023263
Subarna, Barcelona . . 085665, 126727
Subarunoki, Sapporo 111391
Subastas, Madrid 139115
Subastas de Barcelona,
Barcelona 126728
Subastas La Villa Vieja, Alicante 126710
Subastas la Villa Vieja, Alicante 085525
Subastas Segre, Madrid 126763
Subastas y Galeria de Arte,
Valencia 086362, 115615
Subert, Alberto, Milano 080571
Subert, Alberto e Michele,
Milano 080572
Subex, Barcelona 115054
Subiaco Museum, Subiaco 001523
Subjektiv, Sankt-Peterburg 139060
Sublett, R.D., Louisville 094426, 136114
Submarine Force Museum and
Historic Ship Nautilus, Groton . 049246
Subra, Catherine, Toulouse 073764
Subra, Eric, Paris 071878
The Substation Gallery,
Singapore 114694
Subun-so, Tokyo 142759
Suburban 312 Gallery, Brighton,
Victoria 098631
Succès, La Chevrolière 068935
Successories, Cincinnati 120658
Succotash, Saint Paul 096698
Sucesores de Giganto, Madrid . 133748
Suchanek-Orenczuk, Elzbieta,
Berlin 074889
Sucharduv Dům, Městské Muzeum,
Nová Paka 009560
Suchna Kendra Gallery, Lucknow 109426
Suchomsky, Gerd, Köln 076848
Suchow & Seigel, New York . . . 095604
Suciu, Emilia, Ettlingen 106904
Suckau-Pirow, K., Sylt 078581
Suckau, Irmgard, Berlin 129820
Sucksdorff, Jürgen, Berlin 074890
Sucret, Lionel, Rodez 072475
Sud 70, Cannes 067597
Sud Antik, Montauban 070150
Sud Loire, Pont-Saint-Martin . . . 072221
Sud Textiles, Bobigny 103353
Sudan National Museum,
Khartoum 040299
Sudan Natural History Museum,
University of Khartoum,
Khartoum 040300
Sudbury Region Police Museum,
Sudbury 006929
Suddaby, Blairgowrie 139679

Sudeley Castle, Winchcombe . . 046166
Sudhaus Sorgendorf, Bleiburg . . 001774
Sudley House, Liverpool 044743
Sudmann, Brigitte, Stuttgart . . . 108741
Suðsuðvestur, Keflavik 109232
Sue Ellen Gallery, Main Beach . . 061751
Sue Ryder Art Gallery, Herceg-
Novi 112097
Sueck, Ursula, Coesfeld 075221
Sueclaytables, Unley 062371
Süd West Galerie, Hüttlingen . . 076525
Südbahn, Museum Mürzzuschlag am
Semmering, Mürzzuschlag 002377
Süddeutsche Verlagsgesellschaft Ulm,
Jan Thorbecke Verlag, Ulm . . . 137641
Süddeutsches Eisenbahnmuseum,
Heilbronn 018865
Südharzer Eisenhüttenmuseum, Bad
Lauterberg 016606
Südhessisches Handwerksmuseum,
Roßdorf 021100
Südmährer Heimatmuseum, Laa an
der Thaya 002222
Südmährisches Landschaftsmuseum,
Geislingen an der Steige 018341
Südostbayerisches Naturkunde- und
Mammut-Museum, Siegsdorf . 021457
Südpfälzische Kunstgilde e.V., Bad
Bergzabern 059165
Südsauerlandmuseum, Attendorn 016441
Südschwäbisches Archäologiemuseum,
Mindelheim 020073
Südtiroler Gesellschaft für
Photographie, Bolzano 059404
Südtiroler Landesmuseum für Kultur-
und Landesgeschichte Schloss Tyrol,
Tirolo di Merano 027914
Süess, Robert, Dierikon 116342
Sülchgau-Museum, Rottenburg am
Neckar 021134
Sümegi Vármúzeum, Sümeg . . . 023584
Suermondt-Ludwig-Museum,
Aachen 016254
Sütel, Hans-Richard, Preetz . . . 078007
Suezumi, Kobe 081831
Suffolk County Historical Society
Museum, Riverhead 052491
Suffolk County Vanderbilt Museum,
Centerport 047463
Suffolk House Antiques, Yoxford 091855
Suffolk Museum, Suffolk 053475
Suffolk Punch Heavy Horse Museum,
Woodbridge 046208
Suffolk Rare Books, Sudbury,
Suffolk 144611
Suffolk Regiment Museum, Bury Saint
Edmunds 043596
Suffolk Resolves House, Milton . 050838
The Suffolk Table Company,
Debenham 088836, 134634
Suffren, Saint-Tropez . 073280, 105585
Suga, Tokyo 111515
Sugan, Dublin 079483
Sugar, Houston 093640
Sugar Antiques, London 090362, 135112
Sugar Barrel Antiques,
Vancouver 064833
Sugar Bear Antiques Mall,
Jacksonville 093875
Sugar Industry Museum, Ciaotou 042011
The Sugar Refinery, Vancouver . 101701
Sugarhill Art Center, New York . 123352
Sugarhouse, Salt Lake City . . . 096760,
096761, 124238, 136584
Sugarman, Budd, Toronto 064706
Sugarplums, Las Vegas 094015
Suger, Paris 071879
Sugères, Bruno, Clermont-
Ferrand 067981
Sugesa, Madrid 086089
Sugihara, Tokyo 142760
Sugimoto Bijutsukan, Mihama . . 028838
Sugino Gakuen Isho Hakubutsukan,
Tokyo 029411

Sur la Route du Chineur, Sens . 073463
Sur les Ailes du Temps, Paris . . 071880
Sur Meuse, Maastricht 112669
Surahammars Bruksmuseum,
Surahammar 040871
Surbhi Arts and Crafts, Jaipur,
Rajasthan 109403
Surcontre, Napoli 080774
Surek-Becker, Marie-Luise,
Berlin 106440, 141509
Surface Design Association,
Sebastopol 060754
Surface Design Journal,
Sebastopol 139535
Surface Gallery, Nottingham . . . 045365
Surgeons' Hall Museums, The Royal
College of Surgeons of Edinburgh,
Edinburgh 044100
Surinaams Museum, Paramaribo 040308
Surnadal Bygdemuseum,
Surnadal 033822
Surplus Store, Innishannon . . . 079528
Surprise, Modena 080653
Surprises, Houston 121416
Surratt House Museum, Clinton . 047799
Surrey, Cincinnati 092737
Surrey Antiques, Horley 089385
Surrey Antiques Fair, Guildford . 098238
Surrey Art Gallery, Surrey 006936
Surrey Clock Centre, Haslemere 089263,
134761
Surrey Crescent Traders,
Auckland 083647
Surrey Heath Museum,
Camberley 043625
Surrey Hills Art Gallery, Surry
Hills 099616
Surrey Museum, Surrey 006937
Surroundings, Indianapolis . . . 093767
Survey Museum, Roorkee 024155
Survivors, Kerikeri 083810
Surxondaryo Vilojati Arxeologiya
Muzeyi, Termiz 054585
Surya Gallery, Hyderabad 109389
Susan B. Anthony House,
Rochester 052523
Susan Sheehan Gallery, New
York 123356
Susan Street Fine Art Gallery, San
Diego 124428
Susane, R., Miami 094644
Susannah, Bath 088176
Susannah Place Museum,
Sydney 001548
Susan's Antiques, Hamilton . . . 064276
Susan's Antiques, Toronto 064707
Susan's Selections, Richmond . 096416
Sushart, Pune 109525
Sushi Performance and Visual Art,
San Diego 052878
Susini, Aix-en-Provence 103157
Susini, Bruno, Bachant 066842
Susini, Pierre, Montpellier 129048
Suslow, Larissa,
Fürstenfeldbruck 075867
Susquehanna, Washington 097696
Susquehanna Art Museum,
Harrisburg 049333
Susquehanna County Historical
Society, Montrose 050970
Susquehanna Museum of Havre de
Grace, Havre de Grace 049372
Sussex Combined Services Museum,
Eastbourne 044040
Sussex County Historical Society
Museum, Newton 051468
Sussex Farm Museum,
Heathfield 044406
Sussex Fine Art and Antiques Fair,
Little Horsted 098239
Sussi, Riga 111819
Sussman, Arthur, Albuquerque . 111819
Sutama-cho Bijutsukan, Sutama 029232
Sutama-cho Rekishi Hakubutsukan,

Sutama 029233
Sutcliffe Galleries, Harrogate . . 089243,
134753
Sutcliffe Gallery, Whitby 046139
Sutcliffe Gallery Publication,
Whitby 138347
Sutcliffe, Malcolm, Penryn 119116
Sutcliffe, Tony & Anne, Southport 091236
The Suter Art Gallery, Te Aratoi o
Whakatu, Nelson 033074
Suter, Owen, Richmond 096417
Sutherland, New York 123357
Sutherland Art Gallery,
Sutherland 099617
Sutherland Steam Mill Museum,
Denmark 005593
Sutherland, Martha, New York . . 123358
Sutter, Cleveland 092812
Sutter-Kress, Martina, Erlangen . 106860
Sutter, Karin, Basel 116199
Sutton, Fitzroy 098888
Sutton, New Orleans 122495
Sutton-Ditz House Museum,
Clarion 047727
Sutton Gallery, Melbourne 099188
Sutton-Grenée, Martine, Paris . . 071881
Sutton Hoo, Woodbridge 046209
Sutton Park, Sutton-on-the-
Forest 045918
Sutton Place Antiques, New York 095607
Sutton Valence Antiques, Charing 088605
Sutton Windmill and Broads Museum,
Sutton, Norwich 045917
Sutton, Jack, New Orleans 095002
Sutton, Lea, Tulsa 097594
Suty, Coye-la-Forêt 103590
Suur – Helsingin Vaihtopörssi,
Helsinki 066306
Suur-Miehikkälän Kylämuseo, Suur-
Miehikkälä 011206
Suur-Savon Museo, Mikkeli . . . 010985
Suwa-ko Somei-kan (Orugoru
Hakubutsukan), Shimosuwa . . 029205
Suwa-shi Bitjutsukan, Suwa . . . 029236
Suworow-Museum, Schwanden 041714
Suworow-Museum im Glarner Land,
Linthal 041446
Suze, Jean-Michel, Périgueux . . 126050
Suzhou Antique, Suzhou 065075
Suzhou Art Gallery, Five-Hundred
Famous Ancient Sages Hall,
Canglang Pavilion, Suzhou . . . 008134
Suzhou Beike Guan, Suzhou . . 008135
Suzhou City Art Base, Suzhou . 102142
Suzhou Folkways Museum,
Suzhou 008136
Suzhou Gardens Museum,
Suzhou 008137
Suzhou Museum, Shanghai . . . 008079
Suzhou Museum, Suzhou 008138
Suzhou National Treasure
Numismatics Museum, Suzhou 008139
Suzhou Silk Museum, Suzhou . . 008140
Suzhou Sportqu Museum, Suzhou
Sportqu Art Institute, Suzhou . 008141
Suzu-yaki Kyodo Bijutsukan,
Suzu 029239
Suzuki Bokushi Kinenkan,
Shiozawa 029212
Svalbard-Museum, Longyearbyen 033583
Svaneholms Slotts Museum,
Skurup 040763
Svaneke Antikvitetshandel,
Svaneke 066079
Svaneti History-Ethnography Museum,
Mestia 116194
Svart och Vitt, Malmö 115867
Svato Verlag, Hamburg 137452
Svatopluk Čech, Louny 065353
Svaz Antikvářů ČR, Praha 058511
Svedinos Bil- och Flygmuseum,
Slöinge 040765
Sveindal Museum, Kollungtveit . 033530
Svelvik Museum, Svelvik 033824

Svendborg Antikvariat Æseløret,
Svendborg 140626
Svendborg Auktionerne,
Svendborg 125744
Svendborg og Omegns Museum,
Svendborg 010169
Svendsen, Annalena, New York . 095608
Svendsen, Birgit & Kaj,
Bjerringbro 140523
Svendsen, Kaj, Bjerringbro 140524
Svensgaard, Britta & Kim,
Herning 065685
Svensk Konst och
Antikvitetsförmedling, Malmö . 086674
Svensk Konsthandel, Uppsala . 086941
Svensk Möbelkonservering,
Huddinge 133893
Svenska Antikvariatföreningen,
Stockholm 059818
Svenska Galleriförbundet,
Stockholm 059819
Svenska Konstgalleriet, Malmö . 115868
Svenska Konstkritikersamfundet,
Stockholm 059820
Svenska Konstnärer Galleri och
Bokförlag, Jönköping . 115792, 138099
Svenska Möbler, Chicago 092633
Svenska Möbler, Los Angeles . . 094319
Svenska Rum Antikt, Stockholm 086879
Svenska Statens Porträttsamling,
Mariefred 040642
Svensson, Kurt, Stockholm 116029
Sverdén, Bo, Växjö 116093
Sveriges Allmänna Konstförening,
Stockholm 059821, 116030
Sveriges Järnvägsmuseum,
Gävle 040440
Sveriges Jörnvögsmuseum,
Ängelholm 040317
Sveriges Konst- och
Antikhandlareförening,
Stockholm 059822
Sveriges Konstföreningar,
Limhamn 059823
Sveriges Konstföreningar Skåne,
Lund 059824
Sveriges Konsthantverkare och
Industriformgivare, Stockholm . 059825
Sveriges Museimannaförbund,
Nacka 059826
Sveriges Rundradiomuseum,
Motala 040666
Sveriges Sjömanshusmuseum,
Uddevalla 040900
Sveriges Teatermuseum, Nacka 040670
Sveriges Tennis Museum, Båstad 040363
Sveriges VVS-Museum,
Katrineholm 040549
Sverko, Mario, Toulouse 129544
Švestka, Jiří, Praha 102686
Svet-L, Kyïv 117216
Svetska Galerija na Karikaturi, Muzej
na Grad Skopje, Skopje 030457
Svettini, Adele, Milano 080573
Svijažskij Architekturno-
chudožestvennyj Muzej,
Gosudarstvennyj Muzej
izobrazitelnych iskusstv Respubliki
Tatarstan, Svijažsk 037732
Svjato-Troickij Sobor, Sankt-
Peterburg 037648
Svjatogorskij Monastyr, Puškinskie
Gory 037508
Svolis, Giannis, Zografou 109120
Svrzina Kuća, Sarajevo 004198
Swaen, Paulus, Paris . 126043, 141243
Swaffer, Spencer, Arundel 088056
Swaffham Museum, Swaffham . . 045919
Swain, Marilyn, Grantham 127125
Swainbanks, Liverpool 089667
Swakopmund Museum,
Swakopmund 031679
Swalcliffe Barn, Swalcliffe 045920
Swaledale Museum, Reeth 045566

Swan, London 090365
Swan, Moonah 139859
The Swan, Tetsworth . 091444, 135480
Swan Antiques, Baythorne End . 088185
Swan Antiques, Cranbrook 088779
Swan Antiques Boxmoor, Hemel
Hempstead 089303
Swan Books, Billericay 144018
Swan Coach House Gallery,
Atlanta 046608
Swan Gallery, Burford . 088493, 134502
Swan Gallery, Sherborne 091161,
119355, 135387
Swan Hill Regional Art Gallery, Swan
Hill 001529
Swan Street Antique Mall,
Louisville 094428
Swan Valley Historical Museum, Swan
River 006942
Swan, Milvia, Chicago 092634
Swanage Museum, Tithe Barn
Museum and Art Centre,
Swanage 045921
Swanage Railway, Swanage . . . 045922
Swanberg, Sacramento 096486
Swangrove, New York 095609
Swann, New York 127627, 145114
Swann, Nice 140966
Swann Gallery, Rye 119247
Swann Gallery, Woodstock 119689
Swans Antique Centre, Oakham 090752,
135242
Swansea Antiques Centre,
Swansea 091384
Swansea Art Society, Swansea . 060254
Swansea Festival of Music and the
Arts, Swansea 098240
Swansea Museum, Swansea . . . 045930
Swansea Museum Boats and Ships,
Swansea 045931
Swansea Print Workshop,
Swansea 060255
Swanson, Minneapolis 122318
Swanson Cralle, Louisville 121950,
121951
Swanson, David, Petworth 090856
Swanson, Trevor V., Phoenix . . . 123766
Swanton Mill, Ashford 043190
Swarovski, Saint Louis 096617
Swarovski Kristallwelten,
Wattens 002833
Swart, J.A., Hercules 133432
De Swarte Leeuw, Middelburg . 083314
Swarthout Memorial Museum, La
Crosse 049985
Swastika, Delhi 109358
Swat Archaeological Museum, Saidu
Sharif 033960
Swatland, Sally, New York 123359
Swayambunath Museum and Art
Gallery, Kathmandu 031701
Swaziland National Museum,
Lobamba 040310
Sweden Antique and Decoration,
Helsingborg 086555
Swedenborg, Boston . 120204, 144755
Swedish American Museum,
Chicago 060755
Sweeney Art Gallery, University of
California, Riverside 052498
Sweerts de Landas, Ripley,
Surrey 090963, 135313
Sweet Briar College Art Gallery, Sweet
Briar 053510
Sweet Briar Museum, Sweet
Briar 053511
Sweet Home, Hamburg 076261
Sweet Memories, Tampa 097425
Sweet Repeats, Charlotte 092466
Sweet Shop Museum, Donghe . 042025
Sweet Slumber Antiques,
Kempsey 061668
Sweetbriar Gallery, Helsby 089299
Sweeting Antiques, Sanderson,

T.I.A., Migennes 104186
T.J.'s Gallery on Evans, Mackay 099108
T.W. Wood Gallery and Arts Center,
Montpelier 050963
T20, Murcia 115411
Ta' Kola Windmill, Xaghra 030593
Ta Matete, Bologna 109880
Ta Matete Living Gallery, Roma . 142660
Taalintehtaan Ruukinmuseo,
Dalsbruk 010591
Taba, Murcia 133765
Tabak- & Zigarrenmuseum aargauSüd,
Menziken 041498
Tabak Musea, Geraardsbergse Musea,
Geraardsbergen 003574
Tabak-Museum der Stadt Hockenheim,
Hockenheim 018971
Tabakhistorische Sammlung
Reemtsma im Museum der Arbeit,
Hamburg 018728
Tabakmuseum, Lorsch 019780
Tabakmuseum, Oberzeiring 002431
Tabakmuseum, Städtische Museen
Schwedt/Oder, Schwedt / Oder 021381
Tabako to Shio no Hakubutsukan,
Tokyo 029414
Tabakspeicher, Museum für
Nordhäuser Handwerks-
und Industriegeschichte,
Nordhausen 020472
Tabán Múzeum, Budapest 023233
Tabáni Tájház, Szolnok 023654
La Tabard, Booterstown 109569
Tabasso, Maddalena, Milano ... 080574
Tabbernee, D., Rotterdam 083406
Tabene, Saint-Jean-de-Luz 105492
Taber, Sacramento 096487
Taber and District Museum,
Taber 006952
Taberna Libraria, Fortaleza 140249
Taberna Libraria, Pistoia 142608
Tabiah, Mohammed Samir,
Damascus 087859
Tabibnia, Milano 080575
Tabla y Lienzo, Madrid 086090
Table Rock Historical Society Museum,
Table Rock 053523
Tableau, Seoul 111778
Tableaux à Tous Prix, Dax 103607
Tabler, Joseph, San Diego 145270
Tabley House, Knutsford 044614
Taboada, Austin 119984
Tabor Opera House Museum,
Leadville 050152
Táborvárosi Múzeum, Budapesti
Történeti Múzeum, Aquincumi
Múzeum, Budapest 023234
Tábua Rasa, Lisboa 133320
Tabula, Zamora 086410, 133840
Tabula Buch & Kunst, Tübingen . 142268
Tabula Rasa, Paris 129379
Táburi, Santiago, Lima 113461
Tabusintac Centennial Museum,
Tabusintac 006953
Tabutin, Hervé, Marseille 125915
Taby, Paul, Sens 073464
Tacconi, Dina, Modena 131980
Tacken, H.W., Velserbroek 133033
Tackenberg, Hürth 107428
Tacla Taid Transport and Agriculture
Museum, Newborough 045271
Taco Bell Discovery Science Center,
Santa Ana 052976
Tacoma Art Museum, Tacoma .. 053533
Tacticos, Timişoara 084969
Tactual Museum, Greek Lighthouse for

the Blind, Kallithea 022716
Tacussel, Paul, Marseille 137112
Tadema, London 090368, 118785
Tadmor, Dubai 087948
Tadre Mølle, Hvalsø 009991
Tadu Contemporary Art, Bangkok 117047
Tadzio, Kyïv 117217
Tändsticksmuseet, Jönköping .. 040525
Täuber, Claudia, Wien 063034
Täuber, Hans-Joachim, Bad
Salzuflen 074546
Taexpolsa, Lima 113462
Taff, James F., Sacramento ... 096488
The Taft Museum of Art,
Cincinnati 047711
TAG, Den Haag 112500
Tag Diamond Jewelry, Buffalo .. 092396
Taganrogskaja Kartinnaja Galereja,
Taganrog 037747
Taganrogskij Gosudarstvennyj
Literaturnyj i Istoriko-architekturnyj
Muzej-zapovednik, Taganrog . 037748
Taganrogskij Kraevedčeskij Muzej,
Taganrogskij gosudarstvennyj
literaturnyj i istoriko-architekturnyj
muzej-zapovednik, Taganrog . 037749
Taganrogskij Muzej im. A.P. Čechova,
Taganrog 037750
Tagawa Bijutsukan, Tagawa ... 029242
Tage, E ., Philadelphia 096000
Tagelöhner- und Brennereimuseum
Faißt, Bad Peterstal-Griesbach 016631
Taggart, Hollis, New York 123361,
123362
Tagliapietra, Ivano, Torino 132592
Tagliapietra, Lino, Seattle 124855
Tagliapietra, Maurizio, Verona .. 132686
Tagliareni, Salvatore J.,
Philadelphia 123710, 136448
Taha Hussein Museum, Cairo .. 010393
Tahir Pasa Konagi, Mudanya .. 042760
Tahiti Imports, Honolulu 093409
Tahsis Museum, Tahsis 006958
Tahydromiko Moyseio, Athinai .. 022623
Tai, Hong Kong 065019
Tai Sing, Hong Kong 065020
Tai Wo & Co., Hong Kong 065021
Tai & Co., J.T., New York 095611
Tai'an Museum, Tai'an 008143
Taicang Museum, Taicang 008144
Taichung Distillery Museum,
Taichung 042200
Taide, Helsinki 138670
Taide ja Kehys Pekkala, Oulu .. 103117
Taidehistorian Seura, Föreningen för
Konsthistoria, Helsinki 058550
Taidekeidas, Turku 066346
Taidekeskus Mältinranta,
Tampere 011226
Taidekoti Kirpilä, Helsinki 010698
Taidemaalariliiton Galleria,
Helsinki 103109
Taidemuseo, Kokkola 010846
Taidesalonki, Helsinki . 066307, 103110
Taidesalonki Husa, Tampere ... 066338
Taidesalonki Piirto, Helsinki ... 103111
Taieri Historical Museum, Outram 033087
Taifa Llibres, Barcelona 143540
Taiga, Tobetsu 081955
Taigh Chearsabhagh Museum and Arts
Centre, Lochmaddy 044781
Taihao Mausoleum, Zhoukou .. 008392
Taihape & Districts Museum,
Taihape 033128
Taihe Museum, Taihe 008146
Taiheiyo Bijutsukai, Tokyo 059436
Taikomosios dailės, Vilnius ... 111865
Taikomosios Dailės Muziejus, Lietuvos
Dailės Muziejus, Vilnius 030372
Taikoo Books, York 144687
Tailai Museum, Tailai 008147
Tain and District Museum, Tain . 045939
Tainan County History Museum,
Syuejia 042192

Tainan Municipal Cultural Center,
Visual Art Section, Tainan 042215
Tainan National University of the Arts,
Tainan 056413
Tainan National University of the Arts
Museum, Kuantien 042098
Tainan Natural History Museum,
Zuojhen 042334
Tainan Salt Museum, Cigu
Township 042012
Taining Museum, Taining 008148
Taipa House Museum, Macau .. 007880
Taipei Astronomical Museum,
Taipei 042271
Taipei Caves Gallery, Taipei ... 117012
Taipei Children's Art Museum,
Taipei 042272
Taipei Fine Arts Museum, Taipei 042273
Taipei National University of the Arts,
Taipei 056420
Taipei Story House, Taipei 042274
Taiping Kingdom History Museum,
Nanjing 007920
Tairawhiti Museum, Gisborne .. 033021
The Taise Gallery, Ballycastle . 117343
Taishan Doll Museum, Taishan . 042288
Taishan Museum, Taishan 008149
Taishun Museum, Taishun 008150
Taitoko, Levin 083815
Taitung Aboriginal Exhibition Room,
Taitung 042290
Taitung Museum of Natural History,
Chengkung 042008
Taivalkosken Kotiseutumuseo,
Taivalkoski 011209
Taivassalon Museo, Taivassalo . 011210
Taiwan Aboriginal Culture Park,
Majia 042116
Taiwan Coal Mine Museum,
Pingsi 042135
Taiwan Craft Center, Taipei ... 042275
Taiwan Democratic Movement
Museum, Taiwan Tsunah Foundation,
Wujie 042306
Taiwan Folk Arts Museum, Taipei 042276
Taiwan Folk Culture Museum,
Bali 041989
Taiwan Folklore Museum,
Taichung 042201
Taiwan Forestry Exhibition Hall,
Taipei 042277
Taiwan High Speed Rail Exhibition
Center, Jhubei 042070
Taiwan Historica, Nantou 042129
Taiwan International Visual Arts Center,
Taipei 042278
Taiwan Medical Museum,
Kaohsiung 042090
Taiwan Museum of Art Sanri,
Sanyi 042164
Taiwan Mushroom Museum,
Wufeng 042305
Taiwan Nature Lacquer Culture
Museum, Taichung 042202
Taiwan Silk Culture Museum,
Gongguan 042039
Taiwan Sugar Industry Museum,
Tainan 042216
Taiwan Television Exposition,
Taipei 042279
Taiwan Temple and Shrine Art
Museum, Douliou 042030
Taiwan Theater Museum, Yilan . 042314
Taiyi, Shanghai 102103
Taiyuan Painting Gallery, Taiyuan 008155
Taizhou Museum, Taizhou 008156
Taizi Harada Bijutsukan, Suwa . 029237
Taizz National Museum, Taizz .. 054762
Le Taj, Cairo 010397
Tajan, Paris 126044
Tájház, Balatonszentgyörgy ... 023112
Tájház, Kazár 023253
Tajmyrskij Okružnoj Kraevedčeskij
Muzej, Dudinka 036802

Taka Ishii Gallery, Tokyo 111516
Takachiho-cho Rekishi oyo Minzoku
Hakubutsukan, Takachiho ... 029246
Takács, Dezső, Győr 079207
Takada, San Francisco 124657
Takahama-shiritsu Kawara Bijutsukan,
Takahama 029247
Takahashi, Kyoto 081869
Takahashi, Imono Kojo, Kyoto . 081870
Takamatsu City Museum of Art,
Takamatsu 029255
Takamatsuzuka-Hekigakan,
Asuka 028312
Takamiya, Osaka 111380
Takamura's Cottage Memorial
Museum, Hanamaki 028425
Takanawa Ippodo Lobby Gallery,
Tokyo 111517
Takaoka-shi Bijutsukan, Takaoka 029259
Takaoka Shiritsu Hakubutsukan,
Takaoka 029260
Takara, Hiroshima 111279
Takarada, T. & M., Yokohama . 082057
Takarazuka Daigaku Hakabutsukan,
Takaraduka 029261
Takarazuka Zokei Geijutsu Daigaku,
Takaraduka 055984
Takasaki City Gallery, Takasaki . 029265
Takasaki-shi Bijutsukan,
Takasaki 029266
Takasawa Folk Craft Museum,
Niigata 028995
Takashi, Wada, New York 123363
Takayama Jinya, Takayama ... 029277
Takayama-shi Kyoudokan,
Takayama 029278
Take it for Granted, Parkhurst . 085481
Take Ninagawa, Tokyo 111518
Take Time, Macroom 079558
Takeaway Gallery, Reading ... 119203
Takehisa Yumeji Ikaho Kinenkan,
Ikaho 028491
Takenaka Carpentry Tools Museum,
Kobe 028668
Takenaka, Kenij, Kyoto 137870
Takenouchi Kaido Rekishi
Hakubutsukan, Taishi 029243
Takeuchi, Tokyo 142761
Takeyama, Eiichi, Rothenburg ob der
Tauber 108530
Takht-e-Jamshid, Marvdashd .. 024414
Takht-e-Jamshid, Shiraz 024433
Taki, Ayse, İstanbul 117156
Takkenberg, M., Zaandam 083513
Tako no Hakubutsukan, Tokyo .. 037943
Taksu, Bali 109531
Taksu, Kuala Lumpur 111967
Taksu, Singapore 114698
Takumi, Tokyo 082033
Tal, Bordeaux 067302
Tal Museum Engelberg,
Engelberg 041240
Talabardon & Gautier, Paris ... 105213
Talacea, Vigo 086391
Talamini, Gianni, Padova 110598
Talana Museum and Heritage Park,
Dundee 038517
Talaos, Auray 066759
Talas, New York 136357
Talavan Moraleda, Felipe, Madrid 133749
Talaverano, Manuela, Sevilla .. 115555
Talboom, Antwerpen 140127
Talbot & Co, Edwin, Carlisle .. 117685
Talbot Arts and Historical Museum,
Talbot 001555
Talbot Court Galleries, Stow-on-the-
Wold091337, 119436, 135448
The Talbot Gallery, Dublin 109632
Talbot House, Poperinge 003871
Talbot Rice Gallery, Edinburgh . 044101
Talbot Walk Antique Centre, Ripley,
Surrey 090042
Taldykorganskij Istoriko-Kraevedčeskij
Muzej, Taldykorgan 029673

Tombland Jewellers and Silversmiths, Norwich 090740
Tome Parish Museum, Tome . . . 053645
Tome Pires, Los Angeles 094322
Tomedi, Irene, Bolzano 131408
Tomelilla Auktionshall, Tomelilla . 126897
Tomelilla Konsthall, Tomelilla . . 040881
Tomeo, Cleveland 120740
Tomescheit, Stefan, Ingelheim am Rhein . 076546
Tomimoto Kenkichi Kinenkan, Ando . 028290
Tomintoul Gallery, Ballindalloch . 117342
Tomintoul Visitor Centre, Tomintoul 045992
Tomita, Fukuyama 111268
Tomita, Hiroshima 111280
Tomita, Washington 125215
Tomkinson Antique Stained Glass, Clophill 088717
Tomlin, Dallas 093059
Tomlin, Gerald, Dallas 093060
Tomlinsons, Tockwith 091461
Tomm, A., Naumburg (Saale) . . 077617
Tommasi, Paola, Milano 080580
Tommy Q, Los Angeles 094323
Tommy's Furniture, Albuquerque 135646
Tomo-no-Ura Rekishi oyo Minzoku Hakubutsukan, Fukuyama 028381
Tomorrow's Antique, Helsinki . . 066309
Tomorrow's Treasures Today, Los Angeles 094324
Tomos, Vigo 133837
Tompkins, M.D., Chicago 092640
Tom's Curios, Dublin 079485
Tom's Furniture and Collectables, Tucson 097533, 097534
Tom's Terrific Antiques Shop, Omaha 095896
Tom's Trains & Miniatures, Fresno 093350
Tomsich, Saint Louis 124127
Tomskij Muzej Derevjannogo Zodčestva, Tomsk 037777
Tomskij Oblastnoj Chudožestvennyij Muzej, Tomsk 037778
Tomskij Oblastnoj Kraevedčeskij Muzej, Tomsk 037779
Ton Duc Thang Museum, Ho Chi Minh City . 054742
Ton Sak Yai, Uttaradit 042458
Ton Smits Huis, Eindhoven 032115
Ton Ying & Co., New York 123389
Tonawandas Museum, Historical Society of the Tonawandas, Tonawanda 053647
Tonbandmuseum, Korneuburg . . 002193
Tonbergbaumuseum Westerwald, Siershahn 021459
Tondinelli, Floriana, Roma 110886
Tondo, Elisabetta, Bari 131328
Tondorf, Düsseldorf 106795
Tone, Saitama 111385
Tonella, Danielle, Lugano 087432
Tonelli, Chicago 120562
Tonelli, Milano 110484
Tonello, Alfio & Emilio, Milano . . 131934
Tonen, Erik, Antwerpen 140128
Tong, Singapore 085346
Tong, Mern Sern, Singapore . . . 085347
Tongan Museum, Tongan 008176
Tongarra Museum, Albion Park . 000783
Tongass Historical Museum, Ketchikan 049901
Tongcheng Museum, Tongcheng 008177
Tongdosa Museum, Yangsan . . . 029882
Tongerlohuis Heyderadey, Roosendaal 112712
Tongin, Seoul 082077
Tonglushan Ancient Metallurgy Museum, Daye 007546
Tongue, Dr., Portland 096319
Tongzhou Museum, Beijing 007464
Toni-Merz-Museum, Sasbach . . 021226

Tonic General, Calgary 064220
Tonin, Paolo, Torino 111033
Tonina Hiša v Sveti Petru, Pomorski Muzej Sergej Mašera, Portorož 038410
Toninelli, Luigi Filipo, Monaco . . 082346
Tonini, Matteo, Ravenna 142610
Tonkin, Ha Noi 125375, 125376
Tonkonow, Leslie, New York . . . 123390
Tonne, Terje, Oslo 113345, 133159
Tonner, Jean-Marie, Saint-Mihiel 072945
Tonner, Joseph, Pons 072193
Tonnerre, Joseph, Groix 068695
Tonnesen Hansen, Arnold, Herning 065686
Tonnoirs, Townsville 139963
Tono Kyodo Hakubutsukan, Tono 029448
Tonolli, Rovereto 110904
Tonon, Paolo & Josy, Genève . . 087311
Tonson Gallery, Bangkok 117051
Tony, Madrid 133754
Tony Galeria de Arte e Antiguidades, São Paulo 064157, 100977
Tony Raka Gallery, Bali 109532
Tony's, London 118797
Tony's Antiques, Portland 096320
Tony's Furniture Refinishing, Cleveland 135822
Too Art, Hong Kong 102012
The Tool Shop, Needham Market 090651
The Toolbox, Greytown 083781
The Toolbox, Lower Hutt 083819
Tooley, Adams & Co., Wallingford 144647
Tools Galerie, Paris 105229
Toomey & Tourell, San Francisco 124664
Toon Art, Cincinnati 120660
Toon-in Gallery, Melbourne 099190
De Toonkamer, Amersfoort 082472
Toons On, Philadelphia 123714
Toop, Bill, Broadmayne 117593
Tooraj, Los Angeles 094325
Tooronga Hall Antiques, Armadale, Victoria 061040, 127831
Tooronga Hall Antiques, Caulfield East 061292, 127856
Toot Yung, Bangkok 117052
Toovey, Washington 127346
Toowoomba Antiques Gallery, Toowoomba 062326
Toowoomba Art Society, Toowoomba 058186
Toowoomba Regional Art Gallery, Toowoomba 001582
Toowoon Bay Gallery, Toowoon Bay . 099696
Top Art, Hiroshima 081817
Top Art, Jeddah 085134
Top Art, San Diego 124430
Top Art Galeria Sztuki Współczesnej, Gdańsk 113576
Top Banana Antiques Mall 1, Tetbury 091438
Top Banana Antiques Mall 2, Tetbury 091439
Top Coins & Fine Art, Mall Darwin 061760
Top Drawer Antiques, San Diego 096975
Top Drawer Auction, New Orleans 095006, 127605
Top Fresh Arts Gallery, Singapore 114706
Top of Oklahoma Historical Museum, Blackwell 046998
Top of the Hill, Stoke-on-Trent . 091307
Top of the Ninth, Columbus . . . 092887
Top Rockz Gallery, Kununurra . . 099067
Top Time, Milano 080581
Top, T.T., Kloosterburen 132932
Le Tophet de Salammbô à Carthage, Salammbô 042496
Topkapi, Maubeuge 069944
Topkapı Sarayı Müzesi, İstanbul 042692
Topografika Antikvariat, Oslo . . 143230
Topographie des Terrors, Berlin . 017088
Topp, Hans-Jürgen, Limburg an der

Lahn 077056, 107861, 141952
Toppenish Museum, Toppenish . 053658
Topper, Victor & Renee, Toronto 064709
Toppler-Schlößchen, Rothenburg ob der Tauber 021125
Topsfield Historical Museum, Topsfield 053659
Topsham Museum, Topsham . . . 045993
Topsham Quay Antique Centre, Topsham 091473
Tor 1, Georgsmarienhütte 075920
Tor Sanguigna, Roma 081418
Torahiko Terada Kinenkan, Kochi 028677
Torba Sanat Evi, Muğla 117166
Torbandena, Trieste 111077
Torbay Museum, Torbay 006986
Torbey, M., Mansourih El-Metn . 082141
Torbjörns Fackantikvariat, Göteborg 143662
Torbogenmuseum, Königsbronn . 019397
Torch, Amsterdam 112380
Il Torchio, Torino 132594
Il Torchio – Costantini Arte Contemporanea, Milano 110485
Torcular, Milano 110486, 137796
Tordenskiold, Trondheim 126607
Tordenskjold, Trondheim 084225
Tore Kunst-Auksjoner, Tønsberg 126603
Torekällbergets Friluftsmuseum, Södertälje 040772
Torekovs Sjöfartsmuseum, Torekov 040882
De Toren Antiekcentrum, Breda . 082822
Torenmuseum, Goedereede 032177
Torenmuseum, Mol 003795
Torenverplaatsingsmuseum, Bocholt 003295
Torerísimo de México, Benito Juárez 138966
Toretti, Danièle, Aix-en-Provence 066415
Torfmuseum, Peat Museum, Neustadt am Rübenberge 020401
Torfs, Leonardo, Antwerpen . . . 100370
Torfschiffwerftmuseum, Worpswede 022356
Torgovyj Dom Progres, Moskva . 143464
Torhalle Frauenchiemsee und Vikarhaus, Frauenchiemsee . . . 018195
Torhaus Dölitz, Leipzig 019684
Torhaus-Galerie, Berufsverband Bildender Künstlerinnen und Künstler, Braunschweig 106569
Torhaus Markkleeberg, Museum der Völkerschlacht 1813, Markkleeberg 019947
Torhaus Otterndorf, Sammlung Labiau/Ostpreußen, Otterndorf . 020686
Torhaus Warnau, Warnau 078783
Torhausgalerie, Bottrop 075071
Torindo, Tokyo 111527
Torkild, Malfait, Bruxelles 063503, 128293, 136942
Torlo Centro Antico, Torre del Greco 081609, 081610
Tornabuoni Arte, Firenze 080047, 110088
Tornabuoni Arte, Milano 110487
Tornar, Elena, Pisa 080993
Tornare, Jacques, Genève 116438
The Tornaritis-Pieries Municipal Museum of Marine Life, Ayia Napa 009237
Tornaritis Pierides Municipal Museum of Paloentology, Larnaka 009251
Tornberg, Lund 115834
Tornby, Linköping 086632
Tornionlaakson Maakuntamuseo, Tornio 011250
Torns Möbelrestaurering, Lund . 133905
Tornyai János Múzeum, Hódmezővásárhely 023368
Toro Mera, Margarita Rosa, Cali 128540
Toronski, William, Evere 063557
Toronto Aerospace Museum, Toronto 007044

Toronto Antique Centre, Toronto 064710
Toronto Art Therapy Institute, Toronto 055097
Toronto Board of Education, Records Archives and Museum Department, Toronto 007045
Toronto Dominion Gallery of Inuit Art, Toronto 007046
Toronto International Art Fair, Toronto 097904
Toronto Police Museum and Discovery Centre, Toronto 007047
Toronto School of Art, Toronto . . 055098
Toronto Sculpture Garden, Toronto 007048
Toronto Vintage Paper Show-Canada Antiquarian Book Fair, Toronto . 097905
Toronto's First Post Office, Toronto 007049
Torossian, Armand & Gérard, Grenoble 125868
Torppamuseo, Somero 011189
Torquay Museum, Torquay 044995
The Torrance Gallery, Edinburgh 117929
La Torre, Milano 110488
La Torre, Rimini 110735
La Torre, Verona 081775
Torre Abbey Historic House and Gallery, Torquay 045996
La Torre de Lulio, Oaxaca 142810
Torre del Conde, Herrera Castilla, San Sebastián de la Gomera 039884
Torre dell'Orologio, Musei Civici Veneziani, Venezia 028150
La Torre di Giada, Trieste 081640
Torre Enrica, Genova 080132
I Torre Guaita, San Marino 037928
Torre Monumental, Buenos Aires 000281
Torre, de la, Santiago de Chile . 064934
Torrebianca, Trieste 081641
Torredimare, Pasquale, Milano . 080582
Torrens, Jean, Paris . . . 071903, 129383
Torrent, David, Vic-le-Comte . . . 074060
Torreón Fortea, Zaragoza 040260
Torres, Madrid 086095
Los Torres, San Salvador 103048
Torres Gonzalo, Pedro, Logroño . 115211
Torres Muñiz, Jesus, Granada . . 115185
Torres Strait Museum, Thursday Island 001575
Torres, Albert, Barcelona 133528
Torres, Miguel Alberto, Bucaramanga 102301
Torres, Veronica, Asunción 113430
Torresan, Marina, Milano 131935
Torresdale Station Antiques, Philadelphia 096001
Torretta, Locarno 087409, 134143
La Torretta, Roma 081419
Torri, Angelo, Brescia 079792
Torrington 1646, Great Torrington 044320
Torrington Historical Society Museum, Torrington 053662
Torrington Museum, Torrington . 045998
Torris Barrois, Marc-André, Sainte-Cathérine-lès-Arras . . . 073302
Torrisi, Alfio, Catania 131498
Torrisi, Massimo, Catania 131499
Torsby Finnkulturcentrum, Torsby 040883
Torsby Fordonsmuseum, Torsby . 040884
Torsegno, Federico, Genova . . . 131737
Torsgården Antik och Auktion, Vislanda 086980, 126912
Torshälla Auktionsbyrå, Torshälla 126898
Tort, Andrée, Mirepoix 070077
Torta, Giulio, Palermo 080912
Tortoise Shell, Columbus 092888
Tortora, Bari 109783
Tortora, Farrara 110029
Tortora, Antonio, Roma 132448
Tortora, Julien, Nice 129106
Tortori, Alfredo, Roma 081420
La Tortue Eléctrique, Paris 071904
Torukumen, Yokohama 082058

Universidad de Sevilla. Serie: Bellas Artes, Sevilla –
University of Sydney Art Collection, Sydney

Index of Institutions and Companies

Wasserleitungsmuseum, Reichenau an
der Rax 002527
Wasserlof, Irmgard, Wien 063047
Wassermann, Potsdam 078006
Wassermann, Gudrun,
Schönkirchen 108575
Waßermann, Wolfgang, Höhenkirchen-
Sigertsbrunn 107412
Wassermühle Höfgen, Grimma . 018539
Wassermühle Kuchelmiß,
Kuchelmiß 019487
Wassermühle Selfkant, Selfkant 021435
Wasserschloss Mitwitz, Mitwitz . 020085
Wasserturm-Galerie, Mannheim . 077217
Wassmuth, Agathe, Hann.
Münden 107318
WaSu Galleries, Tucson 125033
Wat Ko Museum, Phetchaburi .. 042443
Wat Phra That Lampang Luang
Museum, Lampang 042426
Wat Si Saket, Vientiane 029919
Watabe, Sapporo 081934
Watanabe, S., Tokyo 111530
Watari-Um, Tokyo 029439
Watashi no Shigotokan, Seika .. 029172
Watatu Gallery, Nairobi 111578
The Watch Doctor, Los Angeles . 094333,
136096
Watch Out, Portland 096324
Watch This Space, Alice Springs 098494
Watchet Market House Museum,
Watchet 046086
Watelet, Olivier, Paris 071966
Water and Colors Gallery, Miami 122152
Water Gallery, Angono 113468
Water Gallery, Bourton-on-the-
Water 117501
Water Mill Museum, Water Mill . 054076
Water Museum, Thessaloniki ... 022966
Water of Leith Visitor Centre,
Edinburgh 044102
Water Ski Hall of Fame, American
Water Ski Educational Foundation,
Polk City 052138
Water Supply Museum,
Weymouth 046131
Water Tower, Louisville 121954
Water Tower Park, Gunnedah 001125
Waterbolk, Niek, Utrecht 143063
Waterbridge Gallery, Bacup ... 117335
Watercolor, New York 139555
Watercolor Art Society Houston,
Houston 060792
Watercolor Gallery, Tucson ... 125034
Watercolor Magic, Cincinnati .. 139556
Watercolor Society of Alabama,
Birmingham 060793
Watercolors Gallery, Pittsburgh . 123832
Watercolour Society of Queensland,
Nundah 058190, 099360
Watercolour Society of Wales,
Raglan 060269
Watercolours & Works on Paper Art
Fair, London 098242
Waterfall Antiques, Ross-on-Wye 098606
Waterfall's, Buffalo 135733
Waterfield's, Oxford 144523
Waterford County Museum,
Dungarvan 024688
Waterford Gallery, Altrincham . 117304
Waterford Historical Museum,
Waterford 054080
Waterfront Antiques Market,
Falmouth 089043
Waterfront Galerie, Gent 100572
Waterfront Gallery, Honolulu .. 121255
Waterfront Museum, Poole ... 045491
Waterfront Museum and Showboat
Barge, Brooklyn 047233
Watergate Antiques, Chester . 088648,
134568
Watergate Gallery, Washington . 125224
The Watergate Street Gallery,
Chester 117728

Waterhouse & Dodd, London ... 118818,
118819, 135130, 135131
Waterhouse Gallery, Barton-under-
Needwood 117363
Wateridge, Barry J., Hindhead . 134780
Waterland Neeltje Jans,
Vrouwenpolder 032831
Waterlane & Dorset, Salisbury . 144567
Waterloo Area Farm Museum, Grass
Lake 049175
Waterloo Center for the Arts,
Waterloo 054086
Waterman, K. & V., Amsterdam . 082719
Watermark, Cockermouth 117771
Watermark Studio, Penrith ... 119113
Watermen's Museum, Yorktown 054465
Watermill Brooklyn Gallery, Byrd
Hoffman Watermill Foundation,
Brooklyn 120226
Waterperry Gardens Gallery,
Wheatley 119624
Waters, Geoffrey, London 090420
Waterside Antiques Centre, Ely . 088991
Waterside Arts, Edinburgh 117934
Waterside Gallery, Bideford ... 117449
Waterside Gallery, Saint Mawes 119302
Watersnoodmuseum, Ouwerkerk 032579
Waterstone, Portland 123932
Waterstraat, Horst, Hamburg ... 076274
Watertown Historical Society Museum,
Watertown 054090
Watervliet Arsenal's Museum of the
Big Guns, Watervliet 054100
Waterway Gallery, Armadale, Western
Australia 098520
Waterways Visitor Centre, Dublin 024676
Waterworks Museum – Hereford,
Hereford 044436
Waterworks Visual Arts Center,
Salisbury 052806
Wates, E. & A., London 135132
Watford Museum, Watford 046088
Watgen, Marc, Landau in der
Pfalz 076944
Watkins Bros., Denver 121066
Watkins, London 144470
Watkins College of Art and Design,
Nashville 057471
Watkins Community Museum of
History, Lawrence 050139
Watkins Gallery, American University,
Washington 054053
Watkins Woolen Mill, Lawson .. 050143
Watkins, Chuck, Fort Worth ... 135912
Watkins, Islwyn, Knighton 089532
Watling Antiques, Crayford ... 088784
Watling Street Galleries,
Towcester 119527
Watling, Bruce, Newstead 099314,
127924
Watson, Christchurch 126529
Watson, Hamburg 076275
Watson & Vincent, Nelson 133106
Watson Arts Centre, Watson .. 099733
Watson Crossley Community Museum,
Grandview 005800
Watson-Curtze Mansion, Erie Historical
Museum, Erie 048560
Watson Farm, Jamestown 049749
Watson-Guptill, New York 138485
Watson Museum, Rajkot 024151
Watson, B., Johannesburg 114892
Watson, G. & J., Turramurra .. 062346
Watson, G. & J., Williamstown . 062419
Watson, Gordon, London 090421
Watson, Peter, Armadale, Victoria 061043
Watson, Stuart J, Maidstone .. 127223
Watson and Son, Thomas,
Darlington 127078
Watsons, Heathfield 127143
Watson's & The Old Mill,
Wairarapa 084008
Watsons Bay Art Gallery, Watsons
Bay 099734

Watson's Creek Antiques, Kangaroo
Ground 061659
Watson's Mill, Manotick 006129
Watt Space Gallery, Newcastle . 099304
Watt, Elizabeth, Aberdeen 134324
The Watteau Society, London . 060270
The Watteau Society Bulletin,
London 139262
Wattebled, Xavier, Lille 125890
Watten Cane Furniture,
Singapore 085354
Wattenbach, Philippsthal 108392
Das Wattenmeerhaus,
Wilhelmshaven 022250
Watterott, Gilbert, Hausen ... 130327
Watters Smith Memorial, Lost
Creek 050420
Watters, Frank, Sydney 099661
Wattis Fine Art, Hong Kong .. 102015
Wattlebark, Mogo 099226
Watt's Antiques, Fochabers .. 089081
Watts Gallery, Compton, Surrey . 043798
Watts Towers Arts Center, Los
Angeles 050412
Watzke, Barbara, Aschaffenburg 074399
Watzl, Ludwigsburg 107886
Watzlawik, S., Regensburg ... 108475
Wauchope District Museum,
Wauchope 001625
Wauconda Township Museum,
Wauconda 054109
Waukesha County Museum,
Waukesha 054111
Wauman, Knokke-Heist 100629
Wave Gallery, Philadelphia ... 123719
Waveland Museum, Lexington . 050201
Wavelength Gallery, Falmouth . 117980
Waverley Antiques, Upper Largo 091548
Waverly, Falls Church . 127487, 144884
Waves, New York 095653
Wavriensia, Wavre 138608
Wawana, Maastricht 112675
Wawota and District Museum,
Wawota 007189
Wax Antiques, Anne and Lou,
London 090422
Wax Museum, Dublin 024677
Wax Museum, Santa Claus .. 052986
Wax Museum Český Krumlov,
Muzeum Voskových Figurín České
Historie, Český Krumlov 009334
Waxin, Marie-Thérèse, Roubaix . 072511
Way We Wore, Houston 093670
Way, R.E. & G.B., Newmarket . 144500
Way, Richard, Henley-on-Thames 144230
Wayfarer Books, Old Hall Bookshop,
Looe 144476
Wayland, Washington 125225
Wayland Historical Museum,
Wayland 054125
Wayne Art Center, Wayne ... 054133
Wayne Campbell Gallery, Toronto 101582
Wayne Center for the Arts,
Wooster 054414
Wayne County Historical Museum,
Richmond 052439
Wayne County Historical Society
Museum, Lyons 050481
Wayne County Historical Society
Museum, Wooster 054415
Wayne County Museum,
Honesdale 049483
Wayne, Arthur, Winnipeg 101762
Wayne, Neil, Belper 088213
Wayne, Shoshana, Santa Monica 124720
Wayne's World, Timaru 113121
Wayser, Saint-Ouen 105527
Waysi Museum, Fufeng 007585
Wayside Antiques, Duffield ... 088898
Wayside Antiques, Tattershall . 091397
Wayside Folk Museum, Zennor . 046267
Wayside Shop, Oklahoma City . 095855
Wayside Treasures, Philadelphia 096010

Wayville Latvian Museum, Brooklyn
Park 000897
Waywood, Byron Bay 098686
Waywood Furniture, Wellington . 133136
Wazee Deco, Denver 093187
Wazzau, Iris, Davos Platz 116336
We, Seoul 111784
Weald and Downland Open Air
Museum, Chichester 043744
Wear It Again Sam, San Diego . 096981
Weardale Museum, Weardale .. 046090
Weasel Pop Studio, Saint Paul . 124186
Weather Discovery Center, North
Conway 051516
Weatherell, Paul, Harrogate .. 089246
Weatherford, David, Seattle ... 097354
Weathersby, Virginia Beach ... 097631,
136784
Weatherspoon Art Museum, University
of North Carolina at Greensboro,
Greensboro 049219
Weaver, Blackheath 098606
Weaver, Tucson 136759
Weaver Gallery, Chester 117729
Weaver Gallery, Northwich ... 119024
Weaver Neave & Daughter,
London 135133
Weaver, Trude, London 090423
Weaver's Cottage, Kilbarchan . 044558
Weavers' Triangle Visitor Centre,
Burnley 043577
Weaving Craft Museum,
Fengyuan 042036
Web Fine Art, Basingstoke 117366
Webantik, Strasbourg 073561
Webb, Buffalo 092404
Webb, Winchester 091737, 119652,
135595
The Webb-Deane-Stevens Museum,
Wethersfield 054232
Webb House Museum, Newark . 051422
Webb, Dan F., Oakland 145129
Webb, Michael, Llangristiolus . 089680
Webb, Roy, Wickham Market . 091701
Webb's, Auckland ... 083659, 126525,
133075
Webbs Road Fine Art, London . 118820
Weber, Baltimore 092209
Weber, Firenze 131675
Weber, Fort Worth 093321
Weber, Saint Louis 096627
Weber & Bläuer, Lugano 087433
Andrea Weber & Andreas Fischer,
Dresden 075388
Weber-Schwenk, Petra, Castrop-
Rauxel 106619
Weber State University Art Gallery,
Ogden 051629
Weber, Alberto, Torino 111037
Weber, Britta, Goch 075967
Weber, Carola, Wiesbaden 108960
Weber & Assoc., Edith, New York 095654
Weber, Frank, Saarbrücken ... 078259
Weber, Gordian, Köln 076854
Weber, H. & L., Straubenhardt . 078490
Weber, Hans, Holzkirchen 130370
Weber, Helga Maria, Hamburg . 130297
Weber, Jamileh, Zürich 116943
Weber, Jean, Wiltz 111927
Weber, Joachim, Stockdorf ... 078479
Weber, Karin, Hong Kong 102016
Weber, L., Badem 074589
Weber, L.& M., Erkerode 075600
Weber, M., Frei-Laubersheim . 075789
Weber, Malavé von, Caracas .. 097833
Weber, Michael, Guldental ... 076070
Weber, Michael, Poole 119167
Weber, Milda, Wimmelbach .. 108960
Weber, Norbert, Eckernförde .. 106820
Weber, Peter, Trier 078623
Weber, Peter, Unterpleichfeld . 131108
Weber, Thomas, Niederzissen . 077705
Weber, W., Kaufungen 076672
Weber, W. & E., Mannheim ... 077218

Wikinger Museum Haithabu,
Stiftung Schleswig-Holsteinische
Landesmuseen Schloß Gottorf,
Busdorf 017476
Wik's Mynt & Kuriosa, Kil .. 086597
Wiktor, Tord, Stockholm 133938
Wilber Czech Museum, Wilber .. 054276
Wilberforce House, Kingston-upon-
Hull 044590
Wilbert, Stanley, Calgary 101132
Wilbrand, Dieter, Swisttal 108750,
137635
Wilbur D. May Museum, Reno .. 052418
Wilbur Wright Birthplace and
Interpretive Center, Hagerstown 049270
Wilbye, Jonathan, Kirkby
Stephen 134836
Wilce Trading, Reims 072363
Wilce, Christine, Le Touquet-Paris-
Plage 069307
Wilce, Christine, Neuville-sous-
Montreuil 070478
Wilcockson, Dr. John, Marburg . 077228
Wilczyński, Tomasz, Lublin 084458
Wild About Music, Austin 119989
Wild Art, Cape Town 114860
Wild Earth Images, Salt Lake
City 124246
Wild Geese Heritage Museum,
Portumna 024784
Wild Goose Antiques, Modbury . 090612
Wild Honey, Guildford 098960
Wild Oates Gallery, Doonan .. 098830
Wild Orchid Antiques, Richmond 096422
Wild Pitch, Portland 096327
Wild Strawberry-Muddy Wheel Gallery,
Albuquerque 119794
Wild Things, Denver 121068
Wild Walls Gallery, Bentleigh
East 098590
Wild Wings Gallery, Saint Paul .. 124187
Wild, Adolf, Lahr 107768
Wild, Alexander, Bern 143853
Wild y Cia, Alfred, Bogotá 102276
Wild, Eva Maria, Frankfurt am
Main 107004
Wild, Eva Maria, Zürich 116947
Wild, George, New York 136371
Wild, Rose, Seattle 097357
Wild, Wolfgang, Zürich 134317
Wilde, Art, Arrington 117318
Wilde-Meyer, Tucson 125035
Wilde, Chris, Harrogate 089247
Wilde, P.S., Toronto 064726
Wilde, Yvan de, Périgueux 072020
Wildeboer, Groningen 083124
Wildeboer, Toon, Hilversum .. 112626
Wildenauer, Hans, Friedenfels .. 075856
Wildenstein & Co., New York .. 123440
Wildenstein, Tokyo 111532
Wildenstein Institute, Paris ... 137267
Wilder, Hannover 141814
Wilder, Salzhemmendorf 142190
Wilder Memorial Museum, Strawberry
Point 053457
Wilderer-Museum Sankt Pankraz,
Sankt Pankraz 002631
Wilderness Reflections Gallery, Kansas
City 121597
Wilderness Road Regional Museum,
Newbern 051427
Wildfellner, Georg, Grieskirchen . 062593,
099882
Wildfowl Art Journal, Salisbury . 139561
Wilding, R., Wisbech . 091752, 135600
Wildlife Art, Ramona 139562
The Wildlife Art Gallery,
Lavenham 118302, 138230
Wildlife Education Centre,
Entebbe 042838
The Wildlife Gallery, Toronto ... 101584
Wildlife Museum, Ulaanbaatar .. 031556
Wildlife Wonderlands-Giant Earthworm
Museum, Bass 000826

Wildling Art Museum, Los Olivos 050419
Wildmeister, Veitshöchheim 078696
Wildner, Wolfgang, Passau 108379
Wildschut, Amsterdam 082723
Wildwood, Edmonton 101172
Wildwood, Fitzroy Falls 098890
Wildwood Auction House,
Wildwood 127762
Wildwood Book Rack, Norman . 145121
Wildwood Center, Nebraska City 051135
Wildwood Gallery, Bury Saint
Edmunds 117632
Wildwood Press, Saint Louis .. 124133,
138503
Wile Carding Mill Museum,
Bridgewater 005371
Wiles, A. Allen, Woodridge ... 062443
Wilfing, Josef, Salzburg 128123
Wilfinger Brüder, Wien 128237
Wilford & Assoc., Cleveland ... 092817
Wilford, H., Wellingborough ... 127349
Wilfrid Israel Museum of Oriental Art
and Studies, Kibbutz Hazorea . 024954
Wilhelm Busch – Deutsches Museum
für Karikatur & Zeichenkunst,
Hannover 018770
Wilhelm-Busch-Geburtshaus,
Wiedensahl 022208
Wilhelm-Busch-Gedenkstätte, Wilhelm-
Busch-Gesellschaft, Seesen . 021424
Wilhelm-Busch-Gesellschaft e.V.,
Hannover 059230
Wilhelm-Busch-Mühle,
Ebergötzen 017834
Wilhelm Busch Zimmer, Dassel . 017602
Wilhelm-Fabry-Museum, Hilden . 018945
Wilhelm-Friedemann-Bach-Haus, Halle,
Saale 018676
Wilhelm-Hack-Museum Ludwigshafen
am Rhein, Ludwigshafen am
Rhein 019805
Wilhelm-Kienzl-Museum, Schauplatz
Evangelimann, Paudorf 002441
Wilhelm Kienzl-Stüberl,
Waizenkirchen 002825
Wilhelm-Morgner-Haus, Soest . 021495
Wilhelm-Ostwald-Gedenkstätte,
Gerda und Klaus Tschira Stiftung,
Grimma 018540
Wilhelm-Panetzky-Museum,
Rammelsbach 020895
Wilhelm Wagenfeld Haus – Design
im Zentrum, Wilhelm Wagenfeld
Stiftung, Bremen 017376
Wilhelm Wagenfeld-Haus, Design im
Zentrum, Bremen 106587
Wilhelm-Zimolong-Gesellschaft e.V.,
Gladbeck 059231
Wilhelm, Eleonore J., Ludwigshafen
am Rhein 107890
Wilhelm, M., Aldingen 074336
Wilhelm, Otto, Frankfurt am Main 075782
Wilhelmietenmuseum, Huijbergen 032337
Wilhem Derix GmbH, Werkstätten
für Glasmalerei und Mosaik,
Düsseldorf 130045
Wilimzig, Ewald, Worpswede .. 108989
Wilk, Józef, Warszawa 113998
Wilk, M., Brühl 075162
Wilke, Nikolaus, Sinsheim 131024
Wilken, I., Rostock 108525
Wilkening, Ludmilla,
Aschaffenburg 105965
Wilkerson, New Orleans 095013
Wilkes, Minneapolis 122333
Wilkes Art Gallery, North
Wilkesboro 051536
Wilkie, Saskatoon 064517
Wilkie and District Museum,
Wilkie 007233
Wilkin County Historical Museum,
Breckenridge 047151
Wilkin, Elizabeth, Thorndon ... 083973
Wilkins, Brett, Lichfield 089630

Wilkins, Joan, Witney 091755
Wilkinson, Doncaster 127084
Wilkinson, London 090434, 090435,
118830, 135137, 135138
Wilkinson & Rhodes, San Antonio 096879
Wilkinson County Museum,
Woodville 054409
Wilkinson, Marcus, Grantham . 089158,
134732
Wilkinson, Marcus, Sleaford ... 091203,
135402
Wilkinson, Tony, Petworth ... 090859
Will Rogers Memorial Museums,
Claremore 047724
Will, Dieter, Ettlingen 075672
Will, Joël, La Chapelle-Bertrand 068914
Will, John, Virginia Beach 097632
Willa Cather State Historic Site, Red
Cloud 052397
Willard House and Clock Museum,
Grafton 049132
Willborg, J.P., Stockholm 086891,
133939, 138106
Willburn Antiques, Christchurch . 083730,
133089
Willcox & Nightingale, Penryn . 090810
Wille, Irmgard, Füssen 075873
Willem de Kooning Academie,
Hogeschool Rotterdam,
Rotterdam 056126
Willem Prinsloo Museum, Rayton 038638
Willemoesgårdens Mindestuer,
Assens 009856
Willem's Winkel, Middelburg ... 083317
Willems, Gerard, Hobart 061629, 099001
Willems, Louis, Bruxelles 128297
Willen, Jürg, Luzern .. 116572, 134172
Willenhall Museum, Willenhall
Historic Map Room and Museum,
Willenhall 046159
Willer, London 118831
Willer Brocante, Willer-sur-Thur 074260
Willi Dickhut Museum,
Gelsenkirchen 018356
Willi Sitte Galerie, Merseburg . 020037
Willi the Clockman, Lesmurdie . 061725
Willi, H.-P., Tübingen 142270
William, Ascott-under-Wychwood 088059
William & Joseph, New Orleans 122503
William A. Quayle Bible Collection,
Baker University, Baldwin City . 046691
William Art Space, Taipei 117014
The William Benton Museum of
Art, University of Connecticut,
Storrs 053440
William Blizard Gallery, Springfield
College, Springfield 053352
William Bonifas Fine Arts Center,
Escanaba 048563
William Booth Birthplace Museum,
Nottingham 045366
William Breman Jewish Heritage
Museum, Atlanta 046609
William Carey Museum, Leicester 044680
William Clark Market House Museum,
Paducah 051795
William Cullen Bryant Homestead,
Cummington 048057
William Fehr Collection, Iziko
Museums of Cape Town, Cape
Town 038510
William H. Harrison Museum/
Grouseland, Vincennes 053868
William H. Van Every jr. and Edward
M. Smith Galleries, Davidson College,
Davidson 048121
William Hammond Mathers Museum,
Bloomington 047018
William Heath Davis House Museum,
San Diego 052884
William Henry Steeves Museum,
Hillsborough 005886
William Holmes McGuffey Museum,
Oxford 051780

William Howard Taft National Historic
Site, Cincinnati 047713
William Humphreys Art Gallery,
Kimberley 038590
William King Regional Arts Center,
Abingdon 046279
William Lamb Studio, Montrose
Museum, Montrose 045223
William M. Colmer Visitor Center,
Ocean Springs 051615
William McKinley Presidential Library
and Museum, Canton 047376
William Morris Gallery and Brangwyn
Gift, London 045055
The William Morris Society,
London 045056
William Pryor Letchworth Museum,
Castile 047423
William Rea Museum,
Murfreesboro 051054
William S. Hart Museum, Natural
History Museum of Los Angeles
County, Newhall 051441
William S. Webb Museum of
Anthropology, Lexington 050202
William Scarbrough House, Ships of
the Sea Museum, Savannah .. 053068
William Street Gallery, South
Yarra 099571
William Trent House, Trenton ... 053681
William Tyndale Museum,
Vilvoorde 004032
William Weston Clarke Emison
Museum of Art, DePauw University,
Greencastle 049199
William Whipple Art Gallery, Soutwest
Minnesota State University,
Marshall 050649
William Whitley House, Stanford 053375
William Woods University Art Gallery,
Fulton 048959
William, Joseph, Portland 123934
William, Robert, Vancouver ... 064845
William'S, Barcelona 085680
Williams, Houston 121433
Williams & Son, London 090436
Williams, Mornington 099246
Williams & Sons, Richmond,
Surrey 090952, 119222
Williams, Salt Lake City 124247
Williams, Tulsa 097600, 127748
Williams, Wellington .. 084059, 113818
Williams & Co., Toronto 064727
Williams American Art, Nashville 122356
Williams College Museum of Art,
Williamstown 054295
Williams County Historical Museum,
Montpelier 050962
Williams, Adam, New York 123441
Williams, Brian, Charlotte 135748
Williams, David, London 144471
Williams, E & B, Levallois-Perret 069391
Williams, Ehoodin, Cincinnati .. 120668
Williams, George, Kells 079529
Williams & Co., H., Toronto .. 125657
Williams, Huw, Porthmadog .. 090887
Williams, Jean, Seattle 097358
Williams, Melvin D ., Pittsburgh 096178
Williams, Nigel, London 144472
Williams, Peter, Boston 120212, 135719
Williams, Philip, New York ... 123442
Williams, Scott, Richmond 096423
Williams, Steve, Jacksonville .. 121553
Williams, Thayne A., Baltimore . 092210
Williams, Thomas, London ... 090437
Williams, Tom, Calgary 140304
Williamsburg Decorative Arts Series,
Williamsburg 139563
Williamson, New Orleans 095014
Williamson Art Gallery and Museum,
Birkenhead 043369
Williamson County Historical Society
Museum, Marion 050622
Williamson Sangma State Museum,

Register der Institutionen und Firmen

Zuckmantler Heimatstube, Bietigheim-Bissingen
– Žytomyrs'kyj Literaturno-memorial'nyj Muzej V.G.